THE TOLEDO MUSEUM OF ART
European Paintings

THE TOLEDO MUSEUM OF ART · TOLEDO · OHIO

Distributed by Pennsylvania State University Press

Library of Congress Catalog Card Number: 76–24500
ISBN (clothbound): 0–271–01249–8
ISBN (paperbound): 0–271–01248–x

Distributed by Pennsylvania State University Press,
University Park and London

Designed by Harvey Retzloff
Photography by Raymond S. Sess and Carl J. Schulz
Composition by Typoservice Corporation, Indianapolis, Indiana
Printed in the United States of America by
The Meriden Gravure Company, Meriden, Connecticut

First Printing 1976

This catalogue is supported in part by grants from
The Ford Foundation and the National Endowment for the Arts,
a federal agency.

Contents

List of Color Plates

Introduction

This catalogue of European paintings is published in celebration of the 75th anniversary of the founding of The Toledo Museum of Art. It is appropriate that a major publication of the Museum's anniversary year should be devoted to European paintings, as they form a significant portion of the Museum's collections.

This is the second catalogue of European paintings to be published by the Museum. The first, published in 1939, included 175 paintings. This catalogue describes and illustrates 444 paintings. The considerable growth of the collection over the years can be easily followed, since the first two digits of the accession numbers indicate the year of acquisition.

HISTORY OF THE MUSEUM

The Toledo Museum of Art was founded April 18, 1901 by a small group of citizens under the leadership of Edward Drummond Libbey, Toledo industrialist, whose successful glass company and its successor companies have formed the economic cornerstone of this city for many years.

The newly founded Museum had no collections and depended on borrowed works of art for its early exhibitions. Acquisitions during the first 25 years were few, as the young Museum used its meager funds and small staff to establish itself as a significant educational institution in its community.

Mr. and Mrs. Libbey formed a personal collection of a limited number of important works of art in the first two decades of the century. Their collection, which included pictures by Rembrandt, Holbein, Turner, Constable and others, came to the Museum after Mr. Libbey's death in 1925. It was also disclosed at that time that Mr. Libbey had left

his residuary estate in trust for the Museum, after providing for his widow, as they had no children.

An unusual and generous clause in Mr. Libbey's will directed that annual income from his estate be used for art acquisitions, with the exception that up to 50 percent could be used for Museum operation if necessary. Mr. Libbey had hoped that all income from his estate could be used to acquire art, and that other funds could be found to operate the Museum's extensive programs and to maintain its building.

Mr. Libbey's hope has yet to be achieved. While generous annual contributions by an ever-increasing number of corporate and individual donors have enabled the Museum to continue its educational services as well as to acquire works of art, a portion of Libbey funds is also used for operations. The Museum receives no direct tax support.

Although Mr. Libbey had given some works of art to the Museum during his lifetime, such as the Zurbarán, and just before his death the portrait of *Antonin Proust* by Manet, it was only in the years subsequent to 1926 that substantial funds for art acquisitions became available from his estate. Florence Scott Libbey, his widow, continued her interest in the Museum, provided funds during her lifetime for substantial additions to the Museum building, and bequeathed her estate to the Museum at her death in 1938. She also provided that 50 percent of her estate's income be used for the acquisition of works of art; these funds have generally been used to acquire decorative arts and American paintings, following her personal interests.

While other generous donors, notably Arthur J. Secor, Mrs. C. Lockhart McKelvy, Mr. and Mrs. William E. Levis and others have given European paintings or provided funds for such acquisitions, the majority of the paintings in this catalogue were acquired with funds bequeathed by Mr. Libbey. So extensive are these acquisitions that unless otherwise indicated in the catalogue, all paintings have been acquired with Libbey funds and are designated as gifts of Edward Drummond Libbey, the Museum's founder and first president.

EARLY YEARS

The years between 1926 when Libbey funds first became available, and 1939 when the Museum's first catalogue of European paintings was published, witnessed the growth of the collections in two principal directions: Italian Renaissance art and French Impressionist paintings.

Under the perceptive guidance of Blake-More Godwin, then the Museum's director, and William A. Gosline, Jr., then its president, most of the paintings in these two categories were acquired at a time when it was still possible to do so at reasonable prices. The great tondo by Piero di Cosimo, the Pesellino, the Giovanni Bellini, paintings by Van Gogh, Gauguin, Monet, Renoir and many others brought important masterpieces as well as the glorious light and color of Impressionist paintings to the Museum's galleries.

By deeds of gift in 1926 and 1933, Arthur J. Secor, the Museum's second president, gave his extensive collection of European and American paintings, including a large num-

ber of Barbizon School and Dutch 19th century pictures, as well as some Dutch 17th century and English 18th century paintings. This remains the largest private collection of paintings ever to be received by the Museum and, together with the Libbey gifts of 1926, the only appreciable number of European paintings not acquired by the Museum's professional staff.

POST-WAR GROWTH

Following the lean years between 1941 and 1946, when practically no European art was acquired, collecting began again in 1946 with the purchase of El Greco's *Agony in the Garden,* inaugurating a 30-year period in which the collections have almost tripled. Sizeable funds from the Libbey estates reserved for art acquisitions had accumulated during the war years. These funds, together with substantially increased annual income from the same sources, provided the opportunity for major post-war growth at a time when many great works of European art came into the market at prices not yet inflated by the decline in value of most international currencies.

The past 30 years have seen a rate of growth in the Museum's collections unprecedented before and unlikely to occur again. Although a substantial portion of available art funds has been allocated for European paintings, almost all the sculpture, furniture, silver and ceramics now in the Museum, most of the objects in the classical collection, and many American paintings were also acquired during these post-war years.

It has been an enjoyable adventure to be associated with this Museum for these 30 years. Arriving in 1946 after completion of military service in World War II, I was given the unusual opportunity to play a major part in the acquisition of much of this art and many of the paintings described in this catalogue. Planning a program to develop and implement the post-war growth of the Museum's collections has been for me a primary responsibility for three decades, initially as the Museum's associate director and subsequently as its director and chairman of its Art Committee.

It seemed apparent in those early post-war years that major areas in the European painting collection which should be developed were Dutch and Flemish 17th century painting where Toledo had only a few examples, French 17th and 18th century painting where the Museum had only one picture, and Italian 17th and 18th century painting where we owned only two pictures. These were categories of art not extensively sought at that time and therefore reasonably valued. The consequent search for art for this Museum has involved extensive negotiations with collectors and dealers, and considerable travel here and abroad, enabling us to develop collections balanced to complement earlier acquisitions.

When significant opportunities in other categories occurred, we have also acquired pictures of quality such as the rare Italian Renaissance paintings by Signorelli, early Flemish pictures such as the Morrison Triptych and the three panels by Gerard David, as well as several important French Impressionist and Post-Impressionist paintings and some 18th century English pictures.

During these years our policy has been to select carefully paintings of high quality in excellent condition. We have not hesitated to acquire pictures out-of-fashion, nor have we sought only great names. The primary requisite has always been the quality of the picture regardless of the current reputation of its author. The collection of European paintings is not large nor is it intended to be encyclopedic. It is instead a carefully selected group of pictures chosen for quality and condition, within the necessary limits of availability and financial resources.

THE CATALOGUE

Any collection catalogue is a complex undertaking to which many contribute; and it is important to understand its intent. This catalogue contains in succinct form as much information as we have at this time on each painting acquired through June 30, 1976. We have attempted to refer to all significant published or written opinions, have weighed the available evidence and have finally based attributions on our own judgment.

Entries in a catalogue such as this can only be summaries of available information. We have attempted to present this information as objectively as possible. The catalogue is the result of continuous research by many members of the Museum staff, as well as of the generously shared knowledge of many scholars in this country and abroad. Entries were prepared by members of the curatorial staff and a number of Museum interns and assistants over a period of some years.

Decisions concerning attribution have been made by an Editorial Committee of three, the director as chairman, the associate director and the chief curator. In the few instances where there was a difference of opinion among members of the Committee, the final decision was made by the director, who is charged by the Museum's trustees with responsibility for the Museum and its collections and therefore must accept responsibility for final decisions on the catalogue content.

Among many who have collaborated in the preparation of this catalogue, grateful acknowledgment should be made of the following: Roger Mandle, associate director, who has given enthusiastic guidance to this project during the past two years; William J. Chiego, former associate curator of European paintings, who assisted in planning the basic format for the catalogue and who supervised research during his two-year tenure here; William Hutton, chief curator, who continued supervision of research after the departure of Mr. Chiego, and who is responsible for the literary style and consistency of the entries; Anne O. Reese, librarian and Joan L. Sepessy, assistant librarian, who have been of great assistance to the curators and researchers during the years of preparation of the catalogue; Patricia Whitesides, registrar, who is in charge of the Museum's documentary files and photographs; Darlene Lindner, curatorial secretary, who has typed every entry not once but several times and who has helped so much to establish consistency of entries.

Roger M. Berkowitz, assistant curator of decorative arts, and Patrick J. Noon, curatorial intern, have made major contributions through their support and assistance in many

phases of research. Many Museum interns have carried out research and have drafted various entries. These include Dan Ewing, who contributed considerable research and writing and William R. Olander, a special research assistant for two summers. Several interns in education also assisted with research. These included Stephanie J. Barron, Tara Devereux, Harold B. Nelson, Beth Pilliod, Danielle Rice and Nancy J. Sher. Carol Orser has been most helpful in reading proof, as have others already mentioned. My secretary, Elaine Dielman, has been endlessly helpful to all of us in coordinating activities related to this catalogue.

We also acknowledge with gratitude the many museum colleagues, collectors, scholars, librarians and art dealers in this country and abroad who have generously shared their specialized knowledge. These are too numerous to begin to acknowledge by name here, but their names appear in the individual catalogue entries. We are indebted to many libraries in this country, especially the Frick Art Reference Library and the libraries of The Metropolitan Museum of Art, the Fogg Art Museum, The Cleveland Museum of Art and The Detroit Institute of Arts, and in Europe, the Rijksbureau voor Kunsthistorische Documentatie, The Hague, and the library of the Victoria and Albert Museum, London. Without their assistance, the bibliographical information would be far less complete.

The initial stimulus for the catalogue was provided by a grant from The Ford Foundation in 1963, which was later generously supplemented. A substantial grant from the National Endowment for the Arts in 1975 assured additional funds for research and publication. Funds to match these grants were provided by the Museum.

To all institutions and individuals mentioned above and to many others we express our gratitude and appreciation. To the Trustees of this Museum who have always supported the acquisitions of art described in this catalogue and who have been helpful in so many ways during the long period of preparation of the catalogue, we express deepest thanks for their continuing support and encouragement.

OTTO WITTMANN
Director

Toledo, Ohio
September 1, 1976

Explanatory Notes

CATALOGUE ORDER: The catalogue contains three sections:

1. Catalogue entries, listed alphabetically by artist.
2. Illustrations of each painting for which there is a catalogue entry, arranged by country and chronologically within each country.
3. A reserve section of approximately 80 secondary paintings in a separate section following the plates, listed alphabetically and illustrated.

CATALOGUE ENTRIES: Entries in the first section of the catalogue are arranged alphabetically according to the surnames or commonly used names of artists, or according to nationalities where artists are unknown. Cross-references are given for certain alternative names. Names with the word Master are listed under that heading. Dutch and German names are listed by the surname proper (*e.g.* GOGH, not VAN Gogh). French names with *Le* or *La* are listed by these prefixes (*e.g.* LE NAIN, not NAIN). Where there are two or more works by the same artist, entries appear in chronological order, or in order of accession numbers.

ILLUSTRATIONS: All paintings are illustrated and each catalogue entry indicates the plate number. Plates are arranged by country and chronologically within each of these national groups: Italy, Spain, Germany, Netherlands, France, Britain.

RESERVE SECTION: Approximately 80 paintings have been placed in a reserve section of secondary pictures. This section follows the plates. It is also arranged alphabetically by surname, and each entry contains a small illustration.

MEDIUM: Works in this catalogue are defined as paintings on the basis of their medium (chiefly oil or tempera) and support (chiefly canvas or wood panel). A few pastels and watercolors are included because their scale brings them into closer relationship with paintings than with works on paper.

ACCESSION NUMBERS: The first two digits indicate the year of acquisition; the last digits, the serial number within the year (*e.g.* 76.1 indicates the first work of art acquired in 1976).

DIMENSIONS: The measurements represent stretcher or panel size unless otherwise indicated. These are given in inches, followed by centimeters in parentheses. Height precedes width.

SIGNATURES AND INSCRIPTIONS: Transcribed as accurately as possible, virgules indicating breaks between lines. Cited inscriptions other than on the faces of paintings are those believed to be in the artist's hand unless otherwise noted.

RIGHT AND LEFT: Unless otherwise stated, these terms indicate the spectator's right and left.

COLLECTIONS: Known owners are listed chronologically. Dealers' names and auction sales appear in parentheses. Inclusive dates indicate known periods of ownership.

EXHIBITIONS: Only those significant for their subject or scholarship or for evidence of dating or early ownership are listed. Cities are omitted if clearly contained in museum names. The English spelling is given for the names of foreign cities.

REFERENCES: These are selective. In general, entries include early references, standard *catalogues raisonnés* and monographs, specialized studies and critical commentaries or analyses. The complete issue of *Apollo* magazine for December, 1967 was devoted to articles on the collections of this Museum. References to this issue of *Apollo* are not specifically indicated in this catalogue.

ATTRIBUTIONS: Where the painting is considered autograph, the painter's name is used. If the artist's workshop is thought to be involved, the term "workshop of" is used. Where there is some reasonable doubt that the artist executed the picture, the term "attributed to" is used. "Follower of" indicates the work is not considered to be by the artist, and may not necessarily be contemporary with him.

SOURCES: Unless otherwise indicated, all paintings accessioned through 1926 were given or bequeathed by Edward Drummond Libbey, while those accessioned after 1926, unless otherwise indicated, were acquired by the Museum with funds bequeathed by him. Following his wishes, such acquisitions are designated Gift of Edward Drummond Libbey.

ABBREVIATIONS: These bibliographical and other abbreviations have been used:

B. Fredericksen and F. Zeri, *Census:* B. Fredericksen and F. Zeri, *Census of Pre-Nineteenth Century Italian Paintings in North American Collections,* Cambridge (Mass.), 1972.

C. Hofstede de Groot: C. Hofstede de Groot, *A Catalogue Raisonné of the Works of the Most Eminent Dutch Painters of the Seventeenth Century Based on the Work of John Smith,* London, 1907–28, 10 vols.

J. Smith: J. Smith, *A Catalogue Raisonné of the Works of the Most Eminent Dutch, Flemish and French Painters,* London, 1829–37, 8 vols.

W. Stechow: W. Stechow, *Dutch Landscape Painting of the Seventeenth Century,* London, 1966, 2nd ed., 1968.

Thieme-Becker: H. Thieme and F. Becker, *Allgemeines Lexikon der bildenden Künstler,* Leipzig, 1907–50.

R.A.: Member of the Royal Academy.

A.R.A.: Associate member of the Royal Academy.

Catalogue

ANDREA DI BARTOLO

Ca. 1370–1428. Italian. Active in Siena, where he studied with his father, Bartolo di Fredi. Influenced by the Lorenzetti and Taddeo di Bartolo, Andrea's work has often been confused with paintings by both the latter and by his own father.

The Crucifixion PL. 4

[After 1400] Tempera on wood panel
19-11/16 x 33-3/16 in. (50 x 84.3 cm.)

Acc. no. 52.103

COLLECTIONS: Georges Chalandon, Paris; (Otto Wertheimer, Basel, by 1952); (Knoedler, New York).

REFERENCES: B. Berenson, *The Central Italian Pictures of the Renaissance,* New York, 1909, p. 141; "An Early Sienese Painting of The Crucifixion," *Toledo Museum of Art Museum News,* XVI, Apr. 1953, pp. [1–2], repr.; B. Berenson, *Italian Pictures of the Renaissance: Central Italian and North Italian Schools,* London, 1968, I, p. 8; B. Frederickson and F. Zeri, *Census,* pp. 6, 292, 641.

Although attributed by Berenson (1909) to Bartolo di Maestro Fredi and originally by the Museum to Taddeo di Bartolo, there is now general agreement, including Berenson (1968), that the Toledo panel is by Andrea di Bartolo. According to G. Coor-Aschenbach (letter, 1955), a workshop hand was probably also involved. She dated this picture after 1400, when Andrea was strongly influenced by Taddeo di Bartolo. F. Zeri suggests that Toledo's *Crucifixion* was the central part of a predella, and may be from the same series as five panels in the Edoardo Ruffini collection, Rome (in letter from Baetjer, June 1976).

BALTHASAR VAN DER AST

1593/94–1657. Dutch. Born in Middelburg. Studied and worked with his brother-in-law, the flower painter Ambrosius Bosschaert. In 1619 entered the guild of painters at Utrecht, where he lived until 1632, when he settled in Delft.

Fruit, Flowers and Shells PL. 94

[1620s] Oil on wood panel
21¾ x 35⅛ in. (55.2 x 89.2 cm.)
Signed lower left: B. vander.ast.

Acc. no. 51.381

COLLECTIONS: Reginald Marnham, Westerham, Kent; (Eugene Slatter, London, by 1945).

EXHIBITIONS: London, Slatter, *Masterpieces of Dutch Painting in the Seventeenth Century,* 1945, no. 25; Toledo Museum of Art, *The Age of Rembrandt,* 1966, no. 99, repr.

REFERENCES: L. J. Bol, "Een Middelburgse Brueghelgroep (Part III: In Bosschaerts Spoor, 1. Balthasar van der Ast)," *Oud Holland,* LXX, 1955, p. 142, n. 26; L. J. Bol, *The Bosschaert Dynasty,* Leigh-on-Sea, 1960, p. 83, no. 104; P. Mitchell, *European Flower Painters,* London, 1973, p. 40, fig. 40.

The basket of fruit, Chinese Wan-li porcelain vase, animals and shells, alone or variously combined, often appear in Van der Ast's pictures. The same vase is shown in other still life paintings of the 1620s (dated 1620 and 1621, Rijksmuseum, Amsterdam; 1623, Ashmolean Museum, Oxford). Although Van der Ast's style changed little during his career, it is likely the Toledo picture was painted during this decade, his most active period.

The porcelain, parrot and shells (from the Indian and South Pacific Oceans, except one from the Mediterranean) were natural and man-made rarities that fascinated contemporaries, who often combined scientific and artistic collecting interests.

HENDRIK AVERCAMP

1585–1634. Dutch. Baptized in Amsterdam; lived in Campen. His style was based on that of the Flemish followers of Pieter Brueghel the Elder. Specialized in winter skating scenes. His nephew, Barent Avercamp, was his pupil and imitator.

Winter Scene on a Canal PL. 93

[Ca. 1615] Oil on wood panel
18⅞ x 37⅝ in. (47.6 x 95.5 cm.)
Signed center left (on tree): HA (in monogram)

Acc. no. 51.402

COLLECTIONS: Augustus II, Elector of Saxony and King of Poland (died 1733); Countess Kosciencka, Poland; (Duits, London).

EXHIBITIONS: Paris, Orangerie, *Le paysage hollandais au XVIIe siècle,* 1950, no. 2, repr.; Toledo Museum of Art, *Dutch Painting, The Golden Age,* 1954, no. 1, repr.

REFERENCES: J. Rosenberg, S. Slive and E. ter Kuile, *Dutch Art and Architecture, 1600 to 1800,* Harmondsworth, 1966, p. 145, pl. 121A.

The chronology of Avercamp's work is unclear because his style changed relatively little and few pictures bear

dates. This picture is dated about 1615 on the basis of the costumes.

BARTOLO (*see* ANDREA)

POMPEO BATONI

1708–1787. Italian. In 1727 left his native Lucca for Rome, where he studied antique sculpture, Raphael and the Old Masters. Batoni painted religious, mythological and classical subjects, though from the 1740s until his death, he was best known for portraits of noblemen on the Grand Tour. His work represents the transition of Roman painting from baroque to neoclassical style.

The Madonna and Child in Glory　　　PL. 31

[Ca. 1747] Oil on canvas
46½ x 24 in. (118 x 61 cm.)

Acc. no. 63.5

COLLECTIONS: Merenda collection, Forlì; (Colnaghi, London).

REFERENCES: E. Casadei, *La città di Forlì e i suoi dintorni*, Forlì, 1928, p. 382, repr. p. 381; L. Marcucci, "Pompeo Batoni a Forlì," *Emporium*, XXII, Apr.–June 1944, p. 95, n. 1 (no. 5); B. Fredericksen and F. Zeri, *Census*, pp. 20, 341.

This painting is either a devotional picture, or a *modello* for a larger unknown or unexecuted altarpiece.

A. M. Clark dated this picture ca. 1745 (letter, Mar. 1963). This is confirmed, Clark advises (letter, Feb. 1976), by the recent appearance on the London art market of a signed oil sketch for this composition bearing the artist's dated (1747) authentication on the back of the canvas. The Toledo canvas was one of several dozen Batonis owned by the Merenda family of Forlì, whose collection of 16th, 17th and 18th century art was formed in the 1730s and 40s.

Four red chalk drawings are related to this composition: the angel playing the recorder at the left (National Gallery of Scotland, inv. no. D781); the pointing angel at the upper left (private collection, U.S.A.); the figure of the Madonna, and hand and drapery studies (Armando Neerman, London); and studies of the head of the Child, including the two angels to the right of the Madonna (Witt Collection, Courtauld Institute, London, no. 4703).

SIR WILLIAM BEECHEY

1753–1839. British. Lived in Norwich early in his career; settled in London, 1787. Studied in Royal Academy schools, 1792. Elected A.R.A. in 1793, the year he was made Portrait Painter to the Queen, and R.A. in 1798.

The Dashwood Children　　　PL. 322

[Ca. 1791] Oil on canvas
71¾ x 72 in. (182.2 x 182.8 cm.)

Acc. no. 48.61

COLLECTIONS: Sir Henry Watkin Dashwood, 3rd Bt., and descendants, Kirtlington Park, Oxfordshire; Sir Robert Henry Seymour Dashwood, 7th Bt., Duns Tew Manor, Oxford; (Christie, London, July 12, 1946, lot 78); (Frost and Reed, London); (Arthur Tooth and Sons, London).

EXHIBITIONS: London, Royal Academy, 1791, either no. 127 or no. 257.

REFERENCES: W. Roberts, *Sir William Beechey, R.A.*, London, 1907, pp. 222, 247; E. Waterhouse, *Painting in Britain, 1530 to 1790*, London, 1953, p. 227.

The children are those of Sir Henry Watkin Dashwood, and identified as (from left to right) Charles, Anna, George (afterwards 4th Bt.) and Henry (died in 1803, before his father). This painting hung in the dining room of Kirtlington Park (now in the Metropolitan Museum of Art) as seen in a watercolor (ca. 1891) by Susan Alice Dashwood, daughter of Sir Henry William Dashwood, 5th Bt. (repr. *Connoisseur*, CXXXVIII, Oct. 1956, p. 1).

GIOVANNI BELLINI

1430/31–1516. Italian. Born in Venice, the son of the painter Jacopo Bellini. Trained by his father and influenced by his brother-in-law Andrea Mantegna. First recorded in Venice in 1459. Collaborated with his father and brother Gentile on an altarpiece, now lost, for the Duomo in Padua, reportedly signed and dated 1460. In 1479, with the departure of Gentile to Constantinople, appointed to direct the work on the historical paintings for the Doge's Palace in Venice. From that date, employed continuously by the state, churches and private patrons. Primarily a painter of religious pictures, Giovanni exerted a strong influence on Giorgione and Titian.

Christ Carrying the Cross　　　PL. 10

[Ca. 1503] Oil on wood panel
19½ x 15 ¼ in. (49.5 x 38.7 cm.)

Acc. no. 40.44

COLLECTIONS: Taddeo Contarini, Venice, by 1527; Marquis de Brissac, Paris; Marquise de La Châtre, Paris, early 19th century; Comte Louis de Brissac, Paris; Henriette de Lorge (née de Brissac), Paris; Duc Robert de Lorge, Paris; (Hans Wendlend, Switzerland); (Jacob M. Heimann, New York).

EXHIBITIONS: Toledo Museum of Art, *Four Centuries of Venetian Painting*, 1940, no. 6, repr. (cat. by H. Tietze).

REFERENCES: T. Frimmel, *Der Anonimo Morelliano (Marcanton Michiel's Notizia d'opere del disegno)*, Vienna, 1888, p. 88; G. M. Richter, "Christ Carrying the Cross by Giovanni Bellini," *Burlington Magazine*, LXXV, Sep. 1939, pp. 94–7, repr.; H. Tietze, "Bellini's Christ Acquired," *Toledo Museum of Art Museum News*, June 1940; P. Hendy and L. Goldscheider, *Giovanni Bellini*, London, 1945, p. 33, pl. 85; B. Berenson, *Italian Pictures of the Renaissance: Venetian School*, I, New York, 1957, p. 34; F. Heinemann, *Giovanni Bellini e i Belliniani*, Venice, 1962, no. 151, fig. 91; R. Pallucchini, *Giovanni Bellini*, Milan, 1962, pp. 92, 152–53, fig. 160; S. Bottari, *Tutta la pittura di Giovanni Bellini*, Milan, 1963, II, p. 30; F. Gibbons, "Practices in Giovanni Bellini's Workshop," *Pantheon*, XXIII, May–June, 1965, pp. 149–50, fig. 5 (as workshop); S. Ringbom, "Icon to Narrative: the Rise of the Dramatic Close-up in Fifteenth Century Devotional Painting," *Acta Academiae Aboensis*, XXXI, 1965, pp. 149–50, 152, fig. 120; G. Robertson, *Giovanni Bellini*, Oxford, 1968, p. 124, pl. CXIIa; R. Ghiotto and T. Pignatti, *L'opera completa di Giovanni Bellini detto Giambellino*, Milan, 1969, no. 156; B. Fredericksen and F. Zeri, *Census*, pp. 23, 286 (as school of Bellini); P. Hendy, *European and American Paintings in the Isabella Stewart Gardner Museum*, Boston, 1974, pp. 20, 22.

This painting was unknown to scholars until Richter published it as an autograph work by Bellini. With the exception of Gibbons and Fredericksen and Zeri, it is now generally accepted as the work by Giovanni mentioned by Marcantonio Michiel in 1527 as in the Palace of Taddeo Contarini at Venice. Richter dated the panel about 1510, although Tietze convincingly argued for a date about 1505, noting the softness of the draperies and the subtle color scale which are closer to the S. Zaccaria altarpiece dated 1505 than to work done after then under the influence of Dürer. Tietze also disputed Richter's view that the Toledo painting is after Giorgione's *Carrying of the Cross* in S. Rocco, Venice, as he believed it was the model for it. More recently, Heinemann noted that a copy by Marco Palmezzano is signed and dated 1503, which suggests a possible *terminus ante quem* for the Toledo painting. Robertson, who believes the Toledo

painting is the only autograph version known, suggested that Bellini may have painted an earlier version in the 1490s.

The importance of the Toledo picture is proven by the many copies of it. Heinemann lists 55, including the painting in the Isabella Stewart Gardner Museum, Boston, variously attributed to Giorgione, Palma Vecchio and a follower of Bellini, and another in the Accademia dei Concordi, Rovigo, which was formerly identified as the Contarini Bellini.

According to Ringbom, this composition is an original type of non-narrative devotional image that originated in Milan at the end of the 15th century, and subsequently developed by Bellini in this painting.

AMBROSIUS BENSON

Active 1519–1550. Flemish. Originally from Lombardy. In Bruges by 1519, when he entered the painters' guild; remained there until his death.

Portrait of a Woman　　　　　　　　　　PL. 80

[Ca. 1525–30] Oil on wood panel
16 x 10⅝ in. (40.6 x 27 cm.)

Acc. no. 50.239

COLLECTIONS: Robert Walpole, 1st Earl of Orford; Horace Walpole, 4th Earl of Orford, Strawberry Hill, Twickenham; Anne Seymour Damer, Strawberry Hill; Dowager Countess of Waldegrave, Strawberry Hill; George, 4th Earl of Waldegrave, Strawberry Hill (George Robins, Strawberry Hill, 1842, p. 197, lot 31); George Tomline, Orwell Park, Ipswich; George Pretyman, Orwell Park (Christie, July 28, 1933, lot 20, repr.); (Frank Sabin, 1933); (D. A. Hoogendijk, Amsterdam).

EXHIBITIONS: London, Guildhall Art Gallery, *Exhibition of Works by Flemish and Modern Belgian Painters*, 1906, no. 63; London, Royal Academy, *Works by the Old Masters*, 1908, no. 5.

REFERENCES: H. Walpole, *Catalogue of Pictures and Drawings in the Holbein Chamber at Strawberry Hill*, 1760; H. Walpole, *Anecdotes of Painting in England*, London, 1762, (1849 ed., I, p. 94); H. Walpole, *A Description of the Villa of Mr. Horace Walpole . . . at Strawberry Hill*, London, 1784, (1964 reprint, p. 44); M. J. Friedländer, *Die Altniederländische Malerei*, Leyden, 1934, XI, no. 293; G. Marlier, *Ambrosius Benson et la peinture à Bruges au temps de Charles-Quint*, Damme, 1957, p. 246, no. 128, pl. LXVII; M. J. Friedländer (ed. H. Pauwels), *Early Netherlandish Painting*, New York, 1974, XI, no. 293, pl. 182.

This portrait was attributed to Benson by both Fried-länder and Marlier, the latter citing it as the masterpiece among Benson's portraits of sitters in prayer, probably originally united with a devotional panel to form a dip-tych or triptych.

At Strawberry Hill the painting was placed in the Hol-bein Chamber, as it was then considered a portrait of Catherine of Aragon by Holbein. The sitter has also been called Louise of Savoy, an equally spurious identi-fication of uncertain origin.

The painting was engraved in 1743 by Houbraken for Birch and Vertue's *Illustrious Heads* as a portrait of Catherine of Aragon by Holbein.

NICOLAES BERCHEM

1620–1683. Dutch. Son of the still life painter Pieter Claesz. Active chiefly in Haarlem, where he was born. Studied with his father and Jan van Goyen, among oth-ers. Entered the Haarlem painters' guild in 1642. In Rome 1642/43–45, a visit which deeply influenced his style. His pictures are mostly Italianate landscapes seen through a golden haze and peopled with travelers or Arcadian shepherds and their flocks, and he is the prin-cipal Dutch painter of Italian pastoral scenes. He was highly productive and versatile, and also made a num-ber of etchings.

Pastoral Landscape PL. 117

[1649] Oil on wood panel
27½ x 32⅞ in. (69.9 x 84 cm.)
Signed and dated lower left: Berighem 1649

Acc. no. 55.82

COLLECTIONS: Charles Scarisbrick, Scarisbrick Hall, Lan-cashire (Christie, London, May 11, 1861, lot 207); Dela-pierre, 1861–63); René Beller, France; (J. Kugel, Paris); (Nystad, The Hague, 1955).

REFERENCES: W. Roberts, *Memorials of Christie's (1766–1896)*, London, I, 1897, p. 193; C. Hofstede de Groot, IX, no. 225a (as perhaps identical with no. 227a); E. Schaar, *Studien zu Nicolaes Berchem*, unpublished Ph.D. dissertation, Cologne University, 1958, p. 27; W. Stechow, "Über das Verhältnis zwischen Signatur und Chronologie bei einigen holländischen Künstlern des 17. Jahrhunderts," *Festschrift für Dr. h.c. Eduard Traut-scholdt*, Hamburg, 1965, p. 114, fig. 62 (detail).

Schaar groups this landscape with others painted about 1647–49 which are characterized by high mountains and prominent figures.

This painting and Hofstede de Groot no. 227a are, in fact, not identical because the sizes are different.

ABRAHAM VAN BEYEREN

1620/21–1690. Dutch. Born in The Hague. Possibly a pupil of the still life painter Pieter de Putter. Later, he was influenced by J. D. de Heem. In Leyden, 1639; re-turned to The Hague, 1640. Later in Delft, again in The Hague, Amsterdam, Alkmaar, and finally in Overschie, near Rotterdam. He was one of the chief masters of the mature phase of Dutch still life painting.

Still Life with a Wine Ewer PL. 126

[After 1655] Oil on canvas
31¼ x 25 in. (79.3 x 63.5 cm.)
Signed lower right (on table edge): AB (in monogram)

Acc. no. 52.24

COLLECTIONS: M. Meisgeier, Vienna; (Frederick Mont, New York).

EXHIBITIONS: Paris, Orangerie, *La nature mort de l'an-tiquité à nos jours*, 1952, no. 46, pl. XX (cat. by C. Ster-ling).

REFERENCES: S. Sullivan, "A Banquet-Piece with Vanitas Implications," *Bulletin of the Cleveland Museum of Art*, LXI, No. 8, Oct. 1974, p. 275; M. Johnson, "Abraham van Beyeren's Banquet 'Still-Life,'" *Krannert Art Mu-seum Bulletin* (University of Illinois), I, No. 2, 1976, pp. 16, 18, 19, 20, fig. 6.

According to Sullivan and Johnson, the moral intended by the subject is moderation in pride and pleasure before this rich array. The objects shown symbolize the tran-sience of human life (watch), earthly existence (wine ewer, goblet), or the Resurrection (grapes, grapevine, wine). Johnson believes the artist's self-portrait reflected in the ewer may be a further reminder to be contempla-tive in the face of such plenty (p. 23).

Van Beyeren painted other "banquet" still lifes con-taining the same silver wine ewer, Wan-li porcelain bowl, tablecloth and watch. Two of these are dated (1653, Alte Pinakothek, Munich; 1655, Worcester Art Mu-seum). Johnson suggests the Toledo picture was prob-ably painted later than these two because of its simpler composition and greater emphasis on light and color.

Still Life with Wine Glasses PL. 127

Oil on wood panel
14¼ x 13¼ in. (36.2 x 33.6 cm.)
Acc. no. 50.247

COLLECTIONS: (Douwes, Amsterdam).

The reflections in the roemer are similar to those in still lifes at the Nationalmuseum, Stockholm (I. Bergström, *Dutch Still-Life Painting in the Seventeenth Century*, London, 1956, fig. 203) and Ashmolean Museum, Oxford (J. G. van Gelder, *Catalogue of the Collection of Dutch and Flemish Still-life Pictures Bequeathed by Daisy Linda Ward*, Oxford, 1950, no. 9). Van Gelder dates the latter ca. 1655–60. Bergström (letter, Jan. 1976) compares the Toledo painting to a still life in the Boymans-van Beuningen Museum, Rotterdam (inv. no. 1051) in terms of composition and size.

JACQUES BLANCHARD

1600–1638. French. Born in Paris, where he studied with his uncle Nicolas Ballery. In Lyons with the painter Horace Le Blanc, 1620–23. In Rome, Venice, Turin 1624–28. Returned in 1629 to Paris, where he had immediate success. In 1636 mentioned as a "peintre du roi." Older brother of the painter Jean. Greatly admired in the 18th century, Blanchard's importance lay in introducing to France the richness of Venetian color, which he united with Roman and Bolognese classicism.

Portrait of a Sculptor PL. 181

[Ca. 1632–35] Oil on canvas
37⅝ x 31½ in. (95.5 x 80 cm.)

Acc. no. 55.32

COLLECTIONS: Earls Cowper, Panshanger, Hertfordshire, before 1854 (Christie, London, Oct. 16, 1953, lot 112, as Poussin, *Duquesnoy*); (Agnew, London).

EXHIBITIONS: London, Agnew, *Autumn Exhibition of Fine Pictures by Old Masters*, 1954, no. 15 (as Blanchard); Cleveland Museum of Art, *Style, Truth and the Portrait*, 1963, no. 5, repr.

REFERENCES: G. Waagen, *Treasures of Art in Great Britain*, London, 1854, III, p. 16 (as Poussin, *Duquesnoy*); M. L. Boyle, *Biographical Catalogue of the Portraits at Panshanger, The Seat of Earl Cowper, K. G.*, London, 1885, pp. 63–4 (as Poussin, *Duquesnoy*); W. Friedländer, *Nicolas Poussin, die Entwicklung seiner Kunst*, Munich, 1914, p. 111 (as Poussin, *Duquesnoy*); O. Grautoff, *Nicolas Poussin, sein Werk und sein Leben*, Munich and Leipzig, 1914, I, p. 265 (as Poussin, *Duquesnoy*); É. Magne, *Nicolas Poussin, premier peintre du roi, 1594–1665*, Brussels and Paris, 1914, p. 218, no. 327 (as Poussin, *Duquesnoy*); B. N. (B. Nicolson), "Current and Forthcoming Exhibitions," *Burlington Magazine*, Nov.

1954, p. 362, fig. 28; C. Sterling, "Les peintres Jean et Jacques Blanchard," *Art de France*, I, 1961, no. 70, p. 108, repr. p. 105; A. Blunt, *The Paintings of Nicolas Poussin, A Critical Catalogue*, London, 1966, no. R4 (as Blanchard, *Duquesnoy*); J. Thuillier, *Tout l'oeuvre peint de Poussin*, Paris, 1974, no. R5 (as Blanchard, *Duquesnoy*).

Until Charles Sterling attributed this portrait to Blanchard for the catalogue of the 1954 Agnew exhibition, it had been repeatedly published as a portrait by Nicolas Poussin of the Flemish sculptor François Duquesnoy. Sterling (1961) dates it about 1632–35 on the basis of costume, the range of color, and its similarity to a Blanchard portrait dated 1631 (Detroit Institute of Arts). Sterling also points out that when Blanchard left Rome in 1626, Duquesnoy, then working in Rome, was about 32, while the subject of this portrait appears older. Sterling suggests that the sitter, shown with a terracotta figure of *Charity* on his modelling stand, may be the Parisian sculptor Jean Blanchard (born ca. 1596), a relative of Jacques.

Allegory of Charity PL. 182

[Ca. 1637] Oil on canvas
42½ x 54½ in. (108 x 138.4 cm.)

Acc. no. 75.9

COLLECTIONS: Prince de Carignan (Prestage, London, Feb. 26, 1765, lot 40, as Blanchard, *Charity and Her Children*, 3 ft. 5 in. x 4 ft. 3 in.)?; Dukes of Richmond and Gordon, Goodwood House, Sussex, by 1822– (Sotheby, London, Mar. 27, 1974, lot 61, repr.); (Newhouse, New York).

EXHIBITIONS: London, Royal Academy, *Seventeenth Century Art in Europe*, 1938, no. 324 (as La Hire); Montreal Museum of Fine Arts, *Héritage de France, French Painting 1610–1760*, 1961, no. 30, repr. p. 100 (as La Hire).

REFERENCES: D. Jacques, *A Visit to Goodwood near Chichester, The Seat of His Grace the Duke of Richmond*, Chichester, 1822, p. 38 (as La Hire); W. Mason, *Goodwood, its House, Park and Grounds, with a Catalogue Raisonné of the Pictures*, London, 1839, p. 21 (as La Hire); O. Merson, *La peinture française au XVIIe siècle et XVIIIe*, Paris, 1900, p. 21, fig. 5 (as Blanchard; repr. of engraving captioned as in Louvre); A. Blunt, *Art and Architecture in France, 1500–1700*, Harmondsworth, 1953 (2nd ed., 1970), p. 151, pl. 112B (as Blanchard); C. Sterling, "Les peintres Jean et Jacques Blanchard," *Art de France*, I, 1961, no. 58, p. 113, repr. p. 112; A. Châtelet and J. Thuillier, *French Painting from Fouquet to Poussin*, Geneva, 1963, p. 206, repr. p. 205.

Until Blunt correctly identified this painting as by Blanchard, it was long attributed to Laurent de La Hire. In addition, a contemporary engraving of it by Antoine Garnier (Sterling, fig. 58 bis) names Blanchard as the painter. There are stylistic similarities with Blanchard's *Charity* dated 1637 (Courtauld Institute, London). Sterling, in his comprehensive study of the artist, believes the Toledo painting was done about the same year.

Charity with children was painted several times by Blanchard in his last years. According to Sterling, this undoubtedly reflects the contemporary humanitarian work of St. Vincent de Paul with Paris foundlings. This movement, popular among the same wealthy circles that included Blanchard's clients, led to the founding by the Ladies of Charity of a hospital to shelter these children in 1638. Sterling also notes that the relief at right of soldiers in Roman dress symbolizing war contrasts with the benefits of peace, of which Charity is the principal.

Another *Charity*, unknown to Sterling in 1961, is at Bob Jones University, Greenville, S.C. (P. Rosenberg, "Quelques nouveaux Blanchard," *Etudes d'art français offertes à Charles Sterling*, Paris, 1975, pp. 220–21).

The Toledo picture has been identified with the Blanchard in the 1765 Carignan sale by D. Carritt (letter, Apr. 1975).

ABRAHAM BLOEMAERT

1564–1651. Dutch. Born in Gorinchem, the son and pupil of the architect and sculptor Cornelis Bloemaert. Pupil of Joos de Beer in Utrecht. Went to Paris in 1580. Returned to Utrecht in 1583 for the remainder of his life, except for two years in Amsterdam, 1591–93. Among his pupils were Honthorst, Terbrugghen, Bijlert, Both, Poelenburgh and Weenix.

Shepherdess Reading a Sonnet PL. 97

[1628] Oil on canvas
41 x 29½ in. (104.2 x 74.9 cm.)
Signed and dated upper right: A. Bloemaert. fe:/1628

Acc. no. 55.34

COLLECTIONS: Anthony Aupine, Hoviton, Norfolk?; Sophia Dawson and her descendants, St. Leonard's Hill, Windsor Forest, by 1818–1955; (Sotheby, London, Apr. 6, 1955, lot 96); (Speelman, London).

EXHIBITIONS: Indianapolis, John Herron Art Museum, *The Young Rembrandt and His Times*, 1958, no. 76, repr.

REFERENCES: J. Lauts, *Holländische Meister aus der*

Staatlichen Kunsthalle Karlsruhe, Karlsruhe, 1960, in no. 11.

The poem which the shepherdess reads is as follows (transcription and translation by letter from J. G. van Gelder, Feb. 1955):

Nieuw liedeken
Silvia harderin waer heen?
Waer gaet ghy int wout alleen?
Schort uw ganck en wilt niet vlien
Wout Coridon weest niet besien
Ich bid U numphe keert U weer
Waerom ist dat ghy loopt so ras
 al door het gras
ij lieve, set U toch wat neer
(het is toch . . . komt . . .)

New Small Poem
Silvia whither art thou going?
Whither goest thou in the woods alone?
Go more slowly and do not flee
If Corydon has been wouldst not wish
 to see him
I pray thee Nymph turn back
Wherefore does thou go so fast through
 the grass
pray sit down a little
(it is of course . . . comes . . .)

Although the author of the verse is unknown, W. A. P. Smit (letter to J. G. van Gelder, July 1955) stated, "The motive of the poem is very traditional . . . certainly the sonnet is associated with the numerous books of poems of the beginning of the 17th century."

The arcadian subject matter, classicizing profile of the shepherdess, raking light and half-length figures are characteristic of a number of Bloemaert's paintings of the late 1620s.

THÉOPHILE DE BOCK

1857–1904. Dutch. Born in The Hague. Studied with J. W. van Borselen and J. H. Weissenbruch. At Paris and Barbizon, 1878–83; again at Barbizon just before his death. Founding member and chairman of the Hague Art Circle; primarily a landscape painter; also a printmaker.

Castle at Arnhem PL. 168

[1891] Oil on canvas
25 x 18 in. (63.5 x 45.7 cm.)
Signed and dated lower left: Th. de Bock 91

Acc. no. 25.44

COLLECTIONS: (Reinhardt, New York); Edward Drummond Libbey, 1910–25.

The identity of the castle is not known, but there are several in the vicinity of Arnhem in eastern Holland, not far from Renkum, where the artist lived from 1895 to 1902.

Solitude PL. 169

Oil on wood panel
14 x 19 in. (35.6 x 48.3 cm.)
Signed lower left: Th de Bock

Acc. no. 22.38
Gift of Arthur J. Secor

COLLECTIONS: (Vose, Boston); Arthur J. Secor, 1912–22.

LOUIS-LÉOPOLD BOILLY

1761–1845. French. Studied briefly with his father, then in Douai and Arras before settling in Paris by 1785. Exhibited scenes of Parisian society and portraits at the Salon for more than thirty years. The detail and execution of his typically small-scale works reflect the influence of Dutch 17th century genre painters.

S'il vous plaît PL. 213

[Ca. 1790] Oil on wood panel
15⅞ x 12⅝ in. (40.4 x 32 cm.)

Acc. no. 75.58

COLLECTIONS: Georges Lutz (Georges Petit, Paris, May 26, 1902, lot 9, as *La récompense*); (Agnew, London); (Wildenstein, London); Sir Robert Mayer, London; (E. V. Thaw, New York).

REFERENCES: H. Harrisse, *L.-L. Boilly, peintre, dessinateur et lithographe*, Paris, 1898, p. 130, no. 502; P. Marmottan, *Le peintre Louis Boilly*, Paris, 1913, p. 251 (as *La récompense*); A. Mabille de Poncheville, *Boilly*, Paris, 1931, p. 24.

While the artist rarely signed or dated his work, costumes indicate a date about 1790. This painting was engraved by Jean Testard (born ca. 1740) with the present title (C. Le Blanc, *Manuel de l'amateur d'estampes*, Paris, 1854–90; Testard no. 2).

FERDINAND BOL

1616–1680. Dutch. Born in Dordrecht. He was one of the most gifted pupils of Rembrandt, with whom he studied in Amsterdam from the early 1630s to ca. 1642. Admitted to the Amsterdam guild of painters ca. 1654.

He was a successful portraitist, but apparently ceased painting about 1669, and in 1670 was described as a merchant.

The Huntsman PL. 133

[1650s] Oil on canvas
50½ x 40⅝ in. (128.3 x 103.2 cm.)
Signed and dated lower left (fragmentary): Bol (1)65(?).

Acc. no. 26.153
Gift of Arthur J. Secor

COLLECTIONS: Duncan Davidson, Tulloch, Scotland, ca. 1840; (Sedelmeyer, Paris); (Howard Young, New York, 1926); Arthur J. Secor.

As in several dated portraits of the 1650s (*Young Man*, 1652, Mauritshuis, The Hague; *Girl with a Basket of Fruit*, 1657, Metropolitan Museum of Art, New York), Bol placed his subject outdoors rather than relying on the dark, modulated chiaroscuro of his earlier style.

The Huntsman resembles several self-portraits illustrated by A. Bredius ("Self Portraits by Ferdinand Bol," *Burlington Magazine*, XLII, 1923, p. 72 ff.) and J. H. J. Mellaart ("Self Portraits by Bol," *Burlington Magazine*, XLIII, 1923, p. 152 ff.).

Overpainting which had altered various portions of the painting (especially the face, collar, hat and tree) was removed in 1962. The signature and date were also revealed at that time.

PIERRE BONNARD

1867–1947. French. Born in Fontenay-aux-Roses. Studied at the Académie Julian and École des Beaux-Arts, 1888. In 1883 met Vuillard, Denis and Sérusier, who from ca. 1889 to 1899 belonged to the group called the Nabis. From 1892 he frequently exhibited at the Salon des Indépendants; exhibited at Salon d'Automne, 1903. Active as a painter, etcher and lithographer, he also illustrated many books, periodicals and posters.

The Abduction of Europa [COLOR PL. XII] PL. 288

[1919] Oil on canvas
46¼ x 60¼ in. (118 x 154 cm.)
Signed lower left: Bonnard

Acc. no. 30.215

COLLECTIONS: (Galeries Druet, Paris); (Ethel Hughes, Versailles); (René Gimpel, Paris).

EXHIBITIONS: San Francisco, California Palace of the Legion of Honor, *French Painting*, 1934, no. 61; New

York, Museum of Modern Art, *Bonnard Memorial Exhibition*, 1948, no. 37, repr. (cat. by J. Rewald); Paris, Musée National d'Art Moderne, *L'oeuvre du XXe siècle*, 1952, no. 4; Lyons, Musée des Beaux-Arts, *Bonnard*, 1954, no. 42, fig. 9; London, Royal Academy, *Pierre Bonnard*, 1966, p. 20, no. 138, repr.

REFERENCES: G. Besson, *Bonnard*, Paris, 1934, p. 2, fig. 33; T. Natanson, *Le Bonnard que je propose*, Geneva, 1951, p. 140; H. Rumpel, *Bonnard*, Berne, 1952, p. 25, fig. 42; A. Vaillant, *Bonnard ou le bonheur de voir*, Neuchâtel, 1965, pp. 124, 229, repr. p. 197; J. and H. Dauberville, *Bonnard, Catalogue raisonné de l'oeuvre peint*, Paris, 1965, II, no. 972, repr.

Zeus was enamored of the beauty of Europa, daughter of the King of Sidon. To disguise himself from his jealous wife Hera, Zeus transformed himself into a bull and carried Europa across the sea to Crete, where she bore him several sons.

In this glowing, sumptuously painted picture, one of a small group of mythological subjects painted in the 1910s, Bonnard was inspired by Titian, as well as by Monet and Renoir.

A crayon study for Europa and the bull is illustrated by Vaillant, p. 124.

GERARD TER BORCH

1617–1681. Dutch. Studied first with his father, Gerard ter Borch the Elder in Zwolle, his birthplace. Subsequently worked under Pieter Molyn in Haarlem, ca. 1634–35. Between 1635 and 1650 he made trips to England, Italy, Germany and Spain, and is thought to have been influenced by the work of Velázquez. Married in 1654 and settled in Deventer. Painted genre scenes and small portraits. His best-known pupil was Caspar Netscher.

The Music Lesson PL. 129

[1660s] Oil on canvas
34 x 27⅝ in. (86.3 x 70.1 cm.)
Signed lower left (on chair): GTB (in monogram) 166(?).

Acc. no. 52.9

COLLECTIONS: Hermitage Palace, St. Petersburg, until ca. 1930; (Wildenstein, New York).

EXHIBITIONS: Kansas City, Nelson Gallery of Art, *Paintings of the 17th Century, Dutch Interiors*, 1967, no. 24, p. 41, repr.; The Hague, Mauritshuis, *Gerard ter Borch*, 1974, no. 61, p. 197, repr.

REFERENCES: A. Somoff, *Catalogue de la galerie des tableaux*, St. Petersburg, 1895, II, no. 874; N. Wrangell, *Les chefs d'oeuvre de la galerie de tableaux de l'Ermitage Impérial à St. Petersbourg*, London, 1909, pp. XVIII–XIX, p. 159, repr.; F. Hellens, *Gerard ter Borch*, Brussels, 1911, p. 126, repr. opp. p. 96; C. Hofstede de Groot, V, in no. 140 (as an "old copy"); P. Weiner, *Les chefs d'oeuvre de la galerie de tableaux de l'Ermitage à Petrograd*, Munich, 1923, p. 179 repr.; E. Plietsch, *Gerard ter Borch*, Vienna, 1944, p. 52, no. 92 repr.; O. White, "Dutch and Flemish Paintings at Waddesdon Manor," *Gazette des Beaux Arts*, July–Aug. 1959, pp. 70–2; S. J. Gudlaugsson, *Katalog der Gemälde Gerard ter Borchs*, The Hague, 1960, II, no. 271/II; E. Waterhouse, *The James de Rothschild Collection at Waddesdon Manor: Paintings*, Fribourg, 1967, p. 170.

The discovery in 1975 of a monogram and partial date corrects Gudlaugsson's statement that the Toledo painting is an unsigned replica by Ter Borch after the painting dated 1675 in the Rothschild Collection, Waddesdon Manor.

Gudlaugsson pointed out that the history of the Toledo painting before it entered the Hermitage as given by Somoff and Hofstede de Groot belongs instead to a painting in the National Gallery, London (Gudlaugsson no. 220).

JOHANNES BOSBOOM

1817–1891. Dutch. Born in The Hague, where he mostly lived. Studied with Bart van Hove. Traveled in Germany, Belgium, and France. Painted many church and synagogue interiors in the 17th century tradition. Major figure of the Hague School.

In Trier Cathedral PL. 149

[1867] Oil on wood panel
33⅜ x 26 in. (85 x 66 cm.)
Signed lower left: J. Bosboom

Acc. no. 26.78

COLLECTIONS: Roël-van Rappard?; W. C. Robinson, Amsterdam (Frederik Muller, Amsterdam, Nov. 13, 1906, lot 21, pl. 20); (Henry Reinhardt, New York); Edward Drummond Libbey, 1908–25.

EXHIBITIONS: The Hague, Pulchri Studio, *Exposition Bosboom*, 1891, no. 106; Amsterdam, Arti et Amicitiae Society, *Exposition Bosboom*, 1900, no. 146; The Hague, Gemeentemuseum, *Meesters van de Haagse School*, 1965, no. 6, repr.

REFERENCES: G. Marius and W. Martin, *Johannes Bosboom*, The Hague, 1917, pp. 60, 143; J. de Gruyter, *De Haagse School*, Rotterdam, 1968, I, pp. 15, 23, 29, 112, no. 18, repr.

Bosboom visited Trier in 1865. There are two other versions of the same interior view of this German church, a larger one dated 1871 (Rijksmuseum Twenthe, Enschede), and a smaller one painted about 1875 (Rijksmuseum, Amsterdam).

The Amstel River, Amsterdam — PL. 150

[After 1883] Oil on canvas
18 x 30⅝ in. (45.7 x 77.7 cm.)
Signed lower left: JB

Acc. no. 60.12

COLLECTIONS: (L. J. Krüger, The Hague?); W. J. R. Dreesmann, Amsterdam (Frederick Müller and Co., Amsterdam, Mar. 22–25, 1960, lot 65); (Nystad, The Hague).

REFERENCES: M. F. Hennus, *Johannes Bosboom*, Amsterdam, n.d., p. 22, repr.; *Verzameling Amsterdam—W. J. R. Dreesmann*, 1951, III, p. 759, repr. opp. p. 763; J. de Gruyter, *De Haagse School*, Rotterdam, 1968, I, pp. 15, 17, 28, 111, no. 16, repr. (as ca. 1869).

This picture was painted after 1883, the date of the Hoogesluis Bridge shown in the center (F. Lugt, letter, May 1961). In this view from the Amstel Rowing and Sailing Club the Amstel Hotel, completed in 1867, appears on the right.

JAN BOTH

1615/18–1652. Dutch. Studied with Abraham Bloemaert in his native Utrecht. In Rome by 1638 where he lived with his brother Andries until 1641. According to Sandrart, both brothers were influenced by Pieter van Laer and Claude Lorrain. Returned in 1641 to Utrecht, where he remained until his death. The leading master of Italianate landscape painting, he was also active as an etcher.

Travelers in an Italian Landscape — PL. 118

[Ca. 1648–50] Oil on canvas
34½ x 41⅞ in. (87.6 x 106.4 cm.)
Signed lower right: JBOTH (JB in monogram)

Acc. no. 55.40

COLLECTIONS: de Piles?; (Sale, Apr. 29–30, 1742, lot 26)?; Dukes of Bedford, Woburn Abbey, Bedfordshire, 1742–1951; (Christie, London, Jan. 19, 1951, lot 11, as by Jan and Andries Both); (Duits, London, by 1952–55).

EXHIBITIONS: London, British Institution, 1843, no. 111; London, British Institution, 1856, no. 16; Milan, Palazzo Reale, *Mostra di pittura olandese del seicento*, 1954, no. 21; Toledo Museum of Art, *The Age of Rembrandt*, 1966, no. 72.

REFERENCES: C. Hofstede de Groot, IX, no. 230; J. Burke, *Jan Both: Paintings, Drawings and Prints*, New York and London, 1976, no. 112.

As is the case with most of Both's paintings, the Toledo picture was probably painted in the 1640s, the decade prior to his early death (see W. Stechow, 1968, p. 154). Burke believes that it was probably done ca. 1648–50. He compares the Toledo painting to related landscapes in the Indianapolis Museum of Art and Boston Museum of Fine Arts, among others, and believes that these paintings represent the high point of Both's mature landscape style.

FRANÇOIS BOUCHER

1703–1770. French. First studied with his father, then with François Lemoine and the engravers L. Cars and J. de Julienne. Awarded Prix de Rome in 1724; to Italy in 1727. Returned to Paris in 1731, having traveled with Carle van Loo and entered the Académie Royale as a history painter. Influenced by Rubens and Watteau. Under the patronage of Mme. de Pompadour for about 20 years, he worked on important decorations for the royal residences. Director of the Gobelins Factory, 1755; in 1765 First Painter to Louis XV, supervisor of the Beauvais Manufactory and Director of the Académie.

The Mill at Charenton — PL. 201

[1758] Oil on canvas
44½ x 57½ in. (113 x 146 cm.)
Signed and dated lower right: f. Boucher/1758

Acc. no. 54.18

COLLECTIONS: Mme. Veuve Lenoir, Paris (Boussaton & Pillet, Paris, May 18, 1874, lot 3); Baron Anselm de Rothschild; Baron Albert de Rothschild, Vienna; Baron Louis de Rothschild, Vienna; Baron Maurice de Rothschild, Château de Prégny, Switzerland; (Rosenberg & Stiebel, New York).

EXHIBITIONS: London, Royal Academy, *France in the*

Eighteenth Century, 1968, no. 55, fig. 129; Toledo Museum of Art, *The Age of Louis XV: French Painting 1710–1774*, 1975, no. 10, pl. 89 (cat. by P. Rosenberg).

REFERENCES: A. Michel, L. Soullié and C. Masson, *François Boucher*, Paris, 1889, no. 1763.

Charenton, at the junction of the Seine and Marne Rivers, was the site of many mills in the 18th century. The best known of them was Quinquengrogne, which may have inspired this subject, although Boucher's combination of fantasy and reality makes a specific geographical identification hazardous.

Boucher's drawings from nature at this location served as sources for figures, such as the washerwoman and the woman peering from the doorway, and other motifs, such as the foreground log and the barge, which he used in several paintings, especially smaller scale examples such as *Le Moulin* and *Le Pont* (Louvre), *La Lavandière* and *The Water Mill* (Cincinnati Art Museum), and *The Mill* (London, Sotheby, June 29, 1960, lot 35, ex-col. Viscount Ednam).

Versions of Toledo's painting, which is among Boucher's largest landscapes, are in the National Gallery, London, and the museum at Orléans. This type of picturesque genre scene in a naturalistic landscape was influenced by the 17th century Dutch Mannerist Abraham Bloemaert. Toledo's idyllic landscape, created with imagination and poetry, is considered "one of the masterpieces of landscape in Boucher's *oeuvre*" (Rosenberg).

The Footbridge PL. 202

[1760] Oil on canvas
19⅞ x 24 in. (50.5 x 61 cm.)
Signed and dated lower left: f. Boucher/1760

Acc. no. 57.38
Gift of Mrs. C. Lockhart McKelvy

COLLECTIONS: Château de Beauregard, Seyssinet, near Grenoble, France, from early 19th century to 1957; (Cailleux, Paris, 1957); Mrs. C. Lockhart McKelvy.

EXHIBITIONS: Toledo Museum of Art, *The Collection of Mrs. C. Lockhart McKelvy*, 1964, p. 6, repr. p. 7; Bordeaux, Musées de Bordeaux, *La peinture française: collections américaines*, 1966, no. 22, pl. 23.

Like *The Mill at Charenton*, this rustic pastorale was probably inspired by the picturesque countryside around the junction of the Seine and Marne rivers.

According to Cailleux, a drawing for this painting was in the Georges Bourgarel sale (Hôtel Drouot, Paris, June 15–16, 1922, lot 12).

PIETER VAN BOUCLE

Before 1610–1673. French. Probably born at Antwerp, Pieter (or Pierre) van Boucle (or Bouck or Boeckel) was the son of an engraver. He appears to have been in Paris from the 1620s, and may have worked in the studio of Simon Vouet. While his work was similar to that of Lubin Baugin, he was also influenced by Jan Fyt and Frans Snyders, and may have had some contact with Sébastien Stosskopf. Primarily a still life painter.

Basket of Fruit PL. 185

[1649] Oil on canvas
20 x 24½ in. (50.8 x 62.2 cm.)
Signed and dated lower right: P.V.B. fecit. 1649.

Acc. no. 61.28

COLLECTIONS: Private collection, Paris (Hôtel Drouot, sale before Nov. 1960); (J. Aubry, Paris); (Heim, Paris).

EXHIBITIONS: Paris, Musée des Arts Décoratifs, *Louis XIV, faste et décors*, 1960, pl. 510.

REFERENCES: M. Faré, *La nature morte en France, son histoire et son évolution du XVIIe au XXe siècle*, Geneva, 1962, II, fig. 88; M. Faré, *Le grand siècle de la nature morte en France, le XVIIe siècle*, Fribourg, 1974, repr. p. 98; J. Foucart, "Un peintre flamand à Paris: Pieter van Boucle," in *Études d'art français offertes à Charles Sterling* (ed. A. Châtelet and N. Reynaud), Paris, 1975, pp. 238, 248, 251–52, 255.

As no known picture by Van Boucle is dated before 1648 (Musée d'Art et d'Histoire, Geneva), this picture is among his earliest signed and dated works. The subject was a favorite with the artist, and is an example of the blending of Flemish and French influences in French painting at this time.

EUGÈNE BOUDIN

1824–1898. French. Born in Honfleur. While working in Le Havre, he met Troyon, Isabey and Millet, who encouraged him to take up painting. Studied in Paris, 1851–53. Major influence on Monet, whom he met in 1858, and who in turn introduced him in 1862 to Jongkind, who guided him toward direct observation of nature. Exhibited at Salon regularly from 1863 to 1897 and at the first exhibition of the Impressionist group, 1874. Best known for paintings of the coast of northern France.

The Beach, Trouville PL. 238

[1865] Oil on wood panel
13⅝ x 22⅝ in. (34.5 x 57.5 cm.)

Signed and dated lower right: E. Boudin-65

Acc. no. 51.372

COLLECTIONS: M. Gillou, Paris; Mrs. R. Fenwick, Paris; (Reid & Lefevre, London).

Boudin often spent summers in Trouville, a fashionable resort on the coast of Normandy near his birthplace. In 1865 he went there with his friends Courbet and Whistler, who helped him find buyers for his small paintings of groups of well-dressed people on the beach. Paintings such as this anticipated the Impressionists' light, brilliant colors and broken brushwork, as well as the holiday mood that prevailed in much of their work.

WILLIAM ADOLPHE BOUGUEREAU

1825–1904. French. Born at La Rochelle. Studied in Bordeaux before entering the Paris École des Beaux-Arts in 1846. After winning the Prix de Rome in 1850, he spent four years in Italy. One of the most popular academic painters of his time, he exhibited at nearly every Salon from 1854 until his death.

The Captive PL. 269

[1891] Oil on canvas

51½ x 30½ in. (130.8 x 77.5 cm.)

Signed and dated center left: W-BOVGVEREAV-1891

Acc. no. 23.25

Gift of Sidney Spitzer

COLLECTIONS: Ceilan M. Spitzer, Toledo.

REFERENCES: A. Gowans, *The Restless Art: A History of Painters and Painting*, Philadelphia, 1966, pp. 121–22, fig. 16C.

SIR FRANK BRANGWYN

1867–1956. British. Born in Bruges of Anglo-Welsh parents who returned to London in 1875. Self-taught. Employed by William Morris from about 1882 to 1884. Exhibited regularly at the Royal Academy, 1885–1900. After 1900, occupied primarily with mural decorations, including commissions for Skinners Hall, London, 1904–09, and Rockefeller Center, New York, 1930–34. Traveled extensively. Member, Royal Academy in 1919; knighted in 1941.

The Golden Horn, Constantinople PL. 339

[Ca. 1890] Oil on canvas

25 x 30⅛ in. (63.5 x 76.5 cm.)

Signed lower right: F. Brangwyn

Acc. no. 31.1

COLLECTIONS: Hurst Walker; Andrew G. Kidd, Dundee, Scotland (Christie, London, May 16, 1930, lot 88); (Barbizon House, London); (Vose, Boston).

REFERENCES: V. Galloway, *The Oils and Murals of Sir Frank Brangwyn*, Leigh-on-Sea, 1962, no. 257.

Brangwyn traveled to North Africa, Turkey and the Balkans in 1890. This view of the Bosporus with Constantinople in the background, was painted soon after this trip.

GEORGES BRAQUE

1882–1963. French. Born at Argentenil-sur-Seine. Son of a decorator and amateur painter who encouraged his interest in art. First studied in Le Havre, and from 1902 in Paris, where he established a studio in 1904. Exhibited with the Fauve group in 1906. In 1907 met Picasso, with whom he formulated the Cubist style. Also a printmaker and sculptor.

Still Life with Fish PL. 301

[1941] Oil on canvas

23⅝ x 28¾ in. (60.4 x 73 cm.)

Signed lower left: G Braque

Acc. no. 47.60

COLLECTIONS: Alfred Poyet, Paris; (Theodore Schempp, New York).

EXHIBITIONS: Munich, Haus der Kunst, *Georges Braque,* 1963, no. 105, fig. 97; New York, Knoedler, *Braque: An American Tribute*, 1964, no. 8, repr.

REFERENCES: N. Mangin, ed., *Catalogue de l'oeuvre de Georges Braque: peinture 1939–41*, Paris, 1961, no. 96, repr.

BARTHOLOMEUS BREENBERGH

1599/1600–1657. Dutch. Born in Deventer. In Rome ca. 1619, where he may have studied under Agostino Tassi and/or Paul Bril. Influenced by Elsheimer. Co-founder of the *Schildersbent*. Returned to Amsterdam ca. 1629. He belongs to the first generation of the Dutch Italianate landscape painters. Also an etcher.

Landscape with Ruins PL.96

[Ca. 1630] Oil on wood panel

12⅛ x 21⅝ in. (31.1 x 55 cm.)

Acc. no. 65.170

COLLECTIONS: Private collection, England (Christie, London, May 1, 1964, lot 163); (Alfred Brod, London, 1964–65); (Nystad, The Hague).

EXHIBITIONS: Utrecht, Centraal Museum, *Nederlandse 17e eeuwse, italianiserende landschapschilders*, 1965, no. 27, fig. 28, repr. on cover; Toledo Museum of Art, *The Age of Rembrandt*, 1966, no. 70, repr. p. 122.

REFERENCES: M. Röthlisberger, *Bartholomäus Breenbergh, Handzeichnungen*, Berlin, 1969, in no. 96.

The Toledo painting may be dated by comparison with a landscape signed and dated 1631 (Utrecht, exh. cat., 1965, no. 28, fig. 29).

A signed drawing in the Louvre, dating from Breenbergh's later years in Rome, shows a ruin similar to the one in the Toledo painting (Röthlisberger).

GEORGE HENDRIK BREITNER

1857–1923. Dutch. Born in Rotterdam. In 1875 entered the Hague Academy. Studied with Willem Maris, 1880. In 1882 enrolled in the Rotterdam Academy. In his early career best known for military subjects. Under the influence of Jacob Maris, developed his gift for color and composition; with Van Gogh in The Hague, 1883. To Paris, 1884; Amsterdam, 1886. His greatest contribution to Dutch art was the force of his naturalistic style in subjects ranging from figural studies to town views, especially of Amsterdam.

Warehouses, Amsterdam　　　　　　PL. 173

[1901] Oil on canvas
32 x 51¼ in. (81.5 x 130 cm.)
Signed lower left: G. H. Breitner

Acc. no. 76.14

COLLECTIONS: E. J. van Wisselingh, Amsterdam; C. G. Vattier Kraane, Aerdenhout (Frederik Muller, Amsterdam, Mar. 22–29, 1955, lot 70, repr.); B. de Geus van den Heuvel, Niewersluis (Sotheby Mak van Waay, Amsterdam, Apr. 27, 1976, lot 252, repr.).

EXHIBITIONS: The Hague, Gemeentemuseum, *Breitner Tentoonstelling*, 1928, no. 145, repr. p. 53; Amsterdam, Stedelijk Museum, *Tentoonstelling Breitner*, 1933, no. 68, pl. 62; The Hague, Gemeentemuseum, *G. H. Breitner*, 1947, no. 85; Amsterdam, Stedelijk Museum, *Breitner en Amsterdam*, 1947, no. 123; Rotterdam, Museum Boymans-van Beuningen, *Breitner Tentoonstelling*, 1954, no. 47, repr.; Leiden, Stedelijk Museum de Lakenhal,

Tijdgenoten van Floris Verster, 1957, no. 30; Amsterdam, Stedelijk Museum, *Breitner*, 1957, no. 37 (as 1901); Amsterdam, Stedelijk Museum, *Van Romantiek tot Amsterdamse School*, 1958, no. C.91.

REFERENCES: P. Zilcken, *G. H. Breitner*, Amsterdam, 1921, repr.; A. van Schendel, *Breitner*, Amsterdam, (1939), repr. p. 53; A. M. Hammacher, *Amsterdamsche Impressionisten en hun kring*, Amsterdam, 1941, repr. p. 45.

This view in the Teertuinen district of Amsterdam shows a canal barge in the Eilandsgracht and tar warehouses on the Prinseneiland. The range of sombre colors is characteristic of Breitner's first Amsterdam period (1886–1903) in which he was attracted by the busy modern life of the city rather than by its quiet, picturesque aspects.

JULES BRETON

1827–1906. French. Born near Calais. Studied at Royal Academy in Ghent, and with Felix de Vigne, 1843–46. In the studio of Baron Wappers, Academy of Fine Arts, Antwerp, briefly in 1846. Moved to Paris in 1847 and entered Drolling's studio. Exhibited at the Salon from 1849.

The Shepherd's Star　　　　　　PL. 266

[1887] Oil on canvas
40½ x 31 in. (102.8 x 78.7 cm.)
Signed and dated lower right: Jules Breton/87

Acc. no. 22.41
Gift of Arthur J. Secor

COLLECTIONS: Pitet ainé, Paris, by 1889; (Knoedler, New York); Art Institute of Chicago, 1889–1908; (Knoedler, New York); (Reinhardt, Milwaukee); Arthur J. Secor, 1908–22.

EXHIBITIONS: Paris, Salon, 1888, no. 374; Toledo Museum of Art, *Inaugural Exhibition*, 1912, no. 162, repr.

REFERENCES: *Masters in Art: Breton*, Boston, 1907, pp. 29, 37, pl. IV.

BRITISH, ANONYMOUS

Elizabeth I, Queen of England　　　　PL. 307

[Ca. 1588] Oil on canvas
30 x 25 in. (76.2 x 63.5 cm.)

Inscribed, upper left: by Mark Gerard

Acc. no. 53.94

COLLECTIONS: Lord Tollemache, Peckforton Castle, Cheshire, by 1857 (Christie, London, May 15, 1953, lot 112); (Agnew, London).

EXHIBITIONS: Manchester (England), *Catalogue of the Art Treasures of the United Kingdom*, 1857, p. 114, no. 63; Richmond, Virginia Museum of Fine Arts, *The World of Shakespeare, 1564–1616*, 1964, no. 2, fig. 2.

REFERENCES: W. Bürger (T. Thoré), *Trésors d'art en Angleterre*, Paris, 1865, p. 348; *Sketch Books of Sir George Scharf in the Archives of the National Portrait Gallery*, 49, f.12; F. O'Donoghue, *A Descriptive and Classified Catalogue of Portraits of Queen Elizabeth*, London, 1894, pictures no. 50; "A Portrait of the First Elizabeth," *Toledo Museum of Art Museum News*, No. 147, Sep. 1953, unpaginated, repr. on cover; R. Strong, *Portraits of Queen Elizabeth I*, Oxford, 1963, p. 75, repr. p. 70; R. Strong, *Tudor and Jacobean Portraits*, London, 1969, I, p. 111.

The formula-like style of most portraits of Elizabeth I partly derives from the Queen's practice of having an official portrait taken from life used as the only authorized pattern for all other portraits, although her costume was usually varied in each subsequent copy. Strong (1963, 1969) notes that Elizabeth sat for a new portrait about the time of the defeat of the Spanish Armada in 1588, an event commemorated in several portraits of her (Strong, 1963, pp. 64, 65). The Toledo portrait is one of at least ten belonging to this "Armada pattern."

The inscription at the upper left is a later addition, inscribed in the unfounded belief that this painting was by Marcus Gheeraerts, father or son, both of whom painted portraits of Elizabeth.

AGNOLO BRONZINO

1503–1572. Italian. Agnolo di Cosimo di Mariano, called Bronzino, was born at Monticelli, near Florence. Studied with Raffaelino del Garbo, but more importantly, with Pontormo, with whom he collaborated on major commissions from 1518 to 1557. About 1530–32 in the service of the Duke of Urbino at Pesaro. In 1539 named court painter by Duke Cosimo I de'Medici. Remained in Florence except for short trips to Rome and Pisa. Besides portraits he also painted sacred and mythological subjects, designed tapestries and festival decorations, and wrote poetry.

Cosimo I de' Medici PL. 13

[1546 or after] Oil on wood panel
41 x 30⅝ in. (101.6 x 77.8 cm.)

Acc. no. 13.232

COLLECTIONS: Oscar Hainauer, Berlin, until 1906; (Duveen, New York); Dr. Frank Gunsaulus, Chicago.

EXHIBITIONS: Bruges, *Exposition de la Toison d'Or*, 1907, no. 158 (attr. to G. Vasari).

REFERENCES: F. Harck, "Quadri di maestri italiani in possesso di privati a Berlino," *Archivo storico dell'arte*, II, 1889, p. 205; W. Bode, ed., *Die Sammlung Oscar Hainauer*, Berlin, 1897, no. 68 (attr. to G. Vasari); H. Schulze, *Die Werke Angelo Bronzino*, Strasbourg, 1911, p. iv; A. McComb, *Agnolo Bronzino, His Life and Works*, Cambridge, 1928, p. 133; B. Berenson, *Italian Pictures of the Renaissance, Florentine School*, London, 1963, I, p. 44; II, pl. 1445 (as partially autograph); S. L. Faison, Jr., "From Lorenzo Monaco to Mattia Preti," *Apollo*, Dec. 1967, p. 39, fig. 10; M. Levey, *Painting at Court*, London, 1971, pp. 99–100, fig. 81; B. Fredericksen and F. Zeri, *Census*, pp. 36, 515 (as School of Bronzino); E. Baccheschi, *L'opera completa del Bronzino*, Milan, 1973, no. 54e, repr. p. 95.

Cosimo I (1519–1574), one of the most remarkable of the Medici, united the two branches of his family and was the founder of the Grand Duchy of Tuscany.

In August 1545 Bronzino was at work on a portrait of Cosimo (G. Gaye, *Carteggio inedito d'artisti*, Florence, 1840, II, pp. 330–31). According to Vasari, "The Lord Duke, having seen . . . the excellence of this painter, and that it was his particular and peculiar field to portray from life with the greatest diligence that could be imagined, caused him to paint a portrait of himself, at that time a young man, fully clad in bright armor, and with one hand upon his helmet." (*Lives*, trans. G. D. De Vere, London, 1912–15, I, p. 6).

The actual painting referred to by Vasari has not been conclusively identified among the several versions of it, which are of two types: half-length (Florence, Uffizi and Pitti; Posnan, Museum Narodowe); and three-quarter length (Toledo; Lucca, Pinacoteca Communale; Kassel, Gemäldegalerie; New York, W. Smadbeck collection). The Toledo version was first published as a work by Bronzino by Schulze, as a replica of the Kassel painting, and McComb supported Schulze's proposals (letter, Oct. 1935).

In the Toledo portrait Cosimo wears the Order of the Golden Fleece, awarded in 1546 by Emperor Charles V. As the badge of the order does not appear in the Uffizi

version, the latter may be the original version of 1545, or the closest reflection of it. For a discussion of the significance of the laurel branch as a Medici emblem, see J. Sparrow in *Journal of the Warburg and Courtauld Institutes*, XXX, 1967, especially p. 169, as pointed out by Graham Smith.

Don Giovanni de' Medici PL. 14

[Ca. 1551] Oil on wood panel
18⅛ x 11-13/16 in. (46 x 30 cm.)

Acc. no. 51.305
Gift of William E. Levis

COLLECTIONS: Baron Lazzaroni, Paris; Lawrence P. Fisher, Detroit; (Howard Young, New York); William E. Levis, Perrysburg, Ohio.

EXHIBITIONS: Detroit Institute of Arts, *Italian Paintings from the XIV to XVI Century*, 1933, no. 33.

REFERENCES: W. Heil, "The Lawrence P. Fisher Collection in Detroit," *Antiquarian*, XV, Dec. 1930, p. 46, repr.; B. Fredericksen and F. Zeri, *Census*, pp. 36, 515; E. Baccheschi, *L'opera completa del Bronzino*, Milan, 1973, p. 99, in no. 86 (as Don Giovanni).

Don Giovanni (1543–1562), was the third son of Cosimo I de' Medici and Eleonora da Toledo. As early as 1550 his parents destined him for the church; he later became a Cardinal.

This bust repeats the upper part of a half-length portrait (Ashmolean Museum, Oxford), painted about 1551, the year Bronzino did a series of portraits of the Medici children (D. Heikamp, "Agnolo Bronzinos Kinderbildnisse an dem Jahre 1551," *Mitteilungen des Kunsthistorischen Institutes in Florenz*, Aug. 1955, pp. 133–36).

Although the Oxford and Toledo portraits have traditionally been identified as Giovanni's younger brother Don Garzia (1549–1562), Heikamp reasoned that in 1551 he would have been too young to be the boy in the Oxford portrait, whose costume, including the sash, is identical with that in a later drawing inscribed 1551 (Uffizi, Florence). The question is admittedly complicated by the lack of both detail in contemporary accounts and a sure portrait of Giovanni at this age, and also by the family resemblance of the several Medici sons.

According to M. Levey (letter, Aug. 1975), a picture in the Marquess of Lansdowne collection, England that is related to the Oxford-Toledo portraits shows the hair altered, presumably to show Don Giovanni at a later age.

JAN BRUEGHEL THE ELDER

1568–1625. Flemish. Born in Brussels, the son of Pieter Bruegel the Elder. Studied in Antwerp with Pieter Goekindt. To Italy ca. 1589; reportedly in Naples, 1590; in Rome, 1593–94. In 1596 returned to Antwerp, where he entered the painters' guild the next year. In Prague, 1604; and Nuremberg in 1606 and 1616. He often collaborated with other painters, including his friend Rubens. Painter of landscapes, small-scale figures and flowers. Daniel Seghers and his son Jan Brueghel II were his pupils.

Landscape with a Fishing Village PL. 89

[1604] Oil on wood panel
14 x 25⅜ in (35.6 x 64.4 cm.)
Signed and dated lower left: BRVEGHEL.1604

Acc. no. 58.44

COLLECTIONS: Jacomo de Wit, Antwerp; Augustus II, Elector of Saxony and King of Poland, Dresden, 1710; Gemäldegalerie, Dresden, 1750–1925; Members of the Saxon royal family of Wettin, Halle an der Saale, Germany; (Rosenberg and Stiebel, New York).

REFERENCES: K. Woermann, *Katalog der Königlichen Gemäldegalerie zu Dresden*, 1887, no. 879; Dresden, Gemäldegalerie, *Catalogue of the Pictures in the Royal Gallery at Dresden*, 8th ed., 1912, p. 104, no. 879; Y. Thiéry, *Le paysage flamand au XVIIe siècle*, Paris, 1953, p. 176 (as *Paysage accidenté*; incorrect measurements); *Catalogue of European Paintings in The Minneapolis Institute of Arts*, Minneapolis, 1970, in no. 73.

The Toledo painting shares a similar provenance with Brueghel's *Landscape with Peasants* (Minneapolis Institute of Arts) and *Canal Scene* (Clowes Fund Collection, Indianapolis). All three landscapes were in Dresden from the 18th century until 1925, when they were ceded to the former ruling family of Saxony.

PIETER BRUEGHEL THE YOUNGER

Ca. 1564–1637/38. Flemish. Born in Brussels, son of Pieter Brueghel the Elder (1525/30–69), whose work he frequently copied. He was the brother of Jan Brueghel. Studied with Gillis van Coninxloo at Antwerp, where he entered the painters' guild in 1585. Teacher of Frans Snyders. Died in Antwerp.

Winter Landscape with a Bird Trap PL. 90

[Ca. 1600–25] Oil on wood panel (transferred to masonite)
15¼ x 22¼ in. (38.7 x 56.5 cm.)

Signed lower right: P. BRVEGHEL

Acc. no. 54.77

COLLECTIONS: (Knoedler, New York).

REFERENCES: G. Marlier, *Pierre Brueghel le Jeune*, Brussels, 1969, p. 242, no. 7.

This is a copy of *Winter Landscape with Bird Trap* (1565; Musées Royaux des Beaux-Arts, Brussels) by Pieter Brueghel the Elder. Dated copies by Brueghel the Younger range from 1596 to 1621. According to Marlier, the form of signature on the Toledo painting was used in the first quarter of the 17th century.

The meaning of the scene is not clear. According to Marlier (p. 240), the carelessness with which the birds fly around the trap parallels the skaters' offhandedness as they skate across the thin ice. Both birds and skaters are oblivious to life's precariousness. Marlier also states the scene may illustrate an unknown Netherlandish proverb or, in light of contemporary political events, the bird trap may be an allusion to the dangers of Spain's oppression of the Netherlands. The city on the horizon is probably Antwerp.

Whether or not the composition was originally done with a moralizing or political intent, it is nevertheless among the earliest forerunners of 17th century Dutch winter scenes, and its popularity is clearly evident from the 60 copies and versions listed by Marlier.

GUSTAVE CAILLEBOTTE

1848–1894. French. Born in Paris. Entered the studio of Léon Bonnat in 1873 and, briefly, the École des Beaux-Arts. Participated in all the Impressionist exhibitions except the second and last. Friend and patron of Degas, Monet, Renoir and Pissarro. Bequeathed his collection of Impressionist works to the state. From 1887 lived at Petit-Gennevilliers, where he painted views of the Seine and of his garden.

By the Sea, Villerville PL. 259

[1884] Oil on canvas

23¾ x 28¾ in. (60.3 x 73 cm.)

Signed and dated lower right: G. Caillebotte/84

Acc. no. 53.69

Gift of Wildenstein Foundation

COLLECTIONS: M. Hugo, Paris; (Wildenstein, New York).

EXHIBITIONS: New York, Wildenstein, *Gustave Caillebotte*, 1968, no. 50 (as *Paysage, Bord de Mer*).

REFERENCES: M. Bérhaut, "Catalogue des peintures et pastels," *Gustave Caillebotte*, Paris, Wildenstein, 1951, no. 216 (as *Villerville*).

Villerville is on the Normandy coast, which Caillebotte visited several times in the 1880s.

CALIARI (*see* VERONESE)

ROBERT CAMPIN, Copy after

1378/79–1444. Flemish. Perhaps born in Valenciennes or northern Brabant. By 1406 in Tournai, where in 1410 he became a citizen and was elected dean of the painters guild in 1423. Jacques Daret and Rogier van der Weyden were his pupils. Campin is now generally identified with the artist known as the Master of Flémalle.

The Virgin in an Apse PL. 78

[Ca. 1490–1520] Oil on wood panel

19⅜ x 14 in. (49.2 x 35.6 cm.)

Acc. no. 54.60

COLLECTIONS: Giuseppe Plannuzzi; W. Muller, Berlin, by 1924; Princess K., Berlin, 1954; (Curt Reinheldt, New York).

REFERENCES: M. J. Friedländer, *Die Altniederländische Malerei*, Leyden, 1924, II, no. 74i; M. Frinta, *The Genius of Robert Campin*, The Hague, 1966, p. 115, n. 4; M. J. Friedländer, *Early Netherlandish Painting* (ed. H. Pauwels), New York, 1967, II, no. 74i; M. Davies, *National Gallery Catalogues: Early Netherlandish School*, 3rd ed., London, 1968, p. 29, n. 3.

This painting, one of more than 30 known copies after a lost original by Campin, is exceptional for its inclusion of symbolic flowers and animals.

Friedländer divides the copies into three groups. In the earliest, the apse appears flattened and is seen from above. In the second and slightly later group, including the Toledo picture, the apse is shown frontally in correct perspective. In the third group, mainly 16th century, a background landscape, elaborate architectural setting or more angels are added.

Panofsky (*Early Netherlandish Painting*, Cambridge, 1953, I, p. 350 ff.) and others refer to a revival of van Eyck and Campin compositions ca. 1490–1520, the period from which the Toledo painting may date. This is given some support by the dark garments of the Virgin, a characteristic not present in earlier copies also present in some variants by Quentin Massys (1464/65–1530) and Bernard van Orley (ca. 1488–1541).

CANALETTO

1697–1768. Italian. Born Giovanni Antonio Canal in Venice. In Rome, 1719–20, as a scenographer, returning to Venice where he began his career as a view painter. Probably influenced by Gaspare Vanvitelli and Luca Carlevaris. Aided by the British Consul in Venice, Joseph Smith, Canaletto traveled to London in 1746, returning to Venice about 1755. Not until 1763 was he made a member of the Venetian Academy. His nephew, Bernardo Bellotto, was his chief pupil. Canaletto also is renowned for his etchings.

View of the Riva degli Schiavoni PL. 37

[Late 1730s] Oil on canvas
18½ x 24⅞ in. (47.1 x 63.3 cm.)
Two labels on reverse: 1) Anton Canale/M——zu Venedig/a 1740; 2) No. 191/Tablau Apertenant au Prince Joseph/Wenceslau de [Liechten] stein/—— in 73.

Acc. no. 51.404

COLLECTIONS: Prince Josef Wenzel Liechtenstein, Vienna, about 1740; Princes Liechtenstein, Vienna, to about 1951; (Frederick Mont, New York).

EXHIBITIONS: Detroit Institute of Arts, *Venice, 1700–1800*, 1952, no. 11, repr.; Baltimore Museum of Art, *Age of Elegance: The Rococo and its Effect*, 1959, no. 181; Venice, Palazzo Ducale, *I vedutisti veneziani del settecento*, 1967, no. 52, repr. and pl. 10 (detail) (cat. by P. Zampetti); Art Institute of Chicago, *Painting in Italy in The Eighteenth Century: Rococo To Romanticism*, 1970, no. 17, repr. (cat. entry by B. Hannegan).

REFERENCES: *Description des tableaux et des pièces de sculpture que renferme la gallerie de son Altesse François Joseph, Chef et Prince Regnant de la Maison de Liechtenstein*, Vienna, 1780, p. 74; *Katalog der Fürstlich Liechtensteinischen Bildergalerie im Gartenpalais der Rossau zu Wien*, Vienna, 1873, p. 69, no. 591; G. Ferrari, *I due Canaletto*, Turin, 1920, pl. 14; A. Kronfeld, *Führer durch die Fürstlich Liechtensteinische Gemäldegalerie in Wien*, Vienna, 1927, no. 199; W. G. Constable, *Canaletto: Giovanni Antonio Canal, 1697–1768*, Oxford, 1962, I, p. 112, n. 2 and pl. 30, no. 118, II, no. 118; L. Puppi, *The Complete Paintings of Canaletto*, New York, 1968, p. 92, fig. 35, pl. XXVI.

This view of the Riva degli Schiavoni, Venice from the harbor of St. Mark's includes, from the left, a corner of the Doge's Palace, the Ponte della Paglia (with the Bridge of Sighs partly visible behind), the Prisons, a group of small houses, and, toward the right, the Palazzo Dandolo, later known as the Palazzo (now Hotel) Daniele.

Toledo's painting is one of a series (referred to in various sources as having consisted of eight, nine or twelve pictures) of small Venetian views that were in the Liechtenstein collection and now appear to be divided among various American and Italian collections.

The Harbor of St. Mark's and the Island of San Giorgio from the Piazzetta (private collection, Milan; Constable no. 126) appears to be from this series and a pendant to Toledo's painting. The pendant shows the steeple of San Giorgio Maggiore, constructed in 1726–28. The two paintings thus seem to have been painted between 1728 and 1740. The 1952 Detroit exhibition catalogue dates Toledo's painting to the 1730s, Zampetti to 1729–30, Constable to the early 1730s, and Hannegan to the late 1730s. In addition to stylistic grounds, Hannegan supports his dating by pointing out that the series suggests a commission which, together with the information on the labels on the reverse of the painting, indicate it was painted shortly before entering the Liechtenstein collection in 1740.

There is a version of Toledo's painting in the Landesmuseum, Darmstadt (no. 135), although its attribution is not definite (Constable, II, p. 233).

JAN VAN DE CAPPELLE

1624/26–1679. Dutch. Born and lived in Amsterdam. Self-taught as a painter, but probably inspired by Simon de Vlieger. A successful dye merchant. Had a large art collection with more than two hundred paintings and six thousand drawings by not only Dutch, but Flemish, German and Italian artists. Best known for his seascapes and winter landscapes.

Shipping Off the Coast PL. 122

[After 1651] Oil on canvas
24⅜ x 33⅛ in. (61.9 x 84.0 cm.)
Signed on second ship from left: J.V.C. (traces of a possible full last name)

Acc. no. 56.56

COLLECTIONS: Dukes of Arenberg, Brussels, early 18th century–1955; (Speelman, London).

EXHIBITIONS: The Hague, Mauritshuis, *In the Light of Vermeer*, 1966, no. 26.

REFERENCES: W. Bürger, *Galerie d'Arenberg à Bruxelles*, 1859, no. 10; C. Hofstede de Groot, VII, no. 24; F. T. Kugler, *Handbook of Painting, The German, Flemish and Dutch Schools* (ed. J. A. Crowe), London, 1879, II, p. 501 (as a view of the Scheldt); W. Stechow, "Über

das Verhältnis zwischen Signatur und Chronologie bei einigen holländischen Künstlern des 17. Jahrhunderts," *Festschrift für Dr. h.c. Trautscholdt,* Hamburg, 1965, pp. 115–16; W. Stechow, 1968, p. 118, figs. 232, 233; L. Bol, *Die holländische Marinemalerei des 17. Jahrhunderts,* 1973, p. 266, repr. p. 223; M. Russell, *Jan van de Cappelle, 1624/26–1679,* Leigh-on-Sea, 1975, pp. 20, 24, fig. 9, p. 59, n. 3, p. 64, no. 24.

Russell groups the Toledo painting with the seascapes at the Kunsthaus, Zurich (Hofstede de Groot 21; dated 165?) and the Art Institute of Chicago (Hofstede de Groot 110; dated 1651). All three are characterized by cool tonalities, a centralized composition and an overall luminosity of the water. Stechow (1962) also points out that Van de Cappelle seems to have preferred using a canvas support to panel sometime after 1651.

BRUNO CASSINARI

1912–. Italian. Born in Piacenza. Studied at the Milan Academy. Member of Corrente, 1938. Prizewinner at Venice Biennale. Lives in Milan.

Still Life PL. 43

[1952] Oil on canvas
27¾ x 39¾ in. (70.5 x 101 cm.)
Signed lower right: Cassinari

Acc. no. 52.140
Museum Purchase
COLLECTIONS: (Il Milione, Milan).

JEAN-CHARLES CAZIN

1841–1901. French. Studied at the École des Arts Décoratifs and with Lecoq de Boisbaudran. Traveled in England, Italy and Holland, 1871–75. Following his first success at 1876 Salon, he painted primarily history and religious pictures until ca. 1883. However, his reputation rests on the landscapes he painted from the 1880s onward.

In the Lowlands PL. 276

[Ca. 1890–1900] Oil on canvas
15⅛ x 18¼ in. (38.4 x 46.4 cm.)
Signed lower left: J. C. Cazin

Acc. no. 26.75
COLLECTIONS: Edward Drummond Libbey, by 1903 (?)–1926.

This painting probably dates from the last phase of Cazin's work after 1888, when he painted many similar landscapes, in which the emphasis is on color and tone rather than spatial organization.

PAUL CÉZANNE

1839–1906. French. Born in Aix. In 1862 went to Paris; entered the Académie Suisse, where he met Pissarro. Rejected by the Salon, he exhibited at the Salon des Refusés in 1863, and with the Impressionists in 1874 and 1877. Lived mostly in Paris and Aix, and in later years painted almost exclusively in Provence.

Avenue at Chantilly PL. 261

[1888] Oil on canvas
32 x 25½ in. (81.3 x 64.8 cm.)
Acc. no. 59.13
Gift of Mr. and Mrs. William E. Levis

COLLECTIONS: Ambroise Vollard, Paris; (Hugo Cassirer, Berlin); Mme. Furstenberg, Paris; (J.K. Thannhauser, New York); W. A. M. Burden, New York, 1949–53; (Knoedler, New York, 1953); Mr. and Mrs. William E. Levis, Perrysburg, Ohio.

EXHIBITIONS: Cologne, Sonderbund, *International Kunstaustellung,* 1912, no. 136; Berlin, Cassirer, *Cézanne,* 1921, no. 12; San Francisco, H. M. de Young Museum, *The Painting of France since the French Revolution,* 1940, no. 4, repr. p. 88; New York, Metropolitan Museum of Art, *French Painting: David to Toulouse-Lautrec,* 1941, no. 6; Art Institute of Chicago, *Masterpieces of French Art lent by the Museums and Collectors of France,* 1941, no. 13, pl. XXXIX.

REFERENCES: W. Weisbach, *Impressionismus in der Antike und Neuzeit,* Berlin, 1910–11, II, pp. 160–61, repr.; A. Vollard, *Paul Cézanne,* Paris, 1914, pl. 48; L. Venturi, *Cézanne, son art, son oeuvre,* Paris, 1936, I, no. 627; II, pl. 201; G. Rivière, *Cézanne, le peintre solitaire,* Paris, 1936, p. 142; M. Schapiro, *Paul Cézanne,* New York, 1952, pp. 14, 80, repr. p. 81; A. Gatto and S. Orienti, *L'opera completa di Cézanne,* Milan, 1970, no. 665, repr.

In 1888 Cézanne spent five months working at Chantilly, living at the Hôtel Delacourt.

The Glade PL. 260

[Ca. 1890] Oil on canvas
39½ x 32 in. (100.3 x 81.3 cm.)
Acc. no. 42.18

COLLECTIONS: Mme. Emile Staub-Terlinden, Männedorf, Switzerland; (Wildenstein, New York).

EXHIBITIONS: Basel, Kunsthalle, *Paul Cézanne*, 1936, no. 50; New York, Wildenstein, *Cézanne*, 1947, no. 55, repr. p. 60; New York, Wildenstein, *Cézanne*, 1959, no. 41, repr.

REFERENCES: F. Burger, *Cézanne and Hodler*, Munich, 1920, I, p. 103; II, pl. 109; L. Venturi, *Cézanne, son art, son oeuvre*, Paris, 1936, I, no. 670; II, pl. 215; A. Gatto and S. Orienti, *L'opera completa di Cézanne*, Milan, 1970, no. 689, repr.

This picture is one of a large group in which massed trees form the principal subject. Although Venturi dated the Toledo painting 1892–96, Ronald Alley (letter, Aug. 1974) has suggested it was painted ca. 1889 because of its similarity to pictures such as *Le Grand Pin* (Museo de Arte, São Paulo, Brazil).

PHILIPPE DE CHAMPAIGNE

1603–1674. French. Born in Brussels, where he was first trained as a landscape painter. In 1621 to Paris, where he lived most of his life. Collaborated on the decoration of the Luxembourg Palace for Marie de Medici, and in 1628 was appointed painter to her. Worked for the King and for Cardinal Richelieu. Member of the Académie from its founding in 1648. About 1643, after beginning to work for the austere Catholic Jansenist sect whose beliefs deeply influenced him, his work became more classical in style.

A Councilman of Paris PL. 184

[1654] Oil on canvas
31½ x 25¾ in. (80 x 65.5 cm.)

Acc. no. 33.325
Gift of Felix Wildenstein

COLLECTIONS: Hugot, Paris; Felix Wildenstein, New York.

EXHIBITIONS: Paris, Orangerie, *Philippe de Champaigne*, 1952, no. 35, pl. XIII (cat. by B. Dorival).

REFERENCES: A. Mabille de Poncheville, *Philippe de Champaigne, sa vie et son oeuvre*, Paris, 1952, p. 146, pl. XXI; A. Blunt, "Philippe de Champaigne at the Orangerie, Paris," *Burlington Magazine*, XCIV, June 1952, p. 175; P. Gaudibert, "Philippe de Champaigne: portrait de magistrat parisien récemment identifié," *Bulletin de la société de l'art français*, 1955, p. 44; J. Wilhelm, "Les tableaux de l'hôtel de ville de Paris et de l'abbaye Sainte

Geneviève," *Bulletin de la société de l'art français*, 1956, pp. 25–6; *Wallace Collection Catalogues: Pictures and Drawings*, 16th ed. (ed. F. J. B. Watson), London, 1968, p. 60; B. Dorival, *Philippe de Champaigne*, Paris, 1976, no. 226.

In 1648, 1654 and 1656 Philippe de Champaigne painted the *prévot des marchands* (mayor) and *échevins* (municipal councilmen) for the Paris Hôtel de Ville. These group portraits continued a series painted from the middle of the 16th century onward in which these civic officials are shown kneeling on either side of an altar or royal figure with the *prévot* and three other officials of the *corps municipal* on the left, and the four *échevins* on the right.

Only the 1648 painting has survived (Louvre). B. Dorival states (letter, Apr. 1976) the 1654 group was vandalized by a Revolutionary mob on August 10, 1792, while the fate of the 1656 painting, still intact in 1799, is unknown.

The Toledo painting is one of four similar portraits of *échevins* identified as fragments of the 1654 and 1656 groups (A. Blunt, "Philippe de Champaigne's Portraits of the Echevins of Paris," *Burlington Magazine*, LXXXII, Apr. 1943, pp. 83–7; Blunt, 1952; Gaudibert). The canvas has been enlarged at the sides, the elbow (left) and folds at the back of the robe (right) having been added. According to Dorival (1976), these fragments must be from the 1654 group, which would have been actually painted during the term of office of the *prévot* and *échevins* (1652–54). The other fragments are in the Wallace Collection, London; private collection, Geneva, Switzerland and formerly Kaiser Friedrich Museum, Berlin (destroyed, 1945). While the names of the four échevins of 1654 are known, only the Geneva portrait can be linked to one of these names.

CHAVANNES (*see* PUVIS)

GIORGIO DE CHIRICO

1888–. Italian. Born in Greece of Italian parents. Studied drawing in Athens, then painting at Munich Academy of Fine Arts, 1905–08. Lived in Paris, 1911–31. With Carrà founded the quasi-Surrealist Metaphysical Painting movement in 1917. Has lived in Italy since 1931.

Self-Portrait PL. 41

[Ca. 1922] Oil on canvas
15⅛ x 20⅛ in. (38.4 x 51.1 cm.)

Signed lower right: G. de Chirico se ipsum

Acc. no. 30.204

COLLECTIONS: (Bonjean, Paris); (René Gimpel, Paris).

EXHIBITIONS: Houston Museum of Fine Arts, *Chagall and Chirico,* 1955, no. 21, repr.; Rome, Palazzo dei Esposizioni, *VII quadriennale nazionale de'arte di Roma,* 1955, p. 58, no. 72 (as 1922).

Although de Chirico has painted several self portraits, this appears to be the only one in double form. The architectural setting, classical bust and fruit are recurring images in his work. According to the artist (letter, May 1976), this portrait was painted between 1922 and 1925, probably about 1922.

GIAMBETTINO CIGNAROLI

1706–1770. Italian. A student of Sante Prunati and later Balestra, Cignaroli spent most of his life in his native Verona, making occasional trips to Venice and Parma, never traveling outside Italy. Veronese and the Carracci influenced his style.

Madonna and Child with Saints PL. 29

[Probably 1759] Oil on canvas
62 x 33½ in. (157.5 x 85.2 cm.)

Acc. no. 71.6

COLLECTIONS: (Colnaghi, London).

EXHIBITIONS: Art Institute of Chicago, *Painting in Italy in the Eighteenth Century: Rococo to Romanticism,* 1970, no. 19, repr. p. 61 (entry by B. Hannegan).

REFERENCES: R. Pallucchini, "La pittura Veneta del settecento alla mostra itinerante di Chicago—Minneapolis—Toledo," *Arte Veneta,* XXIV, 1970, p. 287.

The Madonna and Child with Saints Lawrence, Lucy, Anthony of Padua and Barbara, with the Guardian Angel is a finished modello for, or perhaps an autograph reduction (Pallucchini) of, the large altarpiece (Prado) originally in the Spanish royal church of S. Ildefonso, Madrid, the gift of Louise Elisabeth, daughter of Louis XV of France and wife of Philip, Duke of Parma, who commissioned it during Cignaroli's visit to Parma in 1759. Hannegan cites Veronese's altarpiece of the Marogna family in S. Paola, Verona, as the artist's point of departure, while the Madonna recalls Lodovico Carracci.

PIETER CLAESZ.

1596/97–1660. Dutch. Born in Westphalia, Germany. By 1617 in Haarlem, where he remained the rest of his life. Father of the painter Nicolaes Berchem. He and William Claesz. Heda are the originators of monochrome and breakfast still lifes.

Still Life with Oysters PL. 124

[1642] Oil on wood panel
14 x 20⅛ in. (35.6 x 51.1 cm.)
Signed and dated left center: PC (in monogram)/1642

Acc. no. 50.233

COLLECTIONS: Colonel M. A. W. Swinfen Broun, Swinfen Hall, Lichfield (Christie, London, Dec. 10, 1948, no. 84); (Eugene Slatter, London).

CLAUDE LORRAIN

1600–1682. French. Born Claude Gellée in Lorraine. Ca. 1613 in Rome, where he was assistant to the landscape painter Agostino Tassi, ca. 1620–25. In France 1625–27, but returned to Rome for the remainder of his life. The use of light, space and atmospheric tones in his poetic interpretations of the Roman countryside and Mediterranean coast influenced landscape painting for two centuries after his death.

Landscape with Nymph PL. 188
and Satyr Dancing

[1641] Oil on canvas
39¼ x 52⅜ in. (99.6 x 133 cm.)
Perhaps traces of a signature (and date?) on fallen capital, lower right

Acc. no. 49.170

COLLECTIONS: Painted for an unknown patron in Venice, 1641; Hubert, probably France, by ca. 1720 until at least 1777; A. Gilmore, London (Phillips, London, June 2, 1843, lot 76); 2nd and 3rd Lords Bateman, Shobdon, Herefordshire, by 1881–ca. 1930; (Colnaghi, London); (David H. Farr, New York, 1930); (Christie, London, July 14, 1939, lot 119); (Wildenstein, Paris, 1939); seized for Hitler's projected museum at Linz, 1940; (Wildenstein, New York, 1945–49).

EXHIBITIONS: London, Royal Academy, *Winter Exhibition,* 1881, no. 163; New York, Wildenstein, *Gods and Heroes, Baroque Images in Antiquity,* 1968, no. 8, pl. 44.

REFERENCES: J. Smith, VIII, p. 221; Mme. M. Pattison, *Claude Lorrain, sa vie et ses oeuvres,* Paris, 1884, pp.

212, 229; O. T. Dullea, *Claude Gellée Le Lorrain*, London, 1887, pp. 105, 122; M. Röthlisberger, *Claude Lorrain: The Paintings*, New Haven, 1961, I, pp. 195–96; II, fig. 123; M. Röthlisberger, "Nuovi aspetti di Claude Lorrain," *Paragone*, No. 273, Nov. 1972, p. 31; M. Röthlisberger and D. Cecchi, *L'opera completa di Claude Lorrain*, Milan, 1975, no. 119, pls. IV–V, VI.

Beginning in 1633 Claude made record drawings of his paintings, with notations relative to dating and patrons, in the *Liber Veritatis* (British Museum). Claude's drawing in the *Liber* (no. 55) after this picture is inscribed in ink on the reverse: *faict per Venetia* ("done for Venice") and *Claudio fecit in V.R.* ("done by Claude in Rome"). The Venetian patron who commissioned it is not known. Röthlisberger (1961), who dates the painting 1641 based on the chronological order of the *Liber*, considers it Claude's first landscape with a bacchic theme. He also notes (1972) that a satyr appears in only one other painting by Claude.

JOOS VAN CLEVE

Ca. 1485–1540/41. Dutch. Born at or near Cleves. Also called Joos van der Beke. 1511 recorded in Antwerp guild. Except for possible visits to France and Italy, he worked in Antwerp. Primarily a portraitist, he also painted religious subjects.

Portrait of a Man PL. 83

[Ca. 1520–30] Oil on wood panel
16¼ x 13¼ in. (41.2 x 33.6 cm.)

Acc. no. 26.59

Portrait of a Woman PL. 84

[Ca. 1520–30] Oil on wood panel
16⅝ x 13⅜ in. (42.1 x 34 cm.)

Acc. no. 26.62

COLLECTIONS: Earl of Ellenborough (Christie, London, Apr. 3, 1914, lots 106, 107, repr.); (Agnew, London); Edward Drummond Libbey.

REFERENCES: M. Conway, *The Van Eycks and Their Followers*, London, 1921, p. 411; L. Baldass, *Joos van Cleve, der Meister des Todes Mariä*, Vienna, 1925, I, p. 27; II, p. 8, n. 79, p. 26, figs. 57, 58; M. J. Friedländer, *Die Altniederländische Malerei*, Leyden, 1934, IX, no. 116; M. J. Friedländer, *Early Netherlandish Painting* (ed. H. Pauwels), New York, 1972, IXa, no. 116, pls. 120, 121, fig. 116; John G. Johnson Collection, *Catalogue of Flemish and Dutch Paintings*, Philadelphia, 1972, p. 24.

These pendant portraits were painted about 1530, according to Friedländer and Conway, though Baldass dated them ca. 1521–24. A copy of the man is in the Johnson Collection, Philadelphia Museum of Art; the present location of a copy of the woman (Friedländer, 1972, pl. 124) is unknown.

A coat of arms on the back of the Toledo man's portrait identifies him as a member of the Hanneman family of Holland. These arms also appear on the front of the Johnson copy, as does his age, given as 25. As there were two Hannemans about this age around 1530, it is not certain which one is shown. The ring held by the woman may refer to the marriage or betrothal of the couple.

FRANÇOIS CLOUET

Ca. 1510–1572. French. Born in Tours. Son and probably pupil of Jean Clouet. Active as early as 1536. 1540/41 succeeded his father as painter to King Francis I, subsequently serving as painter to Henry II, Francis II and Charles IX. Especially known for his crayon portraits, Clouet also painted mythological scenes and directed a large workshop which produced miniatures, enamel designs and decorations for triumphal entries. Died in Paris.

Elizabeth of Valois PL. 178

[Ca. 1559] Oil on wood panel
14¼ x 9⅞ in. (36.2 x 25.1 cm.)

Acc. no. 29.140

COLLECTIONS: Princess de Croÿ; Count de Lonyay, Nagy-Lonya, Hungary; (Wildenstein, New York).

EXHIBITIONS: London, Royal Academy, *Commemorative Catalogue of the Exhibition of French Art, 1200–1900*, 1932, no. 50, pl. 22.

REFERENCES: "A François Clouet Acquired," *Toledo Museum of Art Museum News*, No. 55, Dec. 1929, unpaginated, repr. on cover; M. Chamot, "Primitives at the French Exhibition," *Apollo*, XV, Feb. 1932, p. 65, repr. p. 60; L. Réau, *French Painting in the XIVth, XVth and XVIth Centuries*, Paris, 1939, p. 35, repr. p. 95.

The identification of the sitter as Elizabeth of Valois, daughter of Henry II of France and third wife of Philip II of Spain, is confirmed by the likeness to a portrait of Elizabeth at nearly the same age by Sanchez Coello in the Kunsthistorisches Museum, Vienna. The Imperial collection provenance of the Vienna portrait and the fact that the Queen's pearl headdress carries the monogram YF (Ysabella, France) secure its identification. The

Toledo sitter strongly resembles the young girl in the drawing in the Musée Condé, Chantilly (E. Moreau-Nélaton, *Les Clouets et leur émules*, 1924, II, fig. 208), probably by Clouet, which bears a 16th century inscription identifying the subject as Elizabeth, Queen of Spain at the age of 14. Since Elizabeth was born in April 1545, this drawing can probably be dated 1559.

Dating is based on the close correspondence in age of the Toledo and Chantilly portraits. The Toledo painting was surely executed before 1560, when Elizabeth joined Philip in Spain.

The attribution of the Toledo portrait to Clouet has been consistently upheld and recently reaffirmed by Charles Sterling (letter, May 1974).

Two copies of Toledo's portrait are known. One was reported to be in the Kleiweg de Zwaan collection, Amsterdam, in 1929, and the other in the collection of Henry Blank, Glen Ridge, New Jersey (Parke-Bernet, New York, Nov. 16, 1949, lot 59, repr.).

JOHN CONSTABLE

1776–1837. British. Born in Suffolk. Entered the Royal Academy Schools, 1799. A.R.A., 1819; R.A., 1829. He divided his time between London and his native Stour Valley, Suffolk. Working from direct observation of nature, he sketched the changing effects of weather, clouds and countryside for use in his pictures. The bright color and spontaneity of Constable's work was much admired by the French, especially Delacroix and the early Barbizon painters. Received a gold medal at the 1824 Paris Salon. He and Turner were the dominant influences on 19th century English landscape painting.

Arundel Mill and Castle PL. 332

[1837] Oil on canvas
28½ x 39½ in. (72.4 x 100.3 cm.)

Acc. no. 26.53

COLLECTIONS: Constable sale (Foster, London, May 16, 1838, lot 81; bought in for John Charles Constable); John Charles Constable (the artist's son), London, 1838–41; Charles Golding Constable (the artist's second son), London, by 1862–79; Holbrook Gaskell, Wootton, 1878 (Christie, London, Jun. 24, 1909, lot 8); (Knoedler, 1909); (Henry Reinhardt, Milwaukee, 1909–10); Edward Drummond Libbey, 1910–25.

EXHIBITIONS: London, Royal Academy, 1837, no. 193; London, Royal Academy, *Works of the Old Masters Associated with Works of Deceased Members of the British School*, 1871, no. 4; Liverpool Art Club, *Oil Paintings by British Artists Born Before 1801*, 1881, no. 15; London, Royal Academy, *Works by the Old Masters and by Deceased Masters of the British School*, 1885, no. 64; London, Grosvenor Gallery, *A Century of British Art from 1737 to 1837*, 1888, no. 47; Boston, Museum of Fine Arts, *Turner, Constable and Bonington*, 1946, no. 147, repr.; London, Royal Academy, *Bicentenary Exhibition: 1768–1968*, 1968, I, no. 97; II, repr. p. 62; London, Tate Gallery, *John Constable*, 1st ed., 1976, no. 335, p. 202, 1837, n. 1 (entry by L. Parris and I. Fleming-Williams).

REFERENCES: C. R. Leslie, *Memoirs of the Life of John Constable*, London, 1843, pp. 109, 115, repr.; [same] (ed. A. Shirley), London, 1937, pp. lxxiii, lxxix, xxxv, 353, 356, pl. 150; C. Holmes, *Constable and His Influence on Landscape Painting*, London, 1902, pp. xiv, 217, 222, 252, repr.; A. Jespersen, "Arundel Mill by John Constable," *Bulletin of the California Palace of the Legion of Honor*, VIII, July 1950, repr. p. [2]; C. Peacock, *John Constable, The Man and His Work*, Greenwich, Conn., 1965, p. 40 and 40n.; G. Reynolds, *Constable, The Natural Painter*, London, 1965, pp. 124–25, 130, 132, 133, 147, pl. 80; R. B. Beckett, ed., *John Constable's Correspondence*, Ipswich, 1962–70, III, pp. 134, 146, 148–50, pl. 6; IV, p. 229; V, pp. 28n, 31, 32, 36, 37, 202; VI, p. 77n; M. Kitson, "Bicentenaire de la Royal Academy," *Revue de l'Art*, V, 1969, p. 94; B. Taylor, *Constable: Paintings, Drawings and Watercolours*, London, 1973, pp. 10, 18, 211, pl. 168; G. Reynolds, *Victoria and Albert Museum, Catalogue of the Constable Collection*, 2nd ed., London, 1973, p. 225; L. Parris, C. Shield and I. Fleming-Williams, ed., *John Constable: Further Documents and Correspondence*, London, 1975, pp. 57, 100, 101, 102 (sketch, 62); I. Fleming-Williams, *Constable Landscape Watercolours and Drawings*, London, 1976, pp. 11, 116, fig. 123.

In 1834 Constable first visited his friend George Constable—no relation—at Arundel, Sussex. In 1835 he went again, accompanied by his two oldest children. Early in 1836 he began a painting of Arundel Mill based on a drawing made in 1835, as well as two drawings in his 1835 sketchbook (Victoria and Albert Museum, London; Reynolds, 1973, nos. 379, 382 (pp. 33, 35), repr.; Fleming-Williams, fig. 84, pl. 50). He did not return to the painting until February 1837, when he wrote a friend, ". . . I am at work on a beautiful subject, Arundel Mill. . . . It is, and shall be, my best picture." (Beckett, III, p. 37). Constable was working on this picture the day he died, March 31. According to the miniature painter Alfred Tidey (1808–1892), "I called on Constable

on March 28th, 1837. He was then working on his "Arundel Castle," and seemed well satisfied with the result of his labours. He said while giving a touch here and there with his palette knife, and retiring to see the effect, 'It is neither too warm, nor too cold, too light nor to dark and this constitutes everything in a picture.'" (note dated Dec. 9, 1838; Mr. and Mrs. Paul Mellon collection, Upperville, Virginia).

A small oil version is in the California Palace of the Legion of Honor, San Francisco. The Toledo picture was engraved in mezzotint by David Lucas in 1855.

CORNEILLE DE LYON

Ca. 1500/10–after March 1574. French. Also known as Corneille de la Haye, after his birthplace, The Hague. By 1533 in Lyons. Became painter to the Dauphin, 1541; in 1551 painter to Henry II, and subsequently to Charles IX. Specialized in small, half-length portraits. Headed a large workshop. Probably died at Lyons.

Maréchal Bonnivet PL. 180

Oil on wood panel
12⅜ x 9⅜ in. (31.5 x 23.8 cm.)

Acc. no. 38.25

COLLECTIONS: Count Montbrizon, Château St. Roche, Montauban; (Wildenstein, New York).

REFERENCES: "An Early French Masterpiece," *Toledo Museum of Art Museum News,* No. 84, Dec. 1938, unpaginated, repr. on cover; L. Réau, *French Painting in the XIVth, XVth and XVIth Centuries,* Paris, 1939, p. 35, fig. 96; A. Châtelet and J. Thuillier, *French Painting from Fouquet to Poussin,* Geneva, 1963, p. 133.

Réau accepted the attribution of this painting to Corneille, while Châtelet and Thuillier suggested a different, though related hand.

The identification of the subject of the Toledo portrait as François Gouffier, Maréchal Bonnivet, son of the famous French army commander, Guillaume Gouffier, is based on a resemblance to a portrait drawing of Bonnivet in the Musée Condé, Chantilly.

JEAN-BAPTISTE-CAMILLE COROT

1796–1875. French. Born in Paris. Studied briefly with Achille Michalon and Victor Bertin. In Italy, 1825–28;

returned there 1834 and 1843. Exhibited annually at the Salon from 1828. Traveled and painted throughout France and worked periodically with the Barbizon artists in the 1840s and 50s. The leading French landscape painter of his time; Corot also did figure paintings and prints.

Canal in Picardy PL. 220

[Ca. 1865–71] Oil on canvas
18⅜ x 24¼ in. (46.7 x 61.6 cm.)
Stamped lower right: Vente/Corot

Acc. no. 22.20
Gift of Arthur J. Secor

COLLECTIONS: (Corot sale, Hôtel Drouot, Paris, May 26–28, 1875, lot 174, repr.); Jules Chamouillet (Corot's grandnephew), Paris, 1875; Marczell de Nemes, Budapest, by 1911 (Galerie Manzi, Joyant, Paris, Jun. 18, 1913, lot 92, repr.); Arthur J. Secor, 1914–22.

EXHIBITIONS: Budapest, *Collection Marczell de Nemes,* 1911; Düsseldorf, Städtisches Kunsthalle, *Die Sammlung des Kgl. Rates Marczell de Nemes—Budapest,* 1912, no. 96, repr.; Art Institute of Chicago, *Corot,* 1960, no. 104, repr.; New York, Wildenstein, *Corot,* 1969, no. 52, repr.

REFERENCES: A. Robaut and E. Moreau-Nélaton, *L'oeuvre de Corot,* Paris, 1905, III, no. 1743, repr. (as 1866–70).

Robaut identified this characteristic example of Corot's poetic late style as a landscape in Picardy. It is probably near Douai and Arras, a region interlaced by canals which Corot often visited between 1865 and 1871.

PIETRO DA CORTONA

1596–1669. Italian. Born Pietro Berrettini at Cortona, where he studied with Andrea Commodi, with whom he went to Rome in 1612/13. First worked there for the Sacchetti family, but was soon patronized by the powerful Barberini family for whose palace he painted his greatest work, the ceiling of the Salone. Except for a trip to Florence and Venice in 1637 and work in Florence for the Medici, 1640–47, he remained in Rome. As a painter and also as an important architect he was one of the founders of the Roman High Baroque.

The Virgin with a Camaldolese Saint PL. 19

[1629/30] Oil on canvas
57⅝ x 44⅝ in. (146.4 x 113.4 cm.)

Acc. no. 60.31

COLLECTIONS: Barberini collection, Rome, ca. 1629–1960; (Colnaghi, London, 1960).

EXHIBITIONS: Cortona, *Mostra di Pietro da Cortona,* 1956, no. 11, pl. XI (cat. by G. Briganti); London, Colnaghi, *Paintings by Old Masters,* 1960, no. 9, pl. V.

REFERENCES: F. Barberini, *Registrato di mandati 1628–39* (MS. Arch. Barb. Armadio 42), Aug. 21, 1629, no. 1934; F. Barberini, *Libro mastro a 1623–29* (MS. Arch. Barb.) Oct. 3, 1629, fol. 289; F. Barberini, *Giustificazioni* (MS. Arch. Barb. Armadio 100), Sep. 1630, no. 1602; *Barberini Collection Inventory* (MS. Barb. Lat. 5635), 1631, no. 63; J. A. Orbaan, *Documenti sul barocco in Roma,* Rome, 1920, p. 506; O. Pollak, *Die Kunsttätigkeit unter Urban VIII,* Vienna, 1928, I, p. 967; E. K. Waterhouse, *Baroque Painting in Rome,* London, 1937, p. 59; A. Blunt, "The Exhibition of Pietro da Cortona at Cortona," *Burlington Magazine,* XCVIII, Nov. 1956, p. 415; B. N. (B. Nicolson), "Three Old Master Exhibitions," *Burlington Magazine,* CII, July 1960, p. 334, fig. 47; G. Briganti, *Pietro da Cortona,* Florence, 1962, pp. 75, 137, 175–76, fig. 54; K. Noehles, "Rezension: Giulio Briganti, *Pietro da Cortona,*" *Kunstchronik,* XVI, 1963, pp. 100, 105; I. Lavin, "Pietro da Cortona Documents from the Barberini Archive," *Burlington Magazine,* CXII, July 1970, pp. 446, 449, 451, fig. 24; B. Fredericksen and F. Zeri, *Census,* 1972, p. 165.

According to documents discovered by Noehles and Lavin, this painting was commissioned about 1629/30 by Cardinal Francesco Barberini, nephew of Pope Urban VIII, for the hermitage of the Camaldolese order at Frascati.

Lavin believes the monk represents a combination of two Camaldolese figures, St. Peter Damian and the Blessed Paul Giustiniani. A cardinal's hat and the saint's veneration of the Virgin identify the former, while the monk's short cape fastened at the neck with a piece of wood, and the two monks in the background retreating to a solitary chapel may allude to Giustiniani's reform of the order by founding its Monte Corona branch. Lavin suggested this painting may have been painted to commemorate the centennial in 1628 of Giustiniani's death.

Briganti cites two drawings in the Uffizi (nos. 841p and 939p) as preparatory studies for the landscape background. He also believed that the painting was commissioned by Giulio Sacchetti in 1626.

COSIMO (see PIERO)

LORENZO COSTA

1460–1535. Italian. Studied in Ferrara; influenced by Francesco del Cossa and Ercole de' Roberti. In Bologna by 1483, he worked for the Bentivoglio court and formed a partnership with Francesco Francia. From 1506 was Mantegna's successor as court painter in Mantua, working for Isabella d'Este until his death.

The Holy Family PL. 11

[Ca. 1510] Oil (and perhaps tempera) on wood panel
35 x 25½ in. (88.9 x 64.8 cm.)
Signed lower right: LAVRENTIVS COSTA F
Inscribed lower right: F. 6.

Acc. no. 65.174

COLLECTIONS: Isabella d'Este, Mantua, from ca. 1510; Este collection, Ferrara, to 1598; Barberini collection, Rome, from 1598 until at least 1936; Corsini collection, Florence, to 1964; (Agnew, London).

REFERENCES: B. Berenson, *North Italian Painters of the Renaissance,* New York, 1907, p. 204; T. Gerevich, "Lorenzo Costa," *Thieme-Becker,* Leipzig, 1912, VII, p. 529; A. Venturi, *Storia dell'arte italiana,* Milan, 1914, VII, part III, p. 806, fig. 596; B. Berenson, *Italian Pictures of the Renaissance,* Oxford, 1932, p. 157; B. Berenson, *Pitture italiane del Rinascimento,* Milan, 1936, p. 135; R. Varese, *Lorenzo Costa,* Milan, 1967, no. 75, fig. 56 (as in Barberini collection); B. Berenson, *Italian Pictures of the Renaissance: Central Italian and North Italian Schools,* London, 1968, I, p. 97.

Painted for Isabella d'Este about 1510, this painting remained in the Este collections until 1598, when Pope Clement VIII took Ferrara into the Papal dominions. With the ensuing looting of the Este collection, the *Holy Family* entered the Barberini collection. It later passed from the Barberinis to the Corsinis through marriage.

Painted at a time when Florence and Rome were already experiencing the High Renaissance, Costa's panel suggests work of the preceding century. The facial type of the Madonna may be compared to the Virgin in Perugino's *The Virgin in Glory with Saints* (Pinacoteca, Bologna), painted in 1494 for a chapel in S. Giovanni in Monte, Bologna. Costa painted the high altar for the same church in 1501–02.

PLACIDO COSTANZI

1701–1759. Italian. Born in Rome, son of the gem engraver Giovanni Costanzi. Until about 1720 studied with Trevisani, then in the studio of Luti. Won early success,

and was patronized by Italians, Spaniards and French. Elected to the Academy of St. Luke, 1741; served as president, 1758–59.

The Trinity with Saints Gregory and Romuald

PL. 30

[1726] Oil on canvas
62 x 30 in. (157.5 x 76.2 cm.)

Acc. no. 75.10

COLLECTIONS: (Paolo Rosa, Rome); (Colnaghi, London, 1973–75).

REFERENCES: V. Moschini, *Le chiesi di Roma illustrate: No. 17, San Gregorio al Celio,* Rome, n.d., p. 13 (fresco); A. M. Clark, "An Introduction to Placido Costanzi," *Paragone,* XIX, May 1968, p. 53, n. 15 (fresco).

This is the *modello* for Costanzi's ceiling fresco in the nave of the church of S. Gregorio Magno, Rome, completed in October 1727. According to Moschini, the sketches, of which this painting is the only one known, were presented for approval in 1726. With minor exceptions, the fresco closely follows the Toledo *modello.* At the top is the Trinity; the two saints kneeling beneath God the Father, are (right) St. Gregory, in whose honor the church was built, and (left) St. Romuald, founder of the Camaldolese order housed in S. Gregorio. Presumably, the fresco was commissioned by the Order, and the sketch may have remained in their possession after the work was completed.

GUSTAVE COURBET

1819–1877. French. Born at Ornans. After study in Besançon and Paris, he copied old master paintings independently at the Louvre. Included in the Salon, 1844 and 1847–70. Frequently exhibited in Belgium, Switzerland and Germany, where he had many admirers. During the 1855 and 1867 Paris Worlds Fairs, he showed his work in private exhibitions. Entrusted with the preservation of art treasures during the siege of Paris, 1870–71, but was later charged with the destruction of the Vendôme Column and sentenced to prison. In 1873, threatened with further reprisals he fled to Switzerland, where he died in exile.

The Trellis

PL. 218

[1862] Oil on canvas
43¼ x 53¼ in. (109.8 x 135.2 cm.)
Signed lower left: G. Courbet.

Acc. no. 50.309

COLLECTIONS: Cotel, Paris, 1878?; Jules Paton, Paris, by 1882 (Bernheim-Jeune, Paris, Apr. 24, 1883, lot 23); T. J. Blakeslee, New York (American Art Galleries, New York, Apr. 10–11, 1902, lot 50); (Durand-Ruel, New York and Paris, 1902–06); Adrien Hèbrard, Paris, 1906; Prince de Wagram, Paris, 1908; Baron Cacamizy, London(?); Blanche Marchesi, London, by 1909–19/20; Mrs. R. A. Workman, London, 1919/20–29 (Paul Rosenberg, Paris, 1929); (Wildenstein, New York, 1929–50).

EXHIBITIONS: Saintes, Hôtel de Ville, *Explication des ouvrages de peinture et de sculpture exposés dans les salles de la mairie au profit des pauvres,* 1863, no. 76 (as *Femme aux fleurs*); Paris, École des Beaux-Arts, *Exposition des oeuvres de Gustave Courbet,* 1882, no. 128; London, Burlington Fine Arts Club, *Pictures, Drawings and Sculpture of the French School of the Last 100 Years,* 1922, no. 28; Paris, Palais des Beaux Arts, *Gustave Courbet,* 1929, no. 41, pl. 8; Berlin, Galerie Wertheim, *Gustave Courbet,* 1930, no. 32, repr.; Zurich, Kunsthaus, *Gustave Courbet,* 1935, no. 70, pl. 23; Baltimore Museum of Art, *Paintings by Courbet,* 1938, no. 10; New York, Wildenstein, *Courbet,* 1949, no. 19, repr.; Detroit Institute of Arts, *From David to Courbet,* 1950, no. 104, repr.; Venice, Biennale, *Courbet,* 1954, no. 21; Lyons, Musée de Lyon, *Courbet,* 1954, no. 26; Paris, Petit Palais, *G. Courbet,* 1955, no. 45, repr. on cover; New York, Paul Rosenberg, *Gustave Courbet,* 1956, no. 8, repr.; Philadelphia Museum of Art, *Gustave Courbet,* 1959, no. 39, repr.

REFERENCES: M. Conil, "L'exposition de peintre de Saintes, G. Courbet," *Courrier des Deux Charentes,* Saintes, Feb. 19, 1863, p. 3; Anonymous, "Exposition de peinture, M. Courbet," *L'Indépendant de la Charente-Inférieure,* Saintes, Jan. 29, 1863, p. 3; J. Bruno, *Les Misères des gueux,* Paris, 1872, fig. 34 (as *Alice à la serre*); A. Estignard, *G. Courbet, sa vie, ses oeuvres,* Besançon, 1896, p. 162; S. Riat, *Gustave Courbet, peintre,* Paris, 1906, pp. 200, 336; T. Duret, *Courbet,* Paris, 1918, pp. 64, 119; J. Meier-Graefe, *Courbet,* Munich, 1924, pls. 27, 29; J. Manson, "The Workman Collection, Modern Foreign Art," *Apollo,* III, Mar. 1920, p. 140, repr. opp. p. 218; P. Courthion, *Courbet raconté par lui-meme et par ses amis,* Geneva, 1948–50, I, p. 168; G. Mack, *Gustave Courbet,* New York, 1951, p. 172, pl. 38; G. Delestre, *Courbet dans les collections privées françaises,* exh. cat., Paris, Galerie Claude Aubrey, 1966, in no. 10; R. Bonniot, "Gustave Courbet dans les collections privées françaises," *Journal de l'amateur d'art,* July 1966, p. 11; R. Fernier, *Gustave Courbet, peintre de l'art vivant,* Paris, 1969, fig. 106; J. Lindsay, *Gustave Courbet, His Life and Art,* Somerset, 1973, pp. 203–04,

fig. 48; R. Bonniot, *Gustave Courbet en Saintonge*, Paris, 1973, pp. 87, 229, 243, 262.

In May 1862 Courbet went to western France on the invitation of the collector and amateur writer Étienne Baudry, in whose château at Rochemont, near Saintes he stayed until October. During this time he painted at least thirty pictures, including the remarkable series of flower still lifes to which the Toledo painting is closely related. After leaving Rochemont, Courbet stayed in and near Saintes until the following spring.

This picture has often been dated 1863 on the basis of the chronological list of Courbet's paintings appended to the catalogue of the 1882 Paris exhibition. It has also mistakenly been identified with No. 108 in Courbet's 1867 Paris exhibition, an unfinished painting with a similar subject (Delestre, 1966, in no. 10; Leger, *Courbet*, 1925, p. 218, no. XXVI).

In January 1863 Courbet organized an exhibition at the Saintes town hall that included some 40 of his own pictures. As reviews by local critics confirm that the Toledo picture was in this exhibition, *The Trellis* was almost certainly painted during Courbet's stay at Rochemont (Bonniot, 1966; 1973, p. 243; letter, 1975).

Landscape Near Ornans　　　　PL. 219

[1864] Oil on canvas
35 x 50⅛ in. (88.8 x 127.2 cm.)
Signed and dated lower left: 64./G. Courbet.

Acc. no. 64.59

COLLECTIONS: Mme. de Marre, Château de Kergouano (Morbihan), France; (Sale, Baden (Morbihan), Jun. 23, 1962); (Wildenstein, New York).

Courbet spent much of 1864 working in the vicinity of his native Ornans in the Franche-Comté region of eastern France. Although he often painted directly from nature, this picture is a composite of major features of the region, the Loue River and the Roche du Mont.

Related landscapes which include the left two-thirds of the composition are in the Neue Pinakothek, Munich (dated 1865); Des Moines Art Center, Iowa; and a presently unlocated canvas (J. Meier-Graefe, *Courbet*, Munich, 1924, pl. 85, wrongly identified as the Munich picture). An etching reproducing a fragment of this composition (H. d'Ideville, *Gustave Courbet*, Paris, 1878, pl. 5) is inscribed "*Paysage 1860.*" This may be the date when Courbet, who often returned to Ornans from Paris, first began to paint this subject.

THOMAS COUTURE

1815–1879. French. Studied with Gros and Delaroche, and strongly influenced by the Venetian Renaissance painters. Exhibited at Salons frequently from 1838 to 1855, and in 1872 and 1879. Achieved fame at the Salon of 1847 with *Romans of the Decadence,* though genre subjects and portraits compose most of his work. An influential teacher, his students included Manet, Feuerbach, William Morris Hunt and Puvis de Chavannes.

The Falconer　　　　PL. 215

[Probably 1846] Oil on canvas
51 x 38½ in. (129.5 x 97.7 cm.)
Signed lower left (on balustrade): T. COUTURE

Acc. no. 54.78

COLLECTIONS: Deforge, 1846–57 (Petit, Paris, Mar. 6, 1857); Faure, Paris; G. von Ravené, Marquard (Berlin), by 1869–1920; (Eduard Schulte, Berlin); (Thannhauser, Berlin, by 1927); (J. K. Thannhauser, New York; Parke-Bernet, New York, Apr. 12, 1945, lot 112); (J. K. Thannhauser, New York).

EXHIBITIONS: Paris, Exposition Universelle, 1855, no. 2820; Munich, Glaspalast, *Internationale Kunstausstellung,* 1869, no. 1194; Dresden, *Grosse Kunstaustellung,* 1912; Berlin, Thannhauser, *Grande exposition de chefs d'oeuvre de l'art français,* 1927, no. 56, pl. 43; Minneapolis Institute of Arts, *The Past Rediscovered: French Painting 1800–1900,* 1969, no. 19, repr.

REFERENCES: T. Gautier, *Les beaux-arts en Europe—1855,* Paris, 1855, I, p. 282; J. de la Rochenoire, *Le Salon de 1855,* Paris, 1855, p. 77; E. About, *Voyage à travers l'exposition des beaux-arts (peinture et sculpture),* Paris, 1855, p. 190; M. du Camp, *Les beaux-arts à l'exposition universelle de 1855, peinture-sculpture,* Paris, 1855, p. 187; E. Müntz, "Exposition Internationale de Munich," *Gazette des Beaux-Arts,* II, 1869, p. 307; R. Ménard, "Exposition Internationale de Londres," *Gazette des Beaux-Arts,* IV, 1871, p. 438; C. Biller, "Zur Erinnerung an Thomas Couture," *Zeitschrift für Bildende Kunst,* XVI, 1881, p. 106, repr. p. 102; C. Clement and L. Hutton, *Artists of the 19th Century,* Boston, 1884, I, p. 166; C. Stranahan, *A History of French Painting,* New York, 1888, p. 292 (incorrectly as in M. Raucune collection, Berlin); H. Knowlton, *Art and Life of William Morris Hunt,* Boston, 1900, p. 7; G. Bertauts-Couture, *Thomas Couture,* Paris, 1932, pp. x, xi, 34–5, 100, 154, repr. opp. p. 25 (incorrectly as in Berlin Museum); A. de Leiris, "Thomas Couture the Painter," *Thomas Couture Paintings and Drawings in American Collections* (exh. cat.),

College Park, University of Maryland, 1970, pp. 21–2, fig. 5.

Although it has been thought that *The Falconer* was painted in 1855 (Stranahan; Bertauts-Couture), the year it was exhibited at the Exposition Universelle (Salon of 1855), Knowlton reported that William Morris Hunt, after seeing it in the window of the dealer Deforge in the fall of 1846, was inspired to become a painter and to study with Couture. Knowlton's account is reinforced by Théophile Gautier and J. de La Rochenoire, who in their reviews of the 1855 exhibition indicate *The Falconer,* which they and other critics enthusiastically praised, was not a recent work. A. Boime (letter, Oct. 1975), who is preparing a monograph on Couture, dates the picture 1844–45, noting that the artist signed his full last name, characteristic of his early easel paintings; later he signed using only initials.

The dealer Justin K. Thannhauser (letter, Apr. 1953) related a story told him by Max Liebermann, that he and all progressive young Berlin painters used to make a weekly pilgrimage to Marquard near Berlin where *The Falconer* could then be seen, in order to study and admire it.

Writing in 1876 to a collector of his work about various pictures just finished or in progress, including his own reduced replica of this painting, Couture said, "Perhaps you will be surprised to see *The Falconer* in this list, but I think I should make it for you as you have pictures of my maturity. This painting of my youth (the Toledo canvas) is considered, perhaps rightly, as my best picture; that is why I want to allow you to make the comparison." (Bertauts-Couture, p. 100).

The present locations of Couture's small replica of 1876 and of a two-color drawing done at the same time are unknown.

According to Bertauts-Couture, the artist's grandson and biographer, a copy by another painter was brought to Couture in 1869 and was retouched by him after 1870. This may be identified with the picture recently on the art market in New York (H. Shickman Gallery, "The Neglected 19th Century, Part II," Oct. 1971) and Paris (Hôtel Drouot, May 20, 1974, lot 53, with incorrect location of the original oil). A *Petit fauçonnier* belonging to the singer Barroilhet was exhibited in Paris in 1852. As Boime found that the Toledo *Falconer* still belonged to Deforge at that time, he believes the Barroilhet version was also a copy, several of which were made by Couture's pupils, including W. M. Hunt.

Alice Ozy PL. 216

[Ca. 1855] Oil on canvas

43⅝ x 33⅛ in. (110.8 x 84 cm.)

Acc. no. 75.82

Gift of Mr. and Mrs. Stanley K. Levison

COLLECTIONS: Marquess of Waterford; Mrs. de la Poer, his widow; (Julius Weitzner, New York); (Jacques Seligmann, New York); Mr. and Mrs. Stanley K. Levison, Toledo, 1966.

EXHIBITIONS: Bordeaux, Musée des Beaux-Arts, *La peinture française, collections américaines,* 1966, no. 42, pl. 26.

REFERENCES: G. Bertauts-Couture, *Thomas Couture,* Paris, 1932, p. 33; J. W. Howe, "Thomas Couture, His Career and Artistic Development," unpublished Ph.D. dissertation, University of Chicago, 1951, p. 83, no. 219, pl. XI; G. Bertauts-Couture, "Thomas Couture," *Études d'art,* Musée des Beaux-Arts, Algiers, 1955–56, nos. 11–12, p. 191 (as *Belle de la Nouvelle Orléans*).

The famous actress Alice Ozy (1820–1893) had many admirers, including Victor Hugo and several artists, among them Théodore Chassériau. This portrait has been identified as the portrait of her painted by Couture, the location of which was unknown to his biographer, Bertauts-Couture.

LUCAS CRANACH THE ELDER

1472–1553. German. Born in Kronach, where he studied with his father. In Vienna, ca. 1500–03. 1505 in Wittenberg, appointed court painter to Frederick the Wise of Saxony and his two successors. A friend of Luther, whose writings Cranach published and sold. A painter, engraver and designer of woodcuts, Cranach directed a large workshop, collaborating with his son, Lucas.

Saints Catherine, Margaret and Barbara PL. 64

[Ca. 1515–20] Oil on wood panel

48½ x 22 in. (123.2 x 55.8 cm.)

Acc. no. 61.32

COLLECTIONS: Prince Ernest of Saxony, Ireland; (Rosenberg & Stiebel, New York).

EXHIBITIONS: Dublin, Municipal Gallery of Modern Art, *Paintings from Irish Collections,* 1957, no. 81, pl. XVII.

This panel was probably the wing of an altarpiece. The attribution to Cranach the Elder has been confirmed by Jakob Rosenberg (letter, Sep. 1974), who relates the panel to several paintings datable about 1518–20. The pose of St. Barbara derives, in reverse, from that of St.

Barbara in the left wing of an altarpiece by Cranach dated 1506, *The Execution of St. Catherine* (Gemälde-galerie, Dresden).

In Germany these three virgin martyr saints were among the fourteen intercessor saints. They are shown here with their attributes: St. Catherine with the torture wheel from which she was miraculously rescued, and the sword with which she was beheaded (the meaning of the letters L·W·(?) embroidered on her bodice is unclear); St. Margaret of Antioch with a prayer book and flaming brand emblematic of her death by burning; and St. Barbara with chalice and Host symbolizing her faith, for which she was also beheaded, as indicated by the sword touching her skirt. Her bodice is embroidered B·A·R·B.

LUCAS CRANACH THE YOUNGER

1515–1586. German. Born in Wittenberg, Saxony. Son and pupil of Lucas Cranach the Elder (1472–1553). First mentioned in his father's workshop, 1535; became its head, 1550. Active in Wittenberg civic government; burgomaster, 1565. Like his father, he was a painter and designer of woodcuts.

Martin Luther and the PL. 66
Wittenberg Reformers

[Ca. 1543] Oil on wood panel
27⅝ x 15⅝ in. (72.8 x 39.7 cm.)

Acc. no. 26.55

COLLECTIONS: Cornelia, Countess of Craven, Coombe Abbey, Warwickshire, by 1854 (Christie, London, Apr. 13, 1923, lot 81); Edward Drummond Libbey.

EXHIBITIONS: Manchester, England, *Catalogue of the Art Treasures of the United Kingdom*, 1857, p. 42, no. 463.

REFERENCES: G. Waagen, *Treasures of Art in Great Britain*, London, 1854, III, p. 219; W. Bürger, (T. Thoré), *Trésors d'art en Angleterre*, 3rd ed., Paris, 1865, p. 144; C. Schuchardt, *Lucas Cranach d.Ä., Leben und Werke*, 1871, III, pp. 259–60; C. Kuhn, *A Catalogue of German Paintings of the Middle Ages and Renaissance in American Collections*, Cambridge, Mass., 1936, no. 150, pl. XXVII, fig. 150; F. Blanke, "Ikonographie der Reformationszeit: Fragen um ein Cranach-Bild," *Theologische Zeitschrift*, VII, Nov.–Dec. 1951, pp. 467–71, repr. opp. pp. 468, 469; E. Fabian, *Der Reformationskanzler Dr. Gregor Brück als der grosse "Unbekannte,"* Frankfort-am-Main, 1951; H. Bornkamm, "Zu Cranachs Reformetorenbild," *Theologische Zeitschrift*, VIII, Jan.–Feb. 1952, pp. 72–4; E. Fabian, "Zum 'Wittenberger Re-

formatorenbild' Cranachs: Brück und Bugenhagen," *Theologische Zeitschrift*, VIII, May–June 1952, pp. 1–4; E. Fabian, "Neue Goethe-Ahnenbildnisse," *Zeitschrift für Genealogie und Bevölkerungkunde*, II, 1952, pp. 42, 46, n. 14; R. Osiander, "Portraits van Andreas Osiander," *Theologische Zeitschrift*, XV, Jan. 15, 1959, pp. 255–64, fig. I; H. Zimmermann, "Über einige Bildniszeichnungen Lucas Cranachs d.J.," *Pantheon*, XX, Jan.–Feb. 1962, pp. 8–9, figs. I, 5; E. Fabian, "Cranach-Bildnisse des Reformationskanzlers Dr. Gregor Brück," *Theologische Zeitschrift*, XX, 1964, pp. 269–78.

This painting, a fragment from a triptych wing or perhaps a larger independent panel (Bornkamm), is historically important as the only known group portrait of the first half of the 16th century to show solely the Saxon reformers (Fabian, 1964).

In the front row, Luther appears on the left; Melanchthon, an educator and close friend, is at the right; John Frederick the Magnanimous, Elector of Saxony, is in the center. The figure to the Elector's left has been accepted by most scholars as Georg Spalatin, secretary to John Frederick and court preacher, though Zimmermann identifies him as Justas Jonas, a legal scholar and translator of Luther's writings. The figure on the Elector's right is probably his chancellor, Georg Brück (Fabian, 1951, 1952 *Theologische Zeitschrift*, 1964; Bornkamm); however, he has also been identified as the Nuremburg reformer Andreas Osiander (Blanke; Osiander). The figure between Brück and Melanchthon may be Bugenhagen, a Wittenberg preacher and professor (Fabian, 1952 and *Theologische Zeitschrift*, 1954). It is difficult to identify the remaining five figures in the back row since their faces are only partially visible. Attempts have been made (Osiander) to recognize them as, from left to right, Lufft, Forster, Major, Jonas and Cruciger.

Most recent authorities attribute this painting either to the workshop of Cranach the Elder or to Lucas Cranach the Younger (Fabian, Zimmermann, Kuhn).

The painting dates after 1532, when John Frederick became Elector, and before 1547, when he received a battle wound on his cheek (Fabian, "Goethe-Ahnenbildnisse"). It has often been noted that the figure of John Frederick corresponds almost exactly to a portrait miniature of him in Cranach the Younger's 1543 album in the Kunstbibliothek, Berlin. Zimmermann also points to costume parallels in works of ca. 1539 and 1541. Recent scholarship has dated the Toledo panel to ca. 1543 or the early 1540s.

The unidentified coat-of-arms held by a putto in the lower left corner of the painting probably is that of an unknown donor (Bornkamm).

HENRI EDMOND CROSS

1856–1910. French. Born in Douai. Studied at Lille with Alphonse Colas. 1881 moved to Paris. Exhibited at Salon des Artistes, 1881 and regularly with Indépendants from 1884. Participated in exhibitions of Les Vingt in Brussels. Traveled frequently to southern France, where he settled in 1891. Associated with the Neo-Impressionists, especially Signac.

At the Fair PL. 281

[1896] Oil on canvas
36⅜ x 25¾ in. (92 x 65.4 cm.)
Signed and dated lower right: henri Edmond Cross 96

Acc. no. 51.308

COLLECTIONS: (A. Vollard, Paris, 1901, from the artist); Prince de Wagram, Paris; Marcel Noréro, Paris (Hôtel Drouot, Paris, Feb. 14, 1927, lot 41, repr.); M. Laffon; (Wildenstein, New York).

EXHIBITIONS: Paris, Société des artistes indépendants, 1896, no. 249; Paris, Galerie Druet, *Peintures et aquarelles de H. E. Cross et P. Signac,* 1911, no. 1; Kristiania (Oslo), *Den Franske Utstilling i Kunstnerforbundet,* 1916; New York, Wildenstein, *Seurat and his Friends,* 1953, no. 60, repr. p. 15 (cat. by J. Rewald).

REFERENCES: P. Signac, "What Neo-Impressionism Means," *Art News,* LII, Dec. 1953, repr. p. 31; I. Compin, *H. E. Cross,* Paris, 1964, pp. 42, 78, 144, no. 55, repr. p. 145.

Cross' mother was English, and the artist used the English form of his surname, Delacroix, to avoid confusion with a contemporary painter with the same initials and surname. According to Compin, Cross' original title for this picture was *Bal villageois dans le Var.* Var is the district on the Mediterranean where Cross lived. Compin lists four studies for this painting, three watercolors of the full composition and a drawing of the woman in the left foreground.

AELBERT CUYP

1620–1691. Dutch. Born in Dordrecht, where he spent his life. He was the son of the painter J. G. Cuyp, and in his earlier work was also influenced by Jan van Goyen. Cuyp's fame is based on the effects of glowing light, learned from the Utrecht Italianate painters, which he brought to remarkable development. The chronology of his work is rather uncertain because there are few dated or otherwise documented pictures. Later, his poetic treatment of light had a great effect on landscape painting in England.

River Scene at Dordrecht PL. 120

[Ca. 1645–50] Oil on canvas
39½ x 55 in. (100.2 x 139.7 cm.)
Signed lower right: A. cuijp

Acc. no. 55.41

COLLECTIONS: (de Winter, Amsterdam, Jan. 24, 1763, lot 6); E. W. Parker, Skirwirth Abbey, Cumberland (Christie, London, July 2, 1909, lot 98, repr.); Miss L. Coats, Fornethy House, Perthshire; (Duits, London, 1954–55).

REFERENCES: C. Hofstede de Groot, II, no. 648a (?); W. Hutton, "The Land and the Waters," *Toledo Museum of Art Museum News,* I, No. 3, Fall 1957, pp. 7–10, repr. p. 7; W. Stechow, 1968, p. 119, fig. 236; S. Reiss, *Aelbert Cuyp,* London, 1975, no. 28, repr. (as ca. 1644).

Stechow believes that the Toledo painting was painted shortly before 1650 when Cuyp was just beginning to develop the "crystalline golden luminosity" of his mature style.

The prominent tower in the right background belongs to the Groothoofdspoort as seen from the southwest shore of the Maas River. The tower was replaced by a dome in 1690.

The Riding Lesson [COLOR PL. VII] PL. 121

[Ca. 1660] Oil on canvas
46¾ x 67 in. 118.7 x 170.2 cm.)
Signed lower right: A. cuyp

Acc. no. 60.2

COLLECTIONS: J. van der Linden van Slingeland, Dordrecht, by 1752 (Yver, Delfos, Dordrecht, Aug. 22, 1785, lot 72); Dubois (Lebrun, Paris, Dec. 20, 1785, lot 17); Marquess of Linlithgow, Hopetoun House, Scotland, by 1854–ca. 1909; Rothschild collection, Paris; (Rosenberg & Stiebel, New York, 1960).

EXHIBITIONS: London, Royal Academy, Winter Exhibition, 1883, no. 238.

REFERENCES: G. Hoet, *Catalogus of Naamlyst van Schilderyen . . . ,* The Hague, 1752, II, p. 495; J. Smith, 1834, V, p. 288, no. 11; G. Waagen, *Treasures of Art in Great Britain,* London, 1854, III, p. 309; C. Hofstede de Groot, II, nos. 448, 615; W. Hutton, "Aelbert Cuyp, The Riding Lesson," *Toledo Museum of Art Museum News,* IV, No. 4, Autumn 1961, pp. 79–85; W. Stechow,

1968, p. 162; S. Reiss, *Aelbert Cuyp*, London, 1975, no. 135, repr. (as late 1650s).

As early as 1752 (Hoet) this picture was listed in the Van Slingeland collection together with *Horsemen and Herdsmen with Cattle* (National Gallery, Washington; Hofstede de Groot no. 430; Reiss no. 136). Smith and Hofstede de Groot (no. 448) also catalogued these pictures as pendants. According to Reiss, however, they were not necessarily intended as pendants despite their similar dimensions and early provenance. Reiss also points out that Hofstede de Groot nos. 448 and 615 both describe the Toledo picture.

The building in the left background is a variation of the Mariakerk at Utrecht, pulled down in 1813.

CHARLES-FRANÇOIS DAUBIGNY

1817–1878. French. Early study with his father, a classical landscapist, followed by travel in Italy, 1836. Briefly a student of Delaroche in 1840, he mainly worked as a graphic artist until 1848. From 1852 he worked closely with Corot, and increasingly from nature; most of his river landscapes were painted from his studio-boat. Exhibited regularly at Salons 1838–68. His style of the 1860s influenced Monet and Pissarro.

On the Oise River PL. 233

[1865] Oil on wood panel
14½ x 27 in. (36.8 x 68.6 cm.)
Signed and dated lower right: Daubigny 1865

Acc. no. 22.46
Gift of Arthur J. Secor

COLLECTIONS: George I. Seney (American Art Association, New York, Feb. 11–13, 1891, lot 152); Charles T. Yerkes, New York (American Art Association, New York, Apr. 6, 1910, lot 32, to Scott and Fowles); Arthur J. Secor, 1910–22.

REFERENCES: *Catalogue of Painting and Sculpture in the Collection of Charles T. Yerkes, Esq.*, New York, 1904, II, no. 32, repr.

Clearing After a Storm PL. 232

[1873] Oil on canvas
26⅛ x 37¼ in. (66.4 x 94.3 cm.)
Signed and dated lower right: Daubigny 1873

Acc. no. 27.131
Gift of Arthur J. Secor

COLLECTIONS: Henri Garnier, Paris (Galerie Georges Petit, Paris, Dec. 3–4, 1894, no. 22, repr. opp. p. 6, as

Les bords de l'Oise); George A. Hearn, New York (American Art Association, New York, Feb. 27, 1918, no. 237, as *On the Oise*); (Ehrich Gallery, New York, 1921); (Vose, Boston, 1921–22); Arthur J. Secor, Toledo, 1922–27.

EXHIBITIONS: Columbus Gallery of Fine Arts, *Relationships between French Literature and Painting in the Nineteenth Century*, 1938, no. 6.

HONORÉ DAUMIER

1808–1879. French. Born in Marseilles. To Paris, 1816. As a lithographer he became a leading political and social cartoonist, producing more than 4,000 prints. Daumier painted little before 1848, but with encouragement from Courbet and Bonvin he entered the Salon exhibitions 1849–53. His style was influenced by Millet, Diaz and Decamps. Daumier was helped financially by Corot after 1873, as he gradually went blind.

Children Under a Tree PL. 221

Oil on canvas
21⅞ x 18½ in. (55.5 x 47 cm.)
Signed lower left: h.D.

Acc. no. 36.86

COLLECTIONS: Alexander Reid, Glasgow; Dr. de Saint-Germain, by 1921; Georges Viau; (Cassirer, Berlin); Katzenellenbogen, Berlin, by 1926; (Walter Feilchenfeldt, Zurich, 1936); (Knoedler, New York).

EXHIBITIONS: Paris, École des Beaux Arts, *Exposition Daumier*, 1901, no. 60; Berlin, Galerie Matthiesen, *Honoré Daumier Austellung*, 1926, no. 64, repr. p. 99; Detroit Institute of Arts, *French Painting from David to Courbet*, 1950, no. 91; Los Angeles County Museum of Art, *Honoré Daumier*, 1958; London, Tate Gallery, *Daumier, Paintings and Drawings*, 1961, no. 22, pl. 9b (cat. by K. Maison).

REFERENCES: E. Klossowski, *Honoré Daumier*, 2nd ed., Munich, 1923, nos. 323, 324, repr. p. 132; E. Fuchs, *Der Maler Daumier*, Munich, 1930, no. 54a, pl. 54a; M.-T. de Forges, *Barbizon*, Paris, 1963, repr. p. 36; K. Maison, *Honoré Daumier, Catalogue Raisonné of the Paintings, Watercolors and Drawings,* New York, 1968, I, no. II-12, pl. 183; L. Barzini and G. Mandel, *L'opera pittorica completa di Daumier*, Milan, 1971, no. 70, repr. (provenance incorrect).

According to Maison, this picture was probably left not quite finished at Daumier's death, and he believes it was completed by another hand. Comparison with earlier

photographs (Klossowski; Fuchs; and Berlin cat., 1926) and examination with ultra-violet light show additions and reinforcements to contours of figures, especially in the facial features. There is also some minor overpainting in the garments. The remaining areas, including the background, appear to be untouched. Maison also concluded that Klossowski's catalogue numbers 323 and 324 are both the Toledo picture.

GERARD DAVID

Ca. 1460–1523. Flemish. Born at Oudewater, Holland, where he was probably trained. By 1484 in Bruges, where he was active. Entered the Antwerp painters guild, 1515, but returned to Bruges by 1521 and died there. The last major master of the Bruges School, he was especially influenced by Hugo van der Goes and Memling; his style also has some relationship to miniature painting at Bruges.

Three Miracles of Saint Anthony 81 a–c
of Padua

(a) *The Drowned Child Restored to Life;* (b) *The Mule Kneeling Before the Host;* (c) *Saint Anthony Preaching to the Fishes*

[Ca. 1500–10] Oil on wood panel
(a) 21-11/16 x 12⅞ in. (55.1 x 32.7 cm.); (b) 22-7/16 x 13⅜ in. (57.3 x 34 cm.); (c) 21⅞ x 12-13/16 in. (55.6 x 32.6 cm.)

Acc. nos. (a) 59.21, (b) 59.22, (c) 59.23

COLLECTIONS: Cardinal Antonio Despuig y Daneto, Raxa, Mallorca; Counts of Montenegro, Raxa; Léon Somzée, Brussels, after 1886; (Agnew, London, 1902); Robert James Loyd-Lindsay, Lord Wantage, Lockinge House, Berkshire, and descendants; Christopher Lewis Loyd, Lockinge House, until 1959.

EXHIBITIONS: London, New Gallery, *Catalogue of the Twelfth Summer Exhibition*, 1899, no. 32; London, Royal Academy, *Catalogue of the Loan Exhibition of Flemish and Belgian Art, A Memorial Volume*, 1927, no. 100, pl. XLVII; London, Royal Academy, *Flemish Art, 1300–1700*, 1953, pl. 9; Bruges, Musée Communal Groeninge, *L'art flamand dans les collections britanniques*, 1956, no. 25, pl. 17.

REFERENCES: C. Justi, "Altflandrische Bilder in Spanien und Portugal: Gerard David," *Zeitschrift für Bildende Kunst*, XXI, 1886, p. 137–38; *A Catalogue of Pictures Forming the Collection of Lord and Lady Wantage*, London, 1905, no. 56B, pl. 56b; E. von Bodenhausen, *Gerard David und seine Schule*, Munich, 1905, no. 31,

fig. 31b; F. Winkler, *Die Flämische Buchmalerei des XV. und XVI. Jahrhunderts*, Leipzig, 1925, p. 174; M. J. Friedländer, *Die Altniederländische Malerei*, Leyden, 1934, VI, pp. 97–8, no. 167; M. Conway, *The Van Eycks and Their Followers*, New York, 1921, pp. 286–87; C. Gaspar, *The Breviary of the Mayer van der Bergh Museum at Antwerp*, Brussels, 1932, p. 73, n. 1; M. J. Friedländer, *Early Netherlandish Painting* (ed. H. Pauwels), New York, VIb, 1971, pp. 90–1, no. 167, p. 132, n. 111, pls. 181, 183, fig. 167.

The Toledo paintings are companions to three similar panels showing episodes from the legend of St. Nicholas of Bari (National Gallery of Scotland, Edinburgh). The six panels probably formed the predella of the *Altarpiece of St. Anne* (Friedländer, 1971, pl. 181), consisting of a triptych with the Virgin and Child, St. Anthony of Padua, and St. Nicholas (National Gallery of Art, Washington). The predella may have also included the *Lamentation* (Art Institute of Chicago; Friedländer, 1971), in the center between the St. Nicholas and St. Anthony panels.

The *St. Anne Altarpiece* has been consistently assigned to David's middle period, defined as 1499–1511 by Friedländer, who dated the altarpiece toward the end of David's middle or the beginning of his last period.

The theme of the mule kneeling before the Host was a particularly popular theme in the Bruges-Ghent region during this period. David's composition can be found, in reverse, in at least seven manuscripts of ca. 1483–1520 from this area, including the *Breviary of Mayer van der Bergh* (Gaspar) and the *Hours of Ferdinand V and Isabella of Spain* (W. Wixom, in *Bulletin of the Cleveland Museum of Art*, LI, 1964, pp. 60–3).

JACQUES-LOUIS DAVID

1748–1825. French. Born in Paris. Studied with the history painter J. M. Vien to whom he was recommended by François Boucher, a distant relative by marriage. Attended classes at the Académie; won the Prix de Rome, 1774. In Rome, 1775–80, where he studied ancient art and 16th and 17th century painting. First success at the Salon, 1781, and from then on younger artists came to learn at his studio, the most popular in Europe for the next thirty years. In Rome, 1784–85. During the Revolution he played an important role in French artistic and political life, and voted for the death of the king. He was an early admirer of Napoleon, whom he glorified in many works. From 1816 he lived in exile at Brussels, where he died. His work includes heroic mythological and historical subjects and portraits.

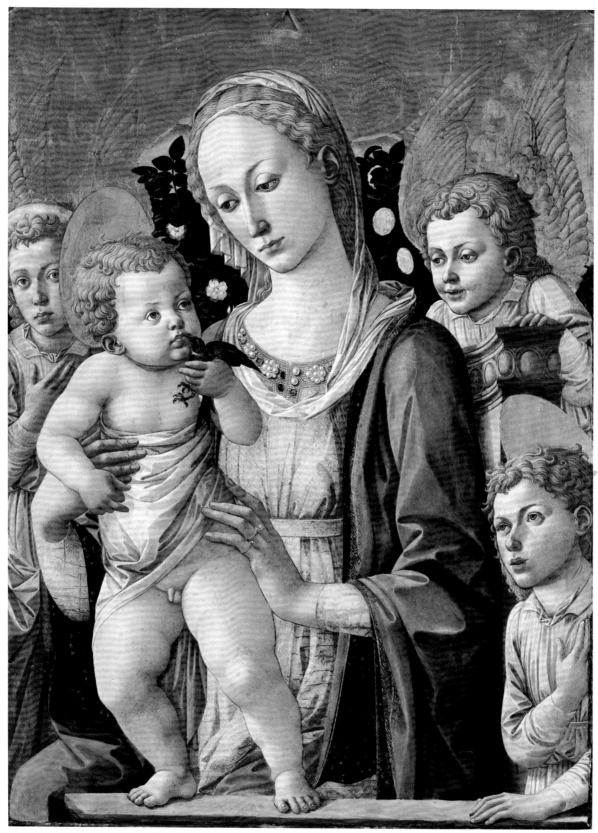

1. Pesellino, *Madonna and Child with Saint John*

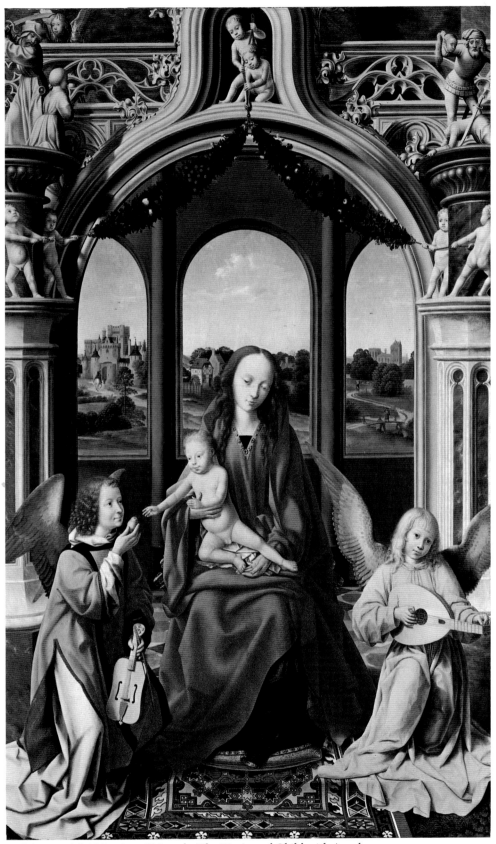

II. Master of the Morrison Triptych, *The Virgin and Child with Angels*

The Oath of the Horatii PL. 211

[1786] Oil on canvas
51¼ x 65⅝ in. (130.2 x 166.2 cm.)
Signed and dated lower left: J.L. David faciebat,/Parisiis,
 anno MDCCLXXXVI

Acc. no. 50.308

COLLECTIONS: Painted for the Comte de Vaudreuil, 1786
(Lebrun, Paris, Nov. 26, 1787, lot 107; as by David, "in
addition a distaff at the feet of the women, a detail to
establish the originality of the picture"); (Lebrun, Paris);
Firmin-Didot family, by 1794; Hyacinthe Didot, 1880;
Louis Delamarre, Paris, by 1913; Baronne Eugène
d'Huart; (Paul Roux et al sale, Paris, Dec. 14, 1936, lot
116); (Wildenstein, Paris and New York, 1937).

EXHIBITIONS: Paris, Galerie Lebrun, *Explication des
ouvrages de peinture exposées au profit des Grecs*, 1826,
no. 40 (as by David, entirely retouched by him five years
after 1786); Paris, Petit Palais, *David et ses élèves*, 1913,
no. 25 (as by Girodet, retouched by David); Rome and
Milan, *Mostra di capolavori della pittura francese
dell'ottocento*, 1955, no. 27 (cat. ed. by G. Bazin; as by
David); Cleveland Museum of Art, *Neo-classicism, Style
and Motif*, 1964, no. 114, repr. (as by David); London,
Royal Academy, *France in the Eighteenth Century*,
1968, no. 179, fig. 338 (as by David).

REFERENCES: L. Thiéry, *Guide des amateurs et des étran-
gers voyageurs à Paris*, 1787, II, p. 548 (as a reduction by
David of the Louvre painting); C. Landon, "Exposition
publique des tableaux du cabinet de M. Didot," *Journal
de Paris*, Mar. 26, 1814, p. 4 (as "excellent copy by Giro-
det"); P. Chaussard, *Notice sur la vie et les ouvrages de
M. Jacques-Louis David*, Paris, 1824, p. 43 (as by David);
A. Thomé de Gamond, *Vie de David, premier peintre
de Napoléon*, Brussels, 1826, p. 162 (as by David); A. Pé-
ron, "Examen du tableau du serment des Horaces peint
par David, suivi d'une notice historique du tableau,"
Annales de la société libre des beaux-arts, IX, 1839–40,
fig. 1 (engraving); J. du Seigneur, "Appendice à la notice
de P. Chaussard sur L. David," *Revue universelle des
arts*, XVIII, 1863, p. 364 (listed as by David); J. L. Jules
David, *Notice sur le Marat de Louis David, suivie de la
liste de ses tableaux dressée par lui-même*, Paris, 1867,
p. 34, no. 24, p. 41 (as by David in list also transcribed
by Wildenstein, 1973, p. 266); Bellier de la Chavignerie,
Dictionnaire général des artistes de l'école français,
Paris, 1868, p. 354 (as nearly wholly by Girodet); J. L.
Jules David, *Le peintre Louis David, 1748–1825, sou-
venirs et documents inédits*, Paris, 1880, I, pp. 59, 636
(as by Girodet, retouched by David); M. Dumoulin, "Les
salons d'autrefois," *L'art*, LXVIII, 1907, repr. p. 91 (en-
graving); R. Cantinelli, *Jacques-Louis David*, Brussels,

1930, no. 48 (as by Girodet); K. Holma, *David, son evo-
lution et son style*, Paris, 1940, pp. 48, 126, no. 54 (as
by David); M. Florisoone, *Exposition en l'honneur du
deuxième centenaire de sa naissance* (exh. cat.), Orange-
rie, Paris, 1948, p. 48; J. Canaday, *Mainstreams of Mod-
ern Art*, New York, 1959, pp. 11–2, repr.; D. L. Dowd,
"Art and the Theater During the French Revolution:
The Role of Louis David," *Art Quarterly*, XXIII, Spring
1960, fig. 3; R. Rosenblum, "Neoclassicism Surveyed,"
Burlington Magazine, CVII, Jan. 1965, pp. 30–3, n. 1;
O. Wittmann, "Letters: Jacques-Louis David at Toledo,"
Burlington Magazine, CVII, June 1965, pp. 323–24, fig. 1
(detail); R. Rosenblum, "Letters: 'Jacques-Louis David
at Toledo,'" *Burlington Magazine*, CVII, Sep. 1965, pp.
473–75; R. Rosenblum, "Letters: The Toledo *Horatii*,"
Burlington Magazine, CVII, Dec. 1965, p. 633; O. Witt-
mann, "Letters: The Toledo *Horatii*," *Burlington Mag-
azine*, CVIII, Feb. 1966, pp. 90, 93; (B. Nicolson),
"Editorial: Frivolity and Reason at Burlington House,"
Burlington Magazine, CX, Feb. 1968, p. 62, no. 179 (as
by Girodet); R. Rosenblum, "Girodet," *Revue de l'art*,
No. 3, 1969, p. 101, n. 1; P. Rosenberg, "Le XVIIIe
siècle français à la Royal Academy," *Revue de l'art*, No.
3, 1969, p. 99, no. 179 (as by Girodet); A. Sérullaz, in
The Age of Neo-Classicism (exh. cat), Arts Council of
Great Britain, London, 1972, p. 41; R. Verbraeken,
*Jacques-Louis David jugé par ses contemporains et par
la posterité*, Paris, 1973, p. 245 (in David's list of ca.
1819); D. and G. Wildenstein, *Documents complémen-
taires au catalogue de l'oeuvre de Louis David*, Paris,
1973, pp. 23 (no. 176), 209 (in no. 1810), 226, 227 (23,
in no. 1938); F. Cummings, in *French Painting 1774–
1830: The Age of Revolution* (exh. cat.), Detroit Institute
of Arts, 1975, p. 41 (as by Girodet).

Following the commission in 1783 from Louis XVI to
paint a history picture, David went to Rome, where he
lived in 1784–85 and painted *The Oath of the Horatii*
(Louvre, Paris). This is his most famous composition,
and probably the most famous French neo-classical pic-
ture. Severe and uncompromising in its subordination of
color to drawing, it was also highly topical in its impli-
cations of republican virtue.

Taken from Roman history, the subject represents the
ideal of heroic self-sacrifice for one's country. The three
Horatii brothers are shown taking the oath given by
their father Horatius before their combat with the Cu-
ratii in which two of the Horatii were slain.

Toledo's picture is a reduced version of the large paint-
ing with life-size figures (Louvre) which caused a sensa-
tion at the Salon of 1785. The compositions are similar,
except that a distaff lying on the floor near the group of

51

grieving women was added in the Toledo canvas. The latter, painted in 1786 for the Comte de Vaudreuil, was included by David in two autograph lists of his own works, one drawn up about 1817 ("*les Horaces, répétition en petit*"), the other about 1822 (as painted at Paris, "*24. Une répétition des Horaces en petit,*" and "*Tableaux d'Histoire: Les Horaces, répétition en petit;*" both, Wildenstein, 1973).

The question whether this picture, on the high quality of which there is general agreement, is correctly attributed to David or was painted by Anne-Louis Girodet-Trioson (1767–1824), among David's best students, has been set forth in some detail (R. Rosenblum, O. Wittmann, *Burlington Magazine*, 1965–66). According to Rosenblum, and to other recent scholars as noted under References, this picture is the work of Girodet, based on opinions of style and certain older written sources. On the other hand, the Toledo picture was fully signed and dated by David, and only a year after it was painted for a man of high rank it was publicly sold in Paris as by David, while the artist was living there, for the high price of 5,700 livres. From what is known of David's studio practice (see especially Rosenblum, *Burlington Magazine*, Sep. 1965), it is entirely possible that Girodet or other pupils could have assisted David with this replica, just as another pupil, J.-G. Drouais, is known to have assisted David in Rome with the large version in the Louvre (Rosenblum, Sep. 1965, p. 473). Nevertheless, it seems reasonable to consider the Toledo painting as the work of David.

The Toledo version was engraved as by David by A. A. Morel in 1810.

EDGAR DEGAS

1834–1917. French. Born in Paris. Studied drawing with Lamothe at École des Beaux-Arts and met Ingres, 1855. In Italy, 1854–59, and New Orleans, 1872–73. Exhibited at the Salon, 1865–70, and at seven of the Impressionist exhibitions. Degas painted contemporary Parisian life, emphasizing draughtsmanship, daring compositions, and movement. Influenced by photography and Japanese prints, he also worked in pastels and made small sculptures.

Victoria Dubourg PL. 244

[1865–68] Oil on canvas
32 x 25½ in. (81.3 x 64.8 cm.)
Signed lower right: Degas

Acc. no. 63.45
Gift of Mr. and Mrs. William E. Levis

COLLECTIONS: Edgar Degas (Georges Petit, Paris, May 6–8, 1918, lot 87, as *Portrait d'une jeune femme en robe brune*); Mme. Lazare Weiller, Paris; Paul-Louis Weiller, Paris; (Paul Rosenberg, New York); Mr. and Mrs. William E. Levis, Perrysburg, Ohio.

EXHIBITIONS: Paris, Georges Petit, *Degas*, 1924, no. 23, repr.; Paris, Orangerie, *Degas, portraitiste, sculpteur*, 1931, no. 36, repr.; San Francisco, M. H. de Young Memorial Museum, *The Painting of France Since the French Revolution*, 1940, no. 29, repr.; New York, Metropolitan Museum of Art, *French Painting from David to Toulouse-Lautrec*, 1941, no. 35, fig. 41; The Hague, Mauritshuis, *In the Light of Vermeer*, 1966, no. 43, repr.

REFERENCES: A. Alexandre, "Degas, nouveaux aperçus," *L'Art et les artistes*, No. 54, Feb. 1935, p. 155, repr.; P. A. Lemoisne, *Degas et son oeuvre*, Paris, 1946, I, p. 56; II, no. 137, repr.; J. S. Boggs, *Portraits by Degas*, Berkeley, 1962, pp. 31, 48, 92n., 117, fig. 50; T. Reff, "The Chronology of Degas's Notebooks," *Burlington Magazine*, CVII, Dec. 1965, p. 609, n. 14; J. S. Boggs, *Drawings by Degas*, City Art Museum of St. Louis, 1966, p. 86; F. Russoli, *L'opera completa di Degas*, Milan, 1970, no. 211, repr. p. 96.

Victoria Dubourg (1840–1926), a still life and portrait painter, was a student of the painter Fantin-Latour whom she married in 1878. In a Degas notebook inscribed "21 February 1866 . . . 27 February . . . 30 June . . . 4 July 1866" (formerly M. Guerin collection, Paris, Carnet 3), there is a preparatory sketch on the basis of which Boggs dated this portrait 1866. Reff has recently stated that since the notebook seems to have been used from 1865 to 1868, it is difficult to date the Toledo picture more precisely without other evidence (letter, Sep. 1975). There are three other studies for the Toledo picture: a full-length drawing and a study of the hands (Boggs, 1966, nos. 49, 50; Paul-Louis Weiller collection, Paris); a sketch of the head and shoulders (Cleveland Museum of Art). Like many of Degas' portraits of his friends, the Toledo painting remained in the artist's possession until his death.

Dancers at the Bar PL. 243

[Ca. 1889] Pastel on paper
18¼ x 40 in. (46.4 x 101.6 cm.)
Stamped lower left: Degas

Acc. no. 50.69
Gift of Mrs. C. Lockhart McKelvy

COLLECTIONS: Edgar Degas, ca. 1889–1917 (Galerie Georges Petit, Paris, May 6–8, 1918, lot 226); Georges Viau (Hôtel Drouot, Paris, Dec. 11, 1942, lot 73); (Ethel

Hughes, Versailles); Mrs. C. Lockhart McKelvy, Perrysburg, Ohio.

REFERENCES: P. A. Lemoisne, *Degas et son oeuvre*, Paris, 1946, III, no. 997, repr. p. 579.

Dated by Lemoisne about 1889, this pastel is a study for a larger oil sketch and is related to two other drawings (Lemoisne, III, nos. 996, 998, 999).

The Dancers PL. 245

[Ca. 1899] Pastel on paper
24½ x 25½ in. (62.2 x 64.8 cm.)

Acc. no. 28.198

COLLECTIONS: Paul Durand-Ruel, Paris, 1899–1928; (Durand-Ruel, New York).

EXHIBITIONS: London, Grafton Galleries, *A Selection from the Pictures of Paul Durand-Ruel*, 1905, no. 64 (as *Ballet Girls*); Paris, Galerie Georges Petit, *Degas*, 1924, no. 164; Paris, Orangerie, *Degas*, 1937, no. 78, pl. XXXII; New York, Paul Rosenberg & Co., *21 Masterpieces by Seven Great Masters*, 1948, no. 9, repr. p. 37.

REFERENCES: G. Grappe, *Degas*, Paris, 1908, p. 30, repr.; J. Meier-Graefe, *Degas*, London, 1923, pl. XCVIII; A. Vollard, *Degas, An Intimate Portrait*, 2nd ed., New York, 1937, fig. 17; C. Mauclair, *Degas*, Paris, 1937, p. 167, pl. 137; P. A. Lemoisne, *Degas et son oeuvre*, Paris, 1944, III, no. 1344, repr. p. 787; D. Rouart, *Degas à la recherche de sa technique*, Paris, 1945, p. 35, repr.; L. Browse, *Degas Dancers*, London, 1949, p. 408, no. 227, repr.; D. Cooper, *Pastelle von Edgar Degas*, Basel, 1952, p. 27, no. 30, repr.; A. Werner, *Degas Pastels*, New York, 1968, pp. 42–3, repr.; F. Russoli, *L'opera completa di Degas*, Milan, 1970, no. 1134, pl. LXII.

As early as 1868, Degas began his methodical study of the ballet. This picture, dated 1899 by Meier-Graefe as an example of Degas' late style, appears to be a captured moment, but is actually the result of the artist's careful observation of the same model who posed for all three figures. There are at least eight studies for this finished pastel (Lemoisne, III, nos. 1345–51), as well as several drawings closely related to it.

EUGÈNE DELACROIX

1798–1863. French. Student of Guérin and contemporary of Géricault and Gros, he was influenced by Constable and Lawrence on a visit to England in 1825. He drew lifelong inspiration from Rubens and the Venetian Renaissance masters. A journey to Morocco and Spain in 1832 was critical to his use of light and color. Exhibited regularly at the Salons 1822–59, and received major decorative commissions. A gifted writer, his famous *Journal* covers the years 1822–24 and after 1847. His easel paintings include all types of subjects, and he was an important lithographer. He also carried out several large-scale mural commissions.

The Return of Christopher Columbus PL. 214

[1839] Oil on canvas
33½ x 45½ in. (85.1 x 115.6 cm.)
Signed and dated lower left: Eug. Delacroix 1839

Acc. no. 38.80
Gift of Thomas A. DeVilbiss

COLLECTIONS: Prince Anatole Demidoff, who commissioned it from Delacroix in 1839 for San Donato Palace, Florence (San Donato sale, Paris, Feb. 21–22, 1870, lot 26, repr. etching by Bracquemond); Hollender, Paris, 1873; E. Secrétan, Paris, by 1885 (Paris, Secrétan Collection, July 1, 1889, lot 16); (Boussod-Valadon, Paris); Edouard André, Paris; Mrs. William A. Slater, New York, by 1928; Dr. Harold Tovell, Toronto, 1929–38; (C. W. Kraushaar, New York).

EXHIBITIONS: New York, Knoedler, *A Century of French Painting*, 1928, no. 9A, repr.; Paris, Louvre, *Exposition Eugène Delacroix*, 1930, no. 92; New York, Knoedler, *Gros-Géricault-Delacroix*, 1938, no. 44, repr.; New York, Wildenstein, *Eugène Delacroix*, 1944, no. 14, repr.; Detroit Institute of Arts, *French Painting from David to Courbet*, 1950, no. 33, repr.; Venice, XXVIII Biennale, *Eugène Delacroix*, 1956, no. 21; Paris, Louvre, *Centenaire d'Eugène Delacroix, 1798–1863*, 1963, no. 285, repr.; Cleveland Museum of Art, *The European Vision of America*, 1975, no. 278, repr.

REFERENCES: A. Moreau, *E. Delacroix et son oeuvre*, Paris, 1873, pp. 94, 259; A. Robaut, *L'oeuvre complet de Eugène Delacroix*, Paris, 1885, no. 690, repr.; E. Moreau-Nélaton, *Delacroix raconté par lui-même*, Paris, 1916, I, pp. 192–93, fig. 181; L. Rudrauf, *Eugène Delacroix et le problème du romantisme artistique*, Paris, 1942, pp. 249–50; E. Lambert, "Delacroix et l'Espagne," *La Revue des arts*, Sep. 1951, pp. 159–71; L. Johnson, "Delacroix at the Biennale," *Burlington Magazine*, XCVIII, Sep. 1956, p. 327; L. Rudrauf, "Delacroix et le Titien," *Actes du XIXe congrès international d'histoire de l'art*, 1958, Paris, 1959, pp. 527–28; L. Johnson, *Delacroix*, London, 1963, pp. 5, 113, 121, pl. 33; R. Huyghe, *Delacroix*, London, 1963, pp. 294, 303–04; M. Sérullaz, *Mémorial de l'exposition Eugène Delacroix*, Paris, 1963, no. 282, repr.; P. Pool, *Delacroix*, London, 1969, pp. 10, 18, 35, pl. 27; F. Trapp, *The Attainment of Dela-*

croix, Baltimore, 1971, pp. 193, 194, 196, fig. 114; L. R. Bortolatto, *L'opera pittorica completa di Delacroix*, Milan, 1972, no. 340, repr.

The Return of Christopher Columbus was one of two works, probably pendants, painted for Prince Anatole Demidoff. The other, *Columbus and His Son at La Rábida* (1838; National Gallery, Washington) shows the explorer on a visit to a Spanish monastery seeking support for his future voyage of discovery.

Delacroix apparently based the composition of the right side of the Toledo picture on Titian's *Presentation of the Virgin* (Accademia, Venice), and the left side on Titian's *Ecce Homo* (Kunsthistorisches Museum, Vienna; see Rudrauf, 1942 and all thereafter). Pool notes the importance of the geometric architectural framework characteristic of Delacroix at this time. Although the Washington pendant clearly reflects sketches made by Delacroix in Spain, except for the architecture at the left, the Toledo canvas shows little of this influence and is predominantly Venetian in inspiration.

ROBERT DELAUNAY

1885–1941. French. Born in Paris. Initially impressed by the analytic use of color by Seurat and Cézanne. Exhibited at the Salon des Indépendants, 1911. From Cubism and his own color theories he developed a style of prismatic and dynamic images, named "Orphism" by the poet Guillaume Apollinaire. Delaunay's color theories influenced several of the German Expressionists.

The City of Paris PL. 287

[Ca. 1911] Oil on canvas
47-1/16 x 67-13/16 in. (119.5 x 172.2 cm.)
Signed and inscribed lower right: la ville de Paris/
 r. delaunay

Acc. no. 55.38

COLLECTIONS: (Flechtheim, Berlin, to 1920s); Streit collection, Germany, from 1920s–1955; (Matthiesen, London, 1955).

This canvas is closely related to the composition of one of Delaunay's most famous works, the large *City of Paris* painted in 1911–12 (Musée d'Art Moderne, Paris). Because the Toledo painting was unknown to scholars until recently, it is not included in either G. Habasque's catalogue of Delaunay's work (1957) or the study of the sources and development of *The City of Paris* by M. Hoog (*La Revue du Louvre*, 1965, no. 1, pp. 29–38).

According to Hoog, who considers the Toledo canvas a study for the Paris painting (letter, 1968), the Three Graces in the center symbolize the elegance and youthfulness of Paris, while the lower part of the left section of the composition with its abstracted theater curtain, sun and buildings, was inspired by a view with a Seine bridge and boat prow in a self-portrait by Douanier Rousseau (National Gallery, Prague). The Eiffel Tower at the right was a favorite theme of Delaunay on which he painted and drew many variations.

A drawing of the full composition dated 1911 is closely related to the Toledo and Paris paintings (Richard S. Davis collection, Wayzata, Minnesota).

ANDRÉ DERAIN

1880–1954. French. Born at Chatou. Studied in Paris at the Académie Carrière. He was one of the original Fauves who exhibited at the Salons des Indépendants and d'Automne in 1905. In London, 1906. After 1919 his style became more traditional, and he changed from strong colors to subdued greens and browns.

Landscape at Carrières-Saint-Denis PL. 283

[1909] Oil on canvas
21 x 31¾ in. (53.3 x 80.6 cm.)
Signed lower left: Derain

Acc. no. 51.379

COLLECTIONS: (Alex Reid & Lefevre, London).

REFERENCES: G. Hiliare, *Derain*, Geneva, 1959, no. 77, repr. (as *Paysage, Carrières-Saint-Denis*, 1909).

Derain and Braque spent the summer of 1909 painting at Carrières-Saint-Denis.

NARCISSE-VIRGILE DIAZ DE LA PEÑA

1808–1876. French. Born at Bordeaux of Spanish parents. Began as a porcelain painter at Sèvres together with Dupré and Raffet about 1823. In 1837 met Théodore Rousseau, who was the primary influence on his work. Exhibited at Salons from 1831 until 1859.

Forest of Fontainebleau PL. 227

[1858] Oil on wood panel
19⅞ x 29 in. (50.5 x 73.6 cm.)
Signed and dated lower left: N. Diaz 58

Acc. no. 22.27
Gift of Arthur J. Secor

COLLECTIONS: Arthur J. Secor ,Toledo, 1906–22.

EXHIBITIONS: Columbus Gallery of Fine Arts, *Relationships Between French Literature and Painting in the Nineteenth Century*, 1938, no. 5; Boston, Museum of Fine Arts, *Barbizon Revisited*, 1963, no. 41, p. 126, repr.

Deep Woods PL. 231

Oil on wood panel
7⅛ x 9½ in. (18.1 x 24.1 cm.)
Acc. no. 31.47
COLLECTIONS: Edward Drummond Libbey, 1906–25.

Robert Herbert (letter, Jan. 1975) is of the opinion that the rather thick pigment of this picture is indicative of the first half of Diaz's career.

Woodland Scene near Fontainebleau PL. 230

[Ca. 1870–72] Oil on wood panel
12⅝ x 16 in. (32.1 x 40.6 cm.)
Signed lower left: N. Diaz
Acc. no. 66.138
Gift of Howard P. DeVilbiss and Virginia DeVilbiss Gordon
COLLECTIONS: Thomas A. Dissel, Winchester, Mass., –1925; (Vose, Boston); Thomas A. DeVilbiss, Toledo, 1926–; Mrs. C. O. Miniger, Perrysburg, Ohio, –1966.

Dating of this picture is based on its similarity to a much larger picture in the Louvre, the *Fôret de Fontainebleau (Enceinte Palissadée)*, (see *Peintures, école française XIXe siècle*, Paris, 1959, II, no. 776, pl. 274), signed and dated 1868, which appears to represent the same wooden palisade at Fontainebleau. The Toledo panel is also stylistically similar to the Louvre picture in the strong tonal contrasts and free brushwork characteristic of Diaz at this time. Robert Herbert (letter, Jan. 1975) suggests a date of about 1870–72.

Edge of the Wood PL. 228

[1871] Oil on wood panel
25¾ x 30⅝ in. (65.4 x 77.8 cm.)
Signed and dated lower left: N. Diaz 71
Acc. no. 22.43
Gift of Arthur J. Secor
COLLECTIONS: Henry Graves, New York (American Art Association, New York, Feb. 26, 1909, lot 22); Herman Schaus, New York (American Art Association, New York, Jan. 15–17, 1912, lot 284); Arthur J. Secor, Toledo, 1912–22.

Fontainebleau PL. 229

[1872] Oil on wood panel
19¾ x 26 in. (50.2 x 66 cm.)
Signed and dated lower left: N. Diaz 72
Acc. no. 30.1
Gift of Jefferson D. Robinson
COLLECTIONS: C. J. Morrill, Boston; (Vose, Boston); Jefferson D. Robinson, Toledo, 1923–30.

KEES VAN DONGEN

1877–1968. Dutch. Born Cornelis Theodorus Marie van Dongen near Rotterdam. After five years at the Academy of Fine Arts there and work as an illustrator, he went to Paris in 1897; he lived most of his life in France. An original member of the Fauve group in 1905, he also exhibited with the German Expressionist Brücke group in 1908. Known before 1914 as the painter of Paris night life; after the war he became famous as the portraitist of stage, society and political celebrities, his work, often startling in color, reflecting the restless, glittering life of the 1920s.

Deauville PL. 298

[1920] Oil on canvas
39½ x 31¾ in. (100.3 x 80.6 cm.)
Signed lower center: van Dongen
Acc. no. 75.55
Gift of Mrs. William E. Levis
COLLECTIONS: (Galerie Maurice Chalom, Paris, 1960); Mr. and Mrs. William E. Levis, Perrysburg, Ohio.

Deauville, on the coast of Normandy, was one of the favorite watering places of the international smart set in the 1920s. Van Dongen often went there, and in this canvas a few strokes sufficed to record his witty view of contemporary high life.

PAUL-GUSTAVE DORÉ

1832–1883. French. Born in Strasbourg. In 1847 moved to Paris, where he began his career as an illustrator. Achieved first popular success in 1854 with engraved illustrations to Rabelais. In London, 1868 and several times thereafter. Though best known as a graphic artist, Doré did many paintings, exhibiting at the Salon from 1851.

The Scottish Highlands PL. 263

[1875] Oil on canvas
42¾ x 72⅛ in. (108.6 x 183.2 cm.)
Signed and dated lower left: Gve. Doré/1875

Acc. no. 22.108
Gift of Arthur J. Secor

COLLECTIONS: Arthur A. Crosby; (Goupil & Company, New York); (Vose, Boston); Arthur J. Secor, Toledo.

EXHIBITIONS: Minneapolis Institute of Arts, *The Past Rediscovered: French Painting 1800–1900*, 1969, no. 32, repr.

REFERENCES: G. Viatte, "Gustave Doré peintre," *Art de France*, IV, 1964, p. 350, repr. p. 349.

This is one of several pictures probably painted from sketches made during Doré's second trip to Scotland in 1874. After his first visit in 1873 he had written to Miss Amelie Edwards: "Henceforth, when I paint landscapes, I believe that five out of every six will be reminiscences of the Highlands. . . ." (B. Jerrold, *Life of Gustave Doré*, London, 1891, p. 313).

The Mocking of Christ PL. 264

[Ca. 1872–83] Oil on canvas
48¾ x 38⅝ in. (123.8 x 98.1 cm.)
Signed lower right: G. Doré

Acc. no. 26.146
Gift of René Gimpel

COLLECTIONS: René Gimpel, Paris.

According to B. Jerrold (*Life of Gustave Doré*, London, 1891, p. 276) and B. Roosevelt (*Life and Reminiscences of Gustave Doré*, London, 1885, p. 333), Doré's first religious painting, begun in 1867, was not finished until 1872. Doré later painted other religious subjects, and *The Mocking of Christ* was probably done between 1872 and his death. Jerrold (p. 410) lists a pen and ink drawing of this subject dated 1881 (whereabouts unknown).

CLAUDE-MARIE DUBUFE

1790–1864. French. A student of Jacques-Louis David, Dubufe exhibited regularly at the Salons from 1810 until 1863. At first he painted history and genre pictures, but from about 1830 he devoted himself to portraiture, achieving great success. His sitters included many of the French nobility and the wealthy Paris bourgeoisie. His son, Edouard Dubufe, was also a noted portraitist.

Portrait of a Man PL. 212

[Ca. 1835–45] Oil on canvas
51¼ x 38½ in. (130.2 x 97.8 cm.)
Signed lower right: Dubufe

Acc. no. 75.1

COLLECTIONS: Private collection, Paris; (Heim, London).

A prolific artist, Dubufe reportedly exhibited 130 portraits at the Salons (C. H. Stranahan, *A History of French Painting*, New York, 1888, p. 357). Most of his portraits are still in private hands. The Toledo portrait can be dated approximately 1835–45 from the costume.

RAOUL DUFY

1877–1953. French. Born in Le Havre. Studied there at the École des Beaux-Arts under C. Lhullier, and then at Paris École des Beaux-Arts under Bonnat. Influenced by Fauvism. Worked with Braque at L'Estaque in 1908. Traveled to Venice, Italy and England. Settled at Perpignan in 1940. Also an illustrator and designer of textiles.

Threshing with a Blue Machine PL. 300

[Ca. 1948] Oil on canvas
21½ x 26 in. (54 x 66 cm.)
Signed lower left: Raoul Dufy

Acc. no. 49.110

COLLECTIONS: (Louis Carré, Paris).

EXHIBITIONS: San Francisco Museum of Art, *Raoul Dufy*, 1954, no. 76, pp. 37, 40.

REFERENCES: J. Canaday, *Mainstreams of Modern Art*, New York, 1959, p. 409, repr.

This painting is one of a series of threshing subjects by Dufy painted in the late 1940s and 50s in the south of France.

DUNOYER (*see* SEGONZAC)

JULES DUPRÉ

1811–1889. French. Studied briefly in 1823 with the landscapist Diebolt, and worked as a porcelain painter in Saint-Yrieix and at Sèvres. Studied the work of Constable while in England in 1831. Exhibited regularly at the Salon 1831–39, but seldom thereafter. 1841–49 worked closely with Rousseau, but retired in 1850, to

Isle-Adam, after which he worked alone. Although important for the Barbizon movement in the 1840s, Dupré's influence diminished after 1850, when he abandoned his initial practice of painting directly from nature.

Return of the Fisherman PL. 234

[Late 1870s] Oil on canvas
12⅞ x 9¾ in. (32.5 x 25 cm.)
Signed lower left: J. Dupré

Acc. no. 30.2
Gift of Jefferson D. Robinson

COLLECTIONS: C. J. Morrill, Boston; (Vose, Boston, by 1923); Jefferson D. Robinson, Toledo, 1923–30.

REFERENCES: M.-M. Aubrun, *Jules Dupré, catalogue raisonné de l'oeuvre peint, dessiné, et gravé*, Paris, 1974, no. 633, repr. (as late 1870s).

Morning PL. 235

[1880s] Oil on canvas
15¾ x 26¾ in. (40 x 67.9 cm.)
Signed lower left: J. Dupré

Acc. no. 22.21
Gift of Arthur J. Secor

COLLECTIONS: Arthur J. Secor, Toledo, 1909–22.

EXHIBITIONS: Iowa City, University of Iowa Gallery of Art, *Impressionism and its Roots*, 1964, p. 4, no. 13, repr.

REFERENCES: M.-M. Aubrun, *Jules Dupré, catalogue raisonné de l'oeuvre peint, dessiné et gravé*, Paris, 1974, no. 675, repr. (as 1880s).

ANTHONY VAN DYCK

1599–1641. Flemish. Born in Antwerp. Probably before 1618 he was an assistant to Rubens, with whom he later collaborated. Member of the Antwerp painters' guild, 1618. He worked for King James I in England, 1620–21. In Italy 1621–26, chiefly in Genoa. In Antwerp 1627–32. To England in 1632, where he was knighted and made court painter by Charles I the same year. Van Dyck returned briefly to the Low Countries in 1634 and 1640 and went to Paris in 1641. He died in London. Painted religious and mythological subjects and portraits.

Portrait of a Man PL. 103

[Ca. 1630] Oil on canvas
41½ x 33 in. (105.3 x 83.7 cm.)
Acc. no. 64.33

COLLECTIONS: Earls of Dalhousie, Dalhousie Castle, Scotland; by descent to Colin Broun-Lindsay, 1963; (Agnew, London).

EXHIBITIONS: King's Lynn, Fermoy Art Gallery, *Pictures by Sir Anthony van Dyck*, 1963, no. 11 (cat. by G. Agnew).

After returning from Italy in 1627, Van Dyck worked in Antwerp until leaving for England in 1632. According to M. Jaffé (letter, Dec. 1963) and O. Millar (letter, Jan. 1964), this portrait was painted at that time, his second Antwerp period. During it Van Dyck enjoyed great success, his sitters including leading Antwerp citizens and members of the Hapsburg governors' court at Brussels. The subject of this portrait is unidentified. The easy grace, patrician reserve and elegance learned from Titian which Van Dyck imparted to his sitters remained the ideal of European portraiture for more than two centuries after his death.

GERBRAND VAN DEN EECKHOUT

1621–1674. Dutch. Born in Amsterdam. Studied with Rembrandt during the late 1630s. Worked in Amsterdam as a portrait, history and genre painter.

The Magnanimity of Scipio PL. 134

[1650s] Oil on canvas
54⅜ x 67½ in. (138.1 x 161.5 cm.)
Signed lower right: G.V. Eeckhout fe/Ano 165(?)

Acc. no. 23.3155
Gift of Arthur J. Secor

COLLECTIONS: Sir John Cotterell (Christie, London, June 7, 1912, lot 9); (Asher Wertheimer, London); T. J. Blakeslee, 1912–23; (Vose, Boston, 1923).

EXHIBITIONS: Montreal Museum of Fine Arts, *Five Centuries of Dutch Art*, 1944, no. 64.

REFERENCES: S. P. Noe, "Two Paintings by Pupils of Rembrandt in the New-York Historical Society," *New-York Historical Society Quarterly Bulletin*, XI, No. 2, July 1927, pp. 38–9, repr.; T. M. D. Wit-Klinkhamer, "Een vermaarde zilveren beker," *Nederlands Kunst-Historisch Jaarboek*, XVII, 1966, p. 92.

The subject is taken from the Roman historian Livy (Book XXVI, 50) and illustrates the moment when Scipio, commander of the Spanish provinces, returns a captive woman to her fiancé and parents after learning of their devotion to her, only requiring their continued friendship with the Roman people.

Three other versions of this subject are known: (1) formerly New York Historical Society (1669); (2) Lille, Musée des Beaux-Arts; (3) Munich, art market ca. 1947 (W. Bernt, *Die niederländischen Maler des siebzehnten Jahrhunderts*, I, no. 262, repr.).

The fact that the faces of the parents and the betrothed couple are different in each version is evidence that these are portraits. Eeckhout frequently introduced such portraits into history pictures.

GEORGES D'ESPAGNAT

1870–1950. French. A student of Courtois and Rixens, d'Espagnat began exhibiting regularly about 1890. From 1899 to 1905 worked with Valtat, André, Denis, Bonnard and Vuillard. One of the founders of the Salon d'Automne in 1903. His work includes portraits, landscapes, still lifes and large decorative schemes for public buildings.

Le Lavandou PL. 279

[Ca. 1899–1905] Oil on canvas
29 x 36¼ in. (73.7 x 92.1 cm.)
Signed lower left: G d E

Acc. no. 06.252
Gift of 100 Members of the Museum

COLLECTIONS: (Durand-Ruel, New York).

EXHIBITIONS: Toledo Museum of Art, *Exhibition of One Hundred Paintings by the Impressionists from the Collection of Durand-Ruel & Sons, Paris*, 1905, no. 24.

Le Lavandou is a town on the Mediterranean coast near Toulon. This picture was probably painted between 1899 and 1905, when d'Espagnat was working with several artists of the Fauve and Nabis groups, many of whom were attracted by the strong light and vivid colors of this region. This and the Museum's painting by Moret were the first Impressionist works acquired by the Museum.

HENRI FANTIN-LATOUR

1830–1902. French. Student of Lecoq de Boisbaudran, and briefly, of Courbet. Close friend of Manet and Whistler. Lived in Paris except for short visits to London in 1859, 1861 and in 1864. Exhibited at the Salons from 1861 to 1899. Painter of still lifes, portraits and imaginative scenes inspired by the music of Wagner, Berlioz and other composers. He was also a lithographer.

Flowers and Fruit PL. 239

[1866] Oil on canvas
28¾ x 23½ in. (73 x 59.7 cm.)
Signed and dated upper left: Fantin 1866

Acc. no. 51.363

COLLECTIONS: C. S. Gulbenkian, Paris; (Wildenstein, New York).

EXHIBITIONS: New York, Wildenstein, *Birth of Impressionism*, 1963, no. 44, repr.; Northampton, Smith College Museum of Art, *Henri Fantin-Latour, 1836–1904*, 1966, no. 9, repr.

REFERENCES: Mme. Fantin-Latour, *Catalogue de l'oeuvre complet (1849–1904) de Fantin-Latour*, Paris, 1911, no. 289; W. Chiego, "Two Paintings by Fantin-Latour," *Toledo Museum of Art Museum News*, XVII, No. 2, 1974, p. 27 ff., repr. cover and fig. 3.

In 1866 the artist painted a group of closely related still-lifes. Two of these are horizontal compositions (National Gallery of Art, Washington; Gulbenkian Foundation, Lisbon); their relation to the Toledo painting is discussed by Chiego. A second vertical painting with the same tray and similar sugar bowl and orange is in the National Gallery of New South Wales, Sydney, Australia.

Portrait of the Artist's Sister PL. 240

[Ca. 1880] Oil on canvas
19½ x 15½ in. (49.5 x 39.3 cm.)

Acc. no. 55.84

COLLECTIONS: Mrs. Clifford Addams (Inez Bates); Dr. Charles Peacock; (Ernest Brown and Phillips, Leicester Galleries, London).

EXHIBITIONS: Northampton, Smith College Museum of Art, *Henri Fantin-Latour, 1836–1904*, 1966, no. 5, repr.

REFERENCES: W. Chiego, "Two Paintings by Fantin-Latour," *Toledo Museum of Art Museum News*, XVII, No. 2, 1974, p. 33 ff., fig. 7.

Marie Fantin-Lator Yanovski became the wife of a Russian army officer in 1866, when she went to live in St. Petersburg. The 1966 exhibition catalogue suggested that this is a study for *La Liseuse* (1861; Louvre, Paris), for which Marie was the model. However, as the dress and hair style were not current until twenty years later, it was probably painted about 1880, a date which also agrees with the artist's treatment of light in this portrait (Chiego).

FLEMISH, ANONYMOUS

Marriage of a Saint PL. 77
("The Marriage of Henry VI")

[Ca. 1475–1500] Oil on wood panel
37¼ x 34⅞ in. (94.6 x 88.6 cm.)
Undeciphered inscription lower center (on border of
 skirt): . . . VOL: SALV . . . BEG(?) . . .

Acc. no. 26.74

COLLECTIONS: Horace Walpole, 4th Earl of Orford,
Strawberry Hill, Twickenham; George, 4th Earl of
Waldegrave, Strawberry Hill (George Robins, Strawberry
Hill, 1842, lot 25); Duke of Sutherland, by 1861; Ed-
ward Drummond Libbey, 1916–25.

EXHIBITIONS: London, Royal Academy, *Art of the Mid-
dle Ages*, 1861; London, South Kensington Museum,
Exhibition of National Portraits, 1866, no. 16 and ap-
pendix, p. 194 (as *Marriage of the Virgin and St. Joseph*,
Flemish, ca. 1500).

REFERENCES: H. Walpole, *Anecdotes of Painting in En-
gland*, Twickenham, 1762, I, repr. pp. 34–5 (engraving);
W. Lewis, *Horace Walpole*, Washington, 1960, p. 122,
n. 30; R. Wilenski, *Flemish Painters, 1430–1830*, New
York, 1960, I, p. 670; II, pl. 147; R. Strong, *Tudor and
Jacobean Portraits*, London, 1969, I, p. 148.

This painting once hung over the fireplace of Walpole's
library at Strawberry Hill, as shown in an engraved view
of the library by Richard Godfrey in *Anecdotes*. It was
probably Walpole who first named the subject *The Mar-
riage of Henry VI*, an unfounded identification that was
accepted until fairly recently. Probably it shows the mar-
riage of a minor male saint who is still unidentified.

 Equal uncertainty surrounds the attribution. While
French and even Spanish origins have been suggested,
the weight of scholarly opinion, including Friedländer's
(letter, Nov. 1936), favors a Flemish authorship. Re-
cently, Sterling (letter, Aug. 1974) has suggested it may
be the work of a Cologne painter about 1485. Opinions
of date have ranged from 1470 to 1500, with some pref-
erence for the decade 1480–90.

FLEMISH, ANONYMOUS

Saint Jerome in His Study PL. 88

[Early 16th century] Oil on wood panel
13⅜ x 10-7/16 in. (34 x 26.9 cm.)

Acc. no. 57.36

COLLECTIONS: Dr. Curt Benedict; (Pardo, Paris).

This painting, which is almost certainly Flemish, is a free
copy after Dürer's engraving, *St. Jerome in His Study*
dated 1514. Clifton Olds (letter, Apr. 1974) has sug-
gested that the grouping of skull, crucifix and stoppered
carafe may have Marian significance, demonstrating St.
Jerome's doctrine of *Mors per Evam, vita per Mariam*
(As death came through Eve, so life came through Mary).

JEAN-HONORÉ FRAGONARD

1732–1806. French. Born in Grasse, and raised in Paris.
After brief study with Chardin, he entered Boucher's
studio in 1748, remaining until 1752, when he won the
Prix de Rome. At the École des Élèves Protégés under
Carle Van Loo, 1753–55; in Italy at the French Academy
at Rome, 1756–61. Admitted as an associate by the
Académie, 1765; soon changed from historical and reli-
gious themes to portraits, landscapes and refined amo-
rous subjects, which found success at court and with rich
financiers and the theatrical world. In Italy 1773–74. A
versatile artist, he was active as a painter, etcher and
illustrator, who was inspired by many sources, includ-
ing Rubens, the Dutch genre painters, Rembrandt and
Watteau.

Blind-Man's Buff [COLOR PL. IX] PL. 203

[Ca. 1750–52] Oil on canvas
46 x 36 in. (116.8 x 91.4 cm.)

Acc. no. 54.43

COLLECTIONS: Baron de Saint-Julien, Paris (Lebrun, Paris,
June 21, 1784, lot 75, with pendant); M(orel), Paris
(Lebrun, Paris, Apr. 19 (May 3), 1786, lot 177, with
pendant); Comte de Sinéty, Paris; Baron Nathaniel de
Rothschild, Vienna; Baron Maurice de Rothschild, Châ-
teau de Prégny, Switzerland; (Rosenberg and Stiebel,
New York).

EXHIBITIONS: London, Royal Academy, *France in the
Eighteenth Century*, 1968, no. 229, pl. VI; Toledo Mu-
seum of Art, *The Age of Louis XV: French Painting
1710–1774*, 1975, no. 36, pl. 82 (cat. by P. Rosenberg).

REFERENCES: E. and J. de Goncourt, *L'art du dix-hui-
tième siècle*, 3rd ed., Paris, 1882, II, pp. 325, 374; R. Por-
talis, *Honoré Fragonard*, Paris, 1889, I, pp. 15, 62; II, p.
273, repr. p. 20 (Beauvarlet engraving); L. Réau, "Les
colin-maillard de Fragonard," *Gazette des Beaux-Arts*,
XV, Mar. 1927, pp. 148–49; P. de Nolhac, *Fragonard
1732–1806*, 3rd ed., Paris, 1931, p. 150; L. Réau, *Fra-
gonard*, Paris, 1956, pp. 39, 158; G. Wildenstein, *The
Paintings of Fragonard*, New York, 1960, no. 47, fig. 31;
C. Sterling, in *The Thyssen-Bornemisza Collection* (ed.,
R. Heinemann), Castagnola (Switzerland), 1969, p. 113;

D. Wildenstein and G. Mandel, *L'opera completa di Fragonard*, Milan, 1972, no. 53, repr.

According to Sterling and Rosenberg (Toledo, 1975), *Blind-Man's Buff* (*Le Colin-Maillard*) and its companion *The See-Saw* (*La Bascule*; Thyssen collection, Lugano) were painted about 1750–52, while Fragonard was still in the studio of Boucher, whose romantic pastoral themes and tones of blue and rose are reflected in this canvas. "One senses, however, a freshness of expression, a taste for movement and a verve which anticipate the mature Fragonard" (Rosenberg). In fact, when these early works were engraved (in reverse) by J. F. Beauvarlet in 1760, the first state named Boucher as the painter, later corrected to Fragonard (M. Roux, *Bibliothèque Nationale, Graveurs du XVIIIe siècle*, Paris, 1933, II, p. 218, nos. 31, 32).

The catalogue of the 1784 Saint-Julien sale lists six Fragonards, almost certainly including the Toledo-Thyssen pair. However, the dimensions given there are almost twice the present heights. The latter are similar to those in the 1786 Morel sale, only two years later. The present compositions also correspond to the Beauvarlet engravings, mentioned in both sales catalogues as after these paintings. This puzzle might be explained by exceptionally tall and narrow wall decorations having been reduced to easel pictures between 1784 and 1786, or the Saint-Julien dimensions may have been wrong. Wildenstein (1960), however, believes that Fragonard painted two pairs of pictures in different sizes.

Several copies, some of them after the engraving, are listed by De Nolhac and Réau (1956).

FRENCH, ANONYMOUS

Saint George and the Dragon PL. 179

[Ca. 1480–90] Oil on wood panel
19½ x 14¼ in. (49.5 x 36.2 cm.)

Acc. no. 43.30

COLLECTIONS: (Henri Haro, Paris); Mr. and Mrs. Otto Kahn, New York; Dr. Preston Pope Satterwhite, Louisville, Kentucky; (French & Co., New York).

EXHIBITIONS: Paris, Louvre and Bibliothèque Nationale, *Exposition des primitifs français* (cat. by H. Bouchot), 1904, no. 91; New York, Kleinberger, *Loan Exhibition of French Primitives and Objects of Art*, 1927, no. 20, repr. p. 57; London, Royal Academy, *Commemorative Catalogue of the Exhibition of French Art, 1200–1900*, 1932, no. 31, pl. XII.

REFERENCES: S. Reinach, *Répertoire de peintures du moyen age et de la renaissance*, Paris, 1907, II, p. 612, repr.; "A French Primitive Acquired," *Toledo Museum of Art Museum News*, June 1943, no. 102, unpaginated, repr. on cover; G. Ring, *A Century of French Painting, 1400–1500*, London, 1949, no. 200.

The attribution of this panel is a puzzle. Bouchot (Paris, 1904) noted French characteristics and suggested the artist may have been Burgundian. Later (New York, 1927; London, 1932), it was attributed to the French painter Simon Marmion (active 1449–89). Ring published the Toledo panel as northern French, and its French character was affirmed by Charles Sterling (verbally, 1961), though he suggested the artist may have worked along the German or Swiss borders.

The castles have been identified with two on the Rhone River, the larger at Tarascon, the smaller on the opposite side of the river at Beaucaire.

THOMAS GAINSBOROUGH

1727–1788. British. In London, 1740–48; then to his native Suffolk where he painted many portraits. His early work reflects the Rococo style of Hayman and Gravelot. At Bath from 1759, the influence of Van Dyck is apparent in portraits and that of Rubens in landscapes. In London from 1774 until his death. A founding member of the Royal Academy, he and Reynolds were the leading British portrait painters of their time. Gainsborough was also an important landscape painter.

The Shepherd Boy PL. 314

[Ca. 1757–59] Oil on canvas
(oval) 32½ x 25½ in. (82.5 x 64.8 cm.)

Acc. no. 33.21
Gift of Arthur J. Secor

COLLECTIONS: Painted for Robert Edgar, Ipswich, Suffolk, and his descendants; Mrs. M. G. Edgar, Ipswich, 1888; (Sir George Donaldson, London, 1890s?); H. Darrell Brown, London, by 1903 (Christie, London, May 23, 1924, lot 20, repr.); (Hugh Blaker, London); (D. Croal Thomson, Barbizon House, London); (Howard Young, New York); Arthur J. Secor, 1926–33.

EXHIBITIONS: London, British Institution, 1861, no. 214; London, Grosvenor Gallery, *A Century of British Art, 1737–1837*, 1887, no. 218 (by F. G. Stephens); Paris, Exposition universelle, 1900, Royal Pavilion, no. 48; London, Royal Academy, *Exhibition of Old Masters,*

1903, no. 122; London, Kenwood House, *The French Taste in English Painting*, 1968, no. 41.

REFERENCES: G. W. Fulcher, *Life of Gainsborough*, London, 1856, p. 235; W. Armstrong, *Life of Gainsborough*, London, n.d., p. 205; E. K. Waterhouse, *Gainsborough*, London, 1958, p. 35, no. 836, pl. 34; R. Riefstahl, "What is Conservation," *Toledo Museum of Art Museum News*, VII, Autumn 1965, p. 57, repr.; J. Hayes, *The Drawings of Thomas Gainsborough*, London, 1970, p. 27, in no. 865.

Gainsborough painted this picture for his friend Robert Edgar at Ipswich, before moving to Bath in 1759. Waterhouse considers *The Shepherd Boy* one of the early forerunners of the "fancy pictures" of the artist's late career. Waterhouse dates the picture in the early 1750s; Hayes, about 1757–59.

The free handling in the distant landscape and the touches of red in the foreground grass are characteristic of this short period in the late 1750s (Hayes, letter, 1975). A drawing for the composition and two studies of sheep are illustrated by Hayes (pls. 323–26).

The Road from Market PL. 316

[1767–68] Oil on canvas
47¾ x 67 in. (121.3 x 170.2 cm.)
Acc. no. 55.221

COLLECTIONS: Lord Shelburne, later 1st Marquess of Lansdowne, Bowood, Wiltshire (Coxe, Burrell and Foster, London, Feb. 26, 1806, lot 105, repr.); William Esdaile (died 1837) and descendants; William C. H. Esdaile, Cothelestone House, Taunton, Somerset, until 1955; (Edward Speelman, London).

EXHIBITIONS: London, Royal Academy, *Exhibition of Works by Old Masters and by Deceased Masters of the British School*, 1887, no. 147; London, Royal Academy, *Bicentenary Exhibition*, 1968, no. 146.

REFERENCES: Anonymous (J. Britton), *The Beauties of Wiltshire*, 1801, II, p. 218; E. K. Waterhouse, *Gainsborough*, London, 1958, p. 24, no. 906, pl. 98; J. Woodward, "Wilkie's Portrait of Esdaile," *Burlington Magazine*, CIV, Mar. 1962, p. 117; J. Hayes, "Gainsborough and Rubens," *Apollo*, LXXVII, Aug. 1963, pp. 90, 91, fig. 4 and cover (detail); J. Hayes, "Gainsborough," *Journal of the Royal Society of Arts*, Apr. 1965, pp. 320–21, 324, figs. 9, 10; J. Hayes, "British Patrons and Landscape Painting," *Apollo*, LXXXVI, Nov. 1967, p. 358, repr.; M. Woodall, *Thomas Gainsborough*, New York, 1970, pp. 77–8, repr. p. 36; J. Hayes, *The Drawings of Thomas Gainsborough*, London, 1970, no. 283; J. Hayes, "A Turning Point in Style: *Landscape with Woodcutter*," *Museum of Fine Arts, Houston Bulletin*, IV, Summer 1973, fig. 3.

The Road from Market was almost certainly one of the three landscapes commissioned in the 1760s by Lord Shelburne for his drawing room at Bowood that were intended "to lay the foundation of a school of British landscapes" (Hayes, 1963), as recounted by John Britton, who visited Bowood in 1798.

Hayes (1963) characterizes this painting as the key picture of Gainsborough's new style of about 1767. He attributes this change to more brilliant colors, bolder brushwork and more impasto to the inspiration of Rubens' landscapes of the 1630s. Hayes further suggests (letter, Nov. 1975) a slightly later date of 1767–68 instead of Waterhouse's 1766–67.

A watercolor, *Wooded Landscape with Horseman* (Hayes, 1970, no. 865), is close to Toledo's painting in composition and handling of light. *The Road from Market* was engraved by Francesco Bartolozzi in 1802.

Lady Frederick Campbell PL. 315

[Ca. 1770–75] Oil on canvas
30½ x 25¼ in. (77.5 x 64 cm.)
Acc. no. 33.20
Gift of Arthur J. Secor

COLLECTIONS: Lady Frederick Campbell; Viscountess Curzon (her sister); Lord Curzon (her stepson); Lord Zouche (his great-grandson), 1863; (Lewis and Simmons); (Agnew, London, 1912); Gerard Le Bevan, London, 1912–23 (Christie, London, May 11, 1923, lot 90); (Agnew, London, 1923–24); (John Levy, New York, 1924); (Howard Young, New York, 1924–25); Arthur J. Secor, 1925–33.

REFERENCES: E. K. Waterhouse, "Preliminary Check List of Portraits by Thomas Gainsborough," *The Walpole Society*, XXXIII, Oxford, 1953, p. 17; E. K. Waterhouse, *Gainsborough*, London, 1958, p. 58.

The sitter was Mary Meredith (1727–1807) who in 1769 married Lord Frederick Campbell, brother of the 4th Duke of Argyll, after her first marriage to Earl Ferrers. This portrait was probably painted during Gainsborough's last years in Bath.

FERNANDO GALLEGO

Active 1466–1507. Spanish. Birthplace unknown, perhaps Galicia or Salamanca. Active mainly in Salamanca, but also in Zamora, Plasencia and Coria. Gallego was widely imitated in northwestern Spain. His chief follower and collaborator was Francisco Gallego, his son or brother.

The Adoration of the Magi PL. 49

[Ca. 1480–90] Oil on wood panel
50 x 40½ in. (127 x 102.9 cm.)

Acc. no. 40.173

COLLECTIONS: De Miró collection, Madrid, by 1888;
H. Pacully, Paris, by 1903.

EXHIBITIONS: Barcelona, Exposición Universal, *Album
de la instalación artistica-arqueológica de la Real Casa
... con un catalogo razonado,* 1888, p. 109, pl. 8; Toledo
Museum of Art, *Spanish Painting,* 1941, no. 25, p. 38,
figs. 25, 26 (cat. by J. Gudiol).

REFERENCES: C. R. Post, *A History of Spanish Painting,*
Cambridge, Mass., 1933, IV (I), p. 136, fig. 31; F. Sanchez
Canton, *Los grandes temas del arte cristiano en España,
I: Nacimiento e infancia de Cristo,* Madrid, 1948, p. 126;
T. Rousseau, Jr., "A Flemish Altarpiece from Spain,"
Metropolitan Museum of Art Bulletin, IX, June 1951,
p. 275; J. Gaya Nuño, *La pintura española fuera de
España,* Madrid, 1958, no. 798; J. Gaya Nuño, *Fernando Gallego,* Madrid, 1958, pp. 19, 37, pl. 26; J. Gudiol, *The Arts of Spain,* New York, 1964, fig. 92.

Post placed this painting at the beginning of Gallego's
career, about 1475–80. More recently, scholars have
dated it about 1480 (Gaya Nuño, *Gallego*) or 1490 (Gudiol, 1941). However, these dates now seem to fall in
the middle of his career, as these scholars agree that Post
dated Gallego's early works 10 to 15 years too late.

The Vision of the Magi in the background is a rare
subject made rarer by both the Virgin and Child shown
as appearing to the Magi rather than the Child alone.

The influence of Flemish art on Gallego, the foremost
Castilian representative of the Hispano-Flemish style in
the late 15th century, is particularly evident in the Toledo panel, which probably formed part of a large
retable.

PAUL GAUGUIN

1848–1903. French. Born in Paris. Lived four years in
Peru when a child. Served in navy and merchant marine,
1865–71, and made several visits to South America.
Painting part-time from 1871, he resigned his position
with a brokerage firm in 1883 to devote himself to art.
Exhibited with the Impressionists, 1879–86. In Brittany
at Pont-Aven in 1880s with Émile Bernard, and at Arles
in 1888 with Van Gogh. To Martinique in 1887; in Tahiti 1891–93 and 1895–1903. Although primarily a
painter, Gauguin also made prints, sculpture and
ceramics.

Street in Tahiti [COLOR PL. XI] PL. 262

[1891] Oil on canvas
45½ x 34⅞ in. (115.5 x 88.5 cm.)
Signed and dated lower right: P. Go/91

Acc. no. 39.82

COLLECTIONS: (Ambroise Vollard, Paris); Hugo Nathan,
Frankfurt, by 1913; Martha Nathan, Frankfurt; (Galerie
Thannhauser, Berlin); (Wildenstein, New York).

EXHIBITIONS: Berlin, Galerie Thannhauser, *Paul Gauguin,* 1928, no. 50, repr. (as *Die Berge*); New York,
Wildenstein, *Paul Gauguin,* 1946, no. 16, repr. p. 30;
Edinburgh, Royal Scottish Academy, *Gauguin,* 1955, no.
42; Art Institute of Chicago, *Gauguin,* 1959, no. 31,
repr. p. 40.

REFERENCES: W. Barth, *Gauguin,* Basel, 1929, pp. 113–
17, pl. XXVIII (as *Die Berge*); A. Alexandre, *Paul Gauguin: sa vie et le sens de son oeuvre,* Paris, 1930, p. 103,
repr. (as *Paysage de la Martinique*); M. Malingue, *Gauguin: le peintre et son eouvre,* Paris, 1948, pl. 173;
C. Estienne, *Gauguin,* Geneva, 1953, p. 62, repr. p. 63;
B. Dorival, ed., *Paul Gauguin, carnet de Tahiti,* Paris,
1954, pp. 20, 28, 41; D. Sutton, "Notes on Paul Gauguin
apropos a Recent Exhibition," *Burlington Magazine,*
XCVIII, Mar. 1956, p. 91; G. Wildenstein, *Gauguin,*
Paris, 1964, p. 174, no. 441, repr.

Painted in Tahiti soon after Gauguin's arrival in June
1891. There are sketches of the hut, horse, and two walking figures in the *Carnet de Tahiti* (Musée National d'Art
Moderne, Paris; Dorival, pp. 9 recto, 12 recto, 13 verso,
18 recto, 22 verso, and 52 verso). There is a pastel sketch
for the seated woman (private collection, Paris), who
also appears in another oil of 1891, *The Sulking Woman*
(Worcester (Mass.) Art Museum), and in a slightly different pose, in *Te Rerioa,* 1897 (Courtauld Institute,
London).

GELLÉE (*see* CLAUDE)

PIER LEONE GHEZZI

1674–1755. Italian. Son and pupil of Giuseppe Ghezzi;
godson of Maratti. Became official painter to the Pope
in 1708. Remained at the papal court throughout his career. Also active as an engraver, caricaturist and decorator.

An Augustinian Nun PL. 28

[Ca. 1725–30] Oil on canvas
29½ x 24½ in. (75 x 62.3 cm.)

Acc. no. 71.4

COLLECTIONS: Princes Corsini, Rome and Florence; Barons Ricasoli, Florence; Princes Corsini, Florence, since 1927 (Galleria Giorgi, Florence, May 7–12, 1970, lot 275) (Heim, London).

EXHIBITIONS: London, Heim, *Paintings and Sculptures of the Baroque*, 1970, no. 21.

In various Corsini inventories this picture was identified as School of Pietro da Cortona or by Carlo Maratti. Anthony M. Clark believes the painting is by Ghezzi, painted about 1725–30 (letter, Jan. 1975; see also A. M. Clark, "Pierleone Ghezzi's Portraits," *Paragone*, No. 165, Sep. 1963, pp. 11–21). The sitter has been tentatively identified as the daughter of Bartolomeo Corsini and Vittoria Altoviti, Maria Lucrezia (in religion Suor Maria Eletta), a nun in the Augustinian convent of S. Gaggio who died in 1736; there were three Corsini nuns in this convent in the first decades of the 18th century (Heim catalogue).

LUCA GIORDANO

1634–1705. Italian. Born in Naples, the son of a painter who was his first teacher. Later studied with Ribera, the influence of whose naturalism was succeeded by that of Veronese, whose work he may have seen on a trip to Venice, Lombardy and Rome, ca. 1650–53. Giordano's dramatic style was synthesized from his study of these and other masters, including Pietro da Cortona and Mattia Preti; and his virtuoso speed of execution resulted in a very large production of oil paintings and fresco decorations. Famous in Naples by age 20, he worked elsewhere much of his life; in 1680–82 at Florence and from 1692 to 1702 in Spain, where Charles II appointed him Court Painter. Giordano made Naples internationally important in the development of Baroque painting, and his work inspired painters in Italy and elsewhere far into the 18th century.

The Rest on the Flight into Egypt　　　　PL. 22

[Ca. 1660] Oil on canvas
69⅞ x 112⅜ in. (177.4 x 285.4 cm.)

Acc. no. 71.158

COLLECTIONS: (Heim, London).

EXHIBITIONS: London, Heim, *Fourteen Important Neapolitan Paintings*, 1971, no. 8, repr. (cat. entry by O. Ferrari).

This recently discovered painting was unknown to Oreste Ferrari at the time of his monograph on Giordano (O. Ferrari and G. Scavizzi, *Luca Giordano*, Naples, 1966). According to his catalogue entry for the 1971 exhibition, it was painted about 1660, and "its overall stylistic character is that of the neo-Venetianism of the end of the 1650s, when Giordano was updating all he had learned during his first visit to Venice (ca. 1653), by merging it with a renewed interest in the art of Rubens." In this connection, Ferrari mentions *Rubens Painting the Allegory of Peace* (Prado, Madrid), two altarpieces in the church of S. Agostino degli Scalzi in Naples (1658), *Venus, Mars and Vulcan* (Denis Mahon collection, London) and *The Sacrifice of Elijah* and *Massacre of the False Prophets* (Schönborn collection, Pommersfelden) (Ferrari-Scavizzi, I, p. 47 ff.; II, p. 36 ff.). Ferrari also points out that two *Bacchanals* (Villa Albani-Torlonia, Rome), which probably date from the early 1660s, have "the same figures of putti and the same brilliant and intense colorism" as the Toledo painting, which, however, is not identifiable with any of the compositions of this subject mentioned by Giordano's first biographers or in other contemporary documentary sources.

The subject is a traditional variation on the theme of the Rest on the Flight into Egypt in its inclusion of the infant St. John the Baptist and a host of angels and cherubs who are present to serve and amuse the Christ Child.

VINCENT VAN GOGH

1853–1890. Dutch. After working for an art dealer in The Hague 1869–76, he studied theology, becoming a lay preacher in 1879. Began to draw seriously in 1880 and studied painting with Anton Mauve in 1882. To Paris, 1886, living with his brother Théo, who introduced him to Impressionism. Briefly entered Atelier Cormon where he met Toulouse-Lautrec. The direction of his painting was greatly influenced by Degas, Seurat and Gauguin. In 1888 was with Gauguin at Arles, where he suffered his first mental breakdown. Voluntarily entered the asylum at St.-Rémy, May 1889. He committed suicide in July 1890 at Auvers, near Paris.

The Wheat Field　　　　PL. 176

[1888] Oil on canvas
29 x 36⅝ in. (73.6 x 93 cm.)

Acc. no. 35.4

COLLECTIONS: Mrs. J. van Gogh, Amsterdam; Julian Leclerq, Paris; Gustave Fayet, Igny; Mrs. Alban d'Andoque de Sériège, Béziers; (Wildenstein, New York).

EXHIBITIONS: Amsterdam, Stedelijk Museum, *Vincent van Gogh*, 1905, no. 106; New York, Paul Rosenberg, *Masterpieces by Van Gogh*, 1942, no. 6; New York, Wildenstein, *Art and Life of Vincent van Gogh*, 1948, no. 41; Cleveland Museum of Art, *Work by Vincent van Gogh*, 1948, no. 8, pl. VIII.

REFERENCES: J. B. de la Faille, *L'oeuvre de Vincent van Gogh*, 1st ed., Brussels, 1928, I, no. 559; II, pl. CLIV; M. Denis, L'epoque du symbolisme," *Gazette des Beaux-Arts*, XI, Mar. 1934, p. 172, fig. 7; W. Scherjon and J. de Gruyter, *Vincent van Gogh's Great Period*, Amsterdam, 1937, p. 76, no. 47, repr.; C. Dekert, H. Eklund and O. Reutersvärd, "Van Gogh's Landscape with Corn Shocks," *Konsthistorisk Tidskrift*, XVI, Dec. 1946, pp. 121–33, figs. 1, 3a, 4a; C. Nordenfalk, *The Life and Work of Van Gogh*, New York, 1953, p. 179; *The Complete Letters of Vincent van Gogh*, Greenwich (Conn.), 1959, II, no. 501, p. 591; J. B. de la Faille, *The Works of Vincent van Gogh: His Paintings and Drawings*, 3rd ed., Amsterdam, 1970, pp. 236, 633, 666, no. F559, repr.; P. Lecaldano, *L'opera pittorica completa di Van Gogh*, Milan, 1971, no. 527, repr.

Painted at Arles, the Toledo landscape is characteristic of Van Gogh's mature style. The date of this picture is based on a letter written to his brother Theo in June 1888: "Among the studies of wheat fields there is one of the stacks, of which I sent you the first sketch; it is on a square size 30 canvas" (*Complete Letters*, no. 501). The Toledo painting corresponds precisely to these measurements. Another version of this subject in the Nationalmuseum, Stockholm was until 1946 generally considered 'the first sketch' mentioned in the letter. However, as Dekert suggested, it now appears that the Stockholm picture is a replica of the Toledo landscape.

Houses at Auvers PL. 177

[1890] Oil on canvas
23⅝ x 28¾ in. (60 x 73 cm.)

Acc. no. 35.5

COLLECTIONS: André Bonger, Amsterdam; (Durand-Ruel, New York).

EXHIBITIONS: Amsterdam, Stedelijk Museum, *Vincent van Gogh*, 1905, no. 209b; New York, Durand-Ruel, *Great French Masters of the Nineteenth Century*, 1934, no. 24, repr.; New York, Wildenstein, *Art and Life of Vincent van Gogh*, 1948, no. 63; Cleveland Museum of Art, *Work by Vincent van Gogh*, 1948, no. 31, pl. XXX; New York, Wildenstein, *Van Gogh*, 1955, no. 73, repr. p. 16.

REFERENCES: J. B. de la Faille, *L'oeuvre de Vincent van Gogh*, 1st ed., Brussels, 1928, I, no. 759; II, pl. CCXII; W. Scherjon and J. de Gruyter, *Vincent van Gogh's Great Period*, Amsterdam, 1937, p. 319, no. 125, repr.; J. Rewald, *Post-Impressionism from Van Gogh to Gauguin*, New York, 1956, p. 402, repr.; *The Complete Letters of Vincent van Gogh*, Greenwich (Conn.), 1959, III, no. 640, p. 280; L. Reidermeister, *Auf den Spuren der Maler der Ile de France*, Berlin, 1963, p. 165, repr.; J. B. de la Faille, *The Works of Vincent van Gogh: His Paintings and Drawings*, 3rd ed., Amsterdam, 1970, pp. 293, 641, no. F759, repr.; P. Lecaldano, *L'opera pittorica completa di Van Gogh*, Milan, 1971, no. 817, repr.

In the last two months of his life at Auvers, Van Gogh did no less than seventy oils, including this painting. Van Gogh wrote that "the modern villas and the middle class houses are almost as pretty as the old thatched cottages which are falling into ruin" (*Complete Letters*, no. 636), and that "Since Sunday I have done two studies of houses among trees," June 10, 1890 (*Complete Letters*, no. 640). The houses in this painting still exist and have been identified by Reidermeister as 5 Rue de Gré.

SPENCER FREDERICK GORE

1878–1914. British. Student at the Slade School, London, 1896–99. In 1911 elected first president of the Camden Town Group, which included W. R. Sickert. Exhibited at Paris Salon des Indépendants. Corot, Pissarro, Cézanne and Sickert variously influenced Gore's work.

Mornington Crescent PL. 340

[1911] Oil on canvas
25 x 30 in. (63.5 x 76.2 cm.)

Acc. no. 52.91

COLLECTIONS: Samuel Carr; (Leicester Galleries, London).

EXHIBITIONS: Columbus Gallery of Fine Arts, *British Art 1890–1928*, 1971, no. 36, fig. 76.

Gore painted several impressionistic views of Mornington Crescent in the Camden Town district of London.

JAN GOSSAERT, called MABUSE

Ca. 1478–ca. 1536. Flemish. Born Jan Gossaert, though he was called Mabuse because he or his family were

from Maubeuge in Hainault. Member of the Antwerp painters guild, 1503. In 1508–09 he accompanied Philip of Burgundy to Italy. Worked in Malines, Brussels, Bruges, Utrecht; he lived mainly at Middelburg. His early work derives from Gerard David and Dürer, but after 1508 he created a style that fused late Gothic decoration with Italiante forms. He first introduced classical subjects with nude figures to Flanders.

Jean de Carondelet PL. 85

[Ca. 1508] Oil on wood panel
15-9/16 x 11⅞ in. (39.6 x 30.3 cm.)

Acc. no. 35.58
Gift of William E. Levis

COLLECTIONS: Charles T. D. Crews, London; (Colnaghi, London, 1910); Leopold Hirsch (Christie, London, May 11, 1934, lot 112).

EXHIBITIONS: London, Royal Academy, *Catalogue of the Loan Exhibition of Flemish and Belgian Art, A Memorial Volume,* 1927, no. 200, pl. LXXX.

REFERENCES: W. H. J. Weale, "Portraits of Archbishop John Carondelet," *Burlington Magazine,* XVI, Mar. 1910, p. 342, pl. I; G. Ring, *Beiträge zur Geschichte niederländische Bildnismalerei im 15. und 16. Jahrhundert,* Leipzig, 1913, p. 147; E. Weisz, *J. Gossart gen. Mabuse,* Parchim, 1913, p. 77; M. Conway, *The Van Eycks and Their Followers,* New York, 1921, pp. 362–63; A. Segard, *Jan Gossart dit Mabuse,* Brussels, 1923, pp. 111–12, 114, 181, repr. opp. p. 112; M. J. Friedländer, *Die altniederländische Malerei,* Berlin, 1934, VIII, pp. 36, 38, 59, no. 51, pl. XLIII, fig. 51; E. Michel, *Catalogue raisonné des peintures . . . : peintures flamandes du XVe et du XVIe siècle, Musée du Louvre,* Paris, 1953, p. 129; P. Fierens, *L'art en Belgique du Moyen Âge à nos jours,* Brussels, n.d., p. 245; Rotterdam, Museum Boymans-van Beuningen, *Jan Gossaert genaamd Mabuse,* 1965, in no. 11; G. von der Osten, "Studien zu Jan Gossaert," *De Artibus Opuscula XL, Essays in Honor of Erwin Panofsky,* New York, 1961, pp. 454, 457–58; S. Herzog, "Jan Gossart, called Mabuse (ca. 1478–1532), A Study of his Chronology with a Catalogue of his Works," unpublished Ph.D. dissertation, Bryn Mawr College, 1968, I, pp. 128–29; II, no. 2; M. J. Friedländer (ed. H. Pauwels and S. Herzog), *Early Netherlandish Painting,* New York, 1972, VIII, pp. 25, 27, 28, no. 51, pl. 45, fig. 51.

Jean Carondelet (1469–1545), one of the leading clerical dignitaries in Flanders, held the posts of Provost of St. Donatian Cathedral at Bruges, Secretary to Emperor Charles V, Archibishop of Palermo, and Chancellor of Flanders. Gossaert, who received his patronage over many years, painted three portraits of Carondelet, of which Toledo's is the earliest.

Friedländer and Fierens dated the Toledo painting about 1514 because a copy at Besançon bears that date. Based on style and Carondelet's apparent age, Conway, Segard and Von der Osten believed it was painted before Gossaert left for Italy in 1508. Herzog observes that Carondelet was elected to the Privy Council at Malines in 1508, and as Gossaert was probably also there in October, it may have been painted at that time.

Later portraits of Carondelet are in the Louvre, Paris (dated 1517) and the Nelson-Atkins Museum of Fine Arts, Kansas City (undated, but probably later). Besides the copy in Besançon, another copy of the Toledo portrait was in an American private collection in 1953.

Wings of the Salamanca Triptych PL. 82a–d

Left wing: *Saint John the Baptist;* verso: *Angel Annunciate*
Right wing: *Saint Peter;* verso: *Virgin Annunciate*

[1521] Oil on wood panel
Left wing: 47¼ x 18½ in. (120 x 47 cm.); right wing: 47¼ x 18½ in. (120 x 47 cm.)
Left wing: Signed lower left and right: IOÃES MALBODI PINGEBAT; Inscribed lower center (on tablet): IOÃNES LVCERNA/ARDS ET LVCENS
Right wing: Dated lower left and right: ANNO 1521; Inscribed lower center (on tablet): PETRE PASCE OVEIS MEAS

Acc. no. 52.85

COLLECTIONS: Salamanca chapel, Augustinian Church, Bruges, by 1609 to ca. 1796; Abbaye des Dunes, Bruges, 1796; St. Donatian Cathedral, Bruges, 1802–10; Edward Solly, London, 1814–37; (C. J. Nieuwenhuys, 1838); King William II of The Netherlands, 1838–50 (De Vries, Roos, Brondgeest, The Hague, Aug. 12, 1850, lots 36 and 37, not sold and withdrawn; De Vries, Roos, Brondgeest, The Hague, Sep. 9, 1851, lots 21 and 22); Schneider collection, France; (Speelman, London); (Agnew, London).

EXHIBITIONS: Rotterdam, Musée Boymans-van Bueningen, *Jan Gossaert genaamd Mabuse,* 1965, no. 14, repr. pp. 115–16 (cat. by H. Pauwels, H. R. Hoetink and S. Herzog).

REFERENCES: C. J. Nieuwenhuys, *Description de la galerie des tableaux S. M. le Roi des Pays-Bas,* Brussels, 1843, pp. 92–5; E. Weisz, *Jan Gossaert gen. Mabuse,* Parchim, 1913, p. 123; A. Segard, *Jean Gossaert dit Mabuse,* Brussels, 1923, p. 177, no. 9; J. Held, "Overzicht der Litteratur betreffende nederlandsche Kunst," *Oud*

Holland, L, 1933, pp. 138–39; M. J. Friedländer, *Die altniederländische Malerei*, Leyden, 1934, VIII, no. 7; G. von der Osten, "Studien zu Jan Gossaert," *De Artibus Opuscula XL, Essays in Honor of Erwin Panofsky*, New York, 1961, p. 464, figs. 10, 11; J. Maréchal, "La chapelle fondée par Pedro de Salamanca, bourgeois de Burgos, chez les Augustins à Bruges, 1513–1805." *Académie Royale de Belgique, Classe des Beaux-Arts, Mémoires*, XIII, Brussels, 1963, pp. 12–5, 81, doc. XVII; H. Borsch-Supan, "Jan Gossaert gen. Mabuse zu den Ausstellung im Museum Boymans-van Beuningen, Rotterdam und im Groeningemuseum, Brugge," *Kunstchronik*, XVIII, 1965, pp. 199–200; G. Marlier, *La Renaissance flamande, Pierre Coeck d'Alost,* Brussels, 1966, p. 80, n. 22; S. Herzog, "Jan Gossart, called Mabuse (ca. 1478–1532), A Study of his Chronology with a Catalogue of his Works," unpublished Ph.D. dissertation, Byrn Mawr College, 1968, I, pp. 102–06; II, no. 24, pls. 29, 31, 32; C. Cuttler, review of G. Marlier, "La Renaissance flamande, Pierre Coeck d'Alost," *Art Bulletin*, LIII, Sep. 1971, p. 410; M. J. Friedländer (ed. H. Pauwels and S. Herzog), *Early Netherlandish Painting*, New York, 1972, VIII, no. 7, p. 120, nn. 53, 54, pls. 15, 17, fig. 7.

Ten 17th, 18th, and early 19th century manuscripts and published documents cited by Maréchal (1963) support Held's proposal (1933) that these wings once formed a triptych with the *Deposition from the Cross* in the Hermitage, Leningrad. These documents trace the Toledo wings and a central *Deposition* back to 1609 in the Salamanca chapel of the Augustinian Church at Bruges, and while the documents do not prove this, it seems likely this altarpiece was commissioned by Pedro de Salamanca for his family chapel, founded in 1513 and completed in 1516. A copy (Ayuntamiento, Segovia) of the Toledo *Annunciation* panels, if correctly attributed to the Bruges painter Ambrosius Benson, suggests that Gossaert's panels were in Bruges before Benson's death in 1550.

Moreover, in 1641 Sanderus identified Gossaert's St. Peter as a portrait of Pedro de Salamanca (A. Sanderus, *Flandria Illustrata*, The Hague, 1641; 1735 ed., II, p. 113). While unconfirmed, the author's other claim that St. John is a self-portrait of Gossaert seems plausible (*cf.* Rotterdam cat.). Both wings have been slightly cut down on top to make the tops symmetrical.

In spite of the documents published by Maréchal, reconstruction of the triptych is still problematical. The lack of visual continuity between the open landscape and agitated movement in the Leningrad painting and the architectural setting and static sculptural figures in

the Toledo panels is perplexing. Marlier suggests the Toledo and Leningrad panels were probably united after 1521, and he also sees merit in the old attribution of the Leningrad panel to Bernard van Orley (ca. 1488–1541). Cuttler has also cited features of the *Deposition* related to Van Orley's style.

Von der Osten and the authors of the Rotterdam exhibition catalogue speculate that the Toledo-Leningrad altarpiece may provide a clue to the appearance of Gossaert's famous Middelburg altarpiece (1516), destroyed in 1568.

FRANCISCO DE GOYA

1746–1828. Spanish. Born near Saragossa. His full name was Francisco José de Goya y Lucientes. By 1766 a student of Bayeu in Madrid, where he spent most of his life except for a visit to Rome in 1771. Early work such as tapestry cartoons, influenced by Tiepolo, and later by Velázquez. Painter to the Spanish court from 1786, he was a major portraitist, as well as a painter of religious and contemporary history subjects. Suffered a severe illness in 1792 which left his deaf. In 1824 became a voluntary exile in France, settling in Bordeaux. Goya was also a master printmaker, producing etchings, aquatints and lithographs.

Children with a Cart PL. 60

[1778] Oil on canvas
57¼ x 37 in. (145.4 x 94 cm.)

Acc. no. 59.14

COLLECTIONS: Royal Tapestry Factory, Madrid, 1779–ca. 1850; Royal Palace, Madrid, to 1868; Philip Hofer, Boston; (Wildenstein, New York).

REFERENCES: D. G. Cruzada Villaamil, *Los tapices de Goya*, Madrid, 1870, pp. 27–8, no. XVII; C. de la Viñaza, *Goya, su tiempo, su vida, sus obras*, Madrid, 1887, no. 17; Z. Araujo Sanchez, *Goya*, Madrid, 1896, no. 17; P. Lafond, *Goya*, Paris, 1902, p. 145, no. 17; V. von Loga, *Francisco Goya*, Berlin, 1903, nos. 589, 592; A. F. Calvert, *Goya*, London, 1908, p. 173, no. 17; A. de Beruete y Moret, *Goya, composiciones y figuras*, Madrid, 1917, II, p. 14, no. 17, p. 163, no. 70; A. L. Mayer, *Francisco de Goya*, Munich, 1923, p. 50, no. 17, p. 218, nos. 713, 716 (same cartoon; incorrectly as in Prado Museum); *Exposicion de pinturas de Goya* (exh. cat.), Museo del Prado, Madrid, 1928, p. 99; V. de Sambricio, *Tapices de Goya*, Madrid, 1946, pp. 108, 111–12, 227–28, nos. 26, 296, n. 25, XXIX–XXX, CLXXVI; X. Desparmet Fitz-Gerald, *L'oeuvre peint de Goya*, Paris, 1928–

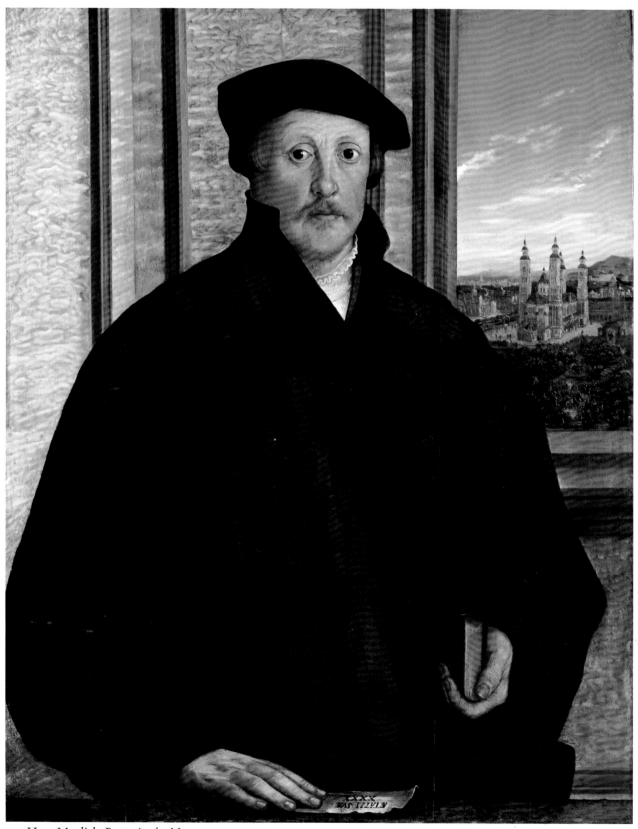

III. Hans Muelich, *Portrait of a Man*

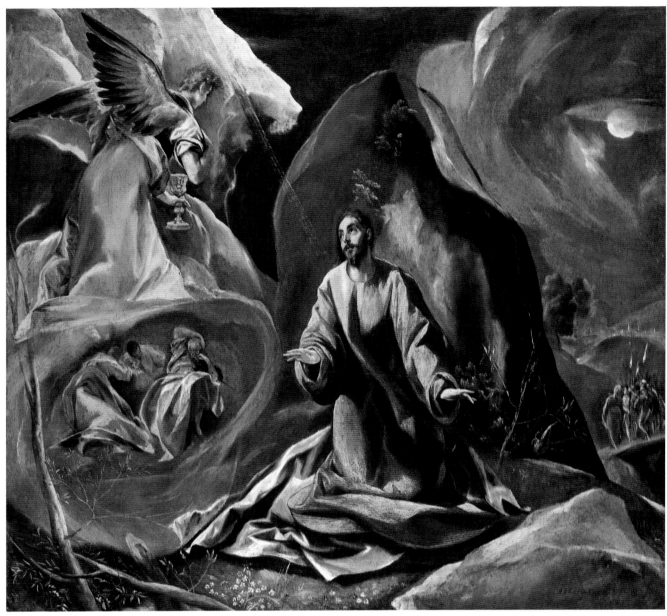

IV. El Greco, *The Agony in the Garden*

50, I, p. 76, no. 17; F. J. Sanchez Cantón, *Vida y obras de Goya*, Madrid, 1951, p. 166; J. Gudiol, *Goya*, New York, 1971, I, pp. 40, 43, no. 80; II, figs. 148–49; P. Gassier and J. Wilson, *Goya, His Life and Work*, London, 1971, pp. 76, 89, no. I.129, repr.; R. de Angelis, *L'opera pittorica completa di Goya*, Milan, 1974, no. 86, repr.

Between 1775 and 1792 Goya painted 63 tapestry cartoons or designs for the Royal Tapestry Factory of Santa Barbara. On January 6, 1779 he delivered six cartoons illustrating "diversions and costumes of the present time" (Gassier and Wilson, p. 88). This cartoon for an overdoor tapestry is number six of that group, which belongs to a series of 20 cartoons for tapestries to decorate the private quarters of the Prince and Princess of Asturias in the Palace of El Pardo, just outside Madrid; all of these except the Toledo painting and one other (National Gallery of Scotland, Edinburgh) are in the Prado, Madrid. In Goya's manuscript invoice, the standing boy with a drum is described as in "Dutch dress" (Sambricio, p. XXX, Gassier and Wilson, p. 76). The Toledo painting was one of six cartoons removed from the Royal Palace, Madrid in 1869 (Sambricio, p. CLXXVI).

According to Sambricio, four tapestries were actually woven from this cartoon; one for El Prado (completed 1785; still *in situ*); a second for the apartments of the Infante Gabriel and his wife in the Escorial (completed 1796; whereabouts unknown); and two others recorded in the 1834 Testament of Ferdinand VII (one lost; the second in the Tapestry Museum, Cathedral of Santiago de Compostella).

FRANCISCO DE GOYA, Attributed to

The Bullfight PL. 61

[Ca. 1824] Oil on canvas
24¾ x 36½ in. (63 x 93 cm.)

Acc. no. 29.139

COLLECTIONS: Edwards, Paris (Hôtel Drouot, Paris, May 25, 1905, lot 18, repr.); Féral, Paris; Xanroff, Paris; (Wildenstein, New York).

EXHIBITIONS: San Francisco, California Palace of the Legion of Honor, *Francisco Goya*, 1937, no. 26, repr.; Toledo Museum of Art, *Spanish Painting*, 1941, p. 146, no. 102, repr. (cat. by J. Gudiol); New York, Wildenstein, *Goya*, 1950, no. 47, repr. p. 42; Richmond, Virginia Museum of Fine Arts, *The Work of Francisco Goya*, 1953.

REFERENCES: X. Desparmet Fitz-Gerald, *L'oeuvre peint de Goya*, Paris, 1928–50, II, p. 270, May 25, 1905, lot 18 (1905 Edwards sales catalogue entry); E. Trapier, *Eugenio Lucas y Padilla*, New York, 1940, p. 58, pl. XLIII (as by Lucas); J. Gudiol, *Goya*, New York, 1941, p. 116, repr. p. 112; E. Lafuente Ferrari, *Antecedente, coincidentias e influencias del arte de Goya*, Madrid, 1947, p. 230 (as by Lucas); J. Gaya Nuño, *Eugenio Lucas*, Barcelona, 1948, p. 33 (as by Lucas); J. Gaya Nuño, *La pintura española fuera de España*, Madrid, 1958, no. 1119 (as Goya, with incorrect provenance); *Goya and His Times* (exh. cat.), London, Royal Academy, 1963, p. 75, in no. 133; J. Gudiol, *Goya*, New York, 1971, I, pp. 221, 349, no. 757; IV, figs. 1252, 1253 (detail); P. Gassier and J. Wilson, *Goya, His Life and Work*, London, 1971, p. 356, notes 1672–75 (as attributed to Lucas); R. de Angelis, *L'opera pittorica completa di Goya*, Milan, 1974, no. 781 (as attributed to Goya).

According to a contemporary source (T. Lopez, "Memorias tradicionales de D. F. Goya," in Viñaza, *Goya, su tiempo, su vida y sus obras*, Madrid, 1887), in his last years Goya painted eight or ten bullfight subjects without brushes, using slivers or knives of cane to lay on color. Paintings believed to belong to this series include those in the Marquesa de Baroja Collection, Madrid, with a contemporary inscription giving Goya's name and the year 1824, and a somewhat smaller painting similar in style and handling in the Prado, Madrid. Two others in the Ashmolean Museum, Oxford were formerly attributed to Eugenio Lucas. They have been re-attributed to Goya because their small dimensions and combination of thickly painted figures with thinly painted backgrounds is similar to the Baroja and Prado paintings (X. de Salas, "A Group of Bullfighting Scenes by Goya," *Burlington Magazine*, CVI, Jan. 1964, pp. 37–8). As these four paintings are reversals of compositions in the *Bulls of Bordeaux* lithograph series (1825), it has been thought that the paintings were the basis for the prints.

The Toledo *Bullfight* is one of two larger paintings, also related to the *Bulls of Bordeaux* lithographs, both of which were in the Edwards collection. Their compositions and those of the lithographs are nearly identical. The Toledo painting is related to the lithograph *Bravo Toro*, while the companion picture in the Edwards sale, of nearly the same dimensions, corresponds to *El Famoso Americano Ceballos* (Mújica Gallo collection, Lima, Peru; Trapier, pl. XLII; Gudiol, 1971, fig. 1251; Gassier and Wilson).

Considered as the work of Goya by Gudiol (1941, 1971), the Toledo painting has also been attributed to Eugenio Lucas (1824–1870), who often copied Goya's

work (Trapier; Lafuente Ferrari; X. de Salas, letter, 1961), and who made a tempera sketch of the central motif of this composition dated 1864 (Trapier, p. 57, pl. XLI; Gaya Nuño, 1948, p. 33).

JAN VAN GOYEN

1596–1656. Dutch. Began his apprenticeship as a painter at age 10. Studied with several artists, including Esaias van de Velde in Haarlem (ca. 1617). Traveled extensively in the Lowlands and France. Lived and worked in his native Leyden until ca. 1632–34, when he moved to The Hague. Van Goyen was the leading representative of the tonal phase of Dutch landscape painting.

View of Dordrecht PL. 113

[1649] Oil on wood panel
26⅞ x 39¼ in. (68.2 x 99.6 cm.)
Signed and dated center foreground (on boat): VG 1649

Acc. no. 33.27
Gift of Arthur J. Secor

COLLECTIONS: C. Butler, London; (Charles Sedelmeyer, Paris, 1894); (J. Eastman Chase, Boston, 1897); David P. Kimball, 1897–1924; (Vose, Boston); Arthur J. Secor, 1924–33.

REFERENCES: C. Sedelmeyer, *Catalogue of 100 Paintings of Old Masters*, Paris, 1894, no. 13, repr.; C. Hofstede de Groot, VIII, no. 95 (description combines TMA painting with Beck no. G300); H.-U. Beck, *Jan van Goyen, 1596–1656*, Amsterdam, 1973, II, no. 310, repr. p. 152.

It is certain that Van Goyen was in Dordrecht several times. There is a drawing of this view of Dordrecht in the Dresden sketchbook of ca. 1648 (Beck, I, no. 846/72). Dordrecht is seen here from the southwest shore of the Dordtse Kil. The large tower in the center belongs to the Gothic Groote Kerk.

Van Goyen painted this view of Dordrecht from the southwest no less than 22 times (Beck, II, nos. 292–305, 307–10, 312–16). In most of them he included the narrow channel of the Kil, the widening expanse of the Oude Maas (left background), several boats and the promontory on which Dordrecht stands.

The River Shore PL. 114

[1651] Oil on wood panel
16⅛ x 20½ in. (41.2 x 52 cm.)
Signed and dated on boat: VG 1651

Acc. no. 25.47

COLLECTIONS: (Galerie Pro Arte, Basel, 1920); (N. Beets, Amsterdam, 1921).

REFERENCES: C. Hofstede de Groot, VIII, no. 498a; H.-U. Beck, *Jan van Goyen, 1596–1656*, Amsterdam, 1973, II, no. 553, repr. p. 255.

This panel has evidently been cut down on both sides, thus accounting for the strong horizontal emphasis, unlike the diagonal recession which Van Goyen usually employed.

DUNCAN GRANT

1885–. British. Born in Scotland. Briefly attended Westminster School of Art, 1902. In Italy 1902–03; in 1906–07 in Paris where he was a pupil of Jacques-Émile Blanche. Later in London was a member of the "Bloomsbury Set," and was influenced by the Post-Impressionist exhibition of 1910, as well as by Matisse and Picasso. Associated with Roger Fry's Omega Workshops. His work includes portraits, landscapes, still lifes, interior decoration and stage and costume designs.

A Sussex Farm PL. 348

[1936] Oil on canvas
25⅜ x 30¼ in. (46 x 76.8 cm.)
Signed and dated lower right: D. Grant 36

Acc. no. 39.87
Museum Purchase

COLLECTIONS: (Alex Reid & Lefevre, London).

EXHIBITIONS: Boston, Institute of Contemporary Art, *Contemporary British Artists*, 1946, no. 9.

WALTER GREAVES

1841?–1930. British. Born in London. Began sketching as a youth. Met Whistler in 1863 and became his student and assistant for over fifteen years. Exhibited infrequently. First major exhibition, 1911. Obscured by the reputation of his teacher, Greaves painted primarily portraits and Thames views.

James Abbott McNeill Whistler PL. 337

[1877] Oil on canvas
30¼ x 25⅛ in. (76.8 x 63.8 cm.)
Signed and dated lower left: W. Greaves/77

Acc. no. 10.14
Gift of Carl B. Spitzer

COLLECTIONS: (Walter T. Spencer, London).

REFERENCES: "Portrait of Whistler," *Toledo Museum of Art Museum News,* IV, Nov. 1910, repr.

Greaves painted several portraits of Whistler (1834–1903) in the style of Whistler's self-portraits, such as the one of ca. 1871–73 in the Detroit Institute of Arts. Versions of the Toledo portrait are in the Art Institute of Chicago (1869) and National Portrait Gallery, London.

EL GRECO

1541–1614. Spanish. Born in Crete as Domenikos Theotocopoulos. In Spain he came to be known as El Greco, "the Greek." Possibly first trained in Byzantine style of Cretan icons. By 1560 in Venice as a pupil of Titian; also influenced by Tintoretto and the Bassani. In 1570 in Rome, where his patrons included Cardinal Alessandro Farnese and Fulvio Orsini. In 1577 in Toledo, where he remained until his death. Received his only royal commission from King Philip II in 1580. Primarily a painter of religious subjects and portraits. He often made several versions of his compositions, many of which were copied by assistants.

The Agony in the Garden　　　[COLOR PL. IV] PL. 53
[1590s] Oil on canvas
40¼ x 44¾ in. (102.2 x 113.7 cm.)
Signed lower right (in Greek characters): doménikos
　　theotokópoulos krès e'poíei

Acc. no. 46.5

COLLECTIONS: Cacho collection, Madrid, until ca. 1919; (Lionel Harris, London); (Durlacher Bros., New York); Arthur Sachs, New York, by 1928–46.

EXHIBITIONS: New York, Metropolitan Museum of Art, *Spanish Paintings from El Greco to Goya,* 1928, no. 26, repr.; New York, Knoedler, *El Greco,* 1941, no. 4, repr.; Toledo Museum of Art, *Spanish Painting,* 1941, p. 66, no. 44, repr. (cat. by J. Gudiol); Art Institute of Chicago, *Masterpieces of Religious Art,* 1947, no. 19, repr.; Amsterdam, Rijksmuseum, *Le triomphe du maniérisme européen,* 1955, no. 60, pl. 31; Cleveland Museum of Art, *The Venetian Tradition,* 1956, p. 14, no. 14, pl. 37.

REFERENCES: A. L. Mayer, *El Greco,* Munich, 1916, p. 30, pl. 59; A. L. Mayer, *Dominico Theotocopuli El Greco,* Munich, 1926, No. 55, repr. p. 10; A. L. Mayer, *El Greco,* Berlin, 1931, p. 120, fig. 11; M. Legendre and A. Hartmann, *Domeniko Theotokopoulos, called El*

Greco, Paris, 1937, pp. 176, 503, repr.; J. Camón Aznar, *Dominico Greco,* Madrid, 1950, II, p. 821, no. 109, fig. 634; P. Guinard, *El Greco,* Geneva, 1956, p. 44, repr. p. 46; H. Soehner, "Greco in Spanien, I: Grecos Stilentwicklung in Spanien," *Müncher Jahrbuch der Bildenden Kunst,* VIII, 1957, pp. 141, 144, 146, 148, 149, 151, fig. 20; J. A. Gaya Nuño, *La pintura española fuera de España,* Madrid, 1958, no. 1294; G. Kubler and M. Soria, *Art and Architecture in Spain and Portugal and their American Dominions, 1500 to 1800,* Harmondsworth, 1959, pp. 213–15, pl. 110; H. E. Wethey, *El Greco and his School,* Princeton, 1962, I, p. 47, fig. 162; II, no. 29 (as ca. 1590–95); G. Manzini and T. Frati, *L'opera completa del Greco,* Milan, 1969, no. 90a, repr.; N. MacLaren, *National Gallery Catalogues: The Spanish School,* 2nd ed., London, National Gallery, 1970, pp. 37, 38, 39, n. 14; J. Gudiol, *El Greco 1541–1614,* Barcelona, 1971, p. 204, no. 169, fig. 186.

According to Wethey, this composition has no prototype, even though the general iconographic elements were used by Titian and others. Combining the four Gospel texts, El Greco represented Christ kneeling in prayer with the angel who strengthens Him (Luke XXII: 41, 43). The cup held by the angel refers to Christ's words, "My Father if this cannot pass unless I drink it, thy will be done" (Matthew XXVI:42). The disciples Peter, James and John (Matthew XXVI:37 and Mark XIV:33) are sleeping, enveloped by the cloud supporting the angel. In the background, Judas approaches with the guards of the High Priest carrying lanterns and torches (John XVIII:3).

El Greco and his studio painted at least eight versions of *The Agony in the Garden* in two different forms: the first, corresponding to the horizontal format of the Toledo painting (other versions, possibly studio works, in the National Gallery, London, and F. V. Izaguerre collection, Bilbao), and the second, a vertical composition in which the sleeping Apostles occupy the foreground, while Christ and the angel are moved to the middle ground (Church of Santa Maria, Andújar). The Toledo painting is uniformly considered an autograph work, and the finest and earliest of known versions of this composition. Mayer dated it 1590–98. This has been generally followed by most writers, although Soria dated it 1580–86 (possibly as early as 1582), while Gudiol has proposed 1597–1603.

Three paintings of this subject appear in the inventory of El Greco's possessions drawn up in 1614. Although two pictures corresponding to the horizontal dimension are recorded in the 1621 inventory of posessions belonging to his son, this painting cannot be iden-

tified with either of these with any certainty (Wethey, p. 28).

The Annunciation PL. 54

[Ca. 1600] Oil on canvas
49⅝ x 32 in. (126.1 x 81.3 cm.)

Acc. no. 51.362

COLLECTIONS: Marqués de Corvera; F. Ortiz de Piñedo, Madrid; Stanislas Baron, Paris; (Durand-Ruel, Paris and New York); Ralph M. Coe, Cleveland, 1928–51.

EXHIBITIONS: Toledo (Spain), *Third Centennial of El Greco,* 1914; Paris, Durand-Ruel, Spring, 1916; Brooklyn Museum, *Spanish Painting,* 1935, no. 37, repr.; Paris, Gazette des Beaux-Arts, *El Greco,* 1937, no. 33, repr.; Toledo Museum of Art, *Spanish Painting,* 1941, p. 66, no. 41, repr. (cat. by J. Gudiol); San Francisco, M. H. de Young Memorial Museum, *El Greco,* 1947, no. 8, repr.

REFERENCES: M. Barrés and P. Lafond, *El Greco,* Paris, n.d., p. 142; M. B. Cossío, *El Greco,* Madrid, 1908, I, no. 301; A. L. Mayer, *Domenico Theotocopuli El Greco,* Munich, 1926, no. 7, repr. p. 3; M. Legendre and A. Hartmann, *Domenikos Theotokopoulos, called El Greco,* Paris, 1937, pp. 102, 503, repr.; L. Goldscheider, *El Greco,* New York, 1938, p. 24, pl. 131; J. Babelon, *El Greco,* Paris, 1946, pl. 78; L. Rudrauf, "The Annunciation: Study of a Plastic Theme and its Variations in Painting and Sculpture," *Journal of Aesthetics and Art Criticism,* VII, June 1949, p. 342, fig. 7; J. Camón Aznar, *Dominico Greco,* Madrid, 1950, II, p. 773, nos. 29, 41, fig. 580; J. A. Gaya Nuño, *La pintura española fuera de España,* Madrid, 1958, no. 1339; H. Soehner, "Greco in Spanien, I: Grecos Stilentwicklung in Spanien," *Münchner Jahrbuch der Bildenden Kunst,* VII, 1957, pp. 158, 160, 164, 167; H. E. Wethey, *El Greco and his School,* Princeton, 1962, I, fig. 169; II, no. 42; G. Manzini and T. Frati, *L'opera completa del Greco,* Milan, 1969, no. 126a, repr.; J. Gudiol, *El Greco 1541–1614,* Barcelona, 1971, pp. 188, 197, no. 144, fig. 174.

This painting is a variation on the theme of the Annunciation (Luke 1:26–38), one of the most popular themes in El Greco's iconographic repertory. Wethey catalogues three versions painted by El Greco in Italy, and six in Spain. In the Toledo picture, as in the earliest versions, only the Virgin and Angel are depicted with the Holy Spirit in the form of a dove. In contrast to the pictures painted in Italy, earthly reality has been abandoned in favor of the mystery. The lilies held by the Archangel Gabriel are a symbol of the purity of the Virgin, while the sewing basket with scissors is included because it is

related that after the departure of the angel, Mary "took the purple linen, and sat down to work it" (A. Jameson, *Legends of the Madonna,* London, 1872, p. 177). The flaming flowers in the vase are a further reference to Mary's virginity: "The bush which burned and was not consumed."

This picture is widely accepted as an autograph work, although Wethey believes the figure of the Virgin is by an assistant. Cossío was the first to publish the Toledo painting with a date of 1594–1604. These dates have been generally followed, although more recent opinion (Mayer, 1597–1600; Soehner, 1599; Wethey, ca. 1600–06) favors placing the Toledo picture after 1596. This canvas, or another lost original of the same composition, was copied repeatedly by El Greco's son and assistants (Wethey, II, nos. X 17–22). Although five paintings of this subject are recorded in each of the two inventories discussed under *The Agony in the Garden,* the Toledo picture cannot certainly be identified with any of those listed.

FRANCESCO GUARDI

1712–1793. Italian. Born and died in Venice. Trained in the studio of his elder brother, Giovanni Antonio (Gianantonio), Francesco's early work consisted of figural painting. After his brother's death in 1760, he devoted himself to the painting of actual and imaginary views of Venice and its vicinity, for which he is best known. He may have studied with Canaletto in the mid-1760s, and was probably influenced by Marco Ricci and Marieschi. Elected to the Academy of Fine Arts as a painter of architectural perspective in 1784.

The Holy Family PL. 35

[Ca. 1740–45] Oil on canvas
45½ x 37⅞ in. (115.7 x 96.2 cm.)

Acc. no. 26.71

COLLECTIONS: Parish Church of Strigno di Valsugana (near Trento), to unknown date during World War I; (D. Barozzi, Venice, by 1922); Edward Drummond Libbey, 1925.

EXHIBITIONS: Florence, Palazzo Pitti, *Mostra della pittura Italiana del sei e del settecento,* 1922, no. 534 (as Francesco); City Art Museum of St. Louis, *Exhibition of Eighteenth Century Venetian Painting,* 1936, no. 15, repr. p. 40 (as Gianantonio); Toledo Museum of Art, *Four Centuries of Venetian Painting,* 1940, no. 31, repr. (cat. by H. Tietze, as Gianantonio, with qualifications); Museum of Fine Arts of Houston, *The Guardi Family,*

1958, no. 1, repr. (introd. by J. Byam Shaw, as Gianantonio); Venice, Palazzo Grassi, *Mostra dei Guardi*, 1965, no. 69, repr. (cat. by P. Zampetti, as Francesco); Art Institute of Chicago, *Painting in Italy in the Eighteenth Century: Rococo to Romanticism*, 1970, no. 25, repr. (cat. entry by B. Hannegan under Gianantonio, but with attribution to Francesco).

REFERENCES: G. Fiocco, *Francesco Guardi*, Florence, 1923, p. 69, no. 39, pl. XXIX (as Francesco); U. Ojetti, L. Dami and N. Tarchiani, *La pittura italiana del seicento e del settecento alla mostra di Palazzo Pitti*, Florence, 1924, repr. p. 157 (as Gianantonio); V. Lasareff, "Francesco and Gianantonio Guardi," *Burlington Magazine*, LXV, Aug. 1934, p. 58 (as Gianantonio); M. Goering, "Francesco Guardi als Figurenmaler," *Zeitschrift für Kunstgeschichte*, Berlin, VII, 1938, p. 289 (as Gianantonio); F. De Maffei, *Gian Antonio Guardi, pittore di figura*, Verona, [1951], pl. XV (detail) (as Gianantonio); A. Morassi, "Conclusioni su Antonio e Francesco Guardi," *Emporium*, CXIV, Nov. 1951, pp. 195, 202, fig. 6 (as Gianantonio); G. Fiocco, "Il problema di Francesco Guardi," *Arte Veneta*, VI, 1952, p. 120 (as Francesco); V. Moschini, *Francesco Guardi*, Milan, 1952, p. 14 (as Francesco); C. L. Ragghianti, "Epiloghi Guardeschi," *Annali della Scuola Normale Superiore di Pisa*, XXII, 1953, pp. 75, 76; N. Rasmo, "Recenti contributi a Gianantonio Guardi," *Cultura Atesina*, IX, 1955, p. 156, n. 20, pl. LXIV, no. 4; V. Moschini, *Francesco Guardi*, London, 1956, p. 18 (as Francesco); D. Gioseffi, "Per una datazione tardissima delle storie di Tobiolo in S. Raffaele di Venezia con una postilla su Bonifacio Veronese," *Emporium*, CXXVI, Sep. 1957, p. 109 (as Francesco); J. Byam Shaw, "Guardi and His Brothers and His Son," *Art News*, LVI, Feb. 1958, pp. 33, 35, fig. 3 (as Gianantonio); R. Pallucchini, *La pittura Veneziana del settecento*, Venice, 1960, p. 139 (as Gianantonio and Francesco); B. Kerber, "'Die Ruhe auf der Flucht' Ein Jugendwerk Andrea Pozzos. Wiederholungen, Varianten Und Kopien," *Cultura Atesina*, XVII, 1963, p. 8, pl. 5, no. 7 (as Gianantonio); R. M. Riefstahl, "What is Conservation?," *Toledo Museum of Art Museum News*, VIII, Autumn, 1965, p. 66, repr.; G. Fiocco, *Guardi*, Milan, 1965, pp. 24, 26, pl. XIII (as Francesco); R. Pallucchini, "Note alla mostra dei Guardi," *Arte Veneta*, XIX, 1965, p. 216 (as Gianantonio with intervention of Francesco); B. Hannegan, "Guardi at Venice," *Art Bulletin*, XLVIII, June 1966, p. 252 (as Guardiesque); A. Morassi, "Altre novità e precisazioni su Antonio e Francesco Guardi," *Atti dell'Accademia di Udine*, VIII, 1966/69, p. 287 (as Gianantonio); D. Mahon, "The Brothers at the Mostra dei Guardi: Some Impressions of a Neophyte," in *Problemi Guardeschi*, Venice, 1967, pp. 81–2, pl. 5

(detail) (as Francesco); B. Fredericksen and F. Zeri, *Census*, pp. 98, 351, 641 (as Gianantonio); A. Morassi, *Guardi: Antonio e Francesco Guardi*, Venice, 1973, I, p. 315, no. 46, pl. X; II, fig. 51 (as Gianantonio).

This painting, originally in the parish church of Strigno di Valsugana in the Italian Tyrol, is a copy after an altarpiece by Andrea Pozzo (1642–1709) formerly in Trento (Church of the Carmelitani alle Laste).

Until 1760 Francesco worked closely with his brother Gianantonio, or Giovanni Antonio (1698–1760), producing religious subjects and allegories. The precise division between their work has been widely studied and debated. Until the 1965 Guardi exhibition at Venice, the Toledo picture was usually attributed to Gianantonio, and it was thus catalogued by the Museum until recently. Since 1965 scholars have generally attributed it to Francesco because of the style and arrangement of figures, stacatto brushwork and Piazzetta-like color. A date ca. 1740–45 is generally accepted.

San Giorgio Maggiore, Venice PL. 36

[1791] Oil on canvas
18¼ x 30-1/16 in. (46.5 x 76.3 cm.)
Signed and dated at extreme left of the front of San Giorgio terrace. The rubbed inscription appears to read: F(G)/179(1?)

Acc. no. 52.62

COLLECTIONS: Maurice Kahn, Paris; Adolph Mayer, The Hague, by 1936; (Rosenberg & Stiebel, New York).

EXHIBITIONS: The Hague, Gemeentemuseum, *Oude Kunst uit Haagsch Bezit*, 1936, no. 89; Rotterdam, Museum Boymans, *Meesterwerken uit Vier Eeuwen, 1400–1800*, 1938, no. 187, repr. p. 121; Detroit Institute of Arts, *Venice 1700–1800*, 1952, no. 30, repr. p. 34; Venice, Palazzo Ducale, *I vedutisti Veneziani del settecento*, 1967, no. 145, repr. (cat. by P. Zampetti); Art Institute of Chicago, *Painting in Italy in the Eighteenth Century: Rococo to Romanticism*, 1970, no. 24, repr. (cat. entry by B. Hannegan; as after 1780).

REFERENCES: A. Morassi, "Una mostra del settecento Veneziano a Detroit," *Arte Veneta*, VII, 1953, p. 61, repr. (as ca. 1770–80); U. Ferroni, "Los 'vedutisti' Venecianos del setecientos," *Goya*, No. 80, Sep.–Oct. 1967, p. 74, repr. p. 69; *Wallace Collection Catalogues: Pictures and Drawings*, 16th ed., London, 1968, p. 140 (ed. F. J. B. Watson); T. Pignatti, *Francesco Guardi*, Brescia, 1971, p. 29, repr.; B. Fredericksen and F. Zeri, *Census*, pp. 97, 641; A. Morassi, *Guardi: Antonio e Francesco Guardi*, Venice, 1973, I, pp. 242, 391, no. 428; II, fig. 447.

In this view across the harbor of St. Mark, at the left is the island with the church and monastery of S. Giorgio Maggiore built by Andrea Palladio; at the right is the island of Giudecca with Palladio's church of the Redentore. Guardi painted this view several times; related pictures are at Temple Newsam House, Leeds; Wallace Collection, London; Schäffer collection, Zürich; Accademia, Venice and Accademia Carrara, Bergamo. There are also drawings in the Wallraf-Richartz Museum, Cologne and in Venice at the Fondazione Giorgio Cini, which now occupies part of the former monastery attached to S. Giorgio.

Signed and dated late works by Guardi are rare.

FRANS HALS, Follower of

Dutch. Hals (ca. 1580–1666) was probably born in Antwerp. By 1590 his parents settled in Haarlem, where he remained for the rest of his life. Portrait and genre painter.

The Flute Player PL. 111

Oil on canvas
25⅝ x 25½ in. (65 x 64.7 cm.)
Acc. no. 26.67

COLLECTIONS: Lady de Clifford, London; (E. Warneck, Paris, 1878); J. Orrock, London; (Christie, London, Dec. 1, 1906, lot 80); Sir J. Linton, 1906–; (Colnaghi, London); (Knoedler, London, 1908); (Henry Reinhardt, New York); Edward Drummond Libbey, 1908–26.

EXHIBITIONS: Detroit Institute of Arts, *Frans Hals*, 1935, no. 14, repr.

REFERENCES: W. Bode, *Studien zur Geschichte der Holländischen Malerei*, Brussels, 1883, no. 76; E. W. Moes, *Frans Hals, sa vie et son oeuvre*, Brussels, 1909, no. 222; C. Hofstede de Groot, III, no. 85; W. Bode and M. J. Binder, *Frans Hals, His Life and Work* (trans. M. Brockwell), Berlin, 1914, no. 59A, pl. 26; W. R. Valentiner, *Frans Hals (Klassiker der Kunst)*, Berlin, 1921, p. 78 (Nyon version); W. R. Valentiner, *Frans Hals Paintings in America*, Westport, Connecticut, 1936, no. 56, repr.; S. Slive, *Frans Hals*, London, 1974, III, no. D28-2, fig. 146; C. Grimm and E. C. Montagni, *L'opera completa di Frans Hals*, Milan, 1974, no. 317.

Although earlier authorities (Bode, Moes, Hofstede de Groot) accepted this painting as by Hals, Slive believes that it is probably by a follower familiar with the artist's late style. Another version (Count de Bendern, Nyon, Switzerland) is also doubted by Slive for the same reason.

When the Toledo picture is hung as a lozenge, the position of the figure is identical with that of the Nyon version. Although this canvas is exceptionally large for the lozenge format, the correctness of this position is supported by Bode, Hofstede de Groot and Slive.

During cleaning in 1959, the monogram FH (?), formerly at the lower right, was found to be a later addition, and was removed.

HENRI-JOSEPH HARPIGNIES

1819–1916. French. Born in Valenciennes. Studied with the landscapist Jean-Alexis Achard, 1846. Did not paint regularly until he was 29. In Italy, 1852–54 and 1863–65. Exhibited annually at the Salon from 1853. A disciple of Corot, he prolonged the Barbizon landscape tradition into the 20th century. Frequently exhibited watercolors at the Royal Watercolor Society, London.

Souvenir of Dauphiné PL. 274

[1898] Oil on canvas
32 x 25⅞ in. (81.3 x 65.7 cm.)
Signed and dated lower left: H J Harpignies·1898

Acc. no. 22.18
Gift of Arthur J. Secor

COLLECTIONS: (Henry Reinhardt, Milwaukee, 1907); Arthur J. Secor, 1907–22.

In a note to Arthur Secor, Harpignies described this painting as "Souvenir du Dauphiné près la rivière d'Ain," implying that it is a composed landscape painted from memory in a manner recalling Corot's late "souvenirs." The Ain River is in the Dauphiné region of southeastern France.

The Mediterranean Coast PL. 275

[1900] Oil on canvas
32⅛ x 25¾ in. (81.6 x 65.4 cm.)
Signed and dated lower left: H J Harpignies·1900

Acc. no. 22.44
Gift of Arthur J. Secor

COLLECTIONS: (Thomas McLean, London); E. H. Cutherbertson, London, by 1908; (Christie, London, May 21, 1909, lot 80, repr. opp. p. 20); (Scott & Fowles, New York, 1909); (Henry Reinhardt, New York, 1909); Arthur J. Secor, 1909–22.

When Arthur Secor acquired this picture, Harpignies wrote to him that it was painted on the Côte d'Azur.

Probably this was near the town of Beaulieu, where Harpignies spent winters at this time.

JAN DAVIDSZ. DE HEEM

1606–1684. Dutch. Son and pupil of the Utrecht artist David de Heem the Elder; also studied under Balthasar van der Ast. In Leyden ca. 1626; in Antwerp, 1636. In Utrecht, 1669–72, then in Antwerp until his death.

Still Life with a View of the Sea — PL. 123

[1646] Oil on canvas
23⅜ x 36½ in. (59.3 x 92.6 cm.)
Signed and dated lower left: J. de Heem.f. Ao 1646

Acc. no. 55.33

COLLECTIONS: Lady Cochran, Abingdon, to ca. 1914; (Lempertz, Cologne, 1930); Private collection, Paris; (Speelman, London, 1955).

EXHIBITIONS: Brussels, Musées Royaux des Beaux Arts de Belgique, Le siècle de Rubens, 1965, no. 106, repr.

REFERENCES: I. Bergström, Dutch Still-Life Painting in the Seventeenth Century, London, 1956, p. 204, n. 18, fig. 169.

J. R. Judson has suggested (letter, July 1975) that this combination of still life and seascape points a moral. Thus, the marine view may show the Ship of Fools sailing blindly through the dangerous waters of life, its goal to reach the Land of Cockayne, a land of frivolity and gluttony, here represented by a sumptuous display of food. The rays of sun falling on the church symbolize the salvation of the soul after death (J. R. Judson, "Marine Symbols of Salvation," Essays in Memory of Karl Lehmann, Locust Valley, New York, 1964, pp. 136–52).

Bergström suggests that the Toledo painting is a collaborative work. The possibility that the seascape is by the Antwerp marine artist Bonaventura Peeters (1614–1652) has been verbally suggested by several scholars.

Still Life with a Lobster — PL. 125

[Late 1640s] Oil on canvas
25 x 33¼ in. (63.5 x 84.5 cm.)
Signed lower left (on table edge): J D. De Heem f.

Acc. no. 55.25

COLLECTIONS: Gsell, Vienna; Max Strauss, Vienna (Glückselig, Wawra, Vienna, Mar. 1926, no. 18); (Mont, New York).

EXHIBITIONS: Paris, Orangerie, La nature morte de l'antiquité à nos jours, 1952, no. 47 (cat. by C. Sterling).

REFERENCES: C. Sterling, La nature morte de l'antiquité à nos jours, Paris, 1952, p. 49, pl. 42; E. Greindl, Les peintres Flamands de nature morte au XVIIe siècle, Brussels, 1956, p. 104, pl. 69.

BARTHOLOMEUS VAN DER HELST

1613–1670. Dutch. Born at Haarlem. Specialized in imposing group and family portraits. Moved to Amsterdam by 1636. Painted first in the style of his teacher Nicolaes Elias. From the 1640s influenced many Dutch portraitists with his adaptation of Van Dyck's elegant style. Founder in 1654 of the "Brotherhood of Painting."

Portrait of a Young Man — PL. 101

[1655] Oil on canvas
38 x 39 in. (96.5 x 99 cm.)
Signed and dated lower center: B. van der Helst. 1655.

Acc. no. 76.12

COLLECTIONS: Leboeuf de Montgermont (Georges Petit, Paris, June 16, 1919, lot 192); A. W. M. Mensing, Amsterdam (Frederik Muller, Amsterdam, Nov. 15, 1938, lot 45, repr.); (Gebr. Douwes, Amsterdam, ca. 1940); B. de Geus van den Heuvel, Nieuwersluis (Sotheby Mak van Waay, Amsterdam, Apr. 26, 1976, lot 22).

EXHIBITIONS: Madrid, 1921; Eindhoven, Stedelijk van Abbe Museum, 1949–52; Schiedam, Stedelijk Museum, 1952, no. 30; Dordrecht, Dordrechts Museum, 1953; Rome, Palazzo degli Esposizioni, Le XVIIème siècle européen, 1956, no. 130; Arnhem, Gemeentemuseum, 1960, no. 22, fig. 39.

REFERENCES: J. J. van Gelder, Bartholomeus van der Helst, Rotterdam, 1921, nos. 176, 527 (probably identical with nos. 285, 290 and 347); H. van Hall, Portretten va Nederlandse Beeldende Kunstenaars, Amsterdam, 1963, p. 134, no. 5.

Catalogued by Van Gelder as a portrait of an unknown man, this painting has more recently been described as a self-portrait (Mensing sale; Van Hall). Since Van der Helst would have been about the age of the sitter in 1655, and as the man's features are similar to those in Van der Helst's depictions of himself, the Toledo painting may be a self-portrait, although the rather casual, indirect gaze of the sitter is unlike Van der Helst's other self-portraits. The work is typical of his lively, elegant later style.

JEAN-JACQUES HENNER

1829–1905. French. Born in Alsace. Paris in 1847 where he studied with Drolling and Picot. Prix de Rome, 1858. Italy, 1858–64, where influenced by Venetian painting. Exhibited in Salons from 1863; lived in Paris from 1864.

Mary Magdalene PL. 265

[1880] Oil on canvas
48½ x 36¾ in. (123.2 x 93.3 cm.)
Signed and dated lower right: J.J. Henner/1880

Acc. no. 30.213
Gift of Arthur J. Secor

COLLECTIONS: Sarah M. Hitchcock, New York, 1880–1930; Mrs. Julia L. Peabody, Westbury, New York, 1930; (E. C. Babcock, New York); (Vose, Boston); Arthur J. Secor, 1930.

EXHIBITIONS: New York, Metropolitan Museum of Art (on loan 1891–1929); Minneapolis Institute of Arts, *The Past Rediscovered: French Paintings 1800–1900*, 1969, no. 48, repr. (intro. by R. Rosenblum).

This painting was commissioned from Henner by Miss Hitchcock, who lent it to the Metropolitan Museum from 1891 to 1929. An earlier version of this composition was in the Salon of 1878. A study for the Toledo painting is reproduced in *The Studio*, XVIII, Nov. 1899, p. 82.

PATRICK HERON

1920–. British. Attended Slade School, London, 1937–39; later studed in Paris and taught at the Central School of Arts and Crafts, London. Heron has also designed textiles and written art criticism.

Pink Table with Lamp and Jug PL. 352

[1948] Oil on canvas
28 x 36 in. (71.2 x 91.5 cm.)
Signed and dated upper right: P. Heron 1948

Acc. no. 52.96
COLLECTIONS: (Redfern, London).

JAN VAN DER HEYDEN

1637–1712. Dutch. Born in Gorinchem, the son of a glass painter, who moved to Amsterdam with his family in 1650. Traveled to Flanders, the Rhineland and possibly England. Specialized in town views; he also painted still lifes and landscapes. Also invented fire-fighting and street-lighting devices.

The Garden of the Old Palace, Brussels PL. 140

[Ca. 1670] Oil on wood panel
19⅝ x 24⅝ in. (49.9 x 62.6 cm.)

Acc. no. 72.1

COLLECTIONS: David Ietswaart (Beukelaar, v.d. Land, Amsterdam, Apr. 22, 1749, lot 33); A. J. Bösch, Vienna (Plach, Kohlbacher, Kaeser, Vienna, Apr. 28, 1885, lot 23); Baron Königswarter, Vienna (Eduard Schulte, Berlin, Nov. 20, 1906, lot 27); (Kleinberger, Paris, 1911); (D. Katz, Dieren, by 1934); H. E. ten Cate, Almelo, by 1937; Frits Markus, New York, by 1954–72; (G. Cramer, The Hague).

EXHIBITIONS: Amsterdam, Amsterdamsch Historisch Museum, *Jan van der Heyden*, 1937, no. 19; Toledo Museum of Art, *Dutch Painting, The Golden Age*, 1954–55, no. 40, repr.; Brussels, Palais des Beaux Arts de Bruxelles, *Rembrandt et son temps*, 1971, no. 53, repr.

REFERENCES: G. Hoet, *Catalogus of Naamlyst van Schilderyen . . .*, The Hague, 1770, p. 240, no. 33; C. Hofstede de Groot, III, no. 50; W. Stechow, 1968, p. 126, fig. 256; H. Wagner, *Jan van der Heyden, 1637–1712*, Amsterdam, 1971, no. 28, p. 73, repr.

The Old Palace of the Dukes of Brabant and its gardens were the subjects of all but one of Van der Heyden's views of Brussels. The Toledo painting shows the gardens looking west from the Palace, destroyed by fire in 1731, toward the so-called House of Isabella and Church of St. Gudule on the left and the House of Archduke Albert on the right. Archduke Albert of Austria and Isabella, daughter of Philip II of Spain, ruled the Spanish Netherlands from 1596 to 1633.

Wagner believes that the Toledo painting can be dated slightly earlier than another view of the same subject dated 1673 in the Wernher collection, Luton Hoo.

The monogram "VDH" recorded by Hofstede de Groot and Wagner proved on cleaning in 1972 to be a later addition and was removed.

IVON HITCHENS

1893–. British. Born in London. Studied at Royal Academy Schools; influenced by Sargent and Orpen. Active in reforming the Seven and Five Society, 1922–35. Moved to Sussex, 1940. Painted several large murals, 1954–63.

Hut in Woodland PL. 357

[Ca. 1949] Oil on canvas
20¼ x 41¼ in. (51.4 x 104.6 cm.)
Signed lower left: Ivon Hitchens

Acc. no. 50.256

COLLECTIONS: Howard Bliss, England; (Leicester Gallery, London).

Arched Trees · PL. 358

[Ca. 1958] Oil on canvas
16 x 35½ in. (40.6 x 90.2 cm.)
Signed lower right: Hitchens

Acc. no. 59.2
Gift of Mrs. Webster Plass

COLLECTIONS: (Leicester Gallery, London); Mrs. Webster Plass, Philadelphia.

MEYNDERT HOBBEMA

1638–1709. Dutch. Lived and worked in Amsterdam. Student of Jacob van Ruisdael for several years ca. 1657–60. In 1668 he married, and in the same year became a wine-gauger for the Amsterdam tax authorities, a position he held for the rest of his life. Most of his paintings are datable to the 1660s, although several pictures carrying later dates have recently been discovered.

The Water Mill PL. 139

[1664] Oil on canvas
37⅜ x 51-13/16 in. (94.9 x 131.7 cm.)
Signed and dated center left: M. Hobbema/1664

Acc. no. 67.157

COLLECTIONS: Louis Bernhard Coclers (v.d. Schley . . . de Vries, Amsterdam, Aug. 7, 1811, lot 30)?; Gerrit Muller, Amsterdam, 1811–27 (de Vries, Brondgeest, . . . Roos, Amsterdam, Apr. 2, 1827, lot 25); Baron Jan Gijsbert Verstolk van Soelen, 1827–46; Samuel Jones Loyd, Lord Overstone, London, 1846–83; Col. Robert James Loyd-Lindsay, Lord Wantage, London, 1883–1901; Lady Wantage, London, 1901–20; David Alexander Edward Lindsay, Earl of Crawford, Balcarres House, Fife, 1920–36; (D. Katz, Dieren, 1936); Hendrikus Egbertus ten Cate, De Lutte, Holland, 1936–67 (G. Cramer, The Hague, 1967).

EXHIBITIONS: Toledo Museum of Art, *Dutch Painting, The Golden Age*, 1954, no. 41, repr.; Rotterdam, Museum Boymans, *Kunstschatten uit nederlandse Verzamelingen*, 1955, no. 77, repr.

REFERENCES: J. Smith, VI, no. 67; G. F. Waagen, *Galleries and Cabinets of Art in Great Britain*, Supplement, IV, 1857, p. 141; F. T. Kugler, *Handbook of Painting: German, Flemish and Dutch Schools* (ed. J. A. Crowe), London, 1898, II, p. 478; Lady Harriet Wantage, *A Catalogue of Pictures Forming the Collection of Lord and Lady Wantage*, London, 1905, no. 103; W. Bode, *Great Masters of Dutch and Flemish Painting*, London, 1909, p. 170; C. Hofstede de Groot, IV, no. 86; G. Broulhiet, *Meindert Hobbema, 1638–1709*, Paris, 1938, no. 22, repr. p. 113; D. Hannema, *Catalogue of the H. E. ten Cate Collection*, Rotterdam, 1955, no. 7; W. Stechow, 1968, p. 77, fig. 152.

According to Stechow (p. 76), the mill which appears in several Hobbemas was directly inspired by Jacob van Ruisdael's painting of 1661 at the Rijksmuseum, Amsterdam. The mill in the Toledo painting appears again in landscapes at the Rijksmuseum, Amsterdam; Wallace Collection, London; and Art Institute of Chicago, though as Stechow points out, they all differ greatly in color and compositional emphasis.

KARL HOFER

1878–1955. German. Studied at Karlsruhe Academy where he was influenced by Thoma and Böcklin. In Rome, 1903–08 where he looked to Hans von Marées. In Paris, 1908–12; he became a member of and exhibited with the Neue Kunstlervereinigung in 1909. A professor at the Berlin Academy, 1920–33, he left when his art was classified as "degenerate" by the Nazis. Turned briefly to abstraction around 1930, but is best known for melancholy, angular figures influenced by Picasso and Cézanne that reflected the spirit of Germany after the war.

Flower Girl PL. 76

[1935] Oil on canvas
39⅞ x 32⅛ in. (101.2 x 81.8 cm.)
Signed and dated lower left: CH 35

Acc. no. 38.43
Museum Purchase

COLLECTIONS: (Nierendorf Galleries, New York).

EXHIBITIONS: Pittsburgh, Carnegie Institute, *The 1937 International Exhibition of Paintings*, 1937, no. 353, pl. 25; Boston, Institute of Modern Art, *Contemporary German Art*, 1939, p. 17, repr. p. 18; Springfield (Mass.), George Walter Vincent Smith Art Gallery, *Karl Hofer,*

1941, no. 9, repr.; Oberlin, Allen Memorial Art Museum, *Five Expressionists,* 1946, p. 14, no. 12.

WILLIAM HOGARTH

1697–1764. British. Born in London. Apprenticed to a silver-plate engraver at fifteen. Studied at Sir John Thornhill's art school and St. Martin's Lane Academy. His work ranged from portraiture, the originality of which was largely unrecognized by contemporaries, and history paintings to the social and moral satires for which he is best known. The wide circulation of his engravings of the latter brought him fame. He is regarded as the leading English painter of the first half of the eighteenth century.

Joseph Porter PL. 308

[Ca. 1740–45] Oil on canvas
35-11/16 x 27-13/16 in. (90.6 x 70.6 cm.)
Acc. no. 26.54

COLLECTIONS: Joseph Porter, Mortlake and London; Miss Lucy Porter (his niece), Lichfield, 1749 to 1807; Rev. J. B. Pearson, by 1808; George Granville, 2nd Marquess of Stafford, later 1st Duke of Sutherland, by 1814; Cromartie, 4th Duke of Sutherland, 1888 to 1913; Lady Millicent Hawes (his widow), 1913; (Knoedler, New York); Edward Drummond Libbey.

EXHIBITIONS: London, British Institution, 1814, no. 126; 1843, no. 171; London, South Kensington Museum, *Second Special Exhibition of National Portraits,* 1867, no. 341 (as Captain Thomas Coram); London, New Gallery, *Exhibition of the Royal House of Guelph,* 1891, no. 320 (as Captain Thomas Coram); London, Tate Gallery, *Hogarth,* 1971, no. 116, repr.

REFERENCES: J. Nichols, *Biographical Anecdotes of William Hogarth,* London, 1785, p. 99; J. Nichols and G. Steevens, *The Genuine Works of Hogarth,* London, 1808, I, pp. 422–3; II, 1810, p. 287, repr. engraving; W. Hogarth, *Anecdotes of William Hogarth,* London, 1833, pp. 288, 381; A. Dobson and W. Armstrong, *William Hogarth,* London, 1902, pp. 185, 232; A. Dobson, *William Hogarth,* London, 1907, pp. 209, 219, 280 (as Captain Coram); A. L. Reade, *Johnsonian Gleanings,* London, 1935, pp. 109–10; R. B. Beckett, *Hogarth,* London, 1949, p. 59, pl. 58.

This forthright portrait of the London merchant Joseph Porter (1688/89–1749) is an example of Hogarth's insistence on the individuality of his sitter, rather than upon stylistic convention. The dating is based upon compari-

son with portraits such as *Captain Thomas Coram* (1740; Thomas Coram Foundation for Children, London), with whose portrait Porter's was confused in the late 19th century, and *Theodore Jacobsen* (1742; Allen Memorial Art Museum, Oberlin College, Ohio).

HANS HOLBEIN THE ELDER

Ca. 1460/65–1524. German. Born in Augsburg. Probably studied in Ulm or Augsburg. Presumed trip to Netherlands 1490–93. Worked mainly in Augsburg, but also Frankfurt and Isenheim. Headed a large workshop which included his brother Sigmund and Leonhard Beck; taught sons Ambrosius and Hans the Younger. Designed stained glass and executed many drawings.

Head of the Virgin PL. 65

[1500–01] Oil on wood panel
17¼ x 14⅜ in. (43.8 x 36.5 cm.)
Acc. no. 51.341

COLLECTIONS: Princes von Lichtenstein, Seebenstein, Austria and Vaduz, Liechtenstein, by 1914–51.

EXHIBITIONS: Lucerne, Kunstmuseum, *Meisterwerke aus den Sammlungen des Fürsten von Liechtenstein,* 1948, no. 59; Augsburg, Rathaus, *Hans Holbein der Ältere und die Kunst der Spätgotik,* 1965, no. 31, fig. 31.

REFERENCES: W. Suida, ed., *Österreichische Kunstschätze,* III, 1914, pl. 73; E. Schilling, "Die Marientafeln Holbeins des Älteren am Frankfurter Dominikaneraltar," *Staedel Jahrbuch,* VI, 1930, pp. 21, 23, fig. IXc; A. Stange, *Deutsche Malerei der Gotik,* Munich, 1957, VIII, pp. 65–7; C. Beutler and G. Thiem, *Hans Holbein d.Ä., die Spätgotische Altar-und Glasmalerei,* Augsburg, 1960, pp. 48, 53; N. Lieb and A. Stange, *Hans Holbein der Ältere,* Munich, 1960, pp. 15–8, no. 17L, figs. 57, 59; P. Strieder, "Hans Holbein der Ältere und die Kunst des Spätgotik," *Kunstchronik,* XVIII, Nov. 1965, p. 294; B. Bushart, *Hans Holbein der Ältere,* Bonn, 1965, pp. 23–4; G. von der Osten, *Painting and Sculpture in Germany and The Netherlands, 1500–1600,* Harmondsworth, 1969, p. 109; F. Koreny, " 'Das Marienleben' des Israhel van Meckenem: Israhel van Meckenem und Hans Holbein d.Ä.," in *Israhel van Meckenem und der Deutsch Kupferstich des 15. Jahrhunderts,* Bocholt, 1972, p. 60, fig. 79.

This is a fragment from the great double-winged altarpiece painted by Holbein and his assistants for the high altar of the Dominican church at Frankfurt-am-Main in

1500–01. It was Holbein's largest altarpiece, extending some twenty-one feet across when opened. Although dismembered in the 18th century, all but three of the nineteen painted panels have survived. The complete altarpiece is described by Lieb and Stange, following the accepted reconstruction by Weizsäcker (*Die Kunstschätze der ehemaligen Dominikaner Klosters in Frankfurt, 1923*).

The Toledo head of the Virgin and the head of the angel Gabriel (private collection, Basel) are the only fragments known of the Annunciation panel, one of four with scenes from the life of the Virgin inside the inner pair of wings. Although Sigmund Holbein and Leonhard Beck collaborated with Holbein on the altarpiece, these four panels are attributed to Holbein himself by most scholars except Beutler and Thieme.

Removal of an overpainted background when the Toledo panel was cleaned following its acquisition revealed a bench and hourglass, partial landscape and red-robed figure in the background. The similarity of the cleaned panel to an *Annunciation* by Israhel van Meckenem supports Koreny's view that this engraving may give an idea of the original appearance of Holbein's *Annunciation*.

HANS HOLBEIN THE YOUNGER

1497/98–1543. German. Born in Augsburg. Son of the painter Hans Holbein the Elder. In Basel by 1515, where he was employed by the printer and publisher Johann Froben. He may have gone to Italy about 1519; in France, 1524. From 1526 to 1538 he worked in England. After nearly four years in Basel, Holbein returned to England, where he was later (by 1536) appointed court painter to Henry VIII. Died in London. Primarily a portraitist, Holbein was also a book illustrator and designer of jewelry, frescoes and stained glass.

A Lady of the Cromwell Family　　　PL. 67

[Ca. 1535–40] Oil on wood panel
28⅜ x 19½ in. (72 x 49.5 cm.)
Inscribed upper third: ETATIS SVAE 21

Acc. no. 26.57

COLLECTIONS: Oliver Cromwell (1742–1821); by descent to Cromwell-Bush family, 1909; (Colnaghi, London, 1909); James H. Dunn, Canada, 1911–14; (Knoedler, New York); Edward Drummond Libbey, 1915–25.

REFERENCES: L. Cust, "A Portrait of Queen Catherine Howard by Hans Holbein the Younger," *Burlington Magazine*, XVII, July 1910, pp. 193–99; A. Chamberlain, *Hans Holbein the Younger*, New York, 1913, II, pp. 192,

194–96, 348; P. Ganz, *Holbein*, 1921, p. 243, pl. 126; V. Christoffel, *Hans Holbein d.J.*, Berlin, 1926, p. 118; W. Stein, *Holbein*, Berlin, 1929, pp. 296, 302; C. Kuhn, *A Catalogue of German Paintings of the Middle Ages and Renaissance in American Collections*, Cambridge, Mass., 1936, p. 83, no. 273, pl. LXXVIII; K. Parker, *The Drawings of Hans Holbein in the Collection of His Majesty the King at Windsor Castle*, London, 1945, p. 53, no. 62; P. Ganz, *The Paintings of Hans Holbein*, New York, 1950, p. 254, no. 118, pl. 157; H. Grohn, *Hans Holbein d.J. als Maler*, Leipzig, 1956, pp. 40, 47, pl. 31; W. Waetzoldt, *Hans Holbein der Jüngere*, Königstein im Taunus, 1958, pp. 23, 80, repr. p. 69; C. Adams, "Portraiture and Geneology," *Geneologists Magazine*, XIV, Sep. 1964, pp. 386–87; R. Strong, "Holbein in England—I and II," *Burlington Magazine*, CIX, May 1967, pp. 278, 281, fig. 19; R. Strong, *Tudor and Jacobean Portraits*, London, 1969, I, pp. 41–4; II, pl. 76; R. Salvini, *L'opera pittorica completa di Holbein il Giovane*, Milan, 1971, p. 108, pl. LIX.

The firm attribution of this picture to Holbein has never been doubted. However, until recently, this painting was considered a portrait of Catherine Howard, fifth wife of King Henry VIII of England. The identification as Catherine Howard was first made in 1898, when the copy in the National Portrait Gallery, London was acquired as a portrait of her, and in 1910 Cust published the Toledo portrait as Catherine Howard, basing his identification on two miniatures (Windsor Castle; Duke of Buccleuch) and a Holbein drawing (Windsor Castle), traditionally known as portraits of her. As the identification of the sitters in the Windsor and Buccleuch miniatures is no longer accepted, no authentic portrait of Catherine Howard is now known.

The Toledo picture once bore a label dated 1817 identifying the sitter as "mother to the Protector Oliver Cromwell." While this is impossible, the portrait did belong to his descendant, a later Oliver Cromwell (1742–1821), and the London copy also has a Cromwell-related provenance. The Cromwells were descendants of Thomas Cromwell, the powerful minister of Henry VIII. Working from this evidence, Adams and Strong have sought a Cromwell-related sitter in the court circle for which Holbein worked. A plausible candidate is Elizabeth, sister of Jane Seymour (Queen 1536–37), who married Gregory, son of Thomas Cromwell. This identification is unproven because no portrait of Elizabeth is known, and although the inscription on the Toledo portrait gives the subject's age as 21, the birth date of Elizabeth is also unknown. It seems unlikely that the Cromwell family would have kept a portrait of Catherine Howard (Queen

1540–42) long after the death of Thomas, as the How-ards were instrumental in his downfall and execution in 1540.

Strong (1967, 1969) dates the painting about 1535–40, comparing the distinctive cut of the sleeves to the costume worn by *Christina of Denmark* (1538; National Gallery, London).

The pendant hanging from the neckline depicting Lot and his wife fleeing from Sodom is based on a drawing by Holbein in the British Museum. The pendant does not survive, and the meaning of its iconography in relation to the sitter is unknown (Strong, 1969).

A second copy formerly belonged to the Duke of Sutherland (Christie, Oct. 27, 1961, lot 45), and another is in the collection of H. H. Black, Kingswood, Surrey.

MELCHOIR D'HONDECOETER

1636–1695. Dutch. Grandson of the landscape painter Gillis d'Hondecoeter, and son and pupil of the landscape and bird painter Gysbert d'Hondecoeter. Also studied with his uncle, Jan Baptist Weenix. Apparently left his native Utrecht for The Hague, ca. 1659. By 1663 settled in Amsterdam, where he remained.

Poultry in a Landscape PL. 141

Oil on canvas
36¾ x 44⅞ in. (93.7 x 113.3 cm.)
Signed right center (on board): M d'hondecoeter

Acc. no. 49.102

COLLECTIONS: (H. Van der Ploeg, Amsterdam).

D'Hondecoeter's earliest known work is dated 1668; though he did not consistently date his work, his style seems to have changed little during his career. Comparison between the Toledo painting and one dated 1686 in Karlsruhe (J. Lauts, *Katalog Alte Meister bis 1800*, Karlsruhe, 1966, no. 346) shows similar types and poses. It is, however, difficult to date the artist's work with any certainty.

Still Life with Birds PL. 142

Oil on canvas
21⅞ x 18⅞ in. (55.5 x 47.8 cm.)
Signed lower right: M. d'Hondecoeter

Acc. no. 62.69

COLLECTIONS: Ghisberti Hodenpijl, Rotterdam or Viruly family, Rotterdam, before 1800; H. J. H. Nauta, The Rague, 1962; (Nystad, The Hague).

The trompe l'oeil type of dead bird still life gained popularity in the second half of the seventeenth century. Other artists who excelled in this category were William Gowe Ferguson, Cornelis Lelienbergh and d'Hondecoeter's teacher, Jan Baptist Weenix. Ferguson's dated still life of 1678 (Cramer, The Hague, cat. XVIII, 1970–71, no. 6) includes a very similar arrangement of a partridge, kingfisher and bullfinch in a niche.

GERRIT VAN HONTHORST, Follower of

Dutch. Honthorst (1590–1656) was one of the leading masters of the Utrecht school of painters influenced by Caravaggio.

A Musical Party PL. 98

[Ca. 1630] Oil on canvas
45 x 62⅛ in. (114.3 x 157.6 cm.)

Acc. no. 55.60

COLLECTIONS: Mme. A. Feyouie, London, –1950; (Robert Frank, London).

The quality of this picture indicates that it is a decorative panel by one of Honthorst's many followers. The composition is a typical illusionistic one of the kind Honthorst painted in the 1620s and was meant to be placed well above eye level, perhaps set into wooden panelling.

PIETER DE HOOCH

1629–after 1684. Dutch. Born in Rotterdam. According to Houbraken, he was a pupil of Nicolaes Berchem in Haarlem. By 1654 he was in Delft, and by 1663 was working in Amsterdam. The date and place of his death are not known. A leading painter of interiors and genre scenes.

Courtyard, Delft PL. 131

[Late 1650s] Oil on wood panel
26¾ x 22⅝ in. (68 x 57.4 cm.)
Signed lower left (on door sill): P d Hooch

Acc. no. 49.27

COLLECTIONS: (J. van der Kellen, Rotterdam); (Cottier, London, ca. 1889–92); W. B. Thomas, Boston; J. Pierpont Morgan, New York; (Rosenberg & Stiebel, New York, 1948).

REFERENCES: C. Hofstede de Groot, I, no. 287; W. R. Valentiner, *Pieter de Hooch (Klassiker der Kunst)*, New

York, n.d., p. 271, repr. p. 40; C. Brière-Misme, "Tableaux inédits ou peu connus de Pieter de Hooch," *Gazette des Beaux-Arts*, XVI période 5, 1927, p. 65; N. MacLaren, *The Dutch School*, National Gallery, London, 1960, p. 185; W. Stechow, 1968, p. 125, fig. 252.

Although Valentiner dated this picture 1656, no date actually appears on it. Stylistically, it belongs among de Hooch's early work at Delft in the late 1650s, such as *Courtyard of a House at Delft* (1658; National Gallery, London). The tower in the background is that of the Oude Kerk at Delft.

Interior PL. 132

[Ca. 1660] Oil on canvas
20⅝ x 23⅞ in. (52.3 x 67 cm.)
Signed lower right: P D Hoog

Acc. no. 26.79

COLLECTIONS: Private collection, England; (Henry Reinhardt, New York); Edward Drummond Libbey, 1913–25.

REFERENCES: C. Hofstede de Groot, I, in no. 78; J. Lauts, ed., *Holländische Meister aus der Staatlichen Kunsthalle, Karlsruhe*, 1960, in no. 25; J. Lauts, *Staatliche Kunsthalle Karlsruhe, Katalog Alte Meister bis 1800*, Karlsruhe, 1966, p. 152.

This painting is one of four versions of this subject. Others are in the Staatliche Kunsthalle, Karlsruhe (HdG 72); National Gallery of Art, Washington (HdG 78); and formerly Philadelphia Museum of Art (HdG 84; Parke-Bernet, Feb. 29, 1956, lot 17). Lauts considers the Karlsruhe painting to be the best preserved, and he and W. Valentiner (*Pieter de Hooch*, New York, n.d., pp. xv, 58, 59) date it about 1660. Hofstede de Groot and Lauts consider all four pictures to be autograph. W. Stechow (letter to Karlsruhe, 1960 paraphrased by Lauts, 1966) felt that they may all be replicas by de Hooch after a lost original.

The woman was identified by Valentiner (p. 274) as the artist's wife.

JOHN HOPPNER

1758–1810. British. Born in London, son of a German surgeon who attended George II. The King sent him to the Royal Academy School in 1775. A.R.A., and Portrait Painter to the Prince of Wales, 1793; R.A., 1795. Primarily a portraitist who also painted landscapes and history pictures.

Mrs. Henry Richmond Gale PL. 319

[Ca. 1787] Oil on canvas
30⅛ x 25⅛ in. (76.5 x 63.8 cm.)

Acc. no. 26.68

COLLECTIONS: General Henry Richmond Gale (great-grandson of sitter), Bardsea Hall, Kilverstone, Lancashire, to 1909; Edward Drummond Libbey, by 1916.

EXHIBITIONS: London, Agnew, *The Annual Exhibition on Behalf of the Artists' General Benevolent Institution*, 1907, no. 20 (as 1785).

REFERENCES: W. McKay and W. Roberts, *John Hoppner, R.A.*, London, 1909, pp. 93–4.

Sarah Baldwin (1765(?)–1823) married Major (later Lieut.-General) Henry Richmond Gale of Bardsea Hall, Lancashire in 1785. The dating is based on the mention of "Mrs. Gale" in a newspaper notice of the Royal Academy, 1787 (McKay and Roberts).

A Lady of the Townshend Family PL. 320

[Ca. 1795] Oil on canvas
31 x 25¾ in. (78.7 x 65.4 cm.)

Acc. no. 33.23
Gift of Arthur J. Secor

COLLECTIONS: 2nd Marquess Townshend, Raynham, Norfolk, 1795–1811; by descent to John James Dudley Stuart, 6th Marquess Townshend, Raynham, Norfolk, 1904 (Christie, London, Mar. 5, 1904, lot 62); Major-General Sir Charles V. E. Townshend, Vere Lodge, Raynham, Norfolk, 1904–23 (Christie, London, July 13, 1923, lot 131); (Knoedler, London, 1923); Arthur J. Secor, 1926–33.

REFERENCES: W. McKay and W. Roberts, *John Hoppner R.A.*, London, 1909, p. 292 (as "A Lady").

This picture was dated by W. Roberts (letter, Aug. 1925).

ARTHUR HUGHES

1832–1915. British. Born in London. Studied with Alfred Stevens, 1846. Entered Royal Academy, 1847; first exhibited there, 1849. Although not a member of the Pre-Raphaelite Brotherhood, he shared their interests and exhibited with them. Worked with Rossetti, Burne-

Jones and others on the decoration of the Oxford Union, 1857. Also a book illustrator.

Ophelia PL. 334
("And he will not come back again")

[Ca. 1865] Oil on canvas
37-5/16 x 23-3/16 in. (94.8 x 58.9 cm.)
Signed lower left: ARTHUR · HUGHES ·

Acc. no. 52.87

COLLECTIONS: Charles K. Prioleau, Liverpool and London, by 1867; John Bibby, Liverpool, by 1886 (Christie, London, June 3, 1899, lot 84); Sir Frank Swettenham (Christie, London, Nov. 22, 1946, lot 161); (Leicester, London, 1946–52).

EXHIBITIONS: Liverpool Academy, 1867, no. 95; Liverpool, Walker Art Gallery, *Grand Loan Exhibition of Pictures,* 1886, no. 1176; Lawrence, University of Kansas Museum of Art, *Dante Gabriel Rossetti and his Circle,* 1958; Indianapolis, Herron Museum of Art, *The Pre-Raphaelites,* 1964, no. 41, repr.; Ottawa, National Gallery of Canada, *An Exhibition of Paintings and Drawings by Victorian Artists in England,* 1965, no. 58; Ann Arbor, University of Michigan Museum of Art, *English Revivalism 1750–1870: The Aesthetic of Nostalgia,* 1968, repr.

REFERENCES: M. Bennett, "A Check List of Pre-Raphaelite Pictures Exhibited at Liverpool 1846–67 and some of their Northern Collectors," *Burlington Magazine,* CV, Nov. 1963, p. 495, n. 67; Detroit Institute of Arts, *Romantic Art in Britain: Paintings and Drawings 1760–1860,* 1968, p. 33 (exh. cat. by A. Staley).

This is the artist's second painting of Shakespeare's Ophelia. The first, a horizontal composition of 1852, is in the City Art Gallery, Manchester, England. There is an identical oil study for the vertical Toledo composition in the John Bryson collection (London, Agnew, *Victorian Painting,* 1961, no. 64). An inscription, probably in Hughes' hand, on the back of the Toledo picture quotes Ophelia's song which inspired Hughes (*Hamlet,* Act IV, Scene 5).

JOZEF ISRAELS

1824–1911. Dutch. Born in Groningen. Studied in Paris with Picot, and at the École des Beaux Arts with Pradier, H. Vernet, and Delaroche. Visited Millet at Barbizon in 1853 and returned to Holland to paint the fishing life at Zandvoort. Began working out of doors in 1857, and in 1871 settled in The Hague. Leader of the Hague School.

The Shepherd's Prayer PL. 152

[1864] Oil on canvas
35⅜ x 49¼ in. (90.3 x 125.5 cm.)
Signed lower left: Jozef Israels

Acc. no. 14.116

COLLECTIONS: Hoey Smit, Rotterdam; (Henry Reinhardt, Milwaukee); Edward Drummond Libbey, 1901–14.

EXHIBITIONS: Toledo Museum of Art, *Inaugural Exhibition, Part IV: Israels Memorial Exhibition,* 1912, no. 226, repr. opp. p. 121.

REFERENCES: J. de Gruyter, *De Haagse School,* Rotterdam, 1968, I, pp. 52, 58, 113, no. 52, repr.; D. Sutton, "Nineteenth-Century Painting: Trends and Cross-currents," *Apollo,* LXXXVI, Dec. 1967, p. 490, fig. 11.

In a letter of 1907 to E. D. Libbey, the artist stated he painted this picture in 1864. A watercolor version was in the De Kuyper sale, Frederik Muller and Co., Amsterdam, May 30, 1911, lot 62.

The Parting Day PL. 151

[Ca. 1869] Oil on canvas
16¾ x 33¼ in. (42.5 x 84.5 cm.)
Signed lower right: Jozef Israels

Acc. no. 22.23
Gift of Arthur J. Secor

COLLECTIONS: Arthur J. Secor, 1907–22.

According to a note by the artist in the Museum's records, this picture was painted about 1869.

Coming Ashore PL. 153

[Ca. 1872] Oil on wood panel
17¾ x 12½ in. (45 x 32 cm.)
Signed lower right: Jozef Israels

Acc. no. 22.24
Gift of Arthur J. Secor

COLLECTIONS: Arthur J. Secor, 1907–22.

EXHIBITIONS: Toledo Museum of Art, *Inaugural Exhibition, Part IV: Israels Memorial Exhibition,* 1912, no. 235, repr. opp. p. 127 (as *Children of the Sea*).

Israels painted several versions of this subject. This picture was done about the same time as a related subject dated 1872 (J. Veth, *Josef Israels and his Art,* Arnhem 1904, no. 28, repr.).

Self-Portrait PL. 154

[1908] Watercolor and gouache on paper
31 x 21⅜ in. (78.7 x 54.3 cm.)
Signed and inscribed lower left: Jozef Israels fecit/for
 Mr. Libbey 28 Oct. 1908

Acc. no. 14.117

COLLECTIONS: (Boussod and Valadon, The Hague);
(Henry Reinhardt, New York); Edward Drummond
Libbey, 1908–14.

EXHIBITIONS: The Hague, Hollandsche Teeken-Maat-
schappij, 1908; Toledo Museum of Art, *Inaugural Exhi-
bition, Part IV: Israels Memorial Exhibition,* no. 243,
repr. opp. p. 107 (memorial address by F. W. Gunsaulus,
pp. 108–09); The Hague, Gemeentemuseum, *Meesters
van de Haageschool,* 1965, p. 43, no. 35, repr. p. 43.

REFERENCES: Boussod, Valadon & Cie, *Half a Century
with Josef Israels,* The Hague, 1910, p. 34, repr. p. 35;
M. Eisler, *Josef Israels,* 1924, pl. 78; L. Goldscheider,
Five Hundred Self-Portraits, Vienna and London, 1937,
no. 421, repr.; H. van Hall, *Portretten van Nederlandse
Beeldende Kunstenaars,* Amsterdam, 1963, p. 152, no. 3;
W. J. de Gruyter, *De Haagse School,* Rotterdam, 1968,
I, pp. 56, 57, 113, fig. 49.

At the time Israels painted this portrait, he wrote to Ed-
ward Drummond Libbey, the Museum's founder (letter,
Oct. 1908), "Herewith goes the watercolor portrait I
just finished. I believe it to be one of my best works, and
it is a pleasure for me to hear that you will give it to the
Museum of Toledo. I remember still with pleasure the
fine evening you gave me in Scheveningen." According
to Boussod, Valadon (1910), Mr. Libbey was among the
American admirers of Israels who tendered him a ban-
quet the day before he acquired this portrait.

In the background is a secton of Israels' largest paint-
ing, *David Playing Before Saul* (1899). Israels also
painted an oil version of the Toledo portrait in 1908
(both, Stedelijk Museum, Amsterdam). There is a related
ink drawing dated 1908 in the H. E. ten Cate collection.

ITALIAN, CENTRAL

Virgin and Child Enthroned PL. 2

[Ca. 1275–85] Tempera on wood panel
37½ x 15⅝ in. (95.2 x 39.7 cm.)

Acc. no. 36.21

COLLECTIONS: Count Ambrozzy-Migazzy; Count Wil-

czek, Schloss Kreuzenstein, Austria; (Silberman, New
York).

EXHIBITIONS: Boston, Museum of Fine Arts, *Arts of the
Middle Ages,* 1940, no. 49.

REFERENCES: R. Van Marle, "Some Unknown Tuscan
Paintings of the XIIIth Century," *Apollo,* XXI, Mar.
1935, pp. 126, 127–28, fig. II; E. B. Garrison, *Italian Ro-
manesque Panel Painting,* Florence, 1949, no. 336, repr.;
B. Fredericksen and F. Zeri, *Census,* pp. 242, 311.

This panel originally formed the central element of a
tabernacle with arched shutters which fitted under the
relief spandrel at the top. Van Marle published it as the
work of a close follower of Berlinghiero Berlinghieri of
Lucca, possibly his son Bonaventura (active 1228–1274),
to whom this panel has heretofore been attributed by
the Museum. Garrison rejected this attribution, propos-
ing an origin in Umbria or the Marches about 1275–85
(1959 and letter, Feb. 1968).

ITALIAN, FLORENTINE SCHOOL

The Adoration of the Child PL. 8

[Late 15th century] Tempera on wood panel
32¼ x 29 in. (81.8 x 73.6 cm.)

Acc. no. 30.214

COLLECTIONS: Private collection, Florence; Charles Tim-
bal, Paris, ca. 1851–71; Gustave Dreyfus, Paris, 1871–
1930; (Duveen, New York).

REFERENCES: S. Reinach, *Tableaux inédits ou peu con-
nus tirés de collections françaises,* Paris, 1906, pp. 28–9,
pl. XX (as Francesco Botticini); S. Reinach, *Répertoire
de peintures du moyen age et de la renaissance (1280–
1580),* Paris, 1918, IV, p. 400 (as Domenico Ghirlandaio);
R. Van Marle, *The Development of the Italian Schools
of Painting,* The Hague, 1931, XIII, pp. 224–25 (as Bas-
tiano Mainardi); B.-M. Godwin, "Our Painting by Filip-
pino Lippi," *Toledo Museum of Art Museum News,*
No. 67, Dec. 1933, pp. [911–17], repr. on cover, details;
L. Venturi, *Italian Paintings in America,* New York,
1933, II, pl. 262; Vienna, 1935, p. 119, pl. 126, no. 212
(as Raffaelino del Garbo); K. B. Neilson, *Filippino Lippi,*
Cambridge, 1938, pp. 213–14, 215, fig. 108 (as partial
imitator of Filippino); S. L. Faison, "From Lorenzo
Monaco to Mattia Preti," *Apollo,* LXXXVI, Dec. 1967,
pp. 33–4, pl. IX; B. Fredericksen and F. Zeri, *Census,*
pp. 35, 111, 344 (by Zeri as Francesco Botticini).

Although Venturi attributed this panel to Filippino Lippi (ca. 1457–1504), as has the Museum heretofore, the presence of several influences makes a specific attribution difficult. It has been attributed to Domenico Ghirlandaio, Francesco Botticini and Raffaello Botticini (Berenson, letter, Aug. 1950). Other scholars have suggested the influence of Lorenzo di Credi (Berenson, letter; Fredericksen; Sheldon Grossman, letter, June 1975). H. B. J. Maginnis (letter, Aug. 1975), while pointing out characteristics of Filippino, finds the Child, foreground vegetation and aspects of the handling of the drapery reminiscent of Francesco Botticini, though he feels an attribution to either painter is not possible.

Neilson rejects a Filippino attribution, but suggests that the panel may be by a partial imitator of Filippino who also drew upon other painters such as Botticini or a Verrocchio follower.

In the opinion of E. Fahy (letter, Apr. 1975), this may be a very early work by Francesco Granacci, and he compares it to parts of Granacci's *Holy Family* (Kress Collection, Honolulu) and scenes from the life of St. John the Baptist (Metropolitan Museum of Art).

ITALIAN, VENICE (?)

Saint Jerome in the Wilderness PL. 9

[Early 16th century] Oil on wood panel
33-3/16 x 24½ in. (84.8 x 62.2 cm.)

Acc. no. 40.43

COLLECTIONS: Count Wittgenstein-Maresch, Vienna; (E. & A. Silberman, New York).

EXHIBITIONS: Toledo Museum of Art, *Four Centuries of Venetian Painting*, 1940, no. 4, repr. (cat. by H. Tietze).

REFERENCES: H. Tietze, "St. Jerome in the Wilderness by Gentile Bellini," *Art in America*, XXVIII, July, 1940, pp. 110–15, repr.; L. Coletti, *Pittura veneta del quattrocento*, Novara, 1953, pp. XLV, LXXXII, n. 58 (attr. to Parentino); B. Berenson, *Italian Pictures of the Renaissance, Venetian School*, New York, 1957, I, p. 26 (attr. to Bastiani); H. Collins, "Gentile Bellini: A Monograph and Catalogue of Works," unpublished Ph.D. diss., University of Pittsburgh, 1970, no. 71 (rejected as Gentile Bellini); B. Fredericksen and F. Zeri, *Census*, pp. 20, 409 (attr. to Bastiani).

Subjects from the life of St. Jerome were particularly popular during the late 15th and early 16th centuries in Venice. This painting illustrates several episodes from the life of the saint: St. Jerome in prayer, accompanied by the lion; the lay brothers gathering wood; and the first appearance of the lion. The group of figures at the entrance to the cave refers to the final moments of the saint's life.

Tietze attributed this painting to Gentile Bellini (1429–1507). Attributions have also been made to Vittore Carpaccio (ca. 1455–1526; Raimond van Marle, letter, ca. 1935), Bernardo Parentino (ca. 1437–1531; Coletti), and Lazzaro Bastiani (active 1449–1512; Berenson, Fredericksen and Zeri).

More recently, Federico Zeri (letter, Dec. 1975) has stated that although the general conception and three main figures are reminiscent of the late period of Bastiani, it is difficult to justify an attribution to him. However, Zeri believes the composition and style of this panel have certain characteristics of early 16th century Venetian painting.

CHARLES-ÉMILE JACQUE

1813–1894. French. First studied with a map engraver. Worked as an illustrator in London 1836–38, and in Paris until 1848. Went to Barbizon with Millet in 1849, but left in 1854 after they quarreled. Worked in and near Paris for the rest of his life. A frequent Salon exhibitor, especially 1850–65. Influenced by Millet in his pastoral and farmyard scenes and by Diaz in his handling of paint. A prolific etcher.

Three Sheep PL. 236

Oil on canvas
10¼ x 12⅜ in. (26 x 31.4 cm.)
Signed lower left: Ch. Jacque

Acc. no. 22.19
Gift of Arthur J. Secor

COLLECTIONS: Arthur J. Secor, 1915–22.

The Shepherd's Rest PL. 237

Oil on canvas
32⅛ x 26¼ in. (81.5 x 66.7 cm.)
Signed lower left: Ch. Jacque

Acc. no. 22.48
Gift of Arthur J. Secor

COLLECTIONS: R. G. Dun; (Vose, Boston); Arthur J. Secor, 1912–22.

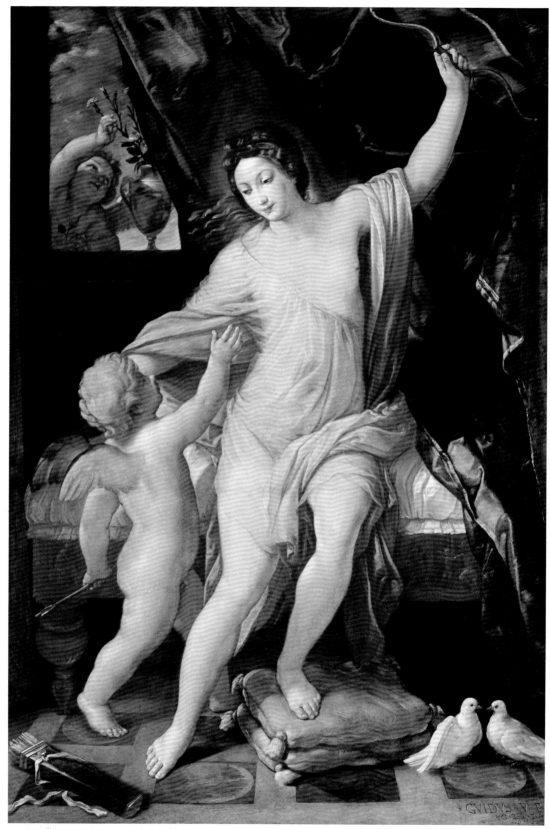

v. Guido Reni, *Venus and Cupid*

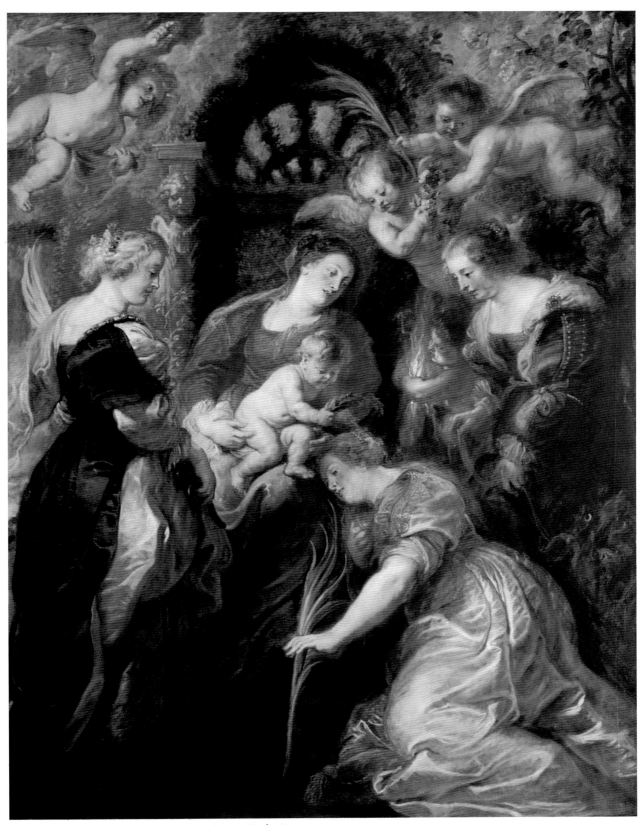

VI. Peter Paul Rubens, *The Crowning of Saint Catherine*

AUGUSTUS EDWIN JOHN

1879–1961. British. Studied at Slade School, 1894–98; professor of painting at Liverpool University, 1901–04. A.R.A., 1921; R.A., 1928, resigning in 1938, but re-elected two years later. Best known for portraits; he also did landscapes and was a draughtsman, etcher and sculptor.

Chrysanthemums PL. 347

Oil on canvas
40 x 30 in. (101.6 x 76.2 cm.)
Signed lower left: John

Acc. no. 53.72
Museum Purchase

COLLECTIONS: Mrs. Stevenson Scott, New York; (Scott & Fowles, New York).

JOHANN BARTHOLD JONGKIND

1819–1891. Dutch. Born in Latrop. Studied at the Academy of Art in The Hague. To Paris in 1846, where he worked briefly in the studios of Isabey and Picot. Exhibited at the Salon irregularly, 1848–72, and at the Salon des Refusés, 1863. With Boudin, he was a precursor of Impressionism and a formative influence on Monet, who called him "the father of modern landscape." He was also an accomplished watercolor painter, and did a few etchings.

Honfleur Harbor PL. 148

[1863] Oil on canvas
13⅛ x 18¼ in. (33.3 x 46.3 cm.)
Signed and dated lower right: Jongkind/1863

Acc. no. 50.71

COLLECTIONS: Mallet collection, London; (Wildenstein, New York).

EXHIBITIONS: Iowa City, University of Iowa Gallery of Art, *Impressionism and its Roots,* 1964, no. 19, repr. p. 32.

REFERENCES: V. Hefting, *Jongkind: sa vie, son oeuvre, son époque,* Paris, 1975, p. 141, no. 271.

From 1862 to 1866 Jongkind spent summers at Le Havre and Honfleur painting on the coast of Normandy. There are several versions of this view in different media. A watercolor dated 1863 is the frontispiece of the painter Paul Signac's book on Jongkind (1927), and there is also an etching done the same year (Delteil no. 10).

JEAN JOUVENET

1644–1717. French. Born in Rouen of a family of painters; member of the painters guild, 1658. In Paris, 1661. Strongly influenced by the art of Poussin. Jouvenet worked under Charles Le Brun on the decoration of royal residences. After ca. 1685 he became the greatest painter of religious subjects of his time. Also painted portraits. Member of the Academy, 1675; Rector, 1707.

The Deposition PL. 190

[1709] Oil on canvas
70⅛ x 54 in. (178 x 139 cm.)
Signed and dated lower right: Jouvenet/1709

Acc. no. 74.56

COLLECTIONS: de Boussayrolles family, Languedoc, France, to 1945; André Fabre, Montpellier, 1945–74; (Heim, Paris).

EXHIBITIONS: London, Heim, *Religious and Biblical Themes in French Baroque Painting,* 1974, no. 14, repr. (entry by A. Schnapper); Toledo Museum of Art, *The Age of Louis XV: French Painting 1710–1774,* 1975, no. 49, pl. 1 (color), pl. 4 (cat. by P. Rosenberg).

REFERENCES: B. N. (B. Nicolson), *Burlington Magazine,* CXVI, July 1974, p. 418; A. Schnapper, *Jean Jouvenet et la peinture d'histoire à Paris,* Paris, 1974, pp. 26, 143, 144, 214, no. 126, fig. 141.

Jouvenet and his studio painted variations of this composition several times during a period of at least ten years. According to Schnapper, the first may have been the *Deposition* (now lost) in the Salon of 1704; probably this is the *Deposition* after Jouvenet engraved by Alexis Loir (died 1713; Schnapper, fig. 134). The earliest surviving version is the large altarpiece dated 1708 in the church of St. Maclou, Pontoise. The Toledo painting represents a later development by Jouvenet which differs from both of these, as well as from later versions, in having a more elaborated composition with the standing figure of Nicodemus and cross added on the right.

ANGELICA KAUFFMANN

1741–1807. Swiss. Born at Coire, Switzerland. Student of her father. To Rome in 1763, where she met Winckelmann. In London ca. 1765–81. A founding member of the Royal Academy, she exhibited there 1769–97. Returned in 1781 to Italy, where she remained until her death in Rome. Primarily a painter of portraits and classical subjects.

The Return of Telemachus PL. 70

[Ca. 1770–80] Oil on canvas
39⅝ x 49¾ in. (100.7 x 126.3 cm.)

Acc. no. 38.24
Gift of Edward A. Filene

COLLECTIONS: Edward A. Filene, Boston, by 1921–38.

EXHIBITIONS: Columbus Gallery of Fine Arts, *Romantic Painting,* 1963, no. 20.

REFERENCES: V. Manners and G. C. Williamson, *Angelica Kauffmann, R.A.,* London, 1924, p. 217, repr.

The subject is from Homer's *Odyssey,* a favored source for the classical subjects Kauffmann painted from about 1764. On the left Penelope embraces her son, Telemachus, and on the right, an old woman, probably the servant Euryclea, rushes to meet him. Nearly identical versions of this composition are in the Chrysler Museum, Norfolk, Virginia, and in 1974 on the London art market. The Toledo picture was probably done in London about 1770–81. Kauffmann exhibited paintings of this subject at the Royal Academy in 1771 and 1775.

JACOB SIMON HENDRIK KEVER

1854–1922. Dutch. Born in Amsterdam. Jozef Israels encouraged him to become a painter. Studied at the Amsterdam Academy 1869–72; Rijks Academy 1874–75; Antwerp Academy 1878–79. Settled in Laren, 1879, but is not considered a member of either the Laren or Hague Schools. Best known for interior scenes and flower pieces.

Sisters PL. 156

Oil on canvas
32 x 23 in. (81.3 x 58.4 cm.)
Signed lower right: Kever

Acc. no. 12.510

COLLECTIONS: (Henry Reinhardt, Chicago); Edward Drummond Libbey.

Mother and Children PL. 157

Oil on canvas
40½ x 50½ in. (102.9 x 127 cm.)
Signed lower right: Kever

Acc. no. 14.68

COLLECTIONS: (Henry Reinhardt, Chicago); Edward Drummond Libbey.

THOMAS DE KEYSER

1596/97–1667. Dutch. Son and pupil of the Amsterdam architect and sculptor Hendrik de Keyser. Primarily a portrait painter until ca. 1640, when he became a stone merchant. Apponted stonemason to the town of Amsterdam, 1662. Known for group and life-size portraits, he also specialized in small-scale full-length and equestrian portraits. He was the leading Amsterdam portraitist until the arrival of Rembrandt in 1631.

The Syndics of the PL. 99
Amsterdam Goldsmiths Guild

[1627] Oil on canvas
50⅛ x 60 in. (127.2 x 152.4 cm.)
Signed and dated lower right (on chair): TDK (monogram)/AN. 1627
Inscribed lower right (on chair): AE TAS/SVAE 44.
Inscribed center (on plate held by second figure from left): AETA. SVA. 45

Acc. no. 60.11
Museum Purchase

COLLECTIONS: Audley Dallas Neeld, Chippenham, Wiltshire; Lionel William Neeld, Chippenham, by 1942 (Christie, London, June 9, 1944, lot 15); (Duits, London, 1944); Philip Vos, K.C., 1944–49); (Duits, London, 1949); (Amsterdam art market); W. J. R. Dreesmann, Amsterdam, 1949 (Frederick Muller & Co., Amsterdam, Mar. 22–25, 1960, lot 6).

EXHIBITIONS: Cleveland Museum of Art, *Style, Truth and the Portrait,* 1963, no. 10, repr.; Toledo Museum of Art, *The Age of Rembrandt,* 1966, no. 28, repr.

REFERENCES: O. Millar, "Portraits at the Arcade Gallery," *Burlington Magazine,* LXXXIX, Nov. 1947, p. 319; *Verzameling Amsterdam—W. J. R. Dreesmann,* Amsterdam, 1951, III, pp. 763, 799, repr.; A. K. Horton, "Thomas de Keyser: The Syndics of the Amsterdam Goldsmiths Guild," *Toledo Museum of Art Museum News,* IV, Autumn 1961, pp. 87–90; K. A. Citroen, *Amsterdam Silversmiths and their Marks,* Amsterdam, 1975, p. 219.

The syndics or governing board of the Amsterdam Goldsmiths Guild shown in this painting have been identified by I. H. van Eeghen and K. A. Citroen (letter, Mar. 1963). From the left: Loeff Vredericx, chief assayer of the guild and standard bearer of Amsterdam; Jacob le Merchier of Brussels; and Jacob Everts Wolff, senior dean of the guild. The second figure from the right is unidentified. Citroen and Van Eeghen (letter, Mar. 1975)

also believe the portrait was probably commissioned by the guild at the end of 1626 and represents the syndics for that year.

The touch needles held by le Merchier were used to identify the gold and silver content of unpurified ores. In the tongs held by Vredericx is a cupel, a porous cup of mutton bone, used to extract gold and silver from these ores. The signet ring on the left hand of Vredericx probably shows his maker's mark. On the table and in Wolff's hand are silver horse bridles made by guild members.

De Keyser painted a second group of the Amsterdam goldsmiths in 1627 (formerly Musée des Beaux-Arts, Strasbourg; destroyed, 1946; repr. by Horton). The guild officers in this portrait are shown with various silver vessels. According to Citroen (letter, Mar. 1975) this portrait may show the outgoing and incoming guild syndics of 1627 and 1628.

OSKAR KOKOSCHKA

1886–. Austrian. Born near Vienna, where he studied at the School of Arts and Crafts. Worked and taught in Vienna, 1911–14 and again, 1931–34; Dresden, 1918–23; Prague, 1935–38; London, 1939–53; traveled widely in Europe, Africa and Asia, 1924–37. Visited the United States, 1949, 1957. Became a British subject, 1947. Lived mostly in Switzerland since 1953. A principal figure of Expressionism, his paintings have included portraits, landscapes, allegories; also a printmaker, stage designer, dramatist and poet.

Autumn Flowers PL. 73
[Ca. 1928] Oil on canvas
39 x 31½ in. (100 x 80 cm.)
Signed lower left: OK

Acc. no. 71.1

COLLECTIONS: (Paul Cassirer, Berlin); Private collection, Lugano, by 1958; (Marlborough, London, by 1970).
REFERENCES: H. M. Wingler, *Oskar Kokoschka, The Work of the Painter,* Salzburg, 1958, no. 238, fig. XV; B. Bultmann, *Oskar Kokoschka,* London, 1961, p. 92, repr. p. 93; P. Mitchell, *European Flower Painting,* London, 1973, p. 154, repr. p. 157.

According to Wingler, Kokoschka said this picture was probably painted in Berlin during the autumn of 1928.

CHARLES-FRANÇOIS GRENIER DE LA CROIX, called LACROIX DE MARSEILLE

Ca. 1700–1782. French. Little is known about Lacroix, whose earliest known work is dated 1743. Presumably born at Marseilles, he was in Rome by 1750 and lived in Italy for an extended period, traveling to Naples in 1757 and working for Italian and also French patrons. By 1780 Lacroix was in Paris, where he exhibited at the Salon de la Correspondence in 1780 and 1782. In Rome Lacroix must have known Adrien Manglard, the teacher of C.-J. Vernet, and Lacroix occasionally copied and imitated both men. In his best work, however, Lacroix differs from Vernet by his taste for fantastic architectural settings and for more ambitious and descriptive compositions.

A Mediterranean Seaport PL. 208
[1750] Oil on canvas
37¼ x 65¾ in. (94.6 x 164.5 cm.)
Signed and dated lower left: Grenier.de La/Croix.fecit Rom/1750.

Acc. no. 56.64

COLLECTIONS: Mrs. F. R. Wynne, Tempsford Hall (Sotheby, London, Nov. 19, 1952, lot 68); (Agnew, London); (Cailleux, Paris).
EXHIBITIONS: London, Royal Academy, *European Masters of the Eighteenth Century,* 1954, no. 334 (with inaccurate bibliographic reference); London, Royal Academy, *France in the Eighteenth Century,* 1968, no. 358, fig. 202; Toledo Museum of Art, *The Age of Louis XV,* 1975, no. 51, pl. 77 (cat. by P. Rosenberg).
REFERENCES: Galerie Heim, *Tableaux de maîtres anciens,* Paris, 1956, in no. 16 (painting dated 1743); M. Davies, *National Gallery Catalogues: French School,* 2nd ed., London, 1957, p. 218, n. 1.

According to Rosenberg (1975) who considers this picture to be the artist's masterpiece, "The charming group of figures descending the stairs on the right and the three Orientals in the center enliven this austere composition where one finds both imagination and precise topographical elements."

ROGER DE LA FRESNAYE

1885–1925. French. Born in Le Mans; raised in Paris. From 1903 to 1908 he studied at the Académie Julian, École des Beaux Arts and, most significantly, with Maurice Denis and Paul Sérusier at the Académie Ranson.

Traveled in Italy and Germany, 1910–11. From 1912 he was closely connected with the Cubists and exhibited with them at the Salon des Indépendants, Salon d'Automne, and the Section d'Or, which he helped found. Served with the army, 1914–18; after 1919 lived as an invalid at Grasse. His last oil painting was done in 1921, but he continued to draw until his death.

Still Life with Coffee Pot PL. 286

[Ca. 1910–11] Oil on canvas
21½ x 32 in. (54.6 x 81.2 cm.)
Signed upper right: R. de la Fresnaye

Acc. no. 51.380

COLLECTIONS: Pierre Faure, Paris (?); (Paul Pétridès, Paris); (Alex Reid & Lefevre, London).

EXHIBITIONS: Paris, Galerie Barbazanges, *Exposition retrospective des oeuvres de Roger de La Fresnaye*, 1926, no. 23 (as *Cafetière et pichet*); Paris, Gazette des Beaux-Arts, *Les créateurs du Cubisme*, 1935, no. 81 (?); Paris, Musée Nationale d'Art Moderne, *Roger de La Fresnaye*, 1950, no. 39.

REFERENCES: G. Seligman, *Roger de La Fresnaye*, Greenwich, Conn., 1969, no. 150, repr.

This belongs to a small group of still lifes painted about 1911, when La Fresnaye was beginning to evolve a personal idiom based on Cubism.

LAURENT DE LA HIRE

1606–1656. French. Son and pupil of the Parisian artist Étienne de La Hire. He also studied with the Mannerist Georges Lallement, and was influenced by the work of Vouet, Caravaggio, the Bolognese painters, and later by Poussin. Among the founders of the Académie Royale in 1648. Painter of religious and mythological subjects and landscapes.

Allegory of Geometry PL. 191

[1649] Oil on canvas
40 x 62½ in. (101.6 x 158.6 cm.)
Signed and dated lower right corner: L. DE LA HIRE
 In.&F. 1649

Acc. no. 64.124

COLLECTIONS: Gédéon Tallement, Paris(?); Private collection, Switzerland; Private collection, France; (Heim, Paris).

EXHIBITIONS: New York, Wildenstein, *Gods and Heroes,*

Baroque Images of Antiquity, 1968, no. 19, repr. opp. p. 20 (cat. by E. Williams).

REFERENCES: P. de La Hyre, "Biography of Laurent de La Hyre," in P. J. Mariette's *Abecedario*, Paris, 1854–56, III, pp. 48–9; G. Guillet de Saint-Georges, "Laurent de La Hire," *Mémoires inédits sur la vie et les ouvrages des membres de l'Académie Royale de Peinture et de Sculpture*, Paris, 1854, I, p. 107; A. Frankfurter, "Museum Evaluations, 2: Toledo," *Art News*, LXIII, 1965, pp. 26, 54, 55; P. M. Auzas, "À propos de Laurent de La Hire," *La revue du Louvre et des musées de France*, No. 1, 1968, p. 11.

The Toledo painting is associated with the series of Seven Liberal Arts commissioned by Gédéon Tallement (1613–1668) for his house in the Marais quarter of Paris, destroyed in the 18th century. Jacques Wilhelm believes (letter, Apr. 1975) that the series formed a frieze in a small room with each Liberal Art alternating with paintings of putti and separated by pilasters or wall mouldings.

Philippe de La Hire and Guillet de Saint-Georges mention the Tallement series in their biographies of the artist. However, Dézallier d'Argenville speaks (*Abregé de la vie des plus fameux peintres . . .*, Paris, 1745, II, p. 274) of another series of Liberal Arts by La Hire at Rouen. The existence of two signed and dated versions of *Grammar* (National Gallery, London, 1650; Walters Art Gallery, Baltimore, 1650), and the nearly identical *Arithmetic* (Hannema-de Steurs Foundation, Heino, The Netherlands, 1650) and *Architecture* (Walters Art Gallery, Baltimore, 1650) is evidence that two series may have existed. Jacques Thuillier (letter, Dec. 1975) points out that it is difficult to determine which paintings belonged to each series; that it is uncertain that any actually belonged to Tallement; and that it is possible even a third series existed.

The other Liberal Arts associated with the Tallement series are *Astronomy* (Musée des Beaux-Arts, Orléans, 1649); *Rhetoric* (private collection, Switzerland, 1650), *Dialectic* (private collection, Switzerland, 1650) and *Music* (Metropolitan Museum of Art, New York, 1648). Two panels with putti, musical instruments and scores (Musée Magnin, Dijon) may have flanked *Music* (T. Augarde and J. Thuillier, "La Hyre," *L'Oeil*, LXXXVIII, 1962, pp. 22–3).

Geometry holds a sheet of paper illustrating the Golden Section in one hand, and a compass and a right angle edge in the other. Williams suggested (Wildenstein catalogue) that the meaning of this painting is the superiority of Greek over Egyptian geometry. Charles Rosen-

berg (letter, Aug. 1975) believes *Geometry* is not only an allegory, but is also connected with the tradition linking Geometry, Melancholy and Saturn.

NICOLAS LANCRET

1690–1743. French. Born and lived in Paris. Student at the Académie Royale where he studied history painting with Pierre Dulin. In 1712 Claude Gillot introduced him to Watteau, the most important influence on Lancret's art. In 1719, member of Académie Royale as a painter of *fêtes galantes,* with which he had great success.

The Dance in the Park PL. 195

[Probably 1730s] Oil on canvas
44 x 57 in. (111.7 x 144.7 cm.)

Acc. no. 54.17

COLLECTIONS: Baron Anselm de Rothschild; Baron Ferdinand de Rothschild, Waddesdon Manor, until 1898; Baron Albert de Rothschild, Vienna and England, from 1898; Baron Eugene de Rothschild, Vienna; Baron Maurice de Rothschild, Château de Pregny, Switzerland; (Rosenberg & Stiebel, New York).

EXHIBITIONS: London, Royal Academy, *France in the Eighteenth Century,* 1968, no. 387.

This unusually large *fête galante* was unknown to Wildenstein (*Lancret,* Paris, 1924). It was probably painted in the 1730s, though Lancret's work is difficult to date accurately. The figure of a man dancing in the center also appears in *La danse des bergers* (Schloss Charlottenburg, West Berlin).

NICOLAS DE LARGILLIERRE

1656–1746. French. Born in Paris, but spent his youth in Antwerp. Peter Lely's assistant in London, 1674–80. After returning to Paris, he became a member of the Académie in 1686 and later its director. His principal rival was Rigaud, though he specialized in portraits of the rich professional classes, leaving the court and aristocracy to Rigaud. His immense output reflected the warm colors and broad brushwork of his Flemish training. He also painted some landscapes and still lifes.

Portrait of a Man PL. 192

[1703] Oil on canvas
57¾ x 45¼ in. (146.7 x 114.4 cm.)

Signed and dated (in brush) on the back of the canvas: peint part N (?) / de Largilliere 1703

Acc. no. 55.35

COLLECTIONS: Mazel (Hôtel Drouot, Paris, Nov. 1922, lot 10); (Founes); Arlette Dorgère (Mathilde Jouve), 1923–49; Louis Margerie, Monte Carlo, 1949–55.

EXHIBITIONS: Cleveland Museum of Art, *Style, Truth and the Portrait,* 1963, no. 12, repr.; London, Royal Academy, *France in the Eighteenth Century,* 1968, no. 408, fig. 43.

Until recently this painting was thought to show the Regent, Philip of Orléans with a portrait of Mme. de Parabère. However, the characteristic signature and date 1703 found on the original canvas rule out this possibility, as Mme. de Parabère was born in 1693. Comparison with known portraits of the Duke of Orléans has also shown that he is not the subject, who remains unknown.

PHILIP DE LÁSZLÓ

1869–1937. British. Born in Budapest as Philip Alexius László de Lombos. Studied at the School of Industrial Art and the National School of Drawing there. Later a student of Liezenmayer at the Royal Academy, Munich, and of Lefèbre and Benjamin Constant at the Académie Julian, Paris. Became a British citizen in 1914.

Edward Drummond Libbey PL. 343

[1922] Oil on canvas
49¾ x 36 in. (126.4 x 91.4 cm.)
Signed and dated upper right: de László/London 1922. Oct.

Acc. no. 26.86

COLLECTIONS: Edward Drummond Libbey, 1922–25.

Edward Drummond Libbey (1854–1925) brought the glass industry to Toledo in 1888. He founded the Museum in 1901 and served as its president until his death, after which the Museum received his own art collection, as well as funds for both future art acquisitions and general operations.

MAURICE-QUENTIN DE LA TOUR

1704–1788. French. Born in Saint-Quentin. Studied briefly with J. Restout, J. J. Spöede, and Depouch. Went

to Paris in 1723, where he remained with the exception of a stay in London (1724–27), until 1784, when he retired to Saint-Quentin. Exhibited at the Salon, 1737–73. Agréé by the Académie, 1737; full member, 1746. A portraitist, he was the most famous French pastellist of the 18th century.

Self-Portrait PL. 198

[1737 or later] Pastel on board
21¾ x 18⅛ in. (55.2 x 46 cm.)

Acc. no. 55.9

COLLECTIONS: Musée A. Lécuyer, Saint-Quentin (?); the painter Charles-Adolphe Bonnegrâce (1808–1882); Auguste Delambre and descendants; M. and Mme. Colson (née Delambre); (Wildenstein, New York).

EXHIBITIONS: Paris, Salon, 1737 (*Livret*, p. 33, "*l'auteur qui rit*") (?).

REFERENCES: P. L. Grigaut, "Baroque and Rococo France in Toledo," *Art Quarterly*, XIX, Spring, 1956, p. 53, fig. 3.

At the Salon of 1737, the first in which he exhibited, La Tour showed a portrait of himself laughing. Besnard and Wildenstein list sixteen examples of this self-portrait (*La Tour*, Paris, 1928, pp. 32, 147, nos. 212–28). The Toledo pastel was unknown to Besnard and Wildenstein in 1928. Among the several versions known, it appears to be of particularly fine quality (Grigaut).

According to a tradition which it has not been possible to verify, the Toledo example was sold to pay for repairs after a fire by the museum at Saint-Quentin, which has the principal collection of La Tour's pastels. The artist left his collection of his work to the school of drawing he founded in his native town.

This composition is often known as *La Tour à l'index* to distinguish it from other self-portraits. A version of it was engraved by G. F. Schmidt in 1742.

MARIE LAURENCIN

1885–1956. French. Born in Paris, Laurencin exhibited at the Salon des Indépendents. Her friendship with many of the French Cubists perhaps influenced the development of her personal and decorative style with its simplified, flat forms and soft colors that remained unchanged throughout her career.

Acrobats PL. 296

[1929] Oil on canvas
36⅜ x 29 in. (92.4 x 73.7 cm.)

Signed and dated lower left: Marie Laurencin/1929

Acc. no. 34.49

COLLECTIONS: (Paul Rosenberg, Paris).

EXHIBITIONS: Pittsburgh, Carnegie Institute, *International*, 1933, no. 188, fig. 59; Pittsburgh, Carnegie Institute, *Retrospective Exhibition of Paintings from Previous Internationals*, 1958, no. 60, repr.

SIR JOHN LAVERY

1856–1941. British. Born in Belfast. Studied in Glasgow, London and Paris. First exhibited at the Royal Scottish Academy, 1881; Paris Salon, 1883; Royal Academy, London, 1886. Early member of the Glasgow School. Close friend of Whistler, with whom he and others formed the International Society in 1898. In London from 1896.

Moonlight, Tetuan, Morocco PL. 341

[1911] Oil on canvas
14⅛ x 25⅛ in. (37.9 x 63.8 cm.)
Signed lower right: J. Lavery
Brush inscription on reverse: MOONLIGHT/TETUAN. MOROCCO/JOHN LAVERY/5 CROMWELL PLACE/LONDON/1911

Acc. no. 12.918
Gift of C. W. Kraushaar

Although Lavery is best known as a portrait painter, landscapes form an important part of his work. He made his first trip to North Africa about 1890, and often returned there.

SIR THOMAS LAWRENCE

1769–1830. British. Executed pastel portraits in Bath from 1782. In 1787 departed for London, studying briefly at the Royal Academy school. Elected ARA in 1791, RA in 1794, and PRA in 1820. In 1792 named Painter in Ordinary to the King. He was knighted in 1815 and achieved international fame when sent to Europe in 1818 by the Prince Regent to make portraits of the leaders of the allied powers who defeated Napoleon.

Sophia, Lady Valletort PL. 326

[Ca. 1790] Oil on canvas
30 x 25 in. (76.2 x 63.5 cm.)

Acc. no. 26.80

COLLECTIONS: Lady Suffield (sister of the sitter), 1832; S. A. Peel, before 1850; J. W. Peel (her son), 1850; (Henry Reinhardt, New York, 1925).

REFERENCES: W. Armstrong, *Lawrence*, London, 1913, p. 167 (as Lady Vallecourt [*sic*]); M. W. Brockwell, *Sir Thomas Lawrence, P.R.A.: "Portrait of Sophia, Countess of Mount Edgcumbe,"* (brochure, London, 1920), pp. 5–9; K. Garlick, *Sir Thomas Lawrence*, London, 1954, pp. 61, 75; K. Garlick, "A Catalogue of the Paintings, Drawings and Pastels of Sir Thomas Lawrence," *Walpole Society*, XXXIX, 1962–64, pp. 189, 292.

Sophia Hobart (1768–1806), third daughter of the 2nd Earl of Buckinghamshire, in 1789 married Richard, Viscount Valletort, who succeeded as Earl of Mount Edgcumbe in 1795. Garlick (p. 189) dates the painting about 1790, also listing a portrait of her husband done at this same time. The later ownership of the painting by the Peels is based upon a pencil inscription on the back of the stretcher.

Sir Thomas Frankland PL. 327

[Ca. 1810–15] Oil on canvas
30⅛ x 25⅛ in. (76.5 x 63.8 cm.)

Inscribed across the bottom at a later date: SIR THOS FRANKLAND/B. 1750 OB 18 I 6TH BARONET, HIGH SHERIFF, YORKS:1792. M.P. THIRSK. 1774–80. 1784–90. 1796–01. Erected THIRKLEBY House. 1782–90. SIR T. LAWRENCE

Acc. no. 33.35
Gift of Arthur J. Secor

COLLECTIONS: Sir Thomas Frankland, 6th Bt., Thirkleby House, Yorkshire, ca. 1810–15 to 1831; by descent to Sir Frederick W. F. G. Frankland, 10th Bt., Thirkleby House, 1883–1927; (Howard Young, New York, 1927); Arthur J. Secor, 1927–33.

REFERENCES: K. Garlick, *Sir Thomas Lawrence*, London, 1954, p. 37; K. Garlick, "A Catalogue of the Paintings, Drawings and Pastels of Sir Thomas Lawrence," *The Walpole Society*, XXXIX, 1962–64, p. 82 (as ca. 1810–15).

Frankland (1750–1831), 6th Baronet Frankland of Thirkleby, served three times as Member of Parliament for Thirsk between 1774 and 1801, and in 1792 was High Sheriff of Yorkshire. A Fellow of the Royal Society, he was a scientist and botanist, as well as an author, classical scholar and authority on British sports. Frankland commissioned James and Samuel Wyatt to build Thirkleby House, sold by the Frankland family in 1927, and since destroyed.

Lady Arundell PL. 328

[Ca. 1812] Oil on canvas
50 x 40 in. (127 x 101.5 cm.)

Acc. no. 26.148
Gift of Arthur J. Secor

COLLECTIONS: James Everard, 10th Baron Arundell of Wardour, Wardour Castle, Wiltshire, 1830; Col. Unthank, Intwood Hall, near Norwich, by 1897; (Robinson and Fisher, London, May 28, 1897, lot 188, as a double portrait); (Renton); (Robinson and Fisher, London, June 21, 1900, lot 156, as a double portrait); (Arthur Tooth, London); (T. G. Blakeslee, 1914); (Vose, Boston, 1914–23); Arthur J. Secor, 1923–25.

EXHIBITIONS: Columbus Gallery of Fine Arts, *Sir Thomas Lawrence as Painter and Collector*, 1955, no. 2.

REFERENCES: K. Garlick, *Sir Thomas Lawrence*, London, 1954, pp. 25, 72; K. Garlick, "A Catalogue of the Paintings, Drawings and Pastels of Sir Thomas Lawrence," *Walpole Society*, XXXIX, 1962–64, pp. 23, 275, 307.

Mary Burnett Jones (died 1853) married James Everard, 9th Baron Arundell of Wardour in 1806. This is a fragment of a double portrait of Lord and Lady Arundell. According to Garlick (1962–64), it was begun in 1812. It remained unfinished in Lawrence's studio at his death, and was presumably acquired by the Arundell family at that time.

The double portrait, measuring 89 x 61 inches, was cut down between 1900 and 1914. The fragment containing the portrait of Lord Arundell (30 x 25 inches) was in the sale of the T. J. Blakeslee collection (American Art Association, New York, Mar. 6–10, 1916, lot 214).

Lord Amherst [COLOR PL. X] PL. 329

[1821] Oil on canvas
93 x 57½ in. (236 x 146 cm.)

Acc. no. 64.32

COLLECTIONS: British East India Company Factory, Canton, China, 1821–35; Sir George T. Staunton, Bt., from 1835; Earls Amherst, to 1962 (Sotheby, London, June 27, 1962, lot 4, repr.); (Agnew, London, 1962–64).

REFERENCES: R. S. Gower, *Sir Thomas Lawrence*, London, 1900, p. 104; W. Armstrong, *Lawrence*, London, 1913, p. 108; K. Garlick, *Sir Thomas Lawrence*, London, 1954, p. 24; K. Garlick, "A Catalogue of the Paintings, Drawings and Pastels of Sir Thomas Lawrence," *Walpole Society*, XXXIX, 1962–64, p. 18.

William Pitt Amherst (1773–1857), 2nd Baron Amherst, was the nephew and heir of Lord Jeffery Amherst, commander of the British forces in North America during the French and Indian Wars. The younger Amherst was a diplomat who led a British embassy to China in 1816. The Emperor did not receive him, however, because Amherst refused to pay homage by kneeling and touching his forehead to the ground, called kowtow, as prescribed by Chinese court etiquette. Later, Amherst was Governor General of Bengal, 1822–28; he was created 1st Earl Amherst in 1826. This portrait was painted for the office and trading depot of the British East India Company at Canton, seen in the background. Amherst's firm stance, his hand placed by the journal of his diplomatic mission, refers to his refusal to undergo public humiliation. The book title reads *Embassy to China:* this is the *Journal of the Proceedings of the Late Embassy to China* (London, 1817) by Henry Ellis, who accompanied Amherst.

The view of Canton showing the trading factories of several Western nations was based on a colored aquatint, *South West View of Canton,* by T. and W. Daniell, from *A Picturesque Voyage to India by the Way of China* (London, 1810, pl. 32).

After the factory was closed in 1834 the portrait was given to Sir George Staunton, the second ranking member of the 1816 mission. There is a mezzotint (1824) of the portrait by Charles Turner, and a half-length stipple engraving (1829) by Samuel Freeman.

EDWARD LEAR

1812–1888. British. Born in London. In 1836 he began to travel and to make the topographical sketches which are an important part of his work. Studied at the Royal Academy, 1850–52; exhibited there, 1850–56. Although best known as the author of *Book of Nonsense* and as a draughtsman and illustrator, Lear did over 290 paintings. Lived abroad most of his life, and died at San Remo, Italy.

Venosa PL. 335

[1852] Oil on canvas
19¾ x 32⅜ in. (50.2 x 82.2 cm.)
Signed, dated and inscribed lower right: E. Lear./1852/ Venosa.

Acc. no. 69.340

COLLECTIONS: James Byam Shaw; (Colnaghi, London).

REFERENCES: A. Staley, *The Pre-Raphaelite Landscape,* Oxford, 1973, p. 153, pl. 84b.

This painting was based on sketches made by Lear on a trip to southern Italy in 1847. According to Staley, it is one of Lear's few works that is purely Pre-Raphaelite in its acute observation and detailed naturalism, perhaps under the influence of Holman Hunt, with whom Lear was working in 1852; on December 19 Lear wrote Hunt, "The *Venosa* is wonderfully true and brilliant. Of course painting out of doors has been out of the question—but I have sloshed as little as possible. . . ."

Venosa is a town east of Naples in the province of Patenza. As an ancient city on the Via Appia, it was renowned for its strategic military position between two deep ravines, one of which is clearly apparent in this view.

MATHIEU LE NAIN

Ca. 1607–1677. French. Like his older brothers, Antoine (ca. 1588–1648) and Louis (ca. 1593–1648), Mathieu was born at Laon. They worked in Paris, where Antoine established a studio in 1629; his brothers joined him as partners in 1630. Mathieu was listed as a master painter to the city of Paris in 1633. In 1648 the three brothers became members of the Académie Royale. They painted religious, mythological and genre subjects, and portraits, and traditionally collaborated on many pictures. There is difficulty separating their independent work because signed pictures bear only a surname; there are dated pictures between 1641 and 1648, the year Antoine and Louis died. Mathieu apparently stopped painting ca. 1660.

The Family Dinner PL. 183

[Ca. 1645–48] Oil on canvas
32½ x 43 in. (82.5 x 109.2 cm.)

Acc. no. 46.28

COLLECTIONS: Duc de Choiseul (Boileau, Paris, Apr. 6, 1772, lot 126); Prince de Conti (Muzier-P. Remy, Paris, Apr. 8, 1777, lot 552); Sollier (Sollier et Remy, Paris, Apr. 3, 1781, lot 166); Prince de Soubise; possibly I. Bertels (Christie, London, Mar. 4, 1791, lot 23); Private collection, England (Christie, London, Feb. 4, 1792, lot 49); Sir Audley Neeld; L. V. Neeld (Christie, London, July 13, 1945, lot 73); (Koetser, New York); (Wildenstein, New York).

EXHIBITIONS: New York, Wildenstein, *French Painting of the Time of Louis XIIIth and Louis XIVth,* 1946, no. 26; Toledo Museum of Art, *The Brothers Le Nain,* 1947, no. 11, repr.; Pittsburgh, Carnegie Institute, *Pictures of*

Everyday Life: Genre Painting in Europe, 1500–1900, 1954, pl. 25.

REFERENCES: *Recueil d'estampes gravées d'après les tableaux du cabinet de Monseigneur le duc de Choiseul,* Paris, 1771, p. 10, no. 104, repr. (engraved as by Le Nain); Champfleury, *Essai sur la vie et l'oeuvre des Le Nain,* Laon, 1850, p. 21; Champfleury, *Catalogue des tableaux des Le Nain qui ont passé dans les ventes publiques de l'année 1755–1853,* Brussels, 1861, pp. 2, 3, 44 (?); C. Blanc, *Histoire des peintres de toutes les écoles: École française,* Paris, 1862, I, p. 8, no. 23, repr. p. 3 (engraving); A. Valabrègue, *Les frères Le Nain,* Paris, 1904, pp. 118, 171; Burlington Fine Arts Club, *Pictures by the Brothers Le Nain,* London, 1910, p. 32 (in "List of Works by, or Attributed to, the Brothers Le Nain"); P. Jamot, *Les Le Nain,* Paris, 1929, p. 96, n. 1; P. Fierens, *Les Le Nain,* Paris, 1930, p. 50; G. Isarlo, "Les trois Le Nain et leur suite," *La Renaissance,* Mar. 1938, p. 26, nos. 111 and 134, fig. 42 (Weisbrod engraving); E. Dacier, "La curiosité au XVIIIe siècle: Choiseul collectionneur," *Gazette des Beaux-Arts,* XXXVI, July–Sep. 1949, p. 74, no. 22, repr. cover and fig. 19; T. Bodkin, "Two Rediscovered Pictures by Mathieu Le Nain," *Bulletin de la Société Poussin,* No. 3, May 1950, p. 26, pl. 20; J. Thuillier and A. Châtelet, *French Painting from Le Nain to Fragonard,* Geneva, 1964, p. 20.

While attributions to the individual Le Nain brothers have been based on groups of characteristics worked out by Jamot, there remains considerable uncertainty about the style of each. This painting is attributed to Mathieu by Jamot, Isarlo and Bodkin. J. Thuillier (1964, p. 15; letter, Dec. 1975) prefers the more general appellation "Le Nain" because there is still no indisputable evidence for relating any painting to only one of the brothers. According to Thuillier, the heads are family portraits, as are those in certain other genre subjects attributed to Mathieu, and he believes this picture was painted ca. 1645–48, a date in agreement with costume style.

While this composition was well known to scholars before 1945 from engravings and other versions, the Toledo painting, which is now recognized as the original, only emerged from obscurity at that time.

Engraved by C. Weisbrod (1771), Pisan (1862) and Best-Hotelin-Reguier. Other versions, considered copies: Paul Rosenberg and Co., New York, with portrait heads of the Poullain family (Isarlo, fig. 43); Cleveland Museum of Art (Fierens, pl. LXXXVI); Capt. Pitts collection (Paris Le Nain exhibition, 1934, no. 46).

VALENTIN LENDENSTREICH

Active ca. 1485–1506. German. Worked at Saalfeld, Thuringia. Lendenstreich headed a workshop which produced altarpieces combining painting and sculpture.

Wings of the Wüllersleben Triptych PL. 63a–d

(A) Left wing, verso: *The Agony in the Garden; A Prophet;* recto: *Angel Annunciate;*
(B) Right wing, verso: *The Flagellation of Christ; A Prophet;* recto: *Virgin Annunciate*

[1503] Oil on wood panel
Overall: 75 x 44½ in. (195 x 113 cm.); large painted panels: 51⅛ x 38⅝ in. (129.7 x 98.5 cm.); small painted panels: 13⅞ x 15⅜ in. (35.2 x 39 cm.); small painted panels, verso: 15½ x 13¾ in. (39.3 x 35 cm.)
Signed and dated on the frames:
(A) Anno dni XVcoIII completa est hec Thabula feria
(B) scda post Cantate facta e in Saluelt per valentinv lendestreich

Acc. no. 23.3154 A–B

COLLECTIONS: Parish church, Wüllersleben, Thuringia; Staatsminister Von Bertrab, Schwarzburg-Rudolstadt; Prince of Schwartzburg-Rudolstadt, Thuringia, by 1891; (Couttelier and Pollack, Brussels).

REFERENCES: P. Lehfeldt, *Bau-und Kunstdenkmäler Thüringens,* XIX, 1894, p. 64; P. Lehfeldt, "Über die Thüringische Familie Lendenstreich," *Zeitschrift des Vereins für Thüringische Geschichte und Altertumskunde,* IX, 1895, pp. 659–75; O. Doering and G. Voss, *Meisterwerke der Kunst aus Sächsen und Thüringen,* Magdeburg, 1906, p. 57; E. Koch, *Valentin Lendenstreich und andere Saalfelder Maler um die Wende des Mittelalters: Archivalische Forschungen,* Jena, 1914, p. 1; M. Riemschneider-Hoerner, "Der Saalfelder Bildschnitzer Valentin Lendenstreich," *Thüringen Monatszeitschrift für alte und neue Kultur,* V, 1929/30, p. 164; C. Kuhn, *A Catalogue of German Paintings of the Middle Ages and Renaissance in American Collections,* Cambridge, Mass., 1936, no. 71, pl. XV, fig. 71; A. Stange, *Deutsche Malerei der Gotik,* Munich, 1958, IX, pp. 151, 152, figs. 282–83; J. Bier, "Hans Gottwalt of Lohr, a Pupil of Tilmann Riemenschneider at Saalfeld," *De Artibus Opuscula XL, Essays in Honor of Erwin Panofsky,* New York, 1961, I, pp. 2, 8, 9; II, p. 1, figs. 2–4; G. Werner, "Der Bildschnitzer Hans Gottwalt von Lohr," *Saalfelder Museumsreihe,* II, 1966, pp. 6, 17, 20.

These wings formed a triptych altarpiece that was dismembered by 1923. The complete opened altarpiece is illustrated by Bier, who states that it is one of four

signed by Lendenstreich. The outsides of the wings are painted, while the insides, except for two painted *Annunciation* panels, are composed of gilt and polychrome wood sculpture and panels of Gothic tracery, as was the center panel of the triptych.

The sculpture, left to right: left wing (23.3154 B), Sts. Alban of Mainz, Peter, Paul, Andrew; right wing (23.3154 A), Sts. John the Baptist, Lawrence, George, Nicholas of Bari. In the now dismantled center panel, figures of (left) Sts. Margaret and Barbara and (right) Catherine of Alexandria and Dorothy formerly flanked a larger image of the Virgin and Child with angels. Sts. Catherine and Dorothy are now in St. John's Church, Lakeville, Conn.; the location of the other sculptures is unknown.

There is uncertainty about the part that Lendenstreich himself had in the production of these altarpieces. According to recent scholarship, he was both a painter and sculptor who also directed a large workshop.

JEAN-BAPTISTE LE PRINCE

1734–1781. French. Student of Boucher. Worked in Paris except for a time in Russia from about 1775 to 1781. Primarily a painter of small, intimate genre scenes. Especially famous for his *"russeries,"* genre scenes in Russian costume. Also a prolific engraver, he perfected the aquatint.

Fear (La Crainte) PL. 204

[1769] Oil on canvas
19¾ x 25¼ in. (50 x 64 cm.)
Signed and dated lower left: J.B. Le Prince 1769

Acc. no. 70.44

COLLECTIONS: Duc de Liancourt; Boittelle (Pillet, Paris, Apr. 24–25, 1866, lot 89); Baroness d'Erlanger, London, 1932; Dr. Ernst L. Tress; (Property of a Gentleman, Sotheby, London, May 14, 1958, lot 144); Count Guillaume de Belleroche, 1958–62 (Christie, London, June 29, 1962, lot 48); (Versailles, Feb. 22, 1970); (Cailleux, Paris).

EXHIBITIONS: Paris, Salon of 1777, no. 55; London, Royal Academy, *French Art, 1200–1900*, 1932, no. 202 (commemorative catalogue), no. 324 (regular catalogue); London, Royal Academy, *France in the Eighteenth Century*, 1968, no. 434; Toledo Museum of Art, *The Age of Louis XV: French Painting 1710–1774*, 1975, no. 66, pl. 115.

REFERENCES: Pidansat de Mairobert, Letter of September 15, 1777, in *Les memoires secrets pour servir a l'his-* *toire de la republique des lettres en France (1762–1787)*, republished in: "Letters sur l'Académie Royale . . . ," *La Revue Universelle des Arts*, XXII, 1865, p. 230; J. Hédou, *Jean-Baptiste Le Prince, 1734–1781 peintre et graveur*, Paris, 1879, p. 55; Dupont de Nemours, "Lettres sur les Salons de 1773, 1777 et 1779," *Archives de l'art français*, 1908, p. 57, no. 1; W. Chiego, "A Boudoir Scene by Le Prince," *Toledo Museum of Art Museum News*, XVII, No. 1, 1974, pp. 11–4, figs. 6, 7; D. Wildenstein, "Sur le Verrou de Fragonard," *Gazette des Beaux-Arts*, LXXXV, Jan. 1975, pp. 18, 24, no. 20, fig. 7; J. Cailleux, "Les artistes français du XVIIIème siècle et Rembrandt," in *Études d'art français offertes à Charles Sterling*, 1975, p. 300.

An example of Le Prince's boudoir subjects, *Fear* is in the tradition of Boucher and Fragonard.

It was engraved by Noel Le Mire soon after Le Prince's death. In a second state of the print (1785), the head of a hiding lover was added at the right by the engraver. A copy of this painting is in the Louvre (R.F. 1970–46).

HENRI LE SIDANER

1862–1939. French. Born in Mauritius. In 1880 came to Paris, where he studied with Cabanel. Lived at Étaples in Normandy from 1882 to 1894, when he returned to Paris. Exhibited at the Salon from 1887 and Société Nationale from 1894. In Italy, 1905; London, 1907–08. Influenced by Neo-Impressionism in the late 1890s. Best known for intimate landscapes and interiors.

In the Garden PL. 273

[1891] Oil on canvas
23⅞ x 32⅛ in. (61.6 x 81.6 cm.)
Signed and dated lower right: Le Sidaner/1891

Acc. no. 33.17

COLLECTIONS: (Henry Reinhardt, New York); Florence Scott Libbey, by 1911–33.

EXHIBITIONS: New York, Wildenstein, *From Realism to Symbolism: Whistler and his World*, 1971, no. 93, pl. 51.

This picture is dated 1891, and was probably painted in the artist's garden at Étaples. The soft, atmospheric quality is typical of Le Sidaner's work, reflecting the poetic aspects of the French and Belgian Symbolists and his interest in Whistler and the Impressionists.

EUSTACHE LE SUEUR

1616–1655. French. Born in Paris, where he spent his life. A pupil of Vouet, ca. 1632. His first important commission was a series of paintings for the Hôtel Lambert, ca. 1646–49. He was a founder member of the Académie Royale in 1648. Although he never visited Rome, the classicism of his later work was greatly influenced by Poussin and Raphael. He painted mythological and religious subjects, as well as portraits and tapestry cartoons.

The Annunciation　　　[COLOR PL. VIII] PL. 189

[Ca. 1650] Oil on canvas
61½ x 49½ in. (156.2 x 125.7 cm.)

Acc. no. 52.63

COLLECTIONS: Charles Briçonnet (or Brissonnet), Paris (1611–1680); Anne-Robert-Jacques Turgot (1727–1781); Étienne-François Turgot, Marquis de Consmont (1721–1789); Robit (Emcelain, Le Brun & Hubert, Paris, Dec. 6, 1800, lot 137); Marquis de Montcalm, Montpellier (Christie, London, May 4, 1849, lot 119); Earl of Normanton, Somerley, Hampshire, England; A. W. Wall; (Wildenstein, New York, 1951).

EXHIBITIONS: Pittsburgh, Carnegie Institute, *French Painting, 1100–1900*, 1951, no. 66, repr.; New Orleans, Isaac Delgado Museum, *Masterpieces of French Painting through Five Centuries, 1400–1900*, 1953, no. 20, p. 23.

REFERENCES: G. de Saint-Georges, *Mémoire historique des ouvrages de M. Eustache Le Sueur, 1690*, included in L. Dussieux *et al.*, *Mémoires inédits sur la vie et les ouvrages des membres de l'Académie Royale de peinture et de sculpture*, Paris, 1854, I, p. 164; A. J. Dézallier d'Argenville, *Voyage pittoresque de Paris*, 1752, p. 207; [A. J. Dézallier d'Argenville], *Abrégé de la vie des plus fameux peintres*, Paris, 1762, IV, p. 116; G. F. Waagen, *Galleries and Cabinets of Art in Great Britain*, London, 1857, Supplement, p. 369; J. J. Guiffrey, "Lettres et documents sur l'acquisition des tableaux d'Eustache Le Sueur pour la collection du Roi: 1776–89," *Nouvelles archives de l'art français*, Paris, 1887, pp. 337, 338; G. Rouchès, *Eustache Le Sueur*, Paris, 1923, pp. 73–4; L. Dimièr, *Histoire de la peinture française du retour de Vouet à la mort de Lebrun, 1627 à 1690*, Paris, 1927, II, p. 6; R. M. Riefstahl, "What Is Conservation?," *Toledo Museum of Art Museum News*, VIII, Autumn, 1965, p. 54, repr.; *Religious and Biblical Themes in French Baroque Painting*, (exh. cat.), Heim, London, 1974, in nos. 7–8.

This was the altarpiece in the ensemble painted by Le Sueur about 1650 for the chapel of the house of Charles Briçonnet, *président à mortier* of the Parliament of Metz, in the Marais district of Paris. The ensemble also included a ceiling painting of the Assumption of the Virgin, as well as eight scenes from the Life of the Virgin and eight allegorical figures of the Beatitudes set into the walls. The Hôtel Briçonnet and the ceiling painting no longer exist. Two of the Beatitudes are known (Heim exhibition, 1974); *Meekness* is now in the Art Institute of Chicago.

A larger and somewhat different version of the *Annunciation,* painted about 1652, is in the Louvre.

LÉON LHERMITTE

1844–1925. French. Studied with Lecoq de Boisbaudran from 1863. Lived in Paris, spending summers at Mont-Saint-Père, his birthplace. From 1869 made many visits to London, where he met Legros. Exhibited at Paris Salons 1864–1925, and in London from 1872. Elected to the French Academy, 1905. Produced oil paintings, pastels, charcoal drawings and etchings.

Rest During the Harvest　　　PL. 280

[1905] Oil on canvas
27½ x 34 in. (69.8 x 86.3 cm.)
Signed and dated lower right: L. Lhermitte, 1905

Acc. no. 22.25
Gift of Arthur J. Secor

COLLECTIONS: (Boussod, Valadon et Cie., Paris); (Henry Reinhardt, Milwaukee); Arthur J. Secor, 1906–22.

EXHIBITIONS: Paris, *Salon*, 1905, no. 819.

REFERENCES: M. M. Hamel, "A French Artist: Léon Lhermitte (1844–1925)," unpublished Ph.D. dissertation, Washington University, St. Louis, 1975, cat. no. 266; M. M. Hamel, *Léon Lhermitte*, Paine Art Center and Arboretum, Oshkosh, Wis., 1974, p. 30.

Although the painting is signed and dated 1905, Lhermitte wrote (statement in the Museum's records) that it was painted at Mont-Saint-Père in 1904 and exhibited in 1905. A related pastel, *Les dernières gerbes: effet de soir*, is dated 1904 (Hamel, 1975, cat. no. 402).

GUSTAVE LOISEAU

1865–1935. French. After study at the École des Arts Décoratifs, Loiseau went to Pont-Aven in 1890, joining the group around Gauguin. Although he exhibited with the Post-Impressionists at the Galerie Durand-Ruel from 1890 to 1896, his own style as a landscape painter was a late version of Impressionism.

The Banks of the Eure PL. 278

[Ca. 1900–05] Oil on canvas
25⅞ x 32⅛ in. (65.7 x 81.6 cm.)
Signed lower right: G. Loiseau

Acc. no. 06.251
Gift of Georges Durand-Ruel

EXHIBITIONS: Toledo Museum of Art, *Exhibition of One Hundred Paintings by the Impressionists from the Collection of Durand-Ruel and Sons,* Paris, 1905, no. 33.

This picture is dated by comparison with *La Seine à Port-Marly,* 1902 and *Lavoir sur la Seine à Herblay,* 1906 (Thiébault-Sisson, *Gustave Loiseau,* Paris, 1930, pp. 13, 21, repr.).

ALESSANDRO LONGHI

1733–1813. Italian. Born in Venice. Son of the painter Pietro Longhi; studied with Giuseppe Nogari. Elected to the Academy, 1759. In 1762 published *Il compendio delle vite de pittori Veneziana,* the lives of contemporary Venetian artists (including his own) with portraits engraved by him. Worked almost exclusively in Venice as a painter of portraits.

Giacomo Casanova PL. 39

[Ca. 1775] Oil on canvas
40¼ x 35½ in. (102 x 90 cm.)

Acc. no. 65.165

COLLECTIONS: Amici collection, Milan (Sale dell'Impresa, Milan, Mar. 14, 1889, lot 12, as Pietro Longhi); Crespi collection, Milan; (Frederick Mont, New York).

REFERENCES: B. Fredericksen and F. Zeri, *Census,* pp. 108, 511, 641.

Ferdinando Bologna ascribed this portrait to Alessandro Longhi (letters, May 1963 and July 1975). This attribution was accepted by Hermann Voss (letter, Oct. 1964) and Fredericksen and Zeri. Bologna characterizes this picture as an excellent example of the artist's power of individualization and of the pictorial qualities frequently found in his work.

In pose and handling of dark tonalities, the Toledo portrait may be compared with other works attributed to Alessandro, including *Carlo Goldoni* and *Gian Maria Sasso* (both Museo Correr, Venice); and the full length *Jacopo Gradenigo* (Museo Civico, Padua). Recently, however, it has been suggested that this painting is not by Longhi but by an unknown Neapolitan in the circle

of Bonito (A. S. Ciechanowiecki, letter, June 1975; M. Chiarini, letter, Sep. 1975) or by a painter influenced by the Udinese artist, Grassi (T. Pignatti, letter, May 1974). Other scholars have also rejected the attribution to Longhi, but agree that the portrait is Venetian (including M. Levey, letter, July 1975).

Bologna suggested a date of 1765–75, similar to that of the portraits of *Lodoli* (Accademia, Venice) and *Bartolomeo Ferracina* (Museo Correr, Venice).

The sitter was identified by a previous owner as the diarist Giacomo Casanova (1725–98). Although there is no conclusive evidence for this identification, the prominence of the book suggests that the sitter was a writer. He bears a resemblance to known portraits of Casanova, among them an earlier work attributed to Longhi (see C. Ver Heyden de Lancey, "Les portraits de Jacques et François Casanova," *Gazette des Beaux-Arts,* XI, 1934, pp. 98–107). Casanova was in Venice for the last time in 1774–83, and if the Toledo portrait is in fact Casanova, this agrees with the decade suggested by Bologna.

LORENZO MONACO

Ca. 1370–1423/24. Italian. Lorenzo Monaco, born Piero di Giovanni in Siena, was called "Lorenzo the Monk" after entering the Camaldolese monastery of Santa Maria degli Angeli, Florence in 1391. He was active ca. 1409–13 as a miniaturist. Lorenzo's early work was much influenced by Agnolo Gaddi, while his later style was inspired by the International Gothic and the sculptor Lorenzo Ghiberti. There are few works attributable to him with certainty.

Madonna and Child PL. I

[1390–1400] Tempera on wood panel
48-11/16 x 24 in. (123.7 x 61 cm.)

Acc. no. 76.22

COLLECTIONS: Church of Santa Maria del Carmine, Florence; Lady Helen O'Brien, London (Sotheby, London, Feb. 26, 1958, lot 49, as Florentine School, ca. 1380); Marchese Niccolò Antinori, Florence; (Agnew, London).

REFERENCES: F. Zeri, "Investigations into the Early Period of Lorenzo Monaco, II," *Burlington Magazine,* CVII, Jan. 1965, pp. 4–11, figs. 1, 11 (detail); L. Bellosi, "Da Spinello a Lorenzo Monaco," *Paragone,* No. 187, 1965, p. 37 (as "by this remarkable anonymous master"); M. Boskovits, *Pittura fiorentina alla vigilia del Rinascimento, 1370–1400,* Florence, 1975, pp. 135, 349, pl. VI (as Lorenzo Monaco, 1395–1400, but notes Bellosi's

placing of it near the Straus Master); F. Zeri, *Italian Paintings in the Walters Art Gallery*, Baltimore, 1976, I, pp. 26–7.

This imposing panel originally formed the center of an altarpiece, dismantled before 1745, whose scattered components were convincingly identified by Zeri (1965). According to his reconstruction, the Toledo panel was flanked by four panels of somewhat smaller standing figures, Sts. Jerome and John the Baptist on the left, and Sts. Peter and Paul on the right (Accademia, Florence; all now on loan to the church of Santa Maria at Quarto, near Florence). The altarpiece was completed with five predella panels: *St. Jerome in the Desert* (formerly Cremer collection, Dortmund, Germany); *St. John the Baptist Leaving for the Desert* (Museum and Art Gallery, Leicester, England); *Nativity* (Gemäldegalerie, Berlin-Dahlem); *Crucifixion of St. Peter* (Walters Art Gallery, Baltimore); *Decapitation of St. Paul* (Art Museum, Princeton University). The predella panels were beneath the appropriate main compartments, with the *Nativity* under the *Madonna and Child*. Zeri (1976) and Boskovits believe the altarpiece was executed for a chapel in the church of Santa Maria del Carmine at Florence, from which the four saints are known to have come in 1810.

Zeri, who attributed this altarpiece to Lorenzo Monaco, believes it was painted early in his career, about 1390 or shortly after, and he describes it as "constituting a significant bridge between the palette of Giotto and that of Fra Angelico," and "a document of fundamental importance for Florentine painting in the last quarter of the Trecento" (Zeri, 1965, pp. 4–7, 8). On the other hand, Bellosi believes it was done by another, anonymous late Gothic Florentine artist related to the Master of the Straus Madonna (active late 14th-early 15th century; named for a picture formerly in the Percy S. Straus collection, New York, now Museum of Fine Arts of Houston; his style is based upon Agnolo Gaddi, Spinello Aretino and Lorenzo Monaco).

LORENZO MONACO, Workshop of

Madonna and Child PL. 3

[Ca. 1418–20] Tempera on wood panel
34½ x 20½ in. (87.4 x 52 cm.)

Acc. no. 45.30

COLLECTIONS: Earl of Orford, Wolterton, by 1854 (Christie, London, June 26, 1856, lot 235, as School of Fra Angelico); Sir Francis Cook, 1st Bt., Doughty House, Richmond, Surrey, before 1868–1901; and by descent to Sir Francis Cook, 4th Bt., 1939–45; Trustees of the Cook Collection.

EXHIBITIONS: London, Burlington Fine Arts Club, *Gothic Art in Europe, ca. 1200–ca. 1500*, 1936, no. 32, pl. III (as Lorenzo Monaco); Toledo Museum of Art, *Masterpieces from the Cook Collection of Richmond, England*, 1944, no. 14, repr.

REFERENCES: G. Waagen, *Treasures of Art in Great Britain*, London, 1854, III, p. 436 (probably painting listed as Taddeo di Bartolo); O. Sirén, *Don Lorenzo Monaco*, Strasbourg, 1905, p. 170; J. A. Crowe and G. B. Cavalcaselle, *A History of Painting in Italy: Umbria, Florence and Siena* (ed. E. Hutton), London, 1908, I, pp. 449–50, n. 4; (ed. L. Douglas, 1911–26, II, p. 302, h.); B. Berenson, *The Florentine Painters of the Renaissance*, New York, 1909, p. 154; T. Borenius, *A Catalogue of the Paintings at Doughty House*, London, 1913, I, no. 14; R. Van Marle, *The Development of the Italian Schools of Painting*, The Hague, 1927, IX, p. 172, fig. 116; P. Toesca, *Florentine Painting of the Trecento*, New York, [1929], p. 57, pl. 114; B. Berenson, *Italian Pictures of the Renaissance*, Oxford, 1932, p. 301; [M. W. Brockwell], *Abridged Catalogue of the Pictures at Doughty House*, London, 1932, p. 25, no. 14; G. Pudelko, "The Stylistic Development of Lorenzo Monaco—II," *Burlington Magazine*, LXXIV, Feb. 1939, p. 76, n. 2; B. Berenson, *Italian Pictures of the Renaissance: Florentine School*, London, 1963, I, p. 121; B. Fredericksen and F. Zeri, *Census*, pp. 111, 315, 355, 641; M. Boskovits, *Pittura fiorentina alla vigilia del Rinascimento*, Florence, 1975, p. 354.

This painting has been attributed to Lorenzo Monaco by Crowe and Cavalcaselle, Berenson ("in great part by Lorenzo Monaco," 1932), Toesca, and Fredericksen and Zeri. It has been attributed to the workshop of Lorenzo Monaco by Sirén, Van Marle and Pudelko. According to Marvin Eisenberg (letter, Sep. 1975), who is preparing a monograph on the artist, it is one of several examples of this subject by his workshop done soon after he painted the *Annunciation* (ca. 1418–20; Accademia, Florence). He characterizes it as such by the presence of exaggerated linear rhythms, for example the mantles of the Virgin and Child. Eisenberg also notes parallels between the type of Christ Child and the form of the Madonna's hand with the *Madonna of Humility* (Johnson Collection, Philadelphia Museum of Art), which he also believes is by the workshop. He dates the Toledo painting ca. 1418–20.

In the gable of the 19th century frame is a medallion of *Christ Blessing,* and in the plinth, *The Man of Sorrows.* It is not certain that either was painted in the Lorenzo Monaco workshop, nor are they by the same hand, although both date from the first quarter of the 15th century. The two escutcheons in the plinth bear the arms of the Mazzinghi family of Florence, but there is no known reason to associate these arms with the commissioning of the painting.

LORRAIN (*see* CLAUDE)

JEAN LURÇAT

1892–1966. French. Born in Bruyères. Studied briefly at the École des Beaux-Arts; exhibited at the Salon des Indépendants. Traveled to Spain, Africa and Greece. After 1939 primarily a designer of tapestries.

Souvenir of Spain: PL. 295
The Birth of a Sailboat

[1931] Oil on canvas
37¼ x 59⅞ in. (94.6 x 152 cm.)
Signed and dated lower right: Lurçat 31

Acc. no. 48.62

COLLECTIONS: (Étienne Bignou, Paris).

EXHIBITIONS: Berlin, Galerie Flechtheim, *Jean Lurçat,* 1931, no. 31; Paris, Galerie Vignon, *Jean Lurçat,* 1931; Paris, Petit Palais, *Les maîtres de l'art indépendants,* 1937.

After extended travel between 1923 and 1925, Lurçat's style moved from Cubism toward Surrealism. This picture was painted in 1931 after his first trip to Spain.

LYON (*see* CORNEILLE)

MABUSE (*see* GOSSAERT)

NICOLAES MAES

1634–1693. Dutch. Studied with Rembrandt ca. 1648 in Amsterdam. Returned to his native Dordrecht in 1653 and remained there until he moved again to Amsterdam in 1673, where he lived for the rest of his life. Traveled to Antwerp ca. 1665–67 to study the works of Rubens and Van Dyck. Houbraken states that he visited Jacob Jordaens during this trip. Maes painted genre scenes under the influence of Rembrandt and possibly de Hooch until ca. 1660, after which time he became a portrait specialist.

The Happy Child PL. 135

[Early 1650s] Oil on wood panel
43¼ x 31½ in. (109.8 x 80 cm.)

Acc. no. 61.12

COLLECTIONS: Pieter de Smeth van Alphen, Amsterdam, 1810 (?); (Le Brun, Paris, 1811) (?); Howard Galton, Hadzor Manor, Droitwich, Worcestershire, by 1850; Prince Paul Demidoff, Florence (San Donato, Florence, Mar. 15, 1880, lot 1150); Baron Edouard de Rothschild, Ferrières, by 1916–61; (Rosenberg & Stiebel, New York).

EXHIBITIONS: Paris, Orangerie, *Les chefs-d'oeuvre des collections privées françaises retrouvé en Allemagne par la Commission de Récupération Artistique et les Services Alliés,* 1946, no. 88; Toledo Museum of Art, *Age of Rembrandt,* 1966, no. 30, repr. p. 65.

REFERENCES: J. Smith, VII, 1836, p. 65, no. 147 (as Rembrandt, dated 1641); G. Waagen, *Treasures of Art in Great Britain,* London, 1854, III, p. 221 (as Maes); W. Bode, *Great Masters of Dutch and Flemish Painting,* London, 1909, p. 50 (as *The Nurse*); C. Hofstede de Groot, VI, 1916, p. 499, no. 85; W. Valentiner, *Nicolaes Maes,* Stuttgart, 1924, pp. 43–4, pl. 5 (etching); H. Gerson, *Het Tijdperk van Rembrandt en Vermeer,* Amsterdam, 1952, p. 25, pl. 61; O. Wittmann, "Nicolaes Maes: The Happy Child," *Toledo Museum of Art Museum News,* IV, No. 4, Autumn 1961, pp. 75–8, repr. on cover.

Early paintings by Maes are rare. Because of the dramatic chiaroscuro, golden tone and Rembrandtesque spirit, which led Smith to catalogue the painting as Rembrandt, Valentiner believed it was done before Maes returned to Dordrecht, while he was still heavily influenced by his teacher.

Portrait of a Man PL. 136

[1680–90] Oil on canvas
19⅜ x 15 in. (49.3 x 38.1 cm.)
Signed lower right: Maes

Acc. no. 26.60

COLLECTIONS: Count Gregory Stroganoff, Rome, by 1912–25; (Sangiorgio, Rome, 1925); Edward Drummond Libbey, 1925.

REFERENCES: A. Muñoz, *Pièces de choix de la collection du Comte Grégoire Stroganoff*, Rome, 1912, II, p. 86, pl. LXVII.

While Van Dyck's influence is apparent, the opulence of dress and proud pose reflects French court portraiture. Dating is based on the style of clothing.

EDOUARD MANET

1832–1888. French. Born in Paris. Studied with Thomas Couture, 1850–56. Submitted to the Salon in 1859; first accepted there, 1861. Exhibited at the Salon des Refusés 1863. Travel to Italy 1853–54; Belgium, Holland, Germany and Italy, 1856; Spain, 1865; England, 1868. A major proponent of realism, Manet was an important influence on many of his friends and contemporaries, including Fantin-Latour, Monet and Renoir. Although much of his late work of the 1870s and 1880s is impressionistic in style, he refused to be identified with the Impressionist group.

Madame Edouard Manet PL. 246

[1873] Pastel on paper, mounted on canvas
21⅛ x 15¼ in. (53.7 x 38.7 cm.)

Acc. no. 52.17
Gift of Mrs. C. Lockhart McKelvy

COLLECTIONS: Eugène Manet, Paris; Ernest Rouart, Paris; (Ethel Hughes, Versailles); Mrs. C. Lockhart McKelvy, Perrysburg, Ohio.

EXHIBITIONS: Paris, Galerie Charpentier, *Cent portraits de femmes*, 1950, no. 67c; Toledo Museum of Art, *The Collection of Mrs. C. Lockhart McKelvy*, 1964, p. 12, repr. p. 13.

REFERENCES: T. Duret, *Manet and the French Impressionists*, Philadelphia, 1910, p. 263, no. 2; T. Duret, *Histoire de Edouard Manet et de son oeuvre*, 2nd ed., Paris, 1919, p. 285, no. 2; E. Moreau-Nélaton, *Manet raconté par lui-même*, Paris, 1926, II, pp. 50, 141, fig. 234; A. Tabarant, *Manet, histoire catalographique*, Paris, 1931, p. 447, no. 2; P. Jamot and G. Wildenstein, *Manet*, Paris, 1932, I, no. 312; II, fig. 244; A. Tabarant, *Manet et ses oeuvres*, Paris, 1947, pp. 237, 259, no. 454; P. Pool and S. Orienti, *The Complete Paintings of Manet*, New York, 1967, no. 191, repr.; D. Rouart and D. Wildenstein, *Edouard Manet: catalogue raisonné*, Lausanne and Paris, 1975, II, no. 2 (erroneously as 61 x 49 cm.).

Suzanne Leenhof (1830–1906), who met Manet in 1850 and became his wife in 1863, was the model for this and another pastel done about the same time (Louvre, Paris). In both she wears the same hat with long black ribbons. The Toledo portrait was dated 1878 by Moreau-Nélaton and Jamot-G. Wildenstein. More recently, however, Rouart and D. Wildenstein have dated it 1873, in agreement with Tabarant.

Antonin Proust PL. 247

[1880] Oil on canvas
51 x 37¾ in. (129.5 x 95.9 cm.)
Signed, dated and inscribed lower left: à mon ami Antonin Proust/1880/Manet.

Acc. no. 25.108

COLLECTIONS: Antonin Proust, Paris, 1880; Baron Vitta, Paris; (Spier, London); (Scott & Fowles, New York).

EXHIBITIONS: Paris, *Salon*, 1880, no. 2450; Paris, École des Beaux-Arts, *Manet, Posthumous Exhibition*, 1884, no. 95; Paris, École des Beaux-Arts, *Seconde exposition de portraits du siècle*, 1885, no. 212; Paris, *Exposition universelle internationale de l'art française*, 1889, no. 492; Paris, Galerie Georges Petit, *Exposition de portraits, écrivains et journalistes*, 1893, no. 743; New York, Wildenstein, *Edouard Manet*, 1937, no. 37, pl. XXXI; Worcester Art Museum, *Art of the Third Republic, French Painting, 1870–1940*, 1941, no. 3, repr; New York, Wildenstein, *Manet*, 1948, no. 37, repr. p. 34; New York, Wildenstein, *Faces from the World of Impressionism and Post-Impressionism*, 1972, no. 42, repr.

REFERENCES: L. Bazire, *Manet*, Paris, 1884, pp. 104–05, repr.; A. Proust, "Edouard Manet inédit," *La Revue Blanche*, Mar. 15, 1897, p. 315; T. Duret, "Les portraits peints par Manet et refusés par leurs modèles," *La Renaissance de l'art français*, July 1918, p. 153, repr.; T. Duret, *Histoire de Edouard Manet et son oeuvre*, Paris, 1919, 2nd ed., pp. 177, 179, 247, no. 263; T. Duret, *Manet and the French Impressionists*, Philadelphia, 1910, pp. 92, 93, 252, no. 263; A. Proust, *Edouard Manet, Souvenirs*, Paris, 1913, pp. 101, 102, 103, pl. 27; E. Moureau-Nélaton, *Manet raconté par lui-même*, Paris, 1926, II, pp. 65–6, 129, figs. 261, 346; A. Tabarant, *Manet, histoire catalographique*, Paris, 1931, pp. 367–69, 584, no. 316; P. Jamot and G. Wildenstein, *Manet*, Paris, 1932, I, pp. 98, 99, 166, no. 376; II, fig. 110; R. Goldwater and M. Treves, *Artists on Art*, New York, 1945, p. 304, repr. p. 305; J. Rewald, *The History of Impressionism*, 1st ed., New York, 1946, p. 344; 4th ed., 1973, p. 443, repr. p. 445; A. Tabarant, *Manet et ses ouvres*, Paris, 1947, pp. 374–82; G. H. Hamilton, *Manet and his Critics*, New Haven, 1954, pp. 230–32, 234–35, 237, 239, 243, 264, 275, pl. 34; F. Hemmings and R. Niess, eds., *Emile

Zola, Salons, Paris and Geneva, 1959, pp. 244, 260; P. Courthion and P. Cailler, eds., *Portrait of Manet by Himself and his Contemporaries,* London, 1960, pp. 30, 31, 163, 196, 216, repr. opp. p. 191; P. Pool and S. Orienti, *The Complete Paintings of Manet,* New York, 1967, pp. 85, 113, no. 303, repr. p. 112; D. Rouart and D. Wildenstein, *Edouard Manet, catalogue raisonné,* Lausanne and Paris, 1975, I, pp. 21–2, no. 331, repr.

Antonin Proust (1832–1905), a close friend of the artist from school days, and also a fellow student in Couture's studio, was a journalist, art critic and politician, who became Minister of Fine Arts in 1881. The evolution of Manet's portrait of him and its generally favorable contemporary critical reception at the 1880 Salon are detailed by Tabarant (1947). Shortly after the opening of the Salon exhibition, Manet wrote to Proust: "You have no idea how difficult it is, my dear friend, to place a single figure on canvas, and to concentrate all the interest on that one and only figure without its becoming lifeless and unsubstantial. Compared with this, it's child's play to paint two figures together who act as foils to each other. . . . Your portrait is painted with the utmost sincerity possible. I remember, as if it were only yesterday, the quick and simple way I treated the glove you're holding in your bare hand and how, when you said to me at that moment, '*Please,* not another stroke,' I felt in complete sympathy with you and could have embraced you." (Goldwater and Treves).

The portrait remained in Proust's possession and was shown in the large memorial exhibition of Manet's work in 1884 which he and the critic Théodore Duret organized.

Manet painted two other portraits of Proust about 1877 (Rouart and Wildenstein, nos. 262, 263: whereabouts unknown; Musée Fabre, Montpellier).

CARLO MARATTI

1625–1713. Italian. Born in Camerino. To Rome ca. 1636; studied with Andrea Sacchi. By 1670 was considered the leading painter in Rome and was patronized by successive Popes.

The Holy Family PL. 23

[Ca. 1700–05] Oil on canvas
28 x 21-1/16 in. (71.1 x 53.5 cm.)

Acc. no. 67.141

COLLECTIONS: John Blackwood, London, by 1769 (?); John Pratt, ca. 1780; by descent to Marquess Camden (Christie, London, June 12, 1841, lot 14); Earl of Nor-

manton and descendants, Somerley, Hampshire, 1841 (Christie, London, July 1, 1966, lot 73); (Colnaghi, London).

EXHIBITIONS: London, British Institution, *The Works of the late Sir David Wilkie, R. A. together with a Selection of Pictures by Ancient Masters,* 1842, no. 170; London, Colnaghi, *Paintings by Old Masters,* 1967, no. 12, pl. X.

REFERENCES: G. F. Waagen, *Galleries and Cabinets of Art in Great Britain,* London, 1857, IV, p. 366; J. W. Goodison and G. H. Robertson, *Catalogue of Paintings in the Fitzwilliam Museum, Cambridge,* II, *Italian Schools,* Cambridge, 1967, pp. 96–7; B. Fredericksen and F. Zeri, *Census,* pp. 119, 351.

According to A. Mezzetti (letter, July 1975) and F. H. Dowley (letter, July 1975) this picture was painted late in Maratti's career, based on comparisons with dated paintings of this subject in Vienna (1704; Kunsthistorisches Museum) and Leningrad (1705; Hermitage).

The relief of Charity on the sarcophagus on which Mary is seated is an allusion to Christ's death, and the drapery on it to His shroud.

A mezzotint engraving by P. J. Tassaert, published in London by J. Boydell in 1769 (C. Le Blanc, *Manuel de l'amateur d'estampes,* IV, 1890, no. 12) is inscribed as being after the original by Maratti in the collection of John Blackwood. A copy of the Toledo painting in the Fitzwilliam Museum, Cambridge is comprehensively discussed by Goodison and Robertson.

EMILE VAN MARCKE

1827–1890. French. Full surname was Van Marcke de Lummen. Born in Sèvres; studied at the Liège Academy before becoming a porcelain painter at Sèvres with Troyon; later specialized in animal subjects. Exhibited at the Salon from 1857. Traveled occasionally in France, but remained for most of his career on his farm at Bouttencourt, Normandy.

The Pasture Pool PL. 267

Oil on canvas
25-3/16 x 32¾ in. (64 x 83.2 cm.)
Signed lower left: Em. van Marcke.

Acc. no. 22.42

Gift of Arthur J. Secor

COLLECTIONS: (Schaus, to 1903); Arthur J. Secor, 1903–22.

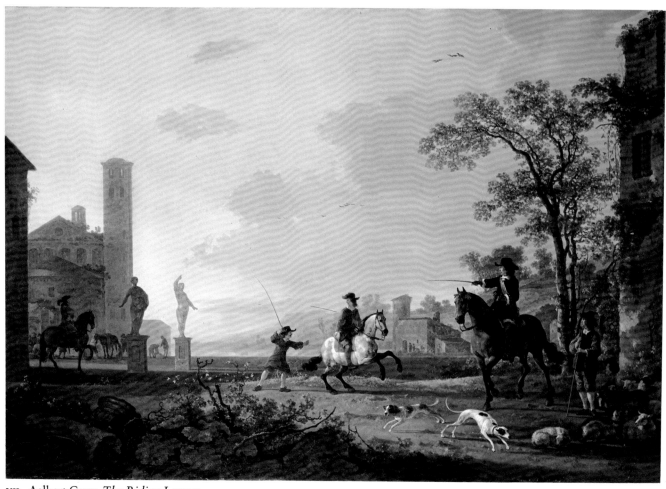

VII. Aelbert Cuyp, *The Riding Lesson*

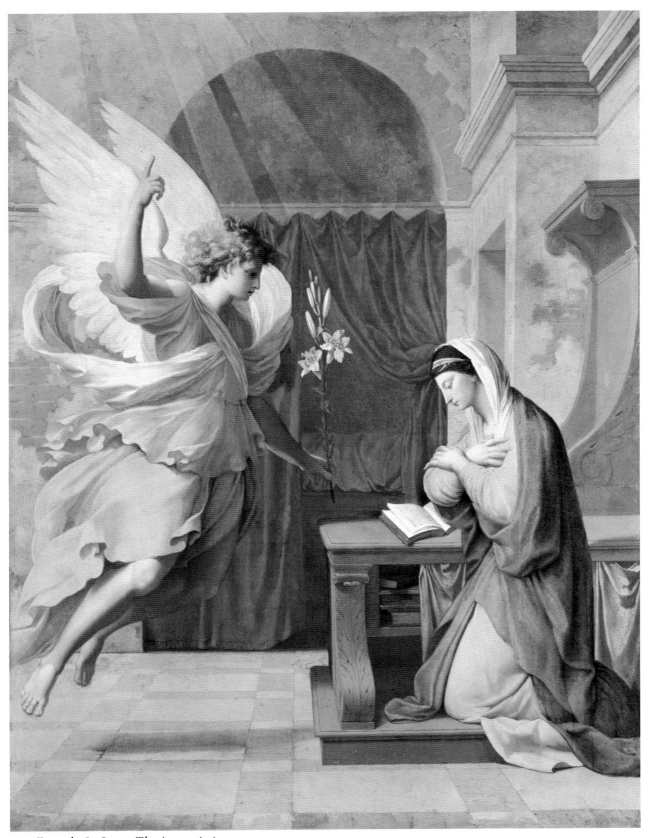

VIII. Eustache Le Sueur, *The Annunciation*

Cows PL. 268

Oil on canvas
19¾ x 25-13/16 in. (50.2 x 65.5 cm.)
Signed lower left: Em. van Marcke.

Acc. no. 25.41

COLLECTIONS: Edward Drummond Libbey, by 1922–25.

JACOB MARIS

1837–1899. Dutch. Born in The Hague, where he studied with the genre painter J. A. B. Stroebel, and later at the Antwerp Academy, 1854–56. Traveled in Holland, the Rhineland, Switzerland, and France. In 1865 to Paris, where he worked in the studio of the genre painter Ernest Herbert. About 1870, under the influence of Corot and the Barbizon School, he turned to landscape painting. After returning to The Hague in 1871, his style increasingly broadened, becoming more atmospheric. His younger brothers Matthijs and Willem were also painters.

Scheveningen PL. 158

[1879] Oil on canvas
21¾ x 16¾ in. (55 x 43 cm.)
Signed and dated lower right: J. Maris 1879

Acc. no. 22.32

Gift of Arthur J. Secor

COLLECTIONS: (Arthur Tooth, New York); Arthur J. Secor, 1909–22.

The nearby fishing port and beach at Scheveningen were often painted by Hague School artists.

 The last figure of the date may also be read 'o', but in 1870 Maris was still in Paris, and this picture is similar to others of the late 1870s (*Fishing Boat on the Beach*, 1878, Gemeentemuseum, The Hague; J. de Gruyter, *De Haagse School*, Rotterdam, 1969, II, fig. 25).

Amsterdam PL. 159

[Ca. 1880–99] Oil on canvas
19⅛ x 31 in. (48.5 x 78.5 cm.)
Signed lower right: J Maris

Acc. no. 25.42

COLLECTIONS: J. H. Van Eeghen, Amsterdam ?; (Henry Reinhardt, New York); Edward Drummond Libbey, 1908–25.

As Maris often repeated his subjects in the 1880s and 90s, it is difficult to date his pictures with any precision.

The Tow Path PL. 160

[Ca. 1890–95] Oil on canvas
15¼ x 23¼ in. (38.5 x 59 cm.)

Acc. no. 25.40

COLLECTIONS: Edward Drummond Libbey, 1925.

EXHIBITIONS: The Hague, Gemeentemuseum, *Meesters van de Haagse School,* 1965, no. 49, repr.

REFERENCES: J. de Gruyter, *De Haagse School,* Rotterdam, 1968, II, pp. 22, 30, repr. p. 24 (as ca. 1890).

Variations on this subject in oil (painted in 1894) and watercolor are in the Rijksmuseum, Amsterdam.

WILLEM MARIS

1844–1910. Dutch. Born and lived in The Hague. Student of his brothers, Jacob and Matthijs. Toured Germany in 1864 and Norway in 1871. His many landscapes with cows were painted in a tight and detailed manner until 1880, and in an increasingly loose and impressionistic style after that.

Pasture in Sunshine PL. 161

[Ca. 1870–80] Oil on canvas
19½ x 31¾ in. (49.5 x 80 cm.)
Signed lower right: Willem Maris F.

Acc. no. 22.33

Gift of Arthur J. Secor

COLLECTIONS: Arthur J. Secor, 1914–22.

EXHIBITIONS: The Hague, Gemeentemuseum, *Meesters van de Haagse School,* 1965, p. 7, no. 76, repr.

REFERENCES: J. de Gruyter, *De Haagse School,* Rotterdam, 1968, II, pp. 50, 59, 101, no. 6, repr.

The Lowlands PL. 162

[Ca. 1880–90] Oil on canvas
21½ x 29½ in. (55 x 75 cm.)
Signed lower right: Willem Maris

Acc. no. 25.43

COLLECTIONS: Edward Drummond Libbey, to 1925.

JOHN MARTIN

1789–1854. British. Born at Haydon, Northumberland. Pupil of Boniface Musso in Newcastle, 1804; followed him to London, 1806. Exhibited irregularly at the Royal Academy from 1811. After 1823 did engravings inspired

by Milton's *Paradise Lost* and after his own paintings. Specialized in spectacularly melodramatic Biblical and historical themes.

The Destruction of Tyre PL. 331

[1840] Oil on canvas
33 x 43⅛ in. (83.8 x 109.5 cm.)
Signed and dated lower right: J. Martin./1840

Acc. no. 52.88

COLLECTIONS: F. W. Goodfellow, London; (Robert Frank, London).

EXHIBITIONS: Newcastle-upon-Tyne, Laing Art Gallery, *Exhibition Recording Tyneside's Contribution to Art,* 1951, no. 147.

REFERENCES: T. Balston, "Recent Martin Discoveries," *Burlington Magazine,* XCIII, Sep. 1951, p. 292; R. Huyghe, *Formes et forces de l'atome à Rembrandt,* Paris, 1971, repr. p. 33; W. Feaver, *The Art of John Martin,* Oxford, 1975, pp. 170, 194, 197, 230, n. 81, pl. 128.

The subject is from the Old Testament, Ezekiel XXVI, in which the prophet foretells the destruction of old Tyre by Nebuchadnezzar, and alludes to the siege of new Tyre by Alexander the Great. This illustration of the words 'when I bring up the deep over you, and the great waters cover you' (verse 19), furnished Martin with a characteristic Romantic theme, the futility of man when confronted by the forces of God and nature.

A small sepia drawing dated 1834 (P. T. Rathbone Collection, New York), engraved for Westall and Martin's *Illustrations of the Old and New Testament* (London, 1837), is closely related to this painting.

ANDRÉ MASSON

1896–. French. Born in Balagny, France. Studied at Académie Royal des Beaux Arts, Brussels, and at Paris École des Beaux Arts. After World War I was influenced by Cubists; friend of Juan Gris. Associated with Surrealists 1924–29. Traveled to Spain 1934–36, America 1941–45. Settled in Aix-en-Province, 1947.

The Harbor Near St. Mark's, Venice PL. 303

[1951] Oil on canvas
39⅜ x 19⅝ in. (100 x 50.1 cm.)
Signed lower left: André Masson
Inscribed on reverse: AM (monogram) Le Bassin de St. Marc 1951

Acc. no. 52.102

COLLECTIONS: (Galerie Louise Leiris, Paris).

CORNELIS MASSYS

Ca. 1510–after 1580. Flemish. Son of Quentin Massys, with whom he probably studied. Admitted to the Antwerp guild of painters, 1531; went to Italy about 1562. Massys did many imaginary panoramic landscapes in the style of the Antwerp painter Joachim Patinir (died ca. 1524). He was also a prolific engraver.

Landscape with the Judgment of Paris PL. 87

[Ca. 1545] Oil on wood panel
12¾ x 17⅛ in. (32.4 x 43.5 cm.)

Acc. no. 35.57

COLLECTIONS: R. Langton Douglas, London.

REFERENCES: E. de Callatay, "Cornelis Massys paysagiste, collaborateur de son père et de son frère et auteur de l'album Errera," *Musées Royaux des Beaux-Arts de Belgique Bulletin,* XIV, 1965, pp. 51, 54, 63, fig. 2; M. Friedländer, *Early Netherlandish Paintings,* (ed., H. Pauwels), IXb, 1973, pp. 132, 138, n. 204.

Previously attributed to Patinir, the attribution to Cornelis Massys was verbally suggested by Josua Bruyn (1958) and Charles Sterling (1960). Callatay compares it to Massys' *Landscape with St. Jerome* of 1547 (Musée Royal des Beaux-Arts, Antwerp).

MASTER OF ÁVILA

Spanish. The leading painter of Ávila in the last third of the 15th century. There have been attempts to identify him as Pedro Diaz of Oviedo, and, especially, as Garcia del Barco.

The Adoration of the Magi PL. 50

[Ca. 1475] Oil on wood panel
46 x 27 in. (116.9 x 68.6 cm.)

Acc. no. 55.27

COLLECTIONS: Dupont, Barcelona.

REFERENCES: C. R. Post, *A History of Spanish Painting,* Cambridge, Mass., 1950, X, p. 349, fig. 140; 1953, XI, p. 416; J. Gudiol, "El Maestro de Ávila," *Goya,* No. 21, Nov.-Dec. 1957, pp. 144, 145, repr. p. 144.

Both Post (1950) and Gudiol agree on the attribution and on Post's suggestion that the Toledo panel may have been part of the same altarpiece as *The Meeting at the Golden Gate* in S. Vicente, Ávila; Post (1950) also suggested that the fragment of a female saint and a *Lamen-*

tation (both Alcázar Museum, Ávila) may have been part of the same altarpiece.

MASTER OF GERIA

Spanish. Active at the end of the 15th century in Castile, particularly in the Valladolid region. His style is related to that of Fernando Gallego, and is especially close to that of the Master of Ávila.

The Retable of Saint Andrew PL. 48

(A) *Virgin and Saint Ildefonsus;* (B) *Crucifixion;* (C) *Martyrdom of Saint Catherine;* (D) *Last Supper with a Donor;* (E) *Saint Andrew;* (F) *Bishop Saint as Patron of a Donor*

[Ca. 1475–1500] Oil on wood panel
(A) 33¼ x 15⅝ in. (84.4 x 39.6 cm.); (B) 36¼ x 23 in. (92 x 58.3 cm.); (C) 33⅜ x 15⅞ in. (84.6 x 40.3 cm.); (D) 33¼ x 15¾ in. (84.5 x 40 cm.); (E) 45¾ x 23⅜ in. (166.2 x 59.3 cm.); (F) 33⅛ x 15¾ in. (84.2 x 40 cm.)

Acc. no. 55.214 A-F

REFERENCES: J. Gudiol, "Una obra inedita del Maestro de Geria," *Studies in the History of Art Dedicated to William Suida on his Eightieth Birthday,* London, 1959, pp. 106–09, figs. 1–4; R. Cruz, "El Maestro de los Claveles," *Goya,* No. 61, 1964, pp. 12, 14–6, repr. pp. 15, 16; R. E. Osman, "The Monte Gargano Episode from the Life of Saint Michael, A Fifteenth Century Castilian Panel Painting," *Archivero,* Santa Barbara Museum of Art, I, 1973, pp. 57, 65 n. 19, 67, repr. p. 58 (accepts attribution of Cruz to Claveles Master).

C. R. Post grouped together several paintings (not including the Toledo retable) which he believed had been painted by the same artist, who he named the Master of Geria, after the town near Simancas (Valladolid province) in which one of them is located ("El Maestro de Geria," *Boletín del Seminario de Estudios de Arte y Arqueologia,* University of Valladolid, XIX, 1952–53).

Gudiol later attributed the Toledo retable to the Master of Geria, as being the most complete work by this master. According to Gudiol (letters, May and Sep. 1956), Post also agreed with this attribution. Cruz, on the other hand, named this painter the Claveles Master.

MASTER OF JÁTIVA

Spanish. Active in the late 15th and early 16th centuries at Valencia. Named for the town where a number of his principal works are located.

The Adoration of the Magi PL. 51

[Ca. 1500] Oil on wood panel
12 x 8¾ in. (30.5 x 22.3 cm.)

Acc. no. 26.82

COLLECTIONS: Edward Drummond Libbey.

EXHIBITIONS: Toledo Museum of Art, *Spanish Painting,* 1941, no. 23, fig. 23 (cat. by J. Gudiol).

REFERENCES: C. R. Post, *A History of Spanish Painting,* Cambridge, Mass., 1941, VIII (pt. 2), p. 719, fig. 342; 1953, XI, p. 430; 1958, XII (pt. 2), p. 663; J. Gaya Nuño, *La pintura española fuera de España,* Madrid, 1958, no. 1509.

Post attributed this panel to the Játiva Master, dating it ca. 1500 (letter, Oct. 1939), and Gudiol agreed on both points. Post (1941) also pointed out the special attention this artist gave to detailed landscape, an unusual feature in Valencian painting of the time strongly evident in this panel.

MASTER OF THE LAST JUDGMENT

Spanish. Active first half of the 12th century in Catalonia.

Saints James and Philip PL. 45

[Ca. 1125] Fresco
55¼ x 33 in. (140.4 x 83.8 cm.)
inscribed upper left on arch: SCS IACOBVS
inscribed upper right on arch: SCS FILIPVS

Acc. no. 56.16

Museum Purchase

Like the *Saint John* from Isabarre in the Toledo collection (see Spanish, Catalonian) this is a fragment of mural painting probably from a church in the same general district of the Pyrenees.

C. R. Post (letter, Oct. 1958), who confirmed the attribution of this fragment to the Master of the Last Judgment, pointed out similarities in style with frescoes in the church of S. Clemente, Tahull. He also suggested the Apostle on the left may be St. James the Less, as he and St. Philip share the same feast day.

MASTER OF THE MORRISON TRIPTYCH

Active ca. 1500. Flemish. Probably worked in Bruges and Antwerp; he may have come from Holland. Named from the following work, once in the Morrison collection, England.

The Morrison Triptych [COLOR PL. II] PL. 79a–e

(A) left wing: *Saint John the Baptist;* verso: *Adam;*
(B) center: *The Virgin and Child with Angels;*
(C) right wing: *Saint John the Evangelist;* verso: *Eve*

[Ca. 1500] Oil on wood panel

(A) 43⅝ x 14⅝ in. (110.8 x 37.2 cm.); (B) 38⅜ x 23¾
 in. (97.5 x 60.4 cm.); (C) 43⅝ x 14⅝ in. (110.8 x 37.2
 cm.)

Acc. no. 54.5 A-C

COLLECTIONS: Perhaps brought from Spain at an un-
known date in the 19th century; Alfred Morrison, Font-
hill House, Tisbury, Wiltshire, to 1897; Hugh Morri-
son; John Morrison; (Rosenberg & Stiebel, New York).

EXHIBITIONS: London, Burlington Fine Arts Club, *Early
Netherlandish Pictures,* 1892, no. 42 (as Jan Gossaert
?); London, Burlington Fine Arts Club, *Catalogue of the
Loan Exhibition of Flemish and Belgian Art, a Memorial
Volume,* 1927, no. 60, pl. XXXII (as attributed to Mem-
ling; "walled up in a monastery during the Peninsular
War").

REFERENCES: M. J. Friedländer, "Der Meister der Mor-
rison Triptychons," *Zeitschrift für bildende Kunst,*
XXVII, 1915, pp. 13, 14, fig. 3; M. J. Friedländer, *Die
altniederländische Malerei,* Leyden, 1934, VI, p. 116, no.
9a; VII, pp. 80–2, no. 81, pls. LVI, LVII; M. Conway, *The
Van Eycks and their Followers,* New York, 1921, pp.
216, 317; L. Baldass, *Joos van Cleve, der Meister des
Todes Mariä,* Vienna, 1925, p. 6, no. 61; G. Nieto Gallo,
"El retablo de San Juan Bautista en la iglesia del Salva-
dor de Valladolid, Quentin Metsys o Adriaen Skille-
man?," *Boletin del Seminario de Estudios de Arte y
Arqueologia,* Valladolid, V-VI, 1939–40, p. 59; M. Davies,
Les Primitifs Flamands: The National Gallery, London,
Antwerp, 1953, I, p. 5; W. R. Valentiner, "Simon van
Herlam, the Master of the Morrison Triptych," *Gazette
des Beaux-Arts,* XLV, Jan. 1955, pp. 7, 10; (W. Hutton),
"The Morrison Triptych," *Toledo Museum of Art Mu-
seum News,* No. 159, Summer, 1955, unpaginated, repr.;
P. Wescher, "Beiträge zu Simon van Haarlem, dem Meis-
ter des Morrisons Triptychons," *Jahrbuch der Berliner
Museen,* VII, 1965, pp. 175, 178, 180; P. Phillipot, "Les
grisailles et les degrés de la réalité de l'image dans la
peinture flamande des XVe et XVIe siècles," *Bulletin des
Musées Royaux de Belgique,* 1966, No. 4, p. 237, fig. 9;
M. Davies, *National Gallery Catalogues: Early Nether-
landish School,* 3rd ed., London, 1968, p. 121; G. von
der Osten, *Painting and Sculpture in Germany and the
Netherlands, 1500–1600,* Harmondsworth, 1969, p. 146;
M. J. Friedländer, *Early Netherlandish Painting* (ed.,
H. Pauwels), New York, 1971, VIa, no. 9a; VII, pp. 41–2,
no. 81, pp. 89–90, pls. 69, 70, fig. 81.

In 1915 Friedländer grouped together several paintings
he believed were by the same unidentified artist, naming
him the Master of the Morrison Triptych after this
work. According to Friedländer, the artist's style has
some relation to the Antwerp painter Quentin Massys
(1465/66–1530). Friedländer later (1934, 1971) acknowl-
edged the difficulties in attributing works to this painter.
Davies, who believed that works attributed to the Mor-
rison Master lack stylistic coherence, questioned the use-
fulness of this name.

Friedländer tentatively identified the Morrison Master
as Adriaen Skilleman (1915), and then later as Quentin
Massys' pupil Ariaen (1934, 1971). G. Nieto Gallo also
believes that the Morrison Master is Adriaen Skilleman.
Valentiner suggested that the Master was Simon van
Herlam (or Haarlem), an identification accepted by
Wescher but rejected by Davies (1955, 1968).

This triptych substantially repeats the composition of
one by the Bruges painter Hans Memling (active 1465–
94) in the Kunsthistorisches Museum, Vienna (Fried-
länder, 1971, VIa, pl. 32–5), though the Morrison Mas-
ter quite freely interpreted Memling's architectural set-
ting and landscape, and his own style is also apparent
in the individual character and scale of some figures.
In addition, the landscape behind the Virgin's head re-
places Memling's brocade panel, and a lute-playing an-
gel his kneeling donor.

In the upper corners of the central panels are two
Old Testament episodes, allusions to Christ's sacrifice
and redemption: left, Abraham and Isaac (Genesis
XXII:9–13) and right, Jephthah and his daughter (Judges
XI:39). The kneeling angel with a pear holds a *lira da
braccia,* an ancestor of the violin.

MASTER OF THE VISION OF SAINT JOHN
German. Active ca. 1450–60 in Cologne. He may have
come from the middle or upper Rhine.

The Adoration of the Magi PL. 62

[Ca. 1460] Oil on wood panel
51 x 28 in. (129.5 x 71.1 cm.)
Inscribed lower right (below knee of the kneeling figure):
 Par--st
 HP

Acc. no. 36.80

COLLECTIONS: Count Julius Andrassy, Hungary; Private
collection, Switzerland; (E. & A. Silberman, New York).

REFERENCES: O. Fischer, "Ein Kölner Meister um 1450–
60," *Pantheon,* IX, Oct. 1936, pp. 318–22, repr. p. 319;

A. Strange, *Deutsche Malerei der Gotik,* Munich, 1952, V, pp. 14, 15, fig. 15.

Fischer attributed this painting, *Saints Cosmas, Damian and Pantaleon* (private collection, Switzerland) and *The Vision of Saint John* (Wallraf-Richartz, Cologne) to the same artist, who he named after the Cologne panel. He also suggested that the Toledo and Swiss panels may have originally been interior wings of one altarpiece.

Stange upheld Fischer's attribution, while earlier H. Tietze (letter, Dec. 1936) and G. Ring (letter, Dec. 1949) found a Cologne origin for the Toledo panel unacceptable. However, these objections should be weighed against the evidence that both the Wallraf-Richartz and Swiss panels have a Cologne provenance. Fischer also observed that as the Saint John Master may have been trained elsewhere, his style could well have differed from those of native Cologne painters.

The significance of the inscription at lower right is unclear.

HENRI MATISSE

1869–1954. French. Born at Le Cateau. Student of Bouguereau, Gérôme and Gustave Moreau. Experimented early with Impressionism and Neo-Impressionism. Influenced by Cézanne. Leader of the Fauve group. Traveled widely and influenced by Oriental, African and Near Eastern art. Also produced sculpture, book illustrations, architectural decoration, prints and drawings. The last thirty years of his life were mostly spent in the south of France.

Flowers PL. 291

[Ca. 1924] Oil on canvas
39⅝ x 32¼ in. (100.1 x 81.8 cm.)
Signed lower right: Henri Matisse

Acc. no. 35.50

COLLECTIONS: Josse Bernheim-Jeune, Paris, 1924–33; (Bernheim-Jeune, Paris).

EXHIBITIONS: Los Angeles County Museum, *Aspects of French Painting from Cézanne to Picasso,* 1941, no. 29.

REFERENCES: R. Fry, *Henri Matisse,* Paris, 1930, fig. 22.

According to Bernheim-Jeune (letter, May 1976), this picture was bought from Matisse in February 1924. It belongs to a series of sumptuous still lifes set in studio interiors, painted in 1924–25, in which the principal subject is arranged on a patterned tablecloth against a background decorated with wallpaper patterns and examples of Matisse's work.

Dancer Resting PL. 292

[1940] Oil on canvas
32 x 25½ in. (81.2 x 64.7 cm.)
Signed and dated lower right: Henri Matisse 40

Acc. no. 47.54

Gift of Mrs. C. Lockhart McKelvy

COLLECTIONS: Mr. and Mrs. Lee Ault, New York, to 1946; (Knoedler, New York); Mrs. C. Lockhart McKelvy, Perrysburg, Ohio.

EXHIBITIONS: New York, Valentine Gallery, *Modern Paintings from the Lee Ault Collection,* 1944, no. 29, repr.; New York, Museum of Modern Art, *Paintings from Private New York Collections,* 1946, no. 3; Toledo Museum of Art, *The Collection of Mrs. C. Lockhart McKelvy,* 1964, pp. 22–3, repr.; Buffalo, Albright-Knox Art Gallery, *Color and Field 1890–1970,* no. 33.

REFERENCES: H. La Farge, "Ruisdael to Pissarro to Noguchi," *Art News,* XLIX, Mar. 1950, p. 59; A. H. Barr, *Matisse: His Art and his Public,* New York, 1951, p. 559.

This painting belongs to a group of pictures begun about 1940 in which a model is seated beside rich foliage with other works by Matisse shown in the background. The model was Lydia Delectorskaya, one of Matisse's favorite models in the 1930s, who acted as secretary and housekeeper in the early 40s. There is a charcoal drawing for the figure and chair dated 1939 (National Gallery of Canada, Ottawa).

ANTON MAUVE

1838–1888. Dutch. Born at Zaandam. Mauve studied at Haarlem with the animal painters Van Os and Verschuur. About 1856–59 lived at Osterbeck, where he met the Maris brothers, whose ideas emphasized a return to nature. In Amsterdam, 1868; to The Hague in 1874, where he became a leading member of the Hague School, a branch of which he established at Laren in 1885; among his pupils was his distant cousin, Vincent van Gogh.

Homeward Bound PL. 166

[Ca. 1872–82] Oil on canvas
26 x 40 in. (66 x 101.6 cm.)
Signed lower right: A Mauve

Acc. no. 25.53

COLLECTIONS: Alexander Young, London, 1905–06; (Agnew, London); Edward Drummond Libbey, 1906–25.

REFERENCES: "The Collection of Mr. Alexander Young, IV. The Modern Dutch Painters," *The Studio*, XXXIX, Jan. 1907, p. 287, repr. (as *The Wet Road*).

According to J. de Gruyter (*De Haagse School*, Rotterdam, 1968, II, p. 71), Mauve often treated similar themes between 1872 and 1882. The free brushwork and brown tonality also suggest a dating after 1870.

A Dutch Road PL. 165

[Ca. 1880] Oil on canvas
20 x 14½ in. (50.5 x 36.8 cm.)
Signed lower right: A. Mauve f.

Acc. no. 22.22

Gift of Arthur J. Secor

COLLECTIONS: (Henry Reinhardt, Milwaukee); Arthur J. Secor, 1909–22.

REFERENCES: D. Sutton, "Nineteenth-Century Painting—Trends and Cross-Currents," *Apollo*, LXXXVI, Dec. 1967, p. 491, fig. 16.

The gray tonality, strong one-point perspective and subject suggest a date about 1880, just before Mauve moved to Laren.

Sheep on the Dunes PL. 167

[Probably after 1882] Oil on canvas
36½ x 75 in. (92.5 x 189 cm.)
Signed lower right: A. Mauve f.

Acc. no. 25.52

COLLECTIONS: (Henry Reinhardt, Milwaukee); Edward Drummond Libbey, 1908–25.

EXHIBITIONS: Toledo Museum of Art, *Inaugural Exhibition*, 1912, no. 187, repr.

REFERENCES: D. Preyer, *Art of The Netherland Galleries*, Boston, 1908, pp. 288, 291, pl. 37 (as at Municipal Museum, Amsterdam); J. Keefe, "Drawings and Watercolors of Anton Mauve," *Toledo Museum of Art Museum News*, IX, Winter, 1966, p. 96, repr.

JUAN BAUTISTA DEL MAZO

1612/16–1667. Spanish. Born in Cuenca province. In Madrid he became the principal pupil of Velázquez, whose daughter he married. In 1634 he was named Usher to the King, and became painter to Prince Baltasar Carlos. In Naples, 1657. After the death of Velázquez (1660) Mazo was appointed Court Painter. Although he was a prolific painter and admired by contemporaries, there are few certain works by him. Many pictures in the style of Velázquez are attributed to him; only two signed works are known.

A Child in Ecclesiastical Dress PL. 59

[Ca. 1660–67] Oil on canvas
65⅞ x 48 in. (167.3 x 121.9 cm.)

Acc. no. 51.364

COLLECTIONS: Harrach collection, Vienna, late 17th century-1950; (Frederick Mont, New York).

REFERENCES: G. F. Waagen, *Der vornehmsten Kunstdenkmäler in Wien*, Vienna, 1866, no. 338 (as Velázquez); C. B. Curtis, *Velázquez and Murillo*, New York, 1883, no. 150 (as Velázquez); P. Lefort, *Velázquez*, Paris, 1888, p. 146 (as Velázquez); C. Justi, *Velázquez und sein Jahrhundert*, 2nd ed., Bonn, 1903, II, p. 260; 4th ed., Zurich, 1933, pp. 683–85, 753, repr. p. 655 (as by Mazo); A. Baldry, *Velázquez*, London, 1905, p. XXIX (as Velázquez); A. de Bereute y Moret, *The School of Madrid*, London, 1909, pp. 119–21 (as Mazo); G. Glück, *Die Harrachsche Bildergalerie*, Vienna, 1923, no. 13, repr. (as Mazo); A. L. Mayer, *Velázquez, A Catalogue Raisonné of the Pictures and Drawings*, London, 1936, no. 437, pl. 112 (as probably Mazo); J. A. Gaya Nuño, *La pintura española feura de España*, Madrid, 1958, no. 1724 (as attributed to Velázquez); G. Kubler and M. Soria, *Art and Architecture in Spain and Portugal and Their American Dominions, 1500 to 1800*, Harmondsworth, 1959, pp. 264, 284 (as Mazo); J. López-Rey, *Velázquez: A Catalogue Raisonné of his Oeuvre*, London, 1963, no. 481, pl. 309 (as perhaps Mazo); M. F. Rogers, "Spanish Painting in the Museum Collection," *Toledo Museum of Art Museum News*, X, Summer 1967, pp. 35–6, repr.; J. B. Fernández, *Juan Carreño, pintor de Camera de Carlos II*, Madrid, 1972, pp. 50–1, repr. p. 129 (as Juan Carreño).

The young boy in ecclesiastical dress stands in a room of the old Alcázar Palace at Madrid, destroyed by fire in 1734. The landscape at the right shows the Jardin del Moro extending to the Manzanares River, beyond which is the Royal Park and Casa del Campo, a garden pavilion, with the Guadarrama Mountains in the distance.

The child has been variously identified as a natural son of Philip IV (Mayer); a son of Ferdinand Harrach, Ambassador to Madrid (Justi); and one of the artist's sons (Rogers), though none of these is conclusive. Justi, who considered the subject of this portrait in detail, believed that the child is wearing the robes of a cathedral

canon rather than those of a cardinal. The boy has some-times been thought to be a cardinal, though no child with that title is known at this time.

Justi assigned this painting to Mazo, an attribution accepted by Glück, Mayer, Soria, López-Rey, and most other writers except Fernández, who believes it is by Juan Carreño (1614–1685). Soria believed it is one of Mazo's best portraits, and López-Rey stated the execution recalls Mazo's portrait of *Queen Mariana* (National Gallery, London), dated 1666.

LORD METHUEN

1886–1974. British. Paul Ayshford Methuen succeeded as 4th Baron Methuen in 1932. Born at Corsham Court in Wiltshire, his family home. Studied with Sir Charles Holmes at Oxford and with Sickert. Landscape painter in both oils and watercolor.

Brympton d'Evercy, Somerset PL. 355

[Ca. 1948–49] Oil on canvas
25¼ x 30¼ in. (64.1 x 76.8 cm.)
Signed lower left: Methuen

Acc. no. 49.81

Museum Purchase

COLLECTIONS: (Leicester Galleries, London).

EXHIBITIONS: London, Leicester Galleries, 1949, no. 36.

Brympton d'Evercy, near Yeovil, was probably built about 1670–80.

PIETER TER MEULEN

1843–1927. Dutch. Studied painting in The Hague, then classics at Leiden University, returning in 1874 to The Hague. Admired the realism of Anton Mauve, with whom he later worked at Laren. His own work con-sisted entirely of landscapes with animals, particularly sheep. As a writer, he was to some extent the theorist of the Hague School painters.

Gelderland Pastures PL. 163

[Ca. 1900] Oil on canvas
28⅝ x 39½ in. (72.5 x 100.5 cm.)
Signed lower left: Ter Meulen

Acc. no. 22.40

Gift of Arthur J. Secor

COLLECTIONS: (A. Tooth & Sons, London); (Vose, Bos-ton, 1909–12); Arthur J. Secor, 1912–22.

GEORGES MICHEL

1763–1843. French. Born in Paris, which he rarely left. Studied with the history painter Leduc. Exhibited at the Salon 1796–1814 without critical or financial success. About 1800 he was commissioned by the Louvre to re-store 17th century Dutch and Flemish paintings, an ex-perience influential on his own art. Michel's entire work consists of landscapes, and he is considered a precursor of the Barbizon painters.

Landscape with Oak Trees PL. 217

Oil on canvas
31½ x 38½ in. (80 x 97.8 cm.)

Acc. no. 62.33

COLLECTIONS: (Cailleux, Paris).

EXHIBITIONS: Paris, Musée Carnavalet, *Paris vu par les maîtres de Corot à Utrillo*, 1961, no. 78, repr.

This landscape with a church spire and characteristic windmills was probably inspired by the countryside near Montmartre, then open land on the northern edge of Paris and an inexhaustible subject for Michel.

The chronology of his work is obscure, and Michel also said that he made a point of not signing his pic-tures.

FRANCISQUE MILLET

1642–1679. French. Born Jean-François Millet in Ant-werp, where he studied with Laurens Francken. Called Francisque to distinguish him from his son and grand-son, painters of the same name. In 1659 to Paris, where he studied with Abraham Genoëls, remaining there for the rest of his life. Member of the Académie Royale, 1673. Although he never visited Italy, he nonetheless produced classical landscapes in the manner of Poussin. His work is unsigned, its identification based on etchings by Théodore after his paintings.

Landscape with Christ PL. 193
and the Woman of Canaan

Oil on canvas
37¾ x 51⅝ in. (95.8 x 131.2 cm.)

Acc. no. 60.28

COLLECTIONS: Chevalier Sébastien Erard (Lacoste-M. Henry, Paris, Apr. 23, 1832, lot 96, as Millé (Jean-Francisque), and Christie, London, June 22, 1833, lot 17, as F. Mille); Comtesse de Franqueville (his great-niece);

Mme. Darcy, Belgium; Chevalier de Schoutheete de Tervarent; Count Zamoyski (Sotheby, London, July 8, 1959, lot 63); (Colnaghi, London).

EXHIBITIONS: London, Colnaghi, *Paintings by Old Masters,* 1960, no. 3, pl. III.

REFERENCES: M. Davies, "A Note on Francisque Millet," *Bulletin de la Société Poussin,* No. 2, Dec. 1948, p. 24.

While this painting does not exactly correspond to Théodore's etching of this subject, the attribution to Millet is certain. In the etching, there are six rather than five apostles, and the other figures have been slightly altered, as has the landscape to a greater extent. The passage from the New Testament which the foreground figures illustrate is Matthew, XV:21–28.

JEAN-FRANÇOIS MILLET

1814–1875. French. Born near Gréville, Normandy, the son of prosperous peasants. Student of Delaroche in Paris, 1837–38. Settled in Barbizon in 1849 and remained there the rest of his life. Exhibited in Salons 1840–70. Beginning his career as a portraitist, after 1848 he became famous for subjects of peasant life. After 1865 he painted many landscapes, encouraged by Théodore Rousseau. He also did many etchings and pastels.

The Quarriers PL. 222

[1846–47] Oil on canvas
29 x 23½ in. (73.6 x 59.6 cm.)
Millet sale stamp, lower right: J. F. Millet
Wax seal removed from stretcher: VENTE/J.F. MILLET

Acc. no. 22.45

Gift of Arthur J. Secor

COLLECTIONS: (Millet Sale, Paris, Hôtel Drouot, May 11, 1875, lot 3, as *Carriers*); Daniel Cottier, Paris; Ichabod T. Williams, New York (American Art Association, New York, Feb. 3–4, 1915, lot 100); (Knoedler, New York); Arthur J. Secor, 1915–22.

EXHIBITIONS: Buffalo, Albright Art Gallery, *The Nineteenth Century: French Art in Retrospect,* 1932, no. 5, repr.; Detroit Institute of Arts, *French Painting from David to Courbet,* 1950, no. 107, repr. on cover; London, Tate Gallery, *The Romantic Movement,* 1959, no. 253, pl. 33; Boston, Museum of Fine Arts, *Barbizon Revisited,* 1963, no. 59, repr. (cat. by R. Herbert); Indianapolis, Herron Museum of Art, *The Romantic Era, Birth and Flowering, 1750–1850,* 1965, no. 47, repr.; New York, Wildenstein, *Romantics and Realists,* 1966, no.

57, repr.; Paris, Grand Palais, *Jean François Millet,* 1975, no. 37, repr. (cat. by R. Herbert).

REFERENCES: E. Wheelwright, "Personal Recollections of Jean-François Millet," *Atlantic Monthly,* XXXVIII, 1876, p. 263; A Sensier, *La vie et l'oeuvre de Jean-François Millet,* Paris, 1881, p. 104; L. Soullié, *Les grands peintres aux ventes publiques: Jean-François Millet,* Paris, 1900, p. 43; P. Brandt, *Schaffende Arbeit und bildende Kunst,* Leipzig, 1928, p. 229; J. Canaday, *Mainstreams of Modern Art,* New York, 1959, p. 123, repr.; M. Brion, *Art of the Romantic Era,* London, New York, 1966, repr.; R. Huyghe, *Sens et destin de l'art, de l'art gothique au XXe siècle,* Paris, 1967, II, p. 219; J. Bouret, *L'école de Barbizon et le paysage français au XIXe siècle,* Neuchâtel, 1972, p. 159, repr. p. 158; K. Clark, *The Romantic Rebellion,* London, 1973, p. 290, fig. 220; T. J. Clark, *The Absolute Bourgeois, Artists and Politics in France, 1848–51,* London, 1973, pp. 74, 78, repr.; K. Lindsay, "Millet's Lost Winnower Rediscovered," *Burlington Magazine,* CXVI, May 1974, p. 270, fig. 7.

During the late 1840s extensive excavations were carried out in Paris for the new railways. Millet could have seen these workers near his home on the Rue Rochechouart. Sensier, Millet's close friend and biographer, mentions a *"Terrassiers occupés aux éboulements de Montmartre* (diggers at work on a cave-in at Montmartre)" among works of 1847. According to Herbert (Paris, 1975), who believes this sketch-like canvas was left unfinished, the tension and energy of the figures, characteristic of Millet's first naturalistic subjects of 1846–47, are closely related to the art of Daumier, with whom Millet often exchanged ideas.

AMEDEO MODIGLIANI

1884–1920. Italian. Born in Livorno, where he studied painting and drawing with G. Micheli. To Paris, 1906. Influenced by Beardsley, Lautrec, Steinlen. Exhibited at Salon des Indépendants intermittently after 1908. Strongly influenced by Cézanne and Brancusi. Executed sculpture 1905–15. Most surviving paintings date 1915–20.

Paul Guillaume PL. 40

[1915] Oil on board
29½ x 20½ in. (74.9 x 52.1 cm.)
Signed and dated lower right: modigliani/SETTEMBRE/ 1915
Inscribed lower left: PAUL GUILLAUME

Acc. no. 51.382

Gift of Mrs. C. Lockhart McKelvy

COLLECTIONS: Paul Guillaume, Paris, to 1934; Jean Walter (Mme. Paul Guillaume), Paris, from 1934; (Carroll Carstairs, New York, 1951); Mrs. C. Lockhart McKelvy, Perrysburg, Ohio.

EXHIBITIONS: Toledo Museum of Art, *The Collection of Mrs. C. Lockhart McKelvy*, 1964, p. 20, repr. p. 21.

REFERENCES: W. George, *La grande peinture contemporaine à la collection Paul Guillaume*, Paris, n.d. (1929), pp. 142, 188, repr. p. 138; A. Pffanstiel, *Modigliani*, Paris, 1929, p. 6, repr. opp. p. 18; A. Pffanstiel, *Modigliani et son oeuvre*, Paris, 1956, no. 36, p. 66; A. Ceroni, *Amedeo Modigliani*, Milan, 1958, p. 50, fig. 56; Cambridge, Fogg Art Museum, *Modigliani: Drawings from the Collection of Stefa and Leon Brillouin*, 1959, p. 22; L. Piccioni and A. Ceroni, *I dipinti di Modigliani*, Milan, 1970, no. 101.

Modigliani was introduced to the dealer and writer Paul Guillaume (1891–1934) in 1914 by the poet and painter Max Jacob. Guillaume was one of Modigliani's earliest supporters, and the artist painted three other portraits of him, one in 1915 and two in 1916 (Ceroni, 1958, nos. 55, 58, 62). There are also a number of related drawings, one of which appears to be a preparatory drawing for the Toledo portrait (J. Modigliani, *Modigliani*, New York, 1958, fig. 83).

JAN MIENSE MOLENAER

Ca. 1610–1668. Dutch. Born in Haarlem. Influenced by Frans and Dirk Hals and Adriaen van Ostade. In 1636 he married the painter Judith Leyster. Lived in Amsterdam from about 1637 until 1648, when he returned to Haarlem. Painter and etcher of genre themes.

Allegory of Vanity　　　　PL. 108

[1633] Oil on canvas
40¼ x 50 in. (102 x 127 cm.)
Signed lower left: MOLENAER 1633

Acc. no. 75.21

COLLECTIONS: (Silberman, New York, by 1942); Julius Held, Old Bennington, Vt., 1946–68; J. M. Cath, New York, by 1973; (Nystad, The Hague).

EXHIBITIONS: Leyden, Stedelijk Museum de Lakenhal, *Ijdelheid der Ijdelheden, Hollandse vanitas-voorstellingen uit de zeventiende eeuw*, 1970, no. 18.

REFERENCES: E. de Jongh, "Vermommingen van Vrouw Wereld in de 17de Eeuw," *Album Amicorum J. G. van Gelder*, The Hague, 1973, p. 202, fig. 7.

The seated woman represents Lady World, a popular allegorical figure in 17th century Dutch art and emblematic literature. As a symbol of vanity, she is richly dressed, and wears a globe on her head. In this painting the symbolism is somewhat disguised. Lady World is being dressed by her maid, the wall map (which touches her head) taking the place of the usual globe (de Jongh). Her feet rest on a skull, a symbol of death and a reminder of the transience of worldly things. Jewels represent the temptations of life, while the musical instruments are attributes of temperance. The boy, a fool, playing with soap bubbles symbolizes worldly folly. The monkey, fettered because he will not willingly submit to discipline, puts on her shoe and symbolically mimics her attitude.

There may be another allegorical message in this painting. According to the Leyden catalogue, the monkey also represents immorality, and together with the open door, ring held by the woman and landscape on the wall, may also symbolize infidelity. Molenaer often disguised his message, and in 1633 he painted another disguised allegory which P. J. J. van Thiel believed is an *Allegory of Fidelity in Marriage* (Virginia Museum of Fine Arts; "Marriage Symbolism in a Musical Party by Jan Miense Molenaer," *Simiolus*, II, 1967–68, pp. 91–9). This may be a thematic pendant to the Toledo painting (Leyden exh. cat.).

MONACO (*see* LORENZO)

CLAUDE MONET

1840–1926. French. Born in Paris. Boyhood spent in Le Havre, where he met Boudin, his first teacher. To Paris, 1859. At the Académie Suisse and the studio of Gleyre, 1862–63. Friend of Bazille, Sisley and Renoir. Exhibited at the Salon in the 1860s and in 1880, and at five exhibitions of the Impressionist group. Worked in France, London and Venice. Monet achieved greatest popular success of the Impressionists, beginning in 1889 with his haystack and Rouen Cathedral series.

Antibes　　　　PL. 257

[1888] Oil on canvas
28⅞ x 36¼ in. (73.3 x 92 cm.)
Signed and dated lower right: Claude Monet 88

Acc. no. 29.51

COLLECTIONS: Paul Durand-Ruel, Paris, by 1892–1921; (Durand-Ruel, Paris and New York).

EXHIBITIONS: Paris, Georges Petit, Monet-Rodin exhibi-

tion, 1889, no. 102 (?); Paris, *Exposition universelle*, 1900, no. 489; London, Grafton Galleries, *A Selection from the Pictures of Paul Durand-Ruel*, 1905, no. 155, repr. p. 22; New York, Museum of Modern Art, *Claude Monet: Seasons and Moments*, 1960, no. 41, repr. p. 19 (cat. by W. C. Seitz); Art Institute of Chicago, *Paintings by Monet*, 1975, p. 32, no. 80, repr.

REFERENCES: G. Lecomte, *L'art impressioniste d'après la collection privée de M. Durand-Ruel*, Paris, 1892, p. 89, repr. (etching); M. O. Maus, *Trente années de lutte pour l'art*, Brussels, 1926, p. 323; O. Reutersward, *Monet*, Stockholm, 1948, p. 285; J. Rewald, *The History of Impressionism*, 4th ed., New York, 1973, repr. p. 551 (also repr. in error, p. 492).

Monet worked on the Mediterranean coast from January to April 1888, when he carried out one of his first series of paintings of a single subject seen under different conditions of light.

This view of Antibes from La Salis appears in three other paintings of the series that are in private collections: Sidney Wohl, Old Westbury, New York; William C. Wright, St. David's, Pennsylvania; Pedro Valenilla Echeverria, Caracas, Venezuela.

ADOLPHE MONTICELLI

1824–1886. French. Born in Marseilles, his father was of Venetian origin. Studied with Delaroche in Paris, copying many pictures in the Louvre, especially those of Veronese, Rembrandt and Watteau. In Marseilles, 1849–56; returned to Paris and met Diaz and Delacroix, who influenced his work. Settled permanently at Marseilles about 1870 and began his most productive period during which he painted briefly with Cézanne. Besides landscapes, portraits and still lifes, his work includes costume subjects inspired by Watteau.

The Greyhounds PL. 270

[Ca. 1871–72] Oil on wood panel
14⅞ x 21½ in. (37.7 x 54.1 cm.)
Signed lower left: Monticelli

Acc. no. 33.24

Gift of Arthur J. Secor

COLLECTIONS: E. André, Marseilles; (Howard Young, New York); (Vose, Boston); Arthur J. Secor, 1923–33.

EXHIBITIONS: New York, Paul Rosenberg, *Loan Exhibition of Paintings by Adolphe Monticelli*, 1954, no. 8, repr.

REFERENCES: G. Arnaud d'Agnel and E. Isnard, *Monti-*

celli, sa vie et son oeuvre, Paris, 1926, pl. XXXII; D. Phillips, "A niche for Monticelli," *Art News*, LIII, Dec. 1954, p. 23, repr. p. 65.

Based on style and theme, A. Alauzen (letter, Oct. 1975) places *The Greyhounds* at the beginning of Monticelli's last period in Marseilles, ca. 1871–72. The painting is perhaps related to the *Scène de parc* painted at Mas Dezeaumes in 1871 (Cailleux collection, Paris). There is a pencil drawing of a page and greyhound in different poses (Basel, Kupferstichkabinett, no. 1960.43, as noted by Dieter Koepplin, letter, Mar. 1967) which is possibly a preparatory work for the Toledo painting.

GIORGIO MORANDI

1890–1964. Italian. Born in Bologna. Studied at Bologna Academy of Fine Arts 1907–13. From 1918–20 allied with de Chirico, Carrà and Metaphysical Painting. Still life subjects in an individual style intermediate between Cubism and Impressionism comprise much of his mature work.

Still Life with a Bottle PL. 42

[Ca. 1951] Oil on canvas
17 x 18½ in. (43.2 x 47 cm.)
Signed lower center: Morandi

Acc. no. 52.142

COLLECTIONS: (Il Milione Gallery, Milan).

WILLEM MOREELSE

Ca. 1620–1666. Dutch. Perhaps the nephew and pupil of the Utrecht painter and architect Paulus Moreelse (1571–1638). He was the head of the Utrecht guild of painters from 1655 to 1664, but little else is definitely known about him. Most paintings that have been tentatively attributed to him are portraits.

Portrait of a Scholar PL. 128

[1647] Oil on canvas
32⅝ x 26⅜ in. (82.8 x 67 cm.)
Signed and dated upper left: W Moreels: 1647
Inscribed upper right: Ano.Aetat.21.
Inscribed on book: Euphorbium/PRAESENTEM MON-
 STRAT/QUAELIBET HER:/BA DEUM ("This herb points
 out the presence of God.")

Acc. no. 62.70

COLLECTIONS: (Hilleveld DeVries. . . . Roos, Amsterdam, Nov. 16–18, 1841, lot 58, as by P. Moreelse);

(Sotheby, London, Apr. 4, 1962, lot 60); (Speelman, London, 1962); (Nystad, The Hague).

EXHIBITIONS: Cleveland Museum of Art, *Style, Truth and the Portrait*, 1963, no. 14 (cat. by R. G. Saisselin).

REFERENCES: A. Frankfurter, "Museum Evaluations, 2: Toledo," *Art News*, LXIII, No. 9, Jan. 1965, pp. 26, 56, fig. 4.

This portrait is the only fully signed and dated work by Moreelse. Although W. Stechow (entry in *Thieme-Becker*) cited a signed portrait in the Galleria Corsini, Rome as by Willem, it bears only the surname, and Stechow later wrote (letter, Nov. 1962) he was "not convinced that they (the Toledo and Corsini paintings) are by the same hand. . . . Thus my attribution of the Roman picture is probably wrong after all. . . ."

This is probably a graduation portrait. The sitter wears the traditional laurel wreath on his doctoral cap. Hanging from his neck on a red and silver cord is the promotion medal of the University of Utrecht given to successful doctoral candidates. The medal bears the coats of arms of both the city and university of Utrecht.

According to J. Struick of the Utrecht City Archives (letter, Nov. 1975), the book which the sitter holds is not his thesis, but probably an invention of the artist. As the extract of euphorbium, the herb shown in the book, was used as a medicine against the plague, Struick believes the sitter may have been a student of medicine.

HENRY MORET

1856–1913. French. Born in Cherbourg. Studied briefly with Gérôme and at the École des Beaux-Arts. First exhibited at the Salon of 1880. Worked with Gauguin at Pont-Aven, 1888–90; later influenced by Monet. Lived mostly in Brittany, where he specialized in coastal subjects.

Seaweed Gatherers　　　　　　　　PL. 277

[1899] Oil on canvas
21½ x 26 in. (54.6 x 66 cm.)
Signed and dated lower right: Henry Moret/99

Acc. no. 06.250

Gift of Georges Durand-Ruel

COLLECTIONS: (Durand-Ruel, Paris).

EXHIBITIONS: Toledo Museum of Art, *Exhibition of One Hundred Paintings by the Impressionists (from the Collection of Durand-Ruel & Sons, Paris)*, 1905, no. 59 (as *Seaweed, Trevignon*).

BERTHE MORISOT

1841–1895. French. Born in Bourges. Lived in Paris from 1851. Studied with Corot 1860–62. Exhibited at the Salon, 1864–73, and participated in all the Impressionist exhibitions except one (1879). Close friend of Manet, whose brother she married. Primarily a painter of figures, she also did watercolors and pastels.

In the Garden at Maurecourt　　　　PL. 258

[1884] Oil on canvas
21¼ x 25⅝ in. (54 x 65 cm.)
Signed lower left: Berthe Morisot

Acc. no. 30.9

COLLECTIONS: Lady Cunard, London; (Chester J. Johnson, Chicago).

EXHIBITIONS: Paris, Durand-Ruel, *Berthe Morisot, exposition commemorative*, 1896, no. 107; New York, Wildenstein, *Berthe Morisot*, 1960, no. 36, repr.; Baltimore Museum of Art, *Manet, Degas, Berthe Morisot and Mary Cassatt*, 1962, no. 88, repr. p. 32; New York, Wildenstein, *One Hundred Years of Impressionism: A Tribute to Durand-Ruel*, 1970, no. 61.

REFERENCES: M. Angoulvent, *Berthe Morisot*, Paris, 1933, p. 128, no. 219; D. Rouart, ed., *The Correspondence of Berthe Morisot*, New York, 1959, repr. opp. p. 90; G. Wildenstein and M.-L. Bataille, *Berthe Morisot, catalogue des peintures, dessins, aquarelles*, Paris, 1960, no. 154, pl. 47.

Maurecourt, near Paris, was the home of Morisot's sister, Edma Pontillon, whose garden was often the setting for Morisot's paintings. These figures have been identified as Edma Pontillon and her daughter (Wildenstein and Bataille), or Edma's two daughters (Baltimore, 1962). Angoulvent and Wildenstein-Bataille date this painting 1884. A watercolor sketch of the same subject, inscribed "Berthe Morisot. Maurecourt" is also dated 1884 by Wildenstein and Bataille (no. 704, fig. 701).

HANS MUELICH

1516–1573. German. Born in Munich; studied with his father Wolfgang and Barthel Beham. About 1536 to Regensburg, where he worked with Altdorfer. By 1540 in Munich, where he remained the rest of his life except for a visit to Italy in 1541. Primarily a portraitist, Muelich also did book illustrations and portrait miniatures for the Bavarian court.

Portrait of a Man [COLOR PL. III] PL. 68

[1540] Oil on wood panel
29½ x 23⅝ in. (74.9 x 60 cm.)
Signed and dated right center: HM 1540
Inscribed lower center: AETATIS SVAE XXXX

Acc. no. 55.226

Portrait of a Woman PL. 69

[1540] Oil on wood panel
29½ x 25⅝ in. (74.9 x 65.1 cm.)
Signed and dated left center: HM 1540

Acc. no. 55.227

COLLECTIONS: Private collections, Italy, until 1955.

REFERENCES: K. Löcher, "Studien zur oberdeutschen Bildnis-Malerei des 16. Jahrhunderts," *Jahrbuch der Staatlichen Kuntssammlungen in Baden-Württemberg*, IV, 1967, pp. 72-4, 84, nn. 155-56, figs. 48, 49.

The subjects of these portraits are a husband and wife, though they have not been identified. As the martyrdom by stoning of St. Stephen is shown in the garden behind the man, this may refer to his Christian name. According to Löcher, the large church is probably an architectural fantasy. The castle behind the woman has not been related to a known site.

BARTOLOMÉ ESTEBÁN MURILLO

1617-1682. Spanish. Pupil of Juan del Castillo in his native Seville. Early in his career influenced by Zurbarán and Ribera. He may have visited Madrid before 1646; he did go there in 1658. A founder and first president of the Seville Academy, 1660. Best known for religious paintings, as well as genre paintings and portraits.

The Adoration of the Magi PL. 58

[Ca. 1655-60] Oil on canvas
75⅛ x 57½ in. (190.7 x 146 cm.)

Acc. no. 75.84

COLLECTIONS: William Stanhope, later 1st Earl of Harrington (acquired in Spain in 1729 when he concluded the Treaty of Seville); 3rd Duke of Rutland, Belvoir Castle, Leicestershire, ca. 1760; Dukes of Rutland, Belvoir Castle (Christie, London, Apr. 16, 1926, lot 26); Count Alessandro Contini-Bonacossi, Florence; Anonymous owner (Christie, London, July 7, 1972, lot 83, repr.); (Wildenstein, New York).

EXHIBITIONS: Rome, Galleria Nazionale d'Arte Moderna, *The Old Spanish Masters from the Contini-Bonacossi*

Collection, 1930, no. 49, pl. XLII (as ca. 1650-60; cat. by R. Longhi and A. Mayer).

REFERENCES: I. Eller, *The History of Belvoir Castle . . . ,* London, 1841, pp. 242-43; G. Waagen, *Treasures of Art in Great Britain,* London, 1854, III, pp. 395, 398; F. M. Tubino, *Murillo, su época, su vida, sus cuadros,* Seville, 1864, p. 206; C. B. Curtis, *Velázquez and Murillo,* New York and London, 1883, p. 167, no. 125; W. Stirling-Maxwell, *Annals of the Artists of Spain,* London, 1891, IV, p. 1618; A. Mauer, "Zur Austellung der spanischen Gemälde des Grafen Contini in Rom," *Pantheon,* V, May 1930, p. 207, repr. p. 208; W. Suida, "Spanische Gemälde der Sammlung Contini-Bonacossi," *Belvedere,* I, 1930, p. 144; R. Heinemann et al., *The Thyssen-Bornemisza Collection,* Castagnola, 1969, I, in no. 228.

The composition and strong contrasts of light and dark reflect the Italian Renaissance masters, as well as Rubens and Van Dyck, whose work Murillo probably saw in the royal collection at Madrid. So far as is known, this is Murillo's only painting of the subject.

According to Diego Angulo (letters, Mar. and Apr. 1976), who is preparing a monograph on Murillo, this picture was painted about 1655-60, soon after Murillo had reached artistic maturity. Mayer and Suida also believed it was painted in the 1650s.

Heinemann refers to this picture and the *Virgin and St. Rose* in the Thyssen Collection as companions. Though their sizes are the same and both were acquired by Stanhope in 1729, as the style of the Toledo picture is several years earlier than that of the other, it is unlikely they were painted as pendants. A copy of the Toledo picture is in the Cartuja, Jerez (Angulo).

PAUL NASH

1889-1946. British. Born in London. Studied at Slade School 1910-11. Served as an official war artist in World Wars I and II. Associated with Roger Fry at Omega Workshops. Founder of Unit One, 1933. Exhibited at Paris Surrealist exhibitions, 1938. Also a designer, photographer and illustrator.

French Farm PL. 345

[Ca. 1926] Oil on canvas
21¼ x 28¾ in. (54 x 73 cm.)
Signed lower left: Paul Nash

Acc. no. 50.258

COLLECTIONS: Miss Winifred Felce, England; (Redfern, London).

EXHIBITIONS: London, Tate Gallery, *Paul Nash Memorial Exhibition*, 1948, no. 13.

REFERENCES: M. Eates, ed., *Paul Nash: Paintings, Drawings and Illustrations*, London, 1948, no. 46, fig. 46; A. Bertram, *Paul Nash, The Portrait of an Artist*, London, 1955, pp. 156, 321.

This picture belongs to a group painted following a visit to Cros-de-Cagnes on the French Riviera in 1925.

JEAN-MARC NATTIER

1685–1766. French. Born in Paris, Nattier studied with his father, a portraitist, and with his godfather, Jean Jouvenet. In Holland, 1717. Entered the Académie as a history painter, 1718. However, he worked mostly as a portraitist, achieving considerable success with lightly allegorized portrayals of women, including the daughters of Louis XV.

Princesse de Rohan PL. 200

[1741] Oil on canvas
57⅛ x 44½ in. (145 x 113 cm.)
Signed and dated bottom center: Nattier. pinxit./1741.

Acc. no. 52.64

COLLECTIONS: Prince de Rohan and descendants, Hôtel de Rohan, Paris, from 1741; Count Rohan-Rochefort, Prague; (Wildenstein, New York).

EXHIBITIONS: Paris, Salon, 1741, no. 58 (as *Madame la princesse de Rohan, tenant un livre*).

REFERENCES: J.-J. Guiffrey, "L'Hôtel de Soubise," *Gazette des Beaux-Arts*, I, 1869, p. 403; C. L. V. Langlois, *Les Hôtels de Clisson, de Guise et de Rohan-Soubise au Marais*, Paris, 1922, pp. 167–68; P. de Nolhac, *Nattier*, 3rd ed., Paris, 1925, pp. 99–100; G. Huard, "Nattier," in *Les peintres français du XVIIIe siècle* (ed. L. Dimier), Paris, 1930, II, p. 111, no. 113 (as *prince [sic] de Rohan*).

Marie-Sophie de Courcillon (1713–1756) married Hercule-Mériadec, Prince de Rohan in 1732. This portrait is probably one largely concealed by a column in an engraved view of the Prince's bedroom at the Hôtel de Rohan (G. G. Boffrand, *Livre d'architecture*, Paris, 1745, pl. LXII; Langlois).

As the Toledo painting is the only one of several versions that is signed, presumably it is the portrait in the 1741 Salon (Langlois). Earlier, Nolhac identified an unsigned version (Henri de Rothschild Collection) as the one shown in 1741.

Other unsigned versions include: Bernis-Calvière collection (Langlois, pl. XXIII); J. Porgès (sale, G. Petit, Paris, June 17–18, 1924, lot 90, repr.); Béraudière (sale, American Art Association, New York, Dec. 11–13, 1930, lot 289, repr.); P. de Koenigsberg, Buenos Aires (ex-coll. Demidoff).

The copies show a lock of hair falling over the left shoulder. It may be presumed this is also present in the Toledo portrait, as this area has been overpainted. The book she holds is titled *Histoire universelle*. This may be an edition of *Discours sur l'histoire universelle* by J. B. Bossuet, first published in 1681.

AERT VAN DER NEER

1603/04–1677. Dutch. Lived in Amsterdam except for a brief period in his youth at Gorinchem. May have studied with one or more of the Camphuysen brothers. Best known for moonlit landscapes and winter scenes.

Arrival of the Guests PL. 106

[Ca. 1635–40] Oil on wood panel
15⅝ x 21 in. (39.7 x 53.3 cm.)
Signed lower right: AVDN (in monogram)

Acc. no. 33.30

Gift of Arthur J. Secor

Approaching the Bridge PL. 107

[Ca. 1635–40] Oil on wood panel
15⅝ x 21⅛ in. (39.7 x 53.6 cm.)
Signed lower right: AVDN (in monogram)

Acc. no. 33.31

Gift of Arthur J. Secor

COLLECTIONS: Baron D. W. . . E, Antwerp (Amsterdam, Nov. 17, 1903, lot 57)?; V. G. Fischer, Washington, D.C., 1912?; Roman A. Penn, 1925; (Arthur Tooth & Son, London); (Vose, Boston); Arthur J. Secor, 1926–33.

REFERENCES: C. Hofstede de Groot, VII, nos. 81, 82; W. Stechow, London, 1968, p. 199, n. 17; F. Bachmann, "Die Herkunft Frühwerke des Aert van der Neer," *Oud Holland*, LXXXIX, No. 3, 1975, p. 221.

Stechow dates the Toledo paintings ca. 1637/38, between Van der Neer's earliest signed and dated landscape of 1635 (formerly Wilstach Museum, Philadelphia; Stechow, fig. 131), and a landscape dated 1639 (Rijksmuseum, Amsterdam), while Bachmann (letter, July 1975) dates them ca. 1640.

ALBERT NEUHUIJS

1844–1914. Dutch. After 1876 lived in The Hague and worked with Jacob Maris, Mauve and Israels. A painter of peasant life, he was strongly influenced by Israels. After 1883 he moved frequently between Laren, The Hague, Amsterdam and Zurich.

Mother and Children PL. 155

Oil on wood panel
12¾ x 9¼ in. (32.5 x 23.5 cm.)
Signed lower right: Albert Neuhuijs

Acc. no. 25.880

COLLECTIONS: (Henry Reinhardt, Milwaukee); Edward Drummond Libbey, 1904–25.

BEN NICHOLSON

1894–. British. Born in Denham. Son of the painters William and Mabel Nicholson. Studied at Slade School, London. Influenced by Cubism, Purism and Neo-Plasticism. Frequently traveled abroad with artist wife Barbara Hepworth. Joined the French Abstraction-Création and then the English Axis groups.

Ides of March PL. 359

[1952] Oil on canvas
36 x 30 in. (91.5 x 76.2 cm.)
Signed and dated on stretcher: March 21–52 Ben Nicholson (Ides of March)

Acc. no. 52.90

COLLECTIONS: (Lefevre Gallery, London).

EXHIBITIONS: London, Lefevre Gallery, *Ben Nicholson,* 1952, no. 60; Cleveland Museum of Art, *Paths of Abstract Art,* 1960, no. 69, fig. 69.

REFERENCES: C. B. Johnson, *Contemporary Art: Exploring its Roots and Development,* Worcester, 1973, p. 27, repr. p. 26.

ISAAK VAN OOSTEN

1613–1661. Flemish. Born in Antwerp, where he became a member of the painters guild in 1652. He was a follower of Jan Brueghel the Elder.

The Garden of Eden PL. 91

Oil on canvas
22¾ x 34¾ in. (57.7 x 88.2 cm.)
Signed lower right: I. v. Oosten . fecit

Acc. no. 59.1

COLLECTIONS: Marquise de Bryas; (Cailleux, Paris).

REFERENCES: C. M. Kauffmann, *Victoria and Albert Museum: Catalogue of Foreign Paintings, I. Before 1800,* London, 1973, p. 50.

Little is known about Van Oosten. Among the small number of signed pictures by him—less than six—is another signed version of *The Garden of Eden* (Liechtenstein collection, Vaduz) .

In the background is the temptation of Eve. This composition originated with Jan Brueghel the Elder (1568–1625), and he and his studio painted numerous variants of it, characterized by the combination of late Mannerist landscape conventions with realistic detail. Examples of this composition by Brueghel are in the Szépmüvéseti Múzeum, Budapest; the Victoria and Albert Museum, London; and Windsor Castle.

JACOB CORNELISZ. VAN OOSTSAANEN

Ca. 1470–1533. Dutch. Also called Jacob Cornelisz van Amsterdam. The first important Amsterdam painter; in that city by 1500. To Jerusalem, 1525. Teacher of Jan van Scorel. Painted altarpieces, votive pictures and portraits. Also did woodcuts, especially after Dürer, as well as book illustrations, frescoes and designs for stained glass and embroidery.

The Artist with a Portrait of his Wife PL. 86

[Ca. 1530–33] Oil on wood panel
24-7/16 x 19-7/16 in. (62.1 x 49.4 cm.)
Inscribed upper right: A---.

Acc. no. 60.7

COLLECTIONS: Duke of Newcastle, Clumber Park, Nottinghamshire; Earl of Lincoln, Clumber Park (Christie, London, June 4, 1937, lot 70, repr.); (Katz, Arnhem); Geldner, Basel; (Schultess, Basel); (Frederick Mont, New York).

EXHIBITIONS: Delft, Stedelijk Museum, "Het Prisenhof," *De Schilder in zijn Wereld,* 1964, p. 48, no. 29.

REFERENCES: K. Steinbart, "Nachlese in Werke des Jacob Cornelisz," *Marburger Jahrbuch für Kunstwissenschaft,* V, 1929, p. 37, pl. 70; M. J. Friedländer, *Die altniederländische Malerei,* Leyden, 1935, XII, pp. 97, 197, no. 289a; G. Hoogewerff, *De Noord-Nederlandsche Schilderkunst,* The Hague, 1939, III, p. 133; Amsterdam, Rijksmuseum, *Middeleeuwse Kunst de Noordelijke Nederlanden,* 1958, p. 101, in no. 111; C. Müller Hofstede, "Das Selbstbildnis des Lucas van Leyden im Her-

zog Anton Ulrich-Museum zu Braunschweig," in *Festschrift Friedrich Winkler* (ed., H. Möhle), Berlin, 1959, p. 234; M. J. Friedländer, *Early Netherlandish Painting*, (ed., H. Pauwels), New York, 1975, XII, pp. 53, 119, no. 289a, pl. 155.

In addition to the Toledo painting, Oostsaanen painted two other self-portraits, one dated 1520 (P. de Boer, Amsterdam, Winter, 1962, no. 4, repr.), the other 1553 (Rijksmuseum, Amsterdam). Only in the Toledo panel is Oostsaanen shown at his easel. In the 1520 version the artist holds a brush and palette, though not in the Rijksmuseum painting. In all three works the artist looks over his shoulder in the same way, a pose probably deriving from Lucas van Leyden's *Self-portrait* (Herzog Anton Ulrich Museum, Braunschweig; Müller Hofstede).

The partial letter A in the upper right corner may be a fragment of the date, "ANO CCCCCXXX" that is recorded in some published references to this painting, though not visible in old photographs.

Steinbart and Friedländer both believe that the woman depicted in the easel painting in the Toledo self-portrait is the artist's wife.

ADRIAEN VAN OSTADE

1610–1685. Dutch. Born and lived in Haarlem. According to Houbraken, he was a pupil of Frans Hals at the same time as Adriaen Brouwer. Dean of the Haarlem guild, 1662. Influenced by both Brouwer and Rembrandt, he is best known for his etchings and paintings of peasant genre. His brother Isaak, Jan Steen and Cornelis Dusart were his principal pupils.

Villagers Merrymaking at an Inn PL. 110

[1652] Oil on wood panel
16¾ x 21⅞ in. (42.5 x 55.5 cm.)
Signed and dated lower center (on bench): A v Ostade/ 1652

Acc. no. 69.339

COLLECTIONS: T. Emmerson, London, 1829; Tardieu, Paris (Simonet, Paris, Mar. 31–Apr. 3, 1841, no. 67); Théodore Patureau, Paris (Leroy, Laneuville, Paris, Apr. 20–21, 1857, no. 21); Marquis de Saint-Cloud, Paris (Laneuville, Paris, Apr. 10–11, 1864, no. 67); Alphonse Oudry (Febvre, Paris, Apr. 19–20, 1869, no. 49); Octave Gallice, Epernay; (Charles Sedelmeyer, Paris, 1900); Henry Heugel and descendants, Paris, to 1968; (Heim, Paris).

REFERENCES: J. Smith, IX (Supplement), London, 1842, no. 52; Sedelmeyer Gallery, *Illustrated Catalogue of the*

Sixth Series of 100 Paintings by Old Masters, Paris, 1900, no. 26; C. Hofstede de Groot, III, no. 546; W. von Bode, "Die beiden Ostade," *Zeitschrift für bildende Kunst*, XXVII, 1916, p. 4; F. Godefroy, *L'oeuvre gravé de Adriaen van Ostade*, Paris, 1930, in no. 49.

There is a signed preparatory drawing for this composition in the Musée Condé, Chantilly, and a study for one of the dancing figures in the Kunsthalle, Hamburg (see Godefroy). The Toledo painting was also etched (in reverse) by Ostade (Godefroy, no. 49).

ISAAK VAN OSTADE

1621–1649. Dutch. Born in Haarlem. Brother and pupil of Adriaen van Ostade. Entered the Haarlem guild in 1643. In his short life he painted a large number of pictures, including peasant scenes influenced by his brother's work, though he is best known for landscapes, especially winter subjects.

Skaters Near a Village PL. 109

[1640s] Oil on wood panel
12¾ x 17¾ in. (32.3 x 45.1 cm.)
Signed lower center: Isack. Ostade

Acc. no. 53.76

COLLECTIONS: (Charles Sedelmeyer, Paris, 1899); Maurice Kann, Paris (Galerie Georges Petit, June 9, 1911, no. 38); M. Van Gelder, The Netherlands; E. A. Frost, Limpsfield, Surrey; (John Mitchell, London, 1950); (Horace A. Buttery, London).

EXHIBITIONS: Indianapolis, John Herron Art Museum, *The Young Rembrandt and his Times*, 1958, no. 55, repr.

REFERENCES: Sedelmeyer Gallery, *Illustrated Catalogue of the Fifth Series of 100 Paintings by Old Masters*, Paris, 1899, no. 35; C. Hofstede de Groot, III, no. 261.

According to Stechow (1968, p. 90), Ostade's winter landscapes were painted about 1642–47. The Toledo painting is very freely composed and executed, characteristics which Stechow states are typical of Ostade's smaller winter scenes on panel.

JEAN-BAPTISTE OUDRY

1686–1755. French. Student of his father, Jacques Oudry, and of Largillierre; also influenced by Desportes. His work included landscapes, still lifes and animal paintings, tapestry designs and book illustrations. Pro-

fessor at the Academy of St. Luke by 1717. Member of the Académie Royale, 1719. Director of the Beauvais tapestry manufactory, 1734; he also worked for Gobelins.

Still Life with Musette and Violin　　　　PL. 199

[1725] Oil on canvas
34½ x 25¾ in. (87.5 x 65.4 cm.)
Signed and dated center: J. B. Oudry 1725

Acc. no. 51.500

COLLECTIONS: (Cailleux, Paris).

REFERENCES: P. L. Grigaut, "Baroque and Rococo France in Toledo," *Art Quarterly*, XIX, Spring, 1956, p. 53, fig. 4; A. P. de Mirimonde, "Les oeuvres françaises à sujet de musique au musée du Louvre, II. Natures mortes des XVIIIe et XIXe siècles," *Revue du Louvre*, 1965, No. 1, p. 114, fig. 4.

The musette was a type of bagpipe much in vogue with the French aristocracy in the 18th century. The sheet music is "Divin sommeil" by Louis Lemaire, printed in *Recueil d'airs sérieux et à boire*, Paris, 1718. The same music appears in a rectangular version of this composition dated 1736 (Musée National de Sèvres). The Toledo and Sèvres paintings are versions of the rectangular overdoor panel dated 1719 representing Air as one of the Four Elements (Nationalmuseum, Stockholm).

ISAAK OUWATER

1750–1793. Dutch. Born in Amsterdam; little is known of his training or life. Painter of scenes in Amsterdam, Utrecht, Haarlem, The Hague and other Dutch cities and towns in which he continued Van der Heyden's style of view painting.

The Prinsengracht, Amsterdam　　　　PL. 147

[1782] Oil on canvas
17¾ x 22½ in. (45 x 57 cm.)
Signed and dated lower right: I. Ouwater 1782

Acc. no. 76.13

COLLECTIONS: Bouvy family, Amsterdam, 1782–1940; P. Smidt van Gelder, Amsterdam; (Frederik Muller, Amsterdam, Nov. 1940, lot 480); B. de Geus van den Heuvel, Nieuwersluis; (Sotheby-Mak van Waay, Amsterdam, Apr. 16, 1976, lot 98, repr.).

EXHIBITIONS: Schiedam, Stedelijk Museum, 1951, no. 57; Delft, Stedelijk Museum Het Prinsenhof, 1952, no. 57; Utrecht, Centraal Museum, *Nederlandse Architectuurschilders*, 1953, no. 78; Amsterdam, Stedelijk Museum,

1956–57, no. 73; Laren N. H., Singer Museum, *Kunstbezit Rondom Laren*, 1958, no. 177; Amsterdam, Museum Willet Holthuysen, 1958, no. 33, repr.; Laren N. H., Singer Museum, 1964, no. 9, fig. 5.

REFERENCES: F. M. Huebner, *Romantische Schilderkunst in de Nederlanden*, The Hague, 1942, fig. 7.

Ouwater's view on the Prinsengracht is taken looking down the Spiegelgracht. To the far left at Prinsengracht 578 can be seen the apothecary shop Bouvy and Son, formerly called the "Hoogduitsche Apotheek". The painting was probably commissioned by the Bouvy family, in whose collection it remained for nearly two centuries. The building at Prinsengracht 578 still exists. The view shows a well-known neighborhood a few blocks from the Rijksmuseum.

GIOVANNI PAOLO PANNINI

1691/92–1765. Italian. Born in Piacenza, where he probably studied and worked with Ferdinando Bibiena. Moved to Rome, 1711. In the studio of Benedetto Luti until 1718. Influenced by Vanvitelli and others. Achieved early fame as a painter of decorations in Roman palaces and villas. Elected to the Academy of St. Luke in 1718–19 (president, 1754–55), and to the French Academy in Rome, 1732. Pannini's patrons included not only Italians, but also the cardinal protectors of France and Spain, for whom he painted both actual and imaginary views of Rome, which exerted influence on French as well as Italian view painting.

Architectural Fantasy　　　　PL. 25
with a Concert Party

[Ca. 1716–17] Oil on canvas
39 x 29 in. (99.1 x 73.6 cm.)

Acc. no. 64.30

Ruins with the Farnese Hercules　　　　PL. 26

[Ca. 1716–17] Oil on canvas
39 x 29 in. (99.1 x 73.6 cm.)

Acc. no. 64.31

COLLECTIONS: (William Sabin, London); (Jacques Seligmann, New York); Mr. and Mrs. Walter Travers, New York, ca. 1929–59; (Wildenstein, New York); Private collection; (Hazlitt, London); (Colnaghi, London).

REFERENCES: F. Arisi, *Gian Paolo Pannini*, Piacenza, 1961, nos. 17, 18, figs. 41, 42; A. Frankfurter, "Museum Evaluations, 2: Toledo," *Art News*, LXIII, Jan. 1965, pp.

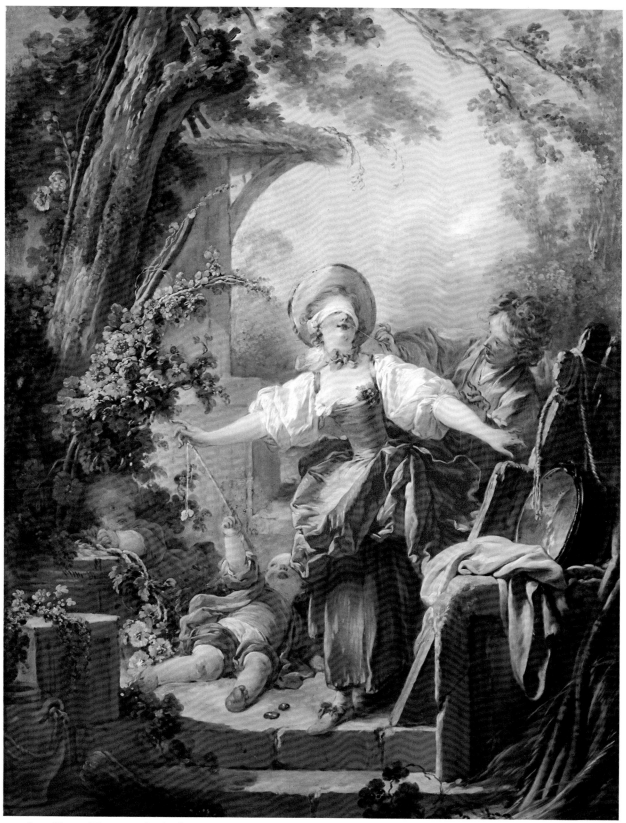

IX. Jean-Honoré Fragonard, *Blind-Man's Buff*

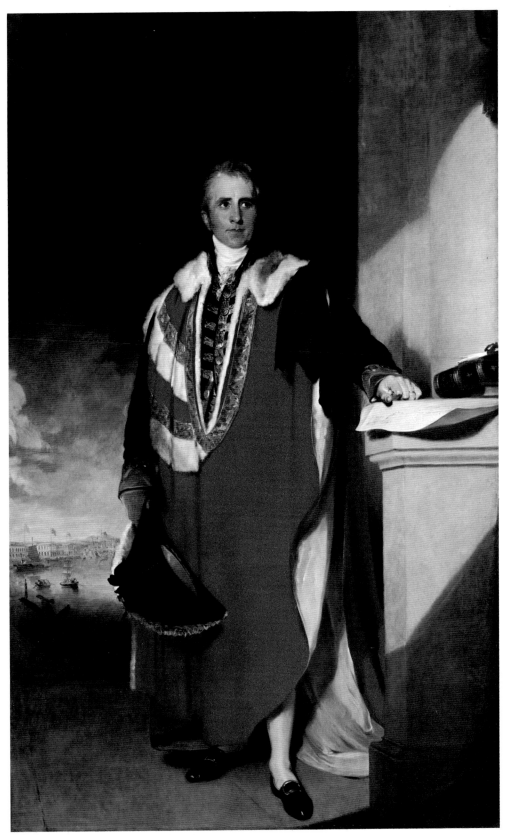

x. Sir Thomas Lawrence, *Lord Amherst*

24, 52–3, fig. 1; B. Fredericksen and F. Zeri, *Census,* pp. 157, 502, 641.

This pair has been dated by Arisi ca. 1716–17 by comparison with similar pairs in the Earl of Northhampton collection dated by Arisi ca. 1715 (Arisi, nos. 14, 15), and the Louvre, dated ca. 1716–18 (Arisi, nos. 19, 20). The Toledo pictures are considered among the earliest works by Pannini.

St. Peter's Square, Rome
PL. 27

[1741] Oil on canvas
38¾ x 53½ in. (98.4 x 135.9 cm.)
Signed and dated lower right: I. PAUL·PANINI/ROMAE 1741.

Acc. no. 71.157

COLLECTIONS: Sir Thomas Lucas, Bt., London, 1902; Captain Stephen Tempest, London (Sotheby, London, Nov. 25, 1970, lot 14, repr.); (Speelman, London, 1970–71).

The subject is the facade and dome of St. Peter's, flanked by the colonnades designed by Bernini, beyond which the Vatican stands to the right. The ruins in the foreground are imaginary.

While Pannini painted several interior views of St. Peter's, views of the exterior are rare. Arisi, to whom Toledo's picture was unknown, recorded only one large scale view of St. Peter's Square, 1756–57, in which a similar viewpoint is used (*Gian Paolo Pannini,* 1961, no. 247). There is a second exterior of St. Peter's, dated 1754 and closely related to the Toledo picture, also unknown to Arisi (Christie, London, Mar. 23, 1973, lot 53, repr.). In both the viewpoint is nearly the same and several of the figures are identical.

The Toledo painting is a pendant to *View of the Piazza del Popolo, Rome,* also signed and dated 1741 (Sotheby, London, Nov. 25, 1970, lot 13, repr.).

JULES PASCIN

1885–1930. French. Born Julius Mordecai Pincas in Vidin, Bulgaria. Early work in Vienna, Berlin and Munich. Lived in Paris, 1905; moved to New York 1913. Became an American citizen, 1920. Committed suicide in Paris, 1930. In his painting color was subordinated to draughtsmanship.

Cinderella
PL. 293

[Ca. 1925–26] Oil on canvas

36½ x 29 in. (95.6 x 73.6 cm.)
Signed upper right: Pascin
Inscribed on reverse: Cendrillon

Acc. no. 30.203

COLLECTIONS: (Galarie Pierre Loeb, Paris, 1928); (Bernheim-Jeune, Paris, 1930).

EXHIBITIONS: Cleveland Museum of Art, *Fifty Years of Modern Art,* 1966, no. 36, repr.

REFERENCES: P. Morand, *Pascin,* Paris, 1931, pl. 30; H. Brodzky, *Pascin,* London, 1946, pl. 19; A Werner, *Pascin,* New York, 1962, pl. 27.

In 1929 Pascin provided several illustrations for an edition of *Cendrillon (Cinderella)* by Charles Perrault. Pascin returned frequently to this subject and variations exist in oil, watercolor, prints and drawings. Werner has dated this painting 1925–26.

JEAN-BAPTISTE PATER

1695–1736. French. Son of a sculptor, Pater first studied with the painter J. B. Guider in his native Valenciennes, 1706–11. In Paris about 1713, where he became Watteau's only pupil. Elected to the Academy in 1728. Pater was greatly influenced by Watteau's style and subject matter, especially the *fête galante.*

The Bathing Party
PL. 197

Oil on canvas
26¼ x 32¼ in. (66.8 x 81.9 cm.)

Acc. no. 54.28

COLLECTIONS: Frederick II, King of Prussia (reigned 1740–86) and successors; Neue Palais, Potsdam, until 1923, when it was ceded by the German government to the former Emperor William II; (Wildenstein, New York, by 1953).

EXHIBITIONS: Berlin, *Die Austellung von Gemälden älterer Meister im Berliner Privatbesitz,* 1883, no. 9; Paris, *Exposition Universelle,* 1900.

REFERENCES: R. Dohme, "Die Austellung von Gemälden älterer Meister im Berliner Privatbesitz, die französische Schule des XVIII Jahrhunderts," *Jahrbuch der Königlich Preussichen Kunstsammlungen,* IV, 1883, p. 253; P. Seidel, *Die Kunstsammlung Friedrichs des Grossen auf der Pariser Weltaustellung 1900,* Berlin, 1900, no. 19; P. Seidel, *Les collections d'oeuvres d'art françaises du XVIIIe siècle appartenant à sa majesté l'empereur d'Allemagne Roi de Prusse,* Berlin, 1900, no. 83; C. Foerster, *Das Neue*

Palais bei Potsdam, Berlin, 1923, p. 61; F. Ingersoll-Smouse, *Pater,* Paris, 1928, no. 326, fig. 102.

The bathing scene was one of Pater's favorite subjects and one developed independently of Watteau. Of nearly thirty pictures on this theme listed by Ingersoll-Smouse, four are close to the Toledo picture in composition and major motifs, especially *Baigneuses* (Ingersoll-Smouse, no. 327). Like most of Pater's work, none of these paintings is dated and no chronology of the artist's short, prolific career has been attempted.

MAX PECHSTEIN

1881–1955. German. Born in Zwickau. Studied at Dresden Academy. Joined the Brücke group, 1906; charter member of New Secession, 1910. Traveled to Italy and the Philippines. One of the leading German Expressionists.

Still Life with Calla Lilies PL. 75

[1931] Oil on canvas
38¼ x 26¾ in. (97.1 x 68 cm.)
Signed and dated lower right: HM Pechstein 1931
Inscribed on reverse by the artist: Calla/HM Pechstein (HMP in monogram)/Berlin W.67/Kürfurstenstr. 126

Acc. no. 34.51

EXHIBITIONS: Pittsburgh, Carnegie Institute, *1933 International,* no. 345; Pittsburgh, Carnegie Institute, *Retrospective Exhibition of Paintings from Previous Internationals,* 1958, no. 61, repr.

GIOVANNI ANTONIO PELLEGRINI

1675–1741. Italian. Born in Venice, he studied with Paolo Pagani and was influenced by Giordano and Sebastiano Ricci. Like many other Venetian painters of his time, he did much work abroad in Austria, England, the Low Countries, Germany, and France, bringing the lightness and gaiety of the Venetian decorative style to many European centers.

Sophonisba Receiving the Cup of Poison PL. 32

[1708–13] Oil on canvas
73⅛ x 60¾ in. (185.7 x 154.3 cm.)

Acc. no. 66.128

COLLECTIONS: Private collection, England; (G. Gasparini, Rome); (Colnaghi, London).

EXHIBITIONS: Art Institute of Chicago, *Painting in Italy*

in the Eighteenth Century: Rococo to Romanticism, 1970, no. 30, repr. p. 83 (entry by B. Hannegan).

REFERENCES: B. Fredericksen and F. Zeri, *Census,* p. 160.

The subject is an incident from the Punic Wars (205–200 B.C.), based on the Roman historian Livy's account of Sophonisba, daughter of the Carthaginian general Hasdrubal, taking poison to avoid captivity or dishonor. It was probably painted during Pellegrini's first stay in England, 1708–13. This painting is the largest and most important of four versions of this subject.

SAMUEL JOHN PEPLOE

1871–1935. British. Born in Edinburgh; studied at the Royal Scottish Academy and later in Paris. Founding member of the National Portrait Society; member of the Royal Scottish Academy. Early work influenced by the Glasgow School, and later, by French Post-Impressionism. Taught at Edinburgh College of Art, 1933–35.

Still Life with Fruit PL. 344

[1928] Oil on canvas
20 x 28 in. (50.8 x 71.2 cm.)
Signed lower right: S. J. Peploe

Acc. no. 48.67

COLLECTIONS: Mrs. Samuel J. Peploe; (Alex Reid & Lefevre, London).

EXHIBITIONS: London, Lefevre Gallery, *Paintings by S. J. Peploe,* 1948, no. 50 (as 1928).

PESELLINO

1422–1457. Italian. Born Francesco di Stefano in Florence, where he was brought up and probably trained by his grandfather, also a painter. From 1453 he worked with Pier di Lorenzo di Pratese and Zanobi Migliore. Although strongly influenced by Filippo Lippi, he was also indebted to the low relief sculpture of contemporaries such as Luca della Robbia, and to the work of Uccello and especially Fra Angelico.

*Madonna and Child
with Saint John* [COLOR PL. I] PL. 5

[Ca. 1455] Tempera on wood panel
28½ x 21¼ in. (72.4 x 54 cm.)

Acc. no. 44.34

COLLECTIONS: William Graham, London, by 1875 (Christie, London, Apr. 8, 1886, lot 261, as Filippo

Lippi); Oscar Hainauer, Berlin, 1886–97; Robert Hoe, New York (American Art Association, New York, Feb. 17, 1911, lot 97, as follower of Filippo Lippi); (T. J. Blakeslee, New York); (Duveen, New York); Harold I. Pratt, New York, by 1924; (Wildenstein, New York).

EXHIBITIONS: London, Royal Academy, *Exhibition of Works by Old Masters*, 1875, no. 185, p. 20; Berlin, Kaiser Friedrich Museum, *Kunstwerken des Mittelalters und der Renaissance auf Berliner Privatbesitz*, 1898 (cat. by H. Mackowsky, publ. 1899), p. 38, pl. vii; New York, Duveen, *Early Italian Paintings*, 1924, no. 10, repr. (cat. by W. Valentiner, 1926).

REFERENCES: F. Harck, "Quadri di maestri Italiani in possesso di privati a Berlino," *Archivo storico dell'arte* II, 1889, p. 205; W. Bode, *Die Sammlung Oscar Hainauer*, Berlin, 1897, pp. 14–5, repr.; London, 1906, p. 67, no. 45; M. Logan, "Compagno di Pesellino et quelques peintures de l'école," *Gazette des Beaux-Arts*, XXVI, July 1901, pp. 33–4, repr.; W. Weisbach, *Francesco Pesellino und die Romantik der Renaissance*, Berlin, 1901, p. 114; F. J. Mather, "Pictures in the Robert Hoe Collection," *Burlington Magazine*, XVII, Aug. 1910, p. 315, fig. 1; A. F. Jaccaci, *Catalogue of the Valuable Art Property Collected by the Late Robert Hoe*, New York, 1911, no. 97, repr.; P. H. Hendy, "Pesellino," *Burlington Magazine*, LIII, Aug. 1928, pp. 68–73, pl. II; R. Van Marle, *The Development of the Italian Schools of Painting*, The Hague, X, 1928, pp. 512–13; XIII, 1931, p. 447; H. Mackowsky, "The Masters of the 'Pesellino Trinity'," *Burlington Magazine*, LVII, Nov. 1930, p. 218; P. H. Hendy, *The Isabella Stewart Gardner Museum: Catalogue of the Exhibited Paintings and Drawings*, Boston, 1931, pp. 253, 259; B. Berenson, "Quadri senza casa: Il quattrocento Fiorentino, II," *Dedalo*, III, Sep. 1932, p. 671, repr. p. 673; B. Berenson, *Italian Pictures of the Renaissance*, Oxford, 1932, p. 443; L. Venturi, *Italian Paintings in America*, New York, 1933, II, no. 227, repr.; (B.-M. Godwin), "Pesellino's Masterpiece," *Toledo Museum of Art Museum News*, No. 110, Dec. 1945, unpaginated; B. Berenson, *The Italian Painters of the Renaissance*, New York, 1952, p. 161; F. Zeri and E. Gardner, *Italian Paintings; A Catalogue of the Collection of The Metropolitan Museum of Art: Florentine School*, New York, 1971, p. 107; B. Fredericksen and F. Zeri, *Census*, p. 162; P. H. Hendy, *European and American Paintings in the Isabella Stewart Gardner Museum*, 2nd ed., Boston, 1974, pp. 176, 180.

While this painting, which Hendy (1974, p. 176) characterizes as "one of the most sensuous devotional panels of the Renaissance," has been attributed to Filippo Lippi or his workshop (London, 1875; Berlin, 1898; Mather),

Giovanni Pesello (Jaccaci), Pier Francesco Fiorentino (New York, 1924; Van Marle) and Graffione (Mackowsky, 1930), it has for more than forty years been accepted as the work of Pesellino.

The influence of Filippo Lippi is strong, and Godwin used comparisons with Lippi's *Madonna and Child* in the Uffizi to date Toledo's painting.

Hendy (1974, p. 180) compared the heads in the Gardner Museum's *Madonna and Child* by Pesellino with those of the later Toledo picture and wrote that in addition to the many contemporary copies of both pictures, there are versions which combine features from the two, suggesting that drawings from Pesellino's workshop were circulated or that both paintings were accessible to artists in Florence. The best known copy of Toledo's painting is that attributed to Pier Francesco Fiorentino in the Uffizi. Other variants are in Budapest, Berlin, the Jacquemart André Museum, Paris, and Metropolitan Museum. While the last is called "Lippi-Pesellino Imitators," most of the other works are assigned to the prolific hand of Pier Francesco Fiorentino and to Pseudo-Pier Francesco Fiorentino.

PABLO RUIZ PICASSO

1881–1973. Spanish. Born in Malaga. Studied at the Academy in Barcelona, 1895, and at the School of Fine Arts and the Madrid Academy, 1895–97. Settled in Paris, 1904, living until 1909 at the Bateau Lavoir. Influenced by Cézanne and Iberian and African art. Developed Cubism with Braque from about 1907. Worked in a great number of styles and media throughout his long and prolific career. Picasso is widely considered the most influential artist of the 20th century.

Woman with a Crow PL. 285

[1904] Charcoal, pastel and watercolor on paper
25½ x 19½ in. (54.6 x 49.5 cm.)
Signed and dated lower right: Picasso/1904

Acc. no. 36.4

COLLECTIONS: Paul Guillaume, Paris; (Edouard Jonas, Paris).

EXHIBITIONS: Paris, Galeries Serrurier, 1905, no. 21 (intro. by G. Apollinaire); Paris, Galerie Georges Petit, 1932, no. 24, fig. IV; Paris, Petit Palais, 1935; Toledo Museum of Art, *Contemporary Movements in European Art*, 1938, no. 89; New York, Museum of Modern Art, *Picasso, Forty Years of his Art*, 1940, no. 25, repr. p. 36 (cat. by A. Barr); Los Angeles County Museum, *From Cézanne to Picasso*, 1941, no. 40; Mexico City, Sociedad de Arte Moderno, *Retrospective Exhibi-*

tion of the Work of Picasso, 1944, p. 44; New York, Museum of Modern Art, *Picasso, Fifty Years of his Art*, 1946, p. 284, repr. p. 30 (cat. by A. Barr); Lyons, Musée des Beaux-Arts, *Retrospective Exhibition of the Work of Picasso*, 1953, no. 10, fig. 3; Milan, Palazzo Reale, *Mostra de Pablo Picasso*, 1953, no. 3, repr.; New York, Museum of Modern Art, *Picasso, 75th Anniversary Exhibition*, 1957, no. 15, repr. (cat. by A. Barr).

REFERENCES: W. George, *La grande peinture contemporaine à la collection Paul Guillaume*, Paris, n.d. (1929), pp. 115, 120, repr. p. 116; C. Zervos, *Pablo Picasso, I: Oeuvres de 1895 à 1905*, Paris, 1932, no. 240, fig. 107; P. Daix and G. Boudaille, *Picasso, The Blue and Rose Periods*, London, 1967, no. XI.10, p. 242, repr. p. 243; A. Moravia and P. Lecaldano, *L'opera completa de Picasso blu e rose*, Milan, 1968, no. 132, fig. XXV; T. Reff, "Love and Death in Picasso's Early Work," *Picasso 1881–1973* (ed. R. Penrose and J. Golding), London, 1973, pp. 22, 28, fig. 24.

Woman with a Crow was painted during Picasso's "Blue Period." According to Barr (1946), Picasso saw the crow at the restaurant Lapin Agile, where it was the pet of Margot, the daughter of the owner, Fredé. Another version, also dated 1904, is in a French private collection (Daix and Boudaille, p. 342, A.7; Moravia and Lecaldano, no. 133, repr.)

PIERO DI COSIMO

1462–1521. Italian. Born and worked in Florence. In the workshop of Cosimo Roselli, whom Piero accompanied to Rome, 1481–84, probably to assist with the frescoes in the Sistine Chapel for Sixtus IV. The influences of Filippino Lippi, Signorelli and Leonardo da Vinci can be found in Piero's mythological and religious paintings. Andrea di Cosimo and Andrea del Sarto were his pupils.

The Adoration of the Child PL. 6

[Ca. 1490–1500] Oil on wood panel
Diameter 63 in. (160 cm.)

Acc. no. 37.1

COLLECTIONS: Lorenzo de'Medici (?), Florence; Guiducci family, Florence; (Metzger, Florence); Alexander Barker, London (Christie, London, June 6, 1874, lot 81, as Signorelli); George Edmund Street, R. A., London, 1874; Arthur E. Street, London, by 1893; (Duveen Bros., New York).

EXHIBITIONS: London, Burlington Fine Arts Club, *Exhi-

bition of the Work of Luca Signorelli and His School*, 1893, p. XVI, no. 17; London, Royal Academy, *Exhibition of Works of the Old Masters*, 1904, no. 33.

REFERENCES: G. F. Waagen, *Treasures of Art in Great Britain*, London, 1854, II, p. 126; Von Hermann Ulmann, "Piero Di Cosimo," *Jahrbuch der königlich preussischen Kunstsammlungen*, XVII, 1896, p. 126; F. Knapp, *Piero di Cosimo, ein Ubergangsmeister vom Florentiner Quattrocento zum Cinquecento*, Halle, 1899, pp. 40–3, repr.; H. Haberfeld, *Piero di Cosimo*, Breslau, 1900, pp. 57–61; G. Mancini, *Vita di Luca Signorelli*, Florence, 1903, p. 176; B. Berenson, *The Florentine Painters of the Renaissance*, New York, 1909, p. 165; A. Venturi, *Storia dell'arte italiana*, Milan, 1911, VII, part 1, p. 706; J. A. Crowe and G. B. Cavalcaselle, *A History of Painting in Italy: Umbria, Florence and Siena, v: Umbrian and Sienese Masters of The Fifteenth Century* (ed. T. Borenius), London, 1914, p. 88, n. 3 (as Signorelli in text; as Piero di Cosimo in editor's annotation); "The Virgin and Child, by Piero Di Cosimo," *Burlington Magazine*, XXIX, Dec. 1916, p. 351, repr. p. 350; R. Van Marle, *The Development of the Italian Schools of Painting*, The Hague, 1931, XIII, pp. 352–53; L. Venturi, *Italian Paintings in America*, Milan, 1933, II: *Fifteenth Century Renaissance*, pl. 288; B. Degenhart, "Piero di Cosimo," *Thieme-Becker*, 1933, XXVII, p. 16; B.-M. Godwin, "An Important Italian Painting," *Toledo Museum of Art Museum News*, No. 78, Mar. 1937, pp. [1103–12], repr.; K. B. Nielson, *Filippino Lippi*, Cambridge, 1938, p. 131, fig. 59; R. L. Douglas, *Piero di Cosimo*, Chicago, 1946, pp. 18, 41, 43–4, 46, 48, 50, 97, 112, 118–19, 129, pls. XXII–XXV; *Duveen Pictures in Public Collections of America*, New York, 1941, nos. 127–31; P. Morselli, "Saggio di un catalogo delle opere di Piero di Cosimo," *L'Arte*, XXIII, 1958, p. 85; L. Grassi, *Piero di Cosimo e il problema della conversione al cinquecento mella pittura fiorentina ed emiliane*, Rome, 1963, p. 54; M. Bacci, *Piero di Cosimo*, Milan, 1966, pp. 27–8, 72–3, 80–2, pl. 9.

Attributed to Signorelli by Waagen and Crowe and Cavalcaselle, this painting was reattributed to Piero di Cosimo in the 1893 London Signorelli exhibition by analogy with the Dresden *Holy Family with the Infant St. John*.

Various dates in the 1490s have been suggested for this painting. Bacci relates the Toledo tondo to *The Visitation and Two Saints* (National Gallery, Washington), which is dated ca. 1490 (J. Walker, *National Gallery of Art, Washington, D.C.*, New York, 1963, p. 87). Douglas supports this by pointing out that if one is to accept the tradition as related by Crowe and Cavalcaselle that Lorenzo de'Medici presented this tondo to a lady of the

Guiducci family, then the work must date before April 1492, the date of Lorenzo's death. Venturi (1933) also dates it around 1490 by associating its forms and colors with the *Madonna Enthroned with Child and Saints* (Galleria dello Spedale degli Innocenti, Florence).

Van Marle places it after 1495 based on Lorenzo di Credi's influence and by comparison to the *Magdalen* (National Gallery, Rome) and the Dresden tondo, while Neilson says that it was probably painted ca. 1494–97, when Filippino Lippi's influence was greatest, and Grassi dates it between 1495 and 1500.

Knapp traces the motif of the Virgin's hands about to be clasped in prayer to the same gesture in the Portinari Altarpiece by Hugo van der Goes (ca. 1474–76; Uffizi, Florence). While generally called an Adoration of the Child, this is said to be the first time the motif of a sleeping Child is used in Florentine art (Douglas). Michael Jaffé (verbally, Jan. 1961, and letter, Apr. 1975) says that the subject also incorporates the Rest on the Flight into Egypt. This latter theme is indicated by the Child's head resting on a sack holding the Family's belongings, the donkey drinking water from a stream, and Joseph shown asleep, wrapped in a mantle and holding a walking stick.

EVERT PIETERS

1856–1932. Dutch. Born in Amsterdam. Moved to Antwerp in the early 1880s, where he studied at the Academy with Verlat and Verstraetens. Member of the Pulchri Studio and the Society "Arti et Amicitae;" exhibited frequently in Europe and the United States. In Paris, 1895–97. Settled in Blaricum, 1897.

In the Month of May PL. 171

[1899] Mixed media on canvas
59¼ x 79¼ in. (150.5 x 201.3 cm.)
Signed and dated lower right: E. Pieters '99

Acc. no. 12.511

COLLECTIONS: Edward Drummond Libbey.

Mother Love PL. 170

[Before 1902] Oil on canvas
26 x 22 in. (66.1 x 55.8 cm.)
Signed lower left: E. Pieters

Acc. no. 22.26
Gift of Arthur J. Secor

COLLECTIONS: Arthur J. Secor, 1902–22.

JOHN PIPER

1903–. British. Born in Epsom, Surrey. He studied with William Rothenstein at the Royal College of Art. Commissioned by the Queen to make drawings of Windsor Castle, 1941–42. As an official war artist during World War II, he recorded bomb damage to the House of Commons and Bath. A painter of landscapes and architectural subjects, he is also an illustrator and has made designs for stained glass and the theater.

Rocky Valley, North Wales PL. 353

[1948] Oil on canvas
35¾ x 48 in. (90.8 x 121.9 cm.)
Signed lower right: John Piper

Acc. no. 49.82

COLLECTIONS: (Leicester Galleries, London).

REFERENCES: S. J. Woods, *John Piper: Paintings, Drawings and Theatre Design*, London, 1955, no. 115, fig. 115.

CAMILLE PISSARRO

1830–1903. French. Born in the Danish Virgin Islands, Pissarro came to France in 1855, remaining there the rest of his life. Worked under Corot and studied at the Académie Suisse, where he met Monet, Manet, and probably Courbet and Cézanne. Exhibited at the Salon in early years and at the Salon des Refusés in 1863. From the late 1860s he was a leader of the Impressionist group and was the only one to exhibit in all eight of its exhibitions, 1874–86. In London with Monet to escape Franco-Prussian War, 1870–71. He painted landscapes, figure subjects and still lifes.

Still Life PL. 248

[1867] Oil on canvas
31⅞ x 39¼ in. (81 x 99.6 cm.)
Signed and dated upper right: C. Pissarro. 1867

Acc. no. 49.6

COLLECTIONS: Madame Pissarro (Georges Petit, Paris, Dec. 3, 1928, lot 33, repr.); Georges Viau, Paris, 1928 (Galerie Charpentier, Paris, June 22, 1948, lot 5); (Wildenstein, New York).

EXHIBITIONS: Paris, Orangerie, *Centenaire de la naissance de Camille Pissarro*, 1930, no. 6; Paris, Gazette des Beaux-Arts, *Naissance de l'impressionisme*, 1937, no. 73; Amsterdam Stedelijk Museum, *Honderd Jaar fransche Kunst*, 1938, no. 186; New York, Wildenstein, *Camille Pissarro: His Place in Art*, 1945, no. 1; Paris, Orangerie,

De David à Toulouse-Lautrec: Chefs d'oeuvre des collections américaines, 1955, no. 24, repr.; New York, Wildenstein, *C. Pissarro,* 1965, no. 3, repr.

REFERENCES: C. Kunstler, "Camille Pissarro," *La renaissance de l'art française,* XI, Dec. 1928, p. 504, repr. p. 498; L. R. Pissarro and L .Venturi, *Camille Pissarro, son art-son oeuvre,* Paris, 1939, I, p. 20, no. 50; II, pl. 9; J. Rewald, *The History of Impressionism,* 1st ed., New York, 1946, pp. 139–40, repr. p. 138; 4th ed., New York, 1973, pp. 157–58, repr. p. 156; H.L.F. (Henry La Farge), "Ruisdael to Pissarro to Noguchi," *Art News,* XLIX, Mar. 1950, p. 32, repr. p. 33; J. Rewald, *Camille Pissarro,* New York, 1963, pp. 19, 69, repr. p. 69; C. Kunstler, *Camille Pissarro,* Milan, 1972, p. 14, repr.; K. Champa, *Studies in Early Impressionism,* New Haven, 1973, pp. 74–5, pl. 18.

This is among Pissarro's few pictures to survive the Franco-Prussian War, when his studio at Louveciennes was ransacked and much early work destroyed. According to Rewald (1963), "Pissarro here seems to have ventured suddenly into a style of incredible forcefulness and originality . . . only very few of Pissarro's works were painted in this vein, with broad brushstrokes and the use of a pallette knife . . . but it was to remain a fairly unique endeavor, as if, in spite of the fact that he has been so successful in this daring canvas, he did not feel tempted to pursue further a road that might have led him away from the intimate contact with nature toward which he had been so persistently inclined until then."

Peasants Resting PL. 250

[1881] Oil on canvas
32 x 25¾ in. (81 x 65 cm.)
Signed and dated lower right: C. Pissarro.81

Acc. no. 35.6

COLLECTIONS: Paul Durand-Ruel, Paris, to 1921; (Durand-Ruel, Paris).

EXHIBITIONS: Paris, Durand-Ruel, *7e Exposition des artistes indépendants,* 1882, no. 104; Paris, Durand-Ruel, *Tableaux et gouaches par Pissarro,* 1910, no. 17; New York, Wildenstein, *Camille Pissarro: His Place in Art,* 1945, no. 19, repr. p. 29; Boston, Museum of Fine Arts, *Barbizon Revisited,* 1962, no. 110, repr. p. 204; Bordeaux, Musée des Beaux-Arts, *La peinture française: collections américaines,* 1966, no. 172, pl. 50.

REFERENCES: L. R. Pissarro and L. Venturi, *Camille Pissarro, son art-son oeuvre,* Paris, 1939, I, no. 542; II, pl. 112.

In 1881 Pissarro worked with Cézanne and Gauguin at Pontoise painting landscapes and peasant genre subjects. This painting was included in the 7th Impressionist group exhibition of 1882. A pastel sketch for it was published by Pissarro and Venturi (II, no. 1549).

The Roofs of Old Rouen PL. 249

[1896] Oil on canvas
28½ x 36 in. (72.3 x 91.4 cm.)
Signed and dated lower right: C.Pissarro.1896.

Acc. no. 51.361

COLLECTIONS: Pissarro estate (inventory no. 125 on stretcher and back of canvas); (Durand-Ruel, Paris); Dr. Hans Ullstein, Berlin; Dr. and Mrs. Heinz Pinner (née Ullstein); (Knoedler, New York).

EXHIBITIONS: Paris, Durand-Ruel, *Exposition d'oeuvres récentes de Camille Pissarro,* 1896, no. 21; Pittsburgh, Carnegie Institute, *Third Annual International Exhibition,* 1898, no. 46; Toledo Museum of Art, *One Hundred Paintings by the Impressionists from the Collection of Durand-Ruel & Sons, Paris,* 1905, no. 83; Paris, Galerie Manzi et Joyant, *Retrospective C. Pissarro,* 1914, no. 13; New York, Wildenstein, *C. Pissarro,* 1965, no. 64, repr.

REFERENCES: G. Mourey, "Camille Pissarro," *Les Arts,* II, Dec. 1903, p. 40, repr.; G. Lecomte, *Camille Pissarro,* Paris, 1922, p. 84, repr.; C. Mauclair, *Les maîtres de l'impressionisme,* Paris, 1923, p. 192, repr.; A. Tabarant, *Pissarro,* Paris, 1924, pl. 33; E. Waldmann, *Die Kunst des Realismus und des Impressionismus,* Berlin, 1927, repr. p. 460; E. Koenig, *Camille Pissarro,* Paris, 1927, repr.; L. R. Pissarro and L. Venturi, *Camille Pissarro, son art-son oeuvre,* Paris, 1939, I, p. 64, no. 973; II, pl. 196; J. Rewald, ed., *Camille Pissarro: Letters to his son Lucien,* New York, 1943, pp. 283, 284, 285, 286, 287, 288, pl. 69; G. Bazin, *L'époque impressioniste,* Paris, 1947, pl. 38; J. Rewald, *Camille Pissaro,* New York, 1963, pp. 43, 144, repr. p. 145; L. Nochlin, "Camille Pissarro: The Inassuming Eye," *Art News,* LXIV, Apr. 1965, p. 61, repr. p. 25.

Pissarro went to Rouen in January 1896. Letters to his son Lucien document the development of this painting. On February 26 he wrote, "I have found a really uncommon motif in a room of the hotel facing north. Just conceive for yourself: the whole of old Rouen seen from above the roofs, with the Cathedral, St. Ouen's church, and the fantastic roofs, really amazing turrets. Can you picture a canvas about 36 x 28 inches in size, filled with old, grey, worm-eaten roofs? It is extraordinary!" (Rewald, 1943, p. 283). *The Roofs of Old Rouen* was completed by March 7 and exhibited at Durand-Ruel in

April. Pissarro, along with Degas, considered this painting an outstanding work (Rewald, 1943, p. 287) and kept it in his own collection until his death.

CORNELIS VAN POELENBURGH

1595/1600–1667. Dutch. Studied in his native Utrecht with Abraham Bloemaert. In Rome by 1617. Co-founder of the Netherlandish artists' society in Rome. By 1621 at Florence in the service of the Grand Duke of Tuscany. In 1627 he returned to Utrecht, and about 1637 went to London for two years at the invitation of King Charles I. Together with Bartholomeus Breenbergh, he was the chief representative of the first generation of Dutch Italianate landscape painters.

Roman Landscape PL. 92

[Ca. 1620] Oil on wood panel
17½ x 23⅝ in. (44.4 x 60 cm.)

Acc. no. 56.52

COLLECTIONS: (Nystad, The Hague).

EXHIBITIONS: Ann Arbor, University of Michigan Museum of Art, *Italy through Dutch Eyes*, 1964, no. 50, pl. 1; Utrecht, Centraal Museum, *Nederlandse 17e eeuwse Italianiserende Landschapschilders*, 1965, no. 13, pl. 14; New York, Wildenstein, *Gods and Heroes, Baroque Images of Antiquity*, 1969, no. 28, pl. 42.

REFERENCES: E. P. Lawson, "Dutch Painters in Italy," *Toledo Museum of Art Museum News*, I, Fall 1957, pp. 11–5, repr. (as Breenbergh); W. Stechow, 1968, pp. 149, 153, fig. 289.

Until Stechow (letter, Sep. 1962) attributed this painting to Poelenburgh, it had been attributed to Breenbergh. Stechow (1968) points out that it corresponds closely in style and composition to two landscapes dated 1620 (Louvre), and that the figures reflect Poelenburgh's classicizing style, which differs greatly from Breenbergh's.

NICOLAS POUSSIN

1594–1665. French. Born near Les Andelys, Normandy, where he studied under Quentin Varin, ca. 1611–12; later in Paris. In 1624 he settled in Rome, and formed his style there under the influence of ancient Roman art, Raphael, Titian and the contemporary Bolognese. In 1640 he returned to Paris to work for Louis XIII; by 1642 he was back in Rome, where he spent the rest of his life.

The Holy Family with Saint John PL. 187

[Ca. 1627] Oil on canvas
66¾ x 47½ in. (169.5 x 127 cm.)

Inscribed on the scroll: ECCE AGNUS DEI

Acc. no. 76.23

COLLECTIONS: Brought to England ca. 1822; Vittore Zanetti, Manchester, England, by 1835; then probably with his descendants in Italy until the late 19th century; Marquess of Crewe (Christie, London, Dec. 9, 1955, lot 70, as Carracci); Private collection, London; (Agnew, London).

REFERENCES: H. de Triqueti, *Répertoire de l'oeuvre de Poussin*, MS in the École des Beaux-Arts, Paris, ca. 1850, p. 48; A. Andresen, *Nicolaus Poussin, Verzeichniss der nach seinen Gemälden gefertigten Kupferstiche*, Leipzig, 1863, French ed. by G. Wildenstein, in *Gazette des Beaux Arts*, LX, July-Aug. 1962, p. 162, no. A.126, repr. (Anderloni engraving); R. Giolli, "Un quadro del Poussin," *Vita d'arte*, 1909, pp. 28–9, repr. (copy with composition reduced at top); A. Blunt, "La première période romaine de Poussin," in *Colloque Poussin*, (ed. A. Chastel), Paris, 1960, I, pp. 165–66, fig. 135 (as by Poussin, ca. 1629); D. Wild, "Charles Mellin ou Nicolas Poussin," *Gazette des Beaux Arts*, LXVIII, Oct. 1966, p. 204 (as by Mellin); A. Blunt, *The Paintings of Nicolas Poussin, A Critical Catalogue*, London, 1966, no. 49, repr. (as Poussin, "probably painted just before 1630"); A. Blunt, *Nicolas Poussin*, New York, 1967, text vol., pp. 75, 77, 81; plate vol., pl. 26 (as Poussin, ca. 1627–29); J. Thuillier, *Tout l'oeuvre peint de Poussin*, Paris, 1974, no. B30, repr. (Anderloni engraving) (questions attribution to Poussin).

Prior to Blunt's first publication of it in 1960, this painting was unknown to scholars except through an engraving of its composition. Blunt subsequently (1966, 1967) confirmed his belief that it was painted by Poussin during his early years in Rome, about 1629 or somewhat earlier. More recently, D. Mahon (verbally, 1972) and K. Oberhuber (verbally, 1975, 1976) have also agreed this painting belongs to Poussin's early Roman years, about 1627. Both scholars believe it was painted shortly before *The Death of Germanicus* (1627; Minneapolis Institute of Arts) and reflects the strong influence of Raphael on Poussin at this time. Oberhuber also noted the influence of Guercino, saying that Poussin found in Guercino an example of a painter who was, like himself, trying to turn from Venetian to Roman tradition. Thuillier, on the other hand, questioned the painting's attribution to Poussin, as earlier documentation is lacking and because he believed the style incongruous with the artist's mature work.

As Blunt has pointed out, "The chronology of Poussin's paintings in the early Roman years is extremely uncertain and has given rise to much discussion. The firm points are few. While Poussin was going through his experimental phase he does not seem to have followed a steady line of development, and furthermore, he seems to have been led to treat different subjects in different manners" (1967, p. 59).

There are marked similarities between the Virgin and Child and the right hand group of women and children in *The Death of Germanicus*. The Toledo composition most nearly resembles *The Holy Family with Saint John Holding a Cross* (Staatliche Kunsthalle, Karlsruhe) of about 1627 (Blunt, 1966, no. 48). The figures in the latter, however, are far smaller in scale than the grave, monumental group in the Toledo painting, which belongs among the few pictures of about 1627–30 in which Poussin used large-scale figures of this kind, culminating in *The Martyrdom of Saint Erasmus* (1628–29; Pinacoteca, The Vatican).

A copy of the Virgin and Child alone was in an anonymous sale, Anderson Galleries, New York, Apr. 15, 1926, lot 56 (as Puglio). Engraved by Faustino Anderloni (d. 1847) after a drawing by Giovita Garavaglia (d. 1835).

Mars and Venus — PL. 186

[Ca. 1633–34] Oil on canvas
62 x 74¾ in. (157.5 x 189.8 cm.)

Acc. no. 54.87

COLLECTIONS: Jean Baptiste Grimbergs, Brussels (Brussels, May 4, 1716; as Poussin, *Mars and Venus*); Prince de Carignan (Poilly, Paris, July 30, 1742, p. 27, and June 18, 1743, p. 23 (as Poussin, *Mars and Venus*); Bragge, London (London, Oct. 31, 1755, lot 60)?; Sir Nathaniel Curzon, later 1st Lord Scarsdale, 1758; Viscounts Scarsdale, Kedleston Hall, Derbyshire; (Wildenstein, New York).

EXHIBITIONS: London, Arts Council, *Landscape in French Art, 1550–1900*, 1949, no. 60 (cat. by A. Blunt); Minneapolis Institute of Arts, *Nicolas Poussin, 1594–1665*, 1959, essays by A. Blunt and W. Friedländer, pp. 6, 7, 12, cat. entry p. 25, fig. 7 (as *Mars and Venus*, late 1620s); Paris, Louvre, *Nicolas Poussin*, 1960, no. 1, pp. 214–15 (as Poussin, *Dido and Aeneas*, ca. 1624; cat. by A. Blunt and C. Sterling).

REFERENCES: J. Smith, VIII, no. 289 (as *Rinaldo and Armida*); G. Waagen, *Treasures of Art in Great Britain*, London, 1854, III, p. 393 (as *Rinaldo and Armida*); O. Grautoff, *Nicolas Poussin, sein Werk und sein Leben*, Munich, 1914, I, p. 130; II, no. 60 (as *Rinaldo and Armida*, ca. 1633–35); P. Jamot, *Connaissance de Poussin*, Paris, 1948, pp. 14–5, pl. 4 (as *Rinaldo and Armida*, pre-Roman period); A. Blunt, "Nicolas Poussin," *Burlington Magazine*, XCI, Dec. 1949, p. 356 (as Poussin, *Rinaldo and Armida*, after 1624); W. Friedländer, ed., *The Drawings of Nicolas Poussin, Catalogue Raisonné*, London, 1949, II, p. 21 (as *Rinaldo and Armida*); R. W. Lee, review of W. Friedländer, ed., *The Drawings of Nicolas Poussin, Part II*, in *Art Bulletin*, XXXV, 1953, p. 159 (suggests title *Toilet of Venus*); A. Blunt, "La première période romaine de Poussin," in *Colloque Nicolas Poussin*, (ed. A. Chastel), Paris, 1960, I, pp. 167, 168 (as Poussin, *Mars and Venus*); D. Mahon, "Poussin's Early Development: An Alternative Hypothesis," *Burlington Magazine*, CII, 1960, pp. 289, 290, 300 (as Poussin, *Dido and Aeneas*, mid-1630s); A. Blunt, review of A. Chastel, ed., *Colloque Nicolas Poussin*, in *Burlington Magazine*, CII, 1960, p. 331 (as *Dido and Aeneas*; questions attribution to Poussin); A. Blunt, "Poussin Studies, XII: The Hovingham Master," *Burlington Magazine*, CIII, 1961, pp. 457, 458, 461 (as The Hovingham Master); J. Thuillier, "L'année Poussin," *Art de France*, I, 1961, p. 340 (rejects Poussin attribution); D. Mahon, "Poussiniana, Afterthoughts Arising from the Exhibition," *Gazette des Beaux-Arts*, LX, 1962, p. 82, n. 241, p. 135, n. 405 (as Poussin, ca. 1634–35); R. Wallace, "The Later Version of Nicolas Poussin's 'Achilles in Scyros'," *Studies in the Renaissance*, IX, 1962, p. 329 (as *Dido and Aeneas* attributed to Poussin); A. Blunt, *The Paintings of Nicolas Poussin, A Critical Catalogue*, London, 1966, no. R-74 (as the Hovingham Master); J. Thuillier, *Tout l'oeuvre peint de Poussin*, Paris, 1974, no. R64 (as by Charles-Alphonse du Fresnoy).

Although consistently attributed to Poussin since the early 18th century, the attribution of this painting has been debated since the 1960 Paris Poussin exhibition, where it was shown as one of Poussin's earliest known works, following the opinion of P. Jamot. However, in the context of other early works exhibited there, this dating proved untenable. A. Blunt, who had formerly accepted the painting as by Poussin, subsequently (1961, 1966) attributed it to the artist he named the Hovingham Master. On the other hand, J. Thuillier (1974) suggested that it is a pastiche by Charles-Alphonse du Fresnoy (1611–1688). Neither of the attributions seems convincing in view of the quality of the painting. Mahon, however, accepted the painting as by Poussin and pointed out (1962) that the painting could very well fit into Poussin's development in the 1630s. He dated it 1634–35 and compared it to the *Choice of Hercules* (Stourhead, Wiltshire), and the lost *Nymphs Bathing* (formerly Duc de Créqui). K. Oberhuber, who has re-

cently taken a fresh look at Poussin's early development, essentially agrees (letter, Feb. 1976) with Mahon's view, and believes it is without question by Poussin, slightly earlier than the *Bacchanals* painted for Cardinal Richelieu in 1635–36.

In the 18th century the subject was identified as *Mars and Venus*. By 1837 (Smith) it was thought to be *Rinaldo and Armida*, from *Jerusalem Delivered* by Tasso. The subject was restudied after the painting was acquired by the Museum, and at that time the title returned to *Mars and Venus*. This identification was confirmed by R. W. Lee (1953; verbally, 1956) and E. Panofsky (letter, Nov. 1958). In the catalogue of the 1960 Paris exhibition, however, the subject was related to a passage in Virgil's *Aeneid* (IV: 175 ff.); subsequently the picture was called *Dido and Aeneas*. While the subject is exceptional in certain details such as the shield used as a mirror, the title *Mars and Venus* seems to best fit the circumstances illustrated. In showing Venus at her toilet attended by the Three Graces, Poussin may have varied his mythological subject with details inspired by other literary sources. Because the scene does not accurately depict a specific scene from either Tasso or Virgil, and because of the presence of elements usually associated with Venus and classical mythology (such as the putti, satyr, river god, rose bush), the present title seems most appropriate.

MATTIA PRETI

1613–1699. Italian. Born in Taverna, Calabria. To Rome about 1630, when he studied with his elder brother, Gregorio. Periodically in Rome until 1655, with trips to Modena, Bologna, Venice and possibly to France. Influenced during this period by the Caravaggisti, Lanfranco, Guercino and Veronese. Elected to the Roman Academy of St. Luke, 1653. To Naples, 1656. By late 1661 he was in Malta, where he worked until his death.

The Feast of Herod PL. 20

[1656–61] Oil on canvas
70 x 99¼ in. (177.8 x 252.1 cm.)

Acc. no. 61.30

COLLECTIONS: Marchese Ferdinando van den Eynden, Naples; Principe Belvedere Caraffa, Naples, by 1742; Principe Colonna di Stigliano, Naples, to ca. 1920; Prof. Zoccoli, Palazzo Roccagiovine; (M. & C. Sestieri, Rome, 1960); (Colnaghi, London).

EXHIBITIONS: London, Colnaghi, *Paintings by Old Masters*, 1961, no. 5, repr.; Detroit Institute of Arts, *Art in Italy 1600–1700*, 1965, no. 151, repr. (entry by F. Cummings).

REFERENCES: B. de Dominici, *Vite de'pittori, scultori, ed architetti napoletani*, Naples, 1742–43, III, p. 344; B.N. (B. Nicolson), "Current and Forthcoming Exhibitions," *Burlington Magazine*, CIII, May 1961, p. 195; "New National Gallery Acquisitions," *Burlington Magazine*, CV, July 1963, p. 296; F. H. Dowley, "Art in Italy, 1600–1700 at the Detroit Institute of Arts," *Art Quarterly*, XXVII, 1964, pp. 524–25, fig. 6; A. Frankfurter, "Museum Evaluations, 2: Toledo," *Art News*, LXIII, Jan. 1965, pp. 5, 24, 53, repr. cover, p. 5; H. Hibbard and M. Lewine, "Seicento at Detroit," *Burlington Magazine*, CVII, July 1965, pp. 370, 371; E. Herzog and J. Lehmann, *Unbekannte Schätze der Kasseler Gemälde-Galerie*, Kassel, 1968, p. 23; B. Fredericksen and F. Zeri, *Census*, pp. 170, 417.

The death of John the Baptist is told in Matthew XIV:1–12. Salome is shown presenting the head of St. John to her mother Herodias and her uncle Herod, the ruler of Galilee and husband of Herodias.

This is probably one of the scenes from the life of St. John the Baptist which De Dominici described as having been painted for Marchese Ferdinando van den Eynden. Preti probably did these while in Naples from 1656 to 1661, when he also produced several other Biblical feast pictures, inspired by Veronese and by Rubens' *Feast of Herod* (National Gallery of Scotland, Edinburgh), which had been brought to Naples about 1640 by the Flemish merchant and collector, Gaspar Roomer, the business partner of Van den Eynden's father.

A smaller version of the same subject by Preti with fewer figures is in the Gemäldegalerie, Kassel.

FRANCESCO PRIMATICCIO

1504–1570. Italian. As a student of Giulio Romano, Primaticcio assisted in the decoration of the Palazzo del Tè, Mantua. In 1532, the Duke of Mantua sent him to the French court at Fontainebleau, where in 1542 he succeeded G. B. Rosso as Director of Works to the King, Francis I. From 1552 his chief collaborator was Niccolò dell'Abbate. He remained at Fontainebleau for the rest of his life, except for several trips to Italy. His few surviving works show the influence of his first teacher, as well as of Raphael, Parmigianino, Correggio and Rosso. Primaticcio was the leader of the first School of Fontainebleau after Rosso's death and was primarily responsible for establishing the Mannerist Fontainebleau style.

Ulysses and Penelope PL. 15

[Ca. 1560] Oil on canvas
44¾ x 48¾ in. (113.6 x 123.8 cm.)

Acc. no. 64.60

COLLECTIONS: Earls of Carlisle, Castle Howard, Yorkshire, by 1805 to 1911; Geoffrey W. A. Howard, Castle Howard, 1911 to ca. 1935; Private collection, England; (Wildenstein, New York, 1945–64).

EXHIBITIONS: Manchester, *Exhibition of the Art Treasures of the United Kingdom,* 1857, p. 26, no. 180; Naples, *Fontainebleau e la maniera italiana,* 1952, p. 20, pl. 27; Indianapolis, John Herron Art Museum, *Pontormo to Greco: The Age of Mannerism,* 1954, no. 28, repr.; Amsterdam, Rijksmuseum, *Le triomphe du maniérisme européen,* 1955, no. 101a (entry by C. Sterling; as by Niccolò dell'Abbate); New York, Wildenstein, *The Painter as Historian,* 1962, no. 4, repr. p. 31; Paris, L'Oeil Galerie d'Art, *L'école de Fontainebleau,* 1963, no. 16, repr.; New York, Wildenstein, *The Italian Heritage,* 1967, no. 41, repr.; Paris, Grand Palais, *L'école de Fontainebleau,* 1972, no. 141, repr. (entry by S. Béguin); Ottawa, National Gallery of Canada, *Fontainebleau: Art in France, 1528–1610,* 1973, I, fig. 30, p. 245; II, no. 141 (entry by S. Béguin), pp. 42, 153.

REFERENCES: *A Descriptive Catalogue of the Pictures at Castle-Howard,* Malton, 1814, no. 32; G. F. Waagen, *Treasures of Art in Great Britain,* London, 1854, III, p. 322; W. Bürger, *Musée d'Anvers et trésors d'art en Angleterre,* Paris, 1865, p. 107; L. Dimier, *French Painting in the Sixteenth Century,* London, 1904, p. 184, repr. opp. p. 186; L. Dimier, *Histoire de la peinture française des origines au retour de Vouet, 1300 à 1627,* Paris, 1925, p. 53; L. Dimier, "Deux tableaux du Primatice," *Bulletin de la société de l'histoire de l'art français,* 1926, pp. 148–49; L. Dimier, *Le Primatice,* Paris, 1928, pp. 32, 45, 98, pl. XXXVI; P. Barocchi, "Precisazioni sul Primaticcio," *Commentari,* II, 1951, p. 215, n. 5; A. Blunt, *Art and Architecture in France 1500 to 1700,* Harmondsworth, 1953, p. 65, pl. 44b; S. Béguin, *L'école de Fontainebleau,* Paris, 1960, p. 54, repr. p. 50; A. Châtelet and J. Thuillier, *French Painting from Fouquet to Poussin,* Geneva, 1963, p. 106, repr. p. 103; A. Hauser, *Mannerism,* London, 1965, I, p. 213; II, pl. 113; A. Frankfurter, "Museum Evaluations, 2: Toledo," *Art News,* LXIII, Jan. 1965, pp. 26, 27, 52, 62, repr. p. 27; W. McA. Johnson, "Niccolò dell'Abbate's *Eros and Psyche,*" *Bulletin of The Detroit Institute of Arts,* XLV, 1966, pp. 30, 32, repr. p. 29; D. Rondorf, "Der Ballsaal im Schloss Fontainebleau zur Stilgeschichte Primaticcios in Frankreich," Bonn, 1967, p. 347 (unpublished Ph.D. thesis); S. Howard ed., *Classical Narratives in Master Drawings*

Selected from the Collections of the E. B. Crocker Art Gallery, Sacramento, 1972, pp. 13, 14, n. 2; P. Verdier, *Catalogue of the Painted Enamels of the Renaissance,* Baltimore, 1967, p. 103; H. Miles, "The 'Treasure-House of Marvels' at Paris," *Burlington Magazine,* CXV, Jan. 1973, p. 32; B. Fredericksen and F. Zeri, *Census,* pp. 170, 478, 641.

"And in turn, Ulysses, of the seed of Zeus, recounted to her (Penelope) all the griefs he had wrought on men, and all his own travail and sorrow, and she was delighted with the story, and sweet sleep fell not upon her eyelids till the tale was ended" (*Odyssey,* XXIII).

Beginning about 1541 Primaticcio and his assistants carried out a complex scheme of painted and sculptural decoration in the Ulysses Gallery at Fontainebleau Palace. This canvas is based on one of the 58 frescoes on the gallery walls illustrating the story of Ulysses. Although the gallery was destroyed in 1738–39, the compositions of the *Story of Ulysses* are known from engravings by the Flemish artist Theodore van Thulden published in 1633. The Toledo *Ulysses and Penelope* is an independently conceived version of a fresco in this series; the tender gesture with which Ulysses takes his young wife's face appears neither in the fresco nor in the copies or variations by others of it (Paris, 1972; Ottawa, 1973).

Scholars have widely agreed on the attribution of this painting to Primaticcio himself. "The *Ulysses and Penelope* is the finest picture we know that reflects Primaticcio's inspiration and style and seems worthy of his hand" (S. Béguin, Paris, 1972; Ottawa, 1973).

PIERRE PUVIS DE CHAVANNES

1824–1898. French. Born in Lyons. Studied in Paris with Henri Scheffer and briefly with Delacroix and Couture, 1848. Most important influence was that of Chassériau. Exhibited at Salon of 1850 but did not achieve first success until Salon of 1861. Received several commissions for large decorative schemes, including the Panthéon, Paris and the Boston Public Library. Influenced younger Symbolist writers and painters.

Ludus Pro Patria PL. 242

[Ca. 1880] Oil on canvas
37 x 49¼ in. (94 x 125.1 cm.)
Signed lower left: P. Puvis de Chavannes

Acc. no. 51.313

COLLECTIONS: Prince de Wagram; (Knoedler, New York).

EXHIBITIONS: Paris, Galerie Georges Petit, *Cent ans de peinture française*, 1930, no. 11; New York, Knoedler, *Masterpieces by Nineteenth Century French Painters*, 1930, no. 9, repr.; New York, Knoedler, *Figure Pieces*, 1937, no. 13, repr.; Los Angeles County Museum, *The Development of Impressionism*, 1940, no. 57, repr.; Detroit Institute of Arts, *Two Sides of the Medal, French Painting from Gérôme to Gauguin*, 1954, no. 92, repr. p. 53; Toronto, Art Gallery of Ontario, *Puvis de Chavannes and the Modern Tradition*, 1975, no. 20, repr.

REFERENCES: L. Werth, *Puvis de Chavannes*, Paris, 1926, pp. 15, 125, no. 15 (as 1881).

This canvas corresponds to the composition of the right third of the large mural, *Ludus Pro Patria*, painted for the main staircase of the Musée de Picardie, Amiens between 1880 and 1882. Puvis received this commission in 1879. The full-size cartoon was shown in the Salon of 1880, and the completed mural (on canvas) in the Salon of 1882, where it won Puvis the Medal of Honor. It is uncertain whether the Toledo painting is a preparatory study for the mural or whether it is a repetition by Puvis painted soon after the mural was finished. From about 1880 until his death, the artist often made reduced copies of his large decorative works as records of their compositions. There are reductions by Puvis of the right section in the Walters Art Gallery, Baltimore (dated 1883), and of the entire mural in the Metropolitan Museum of Art, New York.

The subject of *Ludus Pro Patria* (A Game for the Nation) was chosen to exalt the virtues of devotion to family and country.

ADAM PYNACKER

1622–1673. Dutch. Born in Pynacker near Delft. According to Houbraken, he spent three years in Italy. In Delft, 1649; Schiedam, 1657/58; and finally in Amsterdam from about 1659. One of the second generation of Dutch Italianate landscape painters, he was also an etcher, and in his later years designed wall decorations and tapestries.

Italian Landscape PL. 119

[Ca. 1655–60] Oil on canvas
27¼ x 21½ in. (69.2 x 54.6 cm.)
Signed bottom center: APynacker (AP in monogram)

Acc. no. 72.31

COLLECTIONS: Jean Antoine Gros (Lebrun, Paris, Apr. 13, 1778, lot 15); Charles Alexandre de Calonne (Skinner & Dyke, London, Mar. 26, 1795, lot 48)(?); Prési-

dent Haudry; Van Eyl Sleuter (Paillet, Delaroche, Paris, Jan. 25, 1802, lot 135); Ralph Bernal, London (Christie, London, May 8, 1824, lot 18); Ralph Fletcher, Gloucester (Christie, London, June 9, 1838, lot 53); Edmund Higginson, Saltmarshe, Herefordshire, by 1841 (Christie, London, June 4, 1846, lot 194); James Morrison and descendants, Basildon Park, by 1857; Walter Morrison (Sotheby, London, Apr. 19, 1972, lot 20); (Speelman, London).

EXHIBITIONS: London, Grosvenor Gallery, *III National Loan Exhibition*, 1914, no. 92.

REFERENCES: J. Smith, VI, nos. 4 and 45; H. Artaria, *A Descriptive Catalogue of the Gallery of Edmund Higginson, Esq. of Saltmarshe Castle*, London, 1841, p. 99; J. Smith, Supplement, no. 10 (incorrect transcription of Artaria); G. Waagen, *Galleries and Cabinets of Art in Great Britain*, Supplement, London, 1857, p. 310; C. Hofstede de Groot, IX, nos. 134 (incorrectly as identical with Smith no. 18) and 175.

Dating about 1655–60 is based on the similarity of the composition to a landscape dated 1654 (Staatliche Museum, East Berlin) and to the similar mountain range in a painting dated 1659 (Alte Pinakothek, Munich). The cylindrical watchtower also appears in a painting dated 1661 (Christie, Feb. 23, 1934, lot 57). Stechow (in *Oud Holland*, LXXV, 1960, p. 92; and 1968, p. 157) states that Pynacker's mature work from the mid-1650s to the 60s still reflects the influence of the Dutch Italianate landscape painter Jan Both, and differs greatly from his later decorative wall paintings.

The provenance and subject have been confused with that of other pictures, and this led to its having been catalogued under more than one number by Smith and Hofstede de Groot.

SIR HENRY RAEBURN

1756–1823. British. This leading Scottish portrait painter was essentially self-taught. Lived in Edinburgh except for a brief stay in Rome, 1785–87, which had little influence on his style. The consistent manner in which he painted allows relatively few of his paintings to be firmly dated. Associate of the Royal Academy, 1812; full Academician, 1815. Knighted by George IV, 1822, and appointed "His Majesty's First Limner and Painter in Scotland" in 1823.

Lady Janet Traill PL. 323

[Ca. 1800] Oil on canvas
50¼ x 40¼ in. (128 x 102 cm.)

Acc. no. 26.70

COLLECTIONS: James Christie Traill, Castlehill House, Caithness (Christie, London, July 14, 1911, lot 109); (Duveen, New York); (Henry Reinhardt, New York, 1912); Edward Drummond Libbey, 1912–25.

REFERENCES: J. Greig, *Sir Henry Raeburn, R.A.*, London, 1911, p. 61.

Lady Janet Traill (died 1806), daughter of William, 10th Earl of Caithness, married James Traill of Hobbister and Rattar in 1784. Raeburn's pendant portrait of her husband is in a New York private collection. Dating is based on costume and hair style.

Mrs. Bell PL. 324

[Early 1800s] Oil on canvas
30 x 25¼ in. (76 x 64 cm.)

Acc. no. 33.26

Gift of Arthur J. Secor

COLLECTIONS: W. Hamilton Bell, Edinburgh, by 1880 until at least 1901; (Howard Young, New York); Arthur J. Secor, 1927–33.

EXHIBITIONS: Edinburgh, Royal Scottish Academy, 1880, no. 321.

REFERENCES: W. Armstrong, *Sir Henry Raeburn*, London, 1901, p. 96; J. Greig, *Sir Henry Raeburn, R.A.*, London, 1911, p. 38; F. Rinder (compiler), *The Royal Scottish Academy 1826–1916*, Glasgow, 1917, p. 323.

A manuscript note of 1927 by William Roberts describes this portrait as a typical Raeburn of the early years of the 19th century and identifies the Toledo portrait among the various sitters listed by Armstrong as "Mrs. Bell" as that of Grizel Hamilton, wife of the surgeon Benjamin Bell (1749–1806).

Miss Christina Thomson PL. 325

[Ca. 1822] Oil on canvas
30⅛ x 25⅛ in. (76 x 64 cm.)

Acc. no. 33.25

Gift of Arthur J. Secor

COLLECTIONS: Robert Thomson (sitter's father), Camphill, Renfrewshire, Scotland; Sir Robert White-Thomson, K.C.B., Broomford Manor, Devon, by 1901; Ven. Leonard Jauncey White-Thomson, Archdeacon of Canterbury, until 1921; (Sulley & Co., London); (Howard Young, New York); Arthur J. Secor, 1922–33.

REFERENCES: W. Armstrong, *Sir Henry Raeburn, R.A.*, London, 1901, p. 113; E. Pinnington, *Sir Henry Raeburn,*

R.A., London, 1904, p. 253 (as Mrs. Christine White); J. Greig, *Sir Henry Raeburn, R.A.*, London, 1911, pp. 61–2 (as "Mrs. White"); W. Roberts, *Miss Christina Thomson (Mrs. White) by Sir Henry Raeburn*, London, 1921 (brochure).

Christina Thomson (ca. 1800–1848) married Rev. Thomas H. White in 1834. Armstrong and Roberts both date this portrait about 1822.

REMBRANDT VAN RIJN

1606–1669. Dutch. Born in Leyden. Apprenticed to Jacob van Swanenburgh about three years. May have studied with Jan Pynas ca. 1623 in Amsterdam, and then with Pieter Lastman. Returned to Leyden ca. 1625, then collaborated with another Lastman pupil, Jan Lievens. In 1631 settled in Amsterdam, where his reputation reached its height by 1640. Although he did not travel outside of Holland, he absorbed and reinterpreted the major developments of the international Baroque style, represented by Caravaggio, Rubens and Poussin. His activity as a painter, draughtsman and etcher touched all subject categories, including portraiture, landscape, genre, classical and religious themes.

Young Man with Plumed Hat PL. 100

[1631] Oil on wood panel
32 x 26 in. (81.2 x 66 cm.)
Signed and dated lower left: RHL 1631

Acc. no. 26.64

COLLECTIONS: Stephen Lawley, London; (Henry Reinhardt, New York, 1906); Edward Drummond Libbey, 1906–25.

EXHIBITIONS: Leyden, Stedelijk Museum, *Exposition de tableaux et de dessins de Rembrandt . . .*, 1906, no. 38; New York, Metropolitan Museum of Art, *Catalogue of Paintings by Old Dutch Masters*, 1910, no. 75; Toledo Museum of Art, *Inaugural Exhibition*, 1912, no. 200; New York, Wildenstein, *Rembrandt*, 1950, no. 1, repr.

REFERENCES: W. R. Valentiner and W. Bode, *Rembrandt in Bild und Wort*, Berlin, 1906, p. 45, repr. (as a self-portrait); W. R. Valentiner, "Opmerkingen over Enkele Schilderijen van Rembrandt," *Onze Kunst*, 1907, pp. 64–5 (as a self-portrait); A. Rosenberg, *Rembrandt*, New York, 1909, p. 33, repr.; C. Hofstede de Groot, VI, no. 577 (as a self-portrait); A. Bredius, *The Paintings of Rembrandt*, Vienna, 1936, no. 143; K. Bauch, *Rembrandt Gemälde*, Berlin, 1966, no. 138, repr.; F. Erpel,

Die Selbst Bildnisse Rembrandts, Berlin, 1967, p. 233, repr. p. 201; H. Gerson, *Rembrandt Paintings*, Amsterdam, 1968, pp. 204, 490, repr. p. 205; A. Bredius, *The Paintings of Rembrandt* (3rd ed., rev. by H. Gerson), London, 1971, no. 143.

This portrait was painted the year Rembrandt left Leyden to settle in Amsterdam. According to J. Bruyn (letter, Feb. 1975), it is one of the first experimental large-scale busts Rembrandt painted, probably after his arrival in Amsterdam.

Although the painting was considered a self-portrait by Valentiner, Hofstede de Groot and by this Museum until recently, Rembrandt scholars since Bredius (1936) have identified it as a portrait of an unknown young man.

GUIDO RENI

1575–1642. Italian. Born in Bologna. Studied with Denis Calvaert ca. 1584–ca. 1593 before entering the Caracci Academy in Bologna about 1595. First trip to Rome, 1602. Worked in Bologna and Rome 1603–15, where he received important commissions from the Borghese family and Pope Paul V. After 1615 mostly in Bologna, but carried out commissions for Mantua, Ravenna, Naples and Rome. He employed a large studio and had many pupils.

Venus and Cupid [COLOR PL. V] PL. 18

[1626] Oil on canvas
89⅞ x 62 in. (228.3 x 157.5 cm.)
Signed and dated lower right: ·GVIDVS·V·F·/·C·B·T·P·/ ·16-6·

Acc. no. 72.86

COLLECTIONS: Painted for a goldsmith by whom it was sold in Venice; Dukes of Mantua, 1665–after 1709; Count Poletti, Pozzuoli; Giuseppi Longhi, Milan (died 1831); Angelo Boucheron, Turin; (William Buchanan, London); Sir Andrew C. Fountaine and descendants, Narford Hall, Norwich, by 1854 to 1972 (Christie, London, July 7, 1894, lot 62, bought in); (Agnew, London).

EXHIBITIONS: London, Royal Academy, *Exhibition of Works by Old Masters*, Winter, 1880, no. 101 (as "*Il Diamante*").

REFERENCES: L. Scaramuccia, *Le finezze de' pennelli italiani*, Pavia, 1674, p. 122; C. C. Malvasia, *Felsina pittrice, Vite de' pittori Bolognesi*, Bologna, 1678; 1841 ed., II, pp. 32, 65; G. F. Waagen, *Treasures of Art in Great Britain*, III, London, 1854, p. 430; A. Luzio, *La galleria*

dei Gonzaga venduta all'Inghilterra, 1627–28, Milan, 1913, p. 317; D. S. Pepper, "Guido Reni's 'Il Diamante': A New Masterpiece for Toledo," *Burlington Magazine*, CXV, Oct. 1973, pp. 630–41, figs. 1, 2, 5, 6.

According to his biographer, Malvasia, Reni painted a Venus for a goldsmith in exchange for a diamond. Because of this account, in the 19th century this picture was known as *Il Diamante* (the diamond), although from that time until 1972 it remained almost unknown to scholars.

Venus is shown teasing her son Cupid. A putto in the window arranges roses, the flowers of love. Two doves, also attributes of the goddess, are near the bed, whose decorative freize shows Mars and Venus with Cupid.

As the style of this painting agrees with others of the 1620s, Pepper believes the partly effaced date may be read as 1626. Reni signed only one other painting, according to Pepper, who suggests C.B.T.P. may stand for "*Civis Bononiae* (or *Bononiensis*) *tabulam pinxit* (citizen of Bologna painted the picture)", while V.F. may be the goldsmith's initials.

A copy attributed by Pepper to Reni's pupil, Giovanni Andrea Sirani (1610–1670) was formerly in the Kaiser Friedrich Museum, Berlin (destroyed, 1945; C. Garboli and E. Bacceschi, *L'opera completa di Guido Reni*, Milan, 1971, no. 159, repr.).

PIERRE-AUGUSTE RENOIR

1841–1919. French. Born at Limoges, but raised in Paris. Studied with Gleyre and at the École des Beaux-Arts, 1862–64. Exhibited at the Salon irregularly 1863–90, and with the Impressionists in 1874, 1876, 1877 and 1882. Worked in Paris and elsewhere in France. First of several trips to Italy, 1881. Painted Parisian life, portraits and figures. Also a printmaker and sculptor.

Road at Wargemont PL. 253

[1879] Oil on canvas
31¾ x 39⅜ in. (80.6 x 100 cm.)
Signed and dated lower right: Renoir. 79.

Acc. no. 57.33

COLLECTIONS: (Durand-Ruel, Paris, 1891–1908); Steinhart collection, 1908; (Durand-Ruel, Paris, by 1914); Pinkus collection, by 1917; Walther Halvorsen, Oslo, by 1932; Mrs. Walther Halvorsen; Nicolai Andresen, New York, by 1950; (Wildenstein, New York, 1956).

EXHIBITIONS: Copenhagen, Statens Museum for Konst, *Exposition d'art français du XIX siècle*, 1914, no. 179;

London, Royal Academy, *French Art, 1200–1900, 1932,* no. 483, pl. 133; Paris, Orangerie, *Renoir, 1933,* no. 48, pl. XXIX; London, Reid & Lefevre, *Renoir,* 1935, no. 7; New York, Wildenstein, *Renoir,* 1950, no. 26, repr. p. 52; Art Institute of Chicago, *Paintings by Renoir,* 1973, no. 26, repr.

REFERENCES: J. Meier-Graefe, *Renoir,* Leipzig, 1929, p. 121, pl. 111; K. Clark, "A Renoir Exhibition," *Burlington Magazine,* LXVII, July 1935, pp. 3–4; A. C. Barnes and V. de Mazia, *The Art of Renoir,* New York, 1935, pp. 74n, 75n, 451, no. 95; W. Seitz, "The Relevance of Impressionism," *Art News,* LXVII, Jan. 1969, p. 37, repr.; E. Fezzi, *L'opera completa di Renoir del periodo impressioniste, 1869–1883,* Milan, 1972, no. 365, repr.

In the summer of 1879 Renoir made his first visit to Wargemont near Dieppe in Normandy, where his friend and patron Paul Bérard had a château. As Kenneth Clark observed, it was at this time that he began to feel the limits of Impressionism, for this landscape is not only a record of natural appearances but also a formal exercise in composition and technique.

The Green Jardinière PL. 254

[1882] Oil on canvas
36½ x 26¾ in. (92.7 x 67.9 cm.)
Signed lower right: A Renoir.

Acc. no. 33.174

COLLECTIONS: (Paul Rosenberg, Paris); (Durand-Ruel, Paris and New York, 1911–33).

EXHIBITIONS: New York, Durand-Ruel, *Paintings by Modern French Masters,* 1920, no. 19; New York, Duveen, *Renoir,* 1941, no. 46, repr. p. 68; San Francisco, California Palace of the Legion of Honor, *Paintings by Pierre-Auguste Renoir,* 1944, p. 43, repr.; New York, Wildenstein, *Loan Exhibition of Renoir,* 1950, no. 37, repr. p. 54; London, Tate Gallery, *Renoir,* 1953, no. 16, pl. IV; Los Angeles County Museum, *Pierre-Auguste Renoir,* 1955, no. 26, repr. p. 50; New York, Wildenstein, *One Hundred Years of Impressionism: A Tribute to Paul Durand-Ruel,* 1970, no. 50, repr.; Art Institute of Chicago, *Paintings by Renoir,* 1973, no. 42, repr.

REFERENCES: J. Meier-Graefe, *Renoir,* Leipzig, 1929, p. 18, pl. 152; W. Gaunt, *Renoir,* New York, 1962, p. 78, no. 27, repr.; F. Daulte, *Auguste Renoir, catalogue raisonné de l'oeuvre peint, Vol. I: Figures, 1860–1890,* Lausanne, 1971, no. 412, repr.; E. Fahy, in *The Wrightsman Collection, Vol. V: Paintings, Drawings, Sculpture,* New York, 1973, pp. 191–93, repr.; E. Fezzi, *L'opera completa di Renoir del periodo impressioniste, 1869–1883,* Milan, 1972, no. 535, repr. (as 1882).

According to Meier-Graefe and Daulte, this picture was painted in 1882, though Meier-Graefe believed the Toledo painting was probably completed much later. According to the 1941 Duveen exhibition catalogue, *The Green Jardinière* was finished in 1912. This was later confirmed by Paul Rosenberg, who stated that he was with Renoir in his studio in 1912 while the picture was being finished (quoted in a letter from Duveen, April 1951). Daulte, however, notes the Toledo painting was sold by Rosenberg to Durand-Ruel in December 1911.

A second version, *Young Woman with a Cat* (Wrightsman Collection, Metropolitan Museum of Art) has been dated by Fahy, autumn of 1881, and by Daulte 1882. In both pictures the sitter is identified as Aline Charigot, whom Renoir later married.

Landscape at Cagnes PL. 255

[1910] Oil on canvas
21⅜ x 25¾ in. (54.3 x 65.4 cm.)
Stamped lower right (estate stamp): Renoir.

Acc. no. 62.1

Gift of Mrs. C. Lockhart McKelvy

COLLECTIONS: The artist's estate; Pierre Renoir, Paris (the artist's son); Étienne Vautheret, Lyons (Hôtel Drouot, Paris, June 16, 1933, lot 23); Hodebert collection, Paris; Private collection, Switzerland; (Carstairs, New York); Mrs. C. Lockhart McKelvy, Perrysburg, Ohio.

EXHIBITIONS: Toledo Museum of Art, *The Collection of Mrs. C. Lockhart McKelvy,* 1964, p. 16, repr. p. 17.

REFERENCES: *L'atelier de Renoir,* II, Paris, 1931, no. 402, pl. 130.

Suffering from arthritis, Renoir moved in 1906 to Cagnes on the French Riviera, where he lived until his death. The same view appears in another landscape of 1910 (J. Meier-Graefe, *Renoir,* Leipzig, 1929, fig. 356).

Bather PL. 256

[1912] Oil on canvas
25¾ x 22 in. (65.4 x 55.9 cm.)
Signed lower right: Renoir.

Acc. no. 55.87

Gift of Mrs. C. Lockhart McKelvy

COLLECTIONS: Maurice Gangnat, Paris, 1912 (Hôtel Drouot, Paris, June 25–26, 1925, lot 88, repr.; as 1912); Henri Canonne, Geneva, 1925–39 (Galerie Charpentier, Paris, Feb. 18, 1939, lot 47, repr.); (Sam Salz, New York); Mrs. C. Lockhart McKelvy, Perrysburg, Ohio.

EXHIBITIONS: Toledo Museum of Art, *The Collection of Mrs. C. Lockhart McKelvy,* 1964, p. 18, repr. p. 19.

REFERENCES: R. Bouyer, "Les Renoir de la collection Gangnat," *Gazette des Beaux Arts,* XI, Apr. 1925, p. 248; J. Rewald, ed., *Renoir Drawings,* New York, 1958, p. 23.

From the time Renoir moved to Cagnes in 1906, nudes formed a large part of his work. In this, as in many other late paintings, the model was probably Gabrielle Renard.

Bather was bought from the artist in 1912 by Maurice Gangnat, who owned an important collection of Renoirs. A crayon drawing for the figure is illustrated by Rewald (no. 84, as 1912).

ALAN REYNOLDS

1926–. British. Studied at Woolwich Polytechnic School of Art and Royal College of Art. Taught at Central School of Arts and Crafts and St. Martin's School of Art. About 1960 his representational style became entirely abstract.

Cheveley Well, Suffolk PL. 356

[1952] Oil on cardboard
39⅞ x 30 in. (101.3 x 76.2 cm.)
Signed and dated lower right: Reynolds '52
Acc. no. 58.41.
Museum Purchase

COLLECTIONS: Miss Dorothy Searle; (Redfern, London).

EXHIBITIONS: Pittsburgh, Carnegie Institute, *The 1958 Pittsburgh Bicentennial Exhibition of Contemporary Painting and Sculpture,* 1958, no. 368.

SIR JOSHUA REYNOLDS

1723–1792. British. Born in Devonshire. Apprenticed to the portraitist Thomas Hudson. Traveled and studied in Italy, 1749–53. First President of the Royal Academy, 1768. Influenced by Rubens during visit to Holland and Flanders in 1781. Delivered his famous *Discourses* to Royal Academy students, 1769–90. The most famous British portraitist of his time, he employed many pupils and assistants. As both painter and aesthetician, he was probably the single greatest influence on English artistic life in the second half of the 18th century.

Miss Esther Jacobs PL. 309

[1761] Oil on canvas
36 x 28¾ in. (91.4 x 73 cm.)

Acc. no. 53.42
Gift of Mrs. Samuel A. Peck

COLLECTIONS: (Greenwood, London, Apr. 15, 1796, lot 14); Marquess of Hertford, 1796 to 1884; Charles John Wertheimer, London; W. C. Whitney, New York; Mrs. H. P. Whitney, New York; Mrs. Samuel A. Peck, New York.

EXHIBITIONS: London, Royal Academy, *Works of the Old Masters . . . ,* 1872, no. 50; London, Grosvenor Gallery, *Works of Sir Joshua Reynolds, P.R.A.,* 1883, no 79.

REFERENCES: A. Graves and W. V. Cronin, *A History of the Works of Sir Joshua Reynolds, P.R.A.,* London, 1899–1901, II, p. 511 (as "Miss Jacobs: The Blue Lady"); IV, repr. opp. p. 1376; W. Armstrong, *Sir Joshua Reynolds,* London, 1900, p. 214; E. K. Waterhouse, *Reynolds,* London, 1941, p. 49.

Waterhouse dated this portrait from Reynolds' sitter books. It was engraved in mezzotint in 1762 by Jonathan Spilsbury, as "Miss Jacob" [*sic*].

Captain William Hamilton PL. 310

[1757 (or 1762)–1772] Oil on canvas
30¼ x 25⅛ in. (76.8 x 63.8 cm.)
Acc. no. 26.58

COLLECTIONS: Capt., later Sir William, Hamilton; Miss Hamilton (his niece), 1785; Sir William R. Anson, by 1880 to 1905; Miss F. H. Anson; William McKay, London, by 1917; (Knoedler, New York, 1917); (Henry Reinhardt, New York, 1918); Edward Drummond Libbey, 1918–25.

EXHIBITIONS: London, Royal Academy, *Exhibition of Works by Old Masters and by Deceased Masters of the British School,* 1888, no. 23.

REFERENCES: C. R. Leslie and T. Taylor, *Life and Times of Sir Joshua Reynolds,* London, 1865, I, pp. 156, 162, 219; A. Graves and W. V. Cronin, *A History of the Works of Sir Joshua Reynolds, P.R.A.,* London, 1899–1901, II, pp. 424–25; IV, pp. 1329–30; W. Armstrong, *Sir Joshua Reynolds,* London, 1900, p. 210; A. L. Baldry, *Sir Joshua Reynolds,* London, [1905], p. xxviii; E. K. Waterhouse, *Reynolds,* London, 1941, p. 51, pl. 144B; O. Warner, *Emma Hamilton and Sir William,* London, 1960, p. 15, repr. opp. p. 16.

This portrait of Captain, later Sir William, Hamilton (1730–1803), diplomat and archaeologist, is thought to have been begun in 1757 (Graves and Cronin, IV; War-

ner) or 1762 (Waterhouse), and finished by 1772, with some retouching in 1785. Reynolds' account ledgers show that he also painted other portraits of Hamilton.

Hamilton's wife, Lady Emma, was noted for her association with Lord Nelson.

Master Henry Hoare
PL. 311

[1788] Oil on canvas
50¼ x 39⅞ in. (127 x 102 cm.)

Acc. no. 55.31

Gift of Mr. and Mrs. George W. Ritter

COLLECTIONS: Sir Richard Colt Hoare, 2nd Bt., Stourhead, Wiltshire, 1788–1838; by descent to Sir Henry Ainslie Hoare, 5th Bt., Stourhead, 1857–1883; (S. Wertheimer, London, 1883); Baron S. Albert de Rothschild, Vienna, by 1899; Baron Louis de Rothschild; (Agnew, London, by 1955).

EXHIBITIONS: London, Royal Academy, *Royal Academy of Arts Bicentenary Exhibition, 1768–1968*, 1968, I, no. 120; II, repr. p. 45.

REFERENCES: *A Description of the House and Gardens at Stourhead*, Bath, 1818, p. 9; J. P. Neale, *Mansions of England . . .* , London, 1847, II, p. x4; A. Graves and W. V. Cronin, *A History of the Works of Sir Joshua Reynolds, P.R.A.*, London, 1899, II, p. 468; W. Armstrong, *Sir Joshua Reynolds*, London, 1900, p. 212; E. K. Waterhouse, *Reynolds*, London, 1941, p. 80; M. Cormack (transcribed by), "The Ledgers of Sir Joshua Reynolds," *Walpole Society*, XLII, 1968–70, p. 156; E. K. Waterhouse, *Reynolds*, London, 1973, pl. 112.

Henry Hoare (1784–1836) was a son of the banker Sir Richard Colt Hoare. The painting was engraved by Charles Wilkin (1789) and in mezzotint by Samuel William Reynolds (1773–1835).

Miss Frances Harris
PL. 312

[1789] Oil on canvas
55½ x 44 in. (141 x 112 cm.)

Acc. no. 75.85

Gift of Mrs. George M. Jones, Jr.

COLLECTIONS: Painted for the Earl of Darnley in May 1789; Earls of Darnley, Cobham Hall, Kent; (Duveen, New York); Clement O. Miniger, Perrysburg, Ohio; Mrs. George M. Jones, Jr., Perrysburg, Ohio.

EXHIBITIONS: London, Royal Academy, 1790, no. 243; London, British Institution, 1813, additions to third catalogue, no. 9; Manchester, *Art Treasures of the United Kingdom*, 1857, no. 63; London, Royal Academy, *Ex-*

hibition of Works by Old Masters and by Deceased Members of the British School, 1876, no. 249; London, Grosvenor Gallery, *Catalogue of the Works of Sir Joshua Reynolds, P.R.A.*, 1883, no. 75; London, 45 Park Lane, *Sir Joshua Reynolds Loan Exhibition*, 1937, pl. 83.

REFERENCES: G. Waagen, *Treasures of Art in Great Britain*, London, 1854, III, p. 26; A. Graves and W. Cronin, *A History of the Works of Sir Joshua Reynolds, P.R.A.*, London, 1899, II, p. 442; IV, p. 1336; W. Armstrong, *Sir Joshua Reynolds*, London, 1900, p. 211; E. Waterhouse, *Reynolds*, London, 1941, p. 82; M. Cormack (transcribed by), "The Ledgers of Sir Joshua Reynolds," *Walpole Society*, XLII, 1968–70, p. 156.

The subject (1784–1842) was the second daughter of Sir James Harris, afterwards 1st Earl of Malmesbury. She married Lieutenant-General Sir Galbraith Lowry Cole, Governor of Mauritius and the Cape Colony.

Graves and Cronin quote several contemporary press remarks commenting favorably on the picture when it was shown at the Royal Academy in 1790. The portrait was engraved by J. Grozer (1791), S. W. Reynolds (1836) and J. Scott (1875).

SIR JOSHUA REYNOLDS, Copy after

Sir Joshua Reynolds
PL. 313

[After 1788] Oil on canvas
29⅞ x 25 in. (57.8 x 63.5 cm.)

Acc. no. 26.66

COLLECTIONS: (Henry Reinhardt, New York, 1914); Edward Drummond Libbey, 1914–25.

REFERENCES: O. Millar, *The Later Georgian Pictures in the Collection of Her Majesty the Queen*, London, 1969, p. 98.

According to Millar, this is one of over 15 copies after Reynolds' last self-portrait, painted in 1788 (Royal Collection, Windsor Castle).

JUSEPE DE RIBERA

Ca. 1591–1662. Spanish. Born in Játiva near Valencia. He went to Italy ca. 1610, and by 1616 settled in Naples, where he remained the rest of his life. Painter of religious, mythological and genre subjects; also an etcher. He was patronized by the Neapolitan churches, the

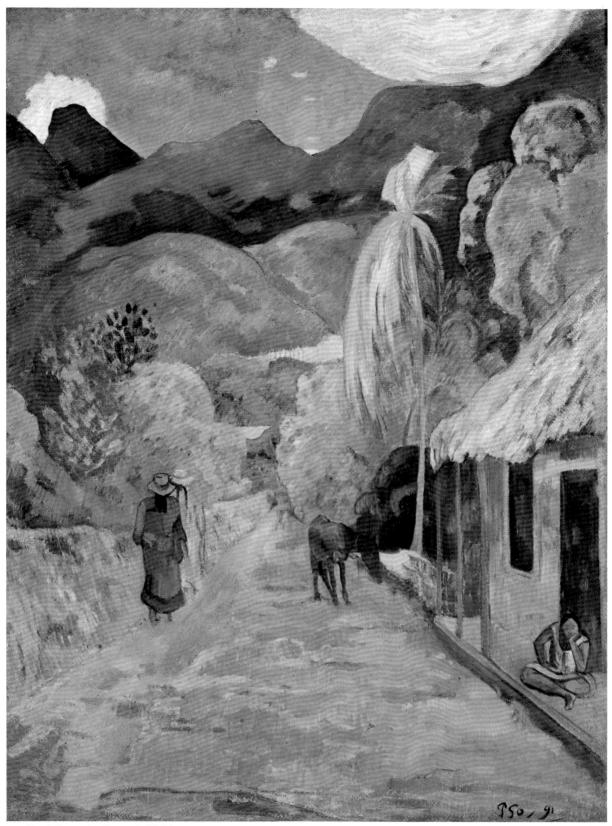

XI. Paul Gauguin, *Street in Tahiti*

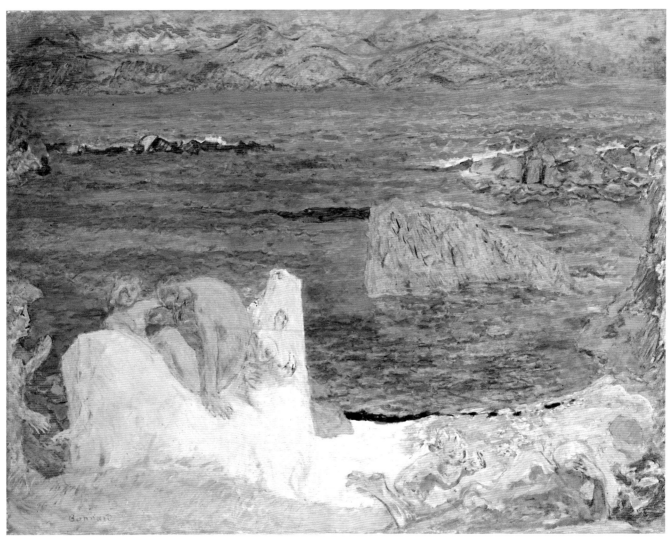

XII. Pierre Bonnard, *The Abduction of Europa*

Spanish viceroys in Naples, and the court at Madrid. In Spain his works were the principal source of the Carravagesque style there.

Giovanni Maria Trabaci, PL. 57
Choir Master, Court of Naples

[1638] Oil on canvas
30⅜ x 24⅝ in. (77.2 x 62.5 cm.)
Signed and dated center right: Jusepe de Ribera/F 1638

Acc. no. 26.61

COLLECTIONS: Augustus III, Elector of Saxony and King of Poland (reigned 1733–63); given to the Potocki family, Poland; Count Gregory Stroganoff, Rome, by 1908; (Sangiorgi, Rome); Edward Drummond Libbey, 1925.

EXHIBITIONS: New York, Metropolitan Museum of Art, *Spanish Paintings from El Greco to Goya,* 1928, no. 54, repr.; Toledo Museum of Art, *Spanish Painting,* 1941, p. 86, no. 54, repr. (cat. by J. Gudiol); Oberlin, Allen Memorial Art Museum, *Paintings and Graphics by Jusepe de Ribera,* 1957, no. 5, repr.; Sarasota, Ringling Museums, *Baroque Painters of Naples,* 1961, no. 11, repr. (cat. by C. Gilbert); Indianapolis, John Herron Museum of Art, *El Greco to Goya,* 1963, no. 65, repr.

REFERENCES: A. L. Mayer, *Jusepe de Ribera (Lo Spagnoletto),* Leipzig, 1908, pp. 124–25, pl. XXVII; 2nd ed., 1923, pp. 127–28, pl. XXXIII; A. Muñoz, *Pièces de choix du collection du Comte Grégoire Stroganoff,* Rome, 1912, II, p. 107, pl. LXXXII; A. L. Mayer, *La pintura española,* 2nd ed., Barcelona, 1929, p. 149; T. Kapterewa, *Velázquez und die spanische Porträtmalerei,* Leipzig, 1956, pp. 39–40, pl. 23; J. A. Gaya Nuño, *La pintura española fuera de España,* Madrid, 1958, no. 2348; G. Kubler and M. Soria, *Art and Architecture in Spain and Portugal and their American Dominions, 1500–1800,* Harmondsworth, 1959, p. 241; U. Prota-Giurleo, "Giovanni Maria Trabaci e gli organisti della Real Cappella di Palazzo di Napoli," *L'Organo,* Dec. 1960, pp. 190–91, repr.; C. M. Felton, "Jusepe de Ribera: A Catalogue Raisonné," unpublished Ph.D. dissertation, University of Pittsburgh, 1971, p. 35, no. A-64, repr.

Relatively few portraits by Ribera are presently known. This portrait of a musician has been identified as Giovanni Maria Trabaci (ca. 1575–1647), organist and choir master of the royal chapel at the viceregal court of Naples from 1604 until his death (Prota-Giurleo). The long staff and roll of music ("*sol-fa*") held by Trabaci were used by seventeenth century choir masters to beat time.

SEBASTIANO RICCI

1659–1734. Italian. Left his native Belluno in 1671 to study in Venice with Federico Cervelli and Sebastiano Mazzoni. In 1678 was in Bologna, then in Parma and Rome until 1694. In 1700 returned to Venice, remaining about 12 years, with trips to Vienna, Bergamo and Florence before going to England with his student and nephew, Marco Ricci, for whose landscapes and architectural backgrounds Sebastiano often did the figures. Returned to Venice in 1716 until his death. Strongly influenced by Veronese, Ricci was one of the principal painters who carried the Venetian decorative style to all parts of Europe.

Saint Paul Preaching PL. 33

[1712–16] Oil on canvas
73½ x 62½ in. (186.9 x 158.8 cm.)

Acc. no. 66.112

COLLECTIONS: Probably painted for Richard Boyle, 3rd Earl of Burlington, ca. 1712/16–1753; Charlotte Elizabeth Boyle (his daughter), 1753–54; William Cavendish, Marquess of Hartington and 4th Duke of Devonshire (her husband), 1754–64 and by descent to 11th Duke of Devonshire (Christie, London, June 27, 1958, lot 12, repr.); (Agnew, London).

EXHIBITIONS: London, Whitechapel Art Gallery, *Eighteenth Century Venice,* 1951, no. 109 (cat. by F. J. B. Watson); Art Institute of Chicago, *Painting in Italy in the Eighteenth Century: Rococo to Romanticism,* 1970, no. 38, repr. p. 99 (entry by B. Hannegan).

REFERENCES: *Vertue Notebooks, IV,* Walpole Society, XXIV, 1935–36, p. 118; O. Osti, "Sebastiano Ricci in Inghilterra," *Commentari,* II, 1951, p. 122, fig. 127; B. Nicolson, "Sebastiano Ricci and Lord Burlington," *Burlington Magazine,* CV, Mar. 1963, p. 122; B. Fredericksen and F. Zeri, *Census,* pp. 175, 439; E. H. Gombrich, *The Ideas of Progress and their Impact on Art,* New York, 1971, p. 12, repr. p. 13.

This painting was seen by the engraver and antiquarian George Vertue in Burlington House, London, and mentioned in his 1736–41 notebooks on artists and collections in England. It was probably commissioned by Lord Burlington, who took a close interest in Ricci and his work. Two mythological decorations by Ricci are still in Burlington House, now the home of the Royal Academy. While Ricci was in England from 1712 to 1716, Nicolson suggests that 1712–14, before Burlington's Grand Tour and his enthusiasms for Neoclassicism, is the most likely date for such a commission. This

painting, strongly influenced by Veronese, is possibly connected with the designs Ricci submitted for the competition for the decoration of the dome of St. Paul's Cathedral.

It is unclear whether the saint is shown preaching at Athens (Acts XVII:22–23) or at Corinth (Acts XVIII: 1–17, especially verse 4). Vertue, who described the painting as St. Paul preaching to the Corinthians, wrote of "one figure of a man—the face almost profil [sic] of the painter of the picture." There are self-portraits by Ricci (J. von Derschau, *Sebastiano Ricci*, Heidelberg, 1922, p. 1, n. 3), and in this painting the artist is almost certainly the prominent portly figure with his hands in his belt at center left.

The Marriage at Cana (Nelson Gallery of Art, Kansas City) is the pendant to the Toledo painting.

Christ and the Woman of Samaria PL. 34

[1720s] Oil on canvas
31⅛ x 24¾ in. (79 x 62.8 cm.)
Signed lower center: Riccivs Fecit

Acc. no. 71.5

COLLECTIONS: Private collection, England; (Ian G. Appleby, London); (Hazlitt Gallery, London).

REFERENCES: D. Ewing, "A New Sebastiano Ricci," *Toledo Museum of Art Museum News*, XVII, No. 1, 1974, pp. 7–10, fig. 4.

While Ewing tentatively dated this painting about 1730, late in Ricci's career, more recently, M. Milkovich (letter, Aug. 1974) has suggested that it was done in the 1720s. A larger version of the same subject probably painted in the mid-1720s is in the Royal Collection, Hampton Court Palace (M. Levey, *The Later Italian Pictures in the Collection of Her Majesty the Queen*, London, 1964, no. 638). Although certain elements of composition in the two pictures are similar, it is unclear which painting preceded the other.

CERI RICHARDS

1903–1971. British. Born in Wales. Student at Swansea School of Art, 1920–24, followed by three years at Royal College of Art, where he was named an honorary fellow in 1961. In 1933 exhibited with the Objective Abstraction Group and from 1940 to 1944 was head of the painting department at Cardiff College of Art. Known for surrealist figures and landscapes.

Music Room PL. 354
(Composition in Red and Black)

[1951] Oil on canvas
40-1/16 x 36-3/16 in. (101.8 x 91.9 cm.)
Signed and dated lower right: Ceri/Richards/'51

Acc. no. 52.95

COLLECTIONS: (Redfern Gallery, London).

HYACINTHE RIGAUD

1659–1743. French. Born in Perpignan, Rigaud studied in Montpellier and Lyons before becoming a student at the Académie Royale. In 1682 he won the Prix de Rome, but did not go to Italy. He entered the Académie in 1700 as a history painter. Inspired by Van Dyck and Philippe de Champaigne, his own portraits became models for other artists, and they represent a culmination of the state portrait tradition. He was official portrait painter to three generations of the Bourbons of France and painted distinguished Europeans. A large studio helped Rigaud meet the great demand for his work.

Marquis Jean-Octave de Villars PL. 196

[1715] Oil on canvas
18½ x 14 in. (47 x 35.5 cm.)

Acc. no. 59.15

COLLECTIONS: Private collection, Paris; (Wildenstein, New York).

EXHIBITIONS: Cleveland Museum of Art, *Style, Truth and the Portrait*, 1963, no. 20, repr.

REFERENCES: J. Roman, *Le livre de raison du peintre Hyacinthe Rigaud*, Paris, 1919, p. 176.

This portrait study has been identified by George V. Gallenkamp (letter, Mar. 1968), who is preparing a monograph on Rigaud, as Marquis Jean-Octave de Villars (born 1658), brother of the famous Claude-Louis-Hector, Duc de Villars and Maréchal Général des Camps et Armées du Roi. While his first name is not given in Rigaud's account book, it is clear that the entry under 1715, *"Mʳ le marquis de Villars, la tête seulement, la reste n'a point été achévé,"* is Jean-Octave, rather than Honoré-Armand, Marquis de Villars (born 1702), son of the Maréchal, as identified by Roman. An age of 57 would agree with the sitter's appearance. Painted from life, this head was probably intended for a large finished work which was never executed.

ROBUSTI (see TINTORETTO)

GEORGE ROMNEY

1734–1802. British. Apprenticed to a traveling portraitist, 1755–57. In London, 1763–73, followed by two years in Italy. Returned to London where he remained until 1798, when he retired to his native Lancashire. Romney was one of the best known English portrait painters of his time.

Lord Macleod PL. 321

[1788] Oil on canvas
50⅛ x 40¼ in. (127.2 x 101.8 cm.)

Acc. no. 28.192

Gift of Arthur J. Secor

COLLECTIONS: Earls of Cromarty, Tarbat House, Scotland; Sir Hugh Lane; (Agnew, London, by 1913–19); Marquise de Ganay, 1919–22 (Georges Petit, Paris, May 8–10, 1922, lot 66, repr.); (Agnew, London, 1922–25); (Howard Young, New York, 1925); Arthur J. Secor, 1925–28.

REFERENCES: W. Fraser, *The Earls of Cromartie*, Edinburgh, 1876, I, p. cclviii, repr. preceding p. cclix; H. Ward and W. Roberts, *Romney*, London, 1904, II, p. 98; R.-C. Catrous, "Collections de Mme. la Marquise de Ganay," *Revue de l'art*, XLI, Apr. 1922, p. 288, repr. p. 291; A. McK. Annand, "Major-General Lord Macleod, Count Cromartie, First Colonel, 73rd Macleod's Highlanders (later 71st and now 1st Bn. The Highland Light Infantry)," *Journal of the Society for Army Historical Research*, XXXVII, 1959, pp. 26–7, repr. facing p. 26.

Lord Macleod (John MacKenzie, 1729–1789) was convicted of high treason in 1745. In 1748 he was pardoned and entered the military service of Sweden, becoming aide-de-camp to the Swedish king. He returned to England in 1777. He had five sittings for this portrait in June 1788, and is shown wearing the 1786 Great Uniform of a Major General of the British Army and the ribbon and star of the Swedish Order of the Sword.

SALVATOR ROSA, Style of

Italian. Rosa (1615–1673) was born at Naples. He was active there, in Rome and in Tuscany, chiefly as a landscape painter. Died at Rome.

Hagar and the Angel PL. 21

Oil on canvas
63 x 74⅞ in. (160 x 192 cm.)

Acc. no. 61.29

COLLECTIONS: Private collection, France; (Heim, Paris).

According to Genesis XXI:9–21, Hagar and the illegitimate son she bore to Abraham wandered in the wilderness of Beersheba after being expelled from the house of Abraham. The angel of the Lord appeared to Hagar as a sign of God's protection of her and of the nation which would come from her son, Ishmael.

Rosa scholars, including L. Salerno, M. Kitson, and R. W. Wallace agree (letters, Oct. and Dec. 1975) this painting is not by Rosa although containing Rosa-related motifs. In the opinion of Salerno, the figures are like those in two paintings with the same subject by the Roman landscape painter and pupil of Domenichino, Francesco Cozza (1605–1682) (1664, Statens Museum for Kunst, Copenhagen; 1665, Rijksmuseum, Amsterdam). Kitson and Wallace believe the Toledo picture may have been painted in the 18th century.

DANTE GABRIEL ROSSETTI

1828–1882. British. Born in London, the son of Italian political refugees. Studied at Royal Academy, 1845–47. Briefly in the studio of Ford Madox Brown in 1848. With Holman Hunt, J. E. Millais, F. G. Stephens and W. M. Rossetti, formed the Pre-Raphaelite Brotherhood in 1848. Influenced the younger William Morris and Burne-Jones. In the 1860s designed stained glass, furniture and tiles with the firm Morris, Marshall, Faulkner, and Co. Painter and poet, Rossetti drew his subject matter primarily from medieval literature.

The Salutation of Beatrice PL. 336

[1880–82] Oil on canvas
60¾ x 36 in. (154.3 x 91.4 cm.)

Acc. no. 60.8

COLLECTIONS: Painted for Frederick R. Leyland, London (Christie, London, May 28, 1892, lot 54); Sir John C. Holder, Birmingham, 1892; Mrs. J. M. S. Holder, Birmingham, 1927; (Wildenstein, New York).

EXHIBITIONS: London, Royal Academy, *Exhibition of Works by Old Masters . . . including a Special Selection from the Works of John Linnell and Dante Gabriel Rossetti*, 1883, no. 323; London, New Gallery, *Winter Exhibition*, 1897, no. 58; Manchester, City Art Gallery, *Loan Exhibition of Works by Ford Madox Brown and the Pre-Raphaelites*, 1911, no. 214; Indianapolis, Herron Museum of Art, *The Pre-Raphaelites*, 1964, no. 78, repr.

REFERENCES: W. Sharp, *Dante Gabriel Rossetti, A Record and a Study*, London, 1882, pp. 264–65, no. 311; "Dante Gabriel Rossetti," *Harper's*, LXV, May 1882, p. 700, repr. p. 696; W. M. Rossetti, "Notes on Rossetti

and His Works," *Art Journal,* 1884, p. 208; T. Childs, "A Pre-Raphaelite Mansion," *Harper's,* LXXXII, Dec. 1890, p. 84; H. C. Marillier, "The Salutation of Beatrice as Treated Pictorially by D. G. Rossetti," *Art Journal,* Dec. 1899, pp. 356–57, repr.; E. L. Carey, *The Rossettis,* New York and London, 1900, pp. 177, 295, no. 194; W. M. Rossetti, "D. G. Rossetti," *Art Journal, Easter Art Annual,* 1902, p. 32; H. C. Marillier, *Dante Gabriel Rossetti, An Illustrated Memorial of His Art and Life,* London, 1904, pp. 141–42, 172, no. 385; E. Waugh, *Rossetti, His Life and Works,* New York, 1928, p. 212; O. Doughty, *A Victorian Romantic, Dante Gabriel Rossetti,* London, 1960, p. 632; M. F. Rogers, Jr., "The Salutation of Beatrice: by Dante Gabriel Rossetti," *Connoisseur,* CLIII, July 1963, pp. 180–81, repr.; V. D. Coke, *The Painter and the Photograph,* Albuquerque, 1964, p. 15, repr. p. 14; A. Scharf, *Art and Photography,* London, 1968, pp. 80, 266; V. Surtees, *The Paintings and Drawings of Dante Gabriel Rossetti (1828–1882), A Catalogue Raisonné,* Oxford, 1971, I, no. 260; II, pl. 390.

This painting illustrates lines from the second sonnet of Dante's *Vita Nuova* which Rossetti translated into English by 1849 and published in 1861. Beatrice, for whom Mrs. William Morris posed, is shown in the streets of Florence. Dante, protected by the wings of Love, appears in the background. The architectural setting, according to W. M. Rossetti (1884), was composed from photographs sent to the artist by Fairfax Murray. The passage from *Vita Nuova* and Rossetti's translation are inscribed on the original frame.

According to Sharp and W. M. Rossetti (1884), this painting, Rossetti's last large work, was not considered finished at the time of his death, though it was very close to completion. Surtees, who suggests that either Madox Brown or Treffey Dunn added the final touches, lists four preparatory drawings which date from about 1872 to 1881. Sharp recorded (no. 292) a fifth drawing of ca. 1878, a crayon sketch for the head of Beatrice.

SIR WILLIAM ROTHENSTEIN

1872–1945. British. Born in Bradford. Studied with Legros at the Slade School, 1888. Moved to Paris, 1889, and attended the Académie Julian, 1889–93. Close friend of Whistler. Returned to England in 1893 and exhibited with New English Art Club from 1894. A painter and printmaker, he was also Principal of the Royal College of Art, 1920–35.

The Painter Charles Conder PL. 338

[1892] Oil on canvas

47⅜ x 21¾ in. (120.3 x 55.2 cm.)

Signed and dated lower left: Will Rothenstein/'92

Acc. no. 52.86

COLLECTIONS: Llewellyn Hacon, Dieppe, from 1894; Mrs. Amaryllis Robichaud, until 1951; (Leicester Gallery, London).

EXHIBITIONS: Paris, Salon du Champ de Mars, 1892 (as *L'homme qui sort*); London, New English Art Club, 1894; London, Tate Gallery, *Sir William Rothenstein, 1872–1945, A Memorial Exhibition,* 1950, no. 4; Columbus Gallery of Fine Arts, *British Art 1890–1928,* 1971, no. 85, fig. 10 (cat. by D. Sutton).

REFERENCES: W. Rothenstein, *Men and Memories: A History of the Arts 1872–1922,* New York, n.d., I, p. 121; J. Rothenstein, *The Life and Death of Conder,* New York, 1938, pp. 141–42; J. Rothenstein, *Modern English Painters: Sickert to Smith,* London, 1952, p. 124; J. Flaizik, "Pictorial Literature," *Toledo Museum of Art Museum News,* III, Spring 1960, pp. 45, 46, repr. p. 44; R. Speaight, *William Rothenstein,* London, 1962, pp. 49, 71–2, repr.; V. Hoff, *Charles Conder,* Melbourne, 1972, pp. 51, 93, n. 21, fig. 20.

Charles Conder (1868–1908) was a painter of landscapes and figure subjects whom Rothenstein met in 1890. The following year Rothenstein exhibited for the first time in a joint showing with Conder in Paris. This is the first of several portraits of Conder by Rothenstein which include at least two paintings and several drawings. Conder was not particularly pleased by this portrait, and Rothenstein (*Men and Memories*) later explained his friend's displeasure by saying, "Conder wished me to make him look more *Daumieresque,* to style his coat and give him a *fatale* and romantic appearance." The second portrait, dated 1896, is in the Musée de Jeu de Paume, Paris.

GEORGES ROUAULT

1871–1958. French. Born in Paris. Apprenticed to a maker of stained glass in 1885. Studied at École des Beaux-Arts, 1891 and with Gustave Moreau, 1892–98. Early Biblical paintings influenced by Rembrandt. Briefly associated with the Fauve group, 1905–06. Exhibited regularly at Salon des Indépendants, 1905–12. He developed an independent Expressionist style as a painter and important printmaker.

The Judge PL. 299

[Ca. 1937] Oil on canvas

31⅛ x 22⅞ in. (79 x 58 cm.)

Acc. no. 48.63

COLLECTIONS: Marie Bell, Paris; (Bignou, Paris).

Judges first appeared in Rouault's work in 1906, and he later commented that if he had made them such lamentable figures it was because he had portrayed the anguish he felt at the sight of a human being who had to pass judgment on others. Rouault returned frequently to this subject, and because he often reworked pictures years later, the dating of his work is difficult. The style of this painting is similar to others painted in 1937–39, notably *The Judge*, 1937 (L. Venturi, *Georges Rouault*, Paris, 1948, pl. 93; present location unknown).

PIERRE-ÉTIENNE-THÉODORE ROUSSEAU

1812–1867. French. Studied with his cousin, the landscape painter Pau de Saint-Martin, Rémond and Guillon Lethière, and was greatly influenced by Claude and the Dutch 17th century masters. Painted at Fontainebleau as early as 1826–29 and throughout France during the 1830s. He divided his time between Barbizon and Paris after 1837. Exhibited at the Salons, 1831–36 and again from 1849, having been excluded in the interim. Dupré and later Millet were his close friends, and he was a great influence on Diaz.

In the Auvergne Mountains PL. 224

[1837] Oil on canvas
25½ x 31⅞ in. (65 x 81 cm.)
Signed and dated lower right: TH. Rousseau 1837

Acc. no. 22.39

Gift of Arthur J. Secor

COLLECTIONS: (Vose, Boston, ca. 1880); Mrs. S. D. Warren, Boston; (Vose, Boston); Oren Westcott, Boston; (Vose, Boston); Arthur J. Secor, 1912–22.

EXHIBITIONS: Detroit Institute of Arts, *French Painting from David to Courbet*, 1950, no. 85, repr.; Boston, Museum of Fine Arts, *Barbizon Revisited*, 1963, no. 90, repr.; Minneapolis Institute of Arts, *The Past Rediscovered: French Painting 1800–1900*, 1969, no. 75, repr.

REFERENCES: J. Foucart, "Paysagistes et petits maîtres," *Art de France*, IV, 1964, p. 348.

Although Rousseau employed the strong tonal contrasts seen here throughout his career, this picture shows unusually restrained brushwork and a particularly dry and grainy paint surface that is unusual in his work.

Under the Birches, Evening PL. 223

[1842–43] Oil on wood panel
16⅝ x 25⅜ in. (42.3 x 64.4 cm.)
Signed lower left: Th. Rousseau

Acc. no. 33.27
Gift of Arthur J. Secor

COLLECTIONS: Louis-Désiré Véron, Paris (bought from Rousseau)—1858 (Hôtel Drouot, Paris, Mar. 17, 1858, lot 60); Henri Didier, Paris, by 1860 (Hôtel Drouot, Paris, June 15, 1868); Baron Nathanial de Rothschild, Paris, from 1868; Baronesse Nathanial de Rothschild, Paris, to 1897; (E. Leroy, Paris, 1897–98); George J. Gould, New York, 1898—after 1910; Arthur J. Secor, 1927–33.

EXHIBITIONS: Paris, Galerie Francis Petit, *Salon Intime, Iᵉ Exposition Boulevard des Italiens*, 1860, no. 294 (as *Le Curé*); Paris, Cercle de l'Union des Arts, *Tableaux modernes*, 1865, no. 116 (as *Curé dans un chemin creux*); Paris, Galerie Georges Petit, *Cent chefs-d'oeuvre*, 1883 (cat. published by Knoedler and Petit, New York, 1885, no. 71, etched by F. Kratké, repr. opp. p. 62, as *Evening*); Paris, Exposition Universelle, 1889, no. 607, cat. *Chefs-d'oeuvre de l'Exposition Universelle de Paris*, Paris and Philadelphia, 1889, I, no. 607, pp. 42–3, repr. p. 23 (as *Evening*); London, Royal Academy, *French Art: 1200–1900*, 1932, no. 498, pl. 107; Paris, Exposition International, *Chefs-d'oeuvre de l'art français*, 1937, no. 409, pl. 78B; Columbus Gallery of Fine Arts, *Relationships Between French Literature and Painting in the 19th Century*, 1938, no. 4; Boston, Museum of Fine Arts, *Barbizon Revisited*, 1962, no. 95, p. 28, repr. p. 32; Paris, Musée de Louvre, *Théodore Rousseau*, 1968, no. 22, in biography 1842–43 and 1860.

REFERENCES: Z. Astruc, *Les 14 Stations du Salon*, Paris, 1859, p. 244; T. Gautier, "Exposition de tableaux modernes," *Gazette des Beaux-Arts*, V, 1860, p. 286; L. Lagrange, "Bulletin Mensuel," *Gazette des Beaux-Arts*, XVIII, 1865, p. 295; A. Sensier, *Souvenirs sur Th. Rousseau*, Paris, 1872, p. 132; F. Michel, *Great Masters of Landscape Painting*, London, 1910, repr. p. 320; P. Dorbec, *Théodore Rousseau*, Paris, 1910, p. 79; P. Dorbec, "L'oeuvre de Théodore Rousseau aux Salons 1849 à 1867," *Gazette des Beaux-Arts*, IX, 1913, p. 107; P. Dorbec, *L'art du paysage en France*, Paris, 1925, pp. 106, 115; J. Canaday, *Mainstreams of Modern Art*, New York, 1959, p. 119, repr. p. 118; P. Granville, "Theodore Rousseau un siècle plus tard," *L'Oeil*, No. 156, Dec. 1967, pp. 14, 15, repr.; J. Kolpinski, *Die Kunst des 19. Jahrhunderts, allgemeine Geschichte der Kunst*, Leipzig, 1969, VI, p. 72, repr. no. 59; J. Bouret, *L'École de Barbi-*

zon et le paysage français aux XIXᵉ siècle, Neuchâtel, 1972, p. 128, repr. p. 129.

Discouraged by continued exclusion from the Salon, Rousseau left Paris in May 1842 for the remote hamlet of Fay in Berry, remaining there until December. According to Sensier, this painting was begun in late October and finished in Paris after Rousseau's return in 1843.

An unpublished preparatory black crayon drawing for this painting in the Museum's collection was apparently drawn by Rousseau on the spot. Although it repeats the basic composition of the trees, the drawing includes a foreground pond which Rousseau eliminated in the painting, but which appears in its pendant, *La Mare* (Musée Saint Denis, Reims; Louvre exhibition, 1968, no. 21), done a few months before the Toledo picture and showing the same site from another angle.

Landscape PL. 226

[Ca. 1845–50] Oil on wood panel
16¼ x 24⅞ in. (41.3 x 63.2 cm.)
Signed lower left: TH Rousseau

Acc. no. 36.3
Gift of Arthur J. Secor

COLLECTIONS: G. Gerardts, Antwerp; (Goupil, New York); L. Z. Leiter, Chicago; Arthur J. Secor, 1934–35.

According to the catalogue of the 1968 Paris Rousseau exhibition (p. 56), pictures of this kind, directly inspired by 17th century Dutch landscapes, were painted for clients who preferred bucolic pastoral scenes to Rousseau's more ambitious compositions. A related painting in the Louvre is dated ca. 1845–48 by H. Adhémar and C. Sterling (*Peintures, école française XIXe siècle*, Paris, 1961, IV, no. 1673, pl. 656).

PETER PAUL RUBENS

1577–1640. Flemish. Born at Siegen, near Cologne. His parents were natives of Antwerp, where he lived mostly after ca. 1588. Studied there and became a master of the Antwerp painters guild in 1598. In 1600 he went to Italy, remaining for eight years in the service of the Duke of Mantua, who sent him to Spain in 1603. After returning to Antwerp, he became court painter to successive Spanish governors of the Netherlands. In 1621 Marie de Médici commissioned decorations for the Luxembourg Palace in Paris. He was involved in diplomatic negotiations for a Spanish-English peace, 1625–30, after which

Charles I knighted him and commissioned decorations for the Banqueting Hall of Whitehall Palace. He later made paintings for Philip IV of Spain, by whom he was ennobled in 1624. One of the principal artists of his century, he was also a scholar, antiquarian, collector and diplomat, as well as a painter.

The Crowning of [COLOR PL. VI] PL. 102
Saint Catherine

[1633] Oil on canvas
104⅝ x 84⅜ in. (265.8 x 214.3 cm.)

Acc. no. 50.272

COLLECTIONS: Church of the Augustinians, Malines, 1633–1765; Gabriel-François-Joseph de Verhulst, Brussels, 1765 (de Neck, Brussels, Aug. 16, 1779, lot 43); Dukes of Rutland, Belvoir Castle, Leicestershire, 1779–1911; (Francis Kleinberger, Paris, 1911–12); Leopold Koppel, Berlin, 1912–33; Albert Koppel, Berlin, 1933–50; (Rosenberg and Stiebel, New York).

EXHIBITIONS: Berlin, Akademie der Kunst, *Austellung von Werken alter Kunst*, 1914, no . 139.

REFERENCES: N. de Tombeur, *Provincia Belgica ordinis F. F. Eremitarum, S. P. N. Augustini*, Louvain, n.d. (ca. 1723–27), p. 118 (Stadsarchief Mechelen MS. 5); G. P. Mensaert, *Le peintre amateur et curieux*, Brussels, 1763, p. 175; J.-B. Descamps, *Voyage pittoresque de la Flandre et du Brabant*, Paris, 1769, p. 122; J. F. Mols, *Pièces justicatives pour l'état des tableaux de Pierre Paul Rubens existant en Europe*, 1776, pp. 56–7 (Bibliotheque Royal de Belgique, MS 5736); J. Reynolds, "A Journey to Flanders and Holland in the year 1781," *The Works of Sir Joshua Reynolds, Knight* (ed. E. Malone), Edinburgh, 1867, pp. 177–78; J. Smith, 1830, II, p. 47, no. 134 (incorrectly described); J. Smith, 1842, Supplement, p. 256, no. 57 (incorrectly described); G. Waagen, *Treasures of Art in Great Britain*, London, 1854, III, p. 399; J. Schoeffer, *Historische Aanteekeningen Mechelen*, Malines, 1858, II, p. 509 (Stadsarchief, Mechelen, MS. M 3014/II (a); M. Rooses, *L'Oeuvre de P. P. Rubens*, Antwerp, 1888–92, II, pp. 236–38, no. 400, pl. 139 (engraving by P. de Jode), V, p. 432; M. Rooses, *Rubens*, Philadelphia, 1904, II, p. 541; E. Plietzsch, "Die Ausstellung von Werken alter Kunst in der Berliner Kgl. Academie der Künste," *Zeitschrift für bildende Kunst*, XXV, 1914, repr. p. 229; R. Oldenberg, *P. P. Rubens*, Stuttgart, 1921, repr. p. 343; G. Glück and F. Haberditzl, *Die Handzeichnungen von P. P. Rubens*, Berlin, 1926, in no. 206; H. G. Evers, *Rubens und sein Werk*, Brussels, 1944, p. 79; L. van Puyvelde, *Rubens*, Paris, 1952, pp. 155, 214 (nn. 184, 185), detail repr. opp. p. 146; H. Gerson and E. H. ter Kuile, *Art and Architecture in Belgium, 1600–1800*, Harmonds-

worth, 1960, pp. 104–05; J. Jacob, "The Liverpool Rubens and other Related Pictures," *Liverpool Bulletin*, IX, No. 3, 1960–61, pp. 20–1, fig. 10; L. Burchard and R.-A. d'Hulst, *Rubens Drawings*, Brussels, 1963, in nos. 174, 186, 187, 194.

The Crowning of St. Catherine was painted for the church of the Augustinian fathers in Malines. According to documents published by De Tombeur (transcribed by Rooses, 1888), in 1633 Rubens was paid 620 florins for this work, 100 of which were contributed by the Tanners Guild. However, though Mols later recorded these payments as made in 1631 (quoted by Puyvelde), 1633 appears a more reasonable date, because from the end of 1630 until early 1632 Rubens was occupied with the *St. Ildefonsus Triptych* (Vienna), for Archduchess Isabella, Governess of the Spanish Netherlands. As the center of that altarpiece and the Toledo canvas are closely related in composition, it is logical that in the latter Rubens should have subsequently painted a variation on an invention made for his greatest patroness.

St. Catherine of Alexandria was martyred for her faith in early Christian times. Rubens shows a dream of St. Catherine in which she is crowned by Christ. She is attached by two richly dressed virgin martyr saints, Apollonia of Alexandria (left) and Margaret of Antioch (right), bearing their respective attributes, a pair of pincers and a dragon. The radial trellis above the Virgin's head, and the angel bearing flames and lightning bolts between her and St. Margaret are probably allusions to the miraculous bolt that destroyed the wheel on which Catherine was to suffer death, and to the fiery deaths of the other two saints. Rubens probably modeled the standing figures on his beautiful young wife, Helena Fourment. Cherubs, emblematic of the divine event, bring wreaths and the palms of martyrdom. Although this painting was intended for the Augustinian's altar of St. Barbara, she does not appear in it, and, according to Rooses, a sculptured figure of the saint may have formed part of the altar ensemble.

A drawing with compositional studies is in the Boymans-van Beuningen Museum, Rotterdam (Burchard and d'Hulst, no. 194 verso; other drawings related to this painting, the *St. Ildefonsus Triptych* and *The Garden of Love* (Prado, Madrid) are discussed under no. 174). Of four engravings after the Toledo painting, the earliest is by Pieter de Jode the Elder (1570–1634) (J. V. Schneevoogt, *Catalogue des estampes gravées d'après P. P. Rubens*, Haarlem, 1973, nos. 36–39).

PETER PAUL RUBENS, Follower of

Holy Family with Saint Elizabeth PL. 105
and Saint John

Oil on canvas
73¾ x 62¾ in. (187.3 x 159.4 cm.)

Acc. no. 30.107
Gift of Arthur J. Secor

COLLECTIONS: Count Nesselrode, Moscow; P. Mersch, Paris (Galerie Georges Petit, Paris, May 28, 1909, lot 80, repr., as "Rubens ? "); Contini collection, Rome; (Howard Young, New York).

REFERENCES: J.-A. Goris and J. Held, *Rubens in America*, New York, 1947, no. A50.

According to Goris and Held, this composition may have been inspired by a Rubens such as the *Holy Family under the Apple Tree* (Kunsthistorisches Museum, Vienna). Recently, Held (letter, Apr. 1976) has stated the Toledo picture is by an unidentified follower of Rubens. M. Jaffé (letters, Jan. 1964 and Sep. 1975) relates it to a drawing of the Virgin and Child with winged cherub heads inscribed with the name of the Antwerp painter Gerard Seghers (1591–1651), who was influenced by Rubens late in his career. E. Haverkamp-Begemann and A.-M. Logan (*European Drawings and Watercolors in the Yale University Art Gallery, 1500–1900*, New Haven, 1970, I, no. 619), however, believe that this drawing may be a copy after a painting by Seghers.

JACOB VAN RUISDAEL

1629–1682. Dutch. Son of a Haarlem framemaker and painter with whom he may have studied. Later he may have worked with his uncle Salomon van Ruysdael. Entered the Haarlem guild of painters in 1648. About 1650 he traveled in east Holland and probably in western Germany as well, where he first saw mountains. About 1655 he settled in Amsterdam, remaining there until his death. Ruisdael was the greatest of the realist Dutch landscape painters, and he exerted great influence on European landscape painting of the 19th century. His chief pupil was Meyndert Hobbema.

Landscape with Waterfall PL. 138

[Ca. 1665] Oil on canvas
45¼ x 58⅛ in. (114.8 x 147.5 cm.)
Signed lower right: JvRuisdael (JvR in monogram)

Acc. no. 30.312
Gift of Arthur J. Secor

COLLECTIONS: Vernon Harcourt, Nuneham Park, 1857; Lewis Harcourt, Nuneham Park; Edward Dent; (Howard Young, New York); Arthur J. Secor, –1930.

REFERENCES: G. Waagen, *Art Treasures in Great Britain*, London, 1854, Supplement, p. 350; C. Hofstede de Groot, IV, no. 267b; W. Stechow, 1968, pp. 7, 146, fig. 3.

According to Stechow, the Scandinavian character of the Toledo landscape, as well as the use of vast open spaces within a forest view are distinctive features of Ruisdael's work in the 1660s. J. Rosenberg (*Jacob van Ruisdael*, Berlin, 1928, p. 42 ff.) believed that Ruisdael's use of northern motifs was influenced by the painter Allaert van Everdingen (1621–1675), who visited Sweden and Norway.

Stechow believed that the figures at right are an 18th century addition. In verbal opinions, J. van Gelder (Mar. 1954), K. Boon (Mar. 1959), and H. Gerson (Feb. 1960) stated that while the figures are not by Ruisdael, they were done in the 17th century. When the painting was cleaned in 1958 by the conservator E. Korany, he also felt the figures are contemporary with the landscape.

RACHEL RUYSCH

1664–1750. Dutch. Apprenticed to Willem van Aelst, 1680–83. Married the portraitist Juriaen Pool; in 1701 they left Amsterdam for The Hague, where they became members of the painters guild. In 1708 she went to Düsseldorf as court painter to the Elector Palatine. After his death in 1716, she returned to Amsterdam. Ruysch was esteemed for the inventive arrangements and refined execution of the flower still lifes in which she specialized.

Flower Still Life PL. 144

Oil on canvas
29¾ x 23⅞ in. (75.6 x 60.6 cm.)
Signed lower right: Rachel Ruysch

Acc. no. 56.57

COLLECTIONS: Bryan, London, (Coxe, Burrell and Foster, London, May 17, 1798, lot 49) (?); William Wells, Redleaf, England, by 1835 (Christie, London, May 12, 1848, lot 54); J. E. Fordham; (Speelman, London).

EXHIBITIONS: London, British Institution, 1832, no. 54; 1855, no. 68.

REFERENCES: J. Smith, VI, no. 17; C. Hofstede de Groot, X, no. 57; M. H. Grant, *Rachel Ruysch 1664–1750*, Leigh-on-Sea, 1956, p. 32, no. 75, pl. 4; P. Mitchell, *European Flower Painters*, London, 1973, p. 224, fig. 318.

The present location of the pendant still life of fruit and flowers (Hofstede de Groot, no. 89) is unknown.

SALOMON VAN RUYSDAEL

1600/03–1670. Dutch. Born in Naarden. Admitted to the Haarlem painters guild in 1623. Although his teacher is unknown, his earliest work reflects the influence of Esaias van de Velde. His work of the 1630s, together with that of Pieter Molijn and Jan van Goyen, best represents the tonal phase of 17th century Dutch landscape painting. Father of Jacob Salomonsz. van Ruisdael; uncle of Jacob Isaacksz. van Ruisdael.

River Landscape with Ferryboat PL. 115

[1653] Oil on wood panel
29⅜ x 41¾ in. (74.6 x 106 cm.)
Signed and dated (on ferryboat): S.v. Rvysdael 1653

Acc. no. 67.15

COLLECTIONS: Dr. Edward Beith (Christie, London, Apr. 8, 1938, lot 51); (N. Katz?); (P. de Boer, Amsterdam, 1938, no. 15); K. Jonas, E. Hesselman, Storängen, Sweden, by 1945; (Nystad, The Hague).

REFERENCES: W. Stechow, *Salomon van Ruysdael, eine Einführung in seine Kunst*, Berlin, 1938, no. 322A; 2nd ed., Berlin, 1975, no. 373A.

Stechow believed that the building in the right background, which also appears in other paintings by Ruysdael (Stechow, 1975, nos. 358, 371, 414 and 508A), is similar, though not identical, to the castle at Duurstede.

Landscape with Cattle PL. 116

[1660s] Oil on canvas
34½ x 44⅝ in. (87.5 x 113.5 cm.)
Signed and dated lower left: S. Ruysdael 166(?)

Acc. no. 48.77
Gift of William E. Levis

COLLECTIONS: Lord Carrington, Wycombe Abbey (Christie, London, May 9, 1930, lot 62, as Jacob van Ruisdael); (Duits, London, 1930–); (J. Goudstikker, Amsterdam, 1936?); Private collection, –1947; (Schaeffer, New York).

EXHIBITIONS: Amsterdam, J. Goudstikker, *Catalogus der Tentoonstelling van Werken door Salomon van Ruysdael*, 1936, no. 57 (as Salomon van Ruysdael, with figures by Adriaen van de Velde).

REFERENCES: J. Smith, *Supplement to the Catalogue Raisonné of the Most Eminent Dutch, Flemish and French Painters*, London, 1842, no. 40 (as Jacob van

Ruisdael, with figures by A. van de Velde); C. Hofstede de Groot, IV, no. 558 (as Jacob van Ruisdael, with figures by A. van de Velde); W. Stechow, *Salomon van Ruysdael, eine Einführung in seine Kunst*, Berlin, 1938, no. 541; 2nd ed., Berlin, 1975, no. 541.

Smith and Hofstede de Groot incorrectly catalogued this painting as by Jacob van Ruisdael although it bears Salomon van Ruysdael's characteristic signature. Stechow disagrees with Smith and Hofstede de Groot's statement that the figures are by Adriaen van de Velde.

RYCKHALS (*see* TENIERS)

FRANCESCO SALVIATI

1510–1563. Italian. Born Francesco de' Rossi; Salviati was the surname of his first patron in Rome. First trained as a goldsmith, he later painted in his native Florence with Bandinelli and Andrea del Sarto. He went to Rome in 1531, occasionally returning to Florence, and also visiting Bologna, Venice, and the court of Francis I of France. He did frescoes, portraits, altarpieces, easel paintings and designs for the decorative arts. His friend Vasari's *Lives of the Artists* included a detailed biography of Salviati, who had an important role in the diffusion of Mannerism.

The Holy Family with Saint John PL. 12

[Ca. 1540] Oil on wood panel
51¼ x 31½ in. (130 x 98 cm.)

Acc. no. 75.83

COLLECTIONS: P. Ducasble, Annemasse, Switzerland, by 1911; Robert Caby, Champigny (Seine), France, by 1957; (Galerie Pardo, Paris); (H. Schickman, London).

REFERENCES: H. Voss, "Kompositionen des Francesco Salviati in der italienischen Graphik des XVI. Jahrhunderts." *Die Graphischen Künste* (supplement), XXXV, 1912, pp. 66–7, fig. 12; H. Voss, *Die Malerei der Spätrenaissance in Rom und Florenz*, Berlin, 1920, I, pp. 246–47; A. Venturi, *Storia dell'arte Italiana*, Milan, 1933, IX (part 6), p. 212, n. 1; L. Mortari, "Alcuni inediti di Francesco Salviati," *Studies in the History of Art Dedicated to William E. Suida on his Eightieth Birthday*, London, 1959, p. 247, fig. 1; I. Cheney, "Francesco Salviati 1510–1563," unpublished Ph.D. dissertation, New York University, 1963, II, p. 355.

The attribution of this painting to Salviati by Voss (1912) has been confirmed by Venturi, Mortari, R. Longhi (let-

ter, Oct. 1957), I. Cheney (1963 and letter, Dec. 1975), and E. Pillsbury (letter, Dec. 1975). Mortari, Cheney and Pillsbury suggest a date of about 1540, when Salviati's style strongly reflected the influence of Parmigianino, and according to Cheney, that of Perino del Vaga. Voss and Mortari suggested that Salviati may have been aware of Parmigianino's *Madonna of the Rose* (Dresden).

Cheney noted a similar, though much repainted version in the Church of S. Pietro, Tivoli.

ADOLPH SCHREYER

1828–1899. German. Born in Frankfort-am-Main. Student of Jakob Becker at the Staedel Institute, and briefly attended the Düsseldorf Academy. Traveled extensively in Russia, Syria and North Africa. Lived in Paris, 1862–70, and exhibited at the Salon. Returned to Germany in 1870. Best known for romantic scenes of Arabian horsemen.

The Wallachian Team PL. 72

Oil on canvas
19⅝ x 33⅛ in. (49.8 x 84.1 cm.)
Signed lower right: Ad. Schreijer

Acc. no. 22.30
Gift of Arthur J. Secor

COLLECTIONS: Arthur J. Secor, 1904–22.

REFERENCES: *Adolf Schreyer*, Paine Art Center and Arboretum, Oshkosh (Wisc.), 1972, p. 57, repr. Schreyer painted several pictures of the outposts along the roads of Wallachia, a part of present-day Romania. His paintings are difficult to date because the chronology of his work has not been established.

The Standard Bearer PL. 71

Oil on canvas
36⅝ x 28 in. (93 x 71.1 cm.)
Signed lower right: Ad. Schreyer

Acc. no. 22.31
Gift of Arthur J. Secor

COLLECTIONS: Baron de Tuyll, Washington, D.C.; (Henry Reinhardt, Milwaukee); Arthur J. Secor, 1906–22.

REFERENCES: *Adolf Schreyer*, Paine Art Center and Arboretum, Oshkosh (Wisc.), 1972, p. 56, repr. The subject and style of this painting are closely related to the Arabian scenes of Delacroix and Fromentin.

WILLIAM SCOTT

1913–. British. Born in Greenock, Scotland and raised in Northern Ireland. Studied at Belfast College of Art and Royal Academy Schools, London, 1928–35. Lived in Italy and France, 1937–39. In 1953 he went to America, where he met Pollock, Kline and Rothko and as a result his work became more abstract. By the 1950s began abstract geometric still lifes for which he is currently known. He is also a sculptor.

Homage to Corot PL. 350

[1946] Oil on canvas
21⅛ x 18¼ in. (51.1 x 46.4 cm.)
Signed and dated lower right: W. Scott 46

Acc. no. 50.255

COLLECTIONS: (Leicester Galleries, London).

Painted during Scott's second visit to Pont Aven, Brittany, in 1946.

DANIEL SEGHERS

1590–1661. Flemish. Born in Antwerp; lived and studied in Utrecht until 1610, when he returned to Antwerp to study with Jan Brueghel the Elder. Became a Jesuit lay brother in 1614, taking final vows in 1625. From 1625 he was with the Order in Rome, returning by 1628 to Antwerp, where he remained the rest of his life. Specialized in flower paintings, especially garlands surrounding a *trompe-l'oeil* sculptured cartouche in which a collaborator painted a religious subject or portrait.

Flowers in a Glass Vase PL. 104

[1635] Oil on wood panel
32-1/16 x 20⅜ in. (81.2 x 51.7 cm.)
Signed and dated lower right: D. Segers. Soc.tis/Jesu
 Ao. 1635

Acc. no. 53.85

COLLECTIONS: Leo Spick, Berlin, to 1953; (Eugene Slatter, London).

REFERENCES: M. Hairs, *Les peintres flamands de fleurs au XVIIe siècle*, Paris, 1955, pp. 60–1, 72, 75, 77, 238, pl. 21, n. 638; G. Bazin, *A Gallery of Flowers*, London, 1960, pp. 102–05, repr.; M. Burke-Gaffney, S.J., *Daniel Seghers (1590–1661)*, New York, 1961, p. 15, repr.; P. Mitchell, *European Flower Painters*, London, 1973, p. 234.

This is Seghers' earliest known signed and dated painting, and it is his largest work on panel. Bouquets of flowers in a vase are rare in Seghers' work; the only other dated pictures are two at Dresden (both 1643).

ANDRÉ DUNOYER DE SEGONZAC

1884–1974. French. Born near Paris. Studied first with Olivier Merson, and then at the Académie Julian. He developed a realistic style that is largely independent of the French art movements of his time. Important as a draftsman, painter in both oils and watercolors and printmaker, he also did book illustrations and stage designs.

Landscape at Saint Tropez PL. 290

[1926] Oil on canvas
23¾ x 39⅜ in. (60.3 x 99 cm.)
Signed lower left: A. D. de Segonzac

Acc. no. 56.73

COLLECTIONS: M. Monteux, by 1929; Lord Ivor Spencer-Churchill, by 1948; (Sam Salz, New York).

EXHIBITIONS: Paris, Galerie Charpentier, *Dunoyer de Segonzac: cinquante années de peinture*, 1960, no. 31 (as *Ferme à l'aire en fin de l'après-midi*, 1928).

REFERENCES: P. Jamot, *Dunoyer de Segonzac*, Paris, 1929, p. 233, repr. p. 3 (as *La ferme à l'aire: créspuscule*, 1926); C. Roger-Marx, *Dunoyer de Segonzac*, Geneva, 1951, p. 80, fig. 88 (as *La ferme à l'aire*, 1926).

The same farm buildings and oaks with a type of stone threshing floor (*l'aire*) peculiar to Provence appear in a series of paintings, drawings and etchings of 1925–26 done by Segonzac near Saint-Tropez. Part of the round floor appears in the lower left corner of this landscape. Both paintings and prints show light effects at different times of day; in the case of the Toledo picture, later afternoon or twilight.

 Jamot illustrates (p. 148) a drawing of this subject. The same motif was also used in seven etchings of 1925–26 (A. Liore and P. Cailler, *Catalogue de l'oeuvre gravé de Dunoyer de Segonzac*, Geneva, 1958, I, nos. 152–58).

JUAN DE SEVILLA

Spanish. Active in the first half of the 15th century in Castille, principally in Sigüenza (Guadalajara). Identical with the Master of Sigüenza and Juan de Peralta. Perhaps born in Seville. The style of his paintings connect him with the school of Toledo.

Retable of Saint Andrew PL. 47
and Saint Antonin of Pamiers

Top (left to right): (A) *Saint Jerome;* (B) *Crucifixion of Saint Andrew;* (C) left: *Saint Bartholomew;* center, *Crucifixion;* right: *Saint John the Baptist;* (D) *Execution of Saint Antonin;* (E) *Saint Augustine;* Bottom (left to right): (F) upper: *Saint Lawrence;* lower: *Saint Margaret;* (G) *Saint Andrew Warning the Bishop;* (H) upper left: *Saint James Major;* lower left: *Saint Catherine;* center: *Saint Andrew and Saint Antonin;* upper right: unidentified saint; lower right: *Saint Lucy;* (I) *Recovery of Saint Antonin's Body;* (J) upper: unidentified saint; lower: *Saint Barbara.*

[Ca. 1417–19] Tempera on wood panel
(A) 16¼ x 3⅛ in. (41.2 x 8 cm.); (B) 25½ x 16⅞ in. (64.7 x 42.7 cm.); (C) left: 17⅜ x 3¼ in. (44.1 x 8.2 cm.); center: 32 x 26 in. (81.2 x 66 cm.); right: 17⅜ x 3¼ in. (44.1 x 8.2 cm.); (D) 25⅝ x 17¼ in. (65 x 43.7 cm.); (E) 16⅛ x 3 in. (41.1 x 7.6 cm.); (F) upper: 15 x 3¼ in. (38.1 x 8.2 cm.); lower: 15⅛ x 3⅛ in. (38.2 x 8 cm.); (G) 30¾ x 16¾ in. (78 x 42.5 cm.); (H) upper left: 17 x 3⅛ in. (43.1 x 8 cm.); lower left: 17⅛ x 3⅛ in. (43.3 x 8 cm.); center: 39⅜ x 26¼ in. (100.5 x 66.5 cm.); upper right: 17 x 3¼ in. (43.1 x 8.2 cm.); lower right: 16¾ x 3⅜ in. (42.5 x 8.5 cm.); (I) 30⅞ x 17½ in. (78.5 x 44.5 cm.); (J) upper: 15 x 3 in. (38.1 x 7.6 cm.); lower: 15¼ x 3 in. (38.6 x 7.6 cm.)

Acc. no. 55.213 A-J

Museum Purchase

COLLECTIONS: Cathedral of Sigüenza; Private collection, Barcelona (?).

EXHIBITIONS: Barcelona, Museo del Palacio Nacional, *El arte en España,* 1929, p. 275, no. 1703 (cat. by M. Gómez Moreno).

REFERENCES: C. R. Post, *A History of Spanish Painting,* Cambridge, 1930, III, pp. 175–76 (as probably Aragonese); 1933, IV (part 2), p. 637 (as *Retable of Sts. Andrew and Vincent*); J. Gudiol, "Juan de Sevilla—Juan de Peralta," *Goya,* No. 5, Mar.-Apr. 1955, pp. 261–62, fig. 5 (detail) (as *St. Andrew and a Holy Deacon*); C. R. Post, *A History of Spanish Painting,* Cambridge, 1958, XII (part 2), p. 611 (as *Retable of St. Andrew and a Hallowed Deacon*); *Trésors de la peinture espagnole* (exh. cat.), Paris, Musée des Arts Décoratifs, 1963 (by M. Laclotte); J. Camón Aznar, *Pintura medieval Española, Summa Artis,* Madrid, 1966, XXII, p. 310, repr. (detail) (as by Juan de Peralta; as *Sts. Andrew and Vincent*); M. Hériard-Dubreuil, "Juan de Peralta," *L'Oeil,* No. 209, May 1972, pp. 4–8, 10, 12, figs. 6–10 (as *Retable of Sts. Andrew and Antonin*).

This retable altarpiece, originally in Sigüenza Cathedral (New Castile), is dedicated to St. Andrew and St. Antonin of Pamiers. According to Hériard-Dubreuil, it was probably commissioned by Alonso de Argüello, Bishop of Sigüenza 1417–19, who had previously been bishop of Palencia, where St. Antonin was especially venerated. St. Antonin was a legendary 10th century martyr who was thought to have caused miracles; St. Andrew is the patron saint of bishops. The coat of arms repeated at the top has not yet been identified (Hériard-Dubreuil, note 10).

The retable was attributed to the Master of Sigüenza by Post (1933), who invented this name to identify the painter of this and another altarpiece in Sigüenza. In 1955 Gudiol identified this artist with both Juan de Sevilla and Juan de Peralta, relating his style to the school of Toledo and its Italianate tendencies. Post (1958) accepted the first part of this identification, though he did not believe that Juan de Sevilla and Juan de Peralta were the same.

WALTER RICHARD SICKERT

1860–1942. British. Born in Munich; his father was a Danish painter, his mother British. To England, 1868. After a brief acting career, in 1882 he entered the Slade School, but shortly left to become Whistler's only pupil. In Paris, 1883, where he met Degas, whose close friend he became. In Venice, 1895, 1901, 1903–04. Lived in Dieppe (Normandy), 1899–1905 and 1918–22. Returned to England, 1905 and in 1911 helped form Camden Town Group. Associate of the Royal Academy, 1924; member, 1934; resigned, 1935. Painted architectural, figure and music hall subjects.

Rio di San Paolo, Venice PL. 342

[1903–04] Oil on canvas
24 x 19½ in. (61 x 49.5 cm.)
Signed lower right: Sickert.
Inscribed on reverse by the artist: Rio da San Polo (*sic*)

Acc. no. 54.70

COLLECTIONS: Mme. Bordeaux, Paris; (Roland, Browse and Delbanco, London, 1954).

EXHIBITIONS: London, Tate Gallery, *Sickert, Paintings and Drawings,* 1960, no. 76; New York, Hirschl and Adler, *Walter R. Sickert,* 1967, no. 40; Columbus Gallery of Fine Arts, *British Art 1890–1928,* 1971, no. 96, fig. 24 (cat. by D. Sutton).

REFERENCES: A. Bertram, *A Century of British Painting 1851–1951,* London, 1951, pl. 14; L. Browse, *Sickert,*

London, 1960, pp. 27, 28, 60, 115, pl. IV; W. Dimson, "Four Sickert Exhibitions," *Burlington Magazine,* CII, Oct. 1960, p. 441; W. Baron, *Sickert,* London, 1973, pp. 73, 81, n. 6, no. 162.

According to Browse and Baron, this picture dates from Sickert's third stay in Venice. The flickering, luminous surface is characteristic of his work at this time, much of which, like this canvas, was acquired by collectors in France, where Sickert had many admirers.

PAUL SIGNAC

1863–1935. French. Born in Paris. No formal art training. Exhibited in last Impressionist show, 1886. Strongly influenced by Seurat and the theories of Pointillism. Exhibited regularly at Salon des Indépendants, 1884–1934. He was the theorist of Neo-Impressionism.

Entrance to the Grand Canal, Venice PL. 282

[1905] Oil on canvas
28-15/16 x 36¼ in. (73.5 x 92.1 cm.)
Signed and dated lower right: P. Signac/1905

Acc. no. 52.78

COLLECTIONS: (Bernheim-Jeune, Paris); G. Loury, Paris; J. J. Puritz, New York; (M. Moos, Geneva).

EXHIBITIONS: Paris, Bernheim-Jeune, *Paul Signac,* 1907, no. 12, repr. (as *Entrée du Grand Canal*); Paris, Bernheim-Jeune, *Paul Signac,* 1930, no. 27, repr.; Paris, Petit Palais, *Paul Signac,* 1934, no. 21; New York, Wildenstein, *Camille Pissarro: His Place in Art,* 1945, no. 68; Paris, Louvre, *Signac,* 1963, no. 65, repr.; New York, Solomon R. Guggenheim Museum, *Neo-Impressionism,* 1968, no. 104, repr.

REFERENCES: G. Besson, *Paul Signac,* Paris, 1935, pl. 8; R. Jullien, *Les impressionistes français et l'Italie,* Paris, 1968, pp. 17, 29.

After a trip to Venice in 1904, the same year Signac exhibited in Paris paintings of the harbor at Venice. This view of the entrance to the Grand Canal with the Church of Santa Maria della Salute appeared again later in an oil painting (Sotheby, London, June 28, 1961, lot 166, repr.) and a watercolor (Musée Marmottan, Paris), both of 1908. Signac's interest in Venice was further stimulated by the Paris publication in 1905 of Ruskin's *Stones of Venice* and by a trip in 1898 to London, where he was impressed by Turner's Venetian scenes such as the Toledo Museum's *Venice, The Campo Santo.*

LUCA SIGNORELLI

Ca. 1441–1523. Italian. A pupil of Piero della Francesca, commissions took him from his native Cortona to Arezzo, Volterra, Città di Castello, Monte Oliveto, Urbino, Perugia, Siena and Rome. His most important commission was the completion of the frescoes in the Cappella Nuova in Orvieto Cathedral. He also worked for Pope Julius II and was one of the artists called by Pope Sixtus IV to decorate the walls of the Sistine Chapel. His bold handling of the human figure had a significant influence on the painting of the High Renaissance.

Figures in a Landscape PL. 7a–b

(A) *Two Nude Youths;* (B) *Man, Woman and Child*

[1498] Oil on wood panel
(A) 27¼ x 16¼ in. (69.2 x 41.2 cm.); (B) 26¾ x 16½ in. (67.9 x 41.9 cm.)

Acc. no. 55.222 A&B

COLLECTIONS: Baron Marochetti; Sir Francis Cook, before 1893–1901; Sir Herbert Cook, Bt., Doughty House, Richmond, Surrey, 1901–39; Sir Francis Cook, Bt., 1939–55 (lent to Fitzwilliam Museum, Cambridge, ca. 1947–55); (Rosenberg & Stiebel, New York).

EXHIBITIONS: London, Burlington Fine Arts Club, *The Work of Luca Signorelli and his School,* 1893, nos. 10, 11; London, Burlington Fine Arts Club, Winter Exhibition, 1906, nos. 18, 21; London, Grafton Galleries, *Exhibition of Old Masters,* 1911, nos. 10, 12, figs. 8, 10; London, Royal Academy, *Exhibition of Italian Art, 1200–1900,* 1930, nos. 219, 220.

REFERENCES: R. Vischer, *Luca Signorelli und die Italienische Renaissance,* Leipzig, 1879, p. 244; M. Cruttwell, *Luca Signorelli,* London, 1899, p. 132; B. Berenson, *The Central Italian Painters of the Renaissance,* London, 1909, p. 250; R. Fry, "Exhibition of Old Masters at the Grafton Galleries, I," *Burlington Magazine,* XX, Nov. 1911, pp. 72, 77, pl. III; T. Borenius, "The Reconstruction of a Polyptych by Signorelli," *Burlington Magazine,* XXIV, Oct. 1913, p. 35; H. Cook, ed., *A Catalogue of the Paintings at Doughty House, Richmond and Elsewhere in the Collection of Sir Frederick Cook Bt.,* London, 1913, I (T. Borenius, *Italian Schools*), nos. 50, 51, pl. VIII; A. Venturi, *Storia dell'arte italiana,* Milan, 1913, VII, part 2, p. 410, fig. 321 (panel A); J. A. Crowe and G. B. Cavalcaselle, *A History of Painting in Italy,* London, 1914, V, pp. 96–7; A. Venturi, *Luca Signorelli,* Florence, 1922, p. 65, pl. 87; L. Dussler, *Signorelli (Klassiker der Kunst),* Stuttgart, 1927, p. 203, repr. pp. 76–7; B. Berenson, *Italian Pictures of the Renaissance,* Oxford, 1932,

p. 533; R. van Marle, *The Development of the Italian Schools of Painting,* The Hague, 1937, XVI, pp. 49–50, 115; B. Berenson, *The Drawings of the Florentine Painters,* Chicago, 1938, I, p. 41; B. Berenson, *The Italian Painters of the Renaissance,* New York, 1952, pl. 287; M. Salmi, *Luca Signorelli,* Novara, 1953, pp. 22, 55, fig. 37; O. A. Rand, Jr., *Luca Signorelli: Martyrdom of St. Catherine and the Bichi Altar,* Sterling and Francine Clark Art Institute, Williamstown, 1961, pp. [7, 8], fig. 9 (photographic reconstruction of Bichi altar; also see exh. cat., *Italian Paintings and Drawings,* Mar. 1961, last plate); "Signorelli Masterpiece Reconstructed in Williamstown, Mass.," *Art News,* LX, Mar. 1961, pp. 36, 37, 55, figs. 4, 5; A. Martingale, "Luca Signorelli and the Drawings Connected with the Orvieto Frescoes," *Burlington Magazine,* CIII, June 1961, p. 220; P. Scarpellini, *Luca Signorelli,* Milan, 1964, pp. 39, 132, pls. 44a, 44b; A. Chastel, *Studios and Styles of the Italian Renaissance,* New York, 1966, p. 350, fig. 307 (panel A incorrectly assigned to Fitzwilliam Museum, Cambridge); B. Berenson, *Italian Pictures of the Renaissance: Central Italian and North Italian Schools,* London, 1968, I, p. 400; F. R. Presenti, "Dismembered Works of Art—Italian Paintings," in *An Illustrated Inventory of Famous Dismembered Works of Art: European Painting,* Paris (UNESCO), 1974, pp. 25, 49, repr. p. 50.

These panels are probably fragments of an altarpiece commissioned in 1498 for the Bichi family chapel in the Church of S. Agostino at Siena, according to the Sienese author Sigismondo Tizio in 1513 (Dussler). It was described *in situ* in a detailed account of the mid-18th century by Abbot Calgano. Bichi (Vischer). The altarpiece was dismembered by 1850. Borenius, who reconstructed the plan of the altarpiece (1913), believed that the two Toledo panels probably formed part of the Baptism of Christ which Bichi described as behind the central wood figure of St. Christopher, to whom the chapel was dedicated. Later scholars agreed with Borenius except for Venturi, who first (1913) attributed the panels to a Signorelli assistant and later (1922) to his workshop; and Van Marle, who believed they were by Signorelli, though not from the Bichi altar.

According to Borenius, the center included the sculptural St. Christopher (Louvre, Paris) in front of the painted element of which the Toledo panels formed a part. This was flanked by panels with (left) Sts. Catherine of Siena, Mary Magdalen and Jerome and (right) Sts. Augustine, Catherine of Alexandria and Anthony of Padua (both Dahlem Museum, Berlin). In the predella were *The Feast in the House of Simon* (National Gallery, Dublin); *Pieta* (Estate of Sir John Stirling-Maxwell,

Glasgow); and *Martyrdom of St. Catherine* (Clark Art Institute, Williamstown, Mass.).

In the Toledo panels, the youth removing his shirt may be compared to the similar figure in *The Baptism* by Piero della Francesca (National Gallery, London), while the youth removing his sandal appears in reverse in Signorelli's *Virgin and Child* (ca. 1490–94; Pinakothek, Munich). The figure of the man in the other panel resembles the piping figure of Olympus in the *Education of Pan* by Signorelli (ca. 1492; formerly Kaiser Friedrich Museum, Berlin; destroyed, 1945). Berenson (1938) relates a drawing in the Marignane collection, Paris to the same figure.

MARIO SIRONI

1885–1961. Italian. Born in Sardinia. Studied engineering in Rome, where he met Severini, Boccioni and Balla. Joined the Futurist movement in 1915, and after World War I exhibited with the Novecento group. He also did frescoes and mosaics.

Composition PL. 44

[Ca. 1952] Mixed media on paper
38¾ x 31½ in. (98.4 x 80 cm.)
Signed lower right: Sironi

Acc. no. 52.141

COLLECTIONS: (Il Milione Gallery, Milan).

EXHIBITIONS: San Francisco Museum of Art, *Art in the 20th Century,* 1955, p. 17.

ALFRED SISLEY

1839–1899. French. Born in Paris of English parents and spent most of life in France. In 1862 entered the École des Beaux Arts, where he met Monet, Renoir and Bazille. Exhibited in the Salon des Refusés, 1863, and in four of the Impressionist exhibitions. Almost exclusively a landscape painter.

The Aqueduct at Marly PL. 251

[1874] Oil on canvas
21⅜ x 32 in. (54.3 x 81.3 cm.)
Signed and dated lower right: Sisley/74

Acc. no. 51.371

COLLECTIONS: (Durand-Ruel, Paris, from 1876); (Alex Reid & Lefevre, London).

EXHIBITIONS: Paris, Durand-Ruel, *Pissarro, Renoir et Sisley,* 1899, no. 130; Paris, Durand-Ruel, *Tableaux de*

Sisley, 1930, no. 19; New York, Paul Rosenberg, *Loan Exhibition of Paintings by Alfred Sisley*, 1961, repr. p. 8; Bordeaux, Musée des Beaux-Arts, *La peinture française: collections américaines*, 1966, no. 80, pl. 35; New York, Wildenstein, *Alfred Sisley, 1839–1899*, 1966, no. 15, repr.

REFERENCES: G. Besson, *Sisley*, Paris, n.d., pl. 20; F. Daulte, *Alfred Sisley: Catalogue raisonné de l'oeuvre peint*, Lausanne, 1959, no. 133, repr.; J. Lanes, "Current and Forthcoming Exhibitions: New York," *Burlington Magazine*, CVIII, Dec. 1966, p. 645, fig. 58.

Sisley lived in the neighborhood of Marly, on the north-western outskirts of Paris, from 1871 to 1877. The year he painted this picture, Sisley participated in the first exhibition of the original group of Impressionists.

The Marly Aqueduct was built in 1681–84 to bring water from the Seine to the palace fountains at Marly and Versailles.

Nut Trees at Thomery PL. 252

[1880] Oil on canvas
22⅝ x 28 in. (57.5 x 71.2 cm.)
Signed lower left: Sisley.

Acc. no. 52.10

COLLECTIONS: (Durand-Ruel, Paris, from 1881); H. Vever (Galerie Georges Petit, Paris, Feb. 1–2, 1897, lot 109); (Durand-Ruel, Paris); Léon Orosdi (Hôtel Drouot, Paris, May 25, 1923, lot 67); (Rosenberg & Stiebel, New York).

EXHIBITIONS: New York, Paul Rosenberg, *Loan Exhibition of Paintings by Alfred Sisley*, 1961, repr. p. 12; New York, Wildenstein, *Alfred Sisley, 1839–1899*, 1966, no. 46, repr.

REFERENCES: B. Bibb, "The Work of Alfred Sisley," *The Studio*, XVIII, Dec. 1899, repr. p. 154; G. Geffroy, *Sisley*, Paris, 1927, pl. 52; F. Daulte, *Alfred Sisley: Catalogue raisonné de l'oeuvre peint*, Lausanne, 1959, no. 397, repr. (as 1880).

Thomery, near Fontainebleau, is on a part of the Seine River where Sisley did much painting while living nearby at Veneux-Nadon from 1880 to 1882.

FRANCESCO SOLIMENA

1657–1747. Italian. Born near Naples, where he settled in 1674. Influenced by Giordano, Preti, Maratta and Lanfranco. He became the leading artist in Naples after Giordano's death in 1705. His fame was international and his paintings were sought in England, France, Spain and Germany. The last great figure of the Neapolitan Baroque, his pupils included Francesco Mura, Corrado Giaquinto and Sebastiano Conca.

Heliodorus Expelled from the Temple PL. 24

[Ca. 1725] Oil on canvas
60 x 80¼ in. (152.4 x 203.8 cm.)

Acc. no. 73.44

COLLECTIONS: (Hôtel Drouot, Paris, July 17, 1877); (Heim, Paris).

EXHIBITIONS: London, Heim, *Paintings and Sculptures of the Italian Baroque*, 1973, no. 10, repr.

The subject is taken from the Apocryphal books of the Bible (Maccabees II, III:1–30). A divinely sent horseman and two angels drove Heliodorus, Chancellor of the King of Asia, from the Temple of Jerusalem after he attempted to seize monies deposited there for safekeeping.

This is a full compositional study for Solimena's vast fresco of 1725 on the entrance wall of the Church as Gesù Nuovo, Naples, one of his most famous works. As reported by the Neapolitan biographer De Dominici, Mons. Camillo Cybo, who visited Solimena's studio while the Naples fresco was in progress, wrote "It will be one of the most beautiful works from his brush: as evidence of this the sketch (*sbozzo*), though well finished, has already been bought by an Englishman for one thousand scudi" (Bologna, p. 194). The fresco, related oil paintings and drawings are discussed by F. Bologna (*Francesco Solimena*, Naples, 1958, pp. 114, 115, 194, 206, 259, 272–74, 276, figs. 165–67). Although in 1958 Bologna identified the sketch mentioned by Cybo with an oil version in the Louvre, he now (letters, May 1973 and Apr. 1976) believes that Cybo was describing the recently discovered Toledo canvas, unknown to him in 1958. He bases this conclusion on the free handling, presence of pentimenti and high quality of execution.

Bologna also stated (letters) that because compositional elements present in the other versions of this subject are all present in the Toledo painting, the latter must have preceded other variants. Other oil versions are in the Galleria Sabauda, Turin and the Galleria Nazionale d'Arte Antica, Rome. Related drawings are in the Louvre (Cabinet des Dessins, no. 9819) and the Duke of Devonshire collection, Chatsworth (J. B. Shaw and T. Wragg, *Old Master Drawings from Chatsworth*, Washington, International Exhibitions Foundation, 1969, no. 63, repr.).

JUAN RODRÍGUEZ DE SOLÍS, Attributed to

Spanish. Active in the early 16th century, mainly in the provinces of Léon and Zamora.

(a) *The Stoning of Saint Stephen* PL. 52a
(b) *The Burial of Saint Stephen* PL. 52b
Oil on wood panel
(a) 50½ x 32⅛ in. (128.3 x 81.6 cm.); (b) 51 x 32½ in. (129.5 x 82.5 cm.)
Acc nos. (a) 56.17; (b) 56.18

COLLECTIONS: Monastery of Valparaiso (Zamora province); Parish Church of Fuentelcarñero (Zamora).

REFERENCES: M. Gómez-Moreno, *Catálogo monumental de España, Provincia de Zamora*, Madrid, 1927, pp. 275–76, no. 693; C. R. Post, *A History of Spanish Painting*, Cambridge, Mass., 1947, IX, part 2, pp. 514, 516, 517, fig. 192.

These panels formed part of a large altarpiece dedicated to St. Stephen that may have been painted for the Monastery of Valparaiso. The complete altarpiece, now dispersed, is described by Post. Another panel, *Juliana Selecting the Bones of Stephen,* is in the Springfield (Mass.) Museum of Fine Arts.

Post agreed with the suggestion of Gómez-Moreno that this altarpiece was by the painter of *Christ as Pantocrator* in the retro-choir of Zamora Cathedral, and he attributed both the Zamora panel and the altarpiece to Rodríguez de Solís. Gudiol (letters, May 1956, Oct. 1974) also attributes Toledo's *Stoning* panel to the master of the Zamora panel. However, he does not identify this artist as de Solís, but instead names him the Zamora Master. Gudiol believes Toledo's *Burial* panel to be by another hand, that of the Astorga Master.

The depiction of St. Stephen in the *Stoning* panel, standing upright and tied to a stake, rather than kneeling, is an iconographic invention of de Solís, according to Post.

The example of an artist such as Perugino is especially evident in the *Burial* panel (Gómez-Moreno), indicative of the strong Italian influence in Spanish art in the early 16th century.

SPANISH, CATALONIA

Saint John PL. 46
[Ca. 1250–75] Fresco
60¼ x 24¾ in. (153 x 62.9 cm.)
Fragmentary inscription, upper right: JO...N

Acc. no. 56.15

COLLECTIONS: Church of San Lorenzo, Isabarre, Catalonia, Spain.

REFERENCES: J. Gudiol-Cunill, *Els Primitius*, Barcelona, 1927–29, I, p. 484; C. Kuhn, *Romanesque Mural Painting of Catalonia*, Cambridge, Mass., 1930, p. 59, pl. LVIII, fig. 1; C. R. Post, *A History of Spanish Painting*, Cambridge, Mass., 1930, I, pp. 144–45, fig. 24; W. Cook and J. Gudiol Ricart, *Pintura y imaginería románicas*, Madrid, 1950, VI, pp. 95–6.

This is a fragment of a series of Apostles formerly in the apse of the small Church of San Lorenzo at Isabarre (Lérida province) in the Pyrenées. Post and Kuhn illustrate the Toledo *St. John* when it was still *in situ*.

According to Post, the date is not earlier than the middle of the 13th century; Kuhn places these frescoes in the 3rd quarter of the century. Post (letter, Oct. 1958) read the inscription at upper right as an abbreviated form of Johannes.

Two other apostles from this series are in the Kunstmuseum, Basel.

NICHOLAS DE STAËL

1914–1955. French. Born in St. Petersburg, Russia. Studied at Brussels Academy of Fine Arts, 1932–33. Settled in France in 1937; worked in Leger's studio. Began to paint abstractions, 1942. Influenced by Braque. His later work marks a return to a kind of representation in which forms, though mostly abstract, were recognizably still life, landscapes or other real objects. Lived in the south of France until his death by suicide in 1955.

White Flowers in a Black Vase PL. 304
[1953] Oil on board
39¼ x 28¾ in. (99.7 x 72.9 cm.)
Signed lower left: Staël
Signed and dated verso: Staël/1953
Acc. no. 53.142

COLLECTIONS: (Paul Rosenberg, New York).

EXHIBITIONS: New York, Paul Rosenberg, *Loan Exhibition of Paintings by Nicholas de Staël, 1914–1955*, 1955, no. 3, repr.; New York, Paul Rosenberg, *Nicholas de Staël*, 1963, no. 7, repr. p. 15.

WILLEM STEELINK

1856–1928. Dutch. Worked in The Hague with Israels, Bosboom and Jacob Maris. Later moved to Laren where

he worked with Anton Mauve, who had established an art colony there in 1882.

Sheep in Pasture PL. 164

[1899] Oil on canvas
21¼ x 31½ in. (53.5 x 80 cm.)
Signed lower right: Wilm Steelink
Dated on reverse: 1899

Acc. no. 02.1

Gift of Grafton M. Acklin

COLLECTIONS: (Henry Reinhardt, Milwaukee); Edward Drummond Libbey, 1901; Grafton M. Acklin, Toledo, to 1902.

According to the dealer Reinhardt, this picture was painted at Laren. It was the first painting to enter the Toledo Museum's collection.

JAN STEEN

1625/26–1679. Dutch. Born in Leyden. Influenced by (or possibly studied with) Nicolaes Knupfer in Utrecht, Adriaen and Isaak van Ostade in Haarlem, and Jan van Goyen in The Hague. Recorded in Leyden ca. 1644–48. Married a daughter of Jan van Goyen in 1649. Lived in Warmond near Leyden from 1656 to 1660. Settled in Haarlem and became a member of its guild in 1661. Returned ca. 1670 to Leyden where he remained until his death. Best known for moralizing genre subjects.

Peasants Before an Inn PL. 130

[1650s] Oil on wood panel
19¾ x 24¼ in. (50.2 x 61.6 cm.)
Signed lower right: JSteen (JS in monogram)

Acc. no. 45.32

COLLECTIONS: Destouches, Paris (Lebrun, Julliot, Boileau, Paris, Mar. 21, 1794, lot 103)?; M. Paignon Dijonval, Paris (Paillet, Bénard, Bonnefonds de la Vialle, Paris, Dec. 17, 1821, lot 101)?; Thomas Emmerson, London, 1821?; Thomas French, London (Christie, London, May 3–4, 1833); Jeremiah Harman (Christie, London, May 17, 1844, lot 109)?; Sir Hugh Hume Campbell, Marchmont House, Berwickshire, 1856 (Foster, London, May 31–June 1, 1858); Samuel Cunliffe-Lister, 1st Lord Masham, Swinton, Yorkshire; Lady Cunliffe-Lister; (D. Katz, Dieren, 1938); H. E. ten Cate, Almelo, 1938; (Schaeffer Galleries, New York).

REFERENCES: J. Smith, IV, no. 133 (described in reverse; incorrect dimensions); T. van Westrheene, *Jan Steen,*

étude sur l'art en Hollande, The Hague, 1856, no. 84 (incorrect dimensions); G. Waagen, *Galleries and Cabinets of Art in Great Britain,* London, 1857, Supplement, p. 442 (incorrect dimensions); C. Hofstede de Groot, I, no. 645 (described in reverse; incorrect dimensions).

Peasant and inn scenes occur frequently among Steen's early works. Both L. de Vries (letter, Sep. 1975) and B. Kirchenbaum (letter, Feb. 1976) agree that the Toledo picture was painted in the early 1650s, and Kirschenbaum compares it to the *Village Wedding* dated 1653 (Boymans-van Beuningen Museum, Rotterdam).

HENDRIK VAN STREEK

1659–1713/19. Dutch. Lived and worked in Amsterdam. Son and pupil of Juriaen van Streek. According to Houbraken, he studied sculpture with Willem van den Hoeven, and later, after 1678, with Emanuel de Witte, whose only pupil he was.

Interior of the Old Church PL. 143
in Amsterdam

[1690s] Oil on canvas
21⅞ x 18¾ in. (55.5 x 47.6 cm.)
Signed (falsely) lower left: E. de Witte
Signed lower right: Streek

Acc. no. 58.05

COLLECTIONS: Lady Cochran, Abingdon; (John Mitchell, London, 1934); Mrs. Geoffrey D. Hart, Forest Row, East Sussex; (John Mitchell, London); (Speelman, London).

REFERENCES: I. Manke, *Emanuel de Witte,* Amsterdam, 1963, no. 327, fig. 116 (as by Van Streek).

Formerly given to De Witte, this painting was reattributed by Manke to Van Streek on the basis of style. Although there is a De Witte "signature," in 1975 it was found that under ultraviolet light the name of Van Streek is visible at lower right.

The manner of representing the interlace ornamentation under the column capitals in the Toledo painting also appears in other signed works by Van Streek (see Manke nos. 328, 342). The costumes of the figures indicate a date after 1690.

FRANZ VON STUCK

1863–1928. German. Born in Tettenweis. Lived in Munich from his youth, where he studied at the Academy of Art, 1882–84. First exhibited in 1889 at the Munich

International. Founder and vice-president of the Munich Sezession. His students included Kandinsky, Klee and Albers. Important in the development of *Jugendstil,* he painted primarily allegorical and mythological subjects.

The Artist's Daughter PL. 74

[Ca. 1910] Oil on wood panel
14¼ x 14¼ in. (36.2 x 36.2 cm.)

Acc. no. 14.69

COLLECTIONS: (Eduard Schulte, Berlin); Florence Scott Libbey, 1912–14.

EXHIBITIONS: Dayton Art Institute, *The Artist and his Family,* 1950, no. 31.

Von Stuck often used the octagonal format. As he did not marry until 1897, it is presumed this portrait of his daughter Maria was painted about 1910.

LÉOPOLD SURVAGE

1879–1968. French. Studied in his native Moscow. In 1908 he enrolled in a school conducted by Matisse in Paris. Exhibited with the Cubists at the Salon des Indépendants in 1911. A founder member of La Section d'Or, his work is a personal synthesis of Cubism and Surrealism.

Landscape with Figure PL. 294

[1929] Oil on canvas
21⅜ x 25¾ in. (54.3 x 65.4 cm.)
Signed and dated lower right: Survage.29.

Acc. no. 38.83

Museum Purchase

COLLECTIONS: (Chester Johnson Gallery, Chicago); (Quest Art Galleries, Chicago).

GRAHAM SUTHERLAND

1903–. British. Born in London. Studied printmaking at Goldsmith's College of Art, 1920–25. Influenced by Blake, Turner and Henry Moore. Exhibited with the London Group from 1932, and at the International Surrealist Exhibition, 1936.

Thorn Trees PL. 351

[1947] Mixed media on canvas
36-1/16 x 35 in. (88.9 x 91.7 cm.)
Signed and dated upper right: Sutherland 7.IV.47

Acc. no. 52.89

COLLECTIONS: British Council, London, to 1948; (Alex Reid & Lefevre, London, 1948–52).

EXHIBITIONS: San Francisco Museum of Art, *Art in the 20th Century,* 1955, p. 17, repr. p. 14; Munich, Haus der Kunst, *Graham Sutherland,* 1967, no. 19, fig. 19.

REFERENCES: D. Cooper, *The Work of Graham Sutherland,* London, 1961, p. 32, pl. 85b.

According to Cooper, "Sutherland temporarily sublimated his conception of the Crucifixion (painted for St. Matthew's Church, Northampton, 1946) in a succession of *Thorn Trees* and *Thorn Heads* whose writhings and prickings imaginatively evoke the flagellation and painful indignities to which Christ's body was submitted. But while these thorn bushes become in one sense private symbols, they do not lose their real identity, because they remain natural growths which have also fascinated the artist by virtue of some curious beauty that he had found there."

YVES TANGUY

1900–1955. French. Born in Paris. Self taught, he began painting in 1924 after seeing a painting by Giorgio de Chirico. Met André Breton in 1927 and became a member of the Surrealist group, contributing to Surrealist publications and manifestos. From 1939 he lived in the United States, becoming an American citizen in 1948.

Passage of a Smile PL. 297

[1935] Oil on canvas
25⅝ x 21¼ in. (64.8 x 54 cm.)
Signed and dated lower right: YVES TANGUY 35

Acc. no. 38.84

COLLECTIONS: (Julien Levy, New York).

EXHIBITIONS: New York, Acquavella Galleries, *Yves Tanguy,* 1974, no. 15, repr.

REFERENCES: J. Levy, *Surrealism,* New York, 1936, p. 151, repr.

DAVID TENIERS THE YOUNGER
and FRANÇOIS RYCKHALS

Teniers. 1610–1690. Flemish. Son and pupil of David Teniers the Elder. Early work influenced by Frans Francken and Adriaen Brouwer. Entered the Antwerp painters' guild, 1632/33; dean, 1645. Moved to Brussels ca. 1645, and became court painter and keeper of the collections to successive governors of the Spanish Neth-

erlands. Co-founder of the Antwerp Academy, 1662. Painted portraits, landscapes, religious subjects and genre scenes.

Ryckhals. 1600–1647. Dutch. Born in Middelburg; his family came from Antwerp. In 1633–34 entered the painters' guild at Dordrecht; in Middelburg by 1642/44 to 1647. His work is closely related to that of Herman and Cornelis Saftleven, and he may have been the teacher of Willem Kalf. Known for peasant genre, still-lifes and landscape subjects.

Shepherds with their Flocks PL. 112

[1640] Oil on wood panel
25⅜ x 33¾ in. (64.4 x 85.7 cm.)
Signed and dated lower right (in two locations): D. TENIERS·FE/FRANS (in monogram) 1640

Acc. no. 53.73

COLLECTIONS: Sir William Hamilton (Christie, London, Mar. 27, 1801, lot 54 ?); (Sotheby, London, Nov. 28, 1951, lot 33); (Douwes, Amsterdam).

REFERENCES: J. Smith, III, no. 386.

The complex monogram in the lower right corner beneath Teniers' signature has been identified (letter, May, 1976) by Margret Klinge-Gross as that of François Ryckhals. She believes that Ryckhals painted the landscape and animals, while Teniers, who often painted staffage, added the figures.

The city in the background is probably Antwerp.

GIOVANNI DOMENICO TIEPOLO

1727–1804. Italian. Born in Venice, the oldest son of Giovanni Battista Tiepolo, who was his first teacher. By 1743, active as a draughtsman and as his father's assistant. Received his first commission before 1747 from the Oratorio del Crocefisso, S. Polo, Venice, for a series of Stations of the Cross. Collaborated with his father and worked independently in Würzburg, 1750–53, and in Madrid, 1762–70. Elected to the Venetian Academy in 1756, and served as its president, 1780–83. Also known as an etcher.

Head of an Old Man PL. 38

[Ca. 1757–75] Oil on canvas
18⅝ x 16 in (47.4 x 40.6 cm.)

Acc. no. 26.51

COLLECTIONS: (Hugo von Grundherr, Munich); George M. Richter, New York; Edward Drummond Libbey.

EXHIBITIONS: Art Institute of Chicago, *Paintings, Drawings and Prints by the Two Tiepolos: Giambattista and Giandomenico*, 1938, no. 17 (as G. B. Tiepolo); Toledo Museum of Art, *Four Centuries of Venetian Painting*, 1940, no. 52, repr. (cat. by H. Tietze; as G. B. Tiepolo).

REFERENCES: A. Morassi, *A Complete Catalogue of the Paintings of G. B. Tiepolo*, London, 1962, p. 50; B. Fredericksen and F. Zeri, *Census*, 1972, p. 198 (as *Bust of an Old Oriental*); G. Knox, " 'Philosopher Portraits' by Giambattista, Domenico and Lorenzo Tiepolo," *Burlington Magazine*, CXVII, Mar. 1975, p. 148, n. 4.

This painting was formerly attributed to Giovanni Battista Tiepolo, who, after 1750, painted and drew numerous heads, characterized by Knox as 'Philosopher Portraits,' that were later etched by Domenico and published in two series after 1770. In neither series does a print after this painting appear. Knox, however, has pointed out that at least ten heads were painted by Domenico after the etchings, and these paintings may be distinguished from his father's by the larger scale of the head and the omission of details, such as hands and accessories (pp. 148–51). These characteristics may be observed in the Toledo picture, and coupled with a looseness of technique indicative of Domenico, but which, however, cannot be connected directly to a specific print.

The attribution of this head to Domenico by Morassi is accepted by Knox (letters, Apr. and May 1974), Fredericksen and Zeri. Knox has suggested that the Toledo painting is a variation on Print 8 of Series I of the *Raccolta di Teste* (letter, Apr. 1974), although several significant changes have been made. The Toledo picture also bears a close relation to Print 7 of the same series, as well as the painting after it, attributed to Domenico, in the Art Institute of Chicago, and a similar work also given to Domenico in the Springfield (Mass.) Museum of Fine Arts. It is equally possible that this picture was inspired by a drawing by Giambattista of *The Head of a Bearded Man*, ca. 1760 (Cambridge, Fogg Art Museum), or the corresponding print by Domenico (Series II, 11).

According to Knox, the prints may be divided into two groups, Style A and B, and dated 1757–58 and after 1770 respectively. Thus, the Toledo painting can be only approximately dated 1757–75, a period which corresponds to the usual dating of the heads by Tiepolo scholars.

JACOPO TINTORETTO

1518–1594. Italian. Born Jacopo Robusti. Took the name Tintoretto after his father's profession of dyer

(*tintore*). His early training is unclear, though he was influenced by Titian and Michelangelo. Remained in Venice his entire career, with exception of a trip to Mantua in 1580. Worked almost continuously in the Doge's Palace and the Scuola di San Rocco, where he painted a large cycle of decorations, 1564–87. Primarily known as a master of religious narrative, Tintoretto also painted a number of portraits, mythological scenes and histories, and employed a large workshop. His assistants included two sons and a daughter.

Noli Me Tangere PL. 16

[1570–80] Oil on canvas
82¼ x 72¼ in. (208.9 x 182.9 cm.)

Acc. no. 67.144

COLLECTIONS: Col. Hugh D. Baillie, London (Christie, London, May 15, 1858, lot 27); A. Jones, London, 1858; Private collection, Scotland; (Wildenstein, New York).

EXHIBITIONS: London, British Institution, *Exhibition of Pictures of Italian, Spanish, Flemish, Dutch, French and English Masters*, 1856, no. 119.

REFERENCES: S. Béguin and P. de Vecchi, *Tout l'oeuvre peint de Tintoret*, Paris, 1971, no. A36 (as attributed to Tintoretto).

This subject is traditionally known by its Latin name. According to the Gospels (John XX:11–18), after Mary Magdalene returned to the sepulchre and found there two angels, Christ appeared to her disguised as a gardener. When she asked where he had hidden Jesus, he said, "Touch me not (*Noli me tangere*); for I am not yet ascended to my Father; but go to my brethren, and say unto them, I ascend unto my Father, and your Father, and to my God, and your God."

F. Zeri and A. Morassi (letters, Dec. 1966 and July 1967) date this painting in the 1570s. According to Zeri, the broad pictorial handling is stylistically related to Tintoretto's cycle in the upper hall of the Scuola di San Rocco, Venice (1576–81). R. Palluchini and C. Gould, however, believe (letters, Sep. 1975 and July 1975) it may be by a member of Tintoretto's workshop, and Palluchini also stated that there are similarities to early works by Tintoretto's son, Domenico (1560–1635).

JAMES-JACQUES-JOSEPH TISSOT

1836–1902. French. Born in Nantes. Went to Paris about 1856, and entered Lamothe's atelier, where he met Degas. Exhibited at the Salon from 1859; the Royal Academy from 1872; and at the Grosvenor Gallery, 1874. Moved

to London, 1871. Traveled to the Middle East in 1886, 1889 and 1896 to make illustrations for the Life of Christ and the Old Testament. Best known for scenes of fashionable contemporary life, he also made many etchings and watercolors.

London Visitors PL. 241

[Ca. 1874] Oil on canvas
63 x 45 in. (160 x 114.2 cm.)
Signed lower left: J. J. Tissot

Acc. no. 51.409

COLLECTIONS: Mrs. Bannister; (M. Bernard, London); (Robert Frank, London).

EXHIBITIONS: London, Royal Academy, 1874, no. 116; London, Leicester Galleries, 1937, no. 16; Ottawa, National Gallery of Canada, *Victorian Artists in England*, 1965, no. 147, repr.; Providence, Rhode Island School of Design, *James Jacques Joseph Tissot*, 1968, no. 19, repr.

REFERENCES: J. Laver, "Vulgar Society," *The Romantic Career of James Tissot, 1836–1902*, London, 1936, p. 67; G. Reynolds, *Painters of the Victorian Scene*, London, 1953, p. 99, fig. 102; J. N. Flaizik, "Pictorial Literature," *Toledo Museum of Art Museum News*, III, Spring 1960, pp. 44–5, repr. p. 41; R. Rosenblum, "Victorian Art in Ottawa," *Art Journal*, XXV, Winter 1965–66, p. 140, fig. 6; E. P. Janis, "Tissot Retrospective," *Burlington Magazine*, CX, May 1968, p. 303, fig. 98; J. Maas, *Victorian Painters*, London, 1969, p. 243, repr. p. 242.

The scene is the portico of the National Gallery, London, looking toward the church of St. Martin's-in-the-Fields. The visitors are typically fashionable Tissot models, arranged in an asymmetrical composition that recalls Degas. The boys are students of Christ's Hospital, identifiable by their long blue coats and yellow stockings.

A smaller and slightly different version of the Toledo painting is in the Milwaukee Art Center. An etching of 1878 shows the same scene, the schoolboy in the foreground replaced by the figure of Kathleen Newton, Tissot's companion and frequent model.

CONSTANT TROYON

1810–1865. French. Early study with Poupart and Riocreaux while painting porcelain in Sèvres. Exhibited yearly at the Salon from 1833–59. Landscapes from 1843–47 strongly influenced by Rousseau and Dupré

with whom he worked at Fontainebleau. In Holland in 1847 where he was influenced by the 17th century Dutch painters, Potter and Cuyp.

The Pasture
PL. 225

[Ca. 1855–60] Oil on canvas
32 x 39¾ in.(81.2 x 101 cm.)
Stamped lower left: Vente/Troyon

Acc. no. 22.34

Gift of Arthur J. Secor

COLLECTIONS: (Vente Troyon, Hôtel Drouot, Paris, Jan.-Feb. 1866, lot 50); Weill, 1866; Arthur J. Secor, 1916–22.

REFERENCES: L. Soullié, *Peintures, pastels, aquarelles, dessins de Constant Troyon,* Paris, 1900, p. 137 (as "Une vache brune et deux moutons en marche dans en prairie").

A version of this painting, signed and dated 1855, is in the Kunsthalle, Hamburg (inv. no. 2277). Although almost identical to the Toledo picture in its dimensions and composition, the Hamburg painting includes an additional animal group at the right. The Toledo painting was unfinished at the artist's death, but probably dates from 1855–60, since the style is similar to that of the Hamburg painting and a picture in the Wallace Collection, signed and dated 1857 (*Wallace Collection Catalogues: Pictures and Drawings,* 16th ed., London, 1968, no. P359).

JOHN TUNNARD

1900–. British. Born in Bedfordshire. Studied at Royal College of Art 1919–23. Early interest in textile design and block printing. Turned to painting 1931. In 1934 joined the London Group and began painting in a nonrepresentational style.

Painting, 1944
PL. 349

[1944] Casein on board
21 x 30¼ in. (53 x 76.8 cm.)
Signed and dated lower left: John Tunnard 44

Acc. no. 53.127

COLLECTIONS: (Ernest Brown & Phillips, London).

JOSEPH MALLORD WILLIAM TURNER

1775–1851. British. Born in London, where he enrolled in the Royal Academy, 1789, and exhibited there the following year for the first time. Trained first as a topo-graphical draftsman and worked chiefly in watercolors until 1796, when he began exhibiting oils. Exhibited regularly at Royal Academy and British Institution from 1790 to 1850. Traveled in British Isles and Europe on annual sketching tours. He and Constable were the chief British landscape painters of their century.

The Campo Santo, Venice
PL. 333

[1842] Oil on canvas
24½ x 36½ in. (61.2 x 91.2 cm.)

Acc. no. 26.63

COLLECTIONS: Elhanan Bicknell, London, bought at the Royal Academy exhibition, 1842 (Christie, London, Apr. 25, 1863, lot 112); (Agnew, London); Henry McConnell, Cressbrook, Derbyshire, 1863–86; (Agnew, London, 1886); (Christie, London, Mar. 27, 1886, lot 76); (Silva White); Mrs. J. M. Keiller, Dundee, Scotland, 1886–1916; (Reinhardt, New York); Edward Drummond Libbey, 1916–25.

EXHIBITIONS: London, Royal Academy, *Annual Exhibition,* 1842, no. 73; Manchester, Royal Manchester Institution, *Exhibition of Art Treasures,* 1878, no. 111; London, Guildhall Art Gallery, *Pictures and Drawings by J. M. W. Turner, R.A. . . . and Some of his Contemporaries,* 1899, no. 36; Boston, Museum of Fine Arts, *Turner, Constable and Bonington,* 1946, no. 16, fig. 16; Indianapolis, John Herron Art Museum, *Turner in America,* 1955, p. iv, no. 46, repr.; New York, Museum of Modern Art, *Turner Imagination and Reality,* 1966, p. 38, no. 25, repr. p. 55; London, Royal Academy, *Bicentenary Exhibition: 1768–1968,* 1968, I, no. 162; II, p. 64; Paris, Petit Palais, *La peinture romantique anglaise et les Préraphaélites,* 1972, no. 273, repr.

REFERENCES: J. Burnet and P. Cunningham, *Turner and His Works,* London, 1852, p. 119, no. 216; G. Waagen, *Treasures of Art in Great Britain,* London, 1854, II, pp. 350–51; W. Thornbury, *Life of J. M. W. Turner, R.A.,* London, 1862, II, pp. 382, 401; C. F. Bell, *Works Contributed to Public Exhibitions by J. M. W. Turner, R.A.,* London, 1901, p. 144, no. 232; W. Armstrong, *Turner,* London, 1902, p. 235, repr.; J. Ruskin, *The Works of John Ruskin* (eds. E. T. Cook and A. Wedderburn), London, 1903–12, III, pp. xxiv, 250, 251n (erroneously as *View of Murano with the Cemetery*); VII, pp. 149n, 157 and 157n, pl. 67; X, p. 38n; XIII, pp. 409, 454, 499; A. J. Finberg, *In Venice with Turner,* London, 1930, pp. 140, 157; A. J. Finberg, *The Life of J. M. W. Turner,* London, 1939, pp. 390, 506, no. 546; J. Rothenstein and M. Butlin, *Turner,* New York, 1964, pp. 52, 66, pl. 116; J. Lindsay, *J. M. W. Turner,* London, 1966, pp. 40–41; K.

Garlick, "The Bicentenary Exhibition at the Royal Academy," *Apollo*, LX, Feb. 1969, p. 93, fig. 7; J. Gage, "La peinture romantique anglaise et les Préraphaélites," *La Revue du Louvre*, XXII, No. 1, 1972, p. 54, fig. 4.

The Campo Santo is the cemetery of Venice. This picture was painted following Turner's third and last trip to Venice, a city whose light and intermingling of architecture and water had special significance for him.

Although Waagen described it in the Bicknell collection as a companion to *The Giudecca from the Canale di Fusina* (1841; William Wood Prince collection, Chicago), it is not certain that the pictures were painted as pendants.

MAURICE UTRILLO

1883–1955. French. Born in Paris. Son of the painter Suzanne Valadon. No formal artistic training. Early works show influence of Pissarro and Sisley. Painter of environs of Montmartre and churches of France. In his signature, V stands for his mother's name.

Street in Montmartre PL. 284

[1910–11] Mixed media on canvas
24½ x 29 in. (62.2 x 73.6 cm.)
Signed lower left: Maurice Utrillo, V,

Acc. no. 51.378

COLLECTIONS: Francis Carco, Paris; (Lepoutre, Paris, by 1921); David Eccles, London; S. Kaye, London; (Alex Reid & Lefevre, London).

EXHIBITIONS: London, Lefevre Gallery, *Twentieth Century French Painting*, 1943, no. 37; London, Lefevre Gallery, *The School of Paris*, 1951, no. 37; Pittsburgh, Carnegie Institute, *Maurice Utrillo*, 1963, no. 24, repr.

REFERENCES: F. Carco, *Maurice Utrillo et son oeuvre*, Paris, 1921, fig. 29 (as 1911); M. Raynal, "Zu dem Werk von Maurice Utrillo," *Cicerone*, Sep. 1923, repr. p. 794; P. Pétridès, *L'oeuvre complet de Maurice Utrillo*, Paris, 1959, I, no. 189, repr. (as ca. 1910).

The identification of the subject by Carco and Pétridès as the Place Jean-Baptiste Clément is confirmed by a 1910 photograph showing the identical view (*Aujourd'hui*, XXI, Mar.–Apr. 1959, p. 87). This picture is the first of several Utrillo painted of the Place Clément (Pétridès, nos. 739, 780, 900, 1099). The paint is a mixture of plaster of Paris and gum with zinc white which Utrillo used during his "white period," ca. 1910–18.

MOYSES VAN UYTTENBROECK

1590/1600–ca. 1647. Dutch. Spent his life in The Hague. It is not known with whom he studied. Became a member of the painters guild in 1620 and was elected its dean in 1627. Possibly visited Rome, though the influence of the Elsheimer-Bril tradition is evident. He received commissions from Frederik Hendrik, Prince of Orange. He also did etchings.

Landscape with Shepherds PL. 95

[Ca. 1625] Oil on wood panel
17¼ x 25 in. (43.6 x 63.3 cm.)
Signed lower right: Mo van wtenbrouck/ 16—

Acc. no. 66.113

COLLECTIONS: Minard family, Paris; Anonymous private collection, Paris (?); (Agnew, London, 1965).

Although this picture was unknown to Weisner at the time he published his study of the artist ("Die Gemälde des Moyses van Uyttenbroeck," *Oud Holland*, LXXIX, 1964, pp. 189–228), he later stated (letter, May 1966) that it was done about 1625 and is comparable to other paintings belonging to Uyttenbroeck's "heroic Italian" landscape style.

The subject is undetermined. However, Uyttenbroeck often painted genre-like Arcadian subjects which have no specific literary or mythological source (Weisner, p. 192).

ANNE VALLAYER-COSTER

1744–1818. French. Daughter of a silversmith, her artistic training is unknown. Admitted to the Académie in 1770, she was chiefly active before 1789. Her entire career was in Paris; she exhibited at the Salons from 1777 to 1817. She was almost exclusively a painter of still lifes.

Still Life with Lobster PL. 206

[1781] Oil on canvas
27¾ x 35¼ in. (70.5 x 89.5 cm.)
Signed and dated lower left: Mme Vallayer-Coster/1781
Frame stamped: E. L. Infroit

Acc. no. 68.01A

COLLECTIONS: Marquis Giarardot de Marigny, Paris, 1783; Achille Fould, Paris; Monsieur X (Paris, Hôtel Drouot, May 22, 1967, lot 20, with pendant); (Cailleux, Paris).

EXHIBITIONS: Paris, Salon de la Correspondance, 1782 (as *Nature morte au homard*).

REFERENCES: E. Bellier de la Chavignerie, *Les artistes français du XVIIIe oubliés ou méprisés*, Paris, 1865 (incorrectly as Salon of 1783); M. R. Michel, "À propos d'un tableau retrouvé de Vallayer-Coster," *Bulletin de la societé de l'histoire de l'art français*, 1965, p. 186; M. R. Michel, *Anne Vallayer-Coster, 1744–1818*, Paris, 1970, no. 226.

Painted in 1781, the year of the artist's marriage and her appointment as *Professor de Peinture* to Queen Marie Antoinette, this painting and its pendant date from the peak of her career. First signed "Mlle. Vallayer," it was re-signed by the artist after her marriage to Coster. The silver objects are probably examples of her father's work. According to M. R. Michel, the reflection in the tureen is that of the artist's studio window and of herself at the easel. The central motif of a lobster was unusual for Vallayer-Coster. Together with the reflected images, it suggests she was inspired by 17th century Dutch pictures such as the Van Beyeren, *Still Life with a Wine Ewer* and the De Heem, *Still Life with Lobster* in the Toledo Museum collection.

Still Life with Game PL. 207

[1782] Oil on canvas
28 x 35¼ in. (71 x 89.5 cm.)
Signed and dated lower left: Mme Vallayer Coster/1782
Frame stamped: E. L. Infroit

Ac. no. 68.01B

COLLECTIONS: Same as 68.01A.

EXHIBITIONS: Paris, Salon, 1783, no. 76 (as *Un tableau de gibier avec des attributs de chasse*).

REFERENCES: M. Faré, *La nature morte en France*, Geneva, 1963, I, p. 180; E. Bellier de la Chavignerie and L. Auvray, *Dictionnaire général des artistes de l'école française*, Paris, 1882–85, I, p. 295; M. R. Michel, *Anne Vallayer-Coster, 1744–1818*, Paris, 1970, no. 286.

Vallayer-Coster painted some two dozen hunt still lifes. However, Michel points out that the landscape background is nearly unique in her work, as a stone ledge and bare wall were her usual setting. The picture was exhibited at the Salon of 1783 as the property of M. Girardot de Marigny who also owned its pendant, Toledo's *Still Life with Lobster*. Kept together throughout their history, the two paintings have identical contemporary frames marked by the framemaker Etienne-Louis Infroit (1720–1794).

VICTOR VASARELY

1908–. French. Born in Hungary. Studied at Budapest Bauhaus, 1929. Settled in Paris in 1930, where he worked as a commercial artist. Since 1944 has devoted himself to painting. His abstract work is characterized by experiments with the optical effects of color.

Alom I PL. 306

[1967–69] Tempera on canvas
78¾ x 78¾ (200 x 200 cm.)
Signed lower center in pencil: vasarely
Inscribed verso: VASARELY 1967–69

Ac. no. 70.49

COLLECTIONS: (Galerie Chalette, New York).

REFERENCES: D. Davis, *Art and the Future*, New York, 1973, fig. 5.

Alom I is one of a series painted between 1965–70 which were the largest canvases Vasarely had painted until that time.

DIEGO VELÁZQUEZ, Attributed to

1599–1660. Spanish. Born in Seville. His full name was Diego Rodríguez de Silva Velázquez. Studied briefly with Francisco de Herrera the Elder, and from ca. 1613–18, with Francisco Pacheco, whose daughter he married. In 1617 became a member of the Guild of St. Luke. First trip to Madrid, 1622. Returned there in 1623 and was appointed to the service of King Philip IV. From this date, the majority of his paintings were portraits of the Royal family and members of the court. With the exception of trips to Italy in 1629–31 and 1649–51, he remained in Madrid until his death.

Man with a Wine Glass PL. 55

[Ca. 1627–28] Oil on canvas
30 x 25 in. (76.2 x 63.5 cm.)

Ac. no. 26.33

COLLECTIONS: Sir Gabriel Prior Goldney, Bt., Derriads, Chippenham, Wiltshire, to 1914; (R. Langton Douglas, London); (Duveen, New York); Edward Drummond Libbey, 1915–25.

EXHIBITIONS: Bristol, Fine Arts Academy, *Loan Exhibition*, 1893 and 1906; New York, Metropolitan Museum of Art, *Spanish Paintings from El Greco to Goya*, 1928, no. 58, repr.; Baltimore Museum of Art, *A Survey of Spanish Painting through Goya*, 1937, no. 10, repr.; To-

ledo Museum of Art, *Spanish Painting*, 1941, p. 96, repr. (cat. by J. Gudiol); Madrid, Casón del Buen Retiro, *Velázquez y lo Velázqueño*, 2nd ed., 1960, no. 45, pl. 38.

REFERENCES: A. L. Mayer, "The Man with the Wineglass by Diego Velázquez," *Art in America*, III, 1915, pp. 183–87, repr.; A. L. Mayer, *Diego Velázquez*, Berlin, 1924, p. 74, repr.; C. Justi, *Diego Velázquez und sein Jahrhundert*, 4th ed., Zurich, 1933 (cat. by L. Goldscheider, no. 29, pl. 26); A. L. Mayer, *Veláquez: A Catalogue Raisonné of the Pictures and Drawings*, London, 1936, no. 447, pl. 148; J. Moreno Villa, *Locos, enanos, negros, y niños palaciegos*, Mexico City, 1939, pp. 74, 100, pl. 17; E. Lafuente Ferrari, *The Paintings and Drawings of Velázquez*, London, 1943, no. XXXIV, pl. 38; B. de Pantorba, *La vida y la obra de Velázquez*, Madrid, 1955, no. 33 (as a pastiche); E. Tietze-Conrat, *Dwarfs and Jesters in Art*, New York, 1957, p. 100, fig. 39 (as *Manuel de Gante*); J. A. Gaya Nuño, *La pintura española fuera de España*, Madrid, 1958, no. 2835; A. Velbuena Prat, "Velázquez y la evasión del espejo mágico," *Varia Velázqueña*, Madrid, 1960, I, p. 182; II, pl. 44a; J. A. Gaya Nuño, "Crónica de la exposición 'Velázquez y lo Velázqueño'," *Goya*, Jan.–Feb. 1961, p. 270; X. de Salas, "The Velázquez Exhibition in Madrid," *Burlington Magazine*, CIII, Feb. 1961, p. 55; J. Camón Aznar, "Algunas precisiones sobre Velázquez," *Goya*, Mar.–Apr. 1963, p. 285, repr. p. 284; E. Harris, in *Burlington Magazine*, CV, July 1963, p. 322; J. López-Rey, *Velázquez: A Catalogue Raisonné of his Oeuvre*, London, 1963, no. 441, pl. 195; J. Camón Aznar, *Velázquez*, Madrid, 1964, I, pp. 307–08, repr.; M. A. Asturias and P. M. Bardi, *L'opera completa di Velázquez*, Milan, 1969, no. 31b, repr. (as copy of Swedish version); J. Gudiol, *Velázquez*, New York, 1974, p. 87, no. 52, fig. 76.

This painting was first published and attributed to Velázquez by Mayer (1915). Lafuente, while accepting the attribution, suggested that the Toledo picture may be a version with variations of the *Geographer* (Musée des Beaux-Arts, Rouen). Following the 1960 Madrid exhibition, De Salas observed that the artist's fame from his youth onwards is evident from the many copies of his paintings, including three versions of the *Geographer* (Rouen, Toledo and Zornmuseet, Mora, Sweden); more recently, he has suggested that the Toledo canvas may be by a non-Spanish artist (letter, Aug. 1975). López-Rey proposed that the Toledo painting is a copy after the nearly identical canvas in Sweden, which he attributes to an unknown seventeenth century painter. Gudiol, however, who has maintained the attribution to Velázquez, believes the Swedish picture is a copy after Toledo's.

The dating of these three works has not been firmly established, although it is generally accepted that the Rouen painting was done between 1624 and 1628. Mayer (1936) dated the Toledo painting 1623–24, while Gudiol (1974) believes it was painted ca. 1627–28.

The subject of the three paintings is the same man, presumably one of the many jesters or buffoons of the Spanish court. Moreno-Villa suggested that he is Manuel de Gante, a *gentilhombre de placer*, Antonio Banuels, characterized as a madman, buffoon and *hombre de placer*, or perhaps the well-known fool, Pabillos de Valladolid. Valbuena Prat also suggested the name of Estebanillo Gonzalez, a favorite of Philip IV.

NICOLAES VERKOLJE

1673–1746. Dutch. Born in Delft. Son and pupil of Jan Verkolje. Influenced by the highly-finished style and genre subjects of Metsu, Ter Borch and Van der Werff. Learned mezzotint technique from his father. Worked in Amsterdam.

The Fortune Teller　　　　　　　　　PL. 145

Oil on wood panel
16⅝ x 13¼ in. (42.2 x 33.6 cm.)
Acc. no. 55.39

COLLECTIONS: Henrietta van der Schagen (Van der Schley, Van Amstel, De Winter, Yver, Amsterdam, May 16, 1781, no. 63); Van Leyden (A. Paillet, H. Delaroche, Paris, Sep. 10, 1804, no. 104); (Bernard Houthakker, Amsterdam, 1955).

The attribution of this picture is confirmed by the mezzotint of it by Verkolje bearing his name. A copy of this print is in the Museum collection.

CLAUDE-JOSEPH VERNET

1714–1789. French. Born at Avignon, son of an artisan-painter. From 1734 until 1753 at Rome where, after study with Manglard, he developed his marine landscape style, influenced by Claude Lorrain, and established an international clientele, including many Englishmen. Exhibiting at the Salon in Paris from 1746, he became a full Académie member in 1753, the year he was also commissioned by Louis XV to paint the famous series depicting the ports of France. He was the father of Carle Vernet and the grandfather of Horace Vernet.

Evening PL. 205

[1753] Oil on canvas
39¼ x 54 in. (99.7 x 137.2 cm.)
Signed and dated lower left: Joseph Vernet.f./1753

Acc. no. 51.499

COLLECTIONS: Ralph Howard (ca. 1724–1786), later 1st
Viscount Wicklow, Dublin, 1753; Earls of Wicklow (sale,
Shelton Abbey, Arklow, Oct. 16–Nov. 3, 1950, lot 1647
[with *Morning*]); Anonymous owner (Sotheby, London,
June 20, 1951, lot 66 [with *Morning*]); (Cailleux, Paris).

EXHIBITIONS: Toledo Museum of Art, *The Age of Louis
XV*, 1975, no. 111, repr. (cat. by P. Rosenberg; French
edition (National Gallery of Canada, Ottawa, 1976) cor-
rects the Ingersoll-Smouse reference and clarifies prove-
nance).

REFERENCES: L. Lagrange, *Joseph Vernet et la peinture
au XVIIIe siècle*, Paris, 1864, p. 335, no. C. 129; F. Inger-
soll-Smouse, *Joseph Vernet*, Paris, 1926, I, nos. 385–89
(TMA 51.499 is one of these; Howard in error called
'Lord Stafford'); London, Greater London Council (Ken-
wood), *Claude-Joseph Vernet* (exh. cat. by P. Conisbee),
1976, Introd. n. 35, and in no. 49.

This is one of five paintings ordered by Ralph Howard
while he was in Rome on the Grand Tour in 1751–52.
Four were marines showing the different times of day,
a favorite theme of Vernet's, whose account book de-
scribes the pictures for Howard as *"représentent des
marines avec sujects différents à ma fantaisie"* (Lagrange).
His words emphasize the imaginary qualities of the To-
ledo picture, which was generally inspired by the coast
of the Gulf of Naples.

 According to P. Conisbee (Ottawa, 1976; letters Oct.
1975 and Apr. 1976), who has clarified the history of
the Howard Vernets, of the marines only *Morning* (pri-
vate collection, Paris) and *Evening* (Toledo) are known;
the other two are missing.

PAOLO VERONESE

Ca. 1528–1588. Italian. Born Paolo Caliari; called Veron-
ese after his birthplace, Verona, where he studied with
Antonio Badile. He settled in Venice ca. 1553; for the
rest of his life he worked for churches, palaces and villas
there and on the neighboring mainland, except for a
trip to Rome in the 1550s or 60s. As relatively few paint-
ings can be firmly dated, the chronology of his work
is problematic, and he also varied his style for differ-
ent types of religious and mythological commissions,
many of which were large-scale decorations. For the

last 30 years of his life he ranked with Tintoretto as the
leading painter in Venice. Veronese's many assistants
included his brother and two sons.

Christ and the Centurion PL. 17

[Ca. 1580] Oil on canvas
39⅛ x 52½ in. (99.2 x 130.8 cm.)

Acc. no. 66.129

COLLECTIONS: (Agnew, London).

The subject is taken from Matthew VIII:5–13. A centu-
rion who asked the Lord to heal his servant felt unwor-
thy of having Christ in his house. Christ marveled at the
centurion's faith and instructed him to go his way, his
servant being healed.

 Veronese's several versions of this subject are similar in
composition, though they vary in size. The earliest of
them was painted ca. 1571. According to Rodolfo Pallu-
chini (letter, May 1965), the Toledo canvas, unknown
to scholars until it was acquired by the Museum, was
painted ca. 1580. It is also the smallest version of this
subject, others of which are in the Gemäldegalerie, Dres-
den; Alte Pinakothek, Munich; Kunsthistorisches Mu-
seum, Vienna and Nelson Gallery of Art, Kansas City
(G. Piovene, *L'opera completa del Veronese*, Milan,
1968, pp. 83, 84).

 Fehl ("Questions of Identity in Veronese's *Christ and
the Centurion*," *Art Bulletin*, XXIX, No. 4, Dec. 1957,
pp. 301, 302, figs. 1–4) believed that the figure on the
far right in the Kansas City example is a self-portrait.

JAN VICTORS, Copy after

Dutch. Victors (1619/20–ca. 1676) was born in Amster-
dam. A pupil of Rembrandt before 1640, he painted por-
traits, religious and genre subjects.

Girl at a Window PL. 137

Oil on canvas
40¾ x 31½ in. (102.7 x 79.9 cm.)

Acc. no. 28.91

Gift of Arthur J. Secor

COLLECTIONS: (Hendricks, Haarlem, Feb. 11, 1816, lot
62) ?; Arthur J. Secor, 1925–28.

REFERENCES: H. Gerson, "Jan Victors," *Kunsthistor-
ische Medelingen van het Rijksbureau voor Kunsthis-
torische Documentatie*, III, No. 2, 1948, pp. 19–22, fig.
2 (as a copy).

According to Gerson (1948 and letter, May 1975), this is a copy after a painting signed by Victors (1640; Louvre, Paris). A spurious signature of Ferdinand Bol was removed when the Toledo painting was cleaned in 1963.

MARIA HELENA VIEIRA DA SILVA

1908–. French. Born in Lisbon. Moved to Paris, 1928. Studied sculpture with Bourdelle and Despiau, painting with Friesz and Leger, and engraving with Hayter. Associated with the School of Paris.

The City PL. 305
[1951] Oil on canvas
37¼ x 32¼ in. (94.6 x 81.9 cm.)
Signed and dated lower right: Vieira da Silva 51

Acc. no. 53.134

COLLECTIONS: (Redfern Gallery, London).

EXHIBITIONS: San Francisco Museum of Art, *Art in the 20th Century*, 1955, p. 18; Minneapolis, Walker Art Center, *School of Paris 1959: The Internationals*, 1959, no. 68; Cleveland Museum of Art, *Paths of Abstract Art*, 1960, no. 56, repr. p. 39.

LOUISE-ÉLISABETH VIGÉE-LE BRUN

1755–1842. French. A pupil of her father, a pastel portraitist, she was also greatly influenced by Greuze. Admitted to Academy of St. Luke in 1774, she became Painter to Queen Marie Antoinette. Member of Académie Royale in 1783. Left Paris at time of Revolution, spending 12 years in Italy, Germany and Eastern Europe, where she continued her career as a portraitist. After a brief return to Paris in 1801, lived in England and Switzerland, returning to Paris around 1812.

Lady Folding a Letter PL. 210
[1784] Oil on canvas
36¾ x 29⅜ in. (93 x 75 cm.)
Signed and dated lower right: Lise Vᵉ LeBrun/1784

Acc. no. 63.33

COLLECTIONS: Baron Albert de Rothschild, Vienna; Baron Louis de Rothschild, Vienna; (Wildenstein, New York).

EXHIBITIONS: London, Royal Academy, *France in the Eighteenth Century*, 1968, no. 716, fig. 326.

REFERENCES: A. Frankfurter, "Museum Evaluations, 2: Toledo," *Art News*, LXIII, no. 9, Jan. 1965, pp. 26, 55–6, repr. p. 26.

Isabella Teotochi Marini PL. 209
[1792] Oil on paper, mounted on canvas
19 x 13⅞ in. (48.2 x 35.2 cm.)
Signed, dated and inscribed lower left: L. E. Vigée Le Brun/pour son ami De Non/à Venise 1792

Acc. no. 50.243

COLLECTIONS: Dominique Vivant-Denon, 1792 (Denon sale, Paris, May 1, 1826, lot 210); Countess Isabella Albrizzi, Venice, 1826–36; Albrizzi family, Venice, 1836–98; (Stefano Bardini, Florence, 1898–99) (Christie, London, June 5–7, 1899, lot 484); E. M. Hodgkins, London, 1899–1913; C. Morland Agnew, London, 1913 (Christie, London, July 9, 1926, lot 132); Frederick A. Szarvasy, London, 1926 (Christie, London, Dec. 10, 1948, lot 60); (Roland Browse & Delbanco, London).

REFERENCES: D. V. Denon, *L'originale e il ritratto*, 1st ed., Bassano, 1792, repr. (etching by Denon); L.-E. Vigée-Le Brun, *Souvenirs de Mme. Vigée-Le Brun*, Paris, [1867], I, pp. 246, 249; II, p. 368; *Collection Bardini*, 1899, pl. 20, no. 355; W. H. Helm, *Vigée-Le Brun, Her Life, Work and Friendships*, London, n.d., p. 114, repr. p. 166; A. Blum, *Madame Vigée-Le Brun*, Paris, [1919], pp. 61, 101 (as Mme. Marini); V. Malamani, *Isabella Teotochi-Albrizzi, I suoi amici-il suo tempo*, Turin, 1882, p. 20; V. Malamani, *Canova*, Milan, n.d., p. 171; P. de Nolhac, *Madame Vigée-Le Brun*, Paris, [1912], pp. 176–77; A. Rubin de Cevin Albrizzi, "Palazzo Albrizzi," *L'Oeil*, June 1964, p. 44, fig. 3.

To escape the Revolution, Mme. Vigée-Le Brun left Paris in 1792 for Venice. That year she was introduced to Isabella Teotochi Marini (1760–1836), later (1796) Countess Albrizzi, famous in Venetian society for her salon, literary gifts and beauty. The introduction was made by Dominique Vivant Denon, a scholar, archeologist and writer who under Napoleon was instrumental in organizing the French museum system, including the Louvre. This freely-painted portrait, inscribed by the artist to Denon, was etched (in reverse) by him the same year for his book *L'originale e il ritratto*. A related oil sketch is in a London private collection.

Malamani (1882, p. 20) quotes a letter from Denon enthusiastically praising both the artist and her sitter, in whose face he finds, "Greek delicacy, Italian passion and French amiability."

JACQUES VILLON

1875–1963. French. Born in Damville. Brother of the artists Raymond Duchamp-Villon and Marcel Duchamp.

Studied painting and printmaking in Paris at Cormon's studio. Influenced by Degas, Lautrec, Fauvism, and, from 1911, Analytical Cubism. Organized the Cubist *Section d'or* in 1912. After 1919 belonged to Abstraction-Creation group. Also an important printmaker.

Flowers PL. 302

[1946] Oil on canvas
36¼ x 28¾ in. (92 x 73 cm.)
Signed lower right: Jacques Villon
Inscribed on reverse: Jacques Villon/46/DES FLEURS

Acc. no. 49.111

COLLECTIONS: (Louis Carré, Paris).

EXHIBITIONS: Copenhagen, Statens Museum for Kunst, *Jacques Villon Retrospective,* 1948, no. 22.

MAURICE DE VLAMINCK

1876–1958. French. Born in Paris, but moved to Chatou in 1892 where he shared a studio with Derain from 1900. Met Matisse in 1905 and the same year exhibited with the Fauve group, of which he was a chief figure. After 1908, inspired by Cézanne's late style and by Van Gogh, he developed an individual expressionist style, principally in landscapes and still lifes. He was also a printmaker and writer.

Farm Landscape PL. 289

[Ca. 1920–22] Oil on canvas
25⅞ x 36⅜ in. (65.8 x 92.4 cm.)
Signed lower right: Vlaminck

Acc. no. 54.79

COLLECTIONS: Mrs. Harry P. Whitney, New York; Major Edward J. Bowes; (J. K. Thannhauser, New York).

Vlaminck never dated pictures, and the artist himself attached little importance to the chronology of his work (M. Sauvage, *Vlaminck, sa vie et son message,* Geneva, 1956, p. 107).

This was probably painted ca. 1920–22 at Valmondois, in the Seine valley north of Paris, where Vlaminck bought a house in 1919.

HENRY WALTON, Attributed to

1746–1813. British. Walton's genre subjects and conversation pieces show the influence of his teacher Zoffany, and of Chardin. Exhibited at the Royal Academy from

1777 to 1779. He also painted portraits and was an advisor to several important collectors.

A Gentleman at Breakfast PL. 318

[Ca. 1775–80] Oil on canvas
25 x 30⅜ in. (63.5 x 77.2 cm.)

Acc. no. 56.77

Gift of an Anonymous Donor

COLLECTIONS: (Knoedler, New York); Mrs. D. H. Carstairs, Philadelphia; (Scott & Fowles, New York, 1948); (Newhouse, New York, 1950–51); Private collection.

EXHIBITIONS: Detroit Institute of Arts, *English Conversation Pieces of the 18th Century,* 1948, no. 28 (as by Benjamin Wilson).

REFERENCES: R. H. Wilenski, *English Painting,* London, 1933, p. 73, pl. 12a (as by Benjamin Wilson); M. F. Rogers, Jr., "Gentlemen and Gentry," *Toledo Museum of Art Museum News,* III, 1960, pp. 30–1, repr. p. 32 (as by Benjamin Wilson).

Previously thought to be by Benjamin Wilson (1721–1788), the attribution of this picture to Walton has been made by Mary Webster from a photograph (letter, May 1975). The freely painted clothes, face and hair are characteristic of Walton's style, according to Miss Webster, who is completing a monograph on Zoffany, Walton's teacher.

Although the picture has been known as *The Squire's Tea,* Miss Webster believes the sitter is shown at breakfast because of the type of room, as well as the presence of a loaf of bread on the table. Dating is based on costume and accessories (Rogers); Walton also seems to have been active chiefly in the 1770s.

ANTOINE WATTEAU

1684–1721. French. Born in Valenciennes. In 1702 went to Paris, where he worked with the decorative painter Audran and the painter of theatrical scenes Claude Gillot. Student at the Académie Royale in 1709; associate in 1712; full member, 1717, as a painter of *fêtes galantes,* a category created especially for him. Watteau's Flemish heritage and admiration of Rubens are evident in the landscapes and figures in his work.

La Conversation PL. 194

[1712–15] Oil on canvas
19¾ x 24 in. (50.2 x 61 cm.)

Acc. no. 71.152

COLLECTIONS: Jean de Jullienne, Paris, by 1733—before 1756; Thomas Baring, London, by 1837—after 1857; Edouard Kann, Paris (Hôtel Drouot, Paris, June 8, 1895, lot 10); (Sedelmeyer, Paris); Henry Heugel, Paris; Jacques Heugel, Paris, until 1970; (Heim, Paris).

EXHIBITIONS: London, British Institution, 1837, no. 160; 1844, no. 121; Paris, Petit Palais, *Le paysage français de Poussin à Corot,* 1925, no. 352; Amsterdam, Rijksmuseum, *Exposition rétrospective d'art français,* 1926, no. 116; London, Royal Academy, *European Masters of the Eighteenth Century,* 1954, no. 244; Paris, Gazette des Beaux-Arts, *De Watteau à Prud'hon,* 1956, no. 92, repr.

REFERENCES: G. F. Waagen, *Galleries and Cabinets of Art in Great Britain,* London, 1857, p. 97 (probably no. 3 or 4); E. de Goncourt, *Catalogue raisonné de l'oeuvre peint, dessiné et gravé d'Antoine Watteau,* Paris, 1875, no. 123; G. Schéfer, "Les portraits dans l'oeuvre de Watteau," *Gazette des Beaux-Arts,* XVI, Dec. 1896, pp. 181–82; E. H. Zimmerman, *Watteau,* Stuttgart, 1912, p. XXV; E. Dacier and A. Vuaflart, *Jean de Jullienne et les graveurs de Watteau au XVIIIe siècle,* Paris, II, 1922, pp. 37, 51, 63, 97, 122, 130, 161; III, 1922, no. 151; E. Pilon, *Watteau et son école,* 2nd ed., Paris, 1924, p. 37; E. Dacier, *La gravure de genre et de moeurs,* Paris, 1925, p. 60; L. Réau, "Watteau," in *Les peintres français du XVIIIe siècle,* (ed. L. Dimier), Paris, 1928, I, pp. 14, 48, no. 192; H. Adhémar, *Watteau, sa vie—son oeuvre,* Paris, 1950, no. 110, pl. 55; K. T. Parker and J. Mathey, *Antoine Watteau, catalogue complet de son oeuvre dessiné,* Paris, 1957, I, nos. 51, 58; II, nos. 533, 729, 915; J. Mathey, *Antoine Watteau, peintures réapparues,* Paris, 1959, pp. 40–1, 77, pls. 94 (detail), 97; E. Camesasca, *The Complete Paintings of Watteau,* New York, 1968, no. 105, repr. p. 103.

La Conversation was engraved in 1733 by J.-M. Liotard for the *Recueil Jullienne,* a collection of prints intended as a permanent record of as many as possible of Watteau's paintings and drawings, published by Jean de Jullienne, director of the Gobelins factory, who was also a major collector of Watteau drawings and probably the first owner of this painting.

Goncourt and Mathey believed Jullienne is the seated man with the large wig. Dacier (with reservations) and Adhémar, on the other hand, identify this figure as Watteau's friend, the financier and art collector, Pierre Crozat. All generally agree, however, that the seated figure, his hand supported on a crutch, is Antoine de la Roque, collector, newspaper director and friend of Watteau, and that the figure in the center is Watteau himself. Goncourt, Dacier, Parker and Mathey, and Camesasca variously dated this painting between 1712 and 1715.

Preparatory drawings include studies of the two figures at the far left with their backs to the viewer (National Gallery, Dublin), the figure of Watteau and the seated bewigged figure (both, École des Beaux-Arts, Paris). There are also studies probably for the body (British Museum) and the head (Louvre) of the servant.

JOHANNES HENDRIK WEISSENBRUCH

1824–1903. Dutch. Born and lived in The Hague; studied at The Hague Academy. After 1875 the region around Noorden in Nieuwkoop became his chief source of subjects. Primarily a landscapist, he was a major figure of the Hague School.

The White Cloud PL. 174

[1901] Oil on canvas
24¼ x 18 in. (61.5 x 46 cm.)
Signed and dated lower left: J. H. Weissenbruch f 1901

Acc. no. 25.878

COLLECTIONS: Edward Drummond Libbey, by 1925.

Low Tide PL. 175

[Ca. 1900] Oil on canvas
31¾ x 24 in. (80.6 x 61 cm.)
Signed lower right: J. H. Weissenbruch

Acc. no. 22.29

Gift of Arthur J. Secor

COLLECTIONS: J. B. Ford; (Scott & Fowles, New York, 1914); (Vose, Boston, 1914); Arthur J. Secor, 1914–22.

Another version of this subject in the Gemeentemuseum, The Hague is dated 1901.

A Windy Day PL. 172

[Ca. 1900] Oil on canvas
19½ x 33½ in. (49.5 x 85 cm.)
Signed lower right: J. H. Weissenbruch f

Acc. no. 25.46

COLLECTIONS: J. J. Tiele, Rotterdam (?); (Holland Art Galleries, Amsterdam); Edward Drummond Libbey, 1903–25.

REFERENCES: W. J. de Gruyter, *De Haagse School,* I, Rotterdam, 1968, p. 114, repr. no. 79.

SIR DAVID WILKIE

1785–1841. British. Born near Edinburgh. Studied at the Edinburgh Academy, 1799 and in London at the Royal

Academy, 1805. For twenty years his work reflected the influence of 17th century Dutch genre painting. A.R.A., 1809; R.A., 1811; he exhibited there regularly 1806–42. Went to Paris in 1814 to see the pictures looted by Napoleon, and spent 1825–28 in Italy, Austria, Germany and Spain. This experience of Italian and Spanish art led him to a new, broader style. Named Painter in Ordinary to the King, 1830; knighted, 1836. Visited the Near East 1840–41 and died on the return voyage. Early specialization in genre subjects gave way to portraiture and history painting in his later work.

William IV, King of England

PL. 330

[Ca. 1833] Oil on canvas
52⅛ x 42⅛ in. (132.4 x 107 cm.)

Acc. no. 23.3156

Gift of Arthur J. Secor

COLLECTIONS: Wilkie sale (Christie, London, Apr. 25, 1842, lot 656) (?); (Sulley, London); (T. J. Blakeslee sale, American Art Association Galleries, New York, Apr. 22, 1915, lot 226); W. Seamon; (Vose, Boston, by 1921–23); Arthur J. Secor.

REFERENCES: H. Vollmer, in *Thieme-Becker*, 1947, XXXVI, p. 4; O. Millar, *The Later Georgian Pictures in the Collection of Her Majesty the Queen*, London, 1969, in no. 1185, cf. p. xi.

This is a version of the full-length portrait of William IV (reigned 1830–37) painted in 1832 for the Waterloo Chamber at Windsor Castle, where it still is. He is shown in the robes of the Order of the Garter, wearing the collar of the order with its pendant St. George insignia and that of the Order of the Bath with pendant cross. This version, in Millar's opinion perhaps the best of five copies known, may be the one in Wilkie's possession at his death. It was probably painted in 1833, when the artist made two copies of a portrait of the King. According to Millar, the head is, in fact, closer to the full-length in military uniform (Wellington Museum, Apsley House, London) painted that year than to the Windsor portrait.

The Toledo canvas was cut down to three-quarter length some time between 1905 and 1915. According to Malcolm Stearns (letter, Oct. 1956), this portrait and a companion portrait of Queen Adelaide (private collection, Dallas, Texas in 1941), each measured 106¼ x 70 inches when acquired by the dealer Sulley about 1900; both had their present dimensions in the 1915 Blakeslee sale.

Millar (no. 1185) gives a comprehensive discussion of the Windsor portrait, versions of it, and related drawings and oil sketches, as well as portraits of the king by Wilkie in other formats. The full-length oil sketch, now lost, was in the Wilkie sale of Apr. 30, 1842 (lot 620).

RICHARD WILSON

1713/14–1782. British. Son of a Welsh clergyman, he was at first a portraitist. After a stay in Italy 1750–57, he devoted himself to landscape, inspired by the classical style of Claude Lorrain and Gaspar Poussin. The advice of Francesco Zuccarelli in Venice and Joseph Vernet in Rome influenced his decision to become a landscape painter. He was a founding member of the Royal Academy in 1768. After a brief period of popularity, his fortunes declined and he died in obscurity.

The White Monk

PL. 317

Oil on canvas
26 x 31½ in. (66 x 80 cm.)
Signed lower left (on boulder): W

Acc. no. 58.38

COLLECTIONS: Sir C. Robinson ?; Lord Poltimore ?; James Orrock; 1st Viscount Leverhulme; Lady Lever Art Gallery, Port Sunlight, Cheshire; (Agnew, London).

EXHIBITIONS: London, National Gallery, Millbank (Tate Gallery), *Loan Exhibition of Works by Richard Wilson*, 1925, no. 29; Manchester, City Art Gallery, *Richard Wilson Loan Exhibition*, 1925, no. 63; Birmingham, City Museum and Art Gallery, *Richard Wilson and his Circle*, 1948, no. 57 (revised edition of catalogue, London, Tate Gallery, 1949, no. 56; incorrect size in both catalogues).

REFERENCES: R. R. Tatlock, *English Painting of the XVIIIth–XXth Centuries . . . A Record of the Collection in the Lady Lever Art Gallery, Port Sunlight formed by the first Viscount Leverhulme*, London, 1928, p. 69, no. 627, pl. 44; A. Bury, *Richard Wilson, R.A., The Grand Classic*, Leigh-on-Sea, 1947, p. 68; W. G. Constable, *Richard Wilson*, Cambridge, 1953, pp. 119, 227 I(1), pl. 122a.

Wilson often repeated his compositions, and among the more than 30 variations of *The White Monk* the Toledo picture is notable as especially highly finished. As he seldom dated paintings, it is difficult to order these variations chronologically. Although the composition was inspired by the landscape of Italy, all the known versions were done after Wilson returned to England in 1757. The title is a traditional one, and was apparently not used by Wilson himself.

JACOB DE WIT

1695–1754. Dutch. Born in Amsterdam of Catholic parents and studied there with Albert van Spiers. Moved to Antwerp in 1708, living with his uncle, a wine merchant and art collector, and studying with Jacob van Hal. He was greatly influenced by the work of Van Dyck and Rubens, and in 1711–12 made drawings of Rubens' ceiling decorations in the Jesuit church at Antwerp. In 1716 De Wit returned to Amsterdam, where he soon gained recognition for ceiling and wall decorations and religious paintings.

Zephyr and Flora PL. 146

[1723] Oil on canvas
20 x 24⅜ in. (50.8 x 61.8 cm.)
Inscribed: J D Wit Invt Ft/1723 (JD in monogram)

Acc. no. 74.43

COLLECTIONS: Mrs. P. M. Simpson (Sotheby, London, July 1973, lot 119); (Herner Wengraf, London); (Nystad, The Hague).

REFERENCES: R. Mandle, "A Ceiling Sketch by Jacob de Wit," *Toledo Museum of Art Museum News*, XVIII, No. 1, 1975, pp. 3–18, fig. 5 and cover (detail).

This was the presentation modello for a ceiling painting commissioned by Jan de Surmout and his bride, Margaretha Catherina Cromhout, for their house at Amstel 216, Amsterdam. Flora, goddess of flowers, is shown in the heavens gesturing to her husband Zephyr, one of the mythical winds. De Wit's own handwriting on a preparatory drawing in the Kupferstichkabinett, Berlin (Mandle, fig. 4), indicates that this design was executed in 1723 as a ceiling painting for Surmout (E. Bock and J. Rosenberg, *Staatliche Museen zu Berlin: Die Niederländischen Meister*, Frankfurt, 1931, I, no. 14577). The house is now a bank, and as far as is presently known the ceiling decoration no longer exists.

CHRISTOPHER WOOD

1901–1930. British. Born near Liverpool. Went to Paris in 1920 where he studied at the Académie Julian and the Grande Chaumière. He was influenced by Picasso and Cocteau. Designed costumes and scenery for the theater, including work for Diaghilev.

Drying Nets, Tréboul Harbor PL. 346

[1930] Oil on board
31¼ x 43⅛ in. (79.5 x 109.5 cm.)

Acc. no. 49.160

COLLECTIONS: Mrs. Lucius Wood, the artist's mother; (Redfern Gallery, London).

EXHIBITIONS: London, New Burlington Galleries, *Christopher Wood: Exhibition of Complete Works*, 1938, no. 175; Philadelphia, Pennsylvania Academy of the Fine Arts, *Contemporary British Painting, 1925–1950*, 1950, no. 88.

REFERENCES: E. Newton, intro., *Christopher Wood, 1901–1930*, London, 1938, no. 385, repr. p. 59; E. Newton, *Christopher Wood*, London, 1959, pp. 16, 17, pl. 15.

Wood spent most of the last year of his life at Tréboul, a fishing port in Brittany. According to R. de C. Nan Kivell (letter, Sep. 1949) this picture was done in June or July 1930, and is among Wood's last paintings.

FELIX ZIEM

1821–1911. French. Born in Beaune. Studied architecture at the École des Beaux-Arts, Dijon, in 1839. Traveled to Italy and Russia in the 1840s. Influenced early in career by Dutch and Barbizon landscapists. Settled in Paris in 1848, and exhibited at Salon 1849–68 and again from 1878. In Venice and south of France annually from 1845 until his death. Specialized in views of Venice.

Venice, Early Morning PL. 271

Oil on canvas
29½ x 42¼ in. (74.9 x 108.5 cm.)
Signed lower left: Ziem

Acc. no. 22.49

Gift of Arthur J. Secor

COLLECTIONS: (Knoedler, New York, by 1899); Dr. L. D. Ward, Newark, 1899–1911 (American Art Galleries, New York, Jan. 13, 1911, lot 68); Arthur J. Secor.

Venice, The Grand Canal PL. 272

Oil on wood panel
24¾ x 37⅝ in. (62.8 x 95.6 cm.)
Signed lower right: Ziem

Acc. no. 30.4

Gift of Jefferson D. Robinson

COLLECTIONS: Mrs. E. M. White, Cleveland; (Felix Gerard Fils, Paris); (Vose, Boston); Jefferson D. Robinson, Toledo, 1916–30.

FRANCISCO DE ZURBARÁN

1598–1664. Spanish. Born in Badajoz province. In 1614 apprenticed to a painter in Seville. Earliest dated work is of 1616. His style shows some Italian influence and knowledge of the work of Ribera and Velázquez. Lived in Llerna 1617–28. In 1629 he settled in Seville, where he and his assistants carried out many large commissions for churches and religious orders. In 1634 he was in Madrid, where he painted ten Labors of Hercules for the Palace of Buen Retiro. Lived in Madrid from 1658 until his death.

The Return from Egypt PL. 56

[Ca. 1640] Oil on canvas
75⅝ x 97⅝ in. (192.1 x 247.9 cm.)

Acc. no. 21.3133

COLLECTIONS: 4th Earl of Clarendon, British ambassador in Madrid, 1833–39, and descendants, The Grove, Watford, 1830s (Christie, London, Feb. 13, 1920, lot 119, as *The Flight into Egypt*); (Scott & Fowles, New York); Edward Drummond Libbey.

EXHIBITIONS: London, British Institution, 1856; New York, Metropolitan Museum of Art, *Spanish Paintings from El Greco to Goya*, 1928, no. 66, repr. (as *The Flight into Egypt*); Toledo Museum of Art, *Spanish Painting*, 1941, p. 108, no. 68, repr. (cat. by J. Gudiol).

REFERENCES: G. F. Waagen, *Treasures of Art in Great Britain*, London, 1854, II, p. 458 (as *Flight into Egypt*); A. L. Mayer, *La pintura española*, 2nd ed., Barcelona, 1929, p. 165, pl. XLI; M. S. Soria, "Francisco de Zurbarán, A Study of his Style—II," *Gazette des Beaux-Arts*, XXV, 1944, p. 158; M. S. Soria, "Zurbarán, Right and Wrong," *Art in America*, XXXII, July 1944, p. 134, fig. 7;

W. E. Suida, *A Catalogue of Paintings in the John and Mabel Ringling Museum of Art*, Sarasota, 1949, p. 281 (as a studio replica); L. Réau, *Iconographie de l'art chrétien*, Paris, 1957, II, pt. 2, p. 275, n. 1; J. A. Gaya Nuño, *La pintura española fuera de España*, Madrid, 1958, no. 2207; P. Guinard, *Zurbarán et les peintures espagnols de la vie monastique*, Paris, 1960, no. 45, repr. (as *La Sainte Famille quittant l'Egypte*); M. F. Rogers, "Spanish Painting in the Museum Collection," *Toledo Museum of Art Museum News*, X, Summer 1967, p. 32, repr. (as *Flight into Egypt*); M. Gregori and T. Frati, *L'opera completa di Zurbarán*, Milan, 1973, no. 550 (as Zurbarán follower after a lost autograph work).

The subject of this picture was long considered to be the Flight into Egypt (Matthew II:13–15), and according to Réau, it shows Mary's farewell to her family and friends. The age of the Christ Child, however, has led other scholars (Suida, Guinard) to believe that it represents instead the departure of the Holy Family from Egypt for Galilee (Matthew II:20–21), a subject rarely represented.

This painting has been attributed to Zurbarán's assistants, the brothers Francisco and Miguel Polanco (Soria, 1943, 1944), and to Zurbarán's studio (Suida). According to Guinard, it may have been painted by a pupil strongly inspired by Zurbarán. Both he and Soria noted similarities in the figures and style to the *Adoration of the Magi* (1638) and *Circumcision* (1639; both Musée des Beaux Arts, Grenoble, France), and Guinard believes the Toledo painting was done ca. 1640. Zurbarán's style developed slowly and it is difficult to place undated works with any real precision.

A workshop repetition of the upper left quarter of the Toledo painting is in the Ringling Museum of Art, Sarasota, Florida.

Plates

ITALY

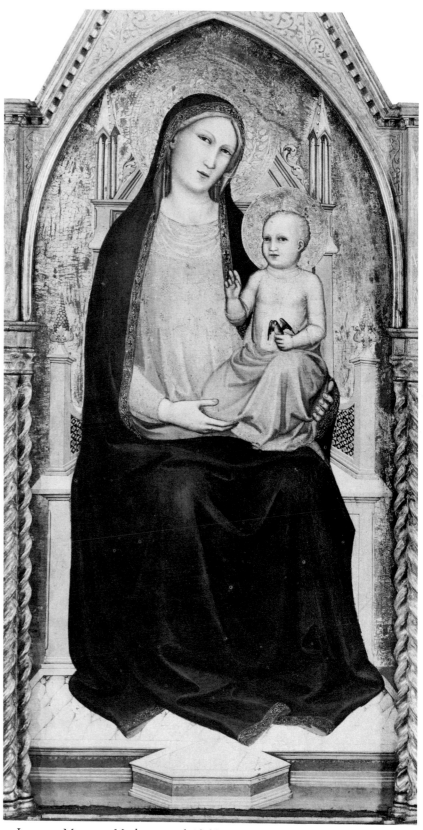

1. Lorenzo Monaco, *Madonna and Child*

2. Italian, Central,
 Virgin and Child Enthroned

3. Workshop of Lorenzo Monaco, *Madonna and Child*

4. Andrea di Bartolo, *The Crucifixion*

5. Pesellino, *Madonna and Child with Saint John*

6. Piero di Cosimo,
The Adoration of the Child

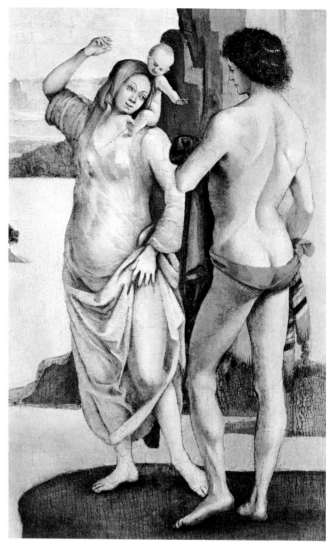

7a. Luca Signorelli, *Figures in a Landscape*
(*Two Nude Youths*)

7b. Luca Signorelli, *Figures in a Landscape*
(*Man, Woman and Child*)

8. Italian, Florentine School,
The Adoration of the Child

9. Italian, Venice (?),
Saint Jerome in the Wilderness

10. Giovanni Bellini, *Christ Carrying the Cross*

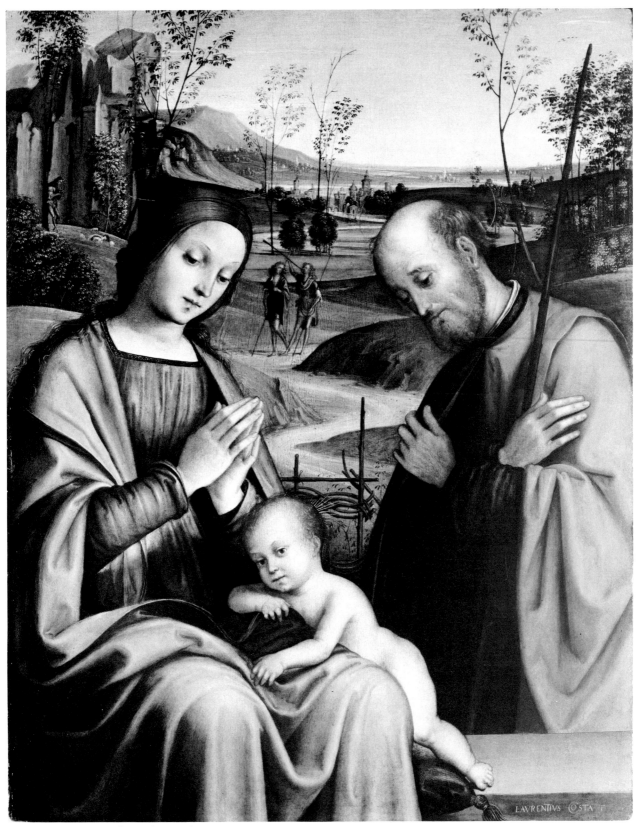

11. Lorenzo Costa, *The Holy Family*

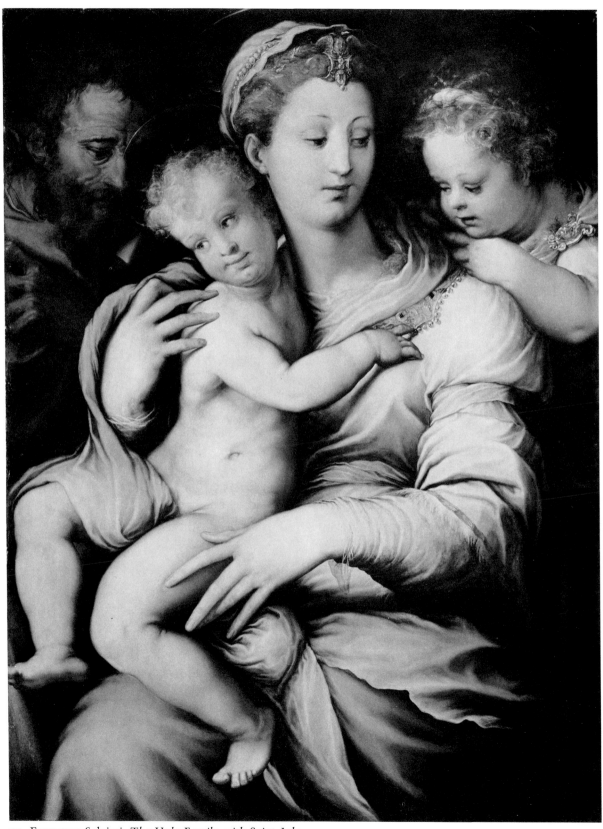

12. Francesco Salviati, *The Holy Family with Saint John*

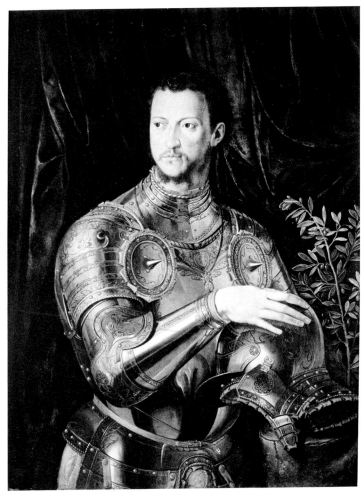

13. Agnolo Bronzino, *Cosimo I de'Medici*

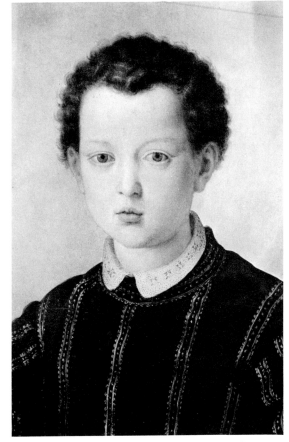

14. Agnolo Bronzino, *Don Giovanni de'Medici*

15. Francesco Primaticcio, *Ulysses and Penelope*

16. Jacopo Tintoretto, *Noli Me Tangere*

17. Paolo Veronese, *Christ and the Centurion*

18. Guido Reni, *Venus and Cupid*

19. Pietro da Cortona, *The Virgin with a Camaldolese Saint*

20. Mattia Preti, *The Feast of Herod*

21. Style of Salvator Rosa,
Hagar and the Angel

22. Luca Giordano,
*The Rest on the
Flight into Egypt*

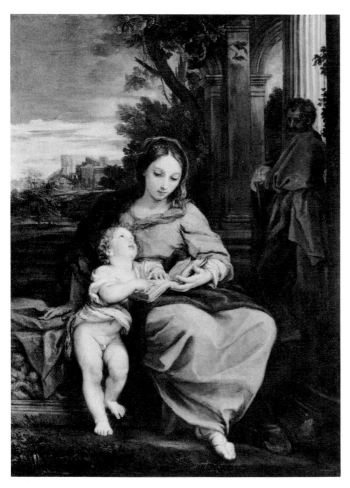

23. Carlo Maratti, *Holy Family*

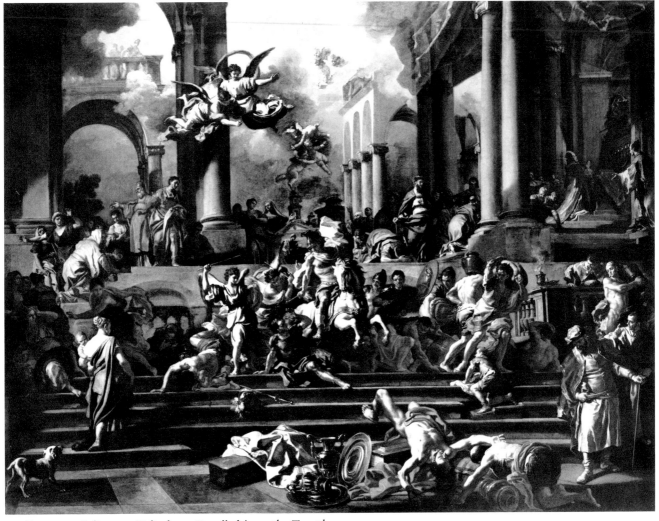

24. Francesco Solimena, *Heliodorus Expelled from the Temple*

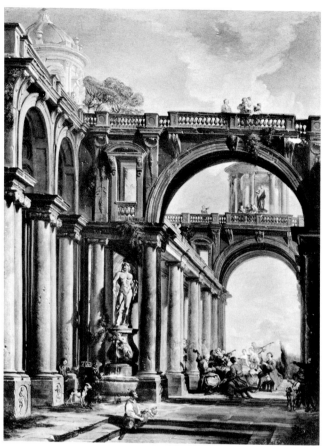

25. Giovanni Paolo Pannini, *Architectural Fantasy with a Concert Party*

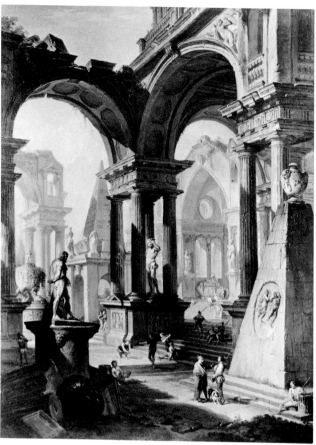

26. Giovanni Paolo Pannini, *Ruins with the Farnese Hercules*

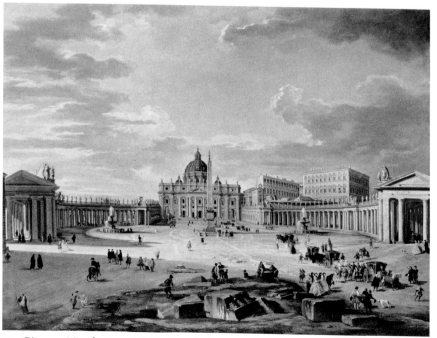

27. Giovanni Paolo Pannini, *St. Peter's Square, Rome*

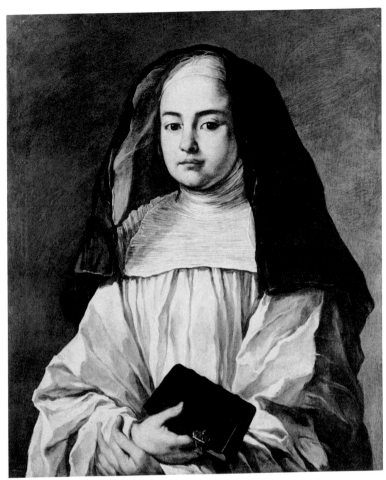

28. Pier Leone Ghezzi, *An Augustinian Nun*

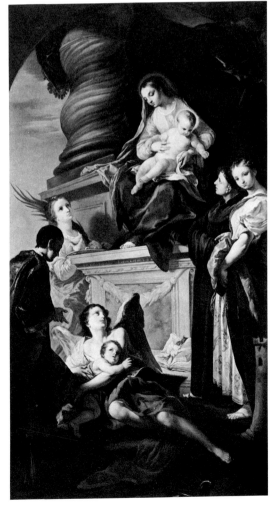

29. Giambettino Cignaroli,
Madonna and Child with Saints

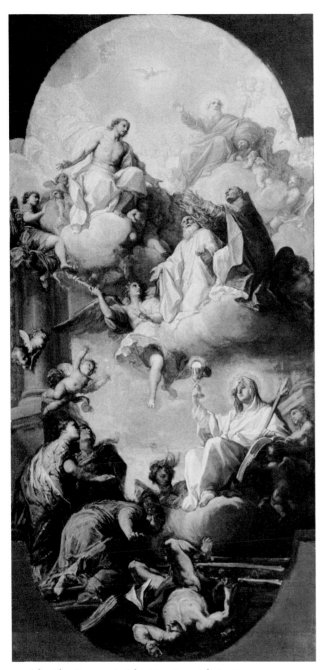

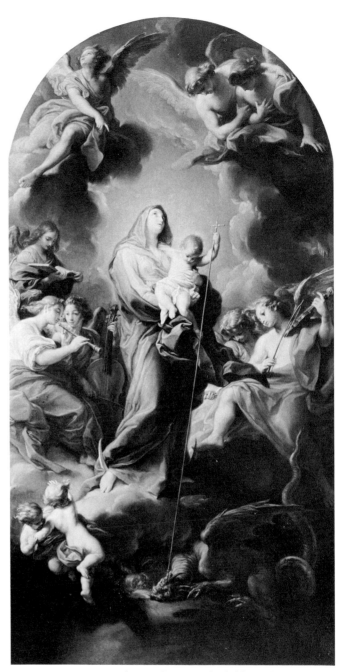

30. Placido Costanzi, *The Trinity with Saints Gregory and Romuald*

31. Pompeo Batoni, *The Madonna and Child in Glory*

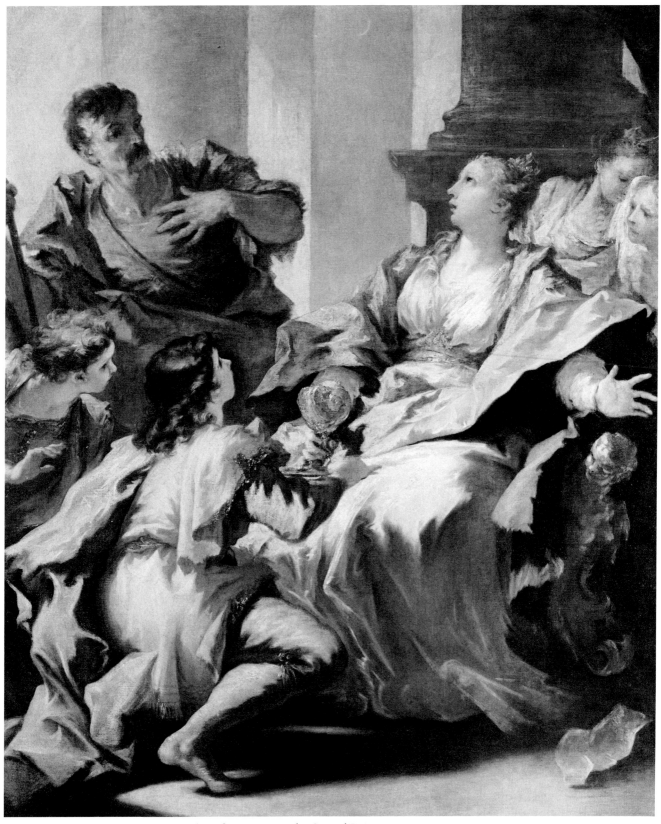

32. Giovanni Antonio Pellegrini, *Sophonisba Receiving the Cup of Poison*

33. Sebastiano Ricci, *Saint Paul Preaching*

34. Sebastiano Ricci, *Christ and the Woman of Samaria*

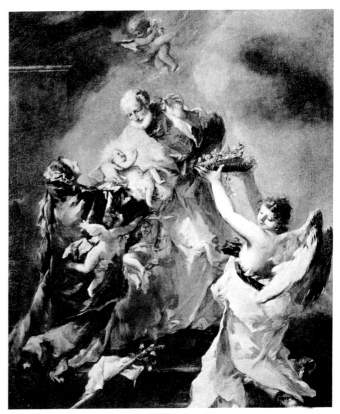

35. Francesco Guardi, *The Holy Family*

36. Francesco Guardi, *San Giorgio Maggiore, Venice*

37. Canaletto, *View of the Riva degli Schiavoni*

38. Giovanni Domenico Tiepolo, *Head of an Old Man*

39. Alessandro Longhi, *Giacomo Casanova*

40. Amedeo Modigliani, *Paul Guillaume*

41. Giorgio de Chirico,
Self-Portrait

42. Giorgio Morandi,
Still Life with a Bottle

43. Bruno Cassinari, *Still Life*

44. Mario Sironi, *Composition*

SPAIN

45. Master of the Last Judgment, *Saints James and Philip*

46. Spanish, Catalonia, *Saint John*

47. Juan de Sevilla, *Retable of Saint Andrew and Saint Antonin of Pamiers*

48. Master of Geria, *Retable of Saint Andrew*

49. Fernando Gallego, *The Adoration of the Magi*

50. Master of Ávila, *The Adoration of the Magi*

51. Master of Játiva, *The Adoration of the Magi*

52a. Attributed to Juan Rodríguez de Solís,
The Stoning of Saint Stephen

52b. Attributed to Juan Rodríguez de Solís,
The Burial of Saint Stephen

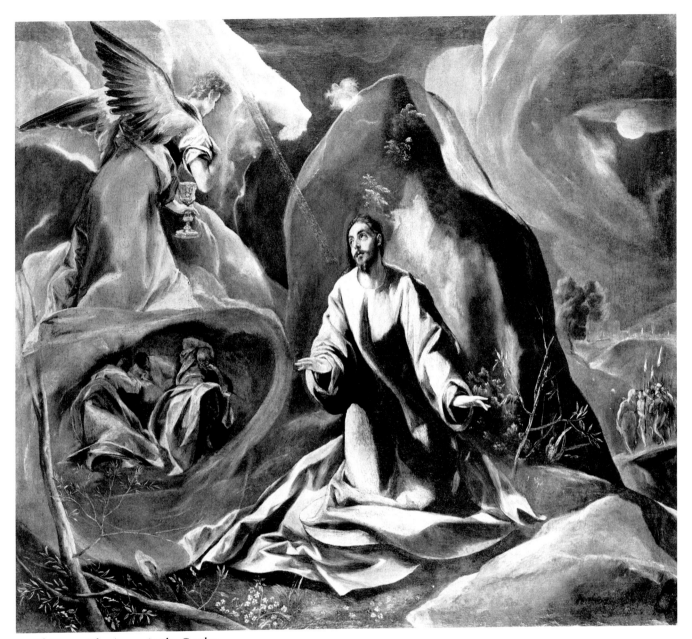

53. El Greco, *The Agony in the Garden*

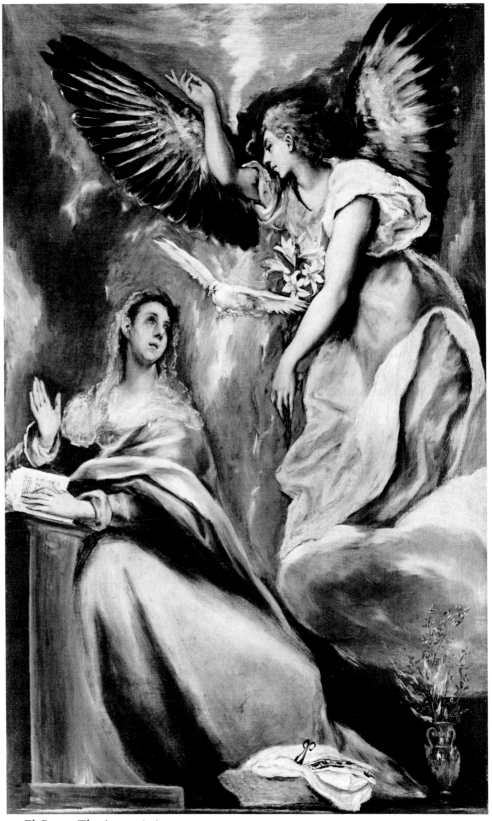

54. El Greco, *The Annunciation*

55. Attributed to Diego Velázquez, *Man with a Wine Glass*

56. Francisco de Zurbarán,
The Return from Egypt

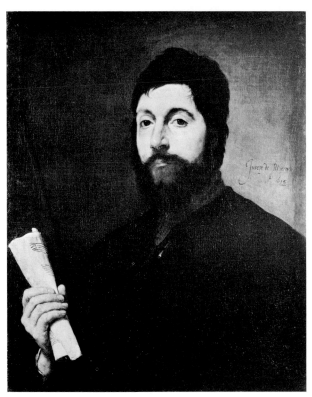

57. Jusepe de Ribera, *Giovanni Maria Trabaci,
Choir Master, Court of Naples*

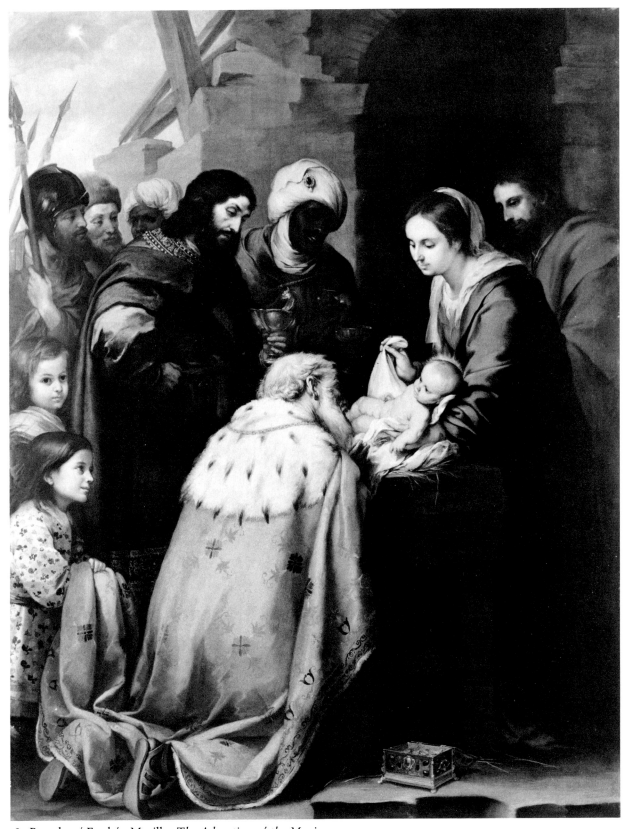

58. Bartolomé Estebán Murillo, *The Adoration of the Magi*

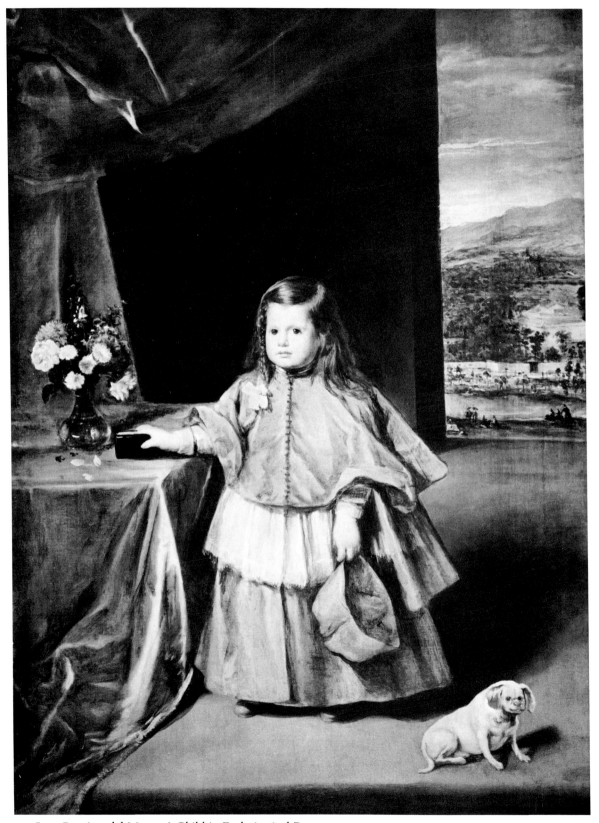

59. Juan Bautista del Mazo, *A Child in Ecclesiastical Dress*

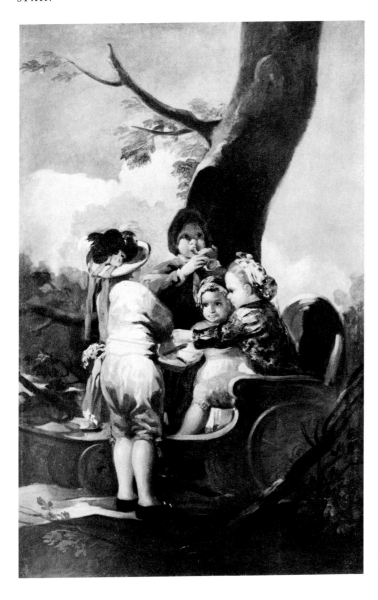

60. Francisco de Goya,
 Children with a Cart

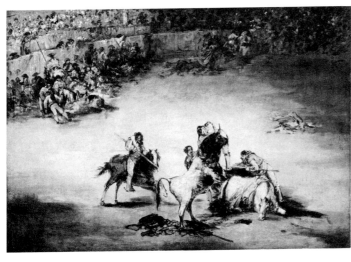

61. Attributed to Francisco de Goya,
 The Bullfight

GERMANY

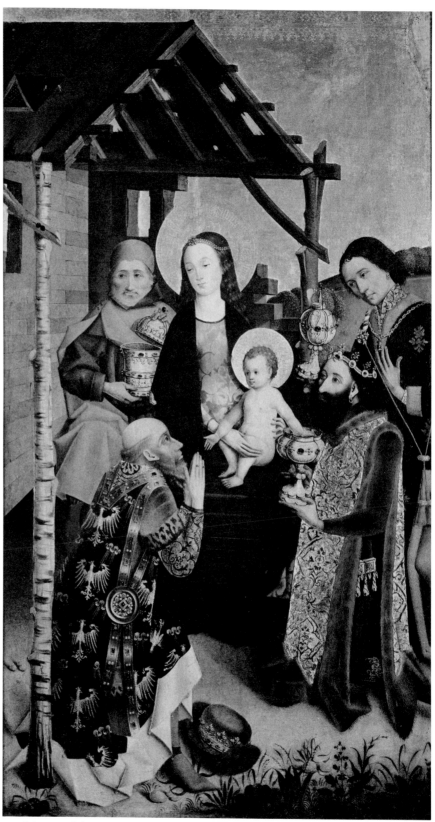

62. Master of the Vision of Saint John, *The Adoration of the Magi*

63a. *The Agony in the Garden; A Prophet*

63b. *The Flagellation of Christ; A Prophet*

63. Valentin Lendenstreich, *Wings of the Wüllersleben Triptych*, a-b verso, c-d recto

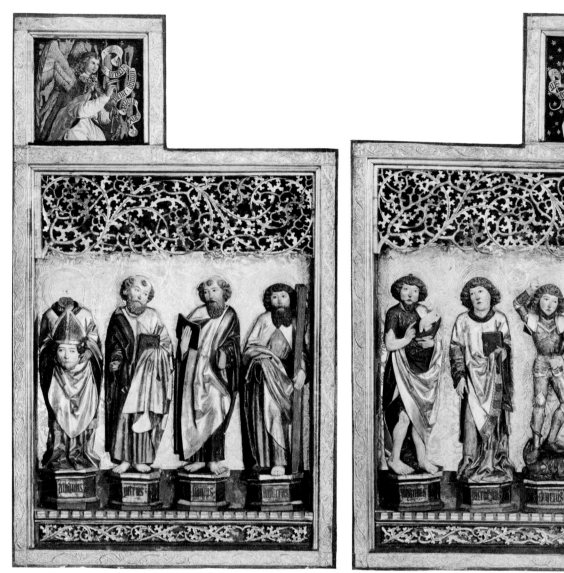

63c. *Saints Alban of Mainz, Peter, Paul and Andrew;*
Angel Annunciate

63d. *Saints John the Baptist, Lawrence, George and*
Nicholas of Bari; Virgin Annunciate

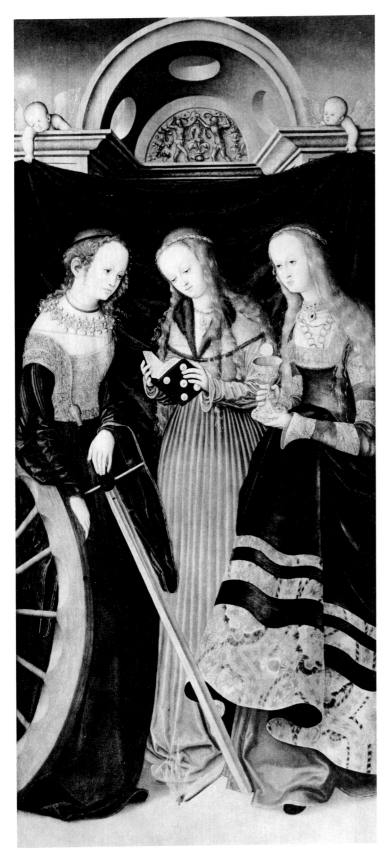

64. Lucas Cranach the Elder,
 Saints Catherine, Margaret and Barbara

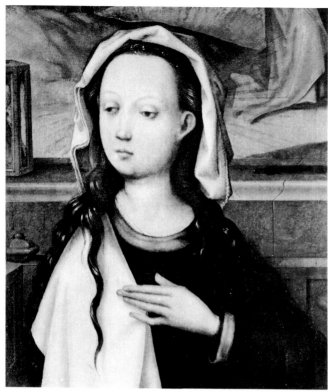

65. Hans Holbein the Elder, *Head of the Virgin*

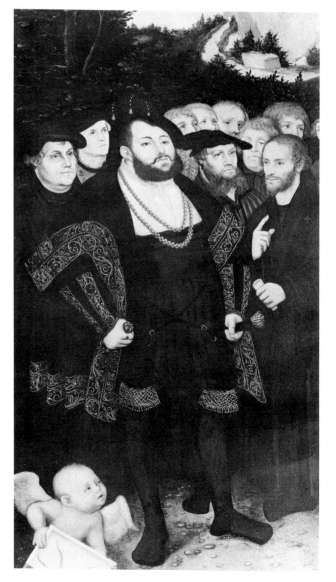

66. Lucas Cranach the Younger,
*Martin Luther and the Wittenberg
Reformers*

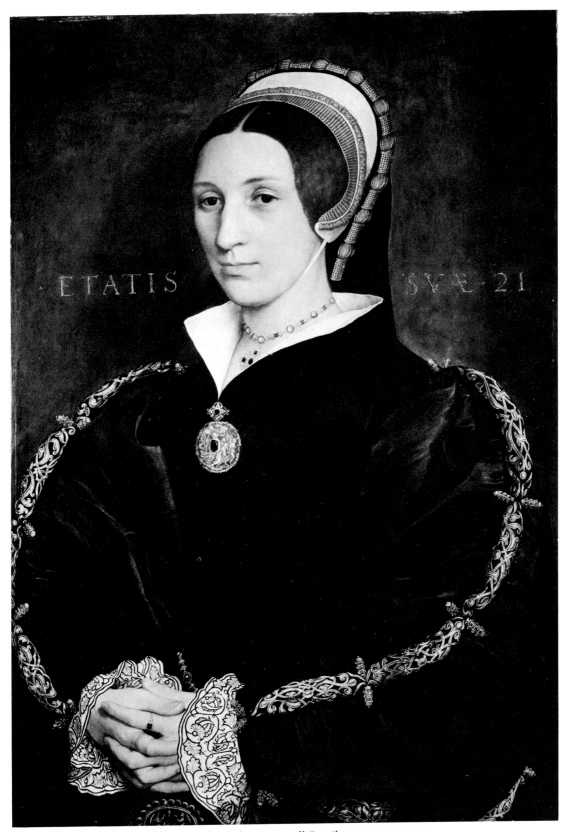

67. Hans Holbein the Younger, *A Lady of the Cromwell Family*

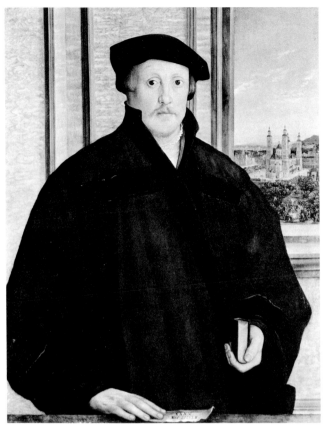

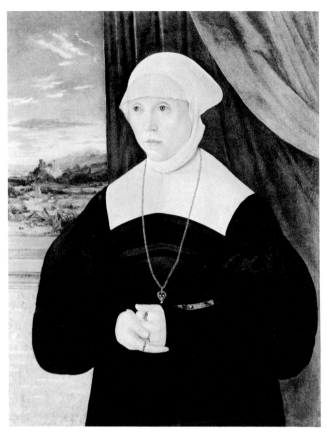

68. Hans Muelich, *Portrait of a Man*

69. Hans Muelich, *Portrait of a Woman*

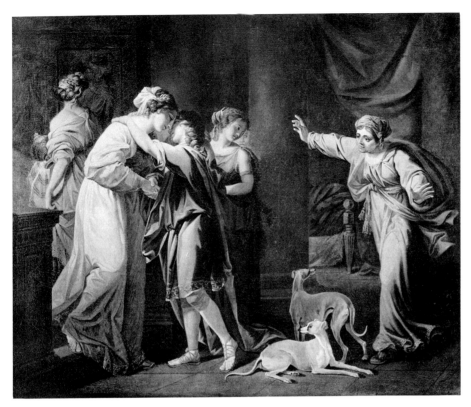

70. Angelica Kauffmann,
The Return of Telemachus

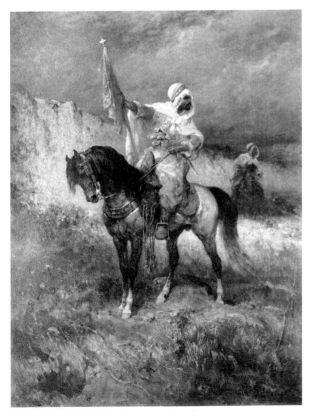

71. Adolph Schreyer, *The Standard Bearer*

72. Adolph Schreyer, *The Wallachian Team*

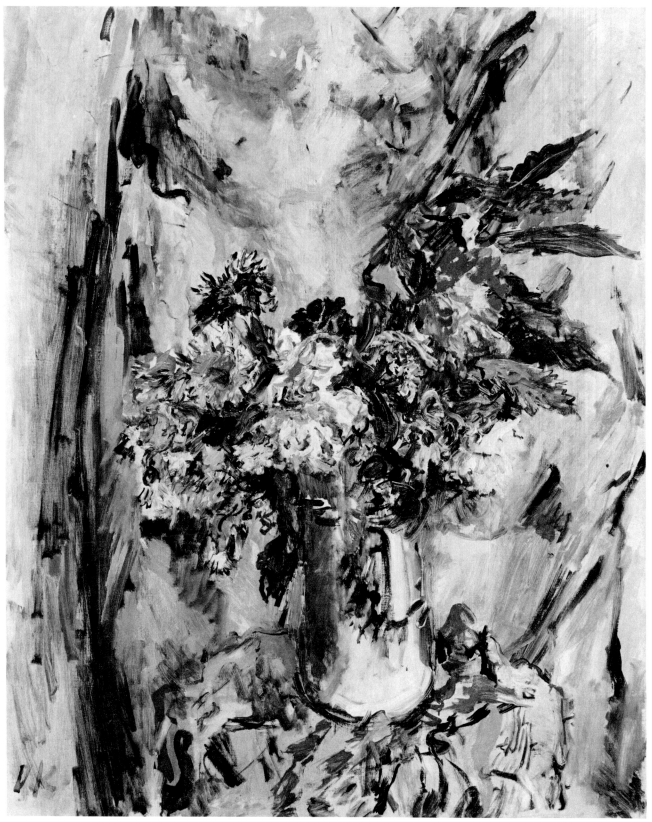

73. Oskar Kokoschka, *Autumn Flowers*

74. Franz von Stuck,
The Artist's Daughter

75. Max Pechstein, *Still Life with Calla Lilies*

76. Karl Hofer, *Flower Girl*

NETHERLANDS

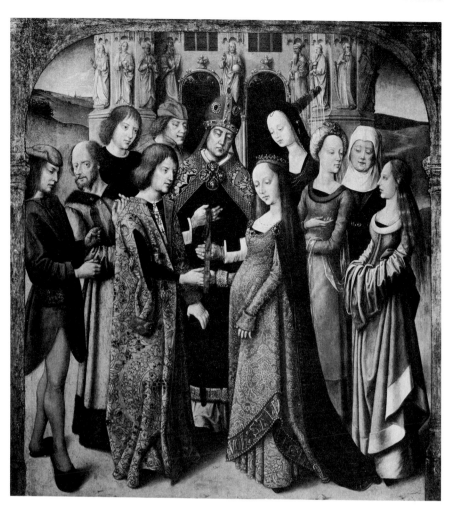

77. Flemish, Anonymous,
Marriage of a Saint

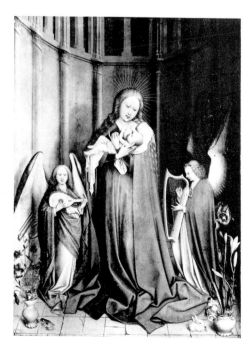

78. Copy after Robert Campin,
The Virgin in an Apse

79a. *Adam*

79b. *Eve*

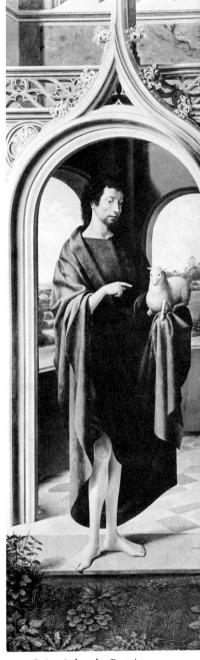

79c. *Saint John the Baptist*

79. Master of the Morrison Triptych, *The Morrison Triptych*, a-b verso, c-e recto

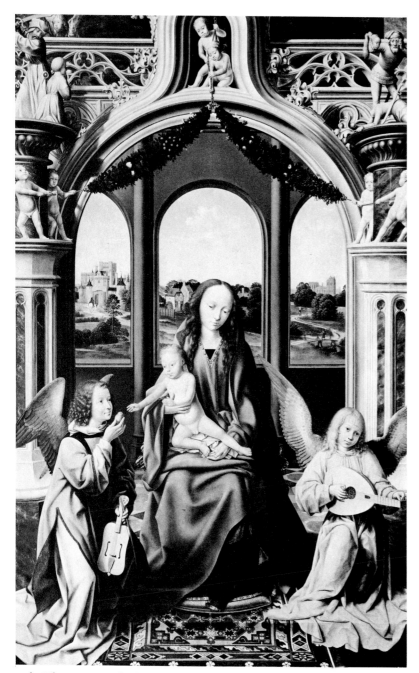

79d. *The Virgin and Child with Angels*

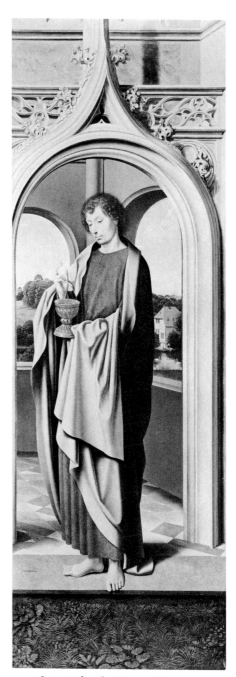

79e. *Saint John the Evangelist*

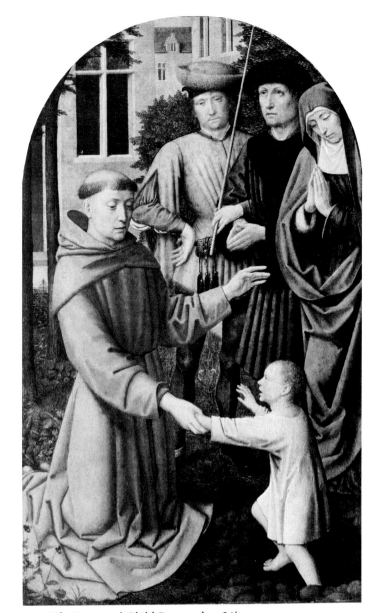

81a. *The Drowned Child Restored to Life*

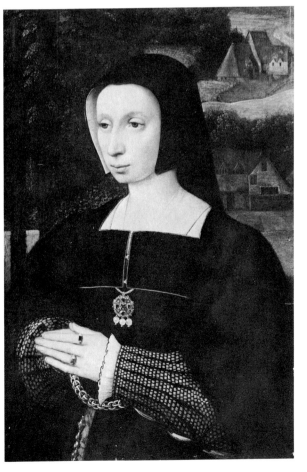

80. Ambrosius Benson,
 Portrait of a Woman

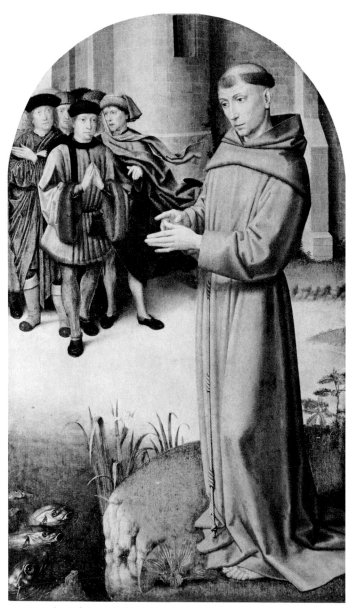

81b. *The Mule Kneeling Before the Host*

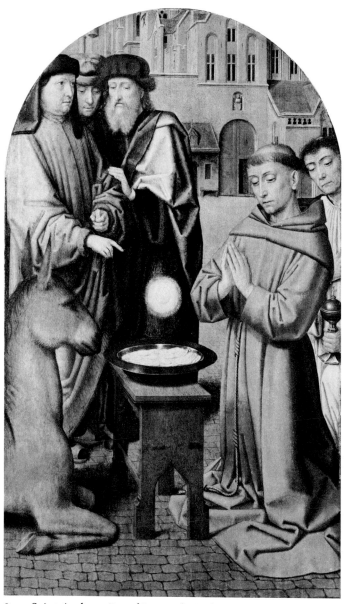

81c. *Saint Anthony Preaching to the Fishes*

81. Gerard David, *Three Miracles of Saint Anthony of Padua*

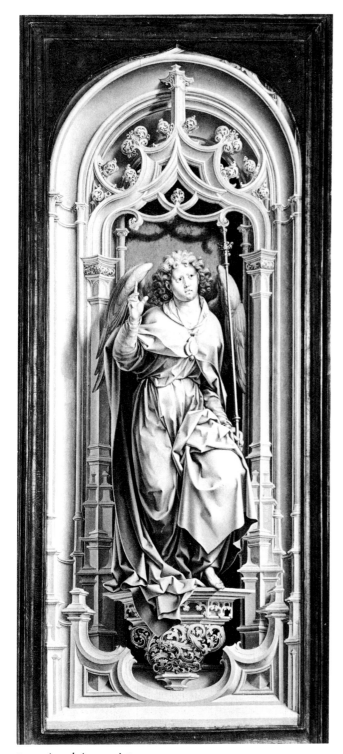

82a. *Angel Annunciate*

82b. *Virgin Annunciate*

82. Jan Gossaert, *Wings of the Salamanca Triptych,* a-b verso, c-d recto

82c. *Saint John the Baptist*

82d. *Saint Peter*

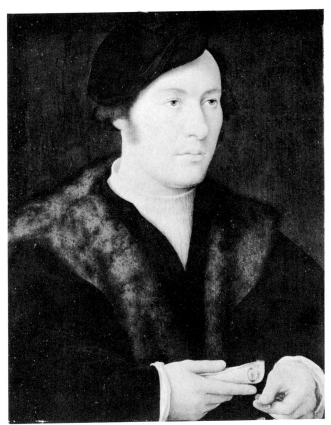

83. Joos van Cleve, *Portrait of a Man*

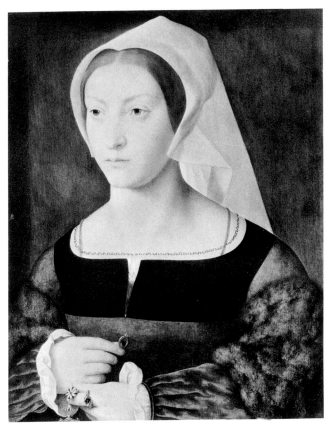

84. Joos van Cleve, *Portrait of a Woman*

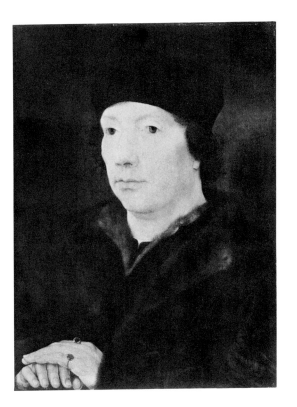

85. Jan Gossaert,
Jean de Carondelet

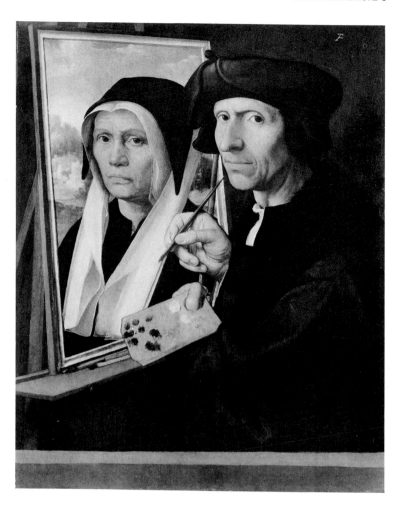

86. Jacob Cornelisz. van Oostsaanen,
*The Artist with a Portrait
of his Wife*

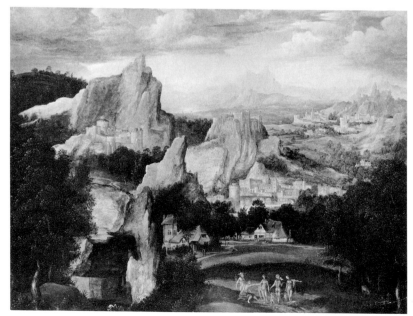

87. Cornelis Massys, *Landscape with the Judgment of Paris*

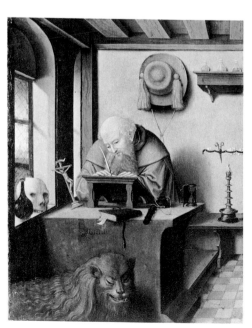

88. Flemish, Anonymous, *Saint Jerome in his
Study*

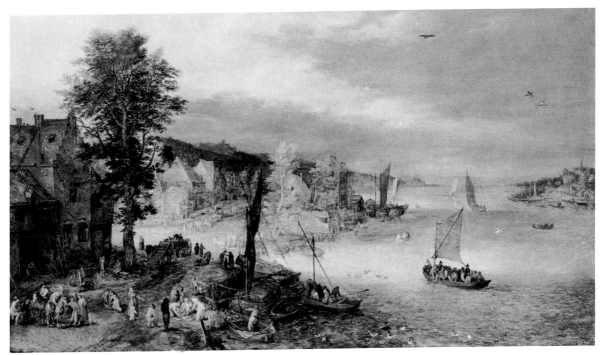

89. Jan Brueghel the Elder, *Landscape with a Fishing Village*

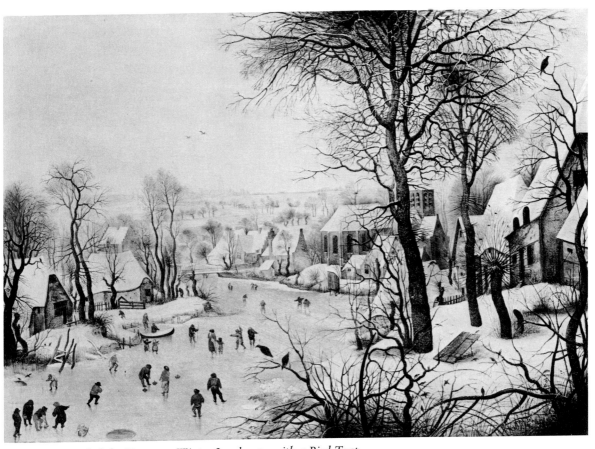

90. Pieter Brueghel the Younger, *Winter Landscape with a Bird Trap*

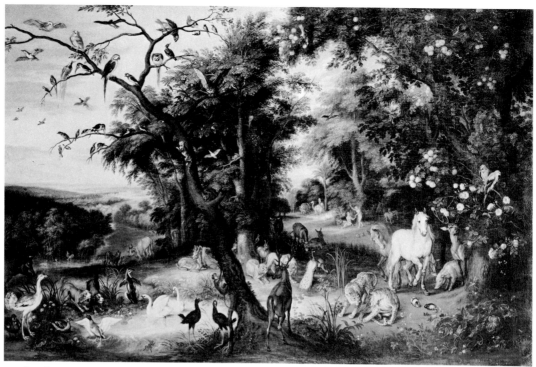

91. Isaak van Oosten, *The Garden of Eden*

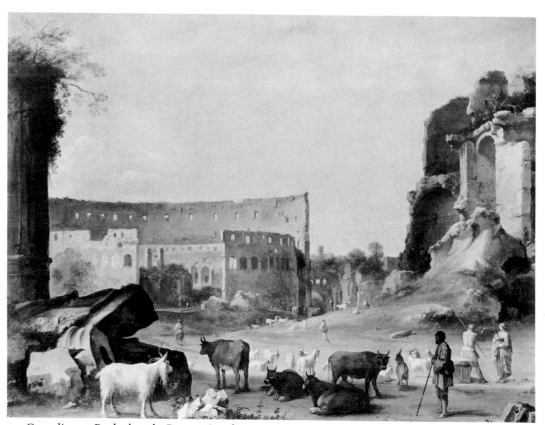

92. Cornelis van Poelenburgh, *Roman Landscape*

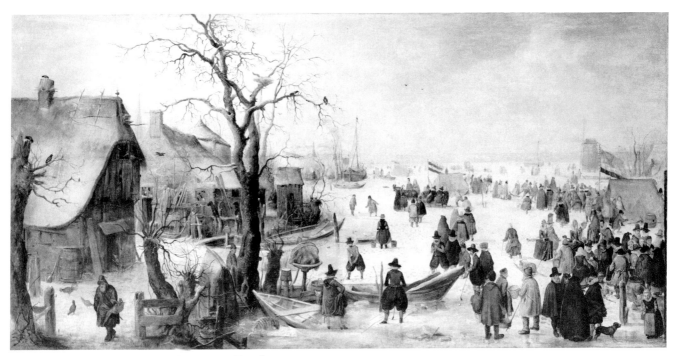

93. Hendrik Avercamp, *Winter Scene on a Canal*

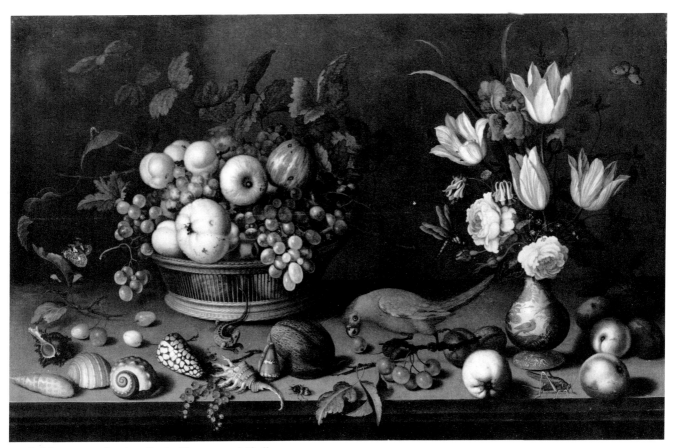

94. Balthasar van der Ast, *Fruit, Flowers and Shells*

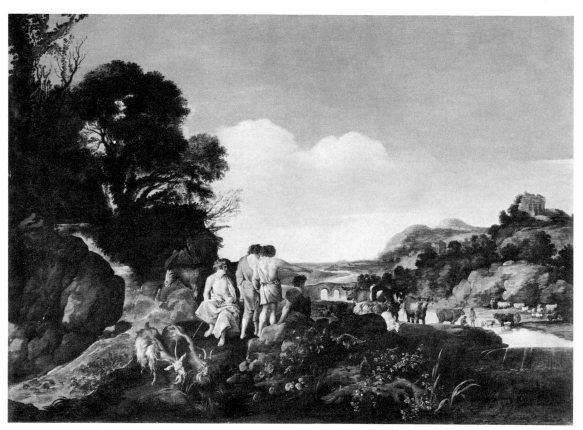

95. Moyses van Uyttenbroeck, *Landscape with Shepherds*

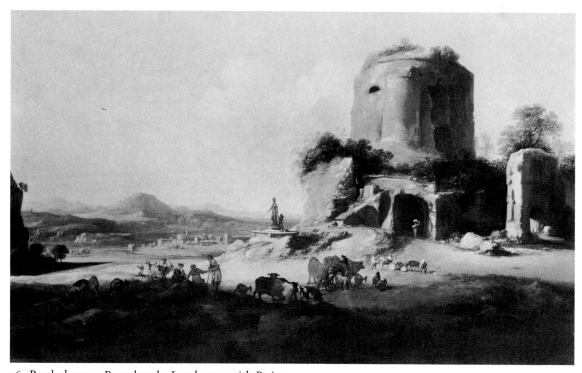

96. Bartholomeus Breenbergh, *Landscape with Ruins*

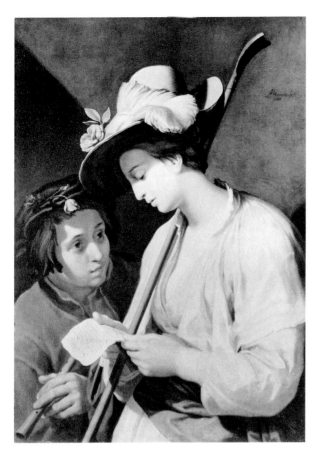

97. Abraham Bloemaert,
Shepherdess Reading a Sonnet

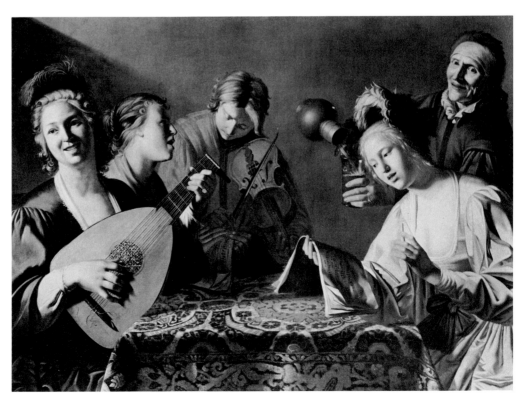

98. Follower of
Gerrit van Honthorst,
A Musical Party

99. Thomas de Keyser, *The Syndics of the Amsterdam Goldsmiths Guild*

100. Rembrandt van Rijn, *Young Man with Plumed Hat*

101. Bartholomeus van der Helst, *Portrait of a Young Man*

102. Peter Paul Rubens, *The Crowning of Saint Catherine*

103. Anthony van Dyck, *Portrait of a Man*

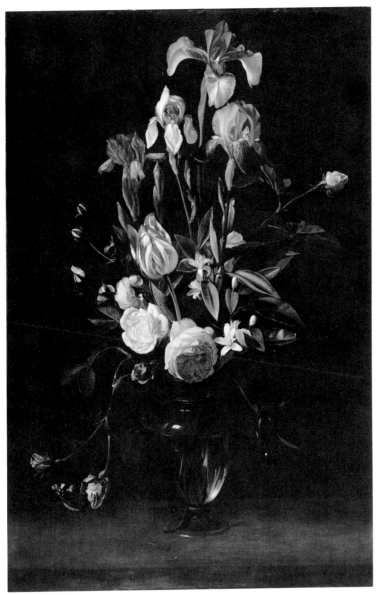

104. Daniel Seghers, *Flowers in a Glass Vase*

105. Follower of Peter Paul Rubens,
*Holy Family with Saint Elizabeth
and Saint John*

106. Aert van der Neer,
Arrival of the Guests

107. Aert van der Neer,
Approaching the Bridge

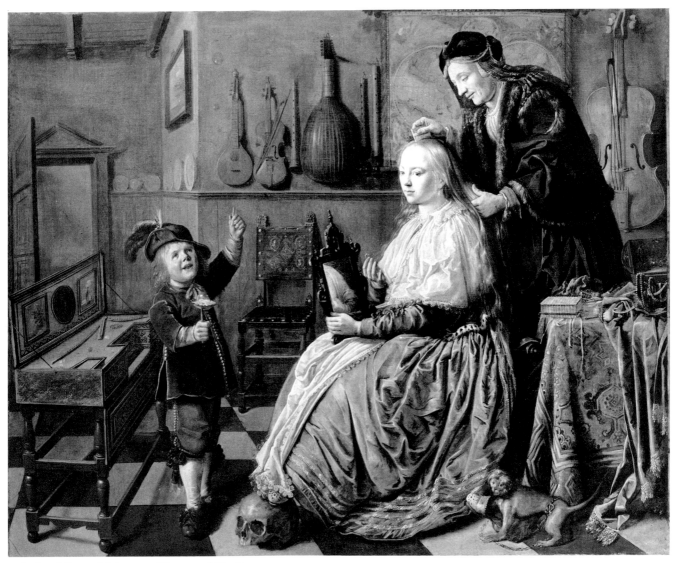

108. Jan Miense Molenaer, *Allegory of Vanity*

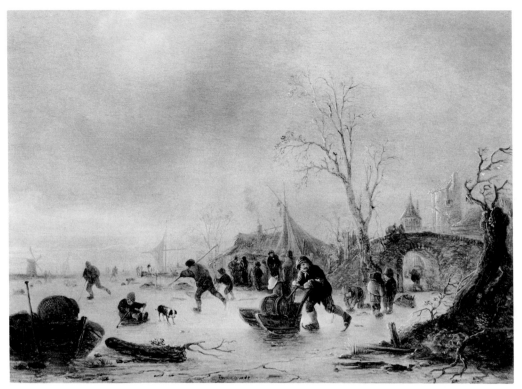

109. Isaak van Ostade, *Skaters Near a Village*

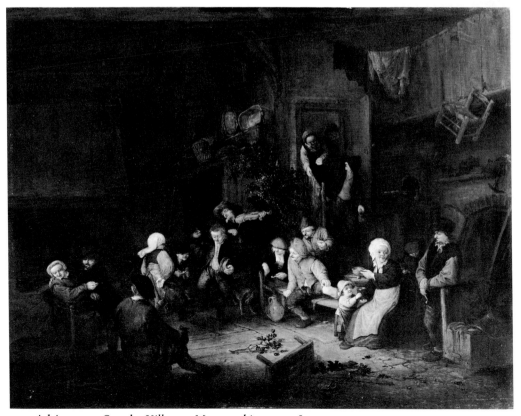

110. Adriaen van Ostade, *Villagers Merrymaking at an Inn*

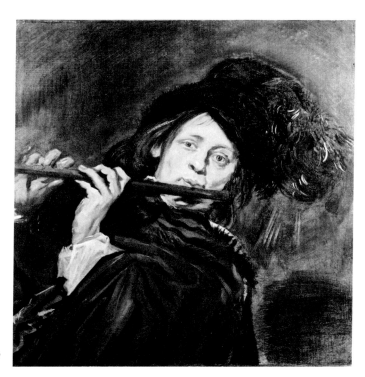

111. Follower of Frans Hals,
The Flute Player

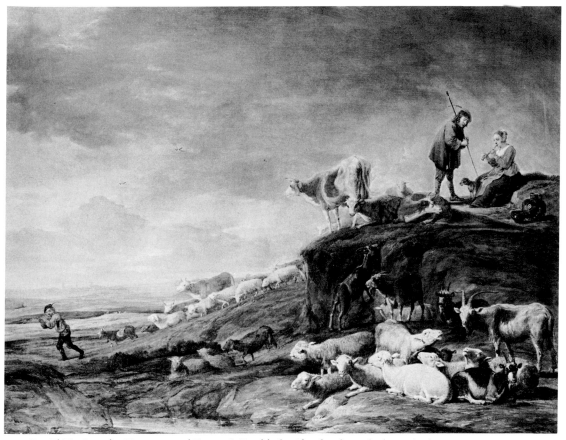

112. David Teniers the Younger and François Ryckhals, *Shepherds with their Flocks*

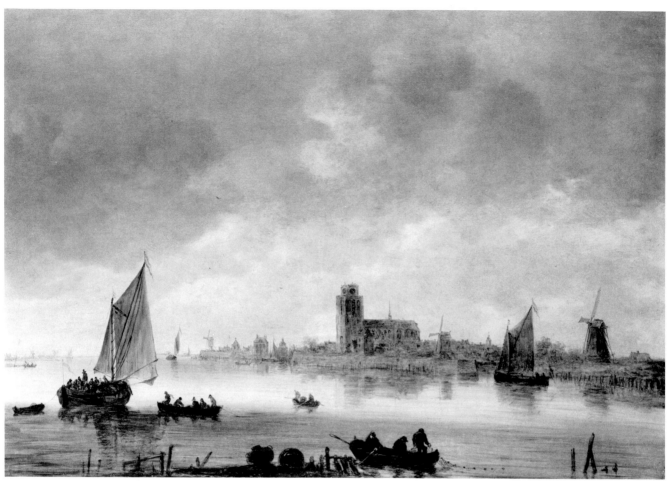

113. Jan van Goyen, *View of Dordrecht*

114. Jan van Goyen,
The River Shore

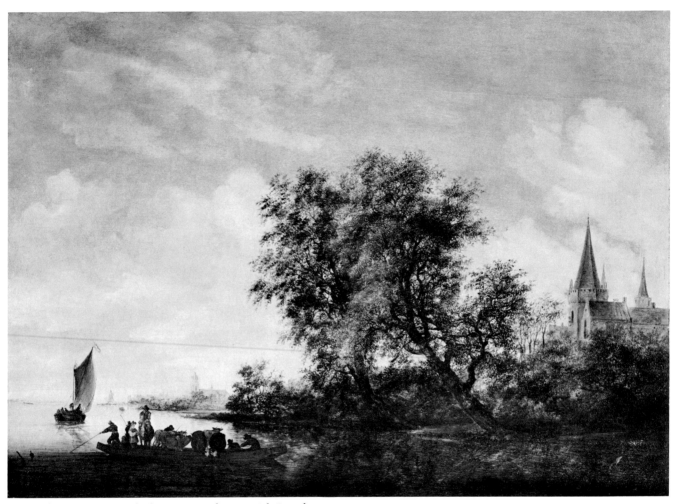

115. Salomon van Ruysdael, *River Landscape with Ferryboat*

116. Salomon van Ruysdael,
Landscape with Cattle

117. Nicolaes Berchem,
Pastoral Landscape

118. Jan Both, *Travelers in an Italian Landscape*

119. Adam Pynacker,
Italian Landscape

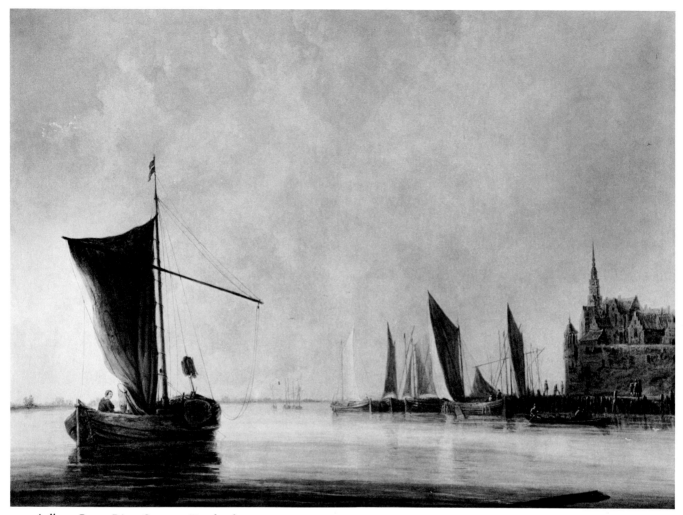

120. Aelbert Cuyp, *River Scene at Dordrecht*

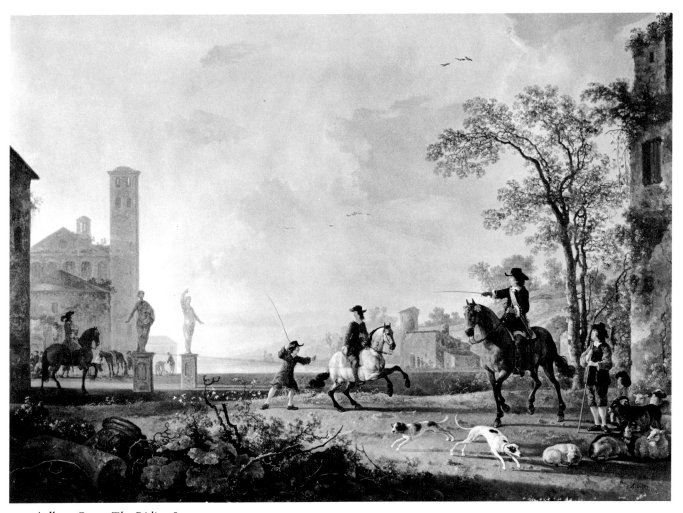

121. Aelbert Cuyp, *The Riding Lesson*

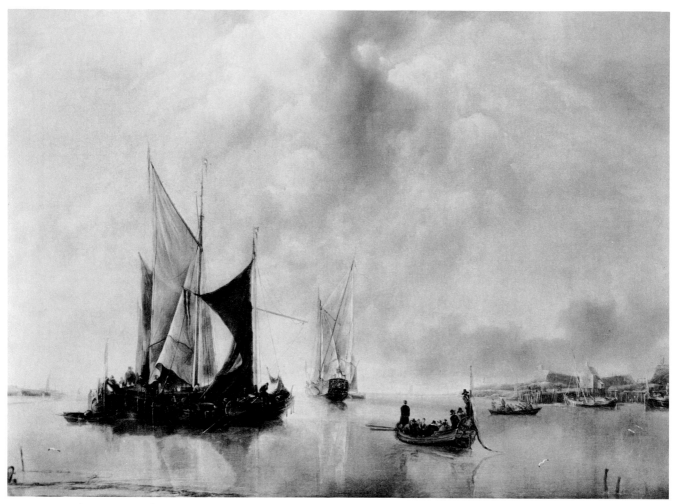

122. Jan van de Cappelle, *Shipping Off the Coast*

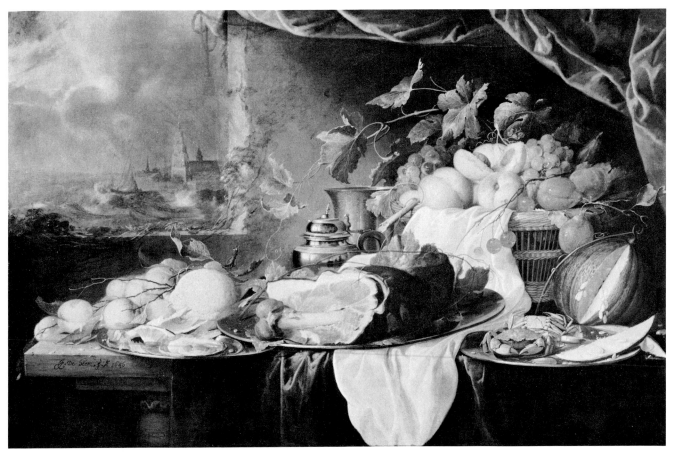

123. Jan Davidsz. de Heem, *Still Life with a View of the Sea*

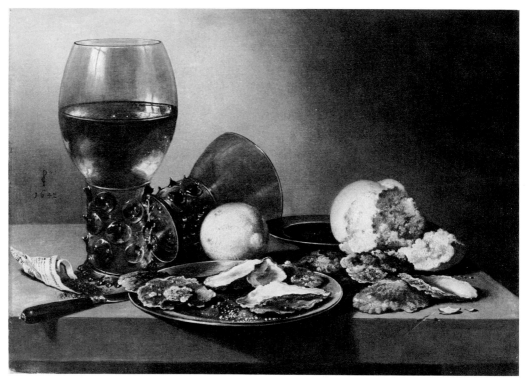

124. Pieter Claesz., *Still Life with Oysters*

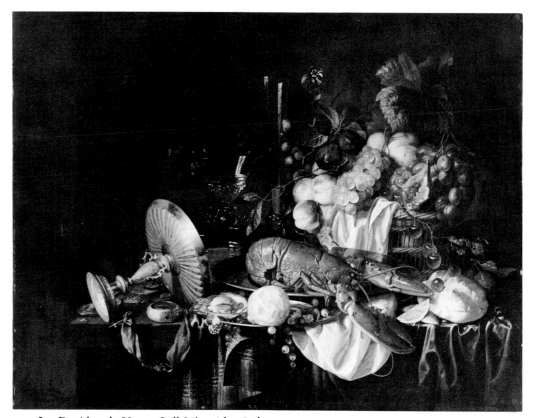

125. Jan Davidsz. de Heem, *Still Life with a Lobster*

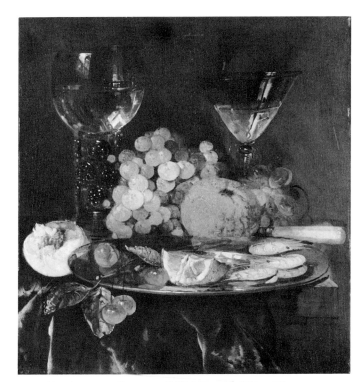

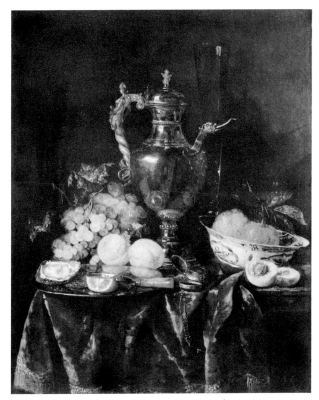

127. Abraham van Beyeren, *Still Life with Wine Glasses*

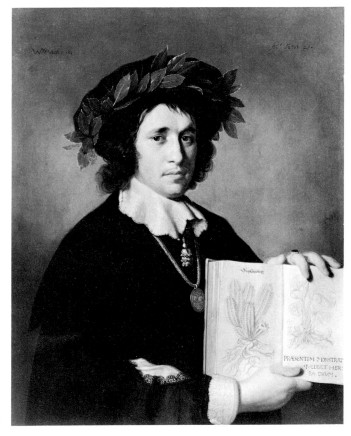

126. Abraham van Beyeren, *Still Life with a Wine Ewer*

128. Willem Moreelse,
Portrait of a Scholar

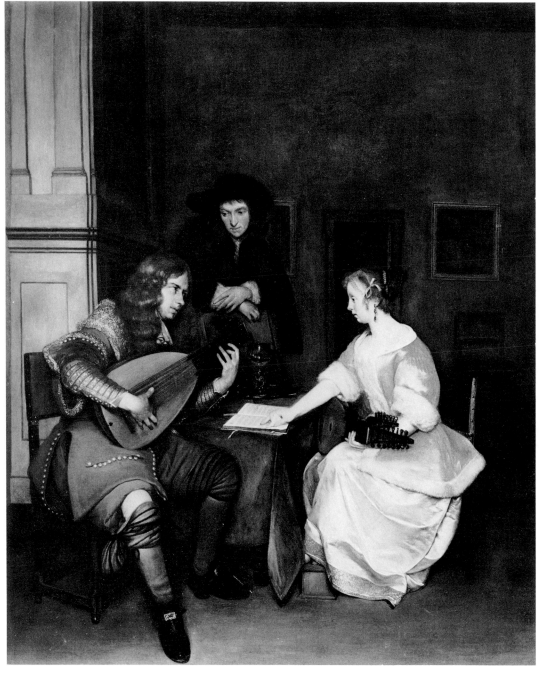

129. Gerard ter Borch,
The Music Lesson

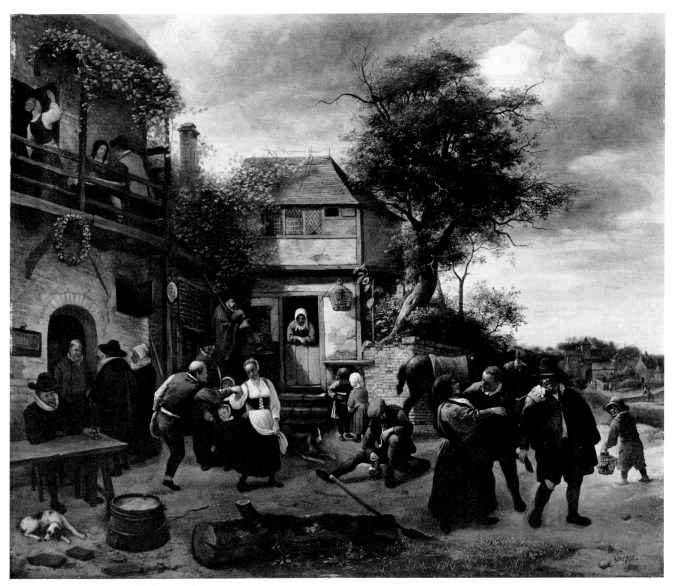

130. Jan Steen, *Peasants Before an Inn*

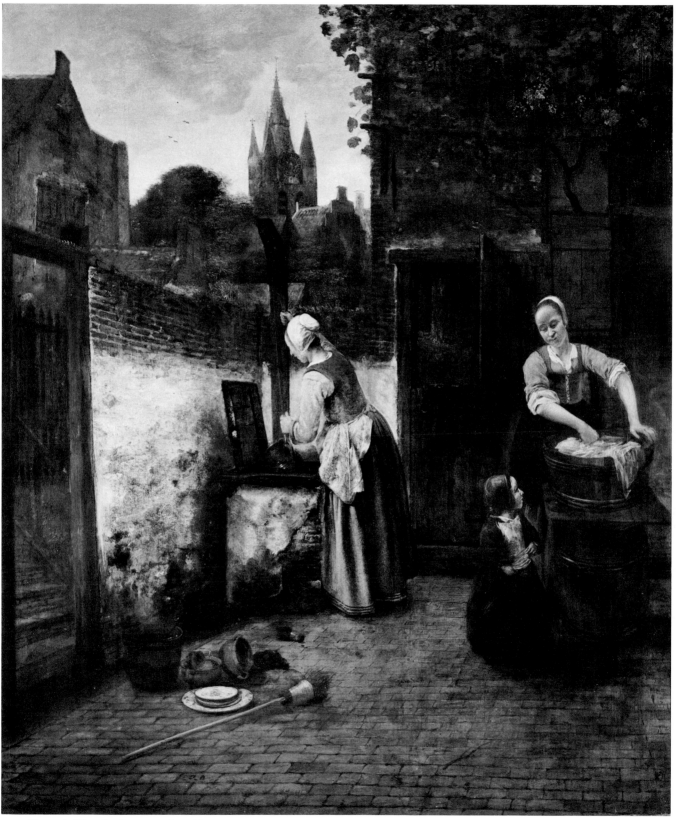

131. Pieter de Hooch, *Courtyard, Delft*

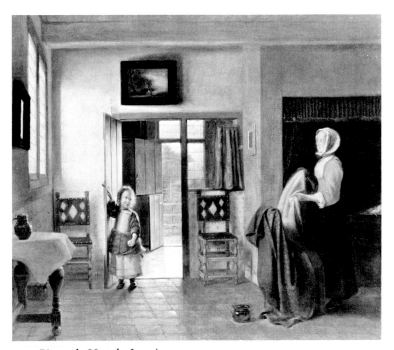

132. Pieter de Hooch, *Interior*

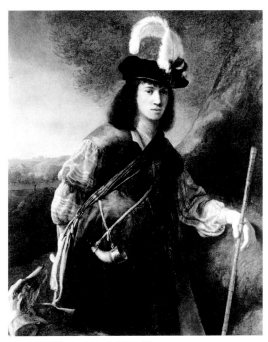

133. Ferdinand Bol, *The Huntsman*

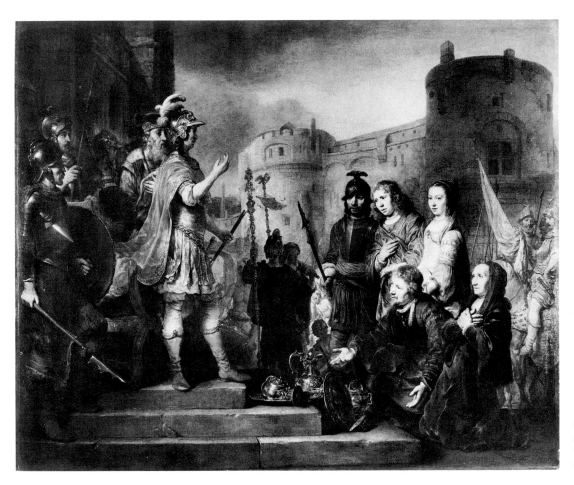

134.
Gerbrand van
den Eeckhout,
*The Magnanimity
of Scipio*

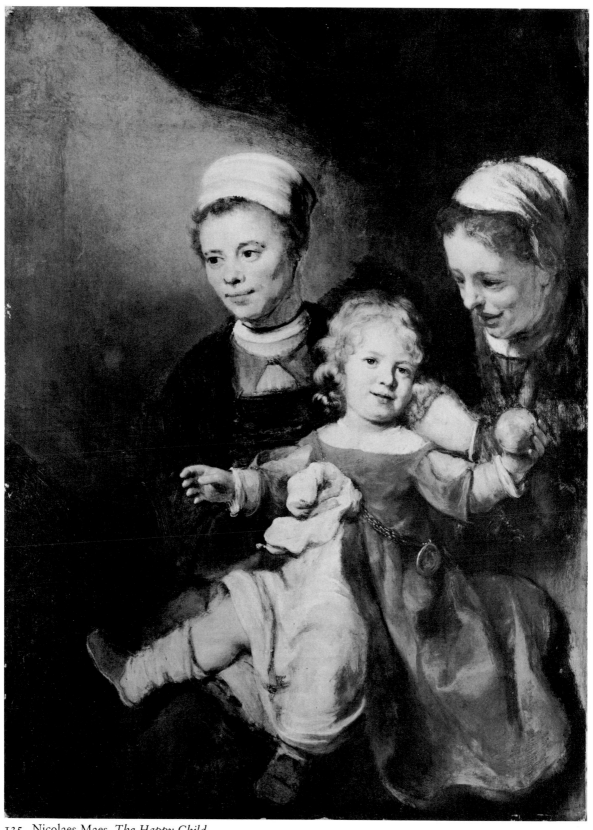

135. Nicolaes Maes, *The Happy Child*

136. Nicolaes Maes, *Portrait of a Man*

137. Copy after Jan Victors, *Girl at a Window*

138. Jacob van Ruisdael, *Landscape with Waterfall*

139. Meyndert Hobbema, *The Water Mill*

140. Jan van der Heyden, *The Garden of the Old Palace, Brussels*

141. Melchoir d'Hondecoeter,
Poultry in a Landscape

142. Melchoir d'Hondecoeter, *Still Life with Birds*

143. Hendrik van Streek, *Interior of the Old Church
in Amsterdam*

144. Rachel Ruysch, *Flower Still Life*

145. Nicolaes Verkolje, *The Fortune Teller*

146. Jacob de Wit, *Zephyr and Flora*

147. Isaak Ouwater, *The Prinsengracht, Amsterdam*

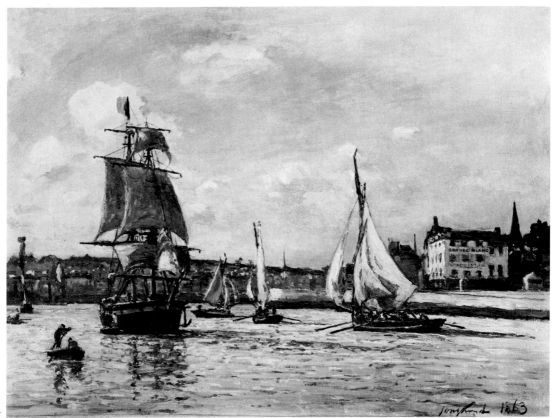

148. Johann Barthold
Jongkind,
Honfleur Harbor

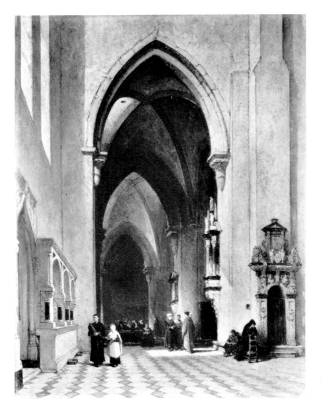

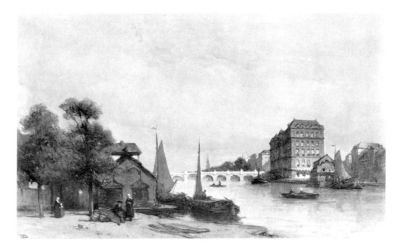

150. Johannes Bosboom, *The Amstel River, Amsterdam*

149. Johannes Bosboom,
In Trier Cathedral

151. Jozef Israels, *The Parting Day*

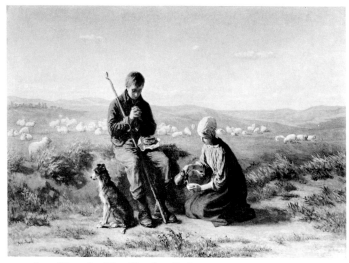

152. Jozef Israels, *The Shepherd's Prayer*

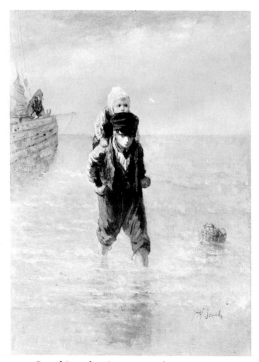

153. Jozef Israels, *Coming Ashore*

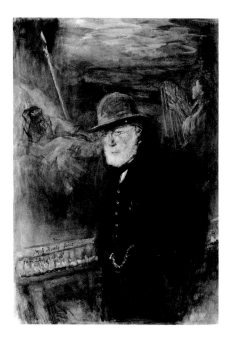

154. Jozef Israels,
Self-Portrait

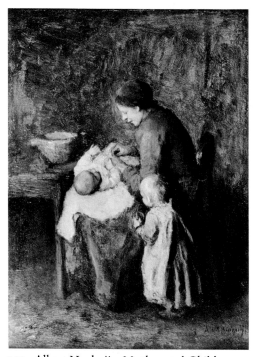

155. Albert Neuhuijs, *Mother and Children*

156. Jacob Simon Hendrik Kever, *Sisters*

157. Jacob Simon Hendrik Kever, *Mother and Children*

159. Jacob Maris, *Amsterdam*

158. Jacob Maris, *Scheveningen*

160. Jacob Maris, *The Tow Path*

161. Willem Maris, *Pasture in Sunshine*

162. Willem Maris, *The Lowlands*

163. Pieter ter Meulen, *Gelderland Pastures*

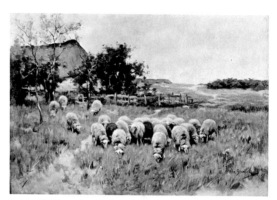

164. Willem Steelink, *Sheep in Pasture*

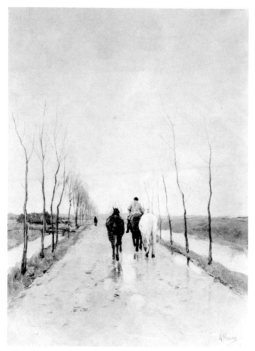

165. Anton Mauve, *A Dutch Road*

166. Anton Mauve, *Homeward Bound*

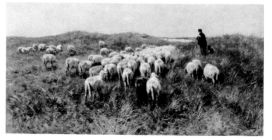

167. Anton Mauve, *Sheep on the Dunes*

168. Théophile de Bock, *Castle at Arnhem*

169. Théophile de Bock, *Solitude*

171. Evert Pieters, *In the Month of May*

170. Evert Pieters, *Mother Love*

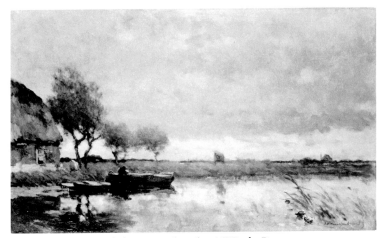

172. Johannes Hendrik Weissenbruch, *A Windy Day*

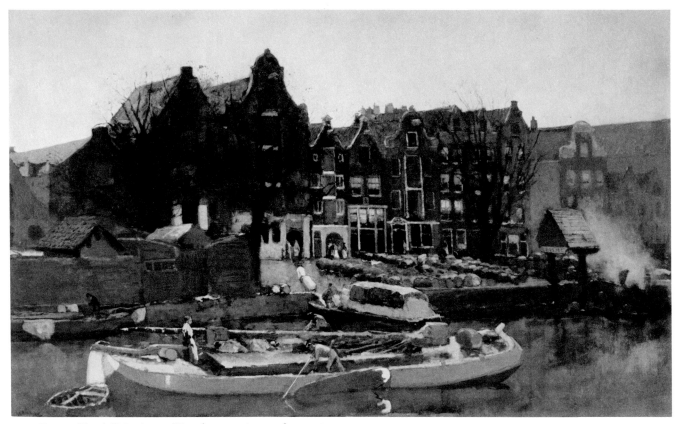

173. George Hendrik Breitner, *Warehouses, Amsterdam*

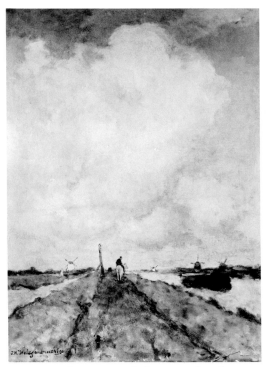

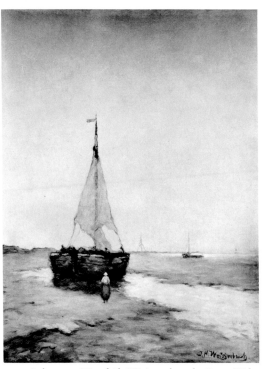

174. Johannes Hendrik Weissenbruch, *The White Cloud*

175. Johannes Hendrik Weissenbruch, *Low Tide*

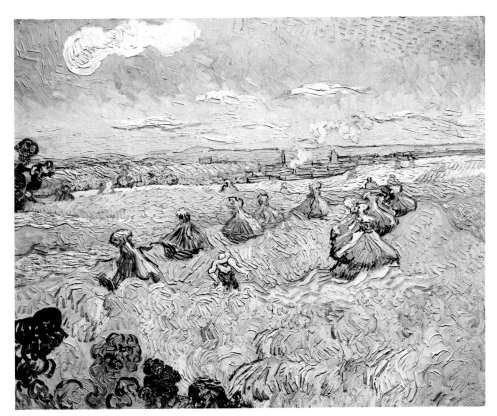

176. Vincent van Gogh,
The Wheat Field

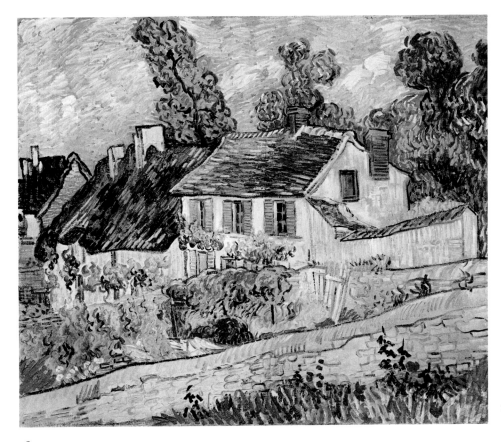

177. Vincent van Gogh,
Houses at Auvers

FRANCE

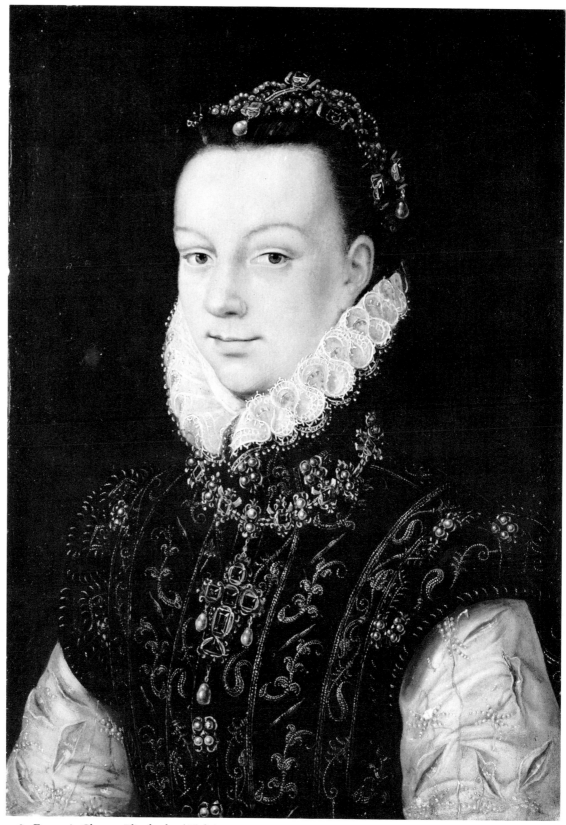

178. François Clouet, *Elizabeth of Valois*

179. French, Anonymous,
Saint George and the Dragon

180. Corneille de Lyon, *Maréchal Bonnivet*

181. Jacques Blanchard, *Portrait of a Sculptor*

182. Jacques Blanchard, *Allegory of Charity*

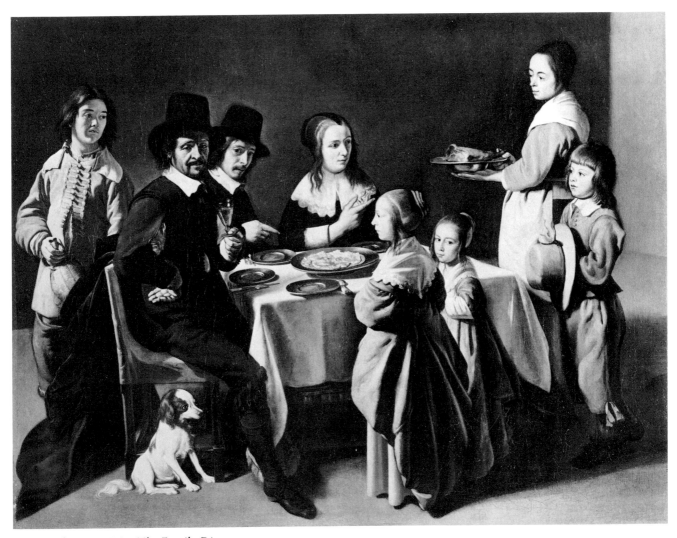

183. Mathieu Le Nain, *The Family Dinner*

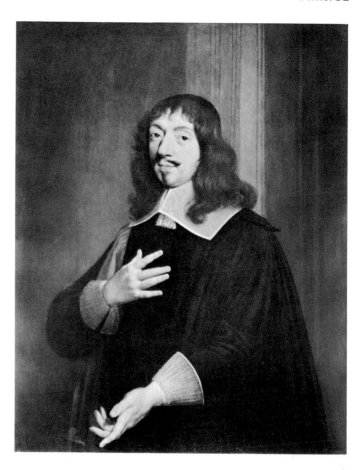

184. Philippe de Champaigne,
A Councilman of Paris

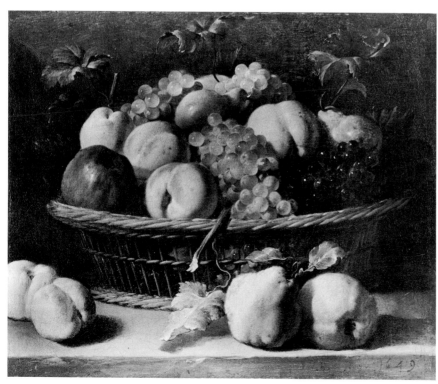

185. Pieter van Boucle,
Basket of Fruit

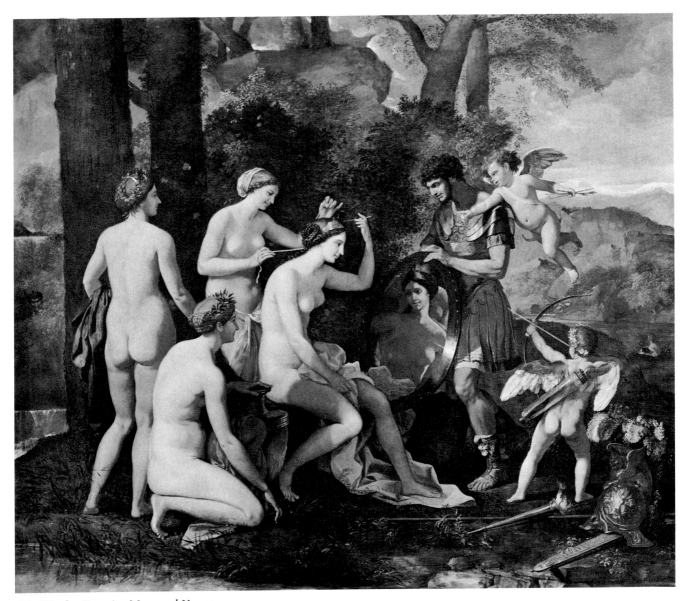

186. Nicolas Poussin, *Mars and Venus*

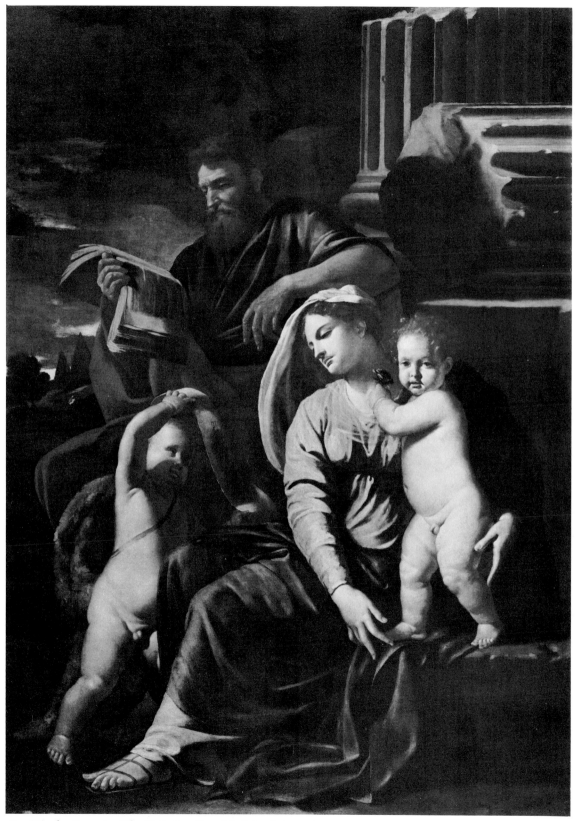

187. Nicolas Poussin, *The Holy Family with Saint John*

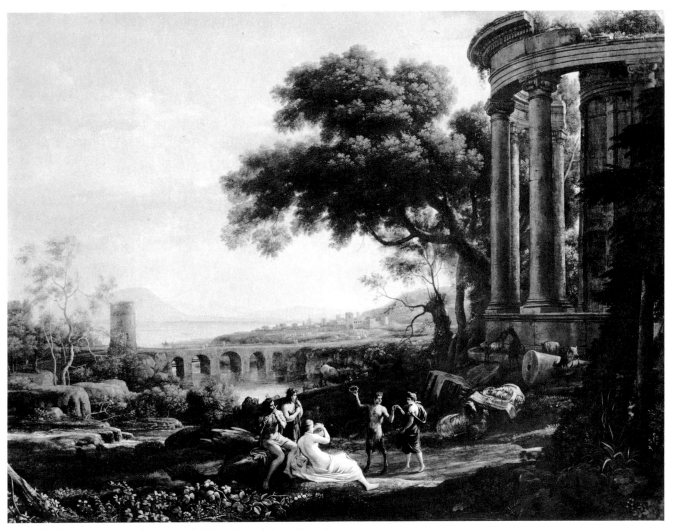

188. Claude Lorrain, *Landscape with Nymph and Satyr Dancing*

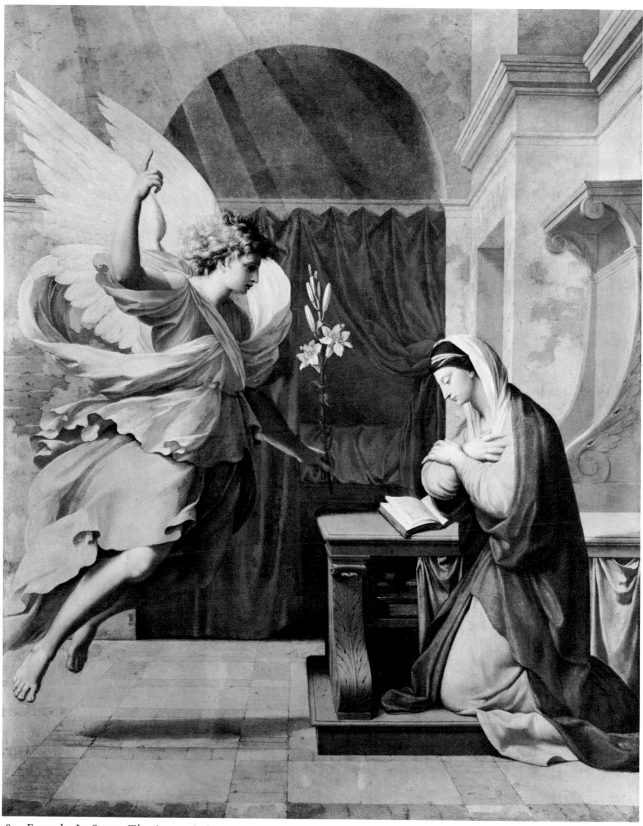

189. Eustache Le Sueur, *The Annunciation*

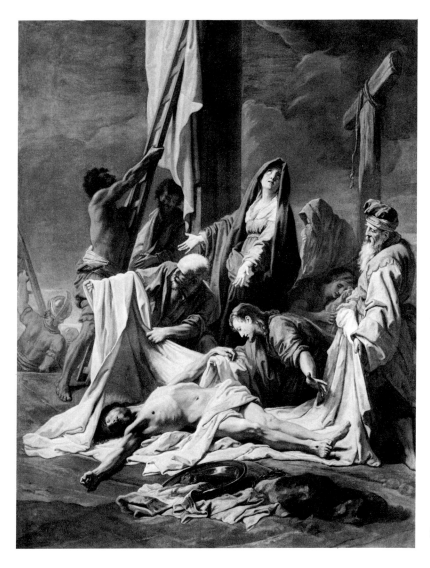

190. Jean Jouvenet,
The Deposition

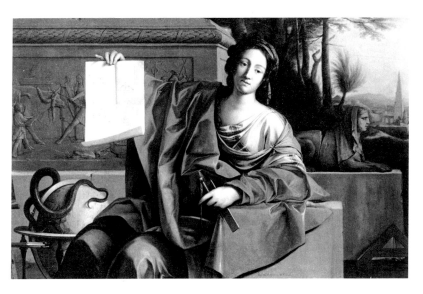

191. Laurent de La Hire,
Allegory of Geometry

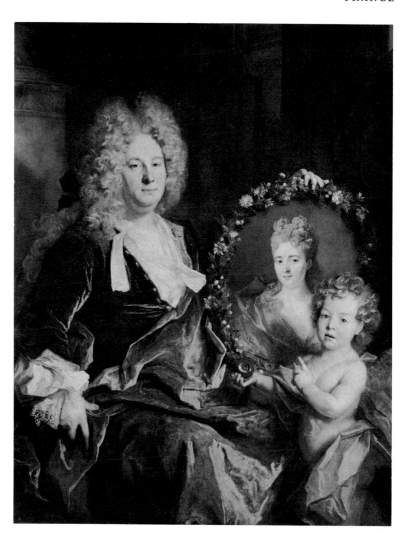

192. Nicolas de Largillierre,
Portrait of a Man

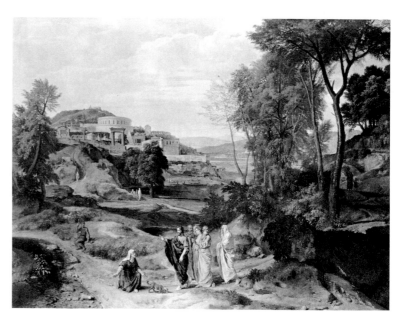

193. Francisque Millet,
*Landscape with Christ
and the Woman of Canaan*

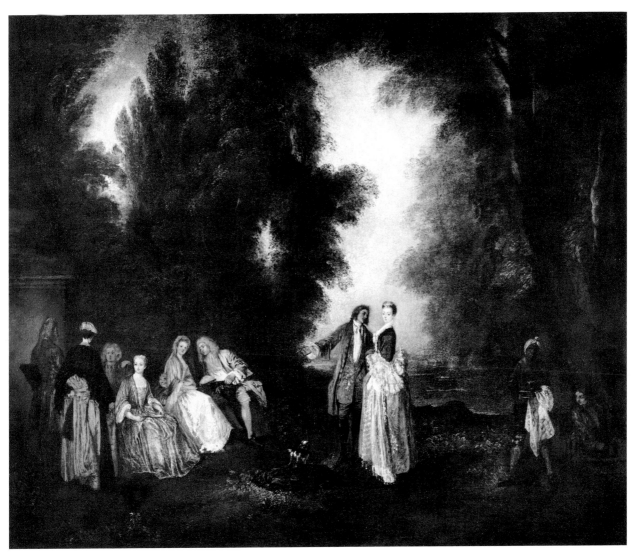

194. Antoine Watteau, *La Conversation*

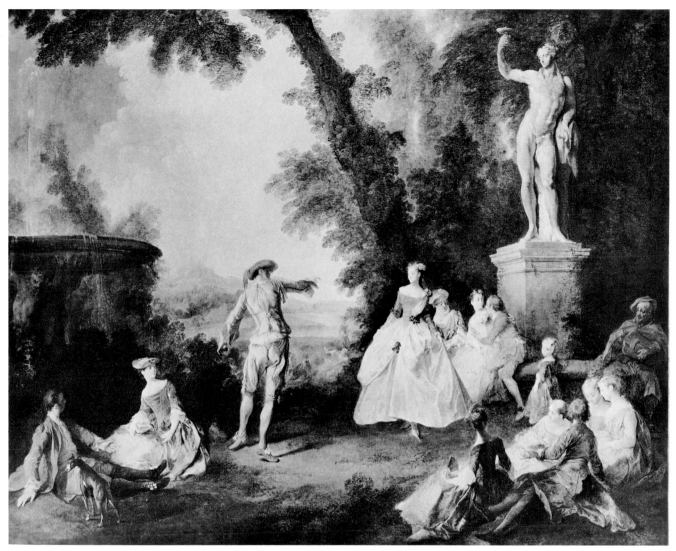

195. Nicolas Lancret, *The Dance in the Park*

196. Hyacinthe Rigaud,
*Marquis Jean-Octave
de Villars*

197. Jean-Baptiste Pater,
The Bathing Party

198. Maurice-Quentin de La Tour,
Self-Portrait

199. Jean-Baptiste Oudry,
*Still Life with Musette
and Violin*

200. Jean-Marc Nattier, *Princesse de Rohan*

201. François Boucher, *The Mill at Charenton*

202. François Boucher, *The Footbridge*

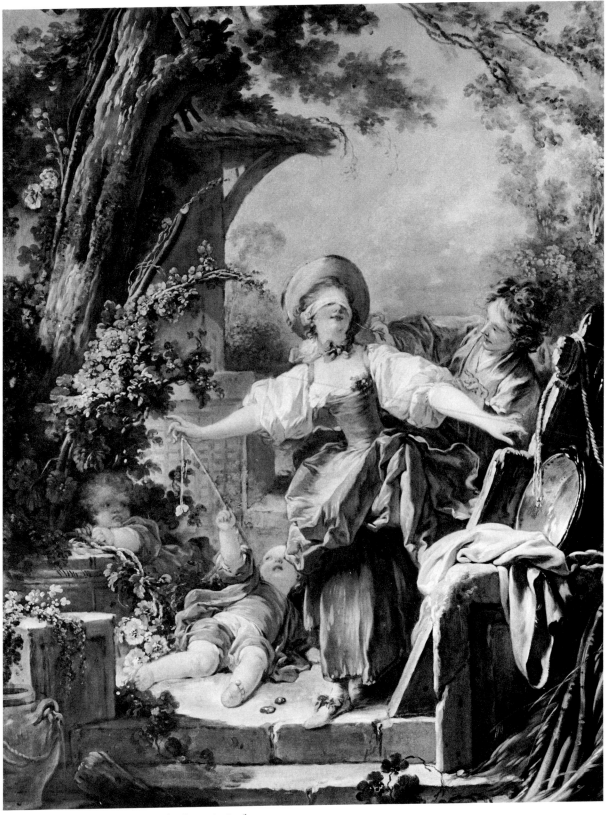

203. Jean-Honoré Fragonard, *Blind-Man's Buff*

204. Jean-Baptiste Le Prince, *Fear*

205. Claude-Joseph Vernet, *Evening*

206. Anne Vallayer-Coster, *Still Life with Lobster*

207. Anne Vallayer-Coster, *Still Life with Game*

208. Charles-François Grenier de La Croix, *A Mediterranean Seaport*

209. Louise-Elisabeth Vigée-Le Brun,
Isabella Teotochi Marini

210. Louise-Elisabeth Vigée-Le Brun, *Lady Folding a Letter*

211. Jacques-Louis David, *The Oath of the Horatii*

212. Claude-Marie Dubufe, *Portrait of a Man*

213. Louis-Léopold Boilly,
S'il vous plaît

214. Eugène Delacroix, *The Return of Christopher Columbus*

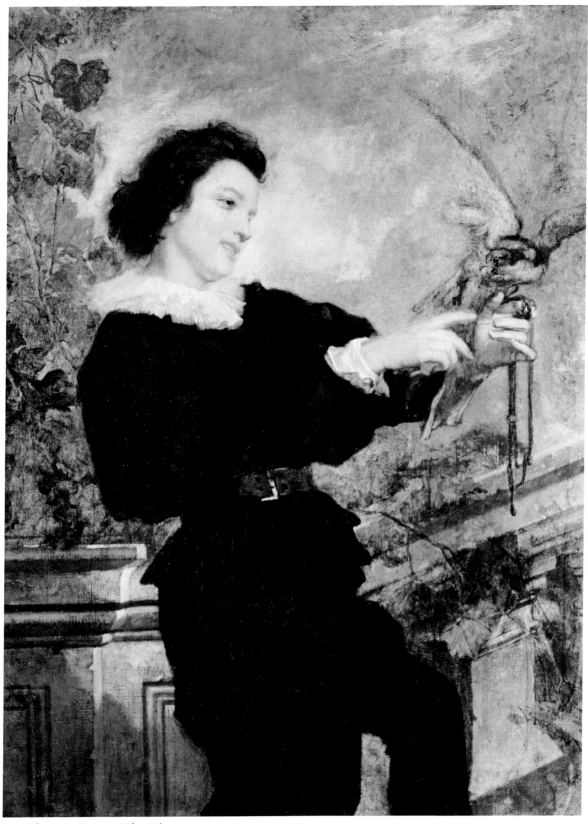

215. Thomas Couture, *The Falconer*

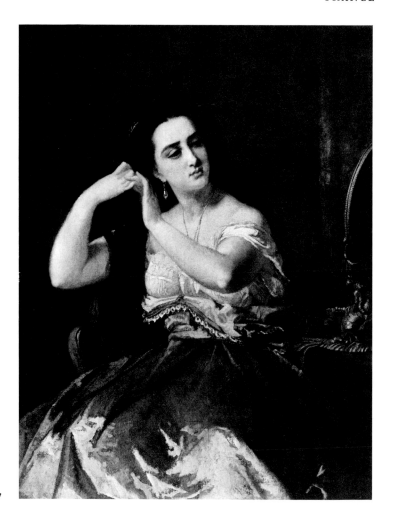

216. Thomas Couture, *Alice Ozy*

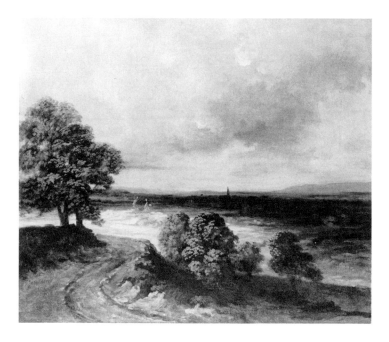

217. Georges Michel, *Landscape with Oak Tree*

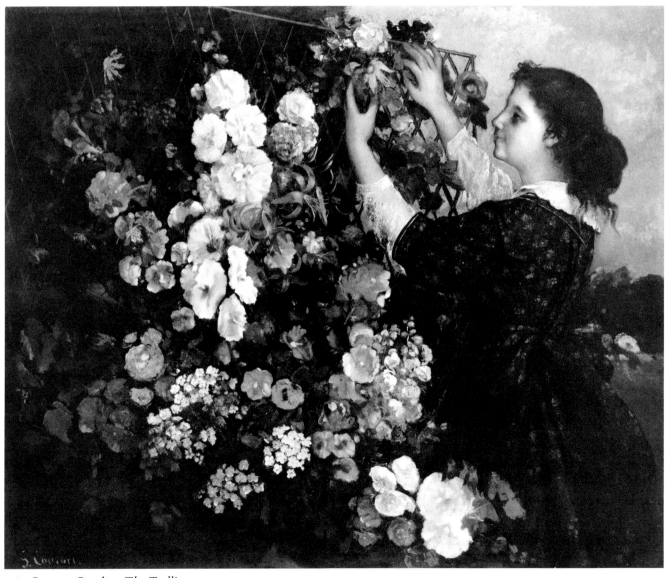

218. Gustave Courbet, *The Trellis*

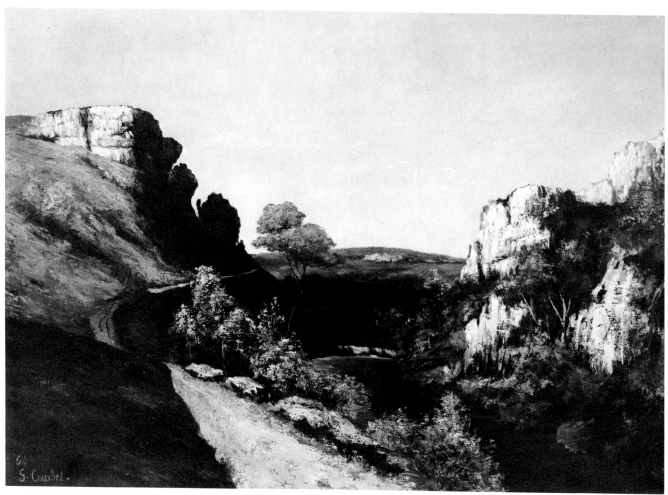

219. Gustave Courbet, *Landscape Near Ornans*

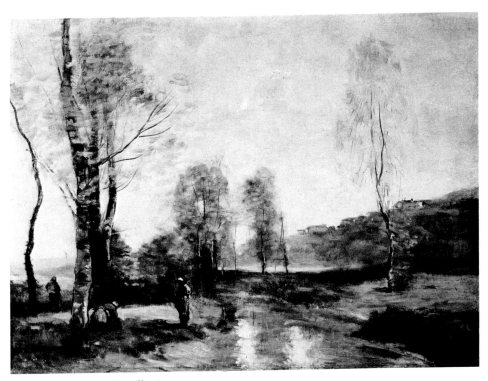

220. Jean-Baptiste-Camille Corot,
Canal in Picardy

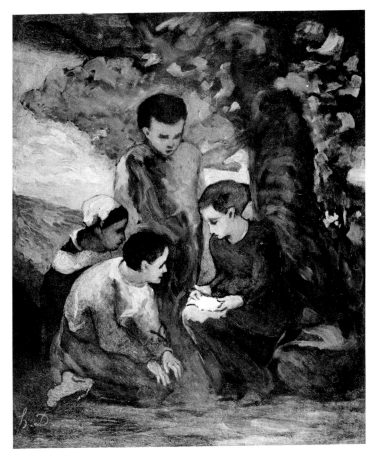

221. Honoré Daumier,
Children Under a Tree

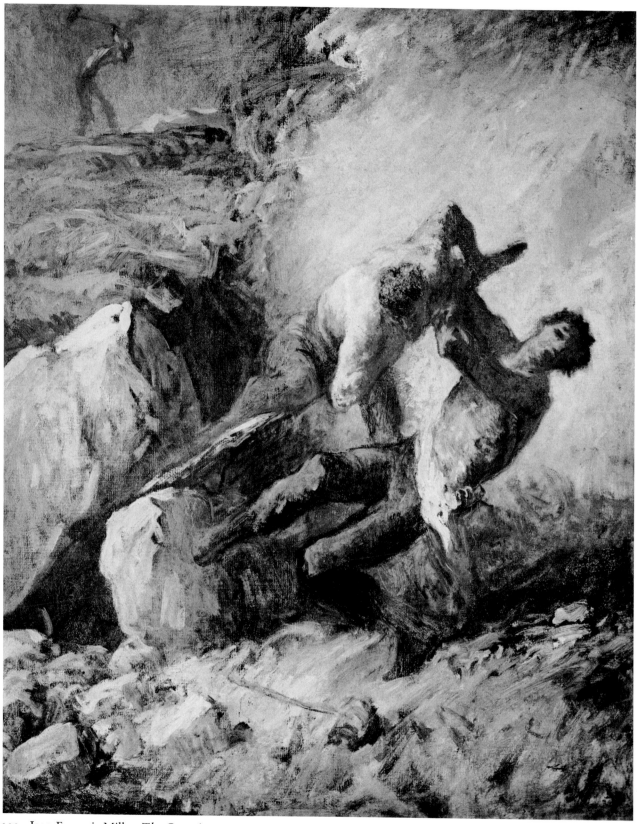

222. Jean-François Millet, *The Quarriers*

223. Pierre-Etienne-Théodore Rousseau, *Under the Birches, Evening*

224. Pierre-Étienne-Théodore Rousseau, *In the Auvergne Mountains*

316

225. Constant Troyon, *The Pasture*

226. Pierre-Étienne-Théodore Rousseau, *Landscape*

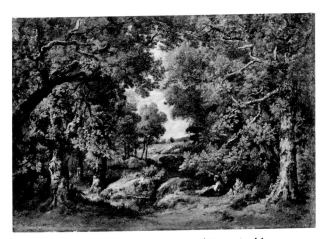

227. Narcisse-Virgile Diaz, *Forest of Fontainebleau*

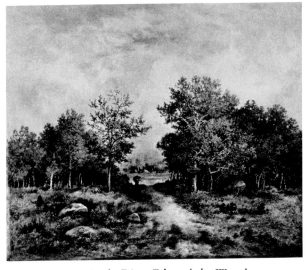

228. Narcisse-Virgile Diaz, *Edge of the Wood*

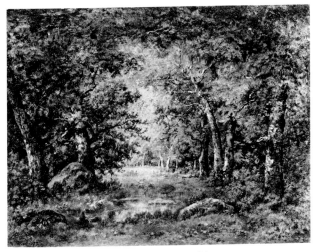

229. Narcisse-Virgile Diaz, *Fontainebleau*

230. Narcisse-Virgile Diaz, *Woodland Scene near Fontainebleau*

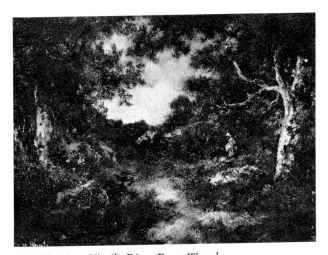

231. Narcisse-Virgile Diaz, *Deep Woods*

232. Charles-François Daubigny,
Clearing After a Storm

233. Charles-François Daubigny, *On the Oise River*

234. Jules Dupré, *Return of the Fisherman*

235. Jules Dupré, *Morning*

237. Charles-Émile Jacque, *The Shepherd's Rest*

236. Charles-Émile Jacque, *Three Sheep*

238. Eugène Boudin, *The Beach, Trouville*

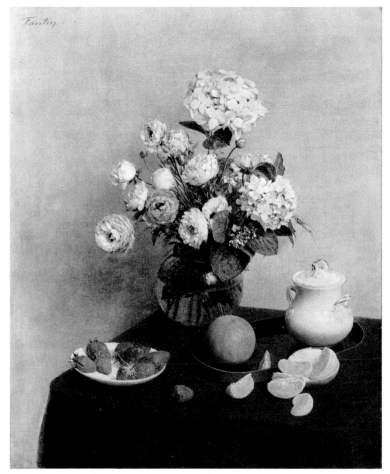

239. Henri Fantin-Latour, *Flowers and Fruit*

240. Henri Fantin-Latour,
 Portrait of the Artist's Sister

241. James-Jacques-Joseph Tissot, *London Visitors*

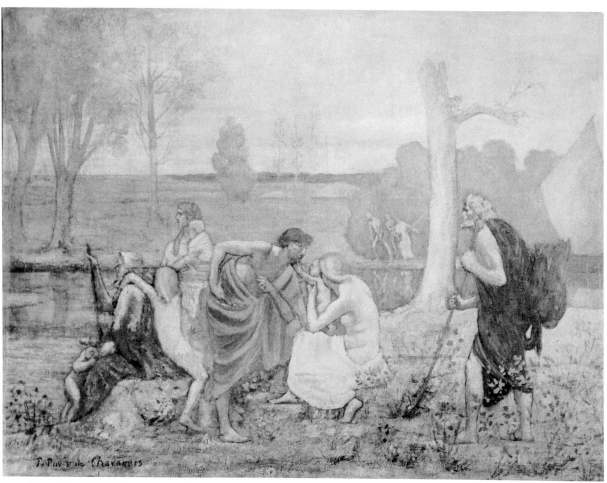

242. Pierre Puvis de Chavannes, *Ludus Pro Patria*

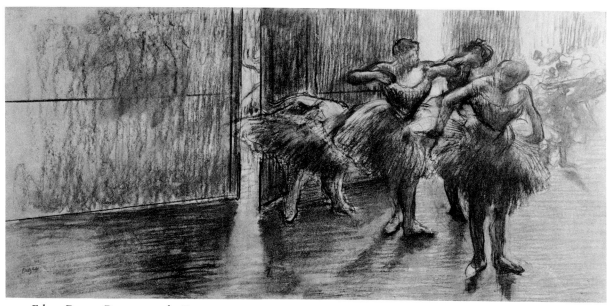

243. Edgar Degas, *Dancers at the Bar*

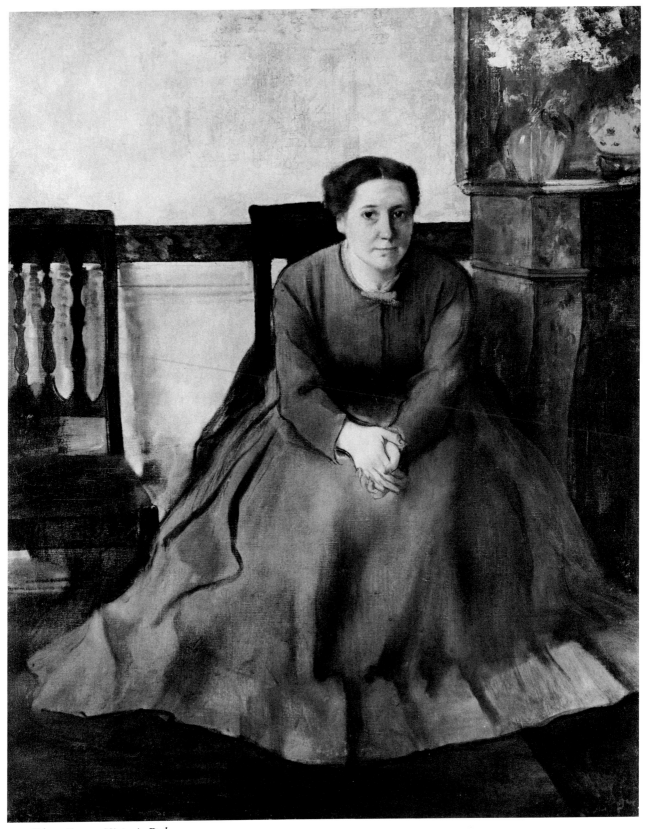

244. Edgar Degas, *Victoria Dubourg*

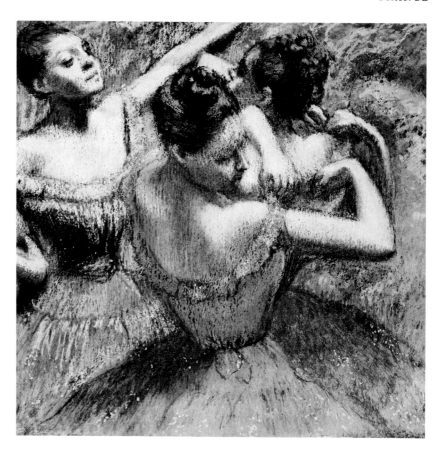

245. Edgar Degas,
The Dancers

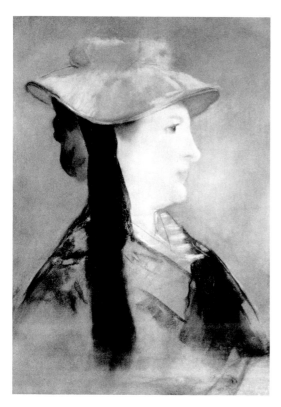

246. Edouard Manet,
Madame Edouard Manet

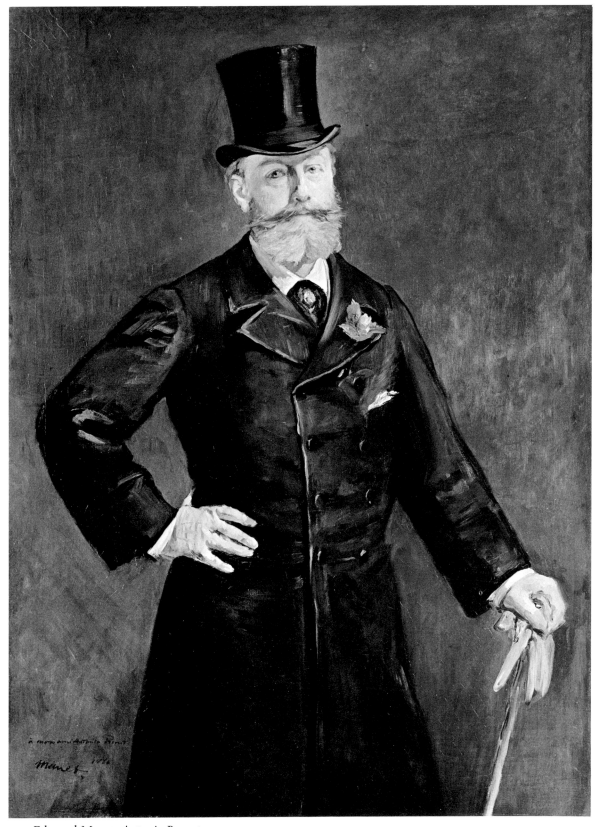

247. Edouard Manet, *Antonin Proust*

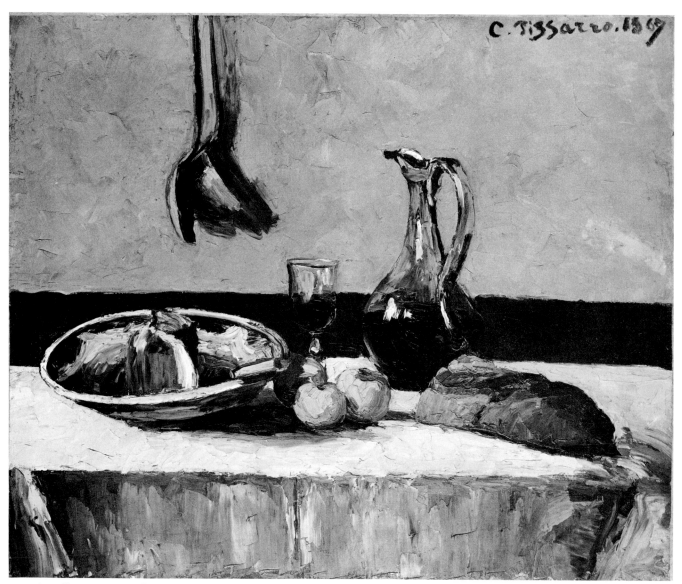

248. Camille Pissarro, *Still Life*

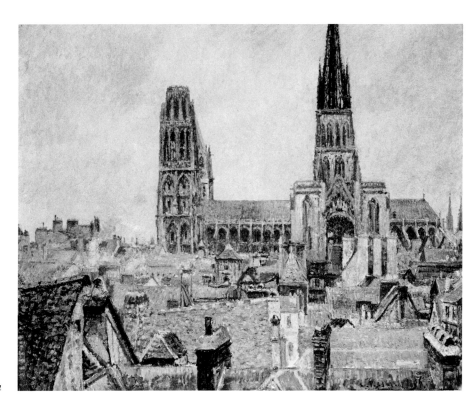

249. Camille Pissarro,
The Roofs of Old Rouen

250. Camille Pissarro,
Peasants Resting

251. Alfred Sisley,
The Aqueduct at Marly

252. Alfred Sisley,
Nut Trees at Thomery

253. Pierre-Auguste Renoir,
Road at Wargemont

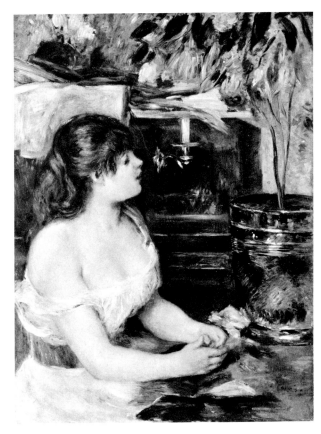

254. Pierre-Auguste Renoir,
The Green Jardinière

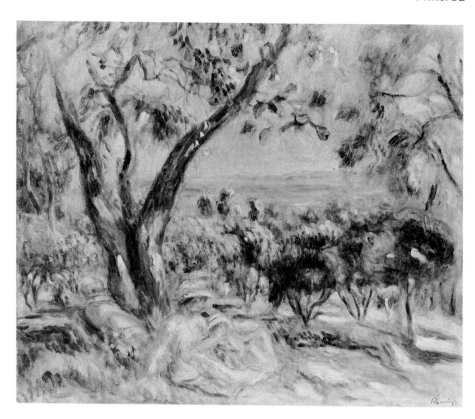

255. Pierre-Auguste Renoir,
Landscape at Cagnes

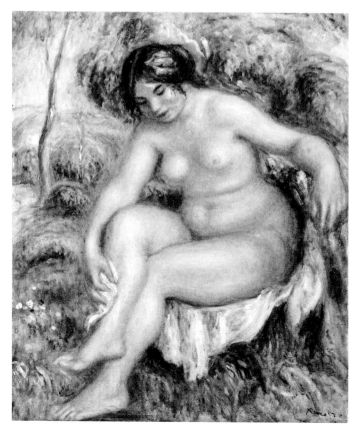

256. Pierre-Auguste Renoir,
Bather

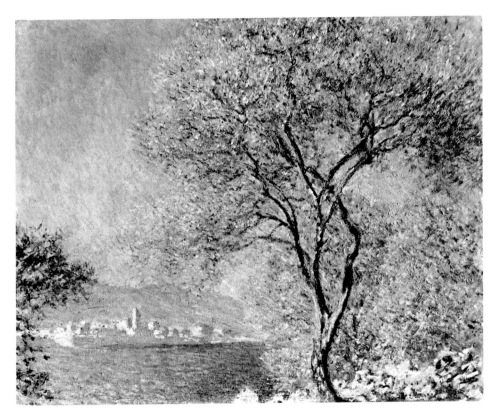

257. Claude Monet, *Antibes*

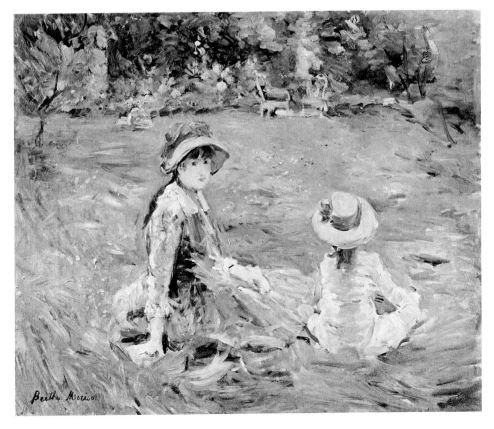

258. Berthe Morisot,
In the Garden at Maurecourt

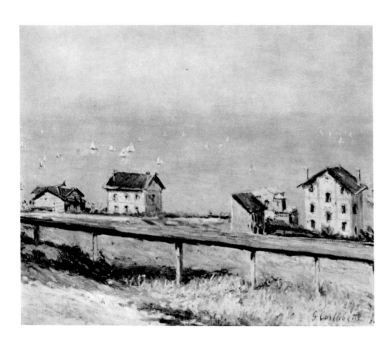

259. Gustave Caillebotte,
By the Sea, *Villerville*

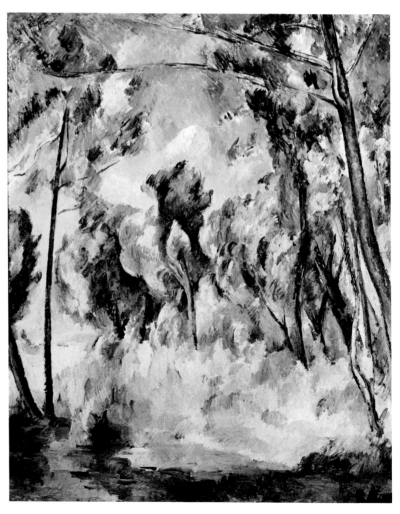

260. Paul Cézanne, *The Glade*

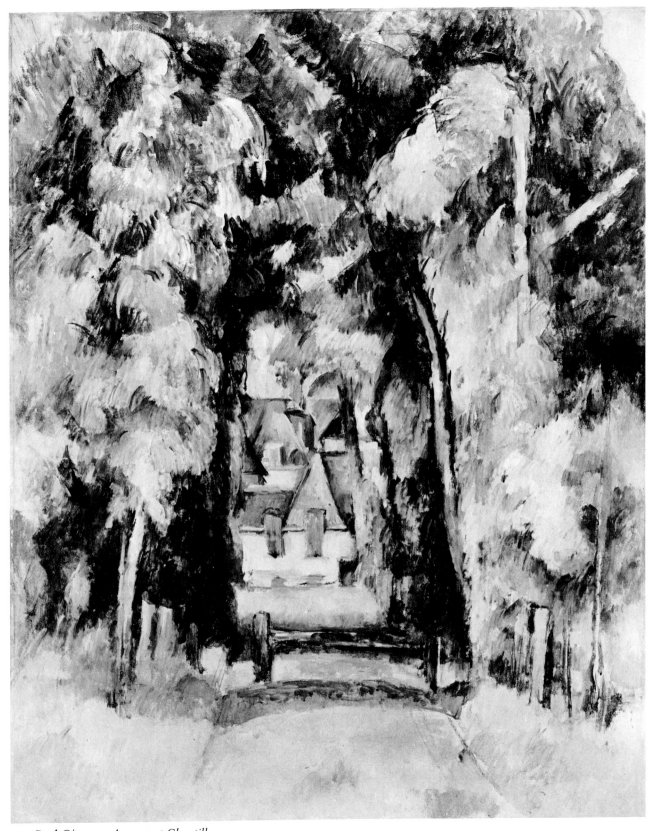

261. Paul Cézanne, *Avenue at Chantilly*

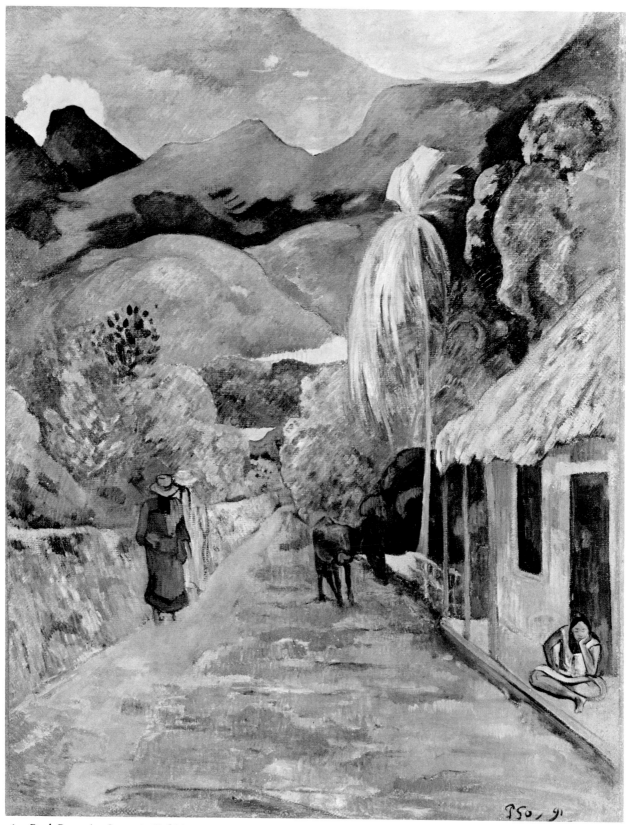

262. Paul Gauguin, *Street in Tahiti*

263. Paul-Gustave Doré, *The Scottish Highlands*

264. Paul-Gustave Doré, *The Mocking of Christ*

265. Jean-Jacques Henner, *Mary Magdalene*

266. Jules Breton, *The Shepherd's Star*

267. Émile van Marcke, *The Pasture Pool*

268. Émile van Marcke, *Cows*

269. William Adolphe Bouguereau, *The Captive*

270. Adolphe Monticelli, *The Greyhounds*

271. Felix Ziem, *Venice, Early Morning*

272. Felix Ziem, *Venice, The Grand Canal*

273. Henri Le Sidaner, *In the Garden*

274. Henri-Joseph Harpignies, *Souvenir of Dauphiné*

276. Jean-Charles Cazin, *In the Lowlands*

277. Henry Moret, *Seaweed Gatherers*

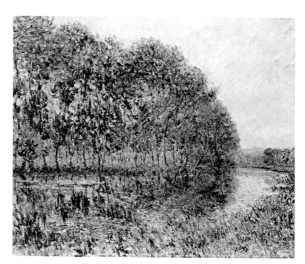

278. Gustave Loiseau, *The Banks of the Eure*

275. Henri-Joseph Harpignies, *The Mediterranean Coast*

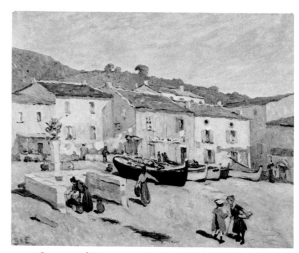

279. Georges d'Espagnat, *Le Lavandou*

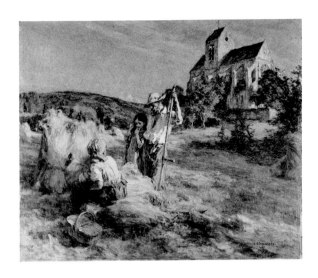

280. Léon Lhermitte,
Rest During the Harvest

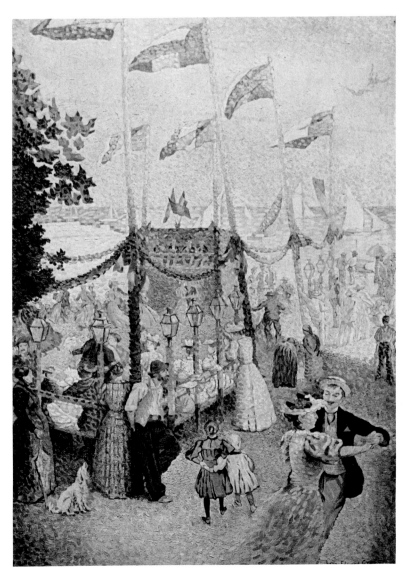

281. Henri-Edmond Cross,
At the Fair

282. Paul Signac, *Entrance to the Grand Canal, Venice*

283. André Derain, *Landscape at Carrières-Saint-Denis*

284. Maurice Utrillo, *Street in Montmartre*

285. Pablo Ruiz Picasso, *Woman with a Crow*

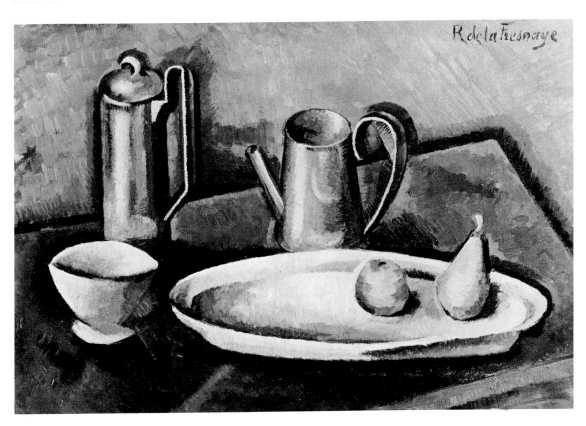

286. Roger de
La Fresnaye,
*Still Life with
Coffee Pot*

287. Robert Delaunay,
The City of Paris

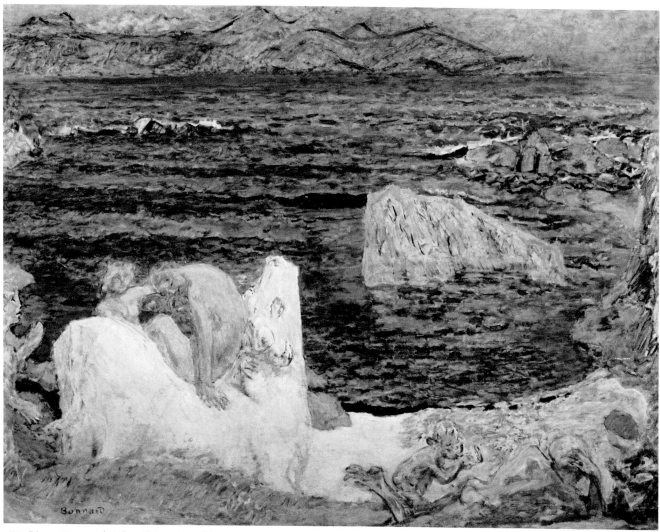

288. Pierre Bonnard, *The Abduction of Europa*

289. Maurice de Vlaminck, *Farm Landscape*

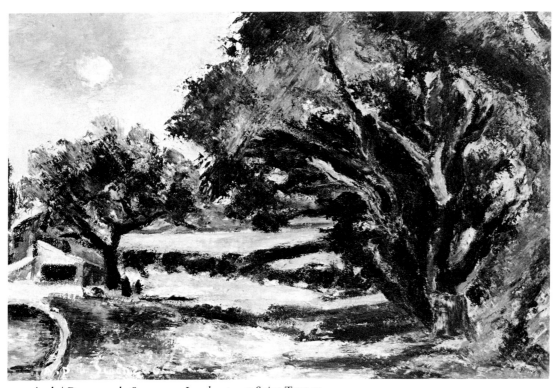

290. André Dunoyer de Segonzac, *Landscape at Saint Tropez*

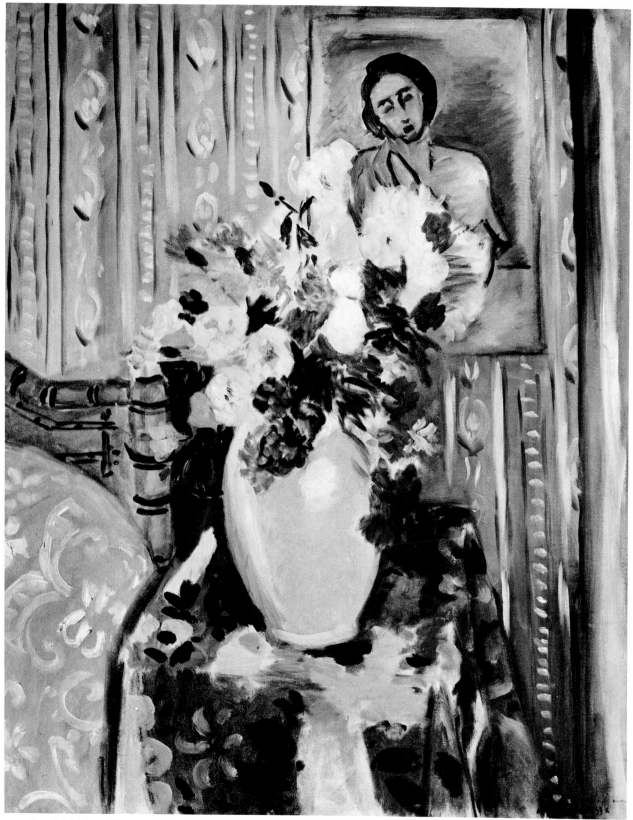

291. Henri Matisse, *Flowers*

292. Henri Matisse, *Dancer Resting*

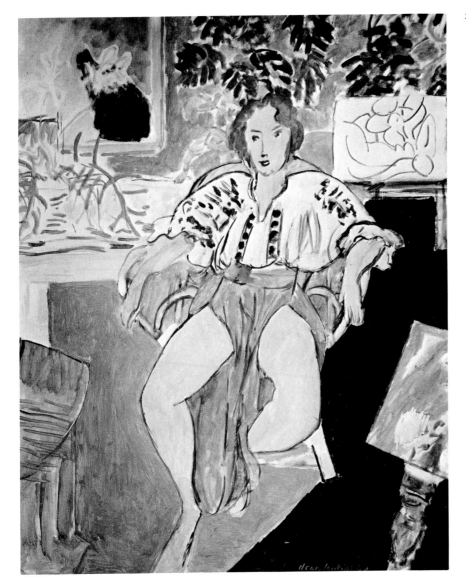

293. Jules Pascin, *Cinderella*

294. Léopold Survage,
 Landscape with Figure

295. Jean Lurçat, *Souvenir of Spain:*
The Birth of a Sailboat

296. Marie Laurencin, *Acrobats*

297. Yves Tanguy,
Passage of a Smile

299. Georges Rouault, *The Judge*

298. Kees van Dongen, *Deauville*

300. Raoul Dufy, *Threshing with a Blue Machine*

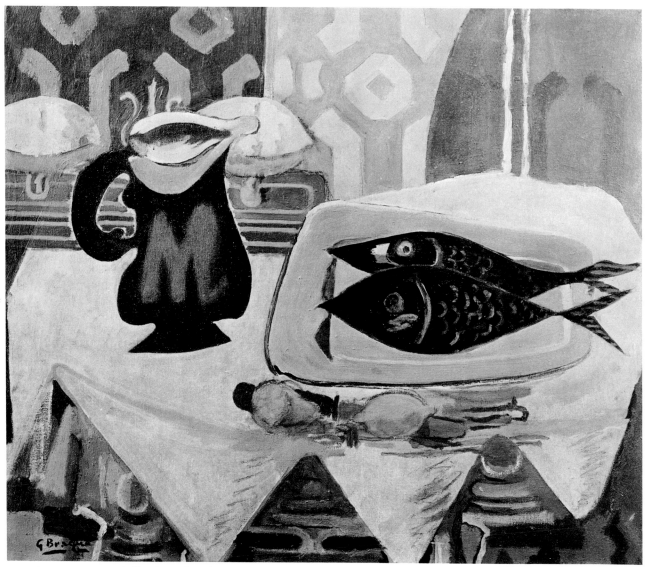

301. Georges Braque, *Still Life with Fish*

302. Jacques Villon, *Flowers*

303. André Masson, *The Harbor Near St. Mark's, Venice*

304. Nicolas de Staël,
*White Flowers in a
Black Vase*

305. Maria Helena Vieira da Silva,
The City

306. Victor Vasarely, *Alom I*

BRITAIN

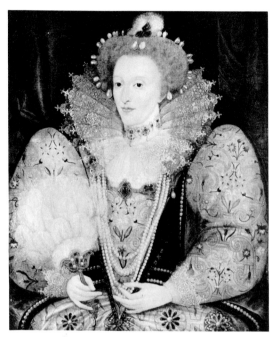

307. British, Anonymous, *Elizabeth I, Queen of England*

308. William Hogarth, *Joseph Porter*

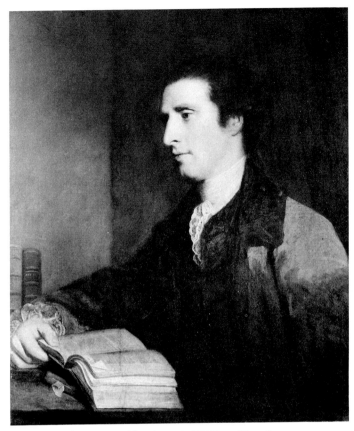

309. Sir Joshua Reynolds, *Miss Esther Jacobs*

310. Sir Joshua Reynolds, *Captain William Hamilton*

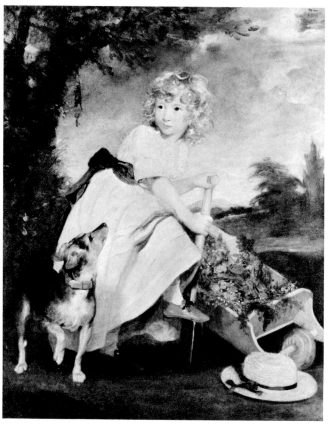

311. Sir Joshua Reynolds, *Master Henry Hoare*

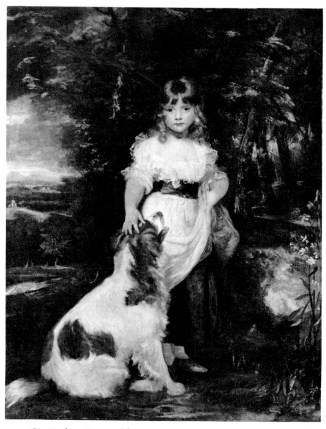

312. Sir Joshua Reynolds, *Miss Frances Harris*

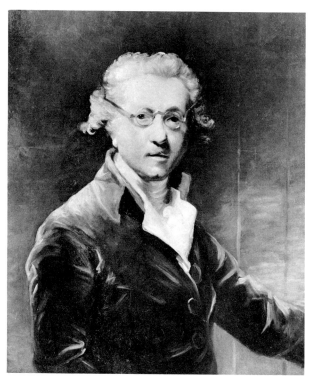

313. Copy after Sir Joshua Reynolds,
Sir Joshua Reynolds

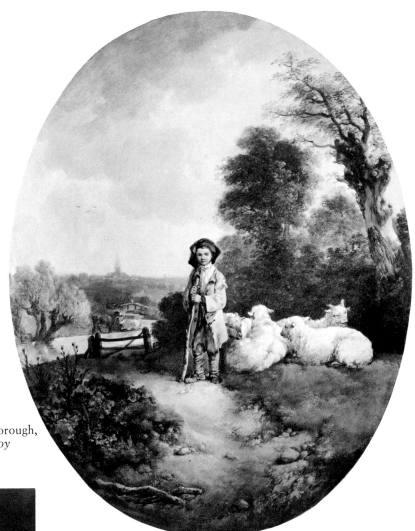

314. Thomas Gainsborough,
The Shepherd Boy

315. Thomas Gainsborough,
Lady Frederick Campbell

316. Thomas Gainsborough, *The Road from Market*

317. Richard Wilson,
The White Monk

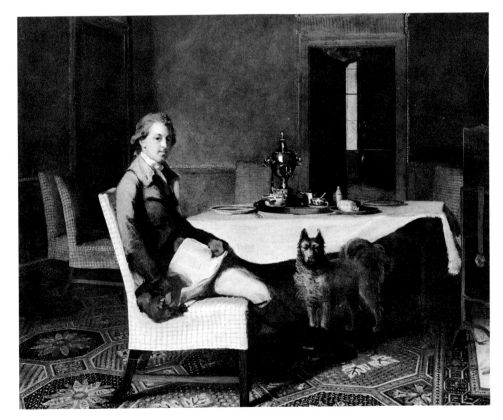

318. Attributed to Henry Walton,
A Gentleman at Breakfast

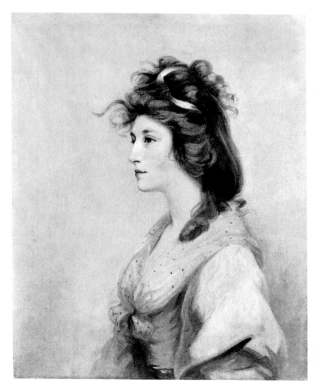

319. John Hoppner,
Mrs. Henry Richmond Gale

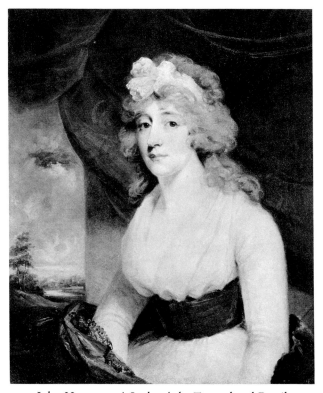

320. John Hoppner, *A Lady of the Townshend Family*

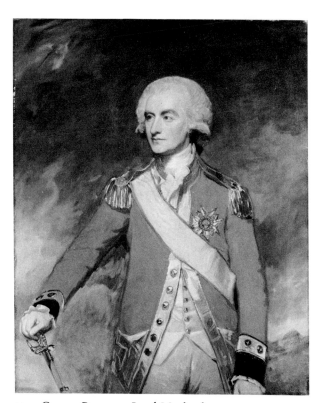

321. George Romney, *Lord Macleod*

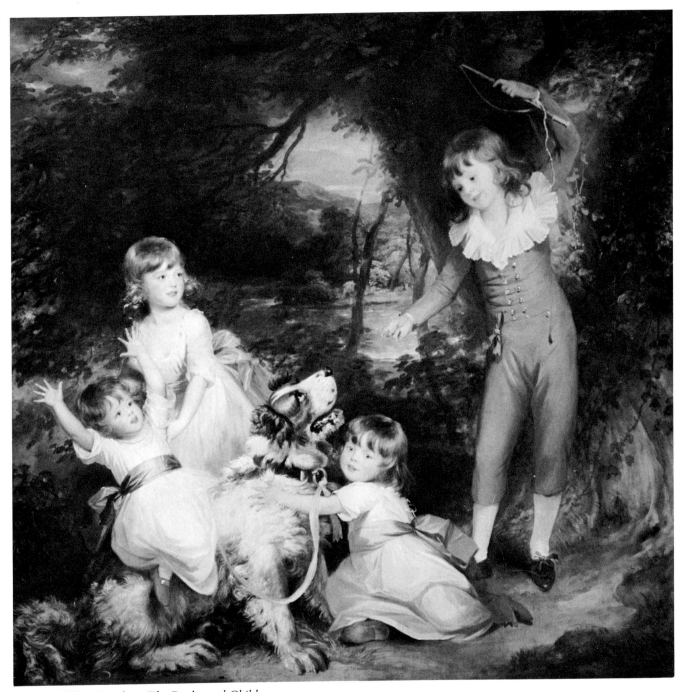

322. Sir William Beechey, *The Dashwood Children*

323. Sir Henry Raeburn, *Lady Janet Traill*

324. Sir Henry Raeburn, *Mrs. Bell*

325. Sir Henry Raeburn, *Miss Christina Thomson*

326. Sir Thomas Lawrence, *Sophia, Lady Valletort*

328. Sir Thomas Lawrence, *Lady Arundell*

327. Sir Thomas Lawrence,
 Sir Thomas Frankland

367

329. Sir Thomas Lawrence, *Lord Amherst*

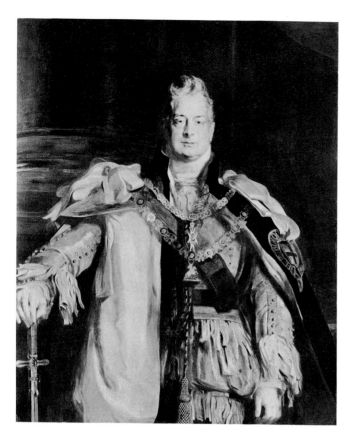

330. Sir David Wilkie,
William IV, King of England

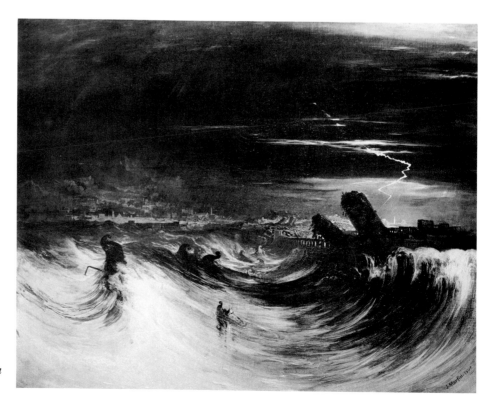

331. John Martin,
*The Destruction
of Tyre*

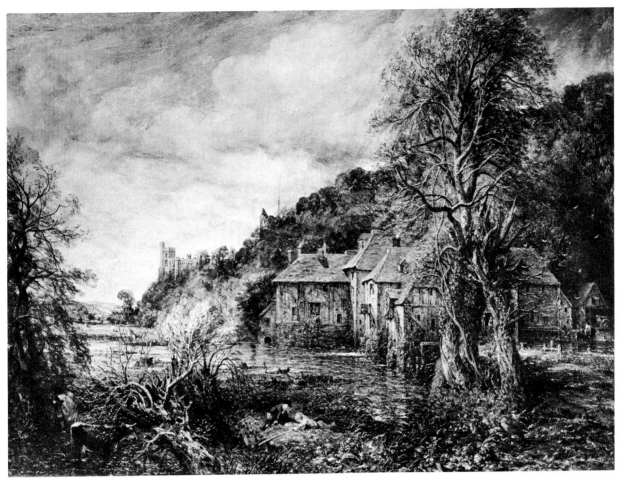

332. John Constable, *Arundel Mill and Castle*

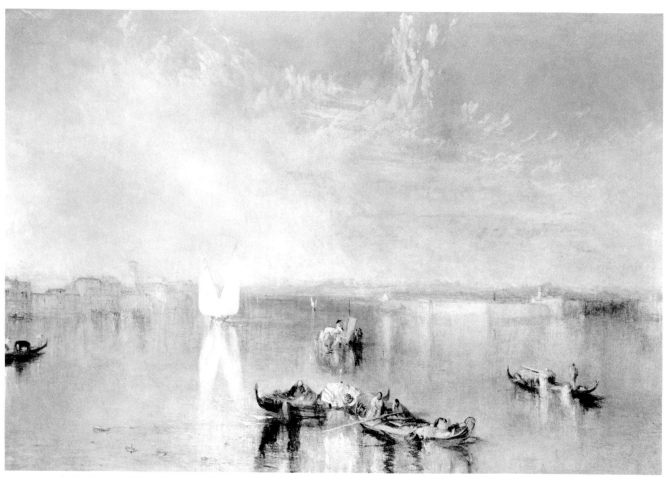

333. Joseph Mallord William Turner, *The Campo Santo, Venice*

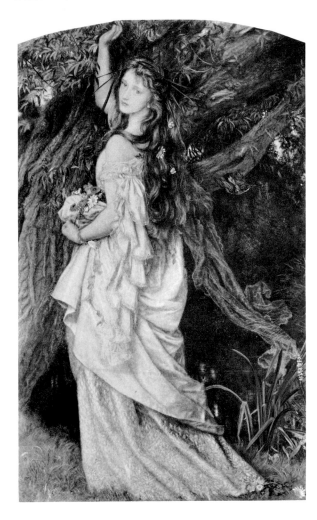

334. Arthur Hughes, *Ophelia*

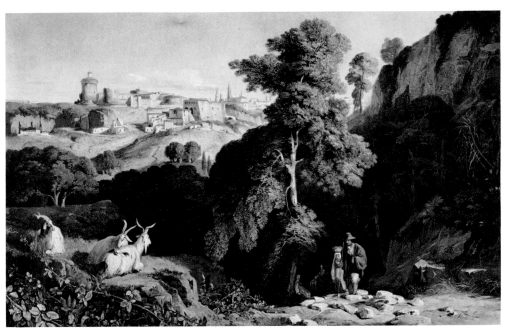

335. Edward Lear, *Venosa*

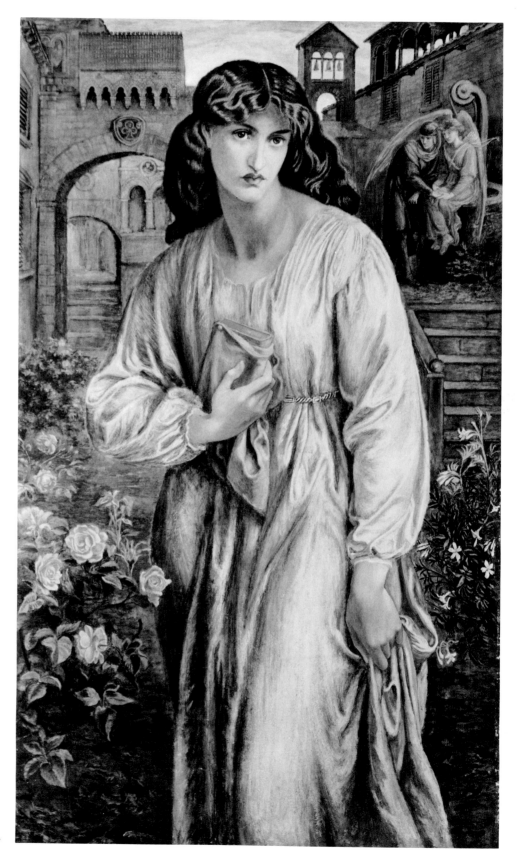

336. Dante Gabriel Rossetti,
The Salutation of Beatrice

337. Walter Greaves, *James Abbott McNeill Whistler*

338. Sir William Rothenstein,
The Painter Charles Conder

339. Sir Frank Brangwyn,
*The Golden Horn,
Constantinople*

340. Spencer Frederick Gore,
Mornington Crescent

341. Sir John Lavery,
Moonlight, Tetuan, Morocco

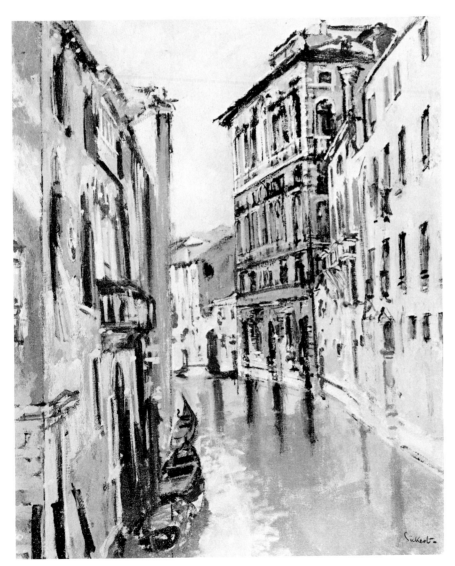

342. Walter Richard Sickert,
Rio di San Paolo, Venice

343. Philip de László,
Edward Drummond Libbey

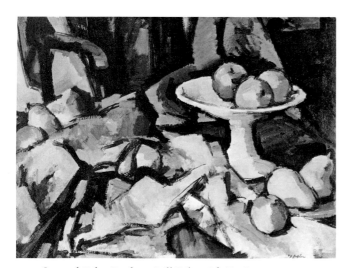

344. Samuel John Peploe, *Still Life with Fruit*

345. Paul Nash, *French Farm*

346. Christopher Wood,
Drying Nets, Tréboul Harbor

347. Augustus Edwin John,
Chrysanthemums

348. Duncan Grant, *A Sussex Farm*

349. John Tunnard, *Painting 1944*

350. William Scott, *Homage to Corot*

351. Graham Sutherland, *Thorn Trees*

352. Patrick Heron, *Pink Table with Lamp and Jug*

353. John Piper, *Rocky Valley, North Wales*

354. Ceri Richards, *Music Room*
(Composition in Red and Black)

355. Lord Methuen,
Brympton d'Evercy, Somerset

356. Alan Reynolds,
Cheveley Well, Suffolk

357. Ivon Hitchens, *Hut in Woodland*

358. Ivon Hitchens, *Arched Trees*

359. Ben Nicholson, *Ides of March*

Reserve Section

GIUSEPPE AJMONE 1923–. Italian.
Still Life, 1962
Oil on canvas
57⅜ x 44¾ in. (145.7 x 113.6 cm.)
Signed and dated lower right: Ajmone 62
Acc. no. 63.1
Museum Purchase Fund

NORMAN ALEXANDER 1915–. British.
Work in Progress, 1958
Oil on canvas
28 x 36 in. (71.1 x 91.4 cm.)
Acc. no. 58.39
Museum Purchase Fund

MAGDA ANDRADE. French.
Lagoon, ca. 1957
Oil on panel
25½ x 21¼ in. (64.7 x 54 cm.)
Signed lower left: Magda Andrade
Acc. no. 57.25
Museum Purchase Fund

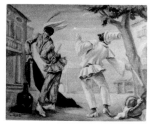

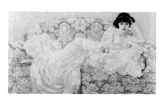

MARIANO ANDREU 1888–. Spanish.
Bastinadoes, 1934
Oil on mahogany board
17⅜ x 22⅛ in. (44 x 56 cm.)
Signed and dated lower left: Mariano
 Andreu/Juillet 34
Acc. no. 36.16
Museum Purchase Fund

HERMENGILDO ANGLADA-
CAMARASA 1873–1959. Spanish.
La Gata Rosa, ca. 1926
Oil on canvas
41 x 75 in. (104 x 191 cm.)
Signed lower right: H. Anglada-Camarasa
Acc. no. 31.15
Museum Purchase Fund

JOSEPH CLAUDE BAIL 1862–1921.
French.
Servants Lunching, ca. 1901
Oil on canvas
72¾ x 60⅜ in. (182.8 x 153.4 cm.)
Signed lower right: Bail Joseph
Acc. no. 26.87

ANDRÉ BICAT 1909–. British.
Portland Bill, ca. 1953
Oil on canvas
19½ x 23½ in. (49.5 x 59.7 cm.)
Acc. no. 53.126
Museum Purchase Fund

FERDINAND BOL 1616–1680. Dutch.
Portrait of a Man, ca. 1650
Oil on wood panel
33¾ x 25⅞ in. (85.7 x 65.6 cm.)
Acc. no. 26.65

PIERRE BOSCO 1909–. French.
Horse Race, 1956
Oil on canvas
23½ x 36 in. (59.7 x 91.4 cm.)
Signed lower right: Bosco
Acc. no. 57.28
Museum Purchase Fund

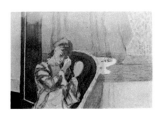

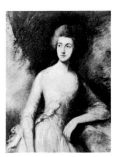

DENIS BOWEN 1921–. British.
Nocturnal Image, 1958
Oil on masonite
29 x 29 in. (73.6 x 73.6 cm.)
Inscribed on back of support: Nocturnal
 Image/Denis Bowen/58
Acc. no. 58.40
Museum Purchase Fund

MAURICE BRIANCHON 1899–. French.
Woman with a Mirror, 1956
Gouache, crayon and pencil on paper
14¼ x 21½ in. (36.8 x 54.5 cm.)
Signed lower right: Brianchon
Acc. no. 56.67
Museum Purchase Fund

BRITISH, ANONYMOUS
Mrs. Fischer (?), probably 18th century
Oil on canvas
42¾ x 34 in. (108.6 x 86.4 cm.)
Acc. no. 26.69

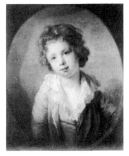

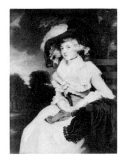

BRITISH, ANONYMOUS
Portrait of a Boy, late 18th century
Oil on canvas
24 x 20 in. (61 x 50.8 cm.)
Acc. no. 33.19
Gift of Arthur J. Secor

BRITISH, ANONYMOUS
Portrait of a Lady, probably 19th century
Oil on canvas
45⅞ x 35⅝ in. (155 x 90 cm.)
Acc. no. 33.33
Gift of Arthur J. Secor

BRITISH, ANONYMOUS
Market Cart, probably 18th century
Oil on canvas
28⅛ x 36 in. (71.5 x 91.4 cm.)
Acc. no. 33.163
Gift of Arthur J. Secor

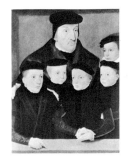

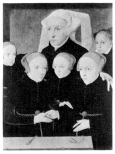

BARTHEL BRUYN THE YOUNGER
1530–1610. German.
Father and Sons, ca. 1570
Oil on wood panel
22½ x 17⅝ in. (57.2 x 44.2 cm.)
Acc. no. 26.52

BARTHEL BRUYN THE YOUNGER
1530–1610. German.
Mother and Daughters, ca. 1570
Oil on wood panel
22½ x 17¾ in. (57.2 x 45.2 cm.)
Acc. no. 26.73

BYZANTINE, ANONYMOUS
*The Old Testament Trinity (Abraham
Receiving the Angels),* probably 16th
century
Tempera on wood panel
Diameter: 6⅜ in. (16.2 cm.)
Acc. no. 48.73

388

BYZANTINE, CRETE
The Old Testament Trinity (Abraham Receiving the Angels), probably mid-17th century
Tempera on wood panel
15¼ x 33¼ in. (38.7 x 84.4 cm.)
Acc. no. 48.75

VALERIOS CALOUTSIS 1927–. Greek.
Formation II, 1960
Oil and plaster on canvas
63¾ x 45 in. (161.8 x 114.3 cm.)
Signed and dated lower left: V. Caloutsis 60
Inscribed on back: Valerios Caloutsis "Formation II" 1960
Acc. no. 61.31
Museum Purchase Fund

SPIRIDION CHRYSOLORAS 17th Century. Cretan.
The Baptism of Christ
Tempera on wood panel
25¾ x 24⅛ in. (65.4 x 61.2 cm.)
Signed lower left (in Greek characters): The hand of Spiridion Chrysoloras
Inscribed over Baptist's head (in Greek characters): The holy John; by Christ's head: The Baptism of Christ
Acc. no. 48.74

MARIE JOSEPH LEON CLAVEL, called Iwill 1850–1923. French.
La Boresca, Venice, ca. 1910
Oil on canvas
23 x 36 in. (58.4 x 91.4 cm.)
Signed lower left: Iwill
Acc. no. 11.24
Gift of Charles L. Borgmeyer

PRUNELLA CLOUGH 1919–. British.
Lorry with Ladder, ca. 1953
Oil on canvas
34½ x 25¾ in. (87.5 x 65.4 cm.)
Signed lower left: Clough
Acc. no. 53.132
Museum Purchase Fund

LUCIEN COUTAUD 1904–. French.
Allegory with Boats
Gouache on paper
19 x 24 in. (48.3 x 61 cm.)
Signed lower left: L. Coutaud
Acc. no. 32.11
Museum Purchase Fund

JACQUES-LOUIS DAVID, Follower of French.
Portrait of a Man, after 1818 (date on book)
Oil on canvas
46 x 35 in. (116.8 x 88.9 cm.)
Acc. no. 24.33
Gift of Arthur J. Secor

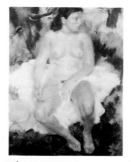

LÉON DEVOS 1897–. Belgian.
Susanna at the Bath, 1935
Oil on canvas
57⅞ x 47 in. (149.7 x 119.3 cm.)
Signed upper left: Leon Devos
Acc. no. 36.13
Museum Purchase Fund

JEF DIEDEREN 1920–. Dutch.
Summer, 1955
Oil on canvas
51¾ x 72⅜ in. (131.5 x 183.8 cm.)
Acc. no. 58.10
Museum Purchase Fund

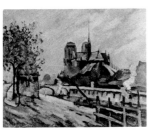

PIERRE DUMONT 1884–1936. French.
Notre Dame from the Left Bank, 1920s
Oil on canvas
28¼ x 36 in. (71.6 x 91.4 cm.)
Signed lower right: Dumont
Acc. no. 54.42
Museum Purchase Fund

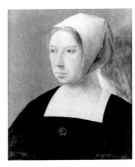

DUTCH, ANONYMOUS
Portrait of a Woman, early 16th century
Oil on wood panel
12⅝ x 10⅜ in. (32 x 27 cm.)
Acc. no. 36.1

ANTHONY VAN DYCK, After
Flemish.
Saint Martin Sharing his Mantle
Oil on wood panel
25¼ x 19¾ in. (64.1 x 50.2 cm.)
Acc. no. 19.39
Gift of Charles Léon Cardon

MERLYN OLIVER EVANS
1910–. British.
Interior with Red and Green, 1952
Oil on canvas
40 x 30 in. (101.6 x 76.2 cm.)
Signed and dated lower left: Evans 52
Acc. no. 53.128
Museum Purchase Fund

PAUL FEILER 1918–. British.
Near Lamorna, 1952
Oil on canvas
25¼ x 30 in. (64.1 x 76.2 cm.)
Signed and dated lower right: Feiler 52
Acc. no. 53.131
Museum Purchase Fund

GUSTAV ADOLF FJAESTAD
1868–1948. Swedish.
Silence: Winter, 1914
Oil on canvas
58 x 72 in. (147 x 183 cm.)
Signed and dated lower right: G. Fjaestad,
1914,/Värmland
Acc. no. 14.119

NILS FORSBERG 1842–1934. Swedish.
Potter at Saint-Amand, 1907
Oil on canvas
51 x 63½ in. (127 x 161 cm.)
Signed and dated lower right: Nils 1907
Acc. no. 07.2
Museum Purchase Fund

WILLIAM GEAR 1915–. British.
Summer Landscape, 1951
Oil on canvas
29¼ x 24¼ in. (74.3 x 61.6 cm.)
Signed and dated lower right: Gear 51
Acc. no. 53.133
Museum Purchase Fund

ARNOLD MARC GORTER
1866–1933. Dutch.
Apple Blossoms
Oil on canvas
39¼ x 53 in. (99.7 x 134.6 cm.)
Signed lower right: A. M. Gorter
Acc. no. 16.46

GIUSEPPE DE GREGORIO
1920–. Italian.
Cold Light, 1963
Oil on canvas
39⅜ x 31½ in.(100 x 80 cm.)
Signed lower center: DE GREGORIO
Acc. no. 64.132
Gift of Mr. and Mrs. W. W. Knight, Jr.

JULES ALEXANDER GRÜN
1868–1934. French.
Effet de Lumière, ca. 1907
Oil on canvas
58½ x 45 in. (148.5 x 114.3 cm.)
Signed lower right: Grün
Acc. no. 07.3
Gift of Frederick B. Shoemaker

TOMÁS HARRIS 1908–. British.
Almond Trees, Majorca, 1954
Oil on canvas
28¼ x 22 in. (71.7 x 55.8 cm.)
Dated lower left: 19-1-54
Acc. no. 54.75
Museum Purchase Fund

EUGEN HETTICH 1848–1888. German.
The Woodlands, 1875
Oil on canvas
35⅝ x 55¾ in. (90.5 x 141.6 cm.)
Signed and dated lower left: E. Hettich
 1875
Acc. no. 06.267
Gift of Mrs. John B. Bell

EDGAR IENÉ 1904–. French.
Castle Courtyard, 1957
Oil on canvas
21⅝ x 23⅝ in. (55 x 65 cm.)
Signed and dated lower left: E. Iené 57
Acc. no. 58.24
Museum Purchase Fund

ITALIAN, ANONYMOUS
Head of an Angel, 17th century
Oil on canvas
23½ x 19½ in. (59.7 x 49.5 cm.)
Acc. no. 25.48

ITALIAN, ANONYMOUS
Head of a Bishop, 17th century
Oil on canvas
20½ x 16 in. (52 x 40.6 cm.)
Acc. no. 25.1135

ITALIAN, ANONYMOUS
Madonna and Child, 16th century
Tempera on wood panel
20½ x 16 in. (52 x 40.6 cm.)
Acc. no. 26.56

ITALIAN, ANONYMOUS
The Holy Family with Angels,
late 15th century
Tempera on wood panel
Diameter: 36½ in. (92.7 cm.)
Acc. no. 26.72

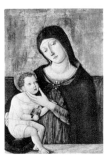

ITALIAN, ANONYMOUS
Madonna and Child, late 14th–
early 15th century
Tempera on wood panel
25 x 18 in. (63.5 x 45.7 cm.)
Acc. no. 26.83

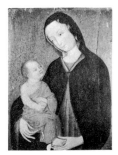

ITALIAN, POSSIBLY SIENA
Madonna and Child, 15th century
Tempera on wood panel
19 x 14 in. (48.2 x 35.5 cm.)
Acc. no. 26.84

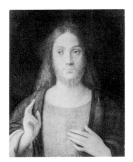

ITALIAN, PROBABLY VENICE
Head of Christ, 16th century
Tempera on wood panel
23½ x 18½ in. (59.7 x 47 cm.)
Acc. no. 26.156

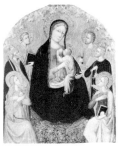

ITALIAN, POSSIBLY FLORENCE
Madonna and Child with Saints,
early 15th century
Tempera on wood panel
15¾ x 13 in. (40 x 33 cm.)
Acc. no. 35.45
Gift of Florence Scott Libbey

ALEXANDER JACOVLEFF
1887–1938. Russian.
Madonna of the Grotto, 1936
Gouache on paper
12 x 18 in. (30.5 x 45.6 cm.)
Signed and dated lower left: A. Jacovleff
 Mexico 1936
Acc. no. 49.103
Gift of Charles E. Feinberg

PIERRE JÉRÔME 1905–. French.
Bunch of Flowers, ca. 1947
Oil on canvas
25½ x 19¾ in. (64.7 x 50.2 cm.)
Signed lower right: P. Jerome
Acc. no. 49.101

KARL N. KAHL 1873–?. Russian.
The Old Mill, ca. 1903
Oil on canvas
32 x 24 in. (81.3 x 61 cm.)
Signed lower right: K. N. Kahl
Acc. no. 06.248
Gift of Wednesday Art History Club

KARL N. KAHL 1873–?. Russian.
End of a Summer Day, ca. 1903
Oil on canvas
27 x 42 in. (68.6 x 106.6 cm.)
Signed lower right: K. Kahl F (?)
Acc. no. 06.249
Gift of Robinson Locke

A. A. KOUDRIAVTSEFF. Russian.
The Fishermen, 1904
Oil on canvas
40 x 55 in. (101.6 x 139.8 cm.)
Signed and dated lower left in Cyrillic:
 A. Koudriavtseff 04
Acc. no. 06.246
Gift of A. M. Chesbrough

ANDRÉ MIKHAILOVITCH LANSKOY
1902–. French.
Objects on Snow, 1944
Oil on canvas
31⅞ x 45⅝ in. (80.8 x 115.7 cm.)
Signed lower right: Lanskoy
Stencilled on stretcher: OBJETS SUR LA
 NEIGE
Acc. no. 49.112

GASTON LARRIEU 1912–. French.
Landscape, ca. 1958
Oil on canvas
25½ x 36⅛ in. (64.8 x 91.6 cm.)
Signed lower right: Gaston Larrieu
Acc. no. 58.25
Museum Purchase Fund

GASTON LA TOUCHE
1854–1913. French.
In the Garden, 1902
Oil on canvas
44 x 40 in. (111.8 x 101.6 cm.)
Signed and dated lower right: Gaston La
 Touche St. C. 02
Acc. no. 26.149
Gift of Miss Elsie C. Mershon, in memory
 of Edward C. Mershon

ROBERT MACBRYDE 1913–. British.
Still Life with Cucumbers, ca. 1949
Oil on canvas
22 x 16 in. (55.8 x 40.6 cm.)
Signed upper left: MacBryde
Acc. no. 50.257
Museum Purchase Fund

DANIEL MACLISE 1806–1870. British.
The Standard Bearer
Oil on canvas
31 x 26 in. (78.7 x 66 cm.)
Acc. no. 05.4
Gift of Carlton T. Chapman

NICOLAES MAES 1634–1693. Dutch.
At the Fountain, 1670
Oil on canvas
45½ x 34¼ in. (115.6 x 87 cm.)
Signed and dated lower left: N. Maes/1670
Acc. no. 24.57
Gift of Arthur J. Secor

MASTER OF THE PANZANO
TRIPTYCH active ca. 1365–1380. Italian.
Saint Anthony of Padua
Tempera on wood panel
44 x 15⅜ in. (111.7 x 39 cm.)
Acc. no. 25.107
Gift of Paul Reinhardt in memory of his
 father Henry Reinhardt

EDWARD MIDDLEDITCH
1923–. British.
Winter, 1960
Oil on canvas
102½ x 82½ in. (260.3 x 208.3 cm.)
Acc. no. 60.25
Museum Purchase Fund

JEAN-FRANÇOIS MILLET,
after 1814–1875. French.
The Gleaner
Oil on wood panel
23¾ x 14¾ in. (58.4 x 37.5 cm.)
Inscribed lower right: J. F. Millet
Acc. no. 33.22
Gift of Arthur J. Secor

ABRAHAM MINTCHINE
1898–1931. French.
Market, Place d'Alleray, Paris
Oil on canvas
35 x 45½ in. (88.9 x 115.5 cm.)
Signed lower right center: A. Mintchine
Acc. no. 30.208
Museum Purchase Fund

JOSEPH MOMPOU 1888–. Spanish.
The Shore, 1932
Oil on canvas
25⅞ x 32 in. (65.7 x 81.3 cm.)
Signed lower right: Mompou
Inscribed verso: J. Mompou 1932
Acc. no. 34.50
Museum Purchase Fund

WINIFRED NICHOLSON
1893–. British.
Lilies and Moonlight, 1930
Oil on canvas
25 x 30 in. (63.5 x 76.2 cm.)
Signed and dated verso: Winifred
 Nicholson 1930
Acc. no. 50.259
Museum Purchase Fund

FRIEDRICH OFFERMAN
1859–1913. Dutch.
The Violin Mender
Oil on canvas
20½ x 16 in. (52.2 x 40.6 cm.)
Signed lower right: F. Offerman
Acc. no. 25.39

ROLAND OUDOT 1897–. French.
Ceres, ca. 1935
Oil on canvas
39⅝ x 24¼ in. (100.6 x 61.5 cm.)
Signed lower left: Roland Oudot
Acc. no. 36.15
Museum Purchase Fund

ROLAND OUDOT 1897–. French.
Coste Bonne Farm at Eygalières, ca. 1962
Oil on canvas
21¼ x 31⅞ in. (54 x 80.7 cm.)
Signed lower right: Roland Oudot
Acc. no. 62.72
Gift of Harold Boeschenstein

BENJAMIN N. POPOFF 1832–. Russian.
The Weaver, 1897
Oil on canvas
26 x 18 in. (66 x 45.8 cm.)
Dated upper right in Cyrillic: 97
Acc. no. 06.242
Gift of Harry E. King

VALENTINE HENRIETTE PRAX
1899–. French.
Allegory with Three People, 1930
Oil on canvas
45½ x 39 in. (115.6 x 99.1 cm.)
Signed and dated lower right: V. Prax 30
Acc. no. 32.6
Museum Purchase Fund

PEDRO PRUNA 1904–. Spanish.
Alice Roullier, 1926
Pastel and pencil on paper
24½ x 18½ in. (62.2 x 47 cm.)
Signed and dated lower right: Pruna,
 Paris 1926
Acc. no. 53.37
Gift of Alice Roullier

HUBERT ROBERT 1733–1808. French.
The Ponte Lucano and Tomb of the Plautii, 1794/95
Oil on canvas
32¼ x 25½ in. (81.8 x 64.8 cm.)
Signed and dated lower right: H. Robert/ 1795 (4?)
Acc. no. 45.24
Gift of Mrs. C. Lockhart McKelvy

HENRIETTE KNIP RONNER 1821–1909. Belgian.
Kittens, 1893
Oil on wood panel
12½ x 15½ in. (31.7 x 39.4 cm.)
Signed and dated upper left: Henriette Ronner 93
Acc. no. 33.16
Gift of Florence Scott Libbey

PETER PAUL RUBENS, Follower of Flemish.
Landscape with a Wagon
Oil on wood panel
16⅞ x 24½ in. (42.8 x 62.2 cm.)
Acc. no. 54.57

PIERO RUGGERI 1930–. Italian.
Figure, 1962
Oil on canvas
71 x 63 in. (180.4 x 160 cm.)
Signed left center: Ruggeri
Inscribed verso: Ruggeri, Figura 1962
Acc. no. 63.2
Museum Purchase Fund

PAVEL D. SCHMAROFF 1874–?. Russian.
Lady in the Carriage
Oil on canvas
57 x 74 in. (144.8 x 187.9 cm.)
Dated lower right in Cyrillic: 190 ?
Acc. no. 06.243
Gift of A. M. Chesbrough

S. M. SEIDENBERG. Russian.
The Plowers, ca. 1903
Oil on canvas
64 x 93 in. (162.6 x 236.2 cm.)
Signed lower left with monogram in Cyrillic
Acc. no. 06.244
Gift of Albion E. Lang

GINO SEVERINI 1883–1966. Italian.
Composition, ca. 1938
Gouache on paper
19⅝ x 24 in. (49.9 x 61 cm.)
Signed lower right: G. Severini
Acc. no. 38.82
Museum Purchase Fund

ANDRÉ VOLTEN 1920–. Dutch.
Composition 7, 1955
Oil on canvas
39¼ x 51 in. (99.6 x 129.5 cm.)
Signed and dated verso: andré volten 7–1955
Acc. no. 58.11
Museum Purchase Fund

CZESLAW WDOWISZEWSKI 1901–. Polish.
Still Life, 1931
Oil on wood panel
17⅜ x 21⅜ in. (44.1 x 54.3 cm.)
Signed and dated lower left: Czeslaw Wdowiszewski 1931
Acc. no. 34.48
Museum Purchase Fund